Celebrating Moore
Works from the Collection of The Henry Moore Foundation

Introduction by
David Mitchinson

Foreword by
Alan Bowness

Contributions from
Julian Andrews
Roger Berthoud
Giovanni Carandente
Frances Carey
Anthony Caro
David Cohen
Susan Compton
Richard Cork
Penelope Curtis
Deborah Emont-Scott
Anita Feldman Bennet
Terry Friedman
Gail Gelburd
Clare Hillman
Phillip King
Christa Lichtenstern
Norbert Lynton
Bernard Meadows
Peter Murray
William Packer
John Read
Reinhard Rudolph
Julian Stallabrass
Julie Summers
Alan Wilkinson

University of California Press
Berkeley Los Angeles London

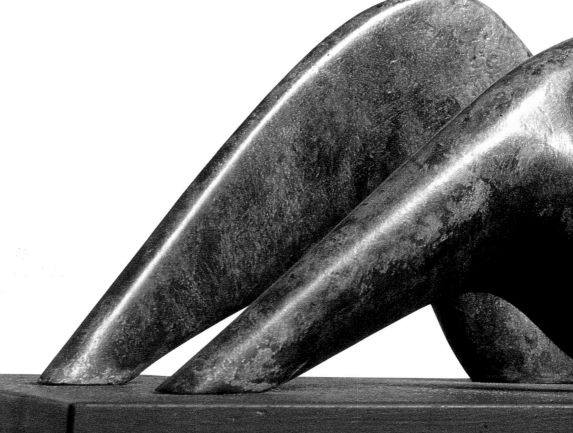

Works from the Collection of
The Henry Moore Foundation

Selected by David Mitchinson

Celebrating Moore

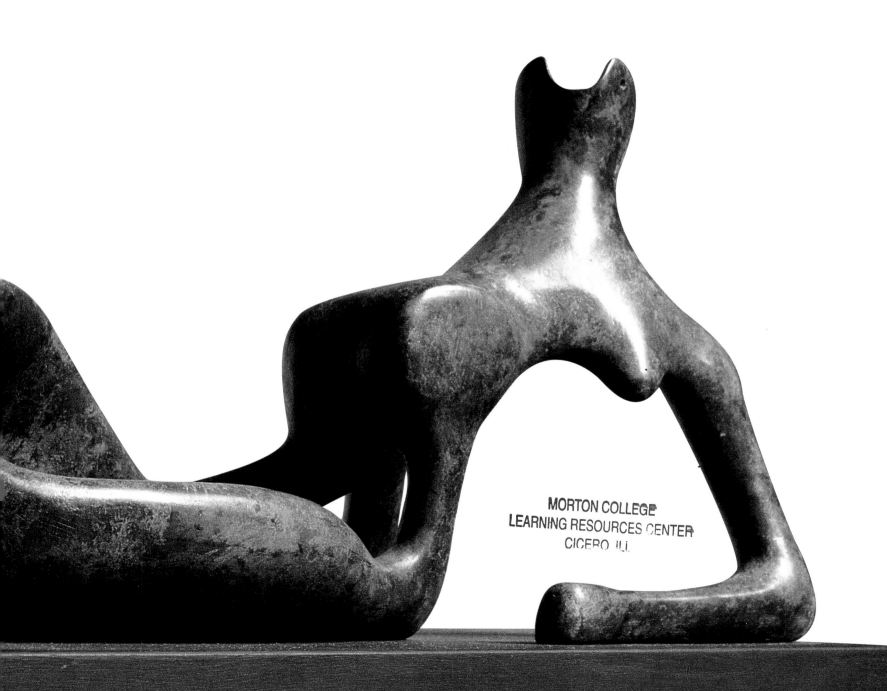

University of California Press
Berkeley and Los Angeles, California

University of California Press, Ltd.
London, England

Published by arrangement with Lund Humphries Publishers Ltd.

Celebrating Moore © 1998 The Henry Moore Foundation
Texts © 1998 the authors

ISBN 0-520-21670-9 (CLOTH)

Designed by Tim Harvey

Printed and bound in Singapore
under the supervision of MRM Graphics

9 8 7 6 5 4 3 2 1

Contents

Henry and Irina Moore

Foreword

Henry Moore was born on 30 July 1898. This book celebrates his centenary by documenting the remarkable and extensive collection of the Foundation that bears his name. It is, however, a very unusual catalogue of a collection. No fewer than twenty-five authors have contributed texts, and the Foundation's curator, David Mitchinson, has written a long introduction which, though not a history of the Foundation, tells us much about that story while tracing the growth and use of the Collection.

Henry Moore talked well, and liked talking about sculpture, but he rarely gave any verbal explanation of his own works. That was for others to do: he was the man who had made the piece and put it out in the world. I think he believed that, like all great art, his best works were open to multiple interpretation. This is the form that the catalogue takes – twenty-five sculptors, art historians, critics, curators, and film makers write about sculptures and drawings that particularly interest them. Contributors range from Bernard Meadows, who worked for Moore in the 1930s, to the new generation of critics who never knew Moore personally, with well-established and deeply knowledgeable writers on Moore adding strength and authority with their evaluations. There is much richness and fascination here, even the occasional repetition, contradiction or uncertainty about exact date. The tone of voice is often personal – Anthony Caro on the original plasters which he helped to make, or Alan Wilkinson on the sketchbook pages which he discussed in detail with Moore twenty-five years ago.

The Collection began in a remarkably unplanned way, and remains somewhat unbalanced. This will always be the case, largely because of Moore's own generous donations to the Tate Gallery in London and the Art Gallery of Ontario in Toronto. Nevertheless, it must be the largest and most comprehensive single-artist collection ever made. Over a sixty-five year working life Moore produced more than 1000 sculptures. Since most were cast in small editions of 3 to 9, it was possible for him to keep an artist's copy, many of which were made over to the Foundation. Of about 5500 drawings,

nearly 2580 belong to the Foundation, including most of the sketchbooks. Inevitably some periods are poorly represented, but sales of late drawings have permitted major acquisitions, and the worst gaps are slowly being filled. The graphics collection is essentially complete: a total of 719 discrete works , with many unique proofs bringing the number of items owned by the Foundation in this category to 8200.

The idea that the Foundation should have such an extensive collection of his work was Moore's own. He wanted people to be able to see his work to the best advantage, as his own careful placing of sculpture at Perry Green showed. Access to his work was, he thought, best achieved by travelling exhibitions, of the kind that the British Council had pioneered from the 1940s onwards. David Mitchinson's detailed account of the exhibition programme carried out by the Foundation, particularly since Moore's death on 31 August 1986, shows that his ambitions have been realised. Recent exhibitions have generally been on a special aspect of his work, or in countries where it has never before been seen. Some were large, some quite small. This was a deliberate decision on the part of the Foundation's Trustees, and even for the centenary year celebratory exhibitions are modest. Over-familiarity, particularly of the bronzes and graphics produced in large numbers in his later years, has tended to leave the general public with a one-sided view of the totality of Moore's achievement, which the present volume may, we hope, help to correct.

As is clear from the text that follows, this is David Mitchinson's book. Nobody has a deeper and more encyclopaedic knowledge of Moore's art in the three media in which he worked – sculpture, drawings and, especially, graphics. The concept of the publication is his, and it stands as a splendid record of his thirty years' service, first as artistic assistant to Moore personally, and then to Moore studies generally.

Alan Bowness

Acknowledgements

To all those who accepted my invitation to contribute to this book their expert knowledge or personal reminiscences concerning Henry Moore, my sincere thanks – working with twenty-five authors was both a challenge and a great pleasure. A second publication could certainly be made discussing how each contributor came to make his or her choice of which drawings or sculptures to write about.

Over many years the Trustees, Director and staff of the Henry Moore Foundation have been most supportive of this book, now published on the occasion of the artist's centenary year. There are also a number of friends and colleagues whom I would like to acknowledge individually.

First as Director, and latterly as a Trustee, Sir Alan Bowness remained constantly encouraging, and I am most grateful for his agreement to write the book's foreword. Those I must thank for enlightening me on certain areas of the story which had previously been a mystery are Margaret McLeod, another of the Foundation's Trustees; its Consultant, Bernard Meadows; two of the Foundation's sculptor conservators who both worked with Moore for many years, John Farnham and Malcolm Woodward; Alan Wilkinson, the former Curator of the Moore Centre at the Art Gallery of Ontario, Toronto; and Diana Eccles, Curator of the British Council Collection in London.

Those involved in photography are mentioned elsewhere but I wish to extend a personal thanks to Michel Muller, who also worked with Moore over a long period, for taking by far the largest number of photographs used in the book, many specifically for it and several under very difficult circumstances. In connection with photography I would also like to thank Angie de Courcy Bower who put the archive of the Yorkshire Sculpture Park at my disposal, and the Foundation's Curatorial Assistant, Emma Stower, for maintaining the selection of colour transparencies in order and not allowing any of it to disappear for other publications. Geoff Robinson organised the movement of sculpture for photography around Perry Green, both on the Foundation's land and on that of our neighbours, John and Robert Prior and the Findlay brothers, whose help was much appreciated.

The Foundation's former Deputy Curator, Julie Summers, made great use of her tape recorder in taking interviews, and Peter Barber and Stefania Bonelli kindly translated texts which originated in German or Italian.

Preparation and co-ordination of the manuscripts and extensive research was undertaken by the Foundation's Librarian, Martin Davis, ably assisted by Janet Iliffe and Jackie Curran – to all three I am hugely indebted. Anita Feldman Bennet and Reinhard Rudolph covered and stood in for me when my preoccupation with the book meant absence from other areas of the Foundation's programme. I was also lucky that Brian Moore was always around to listen.

My concept for the book originated in 1990 and the following year I asked Tim Harvey if he would design such a publication were it ever to come about. I must thank Tim, not only for his patience but also for the sensitive manner in which he has handled all aspects of design and production. As editor, Angela Dyer has made sense of a bewildering multiplicity of written styles and turned pages of disparate text into a readable whole.

Once again I would like to thank John Taylor for his enthusiasm and understanding in accepting an idea and turning it into reality, and Lucy Myers who, on behalf of the publishers, dealt with all matters technical, while at the same time maintaining an interest in the contents of the book.

Finally I want to remember all those who were responsible for creating and then enlarging the Collection of the Henry Moore Foundation, and to thank those who have taken responsibility for it and worked to support and further its presentation to a world-wide audience.

David Mitchinson
Curator
The Henry Moore Foundation

Using the Book

Selection

This publication is not intended as a catalogue of the Henry Moore Foundation's Collection. It is a selection chosen by the Foundation's Curator, from over 12,000 items, to illustrate the diversity and range of the artist's output from a working life of more than sixty years. Many of the pieces are well known, others have been little exhibited and seldom seen in books or catalogues.

Where the Collection has the same sculpture in more than one size, or in different materials, the selection has generally been of the final or largest version and the most permanent material, with over life-size works being included in preference to maquettes and working models, and bronze casts taking precedence over the original plasters.

Contributors

The contributors have only one thing in common – at some past moment each has been involved with the work of Henry Moore or the programme of the Foundation, through writing, exhibitions, or working as an assistant.

Entries

Dating of works follows that of the catalogues raisonnés (see Bibliography p.353). Details of notebooks are given only where they remain extant or have been reconstituted.

Information pertaining to the signature of bronze sculpture is relevant to the cast illustrated, as are the details of exhibitions and loans.

Details of edition sizes, whether or not artist's copies exist, and the name of the foundry at which works were cast are given, though the foundry name applies only to the cast in the Collection since Moore sometimes changed foundries during the casting of an edition.

Cross references to catalogue numbers in this book are given in square brackets; references to works in other publications are in parentheses.

Exhibitions and loans

Reference to exhibitions commences from the time a work was acquired for the Collection, and is given in abbreviated form within the entries, by city, date and catalogue number. Venues are named only when more than one exhibition was held in the same city during the same year. Full information on exhibitions is to be found on pp.350-52, where the publishers of exhibition catalogues are named only if they differ from the exhibition venues.

Details of loans of individual works are given in full.

Publications

Reference to publications, other than exhibition catalogues, is given in abbreviated form within the entries, commencing from the time a work was acquired for the Collection. Full information is to be found in the Bibliography on p.353.

Footnotes

The same abbreviated format for exhibitions and publications has been used for the most frequently quoted references, only the more obscure titles being fully described under each entry.

Plates

All illustrations of sculpture in landscape are photographed at Perry Green unless otherwise indicated in the caption.

Abbreviations

LH Lund Humphries catalogue raisonné numbers for sculptures (see Bibliography p.353)

HMF Henry Moore Foundation archive numbers for drawings (see Bibliography for those volumes already published of the Lund Humphries catalogue raisonné of drawings)

CGM Cramer, Grant, Mitchinson catalogue raisonné numbers for graphics (see Bibliography p.353)

TAP Henry Moore Foundation archive numbers for tapestries

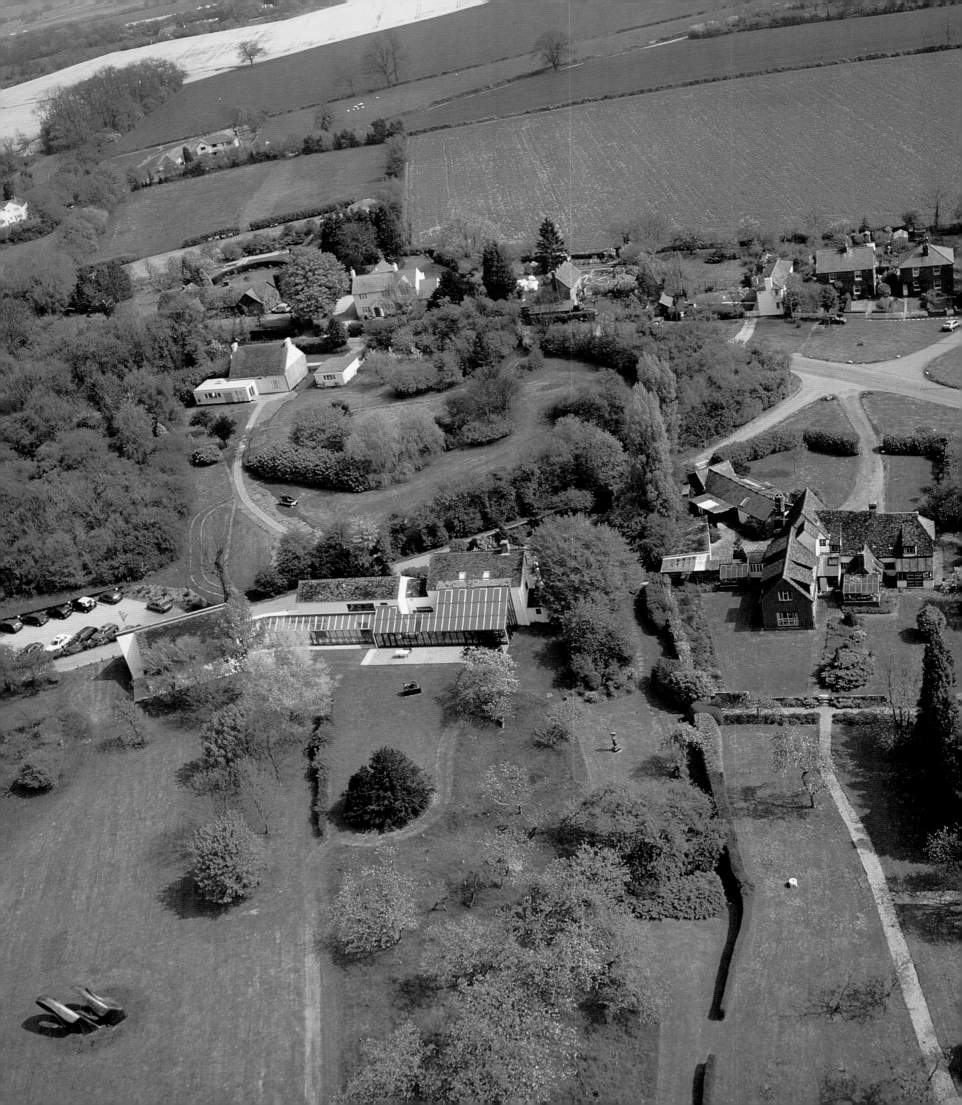

The Henry Moore Foundation's Collection

David Mitchinson

To celebrate the one hundredth birthday of Henry Moore, it seems appropriate to tell the story behind the formation of the greatest collection of his work. Its creation was a peculiarly English affair which could have happened the same way nowhere else. It all began in 1977 with a major gift of work from the artist – but why those particular works and not others, why was the Collection strong in some areas and meagre elsewhere, and how has it been altered and strengthened since? To recall the story of the Collection is not to write a history of the Foundation, that must come later; but as twenty-one years have passed and the Collection remains central to much of the Foundation's programme, it is time to account for what has been achieved and reflect on that which still needs to be done. Before examining the events of 1976-77 relevant to the Collection's origins, some review of what had gone before is necessary.

Perry Green before the Foundation

To the north of London, in the county of Hertfordshire just off the main roads from London to Cambridge, lies the village of Much Hadham, an area of continuous habitation since Roman times.[1] A little to the east, situated on rising ground above the village, is the hamlet of Perry Green. During Moore's lifetime and prior to the creation of the Foundation his estate at Perry Green existed for one prime purpose, production. Everything else was secondary. The Moores had moved to Perry Green in 1941 after their London home sustained damage in the blitz. They bought the house, Hoglands [fig.2], and over the next thirty years created for themselves a micro-world of small unassuming studios scattered across twenty-five hectares of the countryside, transforming part into semi-formal gardens of mown lawns with large shrub beds, while retaining the rest as meadow and pasture for grazing sheep. The Moores' only child, Mary, grew up there, sculpture assistants came and went, and any

...

1. Bryan Smalley, *A Short History of Much Hadham*, published by its author in 1995, gives a detailed account of the area.

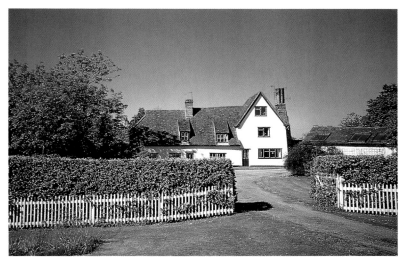

Fig.2. The front of Hoglands as seen from the road running through Perry Green.

casual observer passing along the winding country road that runs within a few metres of the house would have thought Perry Green no different from hundreds of similar hamlets spread over southern England. But different it was. By 1976 nine studios had been constructed, all were functioning and more were needed. Activity was everywhere.

The studios were not grand; they were unprepossessing but easily adaptable, draughty and often cold, but serviceable and with good light. Closest to Hoglands was the House or Top Studio, a converted stable and Moore's original working area at Perry Green where all the immediate post-war carvings had been made. By then it had been partially abandoned to one of the sculpture assistants, John Farnham, who used the space to receive small and medium-sized bronze casts returning from the foundries and as a despatch area for works sold. Patination, cleaning and the numbering and signing of casts also took place there. Moore still kept his rickety wooden tripod in the studio and as the light was excellent used the centre of the room for photographing new work, a task he preferred to undertake himself rather than to delegate. Being so conveniently sited adjacent to the house this studio also

opposite: fig.1. Aerial view of Perry Green with the Foundation's headquarters Dane Tree House in the centre and the Moores' home, Hoglands, to the right.

Perry Green before the Foundation 11

provided Moore with the perfect setting to which to bring prospective clients intent on viewing the latest casts. Selling was a piece of theatre, a performance, but one Moore also preferred to do himself, at least so far as sculpture was concerned, since he set the prices. Graphics were more complicated, as dealers habitually wanted to buy in quantity. This would involve making copious lists and trying to remember all the titles, an activity Moore felt far better left to others.

Tucked away inconspicuously behind the Top Studio in a little room that had once been the village shop was Moore's original Maquette Studio. By the early 1970s its contents of plasters and found objects – bones, flints, roots, shells and other natural detritus – had been moved to a recently built studio further down the estate. Into the emptied space had come a proofing press and all the paraphernalia associated with the etching process. Moore had worked on the plates of the **Elephant Skull Album** 1969-70 (CGM 109-146) in the room while it was still full of sculpture, but having no press had had to wait to see the results. For **Sheep Album** 1972 and 1974 (CGM 196-201, 225-235), and for other etchings which Moore continued to produce into the 1980s, the press became a useful means of obtaining proofs of states before the etching plates were sent to London or Paris to be editioned.

Opposite Hoglands, on the other side of the green, was a small farmyard housing a group of buildings of differing sizes which functioned as workshops and storage spaces. The largest of these contained the crated sculptures that made up the bulk of the family collections. Carvings, bronze casts and a few plasters of medium size which had been out on exhibition would return there. The yard was also the depot for all transport movements and was occasionally brought into use as an outdoor work area when the studios proved too small or overcrowded. Until 1968 all the large sculptures intended to be cast in bronze were first made in plaster, built up on a wood or metal armature. The last to be constructed in this way was **Three Piece Sculpture: Vertebrae** 1968-69 (LH 580). This immensely heavy original was sent to the Noack Foundry in Berlin for casting and had arrived damaged. Time and money were lost on repair, Moore was not pleased. Taking advice from a former assistant, Derek Howarth, he began to experiment with newer, more recently available materials: first with

polyurethane for the large version of **Oval with Points** 1968-70 (LH 596) and then with polystyrene for everything else. Lightness and manoeuvrability of material were soon to have their effect. Enlargements went up in size. Not only were new sculptures constructed to a monumental scale but older ideas were re-examined and larger versions of some produced. The farmyard was turned into a building site in 1969, complete with scaffolding and hoists, for the enlargement of **The Arch** (LH 503b). Its polystyrene original was given a partial coating of plaster to create rigidity and to allow for the addition of surface markings and texture. Later, other enlargements, for example **Draped Reclining Mother and Baby** 1983 (LH 822), were shaped out of polystyrene from which a plaster cast was taken. On this further details and refinements were made before it served as the original for the casting of the bronze edition.

Vehicular access to the gardens and studios that lay behind Hoglands was by a narrow estate road. This left Perry Green at a point beyond the semi-detached house that abutted Hoglands to the left. Of this pair of houses, Gildmore and Muirfield, the former had been bought by the Moores in the early 1970s as a residence for their housekeeper, the latter was still privately owned but would be purchased by the Foundation at a later date. A practical advantage in acquiring Gildmore was that it had two outbuildings at the bottom of its grounds at the junction where the garden path leading down from Hoglands ran into the estate road. Here was a new ready-made workshop in fairly close proximity to the house that could be brought into even closer contact by the removal of part of the hedge separating the two properties, so as to make it easily accessible by car. Moore quickly established the larger workshop as his graphics studio, for drawing and lithography, and in 1975 converted the smaller to another maquette studio. Gildmore Studios would remain Moore's preferred working space to the end of his life.

Continuing beyond Gildmore Studios the road ran in a straight line through the main garden, so carefully designed by Irina Moore to provide the perfect setting for her husband's work, to a small building called Bourne Cottage, named after the stream which marked the left-hand border of the property. Although the house occupied a position at the centre of the estate, it played little part in events other than to provide an idyllic home to one of the gardeners. The

Fig.3. Part of the main garden leading to Bourne Cottage with a fibreglass cast of **Locking Piece** 1963-64 (LH 515).

Fig.4. Moore at work on the polystyrene of **Hill Arches** 1973 [see cat.232].

land in front of it, however, was central to an understanding of who was Henry Moore [fig.3]. The views of the sculpture in landscape seen from strolling down this path were, and remain to this day, as fine as any found in permanent sitings or temporary exhibitions around the world and go a long way to explaining Moore's affinity with nature. This was after all a view he could see every day. Yet nothing in this landscape was ever permanent, planting continued, trees died or were blown away, the changing seasons affected light and colour, and sculptures would be moved and replaced depending on the vagaries of sales and exhibitions.

..

2. Spender 1986, p.46.

One work that moved less frequently than most was **Knife Edge Two Piece** 1962-65 [cat.204], which Moore liked positioned so as to be the first sculpture visitors would see as the panorama of the garden came into view. As Irina Moore put it, 'With my garden I have a vision of things: that's how I planned the walks, the hedges, the trees and flowers. I do things by instinct, and I enjoy the way they look when they are right. When they are wrong I am very cross.'[2] Her instincts worked: there wasn't much done wrong.

Before arriving at Bourne Cottage the road passed a large metal-framed construction encased in translucent corrugated plastic and heavy-duty polythene sheeting. This had been built in 1963 to house the large plaster of **Reclining Figure** 1963-65 (LH 519), whose unique bronze cast was destined for the Lincoln Center in New York. Among polystyrene enlargements made there were **Large Two Forms** (LH 556) in 1969 and **Hill Arches** (LH 636) in 1973. The shelter continued in use for many years thereafter, providing protection from the elements while allowing Moore and his assistants perfect light conditions for work [fig.4]. By the mid-1980s the metal frame had become badly corroded and on Moore's instructions Bernard Meadows, then acting director of the Foundation, had it taken down.

Beyond Bourne Cottage the road turned sharply to the right. To the left a double five-bar gate led into the sheep field. Next was the new maquette studio, built in 1970. This two-roomed building overlooked the sheep field and the more rural areas of the estate beyond. The first room was used for the enlargements to working model size and the second for the creation and display of maquettes. This was at the heart of the creative process, a place Moore could come to think, to work, to be alone and get away from the activities and distractions elsewhere on the estate. Behind it, sited at the edge of the sheep field, was a huge three-bayed agricultural barn which had gone up in the early 1970s to give extra storage space for large crated sculpture. One-third of the area was sectioned off to provide fodder storage for the sheep but the remaining bays, in addition to storage, were later used by the assistants for enlargements to monumental size. It was here that the polystyrene originals of **Mirror Knife Edge** 1977 (LH 714) and **Large Upright Internal/External Form** 1981-82 (LH 297a) were constructed.

To the right-hand side of the road was the White Studio, another two-roomed structure, with a loading bay to its

garden side. These rooms were used for the enlargement of bigger working models and for the patination of casts too large for the Top Studio. Many uncrated bronzes were kept there, as they were on the loading bay outside. The road finally ended at the Yellow Brick Studio, which Moore preferred to keep exclusively for carvings – not those of the pre-war era, which would have been too small and vulnerable, but rather the larger pieces carved by the master masons at the Henraux stoneyards in Querceta. A small number of these had arrived each year at Perry Green since 1965, when the Moores had purchased a holiday home near the stoneyards in the small Italian coastal resort of Forte dei Marmi. These pieces all needed some finishing adjustments which Moore could carry out during the winter months. Also kept there was the elmwood **Reclining Figure** 1959-64 [cat.188], and there too the final elmwood sculpture **Reclining Figure: Holes** 1976-78 [cat.239] was in progress at the time the Foundation was set up.[3]

Of course much activity other than the production of art went on. Besides being a home, Hoglands had to function as an office, with a tiny room provided for Moore's secretary Betty Tinsley and assistant David Mitchinson, coping with requests for anything which might be asked of one of the twentieth century's most prominent artists. It also served as a storage area for much of Moore's archive – papers, letters, colour slides and negatives. One upstairs room acted as a sculpture store for bronze maquettes, while the attic was converted three times in quick succession to take a mixture of books, photographs and framed drawings. The house was always full of people – family, staff, and a never ceasing flow of visitors from around the world, friends and photographers, museum directors, architects and builders, foundrymen, printers and so on. At any one time dealers or collectors might be talking sales over cups of tea in the sun room, curators with their exhibition plans might be strewn over the sitting-room floor, while graphic designers, deep in lay-outs and photographs laid across the dining-room table, might be heard arguing noisily with their editor or publisher. Moore would move quietly among them offering helpful suggestions before making his excuses and returning to his studio.

Over the years since the Moores' arrival at Perry Green the estate had expanded, with land purchased, studios built, cottages and houses acquired for staff accommodation. This estate development was still going on, but until the early 1970s Moore had taken no action to ensure its future or to guard against the threat of death duties. Acting on the advice of an old friend, Maurice Ash, later to become one of the Foundation's Trustees, he took the first tentative steps towards securing the estate's protection.[4] In February 1971 a charitable trust known as The Henry Moore Trust was set up 'for the advancement of education in the fine arts in general and in sculpture in particular'. The Trust Deed was between Henry and Irina Moore; four Trustees of the Tate Gallery, Sir Robert Sainsbury, Stewart Mason, Geoffrey Jellicoe and Niall MacDermot QC, with provision allowed for their successors; the Tate's Director, Sir Norman Reid; and Maurice Ash, acting as an independent. One of its clauses stated: 'Mr Moore considers that part of the farmland would form a suitable site for an uncrowded exhibition exclusive to his own work in the natural setting in which it was conceived and executed.'[5] Part, not all, of the estate was transferred to the Trust, as were a group of sculptures which included a number semi-permanently sited in the grounds, such as the fibreglass **Locking Piece** 1963-64 (LH 515) and the cast concrete version of **Draped Reclining Figure** 1952-53 (LH 336). In 1978 such assets as remained with the Trust were transferred to the Foundation which subsumed the remaining works in its Collection.

Gifts of work
Leaving aside consideration of works that Moore had sold, and some minor donations which had no effect on subsequent events, four gifts or bequests made during the late 1960s and early 1970s had an impact on what remained in Perry Green in 1976. These gifts need to be considered in some detail in order to understand the amount, quality and composition of that which remained.

Quite naturally Moore had made provision for his wife and daughter through specific gifts of drawings and sculpture, to Irina in 1969, 1972 and 1973 and to Mary in 1969 and 1973.[6] These gifts had concentrated on early items – many of them framed drawings familiar from exhibitions, plus carvings from the 1930s and bronze casts from the

...
3. Levine 1978, pp.96-107.
4. Berthoud 1987, p.362.
5. HMF archive.
6. Ibid.

1950s. Both collections included highly significant works, Irina's perhaps the more so. She had two important notebooks, **Sketchbook 1928: West Wind Relief** 1928 [cats.36-41] and the more famous **Second Shelter Sketchbook** 1941 [cats.116-129], plus many other works on paper among which was **Seated Woman** 1928 (HMF 604), long considered by Moore to be one of his most successful life drawings. There were also three major works from the same year, 1939: **Two Heads: Drawing for Metal Sculpture** [cat.106], the archetypal precursor for all the helmet heads and internal/external forms to follow; **Spanish Prisoner** (HMF 1464), the definitive study on which the lithograph cat.107 was based; and **September 3rd, 1939** (HMF 1551), the first war drawing, composed after the Moores had been bathing off Shakespeare Cliff at Dover on the day war was declared. There was also the large **Coalminer Carrying Lamp** 1942 (HMF 1986), one of only two full-size coalmining drawings remaining with the family.

Mrs Moore's sculpture collection was equally impressive, particularly for its pre-war carvings of which she owned an amazing sixteen, three in wood, the remainder in stone, concrete or marble. These included two very early masks of seminal importance, cat.33 and LH 64, **Reclining Woman** 1927 (LH 43), the earliest surviving reclining figure, **Composition** 1931 (LH 99), Moore's first abstract work, the **Composition** in Cumberland alabaster of the same year [cat.57], and two outstanding stringed figures in wood, LH 183 and **Bird Basket** 1939 (LH 205) which David Sylvester described as 'the most complex piece in the series'.[7] There was also the **Reclining Figure** 1959-64 [cat.188] and a large number of post-war bronzes some of which, such as **Family Group** 1948-49 (LH 269) and **Seated Woman** 1957 (LH 435), Mrs Moore had already sold. Among those that remained were **Standing Figure** 1950 (LH 290), **Reclining Figure: External Form** 1953-54 (LH 299) and the artist's copy of **Warrior with Shield** 1953-54 (LH 360).

The collection of Moore's daughter was biased heavily in favour of the small sculptures made around the time of her birth. These included four Madonna and Child maquettes from 1943, LH 216, 223 and 225 in terracotta and LH 222 in bronze (but not the definitive maquette LH 224

..

7. Sylvester 1968, p.105.

which had gone to her mother). Also in this category were a dozen family groups and five terracotta reclining figures, LH 242, 243, 249, 250, 254, from 1945. She had few very early pieces of importance other than the stone **Mask** of 1929 (LH 61). Of the large post-war bronzes many such as **Upright Internal/External Form** 1952-53 (LH 296), **Draped Seated Woman** 1957-58 (LH 428) and **Draped Reclining Woman** 1957-58 (LH 431) had been sold prior to 1976. Among the more interesting which, for the moment, remained were **King and Queen** 1952-53 (LH 350), **Two Piece Reclining Figure No.1** 1959 (LH 457) and **Three Way Piece No.1: Points** 1964-65 (LH 533); there was also the late carving in green serpentine **Arch Form** 1970 (LH 618). Among important working-model sized pieces were **Three Standing Figures** 1953 (LH 322), **Mother and Child with Apple** 1956 (LH 406) and **Seated Figure against Curved Wall** 1956-57 (LH 422), though these too had been sold by 1976 and no plaster of them had survived.

Mary Moore's collection of over four hundred drawings began with **Portrait Head of Old Man** 1921 (HMF 3) and included **Reclining Figure** 1933 (HMF 984), **Figures in a Cave** 1936 (HMF 1260), some pages from the **Coalmine Sketchbook** of 1942 (HMF 1946-1984), the **Prométhée Sketchbook** 1949-50 (HMF 2547-2568), the amusing **Animal Drawing: Pig** 1953 (HMF 2744) and seven sketchbooks from the early 1970s, including the famous **Sheep Sketchbook** of 1972 (HMF 3317-3366) which was reproduced in facsimile in 1980. Although items were constantly being sold, interestingly both Irina and Mary Moore's holdings, perhaps because they had been selected and listed, were already known and thought of as collections long before the Foundation was created, even though they were fully integrated among the rest of the art works at Perry Green.

In 1969, after five years of on/off discussions, Moore reached agreement with Sir Norman Reid over a gift to the Tate Gallery. This group of thirty-six sculptures was selected with the knowledge that the Tate's holding of Moore's work was heavily weighted towards the 1930s and 1940s with six important pre-war carvings, culminating in the green Hornton stone **Recumbent Figure** (LH 191) of 1938, and seven maquettes of Madonna and Child or family group from 1943-45. Post-war sculpture was almost limited to casts of **Family Group** 1948-49 (LH 269) and **King and Queen** 1952-53 (LH 350), while the latest work was **Working Model**

for **Knife Edge Two Piece** 1962 (LH 504) which the Tate had purchased in 1963.

In an attempt to redress the balance and make the collection more representative of Moore's work as a whole, the choice included many of the most significant bronzes from the years between 1952 and 1968. Particularly notable, as will become apparent on examining the paucity of work from this period in the Foundation's collection, was the inclusion of **Upright Motive No.1: Glenkiln Cross** 1955-56 (LH 377), **Working Model for Unesco Reclining Figure** 1957 (LH 415), **Atom Piece** 1964-65 (LH 525) and casts of all three-piece figures, LH 500, 513 and 597. No conditions were attached to the gift other than that the works would leave Moore's possession only when the Tate's exhibition area was increased by fifty per cent. This was not so that they should be permanently exhibited as a group, rather the opposite. Moore had no desire to see his works predominate in the Tate's limited space, preferring to wait until they could be displayed in the context of the gallery's evolving programme and at the discretion of their curators. In fact the works remained at Perry Green beyond the creation of the Foundation and went to the Tate in 1978, there to be exhibited as a group for the only time, along with the earlier acquisitions, as part of the gallery's celebration of Moore's eightieth birthday.[8]

Rather surprising was the fact that at no time did anyone consider looking at the Tate's holding of Moore's drawings. Superb though that was, it was limited to sixteen pieces of which half were Shelter drawings – a low total which might have prompted someone to propose its enlargement. Instead, through the intermediary of Stewart Mason, Curator of the Institute of Contemporary Prints, Moore agreed to donate to the Tate's new Print Department one copy from each edition of graphics that had already been published and to keep the collection up to date with new work as and when it became available.

In total contrast to the arrangements in London was Moore's relationship with the Art Gallery of Ontario in Toronto.[9] Here the intent was to create a Henry Moore Sculpture Centre, within a new extension to an existing gallery, capable of displaying in a purpose-built environment a significant group of Moore's work. What made it unique was the scale and nature of the gift. Between the end of 1969 and the middle of 1970 sixty-five sculptures were selected by

Moore and Alan Wilkinson, who would later become the Centre's curator. Included were works in bronze, terracotta and fibreglass, though these were far outnumbered by original plasters. Moore's attitude towards these plasters had changed gradually over the years – indeed his inclination toward direct carving in stone or wood had meant few modelled pieces occurring in his oeuvre until the late 1930s. The earliest work of any size to be modelled in plaster, with the intention of having a bronze edition cast from it, was **Family Group** (LH 269) at the end of the 1940s but this, like many others of the post-war era, was destroyed, either deliberately to avoid extra casts being taken or simply through neglect. As time went on Moore came to value the plasters as true originals, in some cases in preference to the bronze casts. By the middle of the 1960s large numbers of them had been returned from the foundries and were filling every studio at Perry Green. Some were in poor condition, the process of casting having necessitated cutting and sectioning, resulting in the destruction of their wood or metal armatures.[10] The opening of the Sculpture Centre in October 1974 provided the impetus for restoration. Under Moore's watchful eye this was duly carried out by his three sculpture assistants, John Farnham, Michel Muller and Malcolm Woodward, each of whom was to play a major roll in both the development and conservation of the Foundation's Collection in the years to come. Among the plasters sent to Toronto were many of the same works whose bronze versions went to the Tate Gallery. In all, the overlap between the two gifts was of eleven medium or large-scale sculptures, **Upright Motive No.1: Glenkiln Cross** 1955-56 (LH 377), **Working Model for Unesco Reclining Figure** 1957 (LH 415), **Woman** 1957-58 (LH 439), **Seated Woman: Thin Neck** 1961 (LH 472), **Three Piece Reclining Figure No.1** 1961-62 (LH 500), **Three Piece Reclining Figure No.2: Bridge Prop** 1963 (LH 513), **Working Model for Reclining Figure: Lincoln Center** 1963-65 (LH 518), **Atom Piece** 1964-65 (LH 525), **Working Model for Three Way Piece No.2: Archer** 1964 (LH 534), **Two Piece Sculpture No.7: Pipe** 1966 (LH 543) and **Two Piece Reclining Figure No.9** 1968 (LH 576), the closeness of

. .

8. *The Henry Moore Gift*, Tate Gallery, London 1978.
9. Wilkinson 1987, pp.3-26.
10. Allemand-Cosneau, Fath, Mitchinson 1996, p.59.

the Lund Humphries numbers alone going some way to explain the lack of certain important sculptures from the 1950s and 1960s in the Foundation's Collection – but more on this later. Among other large plasters from the 1950s in Toronto from which Moore did not retain a bronze cast are **Reclining Figure** 1956 (LH 402), **Draped Reclining Woman** 1957-58 (LH 431) and **Two Piece Reclining Figure No.1** 1959 (LH 457), which went to the family; while the gift of a bronze **Working Model for Three Piece No 3: Vertebrae** 1968 (LH 597) echoed the gift of another cast to London, leaving Moore with neither a bronze, nor the original plaster which had been destroyed.

Like the Tate, the Art Gallery of Ontario also received a complete collection of lithographs and etchings. Crucially for the comprehensiveness of their collection they were also able to put to good use the personal interest and scholarly research of Alan Wilkinson, who selected for them a superbly representative portfolio of fifty-seven drawings covering all periods from 1921 to 1972. The Art Gallery of Ontario will remain forever in his debt.

Aims of the Foundation

The Henry Moore Foundation was registered as a company on 23 April 1976 and as a charity under English law on 15 June the same year. It became operational in January 1977 when Moore took over as managing director of Raymond Spencer Company Limited, its newly created trading subsidiary. This active commercial subordinate was necessary since the Foundation, though able to sell its assets, was unable to trade. Moore transferred the resources of his profession as a sculptor – tools, materials and the means of production including his employees – to the Company in return for shares which he then gave to the Foundation. Among the clauses of the Foundation's Memorandum of Association was that it should be 'established to advance the education of the public by the promotion of their appreciation of the fine arts and in particular the works of Henry Moore'.[11] This was not too dissimilar in sentiment to the clause used five years earlier

...

11. HMF archive.
12. Technically at this time referred to as 'members of the Committee of Management'.
13. Plaintiff's witness statement, 30 May 1993.
14. HMF archive.

in the Henry Moore Trust document, though now with greater emphasis on the artist himself. What then were the Foundation's assets, what would be its policy, and how would it operate?

As envisaged in 1976 it was to be a family trust, albeit one that looked out beyond Perry Green to the interests of the art world at large, with Irina and Mary Moore as its Trustees.[12] Moore was advised by his daughter, and her husband Raymond Danowski, that he needed to safeguard the future of Perry Green, which meant that most of the land, studios and houses constituting the estate were given to the Foundation, as was a cash endowment sufficient to make the new organisation operational. In addition all unsold work was to be transferred, and from part of this the Foundation's collection would later be created. As the Company had been formed to handle all means of production as well as sales, it was clear that any new works would technically belong to the Company rather than to the Foundation. Certainly they would no longer be the property of the artist. No one could foresee the problems this would cause a few years later. 'The period', as Mary Moore has stated, 'was characterised by confusion and uncertainty', with her 'father's attitude one of impatience to get the formalities over as soon as possible so that he could get on with his work'.[13]

In an unautographed memorandum of February 1977 some of the objectives of the Foundation were outlined: 'Henry Moore has been anxious for some time that means could be found whereby his collection of his own sculptures and other works of art could be kept together after his death in such a way as to be accessible to the public. He also wished there to be established an organisation which could encourage interest in his work in particular and sculpture in general by setting up a centre where research and studies could take place, possibly a library be built up and the dissemination of information by lecture courses and other means be developed . . . It is intended that the Foundation establishes in the environs of Henry Moore's home . . . a centre at which a permanent display of his works will be housed and a staff will be employed whose activities will include the establishment of archives and documentation of Mr. Moore's work and philosophy.'[14] These well-intentioned proposals would all come to pass, but some of them not for a further two decades.

Henry Moore's collection

Moore enjoyed being surrounded by art, his own in the studios, other people's in his home, and would draw enormous inspiration from the found objects intermingling on the studio shelves with his plaster maquettes, and from the paintings and drawings that hung on the walls of Hoglands. But a distinction must be made between the collecting of objects from the world outside and the accumulation of works by the artist himself, since Moore had little idea of what constituted the collection of his own work, no inventory had ever been taken and he would not have read it if it had. Even the concept of considering his work as a 'collection' would have been alien to him since everything was considered stock-in-trade and could in practice be offered for sale.

There was certainly an understanding among Moore's staff that certain works were not for sale and that the demand for exhibition items could not be assuaged without loans from 'the artist'. Indeed exhibition requests were probably the reason why so many works had been retained. Without this demand more would surely have been dispersed, either as additional gifts or as sales. Exhibitions had always played a large role in each year's programme, and as time moved on had become progressively more ambitious in scale. In establishing the Foundation, Moore was determined that a substantial body of his work should remain together in perpetuity and be available for display without having any precise conception of what this collection should comprise. The success of two large recent shows, the seventieth birthday retrospective at the Tate Gallery selected by David Sylvester in 1968 and Giovanni Carandente's 'spectacular' at Forte di Belvedere in Florence during 1972 were often referred to by Moore as a reason for keeping a group of work intact. The artist had been intimately involved in the preparation, selection and installation for both exhibitions and realised that their integrity would have been compromised without loans from the family collections.

What then remained in Moore's possession in 1976 and what was given to the Foundation? Much time was spent during the autumn of that year preparing an inventory of all the art works at Perry Green and trying to ascertain to whom individual items belonged. This, for a number of reasons, was more complicated than it first appeared. The compiling of the inventory was undertaken by Raymond Danowski, who went through each building recording its contents. As Moore did not own an electric typewriter and remained suspicious of computers, refusing to allow them on to the estate during his lifetime on the grounds that they would make the whole operation 'seem like a business', the information on Danowski's handwritten lists of bronzes and carvings was transferred into a set of the first three volumes of the Lund Humphries catalogue raisonné of Moore's sculpture. As volume four was in the process of production, a galley proof had to suffice for the more recent works. Thousands of graphics were counted – states and proofs as well as editions and part-editions for sale – and identified by their CGM catalogue numbers. As the drawings and sketchbooks obviously didn't receive their HMF archive numbers until after the Foundation had been set up, they were identified by title and date, which made them very difficult to re-identify later when they were ascribed numbers since, for example, one 'Standing Woman 1923' looked much like another. Work that was out on loan, exhibition or sale-or-return was noted, as were items at the foundries or the printers. When this was completed Mary and Irina Moore's collections, plus the sculptures reserved for the Tate, were deleted by Danowski and the lists sent to the Foundation's newly appointed lawyers, McKennas, who were to compile typed schedules, and to Moore's private solicitor, Arnold Goodman, to await transferral of the works from artist to Foundation. Moore kept only eight pieces for himself.[15]

In a letter to Goodman of November 1976, he wrote: 'Here is a list of all the work which I would like to give into the ownership of the Foundation. It has been quite a task to compile this list. I've tried to give the cost of production of all the individual pieces – and of course I've had to make rough estimates of some of them . . . I will send you, next week, a further list, which we are still working on which I couldn't complete by today. On this list will be at least 300 plaster maquettes, and some plasters in progress. To sum up, besides the sculptures on the accompanying list, I want to give approximately one thousand and two hundred & eighty drawings (which cost nothing to produce – just the paper, pencil & watercolour) And also approximately 6,985 prints

. .

15. These were LH 20, 50a, 50b, 146, the lead of 289a, 293, the plaster of 335, the terracotta of 552b.

(etchings & lithographs etc) For these I estimated an average cost of £5 per print.'[16]

From this letter the scale of the transfer becomes clear, even without its stating how many or giving details of the bronze sculptures and carvings to be handed over. Analysis of the McKenna inventory provides the answers. Divided into four schedules, depending on the location of the works, and stating that they were 'physically transferred by Henry Moore to the Foundation on 28th January, 1977 in accordance with Statutory Declaration sworn by . . . ' it registered all the 'Works of Art' given to the Foundation.[17]

Forming the Foundation's Collection

As an organisation set up to receive this gift the Foundation was in many ways ill-equipped to accept it. Dealing with the personal possessions of the artist was quite different to caring for and documenting a collection intended to be preserved for posterity. Nothing at Perry Green was up to even basic museum standards in terms of archive, conservation or storage. Not that the Foundation was ever intended to become a museum in the strict understanding of the word, as for example the Musées Rodin or Bourdelle in Paris. The Collection, or at least major parts of it, would always be treated and thought of in the same way as the holdings of other institutions such as the British Council, the Arts Council and the Government Art Collection, which were stored when not out on loan. Perry Green was, after all, still a place of production and the artist's home; there was a limit to the discussion over what might happen when these requirements ceased, though this silence did not obscure the immediate problems and deficiencies. There was no library, minimal space for photographs, no catalogue raisonné of the drawings, no bibliography, little equipment, no administration or policy direction, there was even a shortage of staff. These problems had to be addressed and a start was made immediately. To begin with, the Foundation needed somewhere from which it could operate: Hoglands was overflowing and becoming untenable as a home. By remarkable good fortune the property adjoining Hoglands to its immediate right became available [fig.5]. Consisting of a medium-sized house of the inter-war years with four rooms

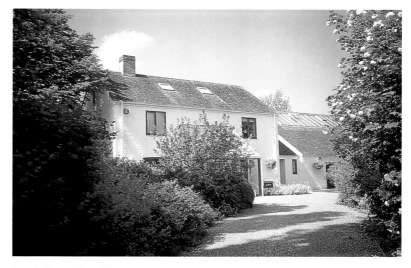

Fig.5. Dane Tree House.

down and the same above, plus a garden, orchard and meadow, it was purchased and quickly transformed into what was intended to become a research centre. Although this function never materialised, Dane Tree House, as it was named by Moore, soon established itself as the centre of the Foundation's operations and quickly superseded Hoglands as the focus of the estate. The staff move from Hoglands to Dane Tree House highlighted only the inadequacies of the latter which had none of the facilities of an office, although it did offer space for the newly appointed keeper of drawings, Juliet Bareau, to make a start on sorting and conserving the works on paper. At the same time Alexander Davis was appointed to research and acquire all printed material on Moore, an undertaking which resulted fifteen years later in the publication of the Henry Moore Bibliography, and led eventually to the creation of the Foundation's library.

Crucially there seems to have been little attention as to the actual content of the gift, all time and thought having gone into the mechanics of the transfer, which itself was part of the far more complex financial and legal process of setting up the Foundation. Did anyone consider that what had arrived was an accumulation of objects, essentially the stock-in-trade, that had survived the depredations of decades and would need years' more modification before a serious collection could be formed? Much needed to be done in scrutinising the content of the schedules and deciding what should or should not be retained. Ostensibly this was an area in which the Foundation ought to have taken a lead, but in

16. HMF archive.
17. Ibid.

reality Moore carried on as before, treating much of the gift as stock. Lack of facilities worsened the situation as there was no possibility of physically separating those items for sale from the rest. The drawings were the most straightforward. They were brought under one roof at Dane Tree House, and a decision was made to retain everything at least until it could be catalogued and photographed. Carvings appear to have been left to the whim of the artist, with no policy formulated. Happily no pre-war pieces were sold, but the reduction of post-war works appears to have been arbitrary. The graphics presented a problem in terms of numbers. Although comparatively easy to divide on paper between states, which would be kept, and numbered and signed editions which would be sold, their distribution in boxes and folders around half a dozen locations on the estate meant that control was always difficult.

More problematic were the bronze sculptures. Casts of any particular piece were not produced together and the casting of an edition of a monumental sculpture might take years, even decades to complete. Each foundry would have several different works in various stages of production and would complete to order on Moore's instruction, which itself was governed by the necessities of sales and exhibitions. Moore would decide how large an edition to produce, usually after seeing the first cast. His preference was editions of nine for the maquettes and working models, with less as the works became larger, though there were many exceptions to this standard. Since the end of the 1950s he had signed and numbered his casts, for example 1/9 to 9/9, and had also produced an extra cast of most editions to keep for himself, this being the so-called artist's copy, marked 0/9. By the late 1970s this signing and numbering process had become a little more streamlined, with most of it left to John Farnham to carry out. Originally Farnham would trace copies of Moore's signature on to each bronze and then incise the letters with an engraving tool. Later a series of metal punches in differing sizes were used to stamp in the signature, the numbering being done similarly.[18] Not that the numbering of the casts was as straightforward as might appear. Moore could change his mind about the size of an edition, as was the case with **Three Piece Reclining Figure: Draped** 1975 (LH 655), where the first four casts are numbered out of six while the remainder, including the artist's copy, are out of seven [see cat.238]. Sometimes a cast

needed for exhibition was taken out of sequence and marked 0; this could cause all kinds of confusions later and might be the explanation of why both the Tate Gallery's and the Foundation's casts of **Large Slow Form** 1968 [cat.199] are marked 0/9. One must be an error but as all the sale casts seem to be accounted for, no change can now be made. As everything had been handed over, the Foundation found itself the owner of multiple casts of some sculptures, though not necessarily the artist's copies which might not have been made. A glance at any exhibition catalogue from the end of the 1970s shows the difficulties. Sculptures are credited as from the collection of the Foundation, whereas in fact they were only sale casts passing through. One example is the large **Three Piece Sculpture: Vertebrae** 1968-69 (LH 580). This work was shown in Paris twice, originally in 1977 at the Orangerie des Tuileries[19] and again at the Parc de Bagatelle in 1992.[20] The sculpture in the earlier exhibition was not the artist's copy and was later sold, leaving the Foundation without a bronze for nearly a decade until another cast, this time the artist's copy, was purchased for the Collection in 1989 and subsequently exhibited at Bagatelle. This situation was further complicated by Raymond Spencer Company becoming the owner of later casts from the same edition, as they were produced, creating the paradox of its owning the cast that should have been in the Foundation's Collection while the Foundation owned the casts for sale. For a long time nothing was done to correct this, though the distortion to the assets of the Company, shown through the accumulating amount of unsaleable stock, grew by the year.

Turning to an examination of the schedules, and leaving aside items obviously for sale, what did the Collection comprise? Of prime importance were the early notebooks which had survived, without being dispersed, as a group from the 1920s. **Notebook No.2** 1921 [cats.3-6], **Notebook No.3** 1922-24 [cats.15-18], **Notebook No.4** 1925 (HMF 269-319), **Notebook No.5** 1925-26 (HMF 364-424) and **Notebook No.6** 1926 [cats.27-29] show the developing interests of the young artist, especially his observations in the British Museum, throughout the most formative decade. As Moore commented years later, 'I feel sorry for people who

..
18. John Farnham in conversation with David Mitchinson, June 1997.
19. Paris 1977, cat.110.
20. Paris 1992, cat.13.

go through life never really seeing the world about them. Everyone thinks they look, but they dont; they don't have the time, or the training, to open their eyes to the marvellous world we live in.' [21] Moore dedicated many years to life drawing, from the early 1920s to the1930s, believing always that intense observation of the human figure was a prerequisite for a sculptor. Of these he gave the Foundation more than one hundred and fifty examples beginning with **Seated Male Nude** 1921 [cat.1], the first work listed on the schedule, and continuing throughout the decade to **Seated Figure** 1930 [cat.50] and beyond. Also well represented were the sketchbook pages from the 1930s, many showing the preliminary ideas for the carvings of the period. For example **Page from No.1 Drawing Book 1930-31: Ideas for Composition in Green Hornton Stone** 1930-31 [cat.54] is one of a number of pages in the same notebook that reveal the derivation of **Composition** 1931 (LH 99). Likewise **Studies for Several-Piece Compositions and Wood Carvings** 1934 [cat.70] and its twin sheet **Studies for Square Forms** 1934 [cat.71] show the origins for the individual elements of the Tate Gallery's **Four Piece Composition: Reclining Figure** 1934 (LH 154). Some fine studies of 'square sculptural forms' such as **Drawing for Sculpture: Two Forms** 1937 [cat.91] were included, but rather fewer of the 'figures in a setting' group characteristic of the immediate pre-war period, though here **Sculpture in a Setting** 1937 [cat.87] pictorially explaining the elmwood **Family** 1935 [cat.82] was an exception. Of the Shelter drawings rather little had remained, the most important being **Eighteen Ideas for War Drawings** 1940 [cat.115] and the study for the much larger work in the Tate Gallery, **Tube Shelter Perspective** 1941 [cat.130], plus four quick watercolour and crayon studies of sleeping shelterers of the same date and from the same notepad, **Tube Shelter Perspective** (HMF 1774), **Shelter Drawing** (HMF 1779), **Shelter Drawing (Tube Shelter Perspective)** (HMF 1780) and **Sleeping Figures** (HMF 1782). Two of the Coalmining sketchbooks had survived intact, **Coalmining Notebook A** 1942 (HMF 1864-1920) and the **Coalmining Subjects Sketchbook** 1942 [cats.134-138], and Moore had kept one of

the finished drawings based on these sketches, **Miner at Work** 1942 [cat.139]. Almost everything from the end of the 1940s had been sold. From 1948, a particularly active year, only one work, **Reclining Figures: Page from Sketchbook 1947-49** [cat.152] was retained. Nor did Moore have any of the larger figurative drawings from the post-war period of mother and child, family group or internal/ external form, nor indeed any coloured sketchbook pages of the same subjects. Such drawings that had been made in the 1950s, not a particularly prolific period, had been passed to the Foundation, as had some of the sketchbooks and sketchbook pages of the 1960s and early 1970s, though not the **Sheep Sketchbook** of 1972 (HMF 3317-3366) which had been given to his daughter.

By 1976 Moore had produced just over four hundred editions of lithographs and etchings, of which three hundred and seventy had appeared in the first two volumes of the graphics catalogue raisonné.[22] States and proofs, exhibition copies, portfolios, albums and deluxe books with signed prints, totalling around 3750 non-saleable items, were handed over, plus a huge amount of stock. Only in a few cases such as **Spanish Prisoner** c.1939 [cat.107] and **Three Standing Figures** c.1950 (CGM 16) where the work had not been editioned was just a single proof available, and only one individual print, **Red and Blue Standing Figures** 1951 (CGM 36), was missing. Some mixed albums and portfolios, with work from different artists and often produced by obscure publishers to whom Moore had contributed complete editions, were also missing, though in all these cases he had kept examples of his own work. Fortunately many other albums came in more than one copy, allowing the Foundation later the ability to keep bound works both complete in their original state and unbound for exhibition purposes.

Among the albums and portfolios of Moore's own graphics were the **Elephant Skull Album** 1969-70 (CGM 109-146), an exploration through etching based on close observation of a skull given to him in the late 1960s by his long-standing friends Julian and Juliette Huxley; **Sheep Album** 1972 and 1974 (CGM 196-201, 225-235), another assemblage of etchings, produced after the drawings in the **Sheep Sketchbook**; **Stonehenge** 1972-73 (CGM 202, 203, 207-223); and the book of lithographic illustrations to **Auden Poems** 1973 (CGM 243-265), both the latter heavily inspired

21. Moore 1981, p.15.
22. Published in four volumes, of which vol.1 appeared in 1973 and vol.2 in 1976.

by the black drawings of Seurat, two of which hung on the walls of Hoglands. Mixed portfolios included *Europaeische Graphik I* 1963,[23] containing three Moore lithographs, **Black on Red Image** 1963 (CGM 42), **Eight Reclining Figures with Architectural Background** 1963 (CGM 44) and **Two Seated Figures in Stone** 1963 (CGM 53) with two prints by Reg Butler and Graham Sutherland and one each by Lynn Chadwick, John Piper and William Scott, and *Omaggio a Michelangelo* 1975 [24] with the lithograph **Four Reclining Figures** 1974 (CGM 333) in addition to twelve prints from Horst Antes, Jorge Castillo, Emilio Greco, Renato Guttuso, David Hockney, Jean Ipoustéguy, Giacomo Manzù, Marino Marini, André Masson, Eduardo Paolozzi, Fritz Wotruba and Paul Wunderlich. One of the last prints published before the inventory was taken, the etching and aquatint **Mother and Child and Reclining Figure** 1974 (CGM 377), was included in Eddy Batache's *La Mysticité Charnelle de René Crevel* 1976, [25] which also had works by Camille Bryen, Jorge Camacho, Robert Couturier, Sonia Delauney, Max Ernst, Man Ray, André Masson, Sebastian Matta, Arpad Szenès, Dorothea Tanning, Vladimir Vélickovic and Vieira da Silva plus a frontispiece by Francis Bacon; this book too was included. The total gift of graphic work left little for the Foundation to acquire over the coming years.

The listings of plasters on the schedule were for all practical purposes useless, with comparatively few small works being identified by their LH number; dozens of entries such as '75 Unfinished plasters in a cardboard box ranging in sizes from 1" to 4"' made only marginally more sense than others like '19 plaster worked pieces approx. 2" on average'. Luckily identification was not immediately necessary as Moore made it clear that all the contents of his maquette studio had been given to the Foundation. A thorough classification would come much later. Among the identifiable maquettes and smaller pieces were **Head of a Girl** 1923 [cat.12] in clay, the two reliefs of 1931, LH 103 and 104, conceivably the earliest extant works in plaster, and the terracotta family groups [cats.143 and 144] of 1944, these latter being a calculated gift as Moore owned no bronzes of the subject. Of the medium and larger works perhaps the most significant were the six for which no bronze casts had been kept, **Reclining Figure No.2** 1953 [cat.166], **Reclining Figure No.4** 1954 [cat.167], **Warrior with Shield** 1953-54 [cat.171], **Reclining Figure** 1957 (LH 413), **Working Model**

for **Draped Seated Woman: Figure on Steps** 1956 [cat.181] and **Three Way Piece No.1: Points** 1964-65 [cat.208]. There were reasons why these specific pieces were still at Perry Green. Moore seldom lent his plasters, but an exception had been in the case of the Victoria and Albert Museum where the three reclining figures were in a group of about half a dozen on loan for many years, thereby missing the boat to Canada. In the aftermath of the Belvedere exhibition Moore had promised the city of Florence a cast of the warrior, and after obtaining permission from the other owners the plaster had been sent to the foundry where it remained out of sight during the production of the new bronze. Alan Wilkinson was asked recently why **Three Way Piece No.1: Points** had not gone to Toronto, as seemingly it was an obvious choice for their collection since a bronze cast of a similar work, **Three Way Piece No.2: Archer** 1964-65 (LH 535), had been installed after considerable controversy outside Toronto City Hall. His reply was that he did not remember seeing it at the time, but would have included it on his list had he been aware of its availability.[26]

Moore gave sixteen carvings – seven pre-war, one from the 1950s and eight of the late Italian marbles. Important, yes, but representative, no – and even of this group half the later works were subsequently sold. From the early pieces the most outstanding were **Woman with Upraised Arms** 1924-25 [cat.23] and **Family** 1935 [cat.82]. Of the remainder **Small Animal Head** 1921 [cat.2] and **Dog** 1922 [cat.10] were tiny carvings made while Moore was studying in London at the Royal College of Art; **Seated Figure** 1924 [cat.22] was unfinished; the **Head** 1936 (LH 170a) in Corsham stone a fragment; and the beautiful serpentine **Head** [cat.94], which was dated 1937, an enlargement from a small plaster of that date carved at Henraux in 1968. **Standing Girl** 1952 (LH 319a) represented the 1950s, as in a way did the **Standing Figure** 1950 [cat.159] which Moore had begun carving during 1971 in readiness for the Belvedere exhibition. In fact this white marble version of the 1950s bronze was considered too fragile for the show and was sent to Perry Green where it has remained in its unfinished state, being replaced in Florence and in many exhibitions since with a

23. Galerie Ketterer, Stuttgart 1963.
24. Bruckmann, Munich 1975.
25. Editions Georges Visat, Paris 1976.
26. Alan Wilkinson in conversation with David Mitchinson, July 1997.

perfectly respectable fibreglass look-alike. Four of the late carvings, LH 585, 644, 670 and 671, were sold, while the remaining three, **Bird Form I** and **Bird Form II** 1973 [cats.228, 229] in black marble and the delicate **Reclining Figure: Bone** 1975 [cat.235] in travertine, probably escaped only because they were often on exhibition and kept crated and out of view while at Perry Green. One further carving was also on the list, the final elmwood piece **Reclining Figure: Holes** 1976-78 [cat.239]. In 1975 Moore had been given an enormous trunk of elm which he began to carve the following year. Pressure from other commitments and the distraction of preparing for the Foundation combined with two unusually hot summers meant progress towards completion was rather slow. When the inventories were taken the elm was in a corner of the Yellow Brick Studio, covered in blankets for protection from drying out. Nevertheless it was discovered later on the schedule as 'An Elan wood [*sic*] Reclining figure (in progress)'. Although never quite finished it was considered sufficiently completed by the spring of 1978 to be included in Moore's eightieth birthday exhibition at the Serpentine Gallery in London which opened later that year.

The schedules of bronzes contained many duplicates, up to six in some cases, though without their cast numbers it was impossible to distinguish between copies for sale and artist's copies to be retained. It did however have many easily identifiable pieces hugely significant for the Foundation's Collection, including casts of the monumental sculptures created after the selection of works for the Tate Gallery. Foremost among these were **Sheep Piece** 1971-72 [cat.230] and **Hill Arches** 1973 [cat.232], described by David Sylvester as 'the most imaginative, most powerful and most personal images that Moore has ever created',[27] and **Goslar Warrior** 1973-74 [cat.233]. Other large pieces came from the end of the 1960s – **Reclining Connected Forms** 1969 [cat.225], **Two Piece Reclining Figure: Points** 1969-70 [cat.222] and **Oval with Points** 1968-70 [cat.220] – while the slightly earlier **Knife Edge Two Piece** 1962-65 [cat.204] had been retained by Moore because he so liked its placing in the Hoglands garden. Of large earlier bronzes there were

..

27. London 1978, introduction.
28. LH 269, 290, 293, 296, 299, 336, 338, 350, 360, 377, 379, 383, 386, 388, 402, 405, 415, 428, 431, 435, 439, 440, 450, 457, 458, 472, 470, 478, 479, 480, 481, 482, 482a, 483, 500, 503, 503b, 513, 515.

few. Moore had produced thirty-nine bronze works[28] suitable for viewing in the open-air before **Knife Edge Two Piece** but had retained casts of only eight: **Draped Reclining Figure** 1952-53 [cat.168], **Upright Motive No.2** 1955-56 (LH 379), **Upright Motive No.5** 1955-56 [cat.175], **Upright Motive No.7** 1955-56 [cat.176], **Relief No.1** 1959 [cat.187], **Two Piece Reclining Figure No.2** 1960 [cat.191], **Three Part Object** 1960 (LH 470) and **The Wall: Background for Sculpture** 1962 (LH 483). Although the proportion improved for works made after the Knife Edge, helped partly by some late castings of artist's copies, serious gaps in the Foundation's collection of outdoor works from the 1950s and 1960s would remain. The balance among maquettes and working models was a little better, though there was a serious shortage of medium-sized works from the 1950s. Included were two later casts of 1930s reclining figures, cat.55 and cat.56; an important group of stringed figures including **Head** 1939 (LH 195); and one maquette, cat.141, from the studies for the Northampton **Madonna and Child**. From the post-war period came **Working Model for Reclining Figure: Festival** 1950 [cat.160], the full-sized version being the most important of the eight Moore retained for himself; the **Animal Head** 1951 [cat.163]; an excellent group of wall reliefs, including cat.173, and upright motive maquettes [see cat.174]; and some of the studies relating to the Unesco commission including the definitive maquette, cat.180. There were four two-piece reclining figure maquettes, LH 474-477, the **Maquette for Atom Piece** 1964 [cat.206] and some significant middle-sized works from the end of the 1960s: **Torso** 1967 (LH 569), **Two Piece Sculpture No.10: Interlocking** 1968 [cat.217] and **Pointed Torso** 1969 (LH 601). Finally came a few works in 'miscellaneous materials' such as fibreglass, and porcelain which included **Moon Head** 1964 [cat.205] – the bronze having gone to the Tate Gallery – and **Three Way Ring** 1966 [cat.210], the only version of that sculptural idea to have survived in Moore's possession.

Looking at the bronze casts in terms of numbers, Moore had given about 345 works, plus or minus a few belonging to other family members or even to the Tate Gallery, that were handed over by mistake, an error which would need to be rectified later. Within ten years this total had been reduced by over half to 163 works for the Collection, the rest having been sold as duplicate casts. One major bronze, **Upright**

Motive No.2 1955-56 (LH 379), of which there was no duplicate, was sold unnecessarily in 1978, though whether by design or through carelessness is impossible to say; considering the volume of sales and the uncertainty over casts a few errors were probably inevitable.

In retrospect it is easy to see why none of the great collections which benefited from Moore's generosity were as imaginatively selected or formed as they might have been, for each had been created in varying circumstances with different objectives in mind and without recognition of the others. For the Foundation, despite some evident gaps and omissions, the gift was a hugely unselfish act which gave it a phenomenal wealth of material on which to base and build its programme, while the proceeds from sales added inestimably to its capital. Overall the strength of the gift lay in its totality. All the facets of Moore's artistic output were represented. It was altruistic too on the part of Moore's family, particularly Mary Danowski who saw disappearing a large part of her potential inheritance.

The contribution of Irina Moore

Over the years little has been written about the contribution made to the creation of the Foundation's Collection by Mrs Moore. Perhaps at the time her gift was overshadowed by that of her husband. In looking back that seems a pity as her donation was considerable, not just in terms of numbers – she gave 55 sculptures, just over half of what she held in 1976 – but because of the individual importance of many of the pieces. Bearing in mind that she had sold a number of works throughout the 1960s and early 1970s her collection was still substantial.

How she was advised on which work to give seems not to be recorded, but the choice contained many items of great significance. Pre-eminent was the elmwood **Reclining Figure** 1959-64 [cat.188], while the inclusion of four pre-war carvings, **Two Heads** 1924-25 [cat.24] and three works each entitled **Carving**, of 1934 [cat.65], 1935 [cat.83] and 1936 [cat.85], increased the Foundation's holding to eleven. Among five stringed figures was the beautiful though fragile lead and string composition of 1939, **Stringed Figure** [cat.109], and from the same period came the cast iron version of **Three Points** 1939-40 [cat.110] and **The Helmet** 1939-40 [cat.111], the earliest of a forty-year series on this theme. From the post-war years were the enigmatic lead

Helmet Head No.1 1950 [cat.158], **Working Model for Upright Internal/External Form** 1951 (LH 295), which was to become the most exhibited of all the pieces in the Foundation's sculpture collection, and **Working Model for Time-Life Screen** 1952 [cat.169]. Among later works the gift included one of the finest of the Italian carvings, **Mother and Child** 1967 [cat.214].

Mrs Moore was advised to retain all her drawings but suggested that the Foundation should have her two important notebooks, **Sketchbook 1928: West Wind Relief** 1928 [cats.36-41] and **Second Shelter Sketchbook** 1941 [cats.116-129], which came after the sculpture as a separate donation towards the end of 1977. Hugely significant gifts these were, as the 1928 sketchbook completed the group of early extant notebooks in the Foundation's collection,[29] and the Shelter sketchbook filled 'with delicate observations and with groups worthy of a Greek pediment' will, as Kenneth Clark put it, 'remain one of the abiding images of the Second World War'.[30]

This, in summary, is how the Foundation's Collection originally appeared: many easily identifiable, important and unique items intended for retention, given by both Henry and Irina Moore, plus a mass of stock for sale. As yet no funding was provided or a policy for the acquisition of missing works agreed, nor was there a register of which pieces should be acquired. Only much later did Alan Bowness, as a Trustee of the Foundation, point out that during certain periods of his career Moore had sold everything and in these circumstances it was justifiable to purchase in order that the Collection should contain work from all periods. Throughout 1977 and most of the following year little was added to the Collection though there was early recognition from Moore that acquisitions would be needed, particularly of drawings. An acute weakness was the lack of full-sized Shelter drawings. To begin addressing this deficiency the Foundation made its first purchase, **Mother and Child among Underground Sleepers** 1941 [cat.131], which was bought from a private collector in October 1977 at a cost of £17,000. It was the first of around forty purchases made during Moore's lifetime.

..

29. By good fortune the only other known early notebook, the **History of Sculpture Notebook** 1920 (HMF 20 (11)-20(48)), is in the collection of the City Art Gallery, Leeds.
30. Clark 1974, p.150.

The programme begins

The launch of the Foundation prompted a number of new policy directives, of which only a few had any bearing on the Collection. Areas of immediate concern included the conservation of the drawings and the improvement to facilities on the estate. The two were not altogether unconnected. Building work recommenced at Dane Tree House where a double-storeyed room was constructed on its right-hand side as a viewing area for recent carvings. On completion this operated as a gallery for a short season until the inexorable demands for more space, particularly for mounting, framing and storage of works on paper, forced the carvings to be moved elsewhere.

Other than taking over as a lender of the work, the Foundation had no immediate effect on Moore's programme of exhibitions which had been increasing steadily for many years and would go on doing so until the mid-1980s. It was a little early yet for the Foundation to have a programme of its own, to curate, direct, organise or be a budget contributor; rather it would agree to the proposals of others as Moore had done in the past. Exhibitions fell into a number of broad categories. By far the largest were dealers' shows, often based round works bought directly from Raymond Spencer Company. As the Company handled sales, while the Foundation dealt with exhibition requests, a situation soon developed whereby the Company was selling works from the Foundation while the Foundation was lending items that belonged to the Company.

Next came loans to mixed exhibitions which Moore resisted as much as possible. They were time-consuming to control, with the ever present possibility that his work might be shown unfavourably compared to others. The final grouping consisted of one-man exhibitions which might be of recent pieces, or retrospective in character and often arranged in conjunction with the Arts Council of Great Britain, if being staged at home, or with the British Council when travelling abroad. Thematic or didactic exhibitions were rare in the 1970s but would become more popular and frequent as time went on. Looking only at solo shows in

. .

31. London 1977, cat.34.
32. Then at the Musée d'Art Moderne and later Director of the Centre Pompidou, Paris.
33. Paris 1977, cat.114.
34. Ibid. cat 97.

terms of numbers, and leaving aside for the moment questions of scale, type or significance, there were fourteen during 1977 and twenty-four in 1978 (the eightieth birthday year). Considering that some of these were tours taking in a number of venues and that loans to mixed exhibitions ought to be added to the number to give a fuller picture, this was already a formidable total and was set to rise dramatically. Not all exhibitions had Foundation participation but many did, and as the Foundation became more established its involvement would increase.

As part of the London celebrations for Silver Jubilee Year in 1977, Bryan Kneale organised an exhibition of twenty-five years of British sculpture in Battersea Park.[31] Among the works from forty-nine sculptors was Moore's **Sheep Piece** 1971-72 [cat.230], probably the earliest loan of a major work from the Foundation's Collection. Or was it? A show at the Orangerie in Paris had also been scheduled for 1977, organised through the British Council, to include eight monumental works, one of which out of a total of 116 sculptures and 108 drawings was **Sheep Piece**, sited on the adjacent terrace above the Tuileries gardens. Under the direction of Dominique Bozo[32] the preparations had been going on throughout the previous year. At the same time the Bibliothèque Nationale was organising an exhibition of Moore's complete graphics oeuvre from the Foundation's Collection – the most comprehensive showing of his etchings and lithographs to date – thereby giving the audience of the French capital a chance to see a cross-section of Moore's work for the first time, for although there had been many earlier shows in Paris nothing on this scale had previously been attempted. This was the Foundation's first participation as a lender to a major retrospective exhibition, though the 1977 gift from Irina Moore came too late for inclusion under its name in the catalogue. One bronze, **Reclining Figure: Arch Leg** 1969-70 (LH 610),[33] cast in the few months that had elapsed since November 1976, was credited as the Foundation's, but without knowing its cast number it is impossible to tell whether it was a sale copy belonging to the Company and lent because it was available, or the artist's copy, also owned by the Company, which the Foundation would acquire at a later date. Others such as LH 580, already mentioned, and **Large Standing Figure: Knife Edge** 1976 (LH 482a)[34] were sale copies given to the Foundation and subsequently sold. But what about **Sheep Piece**? The Paris

exhibition ran from May to August, that in London from June to September, so there had to be a second cast involved. Moore's insistence that everything should be credited to the Foundation as the *lender* even in cases where the Company rather than the Foundation was the *owner* might have made sense at a time when he was trying to promote the Foundation's name and identity, but would give rise to serious confusion over the ownership of individual casts for years to come. In this instance it seems that the London cast of **Sheep Piece** was from the Foundation's Collection, while the Paris cast was a sale copy belonging to the Company, sold later that year.

More importantly, from the point of view of the public and Moore's reputation in France, the show itself was deemed a success, with more than 120,000 visitors in four months[35] – though even Bozo, who had one of the liveliest minds in Paris, could not quite overcome the inherent problems posed by trying to position the larger bronzes on the formal approaches to the Orangerie. Certainly the **Sheep Piece** placed high up overlooking the entrance to the gardens has never looked more uncomfortable or incongruous.

While Paris was enjoying Moore's work from the past, back at Perry Green the Raymond Spencer Company was beginning to function as a conduit for his work of the present. An early decision was for the Company to publish all Moore's future graphics, thereby excluding outside dealers and publishers. One or more print from each edition was held back to provide for archive (marked CC for complete collection) and exhibition (marked EC) copies for the Collection. No one in 1977 anticipated Moore's tremendous energy and output over the next few years. Not just in graphics, of which he produced over 300 more editions, but in sculpture with enough new work to fill two more volumes of the Lund Humphries catalogue raisonné, and in drawing which reached a crescendo in the early 1980s with over 160 works from 1979, doubling to 352 in 1980, before rising to 413 in 1981 and 436 in 1982. Much of this new work would enter the Collection in due course.

As 1977 progressed, preparations for Moore's eightieth birthday exhibitions began. These centred on three main events with the Foundation being involved in each. First came an exhibition in Yorkshire, at Cartwright Hall and Lister Park on the outskirts of Bradford, based on a large

selection from the Foundation and family collections which would make it the most comprehensive showing of Moore's work in the UK outside the capital.[36] London celebrated with two simultaneous shows at the Tate Gallery. One centred on Moore's gift, which meant the departure from Perry Green of the thirty-six sculptures selected nine years earlier, including some exhibited under the artist's name the previous year in Paris. The second, Alan Wilkinson's *The Drawings of Henry Moore* which had begun a tour in Toronto in November 1977 before going on to Japan, was scheduled to open in London during June. A few days later would come *Henry Moore at the Serpentine*, an Arts Council exhibition directed by David Sylvester and Sue Grayson that would give the first opportunity for a selection of sculpture from the Collection to be seen in London.

Being the first to open, the Bradford exhibition benefited from the inclusion of a number of pieces destined for the Tate, rather naughtily exhibited as belonging to the Foundation. These included **Moon Head** 1964 (LH 521), **Working Model for Three Way Piece No.2: Archer** 1964 (LH 534), **Atom Piece** 1964-65 (LH 525) and the plaster **Three Quarter Figure** 1961 (LH 487). Luckily no one complained, and the exhibition received a warm reception in Yorkshire.[37] Of the fifteen pieces catalogued under 'Large Sculpture'[38] as coming from the Foundation's Collection, in fact only eight did so[39] and one of these, **Upright Motive No.2**, would shortly be sold. Among work that did originate from the Collection was the infrequently exhibited **Standing Girl** 1952 (LH 319a) and the recently purchased drawing **Mother and Child among Underground Sleepers** 1941 [cat.131]. Although these statistics may now be of only historical or theoretical interest, they illustrate the confusions over castings and ownership that were current at the time.

Wilkinson's exhibition at the Tate Gallery remains the most comprehensive and thoroughly researched selection of Moore's drawings ever assembled, with a catalogue the most erudite. Allowing once again for errors in ownership, the Foundation was a major contributor with loans of around

· ·

35. Berthoud 1987, p.375.
36. Ibid. p.382.
37. 'Henry, the show is a birthday cracker!' *Telegraph and Argus*, Bradford, 3 April 1978.
38. Bradford 1978, cats.1-15.
39. Ibid. cats.1-4, 7, 8, 11, 12.

fifty works, including its early notebooks, out of the 261 exhibits.

The Serpentine exhibition attracted notice through the sheer size and skilful placing of nine outdoor works in Kensington Gardens, while the indoor display contained mainly new carvings not previously seen by the public. Moore was much involved with Sylvester and Sue Grayson on the positioning in the gardens, commenting, 'We began thinking of the siting nearly a year ago when we were given permission to use the park. It took about four days to decide on the final siting of the the sculptures because we kept changing our minds. It is always a problem. You can't put them on an empty spot, you have to consider where the sun is and the approach that people will see them from. Also, when you are siting in winter you have to remember that the trees will come out and cast shade. The first impression is very difficult to shake off, so you have to consider the background from different points of view.'[40] While Moore was thinking about the siting of the sculpture, Joanna Drew, on behalf of the Arts Council, had been preparing the catalogue. In its preface she thanks Mary Moore for the loan of some carvings, and the Henry Moore Foundation 'for the loan of other works, including new bronze casts of several outdoor pieces'.[41] How wise she was not to put individual credits, since her wording conveyed the sense of where the work had come from without trying to do the impossible and identify the actual owner.

David Sylvester's indoor selection included Moore's last two elmwood carvings, the totally new **Reclining Figure: Holes** 1976-1978 [cat.289], which was placed in one room with the slightly earlier **Reclining Figure** 1959-64 [cat.188]. They would not be seen again together for another eighteen years. Of the Italian carvings there were eleven, the most ever shown in London, of which two, **Mother and Child** 1967 [cat.214] and **Reclining Figure: Bone** 1975 [cat.235], came from the Foundation's Collection, while **Broken Figure** 1975 [cat.240] would be acquired later the same year. The rest came from Mary Moore. Outside, the Foundation's **Sheep Piece** was moved from Perry Green for the last time for nineteen years, until its departure for Bremen in 1997. Of

the remainder, **Reclining Mother and Child** 1960-61 (LH 480) was from Mary Moore, **Hill Arches** 1973 and **Two Piece Reclining Figure: Points** 1969-70 were from the Collection and **Three Piece Reclining Figure: Draped** 1975, **Large Spindle Piece** 1974 (LH 593) and **Large Two Forms** 1969 were sale casts belonging to the Company. Indeed the latter was shortly to be purchased, with Chancellor Helmut Schmidt as intermediary, for the new Bundeskanzleramt in Bonn, leaving the Foundation without a cast until the artist's copy appeared for the Bagatelle exhibition in 1992. Finally there were two casts in fibreglass, **The Arch** 1969 (LH 503b) and **Three Piece Sculpture: Vertebrae** 1968 (LH 580), this latter a subtle piece of subterfuge, since it was catalogued as, and indeed appeared to be, a bronze. Moore had a number of fibreglass pieces made, usually in off-white or ivory to look like bone but occasionally coloured green or golden-brown to resemble a bronze patination. Never intended for sale, they were used for exhibition purposes where a bronze cast was impractical to install or simply not available for loan. The last sale cast of **Three Piece Sculpture: Vertebrae** had been purchased after the Paris show the previous year and once again there would be a long interval before the Foundation's cast was made. **The Arch** in fibreglass had been produced for the Florence exhibition in 1972,[42] and such was its presence in Kensington Gardens that when the London *Evening Standard*[43] orchestrated a campaign for a work to remain after the closure of the exhibition, it seemed an obvious choice. Notwithstanding the fact that there was already a bronze edition of the piece, Moore had a travertine version carved in Italy, thereby enabling him to present the work, on this one occasion only, without the involvement of the Foundation.

An important addition to the Collection came at the end of 1978 with the transferral to the Foundation of the assets of the Henry Moore Trust. Ten pieces were acquired, including the fibreglass of **Standing Figure** 1950 (LH 290) that had been so successfully shown in Florence, and two fine middle-sized bronzes, **Working Model for Stone Memorial** 1971 [cat.198] and **Working Model for Oval with Points** 1968-69 (LH 595).

Beyond the family
Fewer of the exhibitions that took place in 1979 had any significance for the Collection. Two that had were both

40. *Evening Standard*, London, 29 June 1978.
41. London 1978.
42. *Mostra di Henry Moore*, Forte di Belvedere, Florence 1972, cat.129.
43. *Evening Standard*, London, 10-13 October 1978.

directed by Juliet Bareau. To accompany the inauguration of **Large Two Forms** in Bonn, a group of work was selected that included numerous plaster maquettes of organic forms showing the derivation of the huge bronze.[44] Among these were new pieces made for the Company such as **Maquette for Egg Form: Pebbles** 1977 (LH 716) and **Maquette for Mother and Child** 1978 (LH 753), both to be enlarged as carvings.

In New York came a major show of drawings from the previous decade, 1969-79, at the prestigious galleries of one of Moore's American dealers, Wildenstein. Containing many works for sale, it was divided thematically into five sections, each of which was further arranged in subjects, thereby showing the totality of interests that had absorbed Moore during the period. Under each of the main headings – Drawings from life, Landscape subjects, Figures and ideas for sculpture, Drawings from imagination, and Interpretations – were works borrowed from the Collection plus recent pieces belonging to the Company. Here was an immediate problem. Who was to decide which of the Company's drawings should be sold and which retained? Was it to be Moore, or someone delegated by him as director of the Company, or was the Foundation to have an opinion? Juliet Bareau, writing to Wildenstein director Harry Brooks, commented: 'This morning I had a session with Henry reviewing the whole of the exhibition material and making the insurance lists. As you know there are 172 drawings in the catalogue, 76 of these "available" (i.e. not marked Henry Moore Foundation or Private Collection) and Henry has said that you should be able to sell up to 60 of these.'[45] It was a question never totally resolved until Bareau's successor, Ann Garrould, obtained everyone's agreement in the mid-1980s to halt sales of recent work, at least until the publication of the drawings catalogue raisonné. Among the post-1977 works in New York belonging to the Company that remained unsold and would come to the Foundation at a later date were **Old Apple Tree in Winter** 1977 [cat.244][46] and **Two Reclining Figures: Ideas for Sculpture** 1979 [cat.250],[47] and among many loans from the Collection was **Study after Giovanni Bellini's** *Pietà* 1975 [cat.242].

While all was going well in New York, problems were mounting in Perry Green. Moore's initial enthusiasm for his son-in-law had quickly waned through interminable disagreements over estate planning and the public relations fiasco, for which the Danowskis took the blame, over plans to create a sculpture park at Perry Green complete with student hostel and an arboretum of 5000 trees.[48] In addition there had been an unfortunate dispute over a group of works exported to Switzerland, through a scheme which had gone badly wrong. In order to ensure their return Moore had to pay out a huge sum of money, something he thoroughly disliked, and which only made the tensions already apparent within the family much worse. For the Foundation's Collection, however, the sequel turned out to be a happy one as Moore handed over all the works that had been his, while Irina Moore gave four pre-war pieces which complemented those she had donated two years earlier. Moore's gift of 1979 included **Hole and Lump** 1934 [cat.67], the last possible wood carving that the Foundation could have acquired from the family. Of later pieces, **Working Model for Hill Arches** 1972 (LH 653) and the extraordinary **Broken Figure** 1975 [cat.240], which had been exhibited at the Serpentine, were the most memorable. The four works from Irina Moore were **Seated Figure** 1929 [cat.48], **Composition** 1931 [cat.57], **Square Form** 1934 [cat.68] and **Two Forms** 1936 [cat.86], the more important pair, cats.57 and 86, having been lent by her for the Paris exhibition two years previously.

One drawing was purchased in 1979. For the modest sum of £2,600 the Collection acquired a rare study of a male figure, **Reclining Male Nude** 1922 [cat.7]. In the same year came a contribution from Mary Moore, of two carvings, **Two Piece Reclining Figure: Double Circle** 1976 (LH 695) and **Mother and Child: Egg Form** 1977 (LH 717), plus the singular drawing **The Artist's Mother** 1927 [cat.30].

By the beginning of 1980 much of the immediate conservation work had been completed on the drawings and Juliet Bareau turned her attention to their entire remounting and reframing. Obviously all the works on paper, graphics as well as drawings, needed to be framed in a compatible moulding. While in New York, Bareau had noticed and admired an American frame of medium-toned wood with slightly rounded corners. Using one of these as a prototype,

44. Bonn/Ludwigshafen 1979-80, p.7.
45. Letter dated 13 September 1979.
46. New York 1979-80, cat.27, credited erroneously 'private collection'.
47. Ibid. cat.86.
48. *The Guardian*, London, 18 March 1979.

John Farnham redesigned the structure of the frames, with their backs held in position by sliding bolts, to make them suitable for heavy usage and quick changes. As there were far too many items for everything to be mounted, let alone framed, some selection was necessary. This was to prove less of a problem with the graphics, since these could be limited to exhibition copies, though even here the sheer number of loans during the next few years meant that multiple sets of some of the more popular albums were continually being framed. The drawings were more subjective, but Mitchinson and Bareau determined that they would make a break with the past and have everything ready for a major exhibition due in 1981, concentrating first on the works that were going in that show. They spent a long period evaluating the measurements of each work, Bareau the drawings and Mitchinson the graphics, to establish a range of fixed mount sizes, which they hoped would lead to standardised frames and standard crates, thereby making packing and transportation simpler and leading to a reduction in costs. Their final decision was for six sizes giving twelve formats depending on whether they were used vertically or horizontally. Like many well-intentioned theories this didn't entirely work in practice as they had to break their own system repeatedly to accommodate items with unusual proportions and to relieve the monotony. Nevertheless as a rule it worked well enough and has been in constant use ever since.

The appointment of the first non-family member to the Board had occurred in 1979. A senior partner at the Foundation's solicitors, McKenna & Co., P.J. (Pat) Gaynor was appointed in May, to be followed in 1980, after the resignation of Mary Danowski, by Lord Goodman and then Maurice Ash, Sir Denis Hamilton, Sir Leslie Martin and Professor Bernard Meadows.[49] Arnold Goodman was appointed Chairman, a position he held until 1994. There were many changes too among the staff, though few of these had any significance for the Collection. Among those that had was the arrival of a new secretary, Anne Unthank, later

to become the Foundation's Assistant Administrator, a post with a range of responsibilities including sales. After Juliet Bareau's departure, Ann Garrould took over the drawings collection for the next seven years assisted by Jean Askwith, who was to form the archive of drawing photographs, liaising closely with Michel Muller who continued his daytime work in the studios but became the Foundation's photographer at night.

Writing to Pat Gaynor in May 1980, Moore confirmed that five early drawings had just been bought at Sotheby's and that they were all excellent examples of his work dating from 1929 and 1930, and adding: 'Irina remembered them well and agreed that they should certainly be purchased if possible for the Foundation'. This little group, which included **Figure on Steps** 1930 [cat.52], had all belonged to Lois Ventris.[50] Later the same month the Foundation was bidding again, and again acquiring five works, this time four from the Ventris collection, including the superb **Montage of Reclining Figures** 1928 [cat.44] and the wonderfully languid nude study **Seated Nude** 1927 (HMF 507). Also from the sale came the highly coloured sketchbook page **Studies for Sculpture: Reclining Figures** 1940 [cat.114] formerly in the collection of an old friend of Moore's, Sir James Richards.[51] Ten works was certainly the largest external purchase in one month throughout the history of the Collection, and more was to come later in the year. Four drawings were acquired at the summer sales, including **Seated Nude** 1929 [cat.45] which the Foundation has yet to exhibit.[52] Full endorsement for the recommendations for purchase came a year later when it was noted that 'the building up of the Foundation's collection of Moore works in range and quality by purchase and also by gift . . . should be a recognised objective of the Foundation'.[53] Although the number of works bought after 1980 fell annually, the quality of acquisitions remained high.

Of importance to the longer-term housing of part of the Collection was the construction of the Aisled Barn [fig.6]. The timbers for this structure, sited in a corner of the meadow behind Dane Tree House where the new grounds adjoined the Hoglands garden, were brought a few kilometres from a farm on the other side of Much Hadham, recently acquired as an investment by the Foundation. Dated by experts to the sixteenth century, the barn was rebuilt with a new tiled roof and black stained clapboard walls over a

49. HMF Trustees' agenda, 10 September 1981.
50. Sotheby's, London, 5 March 1980; others purchased were HMF 738, 759, 785, 893/894 (two notebook pages later separated).
51. Ibid. 26 March 1980; others were HMF 736, 759.
52. Others acquired at various sales were HMF 919, 1181, 1356.
53. HMF Trustees' agenda, 18 May 1981.

Fig.6. Moore watching the installation of the tapestry **Mother and Child: Interior Background** 1982-83 (TAP 26) in the Aisled Barn.

eight tapestries were woven at West Dean, and in the summer of 1980 these aroused considerable public interest when they were exhibited at the Victoria and Albert Museum. Following some confusion over the ownership of these original eight tapestries – did they belong to Moore, his daughter, the Company or even the Foundation? – which was eventually settled in favour of Mary, Moore commissioned another group specifically for the Foundation's Collection to be hung in the Aisled Barn.

Besides tapestries, other interpretative mediums that interested Moore towards the end of his life were porcelain castings and large-scale aquatints. The former were made in collaboration with the German ceramicists Rosenthal, and during 1980 Moore agreed to hold an exhibition at their factory galleries in Selb and Amberg. This later travelled to Galerie Levy in Hamburg where it accompanied a group of six large bronzes shown on the aptly named Moorweide. All six pieces were credited as coming from the Foundation, though only two, **Oval with Points** 1968-70 [cat.220] and **Hill Arches** 1973 [cat.232], were from the Collection. The remaining four, **Locking Piece** 1963-64 (LH 515), **Upright Motive No. 9** 1979 (LH 586a), **Reclining Figure: Arch Leg** 1969-70 (LH 610) and **Reclining Figure: Hand** 1979 (LH 709), were either sale casts or artist's copies that would be acquired by the Foundation later.

The following year came an exhibition in Rome, at the studios of Valter Rossi, an Italian printer famous for developing presses capable of printing huge aquatint plates. Moore had visited other workshops of Rossi's at Pietrasanta, near Forte dei Marmi, and produced eight plates of up to two metres long, from which Rossi had printed small editions for the Company.[55] Copies of all these aquatints would later pass to the Foundation's Collection, but meanwhile the exhibition in Rome showed a selection of these and other graphics, plus work lent from the Foundation including four larger bronzes for display outside. These were **Draped Reclining Figure** 1952-53 [cat.168] from the Collection and three works, LH 515, 586a and 610, shown the previous year in Hamburg. This became the pattern of exhibitions for the next few years, with the Foundation lending work from its Collection mixed with some items for sale – its own if

brick base. On the inside it consisted of five bays each side, the middle pair of which were extended outwards to provide a grand entrance to the garden front, with toilet and storage facilities to the rear. It was heated and air-conditioned (the influence of the Foundation, no doubt) and given a concrete floor capable of withstanding the weight of heavy carvings, though later Moore added a sprung wooden overlay which somewhat limited its use. To begin with Moore's interest was in the structure of the building, particularly its huge timbered frame. When it came to its usage he remained hesitant, thinking it might serve as a library, picture gallery, lecture theatre, or a combination of all three. Five years previously, in 1976, Moore had agreed to a suggestion by his daughter that he should license the reinterpretation of some of his recent drawings as tapestries, to be woven at West Dean College near Chichester.[54] He had produced tapestries before, with Brose Partick Scottish Weavers in the early 1970s, though none had been kept. Between 1976 and 1980,

54. Garrould, Power 1988.
55. CGM 560, 561, 564-569.

pre-1977, the Company's if more recent – plus artist's copies of new pieces belonging to the Company. Not until 1986-87 was this confusing and ambiguous situation over casts finally resolved. Complicating the position further, the Foundation would also lend work belonging to Irina Moore (who preferred to remain anonymous as an owner) but not, after the spring of 1980, that of Mary Danowski who had taken her collection with her on leaving the Foundation.

Art and diplomacy

Moore's involvement with the British Council had been long standing and highly successful. Since his participation in the Venice Biennale of 1948 there had hardly been a year when an exhibition planned, organised or sponsored by the British Council was not travelling or being curated for a specific venue – Florence and Paris being two recent examples. In 1979 came a request from Spain and Portugal. Would Moore consider an exhibition for these countries during 1981 and 1982? He had not visited Spain since 1934 and had never been to Portugal. Both countries had only recently emerged from long periods of dictatorship and their democratic credentials were still fragile. Moreover no exhibition of the magnitude being suggested had been attempted, either of Moore's work or in Spain. If it could be achieved it would be seen in Madrid as a return by Spain to the heart of European cultural life and in London as a feat of British cultural diplomacy.[56] Over a year's detailed planning ensued involving teams of people in London, Perry Green, and the three venues, Madrid, Lisbon and Barcelona, with much travelling in between. This show turned out to be the first in a long sequence of exhibitions for which the British Council and the Henry Moore Foundation worked in partnership, using the expertise and resources of both organisations to the full. In Spain there was tremendous co-operation from the Ministry of Culture, who put at their disposal the Palacio de Velázquez and Palacio de Cristal, two pavilions in the Retiro Park [fig.7]. It was, and remains, the largest exhibition of Moore's work ever staged, due partially to the scale of the site and also to the British Council's exhibitions officer, Ian Barker, who wished to leave nothing out, combined with Moore's insistence on putting everything in. It was to be the last exhibition for which Moore played a full part in making

..
56. Madrid 1981, pp.iv, v.

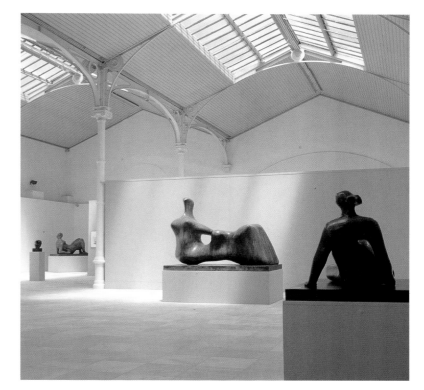

Fig.7. Inside the Palacio de Velázquez, Madrid, 1981.

the selection, for although the fiction was maintained until his death that he was fully involved, in reality he passed the responsibility to the British Council exhibition officers or to the Foundation's staff, who kept him fully informed. Although the show was retrospective in content, it was Barker's decision to arrange it thematically – and very well this turned out, given the nature of the buildings and their relationship to the environment of the park. Of the 230 sculptures shown, only six were outside. Resisting the suggestion of the local police chief in charge of security, that the outdoor works be placed in a straight row along a lit avenue between lamp posts with guard dogs attached, the organisers sited them instead between the two pavilions with **Hill Arches** [cat.232] adjacent to Palacio de Velázquez and **Three Piece Reclining Figure: Draped** on the terrace in front of Palacio de Cristal. The works on paper, 195 drawings and 121 graphics, were shown mainly in four corner rooms of Palacio de Velázquez where air-conditioning had been specially installed. There were more than two dozen lenders, but by far the majority of works came from the Foundation, including most of the works on paper exhibited for the first time in their new mounts and frames. The **Second Shelter Sketchbook** [see cats.116-129]

had been unbound on several occasions in the past in order that individual pages could to be mounted for exhibition, and Moore now agreed that it should be permanently dismantled. Five large frames each holding six pages were specially made, and although the pages were remounted in smaller frames for future exhibitions the sketchbook has remained unbound to this day. Among many drawings from the Collection were a number displayed for the first time.

Although the exhibition was seen by over 250,000 visitors, sadly Moore was not one of them. Despite his enthusiasm for the show, ill health prevented him from travelling. On the eve of the opening he called Margaret McLeod at the British Council in London to break the news to the Duke and Duchess of Gloucester who were representing Britain, and David Mitchinson in Madrid to inform the Spanish dignitaries. Everyone knew that Moore's absence marked the end of an era, and that missing the exhibition in Madrid implied that he would not see it at the remaining venues. This turned out to be correct; he declined invitations to exhibition openings from then on.[57] The show moved to the Fundaçao Calouste Gulbenkian, where this time eleven of the larger works were placed outside. One loan that was displayed inside was **Animal Carving** 1974 (LH 646) which, given its date, should have been in the Foundation's Collection. Its provenance remains a mystery, however, since there is no mention of it on the 1977 schedules. Whatever the reason for its omission, the carving did not remain with the Foundation much longer as the Gulbenkian purchased it shortly after the exhibition for its own newly constructed Centre of Modern Art. The Miró Foundation in Barcelona was the exhibition's final venue and here, owing to more restricted space, a slightly reduced selection of work was displayed.

On a much smaller scale another diplomatically inspired show took place that year when a group of works was sent from the Collection by the British Council to Sofia, with Margaret McLeod and Ann Garrould in charge, as part of the British contribution to the cultural activities arranged to mark the 1300th anniversary of the Bulgarian nation.

One consequence of staging large exhibitions was an even greater awareness of Moore's work coupled with a realisation that the Foundation was a lending organisation in possession of a large collection. Requests for loans, already numerous before 1977, began to flood in. Museum directors,

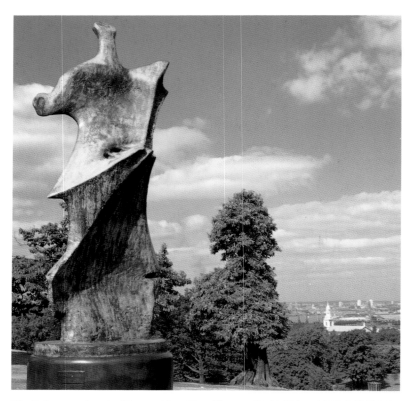

Fig.8. A second cast of **Large Standing Figure: Knife Edge** 1976 (LH 482a) from the Collection, on extended loan in Greenwich Park, London.

mayors, politicians, vice-chancellors and ambassadors all produced schemes of overriding importance for the Foundation's consideration. Often these could be politely refused by explaining that were the Foundation to leave behind one large piece at every venue it would soon have insufficient work to mount an exhibition. More seriously, the inquiries for loans placed the Foundation in something of a dilemma. Who should consider the requests and what should be lent? In the early years no formula was created to deal with these issues, which tended to be resolved on a day-to-day basis. In a few cases the Foundation had access to more than one cast, either a duplicate artist's copy or the possibility of lending a sale cast from the Company. Unfortunately these opportunities were rare, though two artist's copies of **Large Standing Figure: Knife Edge** 1976 (LH 482a) enabled Moore to place one on long loan with the Department of the Environment for display in Greenwich Park, London [fig.8], while the other was included in a full exhibitions programme [see cat.194]. Similarly, sale copies

57. José de Azeredo Perdigao, Chairman of the Gulbenkian Foundation, to Moore, 31 May 1983.

meant that second casts of **Three Piece Reclining Figure: Draped** 1975 (LH 655) and later **Reclining Figure: Hand** 1979 (LH 709) could be borrowed by the European Court of Justice in Luxembourg and the British Embassy in Paris without disturbance to the exhibition schedule, but this duplication would always be insufficient. Among early loans were some which significantly affected the content of exhibitions. **Two Piece Reclining Figure No. 2** 1960 [cat.191] had been included in the Bradford show of 1977 and was thereafter lent to Churchill College, Cambridge, between 1979 and 1987, missing the Spanish/Portuguese exhibition and those that immediately followed. Certainly it was better for this to be seen in Cambridge than kept crated in Perry Green, but its absence and that of many other key pieces over a period of time always made exhibition planning difficult. Only in later years when the Foundation evolved a co-ordinated policy towards loans and exhibitions, which included a resolve to keep no large work in storage if it could be displayed out of doors, would this dichotomy be resolved. **Reclining Connected Forms** 1969 [cat.225] remained absent from any exhibition for ten years after 1977, as it was on loan to the Fitzwilliam Museum, Cambridge. Indeed it had already been in Cambridge, on loan from Moore, for two years prior to its being given to the Foundation. Although shown in four exhibitions between 1987 and 1990, the sculpture's affinity with Cambridge was such that it returned for two more periods between 1990-92 and 1993-96, before being sent to Exeter University later in 1996. Other works in the Collection, seldom seen at Perry Green, which alternated between loan and exhibition were **Oval with Points** 1968-70 [cat.220] and **Two Piece Reclining Figure: Points** 1969 [cat.222]. The former was first exhibited in Hamburg during 1980 and then spent seven years at the University of Leicester; the latter was in the Serpentine exhibition in 1978 before going to the Aldeburgh Foundation at Snape Maltings until 1986. Among other loans from this period, **Large Spindle Piece** 1974 [cat.219] was placed outside the headquarters of the British Council, in Spring Gardens, London, in 1981 where it remained until 1996, changing ownership in 1986 when acquired for the Foundation's Collection from the Company. **Reclining Figure: Holes** 1976-78 [cat.239], the elmwood carving 'finished' for the Serpentine show, was sent to Wildenstein, New York, in 1979 as a centrepiece to the drawings

exhibition, and was then transferred to the Metropolitan Museum of Art where it remained until 1995. Somewhat surprisingly no loan was made to Madrid, though both the Fundaçao Gulbenkian and the Miró Foundation received sculptures: Lisbon had **Reclining Figure** 1982 [cat.246] in 1983, which like cat.219 came into the Collection in 1986, and Barcelona, following the return of a loan from Irina Moore, borrowed **Working Model for Reclining Figure: Hand** 1976-78 (LH 708) in 1989.

Despite a dramatic increase in loans and major exhibitions during the early 1980s, the greatest expansion was in the number of dealers' shows. Not all were as well planned or executed as the Wildenstein exhibition of 1979. Often it seemed that anyone who could lay hands on a few prints and a couple of working models considered that he or she had sufficient material to announce an 'exhibition'. Of twenty-nine venues recorded for one-man shows in 1981 only a fraction had work on loan from the Foundation but the perception was of more. The total number of venues increased to forty-six in 1982 and peaked at an alarming and astonishing seventy-seven in 1983. Even allowing that a tour of graphics around Denmark accounted for twenty venues, it was clear that the situation was getting out of control and that some limitations would need to be set. The Trustees considered the policy for exhibitions at various meetings between 1982 and 1984, being particularly concerned that over-exposure might be damaging to Moore's reputation. Their decision that the programme should be more strictly controlled and that a rigorously selective policy needed to be followed was correct but in practice turned out to be difficult to implement, perhaps because they were looking from the point of view of loans from the Collection, with all the inherent problems of control, staff time, budget demands and availability of work, rather than at sales by the Company which were the main cause of the huge increases. The steady supply of new work and the increasing prices being achieved were certainly feeding the demand for exhibitions, and dealers' shows were not an area over which the Foundation could exert much authority or direction. Had anyone thought to control sales during the early 1980s the number of exhibitions would have fallen dramatically, as was the case a few years later when production of new work ceased.

Among the many exhibitions of 1982 that had Trustee

Fig.9. Moore in 1982 working outside Gildmore maquette studio.

approval and did not involve the British Council were several containing loans from the Collection. Those in Basel, Durham, Forte dei Marmi, Leeds, Seoul and Tel Aviv were among the most significant. At this time David Mitchinson and Ann Garrould worked together on exhibitions, with the three sculpture assistants, but soon pressure of time and travel dictated a division of projects with each curator being responsible for separate events. Bearing in mind that these exhibitions were but a fraction of the whole, and that Garrould and Mitchinson had extensive commitments to other areas of business, the pace could not be maintained. A look at the diary for the second half of the year explains why.[58] The exhibition at the Durham Light Infantry Museum and Arts Centre ran from June to July, that at the Ho-Am Museum outside Seoul from June to August. The show in Durham, entitled *Henry Moore: Head-Helmet*, was an unusual thematic rendition of a subject which encompassed Moore's whole working life. Loans from the Collection ranged from **Head of a Girl** 1923 [cat.12] to **Helmet Head No.4: Interior-Exterior** 1963 [cat.202], with many other items from Perry Green belonging either to Raymond Spencer Company or Irina Moore credited as coming from the Foundation. Among pieces in Mrs Moore's collection masquerading under the Foundation's credit were **Mask** 1927 (LH 46) and **Drawing for Metal Sculpture: Two Heads** 1939 (HMF 1462), which both left Perry Green after her death and were bought at auction for the Collection in 1997 [see cats.33 and 106].

The Korean multinational group, Samsung, sponsored the Ho-Am Museum through its foundation of art and culture and was responsible for the next exhibition, of 122 works from Perry Green which Garrould, Mitchinson and John Farnham installed in Seoul. Korea, like Spain, was emerging from a long period of dictatorship and if not yet democratic (a curfew was still in place during a site visit the previous year) was eager for cultural contact with Europe. The Forte dei Marmi exhibition, timed to coincide with Moore's visit to receive the freedom of the town, opened in August and contained a selection of sculpture, drawings and graphics chosen by Ann Garrould. She hung the exhibition and then collected Moore from Pisa airport. Due to Moore's confinement in a wheelchair, Mitchinson travelled with him to Italy and after leaving him safely with Garrould flew on immediately to Madrid. Tel Aviv opened the following month, a few days after Forte dei Marmi closed, and continued until to the end of October. The exhibition was split between two venues, with the graphics displayed at Tel Aviv University and the drawings and sculpture at the Horace Richter Gallery. So tight was the schedule that Garrould dealt with the university one week and Mitchinson with the gallery the next, allowing less than twenty-four hours for the change-over and an ambassadorial dinner party in between. Basel, an exhibition of recent drawings at Galerie Beyeler, ran from October to November. The show celebrating the re-opening of Leeds City Art Gallery, *Henry Moore: Early Carvings 1920-1940*, which Garrould and Mitchinson had curated with Terry Friedman, commenced in November with a grand opening by Her Majesty The Queen (in the presence of the artist and all the Foundation's staff) and continued until the end of January the following year.

This last show, besides its significance for the long and happy partnership between the City of Leeds and the Foundation, was important in terms of understanding the influences on Moore's early work. Taking as its theme Moore's practice of 'direct carving', it brought together many major pieces from the pre-war period juxtaposed with thirteen items of ancient and tribal art, mainly from the British Museum, that had influenced them. Loans from the Foundation's Collection included **Woman with Upraised**

58. All the desk diaries from 1977 are preserved in the HMF archive.

Arms 1924-25 [cat.23] shown with a Greek marble of the fifth century BC, *Torso of a Youth (kouros)*, and all three of its wood carvings from the period, **Hole and Lump** 1934 [cat.67], **Family** 1935 [cat.82] and **Carving** 1935 [cat.83]. One comparative work borrowed from elsewhere was *Virgin and Child with Three Cherub Heads* by the fifteenth-century Italian, Domenico Rosselli. This came from the Victoria and Albert Museum and was displayed alongside Moore's interpretation, **Head of the Virgin** 1922 [cat.11] to be acquired for the Collection in 1988.[59]

Even the major exhibitions gave rise to concern among the Trustees. Following the perambulations around the Iberian peninsula, the British Council had turned its attention to South America. The Falklands war scuppered plans for an exhibition in Argentina and a major currency crash almost jeopardised the preparations for Mexico, but on hearing the Mexican government's inability to incur foreign currency expenditure the Foundation intervened by agreeing to share the international costs with the British Council. An exhibition of 145 sculptures, 88 drawings and 46 graphics was picked, with some stress placed on projecting the pre-Columbian influences in Moore's work, an emphasis considerably muted at the show's second venue, Caracas, where the director of the museum was not interested in promoting anything regarded as 'Mexican'. Mexico City was hugely favoured by Moore, who had much enjoyed his one visit there in 1953. The circular Museo de Arte Moderno provided a spectacular setting, if a difficult one in terms of installation for Ian Barker, Mitchinson and Michel Muller, and it was a disappointment to everyone that such a great exhibition came too late for Moore to make a second trip to Mexico. The opening in November 1982 was attended by President Lopez Portillo and the show was said to have attracted 400,000 visitors.[60] A major selection of work was on view, mainly from the Collection but including pieces such as **Working Model for Atom Piece** 1964-65 (LH 525) and

Working Model for Three Piece No.3: Vertebrae 1968 (LH 579) given four years previously to the Tate Gallery. The sculptor Helen Escobedo, director of the museum, writing to Moore, commented at the exhibition's close: 'It is like losing an essential part of our being . . . Now it is over, the memories will remain, having enriched each and every one of those who visited the exhibition during the 95 days it has been open to the Mexican public.'[61]

The exhibition ran concurrently with that in Leeds, and it was noted during the autumn that 'Mr Moore expressed his anxiety, shared by Julian Andrews of the British Council, that the Foundation was in danger of having too many exhibitions going on at once. The Foundation's staff were often in great difficulties in providing enough suitable works for the important larger exhibitions such as Mexico, when works were dispersed throughout the world at numerous smaller exhibitions being shown simultaneously.'[62] Whatever this comment implied about exhibition policy, or perhaps its lack, it highlighted both the incessant demand for Moore's work and the inadequacies at least in some areas of the Collection in keeping up with that demand.

Another small show running at the same time as Mexico City was *3 Temas en la Obra de Henry Moore* which opened at the Museo de Monterrey a couple of days later, before making an extensive tour of Venezuela the following year.[63] This consisted entirely of work from the Foundation, divided loosely between smaller-sized mother and child, internal/external forms and reclining figures and some slightly unconnected drawings and graphics. Once again the exhibition was considered a great accomplishment, drawing record attendances at the various regional galleries.

Overlapping the South American tour was the exhibition *Henry Moore: 60 Years of His Art* which opened at the Metropolitan Museum of Art in May 1983 [fig.10] as part of another diplomatic initiative, the *Britain Salutes New York 1983 Festival*. Staged primarily with works from American collections selected by William Lieberman,[64] it focused attention, in the words of the museum's director, Philippe de Montebello, on 'Moore's seminal years, specifically those carvings that indicate the creative intentions as well as the metamorphosis of ideas that reach ultimate, often monumental expression'.[65] The resources of the Foundation's Collection and staff were fully stretched, but Lieberman's requests for works not available in North

59. In 1982 still in the collection of Mr and Mrs Raymond Coxon, to whom Moore had given it as a wedding present.
60. Berthoud 1987, p.404.
61. Letter dated 10 February 1983.
62. HMF Trustees' agenda, 16 September 1982.
63. Maracaibo, Mérida, Barquisimeto, Cumaná, Porlamar, Ciudad Guayana.
64. Chairman, Department of Twentieth Century Art at the Metropolitan Museum of Art.
65. New York 1983, p.9.

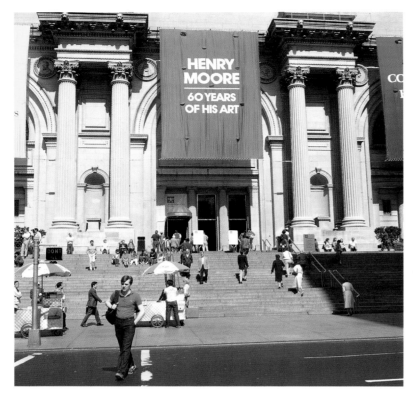

Fig.10. The Metropolitan Museum of Art, New York, announces Moore's exhibition of 1983.

of taking away one side of the building to allow **Reclining Figure: Arch Leg** 1969-70 [cat.224] and **Three Piece Reclining Figure: Draped** 1975 [cat.238][68] to be hoisted in sections on to a first-floor gallery. Even she was unprepared for the reception the show received. President Luis Herrera Campins officiated at the opening, shown round by David Mitchinson and Michel Muller, accompanied by Sophia Imber, Margaret McLeod representing the British Council for the last time, and scores of local and diplomatic dignitaries. The President's speech contained considerable praise for the United Kingdom, the first time he had said anything complimentary since the Falklands war and, according to Imber, 'The Venezuelan media unanimously recognized the Moore Show as the most important and best executed ever presented in this country.' She added, 'In all we have had two hundred thousand visitors in eight weeks, a record for this museum. That the Moore exhibition should have such appeal to a vast public previously unfamiliar with your work is to have one's faith in the power of great art immeasurably reinforced.'[69] Art reinforcing diplomacy, no doubt.

America were satisfied without diminishing too extensively the content of the South American exhibition. Items from the Collection included **Woman with Upraised Arms** 1924-25 [cat.23] and **Three Points** 1939-40 [cat.110], both of which must have gone straight from Leeds, and **Seated Figure** 1929 [cat.48] which with **Carving** 1934 [cat.65] was shown in Mexico but missed Venezuela. The exhibition was by far the largest and most comprehensive seen in the United States and a fitting tribute to Moore's eighty-fifth birthday from his American friends and admirers.[66]

Meanwhile success in Mexico City was matched in Caracas. Moore stressed the diplomatic significance of the occasion: 'I am delighted to be having a major exhibition of my work in your gallery in Caracas, especially since it will form an important part of the Bicentenary Celebrations of Bolivar, that are being held throughout Venezuela this year. I have much admiration for all that Bolivar achieved in the liberation of your country.'[67] Sophia Imber, the hugely energetic director of the Museo de Arte Contemporáneo, familiar to millions locally through her TV breakfast show, cleared the museum of its permanent collection to make enough space available for the exhibition, even to the extent

Giving up control

While many of the Foundation's staff were preoccupied with the exhibitions programme, changes affecting the Collection were taking place at Perry Green. Due to Moore's increasing frailty, Bernard Meadows resigned as a Trustee to take up a consultancy as acting director of the Foundation, a role he would assume for the following five years, and Margaret McLeod took his place as a Trustee. A prostate operation undergone by Moore in the summer of 1983 left him permanently weaker and incapable of managing daily concerns. Only Mary Danowski's return that September, after three years abroad, was enough to remotivate him.[70]

There were more purchases of drawings between 1981 and 1983, many at the instigation of Ann Garrould who remained concerned about gaps in the Collection. With

...

66. Only the 1946 retrospective which started at the Museum of Modern Art, New York, and the *Henry Moore in America* exhibition at the Los Angeles County Museum of Art in 1973 are comparable.
67. Letter to Sophia Imber, 3 February 1983, quoted in Caracas 1983, p.8.
68. Both pieces came into the Collection in 1987.
69. Letter to Moore, 24 May 1983.
70. Berthoud 1987, pp.410-11.

pressures from other directions and financial resources needed elsewhere, it became increasingly difficult to keep attention fixed on the Collection's deficiencies but Garrould did rather well with her recommendations, acquiring five works in 1981, seven the following year and another four in 1983. Key among them was **Reclining Figure** 1933 [cat.59], a strange piece indeed, since on examination the central reclining figure appeared to have been collaged over another. Moore was happy to take a gamble and have the top figure lifted – a risk that paid off – leaving the drawing as we see it today plus another reclining figure, later remounted on to a new backing paper as HMF 995a. Important also were **Ideas for Sculpture** 1939 [cat.104], a pre-war sheet of colourful surreal studies, acquired from a private collector and immediately included in William Lieberman's selection for New York, and **Eleven Ideas for Sculpture: Reclining Figures** 1935 [cat.77], a sheet of three-dimensionally described square forms, acquired by exchange with the Marlborough Gallery in London. Not yet exhibited by the Foundation is **Study for Seventeen Ideas for Metal Sculpture** 1937 (HMF 1321a), a sketchbook sheet depicting the origin of the motifs in its much larger namesake, cat.89. An opportunity to show the two works together is still awaited.[71] Of the 1982 intake[72] by far the most significant was **Group of Draped Figures in a Shelter** 1941 [cat.132], a large and typical Shelter drawing that Lady Huxley had put into Sotheby's. Moore recommended its acquisition to the Foundation's Trustees,[73] realising that their bid would need to be considerable for such an important piece. Certainly the £36,000 paid out a week later was more than double anything the Foundation had previously spent for an addition to the Collection, but the drawing remained one of the most splendid acquisitions made during Moore's lifetime.[74] In 1983 came another work from 1941, **Shelter Drawing: Sleeping Figures** [cat.133], this time presenting a close-up view of the sleeping figures, as well as **Two Seated**

Women 1934 [cat.69] and another sheet from the same notepad as cat.104, the equally impressive **Studies for Sculpture in Various Materials** 1939 [cat.105].[75]

A strengthening to the collection of early graphics came in 1982 when Bernhard Baer presented some exceptional proofs of the collographs published by Ganymed Original Editions in 1951: seven copies of **Figures in a Setting** (CGM 5) and eight each of **Standing Figures** (CGM 9) and **Woman Holding Cat** (CGM 10). Three years later his wife Anne gave the Foundation a copy of the exceedingly rare and unpublished **Three Female Figures** c.1950 (CGM 16) of which only one example had previously been held. In the summer of 1982 Julian Andrews approached David Mitchinson with a suggestion that the British Council and the Foundation should consider an exchange of sculptures where they both had duplicate copies. When the Council first started to exhibit Moore's work abroad it had sometimes purchased two casts of a bronze for use in different touring shows. By the 1980s it was no longer necessary to retain these as Moore's early work was comparatively well represented in its collection, but his later work was rather sparse. The Trustees agreed to the proposal,[76] though it took another nine years to implement fully.

With so many exhibitions to celebrate the eightieth-fifth birthday, 1983 marked the zenith of loans from the Collection. The Trustees' decision early that year to a division of responsibility between Mitchinson and Garrould, with the former working on British Council shows and the latter on the Foundation's, was long overdue, if not entirely implemented,[77] while the appointment of Margaret McLeod added to the Board someone whose ability to assess museum and gallery conditions worldwide was without rival. A continuing problem was that many shows would take place anyway with or without the Foundation's participation. As the Trustees were determined to maintain standards, there was always the possibility of becoming involved in a project to ensure its integrity which they would have preferred never to have been initiated in the first place. Luckily help was at hand. Judging the criteria on which exhibition support and loans should be based would be worked out by Margaret McLeod during the next five years, though her influence came too late to affect the 1983 programme which in most respects repeated that of the previous year, with a mix of exhibitions instigated by a bewildering multiplicity of

71. The remaining works acquired in 1981 were HMF 256a and LH 436.
72. Other works acquired in 1982 were HMF 649a, 663, 696a, 724b, 788a, 1749.
73. HMF Trustees' agenda, 23 November 1982.
74. Berthoud 1987, p.394 recalls the reactions of Moore and Lady Huxley to the sale.
75. The other work acquired in 1983 was HMF 345.
76. HMF Trustees' agenda, 16 March 1983.
77. Ibid. 4 March 1983.

institutions. Seven of these, in addition to those already discussed, drew heavily on time and resources.

The show at Galerie Maeght in Paris was an obvious example of the Foundation supporting a selling exhibition in a prestigious location with some specific loans. These included **Bird Form I** and **Bird Form II** 1973 [cats. 228, 229] plus a carving of 1980 belonging to the Company, **Girl with Crossed Arms** [cat.269], probably lent because Maeght had no carved pieces for sale or display. An exhibition in Honolulu came about through the sale of a large outdoor work by the Company, followed by the desire of the donor to announce its arrival in Hawaii in this way. Ten bronze sculptures and seventy-five graphics were divided between the Honolulu Academy of Arts, whose curator, James Jenson, took responsibility for the show, and the lobby level of Pauahi Tower at Bishop Square, where the purchase, a cast of **Upright Motive No.9** 1979 (LH 586a), was permanently installed. The British Council's contribution to 1983 was a touring exhibition of 100 graphics, with a retrospective selection covering fifty years from 1951 to 1981. This began at the Mestna Galerija in Ljubljana, a city well known for its print biennale, before proceeding to Zagreb, Belgrade, Skopje and Sarajevo. After returning to London the following year it was sent to Greece in 1985 for a showing at the National Gallery in Athens.

One new large touring exhibition commenced in 1983. Curated by Ann Garrould for the Orangerie Palais Auersperg in Vienna and the Residenz in Munich, it later moved to the Kunstmuseum Herning, and the Espace Oscar Niemeyer in Le Havre, where it closed in the summer of 1984. Installed by Garrould and John Farnham at each venue, it consisted of 171 mainly new works, made since 1977. Everything came from Perry Green though only three or four pieces, such as **Upright Motive No.7** 1955-56 [cat.176] and **Goslar Warrior** 1973-74 [cat.233], were from the Collection. The tour was extremely important in terms of organisation and logistics, as it created the opportunity for the Foundation to work directly with museums and galleries around Western Europe without the necessity of support from any outside agency. This was not entirely risk-free as was discovered when, at the last moment, the Herning Kunstmuseum suddenly found itself unable to raise sufficient funds to mount the exhibition. Had it not been able to go to Denmark the show would have to have been brought back and kept in store before being

sent to Le Havre, all at considerable extra cost to the Foundation. Rather than do this, the Trustees agreed to support its showing in Herning with a financial donation.[78] However, as a reaction to this last-minute request they agreed as a point of principle in future not to put money into independently financed exhibitions. This experience would prove invaluable a few years later when the Foundation began to organise its own exhibition programme on a truly intercontinental basis.

Among the many celebratory exhibitions at home, three were prominent, in Folkestone, Winchester and London. The first, presented as the third Kent County Council biennial exhibition by the local Education Committee and staged in the New Metropole Arts Centre, was billed as 'a major retrospective by the world's foremost living sculptor' – which perhaps applied more accurately to the second part of the claim than the first, since there was nothing later in the selection of 153 works than 1953. Among these were the medium-sized **Mother and Child: Arch** 1959 [cat.189] and the small **Maquette for Square Form with Cut** 1969 [cat.221]. Larger pieces were sent to the exhibition *Winchester Celebrates Moore's 85th Birthday* held in the city's castle grounds and Great Medieval Hall. Of the seventeen works, twelve were billed as coming from the Foundation, with four from the Tate Gallery and one lent privately. Those from the Collection included a plaster cast of **King and Queen** 1952-53 (LH 350) about which more later, and the fibreglass versions of **Standing Figure** 1950, **Three Piece Sculpture: Vertebrae** 1968-69 and **The Arch** 1969, with no coyness in the publicity about admitting the material. Both **Upright Motive No.5** and **No.8** [cats.175, 177] were shown, as was the major elmwood **Reclining Figure** 1959-64 [cat.188]. Other pieces came from the Company, including **Girl with Crossed Arms** 1980 [cat.269] which must have been hurried back from Paris.

At the Tate Gallery in London, Alan Bowness presented *Henry Moore at 85: Some Recent Sculptures and Drawings* – so recent in fact that none of the twenty-eight drawings, sixteen bronzes and one carving selected was yet in the Foundation's Collection; all still belonged to the Company. As Bowness told Moore, 'we need to explain somehow that it isn't another major show, and that it contains only your

..

78. HMF Trustees' agenda, 15 February 1984.

newest sculptures and drawings.'[79] Whether or not the particular bronzes exhibited at the Tate were artist's copies or casts for sale remains academic, as examples of each entered the Collection during 1986 and 1987. So too did most of the drawings, including **Three Figures on a Stage** 1981 [cat.257][80] though not **Mother with Child Holding Apple II** 1981 [cat.258] which was not acquired until 1997.[81] The carving displayed was **Thin Reclining Figure** 1979-80 [cat.263], one of eighteen works produced in Italy after the creation of the Foundation. Most of this exhibition, though not the carving, went on to the Sonja Henie-Niels Onstad Foundations in Høvikodden. Ann Garrould, writing to the director Ole Henrik Moe, explained that the drawings were unchanged from those shown in London but added: 'several of the maquettes shown in the Tate were sale, not artist's copies and are no longer available' – proving yet again how difficult it was to identify one cast from another during this period.[82]

The Collection takes shape

As the Moores grew older and less mobile, and were without staff, their property in Forte dei Marmi became too inconvenient for holidays. Moore's last visit to Italy occurred in August 1982 when he received the freedom of Forte dei Marmi, but he remained too short a time to open up the house. The number of Italian carvings also decreased, with only five of the eighteen bearing dates after 1980. Today the Collection holds eight of these, **Draped Reclining Figure** 1978 [cat.248], **Two Standing Figures** 1981 [cat.261], **Single Standing Figure** 1981 [cat.262], **Mother and Child: Egg Form** 1977 (LH 717), **Thin Reclining Figure** 1979-80 [cat.263], **Mother and Child** 1978 (LH 754), **Girl with Crossed Arms** 1980 [cat.269] and **Mother and Child: Hood** 1983 [cat.276], the others having been sold, if not already in the family collections.[83] Of the two monumental works **The Arch**, as already explained, was sited in Kensington Gardens in 1981, and **Large Spindle Piece** (LH 593a), carved in 1981, went in sections straight from Italy to America for erection at

..

79. Letter dated 14 April 1983.
80. London 1983, p.32.
81. Ibid. p.26.
82. Letter dated 13 October 1983.
83. Those in the family collections were LH 686, 719, 724, 736.
84. HMF Trustees' agenda, 5 July 1983.
85. Malcolm Woodward in conversation with David Mitchinson, July 1997.

the Inter-Continental Hotel in Miami. The remaining pieces, **Reclining Figure: Curved** 1977 (LH 689), **Butterfly** 1977 (LH 703), **Reclining Figure: Wing** 1978 (LH 750) and **Stone Form** 1984 (LH 652b), all came to Perry Green before being sold from the studio, one suspects without much concern to evaluate their relevance for the Collection. More extraordinary was the disappearance of **Two Piece Reclining Figure: Double Circle** 1976 (LH 695). This had been a gift to the Foundation from Mary Danowski in 1979. A little later it was gone, sold by Moore to the Museum of Modern Art in Toyama – marvellous that it went to an important Japanese public collection, but disconcerting that no one at the Foundation appeared to notice or pass comment on the disposal of such a major gift.

Problems of space, already acute in 1977, had worsened by 1983. The volume of new work combined with attempts by the staff to improve standards of conservation and storage prompted Bernard Meadows to engage the services of some architect friends to draw up plans for a small building close to Dane Tree House primarily to hold framed works on paper. Sir Leslie Martin scrutinised the proposals and recommended that estimates be obtained and planning permission applied for.[84] This was done, but the Trustees, alarmed at rising costs and perhaps anxious to avoid disturbance due to Moore's illness, shelved the proposal and the planning permission remained forgotten for the next decade.

Discreet changes to previous patterns of production had been developing since 1977 and would intensify once Meadows took charge of studio work after Moore's illness. Not surprisingly the number of maquettes which had been increasing at the beginning of the 1980s declined thereafter. From around forty pieces in 1983, there was suddenly nothing, save for a few late castings in 1984 and 1985 of finished plasters found in the studios. With working models the story was a little different. Hugely profitable to produce in their editions of nine, there was a sudden late rush of these in the early years of the decade which, according to Malcolm Woodward, increased between 1983 and 1986.[85] The amount of casting during Moore's final years was considerable, and not just of new work, since the Trustees had become aware that many artist's copies of sculpture made before 1977 remained uncast. After the disposal of the sale copies, the last piece which remained in the Collection

from the gift of 1977 in terms of chronology was **Twin Heads** 1976 (LH 700), but the Collection would later acquire many works from the Company of post-1977 casts of pre-1977 sculptures, in addition to others which were enlargements made after 1977 from earlier maquettes.

By 1986 late castings of artist's copies produced for the Company included nine large pieces, **Seated Woman** 1958-59 [cat.184], **Locking Piece** 1963-64 [cat.203], **Large Standing Figure: Knife Edge** 1976 [cat.194], **Large Totem Head** 1968 [cat.215], **Reclining Figure** 1969-70 [cat.223], **Reclining Figure: Arch Leg** 1969-70 [cat.224], **Large Four Piece Reclining Figure** 1972-73 [cat.231], **Reclining Mother and Child** 1975-76 [cat.236] and **Three Piece Reclining Figure: Draped** 1975 [cat.238]. In addition many works of small and medium size were cast, among which was **Working Model for Sheep Piece** 1971 (LH 626).

Not counting three unique monumental bronzes,[86] and some working models in progress during 1976-77,[87] there were fifteen post-1977 enlargements from earlier works, including three more of massive size each cast in editions of 1 + 1. **Large Upright Internal/External Form** [cat.162] and its spin-off **Large Interior Form** (LH 279b) were developed from an idea of the early 1950s which already existed in three sizes of bronze and an elmwood carving. As the result of a request from an old architect friend of Moore's, Gordon Bunshaft, for a sculpture for the atrium of a Chicago bank, the Company cast the interior section in an edition of 6 + 1 as well as producing an artist's copy of the complete work. **Large Reclining Figure** [cat.103] was made at the behest of another architect friend, I.M. Pei, for the headquarters of the Overseas Chinese Banking Corporation in Singapore, and cast in 1984 from a plaster and polystyrene enlargement of a small lead reclining figure of 1938, in the Museum of Modern Art, New York.[88] The last work of architectural size, **Large Figure in a Shelter** [cat.237], plus a life-sized version **Figure in a Shelter** (LH 652a) and a separate edition of its interior section, **Bronze Form** (LH 652d), were all enlarged between 1983 and 1986 from the last of Moore's middle-sized helmet heads dating from 1975. Originally intended for an office project outside Chicago, and then briefly suggested for siting on a Greek island or at the Seoul Olympics, the eventual placing, after Moore's death, of **Large Figure in a Shelter** in the Basque city of Guernica would surely have given him much satisfaction. Of the other pieces, four were

the natural progressions to larger size of maquettes made during the early 1970s: **Reclining Figure: Angles** 1979 [cat.245], **Reclining Figure: Hand** 1979 [cat.249], **Reclining Figure** 1982 [cat.246] and the smaller **Mother and Child: Arms** 1980 [cat.247]. Quite different were the remaining five, all of which originated from far earlier ideas. Most unusual of this quintet was **Working Model for Divided Oval: Butterfly** [cat.213], produced in bronze during 1982 from a plaster cast of the white marble carving of 1968, LH 571, and taken as a model for the enormous enlargement. Another reinterpretation of a 1960s idea was **Upright Motive No.9** [cat.218] made in 1979 from a maquette of 1968. In 1980 came **Working Model for Seated Woman** [cat.182] and four years later **Working Model for Seated Woman with Arms Outstretched** [cat.192] enlarged from maquettes of 1956 and 1960. Both were being increased to over life-size by Michel Muller during the mid-1980s and were abandoned on Moore's demise. In conclusion came **Stringed Mother and Child** (LH 186h), enlarged by Malcolm Woodward in 1986 from a tiny maquette of 1938 [cat.100]. As the Company retained artist's copies of fourteen of these sculptures, selling only **Bronze Form** (LH 652d), their addition to the Collection during 1986-87 provided a huge increase and a considerable improvement to the holding of earlier Moore sculptures, though the Trustees were now aware that significant gaps remained.

The Bradford exhibition of 1977 had included a fine plaster cast of **Family Group** 1948-49 (LH 269).[89] According to Margaret McLeod, this was one of a small number of casts Moore had specially made of early bronzes for longer term loan at the request of the British Council, since during the early 1950s he had limited bronzes available.[90] Others made at this time were **Reclining Figure: Festival** 1951 (LH 293), **Upright Internal/External Form** 1952-53 (LH 296), **Draped Reclining Figure** 1952-53 (LH 336), **King and Queen** 1952-53 (LH 350) seen in the Winchester exhibition of 1983, and even the carving permanently sited in Battersea Park, **Three**

..

86. **Mirror Knife Edge** 1977 (LH 714) made for the National Gallery, Washington; **Large Divided Oval: Butterfly** cast 1985-86 (LH 571b) at the Congress Hall, Berlin; **Three Forms Vertebrae** (The Dallas Piece) 1978-79 (LH 580a) made for City Center Park Plaza, Dallas.
87. LH 674, 705, 708.
88. LH 192.
89. Bradford 1978, cat.4.
90. Margaret McLeod in conversation with David Mitchinson, June 1997.

Standing Figures 1947-48 (LH 268), which after being in exhibitions in Greece, South Africa, Scandinavia, Switzerland, Canada and New Zealand was sent to the City Hall in Hong Kong where it stayed for many years. Some of these casts had been returned to Perry Green by the early 1970s, and the Festival figure had gone on to Toronto; the rest were returned at Margaret McLeod's instruction to clear doubts about ownership and copyright. At a meeting in October 1983 the Trustees discussed the Foundation's lack of bronze casts of **Family Group** and **King and Queen** and agreed that new casts should be made. Whether or not they were aware that the original plasters had long since been destroyed is not recorded, but new bronzes were eventually produced from the plaster casts [see cats.156, 170]. While the efficacy of recasting from a plaster cast rather than from the original may have been questionable, the result justified the decision. Indeed the Trustees might have gone further if more originals, rather than plaster casts, had been available and not in the collections of the Tate Gallery or the Art Gallery of Ontario. Certainly Maurice Ash queried whether other casts should be commissioned, and at least one other sculpture, **Atom Piece** 1964-65 (LH 525), was discussed, but its original was in Canada and no plaster cast existed.

Acquisitions of drawings were fewer in 1984 – only three and all from the same private collection, but each of superb quality. **Four Studies of Miners at the Coalface** 1942 [cat.140] doubled the Collection's holding of large coalmine drawings, **Studies of Reclining Figures** 1940 [cat.112] added a major pictorialisation of sculpture in a setting and **Six Studies for Family Group** 1948 [cat.154] introduced a typical work of a familiar subject previously unrepresented. The following year seven more works were added. These included **Seated Figures: Ten Studies of Mother and Child** 1940 [cat.113], a forerunner of the terracotta maquettes of 1943; the highly coloured **Drawing for Wood Sculpture** 1947 [cat.151] out of the unbound **Sketchbook 1947-49**; and the **Seated Figure** 1948 [cat.153], a monumental study from a year poorly represented in the Collection.[91] Graphic work was also augmented in 1985 by acquiring through gift, exchange or purchase ten early proofs, including two copies of the missing **Red and Blue Standing Figures** 1950 (CGM 36).

..

91. Other works acquired in 1985 were HMF 935a, 1111a, 1111b, 2881.
92. Leeds 1984-85, foreword.

Fig.11. Moore in 1981 discussing the patination of **Reclining Woman: Elbow** [cat. 271] with John Farnham.

Slowly but methodically gaps were being filled in the holdings of works on paper and the standard of the Collection was improving.

After the unrelenting pace of the previous three years, the exhibitions timetable became rather less frantic in 1984 and 1985 partly because the Foundation's staff could now submit, via Margaret McLeod, any contentious, unrealistic or ill-timed proposal to the Trustees for consideration rather than to Moore personally. Not that this meant fewer loans from the Collection, rather that some of the new exhibitions were tours and therefore works were committed for longer periods. Of the single venue shows, the most significant was a thematic grouping of mother and child subjects put together at the Foundation for the Skulpturenmuseum Glaskasten in Marl, which explored Moore's abiding interest in the interrelationship of objects of contrasting size through the exploration of the female form and her offspring. **Seated Nude** 1927 [cat.31] and **Mother and Child: Arch** 1959 [cat.189] were among the seventy-five works exhibited. There was another offering from Leeds, where the Henry Moore Centre for the Study of Sculpture produced *Henry Moore: Sculpture in the Making*, which, as explained in the catalogue, explored the relationship between the artist's working methods and his creative inspiration in a way not previously presented.[92] Items lent from Perry Green included many examples of plasters and bronze casts of the same work, such as **Wall Relief: Maquette No.1** 1955 [cat.173]; maquettes and working models of the same

subject, including those for **Reclining Woman: Elbow** 1981 (LH 810) which itself had been lent to the art gallery two years before [fig.11]; early and late carvings such as **Family** 1935 [cat.82] and **Broken Figure** 1975 [cat.240]; a selection of found objects from the studio and even Moore's signature punch.

Two touring exhibitions originated in 1984, both thematic. For the German Democratic Republic came one on Shelter drawings and for the United States a major study of the reclining figure. Both shows had been gestating for some time and were exceedingly well prepared. East Germany was not then an area in which the Foundation would have had the experience or confidence to work without the participation of the British Council, who took responsibility for the tour in co-operation with the local Ministry of Culture. This began in East Berlin where it was seen by 22,000 visitors and continued via Leipzig and Halle to Dresden. Over one hundred war-time drawings were exhibited with many loans from the Collection, including sixty-five pages from the **Second Shelter Sketchbook** 1941 [see cats. 116-129] and several from the **Coalmining Subjects Sketchbook** 1942 [see cats. 134-138]. Of larger drawings **Eighteen Ideas for War Drawings** 1940 [cat.115] and **Miner at Work** 1942 [cat.139] were in the original gift of 1977, while **Group of Draped Figures in a Shelter** 1941 [cat.132] and **Mother and Child among Underground Sleepers** 1941 [cat.131] were subsequent purchases.

In America the reclining figure exhibition was originated by Steven Rosen, chief Curator at Columbus Museum of Art, Ohio, and selected by him in collaboration with Ann Garrould and David Mitchinson. Rosen and the museum's director, Budd Harris Bishop, paid many visits to Perry Green to examine and investigate work for the show, and the atmosphere of the place left a deep impression on them both. Bishop, writing later in the exhibition catalogue, summed up his impressions thus: 'Throughout Moore's property are many of his monumental sculptures, each knowingly placed in the landscape. The impact of all these works, in one place, is memorable.'[93] No large sculptures were included in the exhibition, though 114 objects on the theme were chosen in an attempt to explore in some depth the most fundamental aspect of Moore's work. As with the concurrent shows in Europe of mother and child and *Sculpture in the Making*, it seems rather late to have

suddenly been initiating thematic or didactic shows of this type when so few had been curated before, but whatever the reason for their appearance during the mid-1980s they established a strong trend that was set to continue. From Columbus the show moved on to Austin, Salt Lake City, Portland and San Francisco, taking a year for the whole tour. Among reclining figure drawings from the Collection which remained in America until the end of 1985 were **Reclining Male Nude** 1922 [cat.7], **Reclining Nude and Five Studies of an Arm** 1922 [cat.9] and later work such as **Two Reclining Figures: Ideas for Sculpture** 1979 [cat.250], not acquired by the Collection until two years after its return. Garrould remained preoccupied with this exhibition at its various locations throughout 1985 but Mitchinson had already turned his attention to the next British Council venture, this time an exhibition in the Far East.

Although not scheduled to open in Hong Kong until the spring of 1986, preparations for this show had been going on since a site visit at the beginning of 1984, and following a further visit to both Hong Kong and Japan the following year, Mitchinson, Muller and Woodward had returned via New Delhi to initiate talks on another major project encompassing much of India, suggested for 1987.

In addition to taking a more active role in the planning and mounting of exhibitions, the sculpture assistants were increasingly busy with work in the studio. It says much for the skill and competence of Muller and Woodward that there was no diminution in the quality of the pieces produced at this time. In addition to earlier sculptures cast or enlarged after 1977, Moore created a large quantity of new maquettes, many of which were made in working model or larger size by the assistants, including four in both. These were **Two Piece Reclining Figure: Cut** 1979-81 [cat.268], **Reclining Woman: Elbow** 1981 [cat.271], **Draped Reclining Mother and Baby** 1983 [cat.272] and **Mother and Child: Block Seat** 1983-84 [cat.275], the latter pair much used in the Foundation's exhibition programme after their entry into the Collection in 1986, the others continuously on loan during the same period.[94] Pieces that went only to working model stage numbered twelve, or thirteen if the model for the

93. Columbus/Austin/Salt Lake City/Portland/San Francisco 1984-85, p.6.
94. LH 758 in Colombia University, Arden House, New York; LH 810 at Leeds City Art Gallery.

travertine **Mother and Child: Hood** 1983 [cat.276] is included. Three pieces were marginally less typical than the rest and might be considered the most interesting. First was **Three Figures** 1982 (LH 853), one of the few enlargements by John Farnham, who in the early 1980s was almost entirely concerned with the preparation of sale casts then leaving the studios on a weekly basis. Next came **Horse** [cat.264] enlarged in 1984 from a maquette of 1978 by Woodward, who suggested the idea to Moore as he found the repetition of reclining figure and mother and child somewhat tedious and was looking for a challenging alternative. Moore was a little hesitant at first, explaining that animals were not a subject for which he was known, but Woodward persevered and Moore was hugely pleased with the finished result. Finally there was **Head** 1984 [cat.278], again enlarged by Woodward, this time from an uncast diminutive plaster discovered in the maquette studio by Bernard Meadows.[95]

Two more Trustees were added to the Board during this period of Moore's declining health, Alan Bowness in 1984 while still Director of the Tate Gallery, and John Roberts of the solicitors Goodman Derrick, who acted for the Moores on personal matters. Pat Gaynor's resignation in the spring of 1986 did not presuppose any lessening of his involvement in Foundation affairs as he remained its legal adviser and would rejoin the Trustees three years later. There were also significant additions to the staff, with the arrival of Angela Dyer to assist on publications and act as editor, shortly followed by Emma Stower, who later became curatorial assistant.

The Trustees now began to concern themselves with the question of artist's copies in the ownership of the Company. The anomaly of having casts in the Company which should have been in the Foundation's Collection had been recognised as long ago as 1978, but a potential problem over VAT delayed serious discussion until after 1982 when the tax issue was resolved. By the mid-1980s the dilemma over title had become acute, as with the passing of time more and more artist's copies were cast and the difficulties in correctly cataloguing them arising from this were becoming absurd. As it was clearly recognised by Moore that all the artist's copies cast after 1977 should be in the Foundation's Collection, Meadows was concerned that the Company, of which he was now a director, had cast all outstanding editions of bronzes, so that a transfer of artist's copies from Company to Foundation could be implemented. File cards were made for each individual cast, from which lists of artist's copies, and the remaining carvings, were produced. In January 1986 the first transfer, by Letter Agreement, took place, with about five and three-quarter million pounds' worth of sculpture coming into the Collection.[96] A year later more than three million pounds' worth of work was sold, bringing in examples of the remaining sculptures produced after 1977.[97] The policy of the Foundation that its collection should be as complete and up to date as possible was now realised, though the transfer of sculpture did not conclude the story, as there were still plasters, graphics and drawings to be considered.

The Collection benefited by the addition of 190 works in 1986, nearly thirty more than remained from the original gift of the artist. Except for five carvings, all were bronze artist's copies. Included were many of the post-1977 casts of earlier sculptures, though perhaps more of these were in the transfer of the following year which totalled another 119 works, almost entirely of bronzes but including a couple of fibreglass casts and the two remaining carvings. Other additions were made in 1986. From Lord Rayne, a close friend of the Moores, and a future Trustee, came a bronze of **Reclining Figure: Bunched** 1969 (LH 489a) cast in 1986 from the travertine carving which Rayne had purchased some years previously, and from a current Trustee, Sir Denis Hamilton, a cast of **Working Model for Sundial** 1965 [cat.207] which he presented on realising that the bronze formerly sited in the Hoglands garden did not belong to the Foundation.

The Curwen Gallery in London, whose master-printer Stanley Jones had been responsible for editioning many of Moore's lithographs over a twenty-year period, donated to the Foundation twenty rare proofs from the 1960s, considerably strengthening this area of the graphics archive.[98] One of the missing printed albums was a deluxe copy of Moore's book *Heads, Figures and Ideas*,[99] which was

95. The remaining pieces were LH 731, 752, 792, 797, 827, 832, 870, 903, 907.
96. Bernard Meadows to HMF, 30 January 1986.
97. Bernard Meadows to HMF, 23 January 1987.
98. Five proofs connected with CGM 49, thirteen with CGM 50 and two with CGM 52.
99. Rainbird, London, and the New York Graphic Society, New York 1958.

found in 1986 by Patrick Cramer, not only with the lithograph **Thirteen Standing Figures** 1958 (CGM 41) but also containing the drawing **Girl at Desk Doing Homework** 1956 (HMF 2921a). No other works on paper were purchased, and none would be until 1988. Meanwhile Ann Garrould was compiling an inventory of all the late drawings, from which evolved a list of those she proposed transferring from the Company.

Preparations for the Far East tour, maturing for the previous two years, reached their climax at the beginning of 1986 with the departure of two cargo planes bound for Hong Kong, though many of the larger sculptures were already on their way by sea. During the negotiations Ian Barker had moved on from the British Council, to be replaced by Ann Elliott who would remain in control of the Henry Moore project portfolio at the Council for the next six years. Hong Kong turned out to be one of the most complicated installations ever attempted since the exhibition was mounted in seven venues, three of which were of paramount importance. Like the Spanish exhibition of five years earlier it was arranged thematically, which again made sense owing to the divergence and differing nature of the sites. Monumental bronzes and fibreglass casts were placed on the Kowloon side of the harbour along the Tsim Sha Tsui Promenade jutting out over the water in front of the Regent Hotel. This was a risky business, first because the placing had to be done by lighter from the sea, and second because the local officials were concerned that the wind factor might cause damage or injury. Luckily no problems occurred and the works, so well known in their English landscape settings, looked remarkably comfortable with their moving backdrop of harbour and cityscape beyond. The Hong Kong Arts Centre was home to all the graphics and the smaller bronzes, carefully selected to ensure that everything could ascend in a rather small lift since the gallery was on an upper floor, as it was at the third venue, the Museum of Art, which housed the drawings and carvings. In addition the newly constructed Academy for Performing Arts had **Goslar Warrior** 1973-74 [cat.233] placed on its roof – this accomplished by military helicopter – the City Hall Memorial Garden had five over life-sized works tucked into one of the few 'green' spaces in the central district, while **Three Piece Reclining Figure: Draped** 1975 [cat.238] was sited at Edinburgh Place adjacent to Queen's Pier. American

Fig.12. David Mitchinson explaining **Two Piece Sculpture No.10: Interlocking** 1968 [cat.217] to Prince Naruhito at the opening of the exhibition in the Tokyo Metropolitan Art Museum, 1986.

Express, the exhibition's sponsor, had the recently cast **Horse** 1984 [cat.264] on display in their local travel service office. Among many pieces in Hong Kong shown for the first time were a recently produced fibreglass of **Large Reclining Figure** 1983 (LH 192b) and the new bronze casts of **Family Group** 1948-49 [cat.156] and **King and Queen** 1952-53 [cat.170]. None of these was among the works transferred in 1986, but many others were, though in the pressure and excitement leading up to the opening (at which the Duchess of Kent was guest of Honour, and Pat Gaynor represented the Foundation) it probably went unnoticed that among the 165 sculptures were many credited as coming from the Henry Moore Foundation which had only arrived in the Collection the day before.[100]

Owing to the enormous size of the two Japanese venues, the Metropolitan Art Museum in Tokyo and the art museum in Fukuoka, the exhibition was augmented with extra works flown from London. Though there had been much discussion among the Trustees about a suitable venue for Moore's work in Tokyo, they had no need to be concerned as the Metropolitan Museum situated in Ueno Park could not have been more appropriate. Considering the effort, finance and time that was invested in the exhibition,

...

100. Hong Kong opened on 1 February 1986.

more than any other hitherto, its critical acclaim and popularity with the public came as a huge relief. As a bonus another diplomatic triumph was achieved with the presence of Prince Naruhito at the Tokyo opening [fig.12]. The Japanese catalogue, with a text by William Packer, contained Moore's final published letter, thanking those who had made the exhibition in Tokyo and Fukuoka possible.[101] Typed for him by Betty Tinsley, as anything handwritten was too difficult, it was signed, boldly if a little shakily, 'Henry Moore' – a poignant reminder that time was running out. The exhibition in Fukuoka closed during July, and all the works from the Collection were back at Perry Green by the middle of August. Moore died peacefully in his sleep on the last day of the month.

In memoriam

A number of consequences for the Collection emerged as a result of Moore's death, though not all of them became immediately apparent. The exhibition's programme was hardly affected, since 1986 was not 1982 and there remained little of importance for the rest of the year, save for loans including **Reclining Figure** 1931 [cat.56], the cast concrete **Composition** 1934 [cat.64], the cast iron **Three Points** 1939-40 [cat.110], **The Helmet** 1939-40 [cat.111] and the lithograph **Spanish Prisoner** *c*.1939 [cat.107] to the exhibition *Surrealism in Britain in the Thirties* presented at Leeds City Art Gallery to celebrate the fiftieth anniversary of the *International Surrealist Exhibition* held in London during 1936. The next grand event involving many loans was to be an outdoor exhibition at the Yorkshire Sculpture Park near Wakefield, but that was not scheduled until spring the following year. Two issues of more current concern were the future of the studios and the sculpture assistants. With Perry Green's prime function, production, now terminated, what was the outlook for the estate and those employed in the enlargement processes? Easier to solve was the situation involving unfinished casts, as this had been provided for in Moore's will. While making abundantly clear that no new work should be cast, it stated that at the discretion of the two remaining directors of the Company, his widow Irina and

Bernard Meadows, editions already under way could be completed. Since so much casting had been carried out in the three preceding years little remained to be done in smaller sizes, but six monumental works were still outstanding, five with Noack in Berlin and the other at Singer's in Basingstoke. After some deliberations, the Company directors decided to go ahead with the completion of artist's copies of all save for the **Large Divided Oval: Butterfly** 1985-86 (LH 571b), so vast a piece that it would have been expensive to produce and perhaps of little practical use at Perry Green. The others duly appeared over the next few years: first **Large Figure in a Shelter** 1985-86 [cat.237][102] from Singer's, then **Three Piece Sculpture: Vertebrae** 1968-69 [cat.216] in 1988, and **The Arch** 1969 [cat.200] in 1989. **Double Oval** 1966 [cat.212] came in 1991 and finally **Large Two Forms** 1969 [cat.211] the following year.

At Perry Green work continued, with the sculpture assistants fulfilling a fresh role as sculptor conservators, now concentrating on the restoration of the many late plasters which production pressures had prevented them from attending to before. Nothing much had been done since the Toronto shipments, and the studios were once again crowded with plaster working models. Many of the larger pieces were beyond repair, particularly those constructed in polystyrene with thin plaster coatings, and although Noack returned container loads from Berlin, not much could be salvaged. The estate itself began to suffer from lack of attention; after Moore's death Irina's reclusive nature intensified, while her failing health meant little was accomplished in the gardens other than basic maintenance. No one wanted to intervene in an area which had always been her preserve. A debate also began on the future of the buildings, particularly those not occupied for restoration work – how much should be left as it had been during Moore's lifetime, and what needed to be changed now that production had ceased.

Henry Moore and Landscape, due to open at the Yorkshire Sculpture Park in May 1987 [figs.13 and 14], brought into immediate focus the deficiencies in the Foundation's holding of large outside pieces. As the area of the park was considerable and the project the first of its kind to concentrate on Moore's monumental sculpture it was not surprising that Peter Murray, the park's director, asked for

101. Tokyo/Fukuoka 1986, p.5.
102. Volume 6 of the Lund Humphries catalogue raisonné published in 1988 erroneously states on p.30 that this is unique rather than an edition of 1.

Figs.13-14. Installation at the Yorkshire Sculpture Park in 1987 of **Three Piece Reclining Figure: Draped** 1975 [cat.238] and **Upright Motive No.9** 1979 [cat.218].

as many sculptures as could be available, giving Margaret McLeod the problem of finding sufficient work without leaving Perry Green denuded. One recourse was to recall some of the outstanding loans. **Upright Motive No.9** 1979 [cat.218] was brought back from Switzerland, where it had been at the World Wildlife Foundation Headquarters in Gland since 1984. Other pieces returned included **Two Piece Reclining Figure: Points** 1969-70 [cat.222], at Aldeburgh since 1979; **Hill Arches** 1973 [cat.232] on loan to the Welsh Sculpture Trust for Margam Park, Port Talbot; **Oval with Points** 1968-70 [cat.220] from Leicester University; and **Reclining Connected Forms** 1969 [cat.225] from the Fitzwilliam Museum in Cambridge. Enough pieces were eventually found, with the Foundation lending twenty-six works out of a total of thirty-three.

At the close of the Yorkshire exhibition some of the larger pieces not on a passage to India were borrowed again, with **Reclining Connected Forms** returning to Cambridge and **Two Piece Reclining Figure: Points** 1969 going to the Musée de Cambrai, as part of an exhibition in commemoration of the battle seventy years earlier in which Moore had been badly gassed and many of his companions killed. On its return the following year this went back to Aldeburgh. Other loans from the mid-1980s included **Locking Piece** 1963-64 [cat.203] which, following an exhibition, stayed in Basel from 1984 to 1992; and **Two**

Piece Reclining Figure: Cut 1979-81 [cat.268], sent directly from the foundry in Berlin to Colombia University, New York, in 1986 as one of three pieces intended to initiate a new sculpture reserve at the Harriman family's former home, Arden House. **Mother and Child: Hood** 1983 [cat.276] was the last installation seen by Moore, shortly after its dedication in 1984, at St Paul's Cathedral, London.

In 1984, at the request of Lord Gowrie, a former Arts Minister, the Foundation agreed to lend the Government Art Collection a working model sculpture for display in Number 10 Downing Street. Margaret Thatcher was 'delighted and grateful' when a drawing was shortly added to the loan, to be changed at three-monthly intervals to give variety and protect against damage from light.[103] Starting with **Working Model for Reclining Figure: Angles** 1975-77 (LH 674), three other similar-sized works were lent over a period of time: **Two Piece Sculpture No.10: Interlocking** 1968 [cat.217], **Working Model for Draped Reclining Mother and Baby** 1982 (LH 821) and **Reclining Figure: Open Pose** 1982 (LH 832), while the drawings have totalled more than forty to date. Not that everyone shared the erstwhile Prime Minister's enthusiasm. As Gowrie recalled, two of his cabinet colleagues, Nigel Lawson and Quintin Hailsham, 'thought it rather disgraceful to have this kind of art at No.10. You couldn't find two guys of greater intellectual range, yet they were so conservative visually.'[104] Such prudishness coming from Lord Hailsham, a former Education Minister, at least went to prove that the Foundation's intended philosophy of 'educating the public in the appreciation of the fine arts' was necessary, even if it had a very long way to go. At the end of 1985 **Figure in a Shelter** 1983 (LH 652a) was installed in the gardens of Chequers, the Prime Minister's country estate, where at the request of successive administrations it remains.

One work which caused the Foundation some problems in the aftermath of Moore's death was the cast of **Warrior with Shield** 1953-54 (LH 360) that had been specially made for the City of Florence. None of the conditions of the gift had been met, so title, which remained with the artist, passed to Mrs Moore. A new mayor of Florence, Massimo Bogianckino, took up the challenge of resolving the problem

103. Letter from Sir Robin Catford to David Mitchinson, 4 January 1985.
104. *Daily Telegraph*, London, 6 November 1992.

of finding a site worthy of the sculpture, which had languished in a car-park since its arrival in the city many years before. At the same time he suggested to the Foundation a memorial exhibition in the Sala d'Arme di Palazzo Vecchio to consist of works made since the Belvedere show of 1972. Selected by Mitchinson and with a catalogue written by Giovanni Carandente, the exhibition opened in the summer of 1987 with fifty-two graphics and fifteen late sculptures, mainly from the Collection, including three of the carvings made at the Henraux stoneyards in Querceta, **Reclining Figure: Bone** 1975 [cat.235], **Draped Reclining Figure** 1978 [cat.248] and **Mother and Child** 1978 [cat.267]. Meanwhile in an arrangement worked out by John Roberts, Irina Moore gave **Warrior with Shield** to the British Institute in Florence, which in turn lent it to the city, where Mitchinson found a site that was agreeable to all parties in the cloister of Santa Croce. Amid much celebration, it was installed later that year in the presence of the Italian President.

Two hundred works, most of them from the Foundation's Collection, were sent to India in 1987 for what turned out to be the first posthumous retrospective exhibition. Included were some early stone carvings, shown for the last time without perspex covers, such as **Composition** 1931[cat.57] and **Square Form** 1934 [cat.68], but on conservation grounds no wood pieces since the space was not air-conditioned. An innovation in the selection, made necessary by the long corridors separating the different rooms of the exhibition venue, was the hanging of some of the Italian aquatints, including the largest of all, the two-metre long **Stone Reclining Figure** 1979-80 (CGM 568). The National Gallery of Modern Art in New Delhi had once been a palace of the Maharajas of Jaipur and offered an elegant sequence of rooms on its ground floor with easy access to the surrounding informal gardens. It was here, at the request of the Indian Government, that the Foundation and the British Council in collaboration with India's Department of Culture in the Ministry of Human Resource Development installed the show in the autumn of 1987, as the centrepiece of an educational and cultural event

. .

105. Chandigarh, Bombay, Baroda, Bhopal, Madras, Bangalore, Calcutta, Jaipur.
106. New Delhi 1987, p.7.

throughout the country titled *Henry Moore in India*. Among pieces placed outside in the garden were **Reclining Figure: Hand** 1979 [cat.249], **Draped Reclining Mother and Baby** 1983 [cat.272] and **Mother and Child: Block Seat** 1983-84 [cat.275], all three sent almost straight from Yorkshire, and the even more travelled **Draped Reclining Figure** 1952-53 [cat.168] which had been lent to *British Art in the 20th Century: The Modern Movement*, at the Royal Academy, London, in between. Starting two days later came a touring exhibition of twelve medium-sized sculptures, all from the Collection, and thirty-six graphics which were part of a much larger gift the Foundation had made to the British Council in celebration of its fiftieth anniversary. This proceeded to eight venues in seven months,[105] based on the project that had been so successful in Venezuela four years previously, while at each stop artists, critics, art historians and printers flown out from London took part with colleagues from India in workshops, seminars, lectures and competitions. Both exhibitions were selected by Ann Elliott and David Mitchinson, and installed by them in New Delhi with much help from Woodward and Muller, who later went on to participate in workshop schemes at various Indian art colleges. It was Alan Bowness's first opportunity to represent the Foundation abroad, and the show had full diplomatic backing with HRH The Prince of Wales making the appropriate comments in the catalogue[106] and the Indian Prime Minister Rajiv Ghandi doing the same at the opening.

During the winter of 1982-83 Moore had spent hours in Gildmore Studio working on a group of etching plates which formed his last major graphic album, **Mother and Child** 1983 (CGM 671-700). Ultimately comprising forty images in an edition of 65, it was the largest of any of Moore's print projects and would no doubt have been greater still had not illness and the inability to control an etching needle overtaken him. Nevertheless it was a major achievement in many ways for the elderly artist. Its total of 99 plates took three years to hand-print, at J.C. Editions in London, and just as long for Mitchinson and Angela Dyer to find opportunities for Moore to make over two and a half thousand signatures, an exercise he thoroughly enjoyed but which could be accomplished only by doing a few at a time. Everything was finished in early summer 1986, and great was Moore's excitement in seeing the whole group together for the first time. They were popular with the public,

particularly in America, where publication prompted another touring exhibition with loans from the Collection, this time suggested by the New York art dealer, Alex Rosenberg.

Rosenberg's original proposal as outlined in 1985, while the graphics were still being editioned, was for an exhibition at Hofstra University, Hempstead, and he suggested using the subject of 'mother and child' to illustrate several of Moore's philosophical theories which were outlined as '1) The size of the head determines the size of the work. 2) Perspective and proportion are not primary. The beauty of the work, as seen by the viewer, is paramount. 3) A drawing, being limited to only two flat dimensions, can never by itself be a maquette for sculpture. 4) Objective art is merely abstract art that has been fleshed out so that its form becomes recognizable.'[107] While perhaps not entirely fulfilling all those criteria, the exhibition's curator, Gail Gelburd, selected a formidable variety of works on the theme from local collections, augmented with loans from Perry Green, including **Mother with Child on Lap** 1985 [cat.277], a very late example of the subject. From Hofstra the show split, with some pieces going to the Museum of Art at Pennsylvania State University, University Park, and the remainder to the University of Pennsylvania in Philadelphia before being reunited for its final destination, the Art Museum in Baltimore. No one in 1987 could have supposed that *Mother and Child: The Art of Henry Moore* would remain the last major Moore exhibition to be held in the United States of America to date.

Agreement to transfer nearly a thousand post-1977 drawings from the Company to the Foundation, on the grounds that they would not be sold and should be in the permanent Collection, was reached in the summer of 1987. The following year Ann Garrould resigned from her curatorial responsibilities at Perry Green in order to concentrate full time on the preparation of the drawings catalogue raisonné, a mammoth task impossible to undertake while working on other projects. Since the archive of the later drawings was more comprehensive than that of earlier periods, fewer new works had been sold, and Garrould had personal knowledge of everything produced since 1981, she began the series of volumes with work starting in 1977.[108] Following the publication of volumes 5 and 6 in 1994, the Trustees allowed the sale of a few later

drawings which were held in bulk, specifically to provide a purchase fund for the acquisition of earlier work needed to fill remaining gaps in the Collection. As the 1987 transfer was not comprehensive it left the Company with a number of major items in stock which it would never dispose of, and these were assigned to the Collection in a tidying up procedure in 1997.

Ann Garrould's departure coincided with other staff changes which, though not occurring all at once, were to have consequences for the Collection in terms of how it was managed and the uses to which it would be put. The retirement of Bernard Meadows after five years as acting director – though he remained as Consultant – and Betty Tinsley's decision to leave after more than thirty years' devoted attention to Moore's affairs meant that new operational measures were imperative at Perry Green. A full-time administrator was appointed to handle financial and estate matters, and although the first appointee remained only a short time, the post was continued and enlarged on with great aplomb by his two successors. David Mitchinson was made Curator and given charge of everything to do with the Collection, a streamlining which brought all aspects of Moore's work together for the first time, including exhibitions since Margaret McLeod felt that her period of review was now over. Most importantly, Alan Bowness stood down as a Trustee, on agreeing, at the request of his colleagues, to become the Foundation's Director.

The arrival of the new director came too late in 1988 to have any effect on that year's programme, which centred on two exhibitions in London celebrating Moore's ninetieth birthday: Shelter drawings curated by Frances Carey at the British Museum, and a chronologically presented retrospective at the Royal Academy of Arts. Towards the end of 1985 Roger de Grey, the Academy's president, wrote to Bernard Meadows confirming decisions reached during a conversation that had taken place a little earlier about their interest in mounting 'a great Henry Moore exhibition in the autumn of 1988, using all the main Galleries'. He continued, 'It will be a very great occasion for us indeed. We look forward enormously to receiving your initial proposed

107. Letter from Alex Rosenberg to David Mitchinson, 6 December 1985.
108. See Bibliography (p.353) for publication dates of the six volumes.

lists.'[109] With Meadows preparing the selection of sculptures and Alan Wilkinson doing the same for the drawings, the project – which took three years to put together – was masterminded by Susan Compton as exhibition co-ordinator and drew heavily on work from Perry Green. The show was certainly on the monumental side, with 239 exhibits, many seldom previously seen on exhibition, including the porcelain **Moon Head** 1964 [cat.205] lent from the Collection for the only time, **Large Four Piece Reclining Figure** 1972-73 [cat.231], a cast with an indoor patina often considered too big for indoor display, and **Head of the Virgin** 1922 [cat.11], newly purchased for the Collection on the recommendation of Bernard Meadows. Another first was the appearance of a new lender, the Moore Danowski Trust. During the previous year Irina Moore had been considering the future of the remaining works she owned privately which now included the few that Moore had retained for himself back in 1977. At first she thought of distributing the pieces four ways between the Foundation and her three grandchildren, but then changed her mind and put most of the work into one family trust specifically for the grandchildren's benefit. Despite the change of ownership the works remained for the time at Perry Green, interspersed among the Collection and maintained the same way. Unfortunately Irina Moore was too frail to addend the opening at the Royal Academy which was hosted by Lord Goodman and opened by the Prime Minister, Margaret Thatcher.

As the 1980s advanced the Foundation did not remain aloof from the prevailing tendency of encouraging and working with business sponsorship of the arts, particularly in the field of exhibition support. This had already played a significant role, with Samsung in Korea as early as 1982, with the Standard Oil Company (Ohio) in America during 1984 who underwrote the reclining figure exhibition in Columbus and its tour, then in Hong Kong with American Express and Japan with the newspaper group Tokyo Shimbun. More recently had come British Gas at the Yorkshire Sculpture Park and a group of sponsors in New Delhi headed by Hindustan Lever Ltd. The Royal Academy exhibition was no exception to the trend, since it was

. .

109. Letter dated 25 November 1985.
110. London 1988, p.6.
111. A remark made by John Roberts to the Foundation's accountant Peter Ohrenstein of Casson Beckman, 18 August 1989.

co-sponsored by the Foundation and a leading merchant bank, Salomon Brothers International Ltd. After thanking them for their generous help, the Foundation's Chairman, Arnold Goodman, went on to explain that without their support and that of similar benefactors, exhibitions of this scale would become a rarity.[110] Over the next few years Bowness continued to use sponsorship of this kind to great effect, but he also maintained the view that the Foundation should have its independence and not become reliant on outside agencies for too much of its exhibition programme. Believing that there would always be people in areas of the world who wished to see Moore's work, but who would never be able to raise the necessary cash for a variety of economic or political reasons, he felt that a budget for exhibition outlay should be provided on an annual basis from Foundation funds, worked out over a period of five years. This would make expenditure more easily accountable and allow the curatorial staff greater time and flexibility in forward planning.

'Trouble is brewing'[111]

Back in December 1984 the Foundation received a request from the Fondation Pierre Gianadda in Martigny asking for a summer exhibition of Moore's work. Although the request was sidelined and delayed by the Trustees through prior commitments, the Fondation's director, Léonard Gianadda, persevered and persuaded Bowness and Mitchinson to visit. Eventually agreement was reached for Mitchinson to curate a one-venue exhibition to last six months from May to November 1989 with a complete change of drawings at the half-way stage for conservation reasons. There was one problem. Gianadda wanted an outdoor exhibition in addition to a display inside the Fondation's amazing sepulchral interior. This Mitchinson refused, on the grounds that the garden was too small and already filled with a permanent collection. Undeterred, Gianadda purchased an adjacent orchard of apricot and cherry and within six months had integrated it into the existing garden with paths, walkways, new planting and a small lake. Some trees were cleared to provide spaces of light and areas of grass, and Mitchinson and Woodward were asked back to Switzerland to comment on the changes. It must remain the only occasion that Moore had a garden purpose-built for an exhibition of his work. Gianadda purchased a cast of **Reclining Figure** 1982

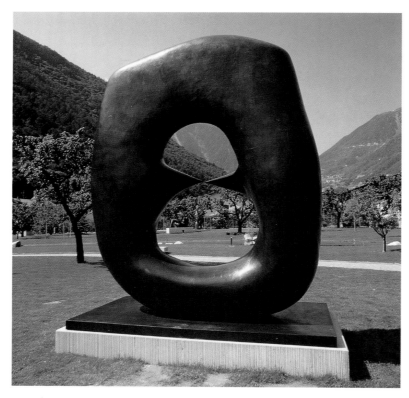

Fig.15. **Oval with Points** 1968-70 [cat.220] on view at the Fondation Pierre Gianadda, Martigny, 1989.

(LH 677a), which was shown alongside works from the Collection such as **Seated Woman** 1958-59 [cat.184], **Two Piece Reclining Figure No.2** 1960 [cat.191], **Goslar Warrior** 1973-74 [cat.233] and **Oval with Points** 1968-70 [cat.220], which looked dramatic with a view of the distant mountains beyond the points [fig.15]. Many drawings were given new mounts for the first time since Madrid, and some more recent purchases were exhibited by the Foundation for the first time. These included **Two Seated Women** 1934 [cat.69] and **Shelter Drawing: Sleeping Figures** 1941 [cat.133] both acquired in 1983, and three works in 1985: **Seated Figures: Ten Studies of Mother and Child** 1940 [cat.113], **Page from Sketchbook 1947-49, Drawing for Wood Sculpture** 1947 [cat.151] and **Seated Figure** 1948 [cat.153]. **Mechanisms** 1938 [cat.95], a splendid study of surreal forms receding into space, the first drawing acquired since Moore's death, had been recommended to the Trustees by Alan Bowness the previous year and purchased for £35,000. Gianadda invited many of the Foundation's staff for the vernisage, which was attended by the President of the Swiss Confederation, Jean-Pascal Delamuraz, who during a subsequent term of office would visit Perry Green. Among the other guests was a

group of French critics and curators who suggested that what had been achieved in the open air in a comparatively small area in Martigny might work well on a huge scale in Paris.

Much can happen during an exhibition of six months duration, and this was the case in 1989. Just prior to the exhibition leaving for Switzerland came the unexpected death of Mrs Moore, who was buried next to her husband in the picturesque churchyard of St Thomas, a few hundred metres along the road from Hoglands [fig.16]. New staff arrived during the year: John Scrope as Administrator, Julie Summers as Assistant Curator, Julian Stallabrass as a researcher, and Julia Bradford who put order to the Foundation's filing and went on to create a systematic structuring of all Moore's papers, creating a documents archive from the 1920s to the present day. Solange de Turenne, one of Léonard Gianadda's guests in Martigny, requested loans for *L'Europe des Grands Maîtres*, an exhibition she was curating at the Musée Jacquemart André in Paris. In what would be the first of many loans from the Collection selected over the following seven years by or with the help of Julie Summers, **Reclining Male Nude** 1922 [cat.7], **Standing Figure: Back View** c.1924 [cat.20], **Figure on Steps** 1930 [cat.52], **Reclining Figure** 1931 [cat.56] and **Reclining Figure** 1933 [cat.59] were among the works sent.

An unforeseen and unwelcome diversion, with major repercussions for the Collection, began in the summer of 1989 and was to continue for the following seven years. John Roberts received a letter from Mary Danowski's solicitors outlining a potential claim against the Foundation in two matters relating to the administration of Irina Moore's estate.[112] The first concerned the bronze artist's copies of work cast after January 1977 and the second all the late drawings. The letter maintained that both groups of work had remained in the possession of the artist, not Raymond Spencer Company, and on Moore's death had passed to his widow. On Mrs Moore's demise therefore they would go under the terms of her will to the residuary beneficiaries, of whom Mary Danowski was one. Although it was possible at this time that Mary Danowski's solicitors were unaware of the three Letter Agreements of 1986 and 1987 by which the Company had sold the Foundation two groups of sculpture

...

112. Letter from Bruce Brodie of Frere Cholmeley, 17 August 1989.

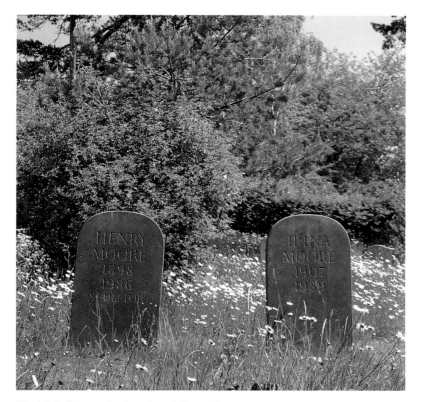

Fig.16. St Thomas's churchyard, Perry Green.

and one of drawings, the implication was that the works were not the Company's to sell, with all the disastrous consequences that interpretation would have for the Collection. In terms of sculpture alone it meant that the ownership of nearly two-thirds of the Collection was questionable. Roberts wrote the following day to Peter Ohrenstein, the Foundation's accountant,[113] and to Pat Gaynor [114] explaining that it was his understanding that the arrangements reached with the Inland Revenue back in 1976 meant that Moore would work full-time for the Company and the Foundation, and not do any other work. At a meeting the following month attended by Ohrenstein, Gaynor and Roberts it was noted that at the time Moore was managing director of the Company it had made sales of drawings to which he must have agreed. The Company had covenanted all trading profits to the Foundation, including those from drawings, of which Mary Danowski as a Trustee of the Foundation until 1980 must have been aware, since the

...

113. Letter dated 18 August 1989.
114. Letter dated 18 August 1989.
115. Attendance Note dated 20 September 1989.

whole issue of tax planning was that Moore should cease all work as an artist in his own right. It was also pointed out that the retention of artist's copies by Moore would have meant him having to make a return for tax purposes of their benefit to him, and that the Company would also have had to disclose that benefit.[115] These points, with only minor changes, and the undeniable fact that the Company had paid all production costs including foundry bills, would form the basis of the position taken by the Foundation throughout the years of litigation that followed.

While the Foundation's professional advisers began to tackle the task of answering and defending its position, the implications of what had been alleged were considered by the Trustees and staff, all of whom took the opinion that the Foundation had acted in good faith and that its programme should continue normally. In practical terms this meant dismantling the Martigny exhibition and moving some of it on to Milan. Attempting to install an outdoor show during a Milanese December was a mistake, though perhaps the work took on a special enchantment when glimpsed against the spectacular backdrop of Castello Sforzesco through freezing fog. The exhibition had been organised as a three-way partnership between the Comune di Milano, the Foundation and the British Council in Italy, and consisted only of work which had been made in monumental size, with about a dozen such pieces displayed outside plus a selection of maquettes and working models for large sculptures, with some related graphics, on view indoors. All the exhibits came from the Collection, some like **Large Totem Head** 1968 [cat.215] being late casts of pre-1977 sculptures, others such as **Draped Reclining Mother and Baby** 1983 [cat.272] being the artist's copies of post-1977 works, but all subject to the impending claim.

Glasgow was designated Cultural Capital of Europe 1990, and as a contribution to the city's programme the Foundation mounted two simultaneous exhibitions, *Henry Moore in Pollok Park*, from an idea of Sir Leslie Martin who thought it would be interesting to see Moore's large sculptures in the vicinity of the Burrell Collection, and *Henry Moore – Sculptor at Work*, a touring show presented in collaboration with the Scottish South West Galleries Association which went to five regional centres in the Glasgow area. As Tessa Jackson, the Visual Arts Officer for the Festivals Office, put it in the catalogue when describing

the touring show, 'It will not only complement and extend the survey of Henry Moore's work across the west of Scotland, but it will also help to illustrate how smaller models and motifs can develop to become imposing and majestic compositions when cast in bronze.' She continued: 'Henry Moore in Scotland and the symbiotic relationship of the two exhibitions has resulted in a major initiative for 1990. The artist's well known comment "Sculpture is an art of the open air", has been explored and proved by many, since it was published in 1951. The debate of siting art in public places continues and is particularly active in Glasgow. As an example Henry Moore's work is one of the most successful and accessible.' Like the show the year before, both exhibitions in 1990 were away for over six months, with nine sculptures in Pollok Park, and seven working models plus maquettes and graphics on the tour. Another touring exhibition began that year and continued into 1991: organised by the South Bank Centre, it consisted of forty-two smaller and four medium-sized works, selected by David Sylvester and Michael Harrison, for display in seven regional galleries across the country. As Sylvester explained in the show's catalogue, the small pieces were often the initial embodiment of an idea in sculptural form and were entirely modelled by the artist without the aid of assistants.

The other key event that year affecting the Collection was the siting in Guernica by Bernard Meadows of the sale copy of **Large Figure in a Shelter** 1985-86 (LH 652c), which had been bought jointly by the central Spanish and local Basque governments. To announce the work's arrival the Ministry of Culture requested an exhibition for the Museo de Bellas Artes in the regional capital, Bilbao. In order to link the large sculpture to the exhibition, Mitchinson and Summers made a selection from the Collection based on the theme of internal/external forms, taking the appropriately named and thematically relevant lithograph **Spanish Prisoner** c.1939 [cat.107] as a starting point. Forty-six works followed, of sculpture, drawings and graphics, arranged to explain and examine the derivation of the large bronze. These included some Shelter drawings, **Working Model for Upright Internal/External Form** 1951 (LH 295) and many of the helmet heads including **Helmet Head No.6** 1975 (LH 651), the working model for **Large Figure in a Shelter**.

During 1990 staffing at Perry Green increased, there were resignations and appointments to the Trustees and a change of name for the Company. Contrary to some expectations the ending of production had increased the numbers of people needed at the Foundation rather than diminishing them. Other areas of activity came forward to more than fill the vacuum. Demand for information of all kinds to do with Moore, his life and work increased, as slowly did the numbers of visitors both scholarly and general. Other Foundation activities which had nothing to do with the Collection, such as donations, were managed from Dane Tree House and produced their own requirements for staff and space. Computerisation came at last, along with new staff to begin the enormous task of recording information both for internal use and for easy access by scholars and students. Janet Iliffe arrived as drawings archive assistant to help with computerisation before moving on to become secretary for the curatorial department. Rosemary Walker, who began as administration secretary, ultimately took control of arrangements for guides and visitors, while Geoff Robinson as foreman began putting the storage in order and looked after packing, crating, transport movements and the construction of showcases and pedestals. There were changes among the Trustees. The untimely death of Sir Denis Hamilton, and the resignations on health grounds of Sir Leslie Martin and Maurice Ash meant new appointments, with Lord Rayne, Joanna Drew and Sir Rex Richards replacing them. John Roberts, believing that with the death of Mrs Moore his role was over, resigned in 1990, a great loss. He was replaced by Henry Wrong, who had run the Barbican Centre for many years and lived locally in Much Hadham. Also to go in 1990 was Raymond Spencer Company Ltd, a name which now sounded outdated and unconnected to the Henry Moore Foundation; it was changed to HMF Enterprises Ltd. At the same time the management structure of the Foundation was strengthened, with Robert Hopper, Director of the Henry Moore Sculpture Trust, set up in 1988 and based in Leeds, joining John Scrope, David Mitchinson and Alan Bowness as directors of the newly named company. The Foundation's association with Leeds City Art Gallery through the Henry Moore Centre for the Study of Sculpture, and the Sculpture Trust, has little bearing on the story of the Collection, except that the staff of the two bodies, now housed within the building of the Henry Moore Institute, have proved valuable working partners for those at Perry Green and hugely supportive of their activities and aspirations.

Art and politics

In retrospect it might have been prudent to wait until the questions involving ownership of work had been settled before embarking on proposals concerning the longer term development of the Perry Green estate, but Bowness had a five-year contract and the general shoddiness of many of the Foundation's buildings, coupled with the never-ending problems of space shortages, meant pressing forward with suggestions for improvement. Four areas of activity respecting Perry Green were looked at, and the appointed architects, Jeremy Dixon and Edward Jones, were asked to consider them in connection with the expansion or reconstruction of existing buildings, rather than to propose new structures on green field sites. The problem areas, all of which impinged in one way or another on the Collection, were poor working conditions and lack of facilities for the staff, no research or study facilities for students and scholars, the need to improve amenities for general visitors, and to provide far better environmental conditions for the storage of the art works and parts of the archive. Nothing had been done to Dane Tree House since the flight from Hoglands in 1977, though the numbers of staff continued to increase. Even the director was without an office, having to make do with the end of a glazed corridor. Computerisation arrived but not a properly networked system. The office staff complained but conditions for the sculptor assistants were worse, cut off in the studios without decent heating or a proper telephone connection. A small library had been created by Alexander Davis and his son Martin, but this was really little more than a book store with no facilities for study. Visitors who came to see the sculptures in the grounds and view the studios were unable to see works on paper, small and medium-sized bronzes or early carvings, often a major disappointment. On a more practical level there was little provision for parking, no reception area with wash-rooms and no place from which to buy so much as a postcard. The storage barns for crated sculptures were not racked, remained insecure and in some places unalarmed, and there was nowhere for framed works on paper. Unframed graphics were still spread across the estate in various locations and decent storage for the maquettes remained a mirage. On top of these specific difficulties, no overall plan, strategy or budget for the long-term maintenance of the grounds and properties at Perry Green had been drawn up.

While Dixon and Jones were preparing proposals for the buildings and their colleague, the landscape architect Janet Jack, surveyed the grounds, the curatorial team was planning three or four years ahead for a number of new exhibitions. In partnership with the British Council, the Foundation had begun discussions in Moscow and Leningrad for a two-venue show during the summer of 1991. On an early site visit to Russia, Mitchinson and Ann Elliott had stopped in Finland where a long forgotten request for an exhibition was reactivated and accepted – Helsinki becoming the third venue, for the autumn of the year. Entitled *Henry Moore: The Human Dimension*, the works selected by Elliott and Mitchinson, and discussed by Norbert Lynton in the catalogue, concentrated on smaller-scale pieces focusing on Moore's humanity and concern for the human form and its relationship with nature. Most of the 118 exhibits came from the Collection, though there were important loans from eleven other sources, including two in America, made necessary by the Foundation's many gaps of medium-sized figurative work of the type needed for a show of that nature. The rococo charm of the Benois Museum in Petrodvorets contrasted well as a venue with the imposing white and red marble interiors of the Pushkin Museum in Moscow, while Helsinski's well-proportioned Taidemuseo provided a superb modern building for the works to be seen in a chronological progression rather than as beautiful displays dictated by the architecture of the buildings in Russia. The show had a huge impact in all three cities, not least in Moscow, where it arrived in the aftermath of the coup against President Gorbachev. The irony of siting **King and Queen** 1952-53 [cat.170] on the front steps of the Pushkin, while all around the capital statues were being toppled from their pedestals, was not lost on the visiting public. On returning from Moscow, Mitchinson was due to give a lecture on Moore, but with events fresh in his memory relating to being trapped in the Soviet Union with four colleagues and millions of pounds' worth of art works, he decided to tell the tale of his adventures instead. Sharing the platform was the architect Roger Hawkins, and during a break in the evening's events the two introduced themselves. Shortly afterwards Hawkins and his partner Russell Brown visited the Foundation, and they and Mitchinson stayed in touch. The meeting seemed unimportant at the time, but it would have major implications later on.

After many years of delay, the exchange of work between the Foundation and the British Council took place in 1991, with the Foundation receiving two bronzes, **Reclining Figure** 1939 [cat.108] and **Family Group** 1948-49 [cat.155]. Casts of these works had once belonged to Irina Moore, but the former had gone to the Moore Danowski Trust in 1987 and the latter to Mary Danowski. By 1991 all the Trust's pieces and those remaining in Mrs Moore's Estate had been removed from Perry Green, as problems between the Foundation and the Estate multiplied. Hoglands, which Moore had indicated should become the property of the Foundation,[116] was closed, and became isolated though surrounded by Foundation land, while the studios closest to it were emptied of their contents. More happily two new drawings had arrived in 1990: a superb example of internal/external forms and helmet heads, **Studies for Sculpture: Ideas for Internal/External Forms** 1949 [cat.157], formerly in the collection of Vera List, which was bought at auction in New York; and **Ideas for Sculpture in Landscape** 1938 [cat.96], one of the earliest studies for sculpture in natural pictorial settings that just happened to include a vignette of the reclining figure coming from the British Council. In 1991 the Redfern Gallery in London exchanged **Seated Woman** 1929 [cat.46] for an album of **Mother and Child** 1983 (CGM 671-700), and a distant relation of the Moore family sold **Head of the Artist's Niece and Figure Studies** 1921 (HMF 29a), a notebook page portraying a pencil sketch of Moore's niece Aline, the daughter of his older brother Raymond. The Swiss publisher Gérald Cramer[117] had owned the impressive **Drawing for Stone Sculpture** 1937 [cat.88] for many years, often lending it for major exhibitions, most recently to the Royal Academy in 1988;[118] three years later he graciously bequeathed it to the Foundation.

The other shows planned during 1990-91 both came to fruition in 1992. First was Sydney. No major Moore exhibition had been to Australia since 1947-48 and although Edmund Capon, Director of the Art Gallery of New South Wales, who first suggested the exhibition, hoped a three-venue tour would be arranged, lack of local funding made that impossible. Capon determined to push on alone and managed to secure some backing from the Hotel Inter-Continental. Co-curated by Mitchinson and Nick Waterlow[119] and mounted in Sydney by them and Malcolm Woodward,

the exhibition contained a cross-section of Moore's work arranged in seven sections according to the decades from the 1920s to the 1980s. Most of the pieces came from the Collection and included less familiar works such as **Ideas for Sculpture** 1938 [cats.97-99], **Classical Landscape with Temple** *c*.1972 [cat.227], **Forest Elephants** 1977 [cat.243], **Three Figures on a Stage** 1981 [cat.257], the newly acquired **Drawing for Stone Sculpture** 1937 [cat.88] and the tapestry **Three Fates** 1983-84 [cat.274], one of ten commissioned by Moore for the Foundation after 1980. One sculpture that did not travel to Australia was **Reclining Figure: Angles** 1979 (LH 675), as a cast had been purchased by Capon some time previously and was splendidly sited in front of the Art Gallery of New South Wales; the Foundation's copy was among the pieces selected for Paris [see cat.245].

Sir Alan Bowness had picked up the suggestion made in Martigny about a major outdoor exhibition in Paris, and after being shown a couple of locations had recommended the Parc de Bagatelle, in the Bois de Boulogne, as the perfect venue. It was, but the logistics were horrific. Mitchinson, Summers, Muller and Woodward spent weeks in Paris discussing the locations of individual works and eventually found sites for twenty-seven, carefully avoiding the underground watering system and millions of spring bulbs. Mitchinson made a presentation at the request of the British Ambassador Sir Ewen Fergusson to encourage business sponsorship, while Catherine Ferbos at the British Council office in Paris and Jacqueline Nebout at the Hôtel de Ville co-ordinated the arrangements with Julie Summers, and an entire installation team from the transport firm MoMart was briefed by its director Jim Moyes for the work to come. Solange de Turenne was involved in dealing with the press and curating the exhibition *Henry Moore Intime* [120] which ran at the same time. The French gardeners and the business executives from seven sponsoring companies came to Perry Green, and British Airways, one of the sponsors, provided free tickets for journeys to Paris.[121] Michel Muller

116. HMF Trustees' agenda, 27 April 1982.
117. Publisher of the first two volumes of the graphics catalogue raisonné.
118. London 1988, cat.87.
119. Senior Lecturer at the University of New South Wales, College of Fine Arts.
120. Opened at Didier Imbert Fine Arts in Paris two months earlier.
121. The others were Compagnie Générale des Eaux, GEC Alsthom, Shell France, British Steel, ICI en France and L'Oréal.

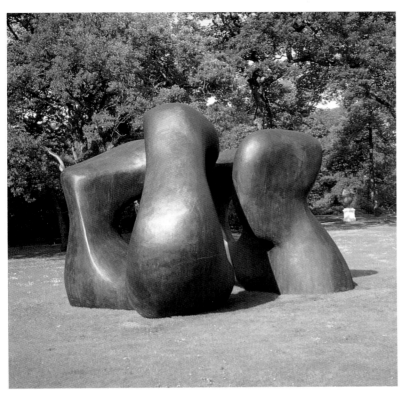

Fig.17. **Large Two Forms** 1969 [cat.211] in the Bagatelle gardens, Paris, 1992.

was asked to record the whole event photographically for a subsequent publication,[122] and in addition a French film team was commissioned to make a documentary about the installation.[123] Twenty-five of the sculptures came from the Collection. The two that did not, **Draped Reclining Figure 1952-53 (LH 336)** and **Reclining Figure** 1982 (LH 677a), were casts lent by Time-Life International Limited in London and Fondation Pierre Gianadda in Martigny, the Foundation's casts being in Sydney and Lisbon at the time [see cats.168, 246]. Among pieces coming from the Collection were some that had arrived recently in transfers from the Company. In 1989 two late casts, **The Arch** 1969 [cat.200] and **Three Piece Sculpture: Vertebrae** 1968 [cat.216], were acquired. The curatorial team tried hard to find positions in Bagatelle for both works. **The Arch** defeated them, but **Three Piece Sculpture: Vertebrae**, sited on the main lawn, provided a focus for the whole display.

. .

122. Cohen 1993 (*Moore in the Bagatelle Gardens, Paris* with photographs by Michel Muller and an essay by David Cohen).
123. Nadine Descendre, *Moore à Bagatelle: Sculpture on the Move*, The Henry Moore Foundation, Much Hadham 1992.

King and Queen [cat.170] was sold to the Foundation by HMF Enterprises in 1991 (along with ten other works not involved with Bagatelle), while among a final transfer of thirteen sculptures, in March the following year, were **Family Group** 1948-49 [cat.156], **Large Two Forms** 1969 [cat.211], and **Double Oval** 1966 [cat.212]. All this, plus much more, was on the eleven transporters which left Perry Green for Paris, save for **Large Two Forms** [fig.17] which arrived direct from Noack in Berlin. After a lengthy installation, Lord Goodman and Sir Alan Bowness, with many Trustees and staff, arrived for a grand opening attended by Sir Ewen Fergusson, the Mayor of Paris Jacques Chirac, President Mitterrand and Her Majesty The Queen.

Thankfully not all exhibitions were major cultural–political events like Bagatelle. Bowness was aware of the need to have small circulating shows, perhaps focused on a particular theme, designed to be appropriate for smaller galleries. In answer to this approach Mitchinson and Summers selected a group of sculpture, drawings and graphics to complement the album of **Mother and Child** 1983 (CGM 671-700). Many unconnected exhibition requests had arrived from Germany during 1990-91 and in order to evaluate them the British Council's Arts Officer in Cologne called the directors and curators together for a meeting which was addressed by the Foundation's curators. This resulted in a five-venue tour between March and December 1992 for the show *Henry Moore: Mutter und Kind*, starting at the Käthe Kollwitz Museum in Cologne and proceeding to Kreis Unna, Norden and Ratzeburg before its final destination, the City Art Gallery in Huddersfield, a single English venue chosen because Huddersfield was twinned with Kreis Unna. In his catalogue essay, Julian Stallabrass considered the whole subject of mother and child as a theme in Moore's work, and the one hundred exhibits included **Mother and Child: Arch** 1959 [cat.189], **Reclining Figure No.7** 1980 [cat.266] and **Mother with Child on Lap** 1985 [cat.277].

Interest and enthusiasm for Moore's work around the world did not mean a similar response to the Dixon and Jones proposals for Moore's legacy at Perry Green, which met with a hostile rebuttal. Not everyone locally was against, but the consensus was that their plans were grandiose and would attract far to many visitors to the area. Bowness's estimate of 20,000 people a year being misquoted in the

press as 200,000 didn't help, and although refuted, the damage was done. The proposal included a print gallery and study centre, plus proper storage for the works on paper and small sculptures along with library and archive space. This was to be placed on the site of Elmwood, a domestic building of no architectural merit situated between Dane Tree House and the main road, which the Foundation had bought in 1982 for additional staff accommodation. The sheep-barn site was suggested as a gallery for small and medium-sized sculpture, while a new octagonal glass structure was proposed for the end of Dane Tree House as a reception centre, with rest-rooms and a shop for visitors. Individually any element of this might have won approval, but collectively it was all too much. The whole development went to a Public Enquiry which the Foundation lost, in an acrimonious debate that became confused in the public consciousness with the litigation dispute over ownership of Moore's work. Expensive and time-wasting for those involved though this incident was, not all was lost as John Scrope remembered the planning permission granted back in 1983, which now had only six months to run. Mitchinson immediately contacted Hawkins and Brown to discover whether they could produce a scheme at short notice, and on hearing that they could Bowness received approval from the Trustees to go ahead. With literally only days to spare, the footings for a new extension to Dane Tree House were laid.

Settled in court

After many years' loyal service to the Foundation and in particular to the drawings collection, Jean Askwith retired in 1992, to be replaced by Reinhard Rudolph who would later become Assistant Curator. Rudolph immediately became involved with the preparations for publishing volume five of the catalogue raisonné of the drawings on which Ann Garrould had been working since 1988. Over the previous fifteen years the curatorial team at Dane Tree House had caught up with many of the problems that had caused concern back in 1977. Despite lack of space, the pending litigation which was expected to be heard towards the end of 1993, and the disappointment of being refused planning permission, it was now clear to all that the move towards modernity was unstoppable and that after only a short delay improvements would be made.

In 1992 Alexander Davis completed the first two

volumes, plus index, of the Henry Moore Bibliography covering 1898 to 1986, in 10,711 fully annotated entries. Another volume, with an index updating and integrating the earlier one, followed two years later, bringing the references to 14,850 by the end 1991. Data continues to be collected, though now on computer only, for what is considered an undertaking unique of its kind. Many books and catalogues were compiled by the Foundation, both for exhibitions and on all aspects of Moore's life and work. Revised editions of the Lund Humphries catalogue of Moore's sculpture continued to appear, with the first edition of volume 6 coming out in 1988, to be followed by a reprint of volume 4 in 1991. Mitchinson and Angela Dyer checked every print in the archive, numbering each proof individually and producing an inventory of everything printed since 1977. In 1992 HMF Enterprises transferred 3,570 listed graphic works to the Foundation which, with a number of other acquisitions, then totalled 8,194 items. Gaps continued to be filled. In 1991 Maria Luigia Guaita Vallechi[124] gave the portfolio *Venti Anni Venti Artisti* which included **Six Mother and Child Studies** 1976 (CGM 426), and the same year Davis bought for the Collection a copy of the *Rothko Memorial Portfolio* with **Architecture** 1971 (CGM 169). Two years later Davis found another missing item, *Lawrence Durrell: Collected Poems 1931-1974*, which contained **Seated Figure: Detail II** 1979 (CGM 531), a later print from a group of which Mary Danowski had the complete editions. One sculpture was added to the Collection in 1992 when **Head and Ball** 1934 [cat.66] was bought at auction. This piece, quite unlike anything else in the holding, was the second acquisition of an early carving since 1979.

Though nobody realised this at the time, a seven-venue exhibition would result from a visit Alan Bowness paid to Portland in the spring of 1991 to see a John Maine sculpture, *Chesil Earthworks*. Encouraged by Margaret Somerville, owner of the Chesil Gallery, Julie Summers selected an exhibition of thirty-six works on the subject *Henry Moore and the Sea* which explored Moore's affinity with landscape, seascape and natural objects. Highly suited to small coastal galleries, the exhibition moved from Portland to Chichester and Wighton in 1993 and to Scarborough, Aldeburgh, Stromness and Canterbury the following year. On a larger

..

124. Owner of Il Bisonte gallery and print workshop in Florence.

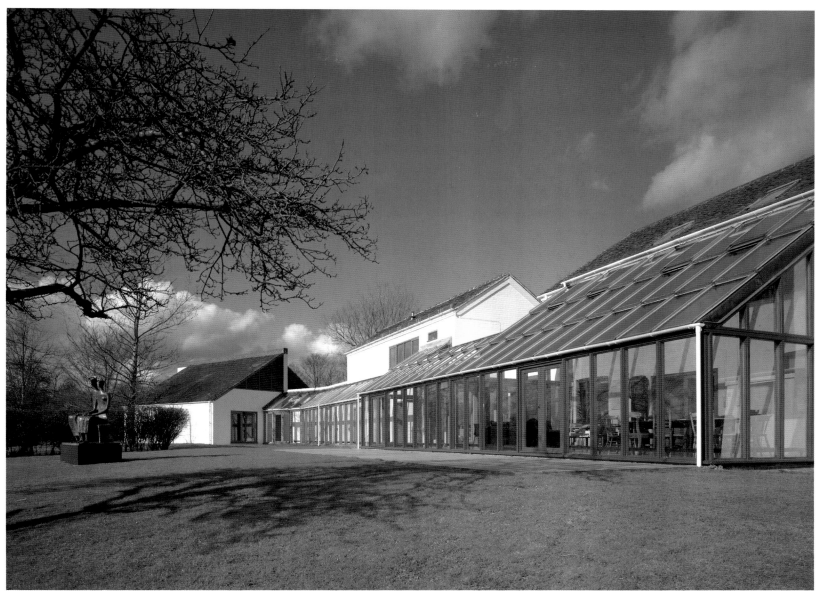

Fig.18. The rear of Dane Tree House with **King and Queen** 1952-53 [cat.170].

scale, many pieces from the Collection were seen during 1993 in central Europe where a major retrospective organised by the Foundation was shown in Budapest, Bratislava and Prague. Consisting of 125 works, the exhibition was similar in range and scale to that sent to Australia the year before and to Russia and Finland in 1991.

The case brought by Mary Danowski and Bruce Brodie against the Henry Moore Foundation and HMF Enterprises Ltd came before Judge Evans-Lombe in the Chancery Division of the High Court during the autumn of 1993, with Lord Irvine of Lairg QC appearing for the plaintiffs and Mr Gavin Lightman QC for the defendants. Rather luckily for all concerned, the press lost interest after the first day as a case

involving the singer George Michael, which had captured the public's attention, was being heard in an adjoining Court. Susan Barty of McKenna & Co., the Foundation's solicitors, had spent four years preparing everything to the final detail. Hundreds of meetings with witnesses, experts, Trustees, past and present staff and professional advisers took place. Thousands of documents were analysed, the provenance and casting details checked of all the sculptures in the Collection, statements from fourteen witnesses and two experts scrutinised, every angle of defence examined. Yet the sense of unease among those present was palpable – had anything been forgotten, would there be any surprises? Bowness and Mitchinson sat through every day, with other

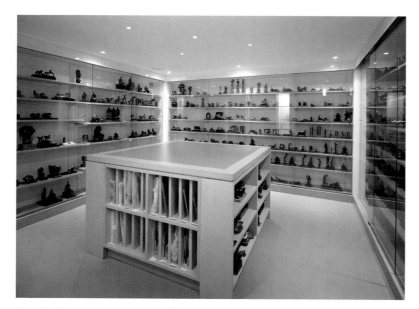

Fig.19. The maquette store in Dane Tree House.

staff members, Trustees and friends coming in regularly to give support to the Foundation's witnesses. The case focused on how Moore had been advised in 1976, the terms of his service contract with Raymond Spencer Company, and the definition in law of an artist's copy. This put a considerable strain on the witnesses, who had to remember precisely events of seventeen years before. Mary and Raymond Danowski gave evidence for the plaintiffs, calling Leslie Waddington and Philomena Davidson Davis as experts. The main witnesses for the defendants were Pat Gaynor, Peter Ohrenstein, John Roberts and Annette Whybrow,[125] with Alan Bowness, Arnold Goodman, David Mitchinson and Betty Tinsley in support. As experts they were well served by Ian Barker and Dennis Farr, both of whom spoke with great conviction.[126] No last-minute surprises were sprung from either side, though the hearing lasted five weeks. There followed a few days' break before Court resumed to await the Judge's verdict. Evans-Lombe began his delivery at 10am and continued speaking until lunchtime, with all in Court knowing that the Foundation had a number of defences against the charges and needed to prove only one to win the case. After about an hour Bowness and Mitchinson turned and glanced at each other; there was no trace of a smile but they both knew that the Foundation had won and the Collection had been saved. The case went to the Court of Appeal, heard three years later in March 1996, but only on the issue of artist's copies. As the Foundation's

Trustees were obliged by their duties as trustees of a public charitable body to defend the action, they were relieved and vindicated when the appeal court upheld the original verdict.[127]

The extension and alterations to Dane Tree House proved extremely popular with both the Foundation's staff and the local public, and Hawkins and Brown received no complaints about how the building functioned or the way it looked [fig.18]. For the Collection the refurbishment was highly beneficial, with environmentally controlled space for all the works on paper, both framed and unframed. Graphics were brought together in one area for the first time and the drawings and their archive given adequate space for study and expansion. Proper storage for maquettes was constructed to allow instant viewing of the whole collection [fig.19], with easy access to an improved packing area. New work-stations were created, allowing the building to accommodate fourteen people comfortably, and with the backing of Sir Rex Richards the computer system was enlarged and networked. While the court case was in progress the Trustees were interviewing for a new director, since Sir Alan Bowness's term was up in the autumn of 1993. He stayed on for another six months until replaced by Tim Llewellyn[128] the following spring, who took up his post in a new purpose-built office in Dane Tree House.

Llewellyn's arrival coincided with the start of the year's exhibitions programme which was distributed three ways, with shows of bronzes for Germany, Shelter drawings for Switzerland and Austria, and bronzes and carvings for the Yorkshire Sculpture Park. *Bronze Sculptures in Bretton Country Park* opened first. This former deer park adjacent to the Sculpture Park displayed fifteen sculptures, nearly all from the Collection, which were installed by Farnham and Woodward as the commencement of a policy decision by the Trustees to keep a permanent presence of Moore's work in Yorkshire. The show ran for one year, after which many pieces were taken for subsequent exhibitions, but some

..

125. Former solicitor at McKenna & Co. in 1976.
126. Ian Barker had moved from the British Council to become Director of Contemporary Art at Annely Juda Fine Art, and Dr Dennis Farr CBE had been Director of the Courtauld Institute Galleries since 1980.
127. Sir Rex Richards comments further on the Court of Appeal's verdict in *The Henry Moore Foundation Review* no.2, Spring 1996, p.3, and Tim Llewellyn examines the whole issue of artist's copies on pp.4-5.
128. Former Managing Director of Sotheby's Europe.

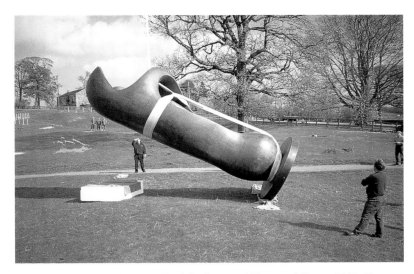

Fig.20. Installation of **Large Upright Internal/External Form** 1981-82 [cat.162] in Bretton Country Park, Wakefield, 1995.

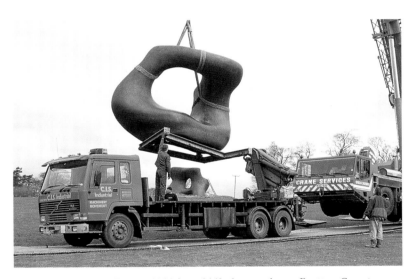

Fig.21. **Large Two Forms** 1966 [cat. 211] about to leave Bretton Country Park in 1996.

remained. **Large Upright Internal/External Form** 1981-82 [cat.162, fig.20] left Perry Green for the only time for this show, and despite its weight of 7500kg was damaged by wind pressure and had to be removed for restoration. Among work that remained in Yorkshire was **Two Piece Reclining Figure No.2** 1960 [cat.191], **Oval with Points** 1968-70 [cat.220] and **Large Spindle Piece** 1974 [cat.219], the latter withdrawn from the British Council headquarters in London after fourteen years. Sculptures which moved on for a variety of reasons included **Seated Woman** 1958-59 [cat.184] in 1996 for a short loan to the British Embassy in Prague, **Reclining Figure: Arch Leg** 1969-70 [cat.224] needed for

exhibition in Venice in 1995, and **Large Two Forms** 1966 [cat.211, fig.21] which paid a return visit to Paris in 1996 for Daniel Abadie's *Un siècle de sculpture anglaise*. The Yorkshire exhibition was attended by the new Director, numerous Trustees and members of staff, who also saw *Henry Moore: Late Carvings* which opened on the same day in the YSP's Pavilion. This included nine carvings from the Collection, the first showing these late pieces had been given in Britain since the Serpentine Gallery exhibition in 1978.

An exhibition of Moore's Shelter drawings, a show rather surprisingly not previously seen outside London and the old East Germany, was mounted at the Kanton Thurgau Kunstmuseum, near Ittingen, and the Rupertinum in Salzburg, in co-operation with the Tate Gallery, the British Museum and the British Council and with additional loans from Wakefield City Art Gallery and the Sainsbury Centre at the University of East Anglia, Norwich. The show in Austria was slightly smaller than that in Switzerland where the exhibition galleries in the restored crypt of an old monastery provided an apt and dramatic underground backdrop for the drawings. While in Austria the Foundation agreed to lend works to an interesting mixed exhibition, *Giacometti, Marini, Moore, Wotruba – Vier Klassiker der Modernen Plastik*, planned for the Kulturhaus in Graz, a show which would include **King and Queen** 1952-53 [cat.170] and **Two Women and a Child** 1951 [cat.161].

One of the German cities that requested an exhibition at the time of the *Mutter und Kind* show was Pforzheim, but their exhibition space in the Reuchlinhaus had been too imposing for the show then invisaged. They were asked to be patient until something more suitable could be arranged. The result was *Henry Moore: Ethos und Form*, an exhibition of thirty-eight bronze sculptures, all from the Collection, including some of a size often impossible to be shown indoors. As this show ran concurrently with the display in Yorkshire, the Collection was stretched to its limits as it had been for Paris in 1992, but here with the added complication of having to decide which pieces were suitable for indoor as opposed to outside display. Among those that went indoors, some probably for the first time, were **Large Standing Figure: Knife Edge** 1976 [cat.194], **Large Totem Head** 1968 [cat.215], **Goslar Warrior** 1973-74 (LH 641), **Reclining Mother and Child** 1975-76 [cat.236] and **Reclining Figure: Hand** 1979 [cat.249]. The show's second venue at the

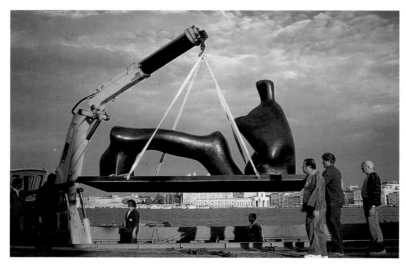

Fig.22. **Reclining Figure: Arch Leg** 1969-70 [cat.224] being lifted at dawn on to the *fondamenta* in front of San Giorgio Maggiore, Venice, 1996.

exquisite Sinclair-Haus in Bad Homburg, recommended by Christa Lichtenstern who also wrote the catalogue essay, was much smaller, and the large pieces remained outdoors.

Moving forward with confidence

Poland had been left out of the 1993 schedule, only because there was interest from more than one city and the Foundation's curators believed that an exhibition tour for three venues should be proposed when a longer time period became available. Negotiations commenced with galleries in Krakow, Warsaw and Gdansk, though a site visit by Mitchinson and Rudolph to the last city convinced them that the museum space proposed was unsuitable for the scale of exhibition necessary at the Galeria BWA in Krakow and the Centre for Contemporary Art, Ujazdowski Castle in Warsaw. It was Llewellyn who suggested the third venue – Venice, in the prestigious galleries of the Cini Foundation on the island of San Giorgio. Another retrospective was selected, which included three tapestries, nineteen graphics, forty-one drawings and seventy-six sculptures, plus three more large works for Venice, where they were displayed on the *fondamenta* in front of Bernini's imposing crystalline façade. These massive bronzes, **Locking Piece** 1963-64 [cat.203], **Reclining Figure: Arch Leg** 1969-70 [cat.224] and **Three Piece Reclining Figure: Draped** 1975 [cat.238], arrived from Perry Green a few days after Rudolph and Farnham had accompanied the rest of the exhibition from Warsaw and were brought at dawn by barge down the Guidecca

canal in a complex operation controlled by a local transport firm who assured the slightly apprehensive Mitchinson that they had been conducting similar manoeuvres since the 1890s [fig.22]. Large retrospective shows continued to draw attention to the weaknesses in the Collection, particularly in places where little depth remained from which to select. Two obvious areas where scope was limited were early figurative carvings and medium-sized bronzes from the 1950s. The Foundation came to rely on others filling these gaps, and is grateful to all those organisations who entrusted their works for what were often quite long periods. Sculptures such as **Half Figure** 1929 (LH 67) and **Girl with Clasped Hands** 1930 (LH 93) from the British Council and **Seated Figure against Curved Wall** 1956-57 (LH 422) belonging to the Arts Council of Great Britain, which were borrowed for Krakow/Warsaw/Venice and for many other shows besides, have been as important to the Foundation in selecting its exhibitions as any of the works in the Collection.

One area in which the Collection happened to be particularly strong was in works made after 1977, thanks to the efforts of Moore and the Trustees to retain as many examples as possible. Here it was perfectly feasible to select a major group despite the Polish/Venice show running at the same time. From this field of work came the exhibition *Henry Moore: gli ultimi 10 anni* chosen specifically for the spectacular setting of the Castelgrande in Bellinzona [fig.23]. The error in choice of season made in Milan a few years earlier was not repeated and the five pieces shown outside, out of a total of thirty-five sculptures and fifty-four drawings, could not have reacted better against their backdrop of sky, landscape and architecture. **Large Standing Figure: Knife Edge** 1976 [cat.194], **Large Four Piece Reclining Figure** 1972-73 [cat.231], **Goslar Warrior** 1973-74 [cat.233], **Reclining Figure: Angles** 1979 [cat.245] and **Mother and Child: Block Seat** 1983-84 [cat.275] were picked to provide a range of subject and form, and when placed in a 360-degree panorama in such a way as to achieve maximum effect from the mountain light, the relationship between them became almost mystical. The selection indoors centred on many drawings seldom or never previously exhibited, such as **Old Apple Tree in Winter** 1977 [cat.244], **Head of Girl** 1980 [cat.255], **Imaginary Architecture** 1981 [cat.259] and **Head of Alice** 1981 [cat.260]. From Switzerland the exhibition moved on to Italy where the two venues, the Castel Nuovo in

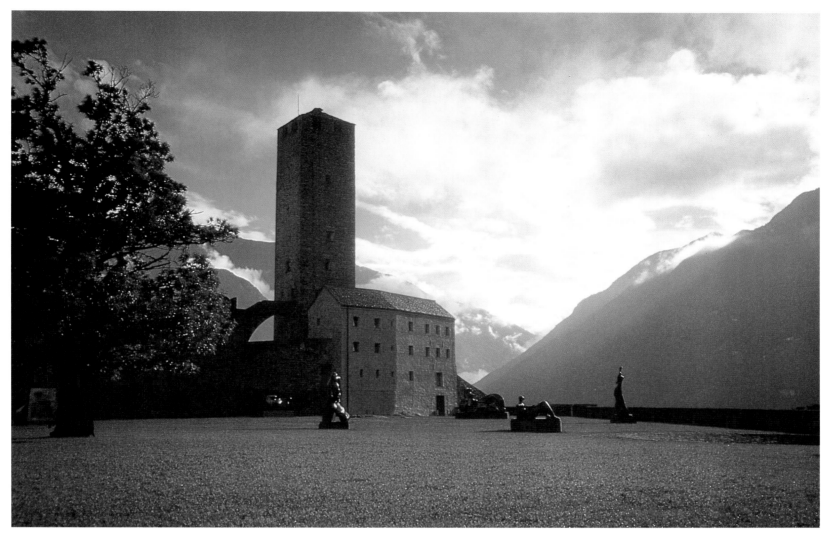

Fig.23. A grouping of bronzes in the Castelgrande, Bellinzona, 1996.

Naples and the Palazzo Re Enzo in Bologna, were both in their own way impressive, though perhaps more significant was the fact that in Venice and Naples the Foundation was able to install and display two major exhibitions at different ends of Italy simultaneously.

Lord Goodman retired as Chairman of the Trustees in July 1994 and was replaced by Sir Rex Richards, while the return of Sir Alan Bowness, the appointment of Dr Andrew Causey and a little later of David Sylvester brought to the Board three of the country's most eminent art historians and writers. Causey[129] was already a Trustee of the Henry Moore Sculpture Trust in Leeds, and Sylvester, besides being a

..

129. Professor of Modern Art History at the University of Manchester.
130. For details see Sir Rex Richards's introduction to *The Henry Moore Foundation Review*, no.2, Spring 1996, p.3.

visitor to Perry Green since the 1940s, had curated three major exhibitions in London of Moore's work.[130] At Dane Tree House, Charles Joint replaced the retired John Scrope as Administrator in 1995 and immediately threw himself into the task of restoring the studios and outbuildings around the estate, working with Hawkins and Brown on plans to convert part of the still under-used Elmwood to a new library. Julie Summers left to pursue her own career at the start of 1996 and was replaced in the summer by Anita Feldman Bennet, while the studio staff had a new addition for the first time in many years with the appointment of James Copper.

One major exhibition, *Henry Moore: From the Inside Out*, selected over the previous two years by Claude Allemand-Cosneau, chief curator of the Musée des Beaux-Artes in Nantes, Manfred Fath, Director of the Städtische

Kunsthalle, Mannheim, and David Mitchinson, took up the whole of 1996. Never before had there been an exhibition of Moore's work on this scale devoted to drawings, plasters and carvings. Plasters had been the impetus for the exhibition, since outside Toronto they remained far less known than the bronze casts that were made from them. They had seldom been exhibited or commented on in monographs or exhibition catalogues, indeed many that remained at the Foundation had never previously been exhibited. Among these were **Warrior with Shield** 1953-54 [cat.171], **Working Model for Draped Seated Woman: Figure on Steps** 1956 [cat.181] and **Three Way Piece No.1: Points** 1964-65 [cat.208], the largest original plaster surviving in the Collection and the only example of this subject. Almost all the medium-sized plasters that remained in the Collection from the 1950s and 1960s were included, carefully restored and cleaned by Muller and Woodward, even **Seated Torso** 1954 (LH 362) which Muller meticulously fixed together from a group of broken parts. From works made after the Toronto gift there was more choice, with a small range of late plasters picked to complement the Italian marble pieces and the final elmwood carvings **Reclining Figure** 1959-64 [cat.188] and **Reclining Figure: Holes** 1976-78 [cat.239], the latter not seen at the Foundation since it went to New York in 1979 and now reunited with the earlier elmwood for the first time since the Serpentine show of 1978. Mitchinson intended to show all the Foundation's early carvings together for the first time, but at the last moment he succumbed to the entreaties of Daniel Abadie who wanted the recently acquired **Head and Ball** 1934 [cat.66] for his show at the Jeu de Paume. Nevertheless all the other sixteen were included, plus two lent by the British Council. 'Ideas for sculpture' was the theme behind the selection of drawings, showing Moore's explorations and experiments in two dimensions during the 1920s and 1930s before proceeding to a three-dimensional carving, in contrast to his fluency for depicting sculptural objects in pictorial space at a later date. All the later plasters in the show were of small or medium size, perhaps reflecting Moore's move to polystyrene for his enlargements. Over 180 originals were transferred from HMF Enterprises to the Foundation in 1993, making them the final massive addition to the Collection. For Nantes and Mannheim only nine of these post-1977 plasters were selected, emphasising the strength of this part

Fig.24. Students in Santiago de Chile drawing **Family Group** 1948-49 [cat.156] in 1997.

of the Collection and allowing the Foundation to retain many of them on view at Perry Green in the studios where they were made.

One other exhibition to note from 1996 was *Interno-Externo: Henry Moore Bronces y Obra Gráfica*, a small thematic exhibition sent to Argentina and Uruguay as a prolegomenon to the much larger exhibition that toured Latin America the following year. Opening at the Museo Nacional de Bellas Artes in Buenos Aires, it continued to Rosario, Mar del Plata and Córdoba before going on to Montevideo. Its selection was made to complement and explain **Reclining Figure: External Form** 1953-54 (LH 299) in the collection of the Museo Nacional. This piece needed restoration, a task undertaken by Malcolm Woodward while he was in Buenos Aires for the installation. The show consisted of thirty-five graphics and nine sculptures, including four helmet heads from the Collection, and the Foundation also borrowed **Working Model for Reclining Figure: Internal/External Form** 1951 (LH 298) from the Arts Council in order to complete the theme. The much larger exhibition which followed in Buenos Aires, *Henry Moore: Hacia el Futuro*, consisting of fifty-one sculptures, forty-two drawings and thirty graphics, had already been to the Centro Wifredo Lam in Havana and the Museo Nacional de Colombia in Bogotá at the beginning of 1997 and would move on to the Museo Nacional de Artes Visuales in Montevideo and Santiago's Museo de Bellas Artes [fig.24], taking the works away from Perry Green for most of the year.

This was by far the most ambitious touring exhibition the Foundation had organised in terms of logistics, budget and manpower without the active involvement of the British Council in London. Following the pattern of recent retrospective exhibitions, its contents included a few drawings and some graphics, with a cross-section of carvings and bronzes of manageable size. Also taken were the pedestals and showcases, with the sizes checked by computer in advance to ensure that everything would fit into the variety of aircraft booked for the internal flights.

To accompany the exhibition the Foundation produced, in Spanish, a special edition of *The Henry Moore Foundation Review*, containing information on its activities and those of the Institute in Leeds, plus a catalogue section for *Henry Moore: Hacia el Futuro*. The *Review* had been initiated by Llewellyn in the autumn of 1995 as a means of disseminating knowledge about the Foundation's past programme and future plans to its friends and supporters around the world. Among much information, articles from staff members and special features, illustrations of new additions to the Collection were noted. Although less frequently than previously, important works continued to be acquired: in 1995 one of Moore's most powerful life studies, **Seated Figure** 1933 [cat.63] and a year later the unusually coloured sketchbook page **Monoliths** 1934 [cat.72] were purchased. Ten sculptures and five drawings by Moore were included among forty-four items, from different parts of the family collections, auctioned at Sotheby's New York in May 1997. The Foundation bought two works, **Mask** 1927 [cat.33], a fundamental subject entirely missing from the Collection, and **Drawing for Metal Sculpture: Two Heads** 1939 [cat.106], a precursor of so much on the internal/external theme that was to follow. Other works acquired included two lead stringed figures [see cats.100, 102], and a bronze cast of **Madonna and Child** 1943 [cat.142], purchased at the beginning of 1994 in honour of Sir Alan Bowness, in response to a request to the Trustees from the staff to mark Bowness's retirement as director in a way that linked his name to the Collection he had done so much to support.

The exhibition programme continued in 1997-98 with *Henry Moore: Animals* designed for three venues in Germany. Selected by Dr Martina Rudloff, Director of the Gerhard Marcks Haus in Bremen, in consultation with the Foundation's curatorial team, it consisted of fifty sculptures

Fig.25. Reinhard Rudolph talking to young visitors at Perry Green about **Family Group** 1948-49 [cat.156].

and eighty works on paper dealing with a subject little understood in Moore's work, but one which interested him throughout his life. Many items, particularly drawings, had not been exhibited before and the choice was enhanced by a large display of found objects from the artist's studio. This included the largest (and Moore's favourite), the elephant skull, *Loxodonta africana*, given to him by Julian and Juliette Huxley in the 1960s, exhibited away from Perry Green for the first time in twenty-five years. The show also included, for Bremen only, **Sheep Piece** 1971-72 [cat.230] which had not left Perry Green since its return from the exhibition *Henry Moore at the Serpentine* in 1978. The remaining tour venues were the Georg Kolbe Museum, Berlin, and the Städtische Museen, Heilbronn, all three interesting partners for the Foundation, as the first two focused on individual sculptors' collections while the third specialised in maquettes and working models of the nineteenth and twentieth centuries.

Perry Green and the Collection today

Tim Llewellyn continued the policy of trying to make more of the Collection available for viewing at Perry Green, adding a dimension of his own by starting a dialogue with the local education authorities to encourage the estate to be used as a resource for study in connection with the National Curriculum. Visitor policy, though still strictly by appointment only, was changed – not to encourage greater numbers but to separate educational groups from general

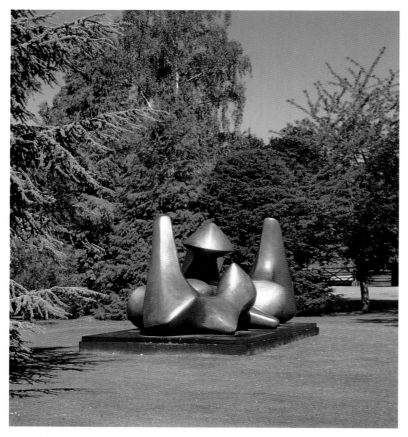

Fig.26. The gardens at Perry Green with **Three Piece Sculpture: Vertebrae** 1968 [cat.216].

visitors, with school parties now specially catered for in the mornings [fig.25]. As the demands made by visitors on the time of the curatorial staff increased and work abroad meant long periods when there was nobody to open the studios and explain Moore's work, a system of trained volunteer guides was introduced. The Foundation also provided information about Perry Green and the Collection to prospective visitors via its website, through tourist information offices and the English Tourist Board database, with the result that fewer people arrived without an appointment, making the visitors programme easier to plan and manage, with less disruption to the staff. This enabled Rosemary Walker to extend opening times to five days a week, allowing the same number of visitors to be spread more evenly. As a tour of the estate takes about an hour and a half, or more for a real enthusiast, the provision of a small reception centre with rest-rooms and shop area has also helped to make a visit to Perry Green more pleasurable.

Experience showed that a need existed to provide facilities for research. To meet this requirement three parts of Moore's archive – correspondence, books and photographs – which had previously been accessible only for internal use, were prepared and reorganised for serious study. The internal rebuilding of Elmwood and its adaptation to library and archive rooms greatly advanced the Foundation's capacity to encourage and help scholars and art historians, providing space for the librarian Martin Davis and archivist Julia Bradford to unpack and make available material previously in store. Much still remains to be done, but Moore's papers, and the ever expanding library of books, exhibition catalogues, journals, videos and press cuttings, are now in order and available for analysis. The library is arranged in a similar way to the bibliography, so that cross-referencing between the two is straightforward. As a CD-ROM on Perry Green is developed, more information computerised and the digitisation of colour material undertaken, the Foundation's archive will have room to expand and react to any future demands. So too the collection of negatives, transparencies and photographs, always extensive and now augmented by the archives of Moore material acquired from John Hedgecoe, Errol Jackson and Frank Farnham.

Much of the Foundation's land had never been used for placing sculpture or been accessible to visitors during Moore's lifetime, but with better management all areas were brought into use. Without crowding the landscape, twenty-seven sculptures were placed on semi-permanent display by 1997. With other bronzes in Yorkshire and fifteen away on long-term loan, perhaps the maximum on the estate at any one time will be around thirty. Only about a third of those placed were part of the gift of 1977, and of the eight largest only **Sheep Piece** 1971-72 [cat.230] had been sited by Moore. Of the rest, **Large Reclining Figure** 1984 [cat.103] and **Large Upright Internal/External Form** 1981-82 [cat.162] arrived at Perry Green during Moore's lifetime but were not permanently sited until a number of years after his death. **The Arch** 1969 [cat.200], **Large Two Forms** 1969 [cat.211], **Double Oval** 1966 [cat.212], **Three Piece Sculpture: Vertebrae** 1968 [cat.216, fig.26] and **Large Figure in a Shelter** 1985-86 [cat.237] all came after 1986 and were sited by members of staff. The slightly smaller outdoor sculptures, which tended regularly to be away on exhibition, moved around the estate quite frequently, depending on the availability of suitable sites. Wherever possible the sites

Fig.27. Inside the maquette studio.

themselves, as designated by Moore, remain the same in the older established parts of the garden and have been extended gradually, often after intense debate, to the more recently acquired or opened up areas.

In order to make the gardens and parkland more attractive as a background to the outdoor sculptures, some careful planting took place to define boundaries, replace trees lost to disease or storm and hide unsightly buildings. As the estate and its surrounding countryside show influences going back to Saxon times, care has been taken to ensure that what remains of the ancient landscape is preserved and new planting done with native trees such as ash, hornbeam, field maple and oak. On the more domestic side, the two orchards have been replanted and extended and the lawns maintained to a height of grass suitable to the sculptures placed on them.

In 1996 Charles Joint began a complete review of the properties on the estate, paying particular attention to the often neglected storage areas. More difficult was deciding what should be done about some of the studios, especially Moore's maquette studio whose fabric had received no attention since it was erected twenty-five years earlier, while its contents had hardly been moved since Moore's illness in 1983. In the winter of 1996 Joint and Mitchinson decided on a combined approach – the building would have a complete

..

131. See particularly Valerie Mendes and Frances Hinchcliffe, *Ascher: Fabric, Art, Fashion*, Victoria and Albert Museum, London 1987, pp.38-39, 50-51, 82-85.

overhaul and the plasters and found objects be cleaned and where necessary conserved. The inside rooms were photographed and each plaster maquette was identified and labelled before Woodward and Copper removed everything, cleaning and making condition reports as they went along. Once the studio was emptied, unnecessary external windows and doors were blocked, a new interior window was created to make viewing easier and prevent non-essential access, and the spaces were redecorated in their original colours. Then came the task of returning all the contents. Over three hundred little plasters were put back, with slightly more on view as the conservators had found some hidden in boxes and drawers. They were also able to restore a number of fragmented works and reassemble others whose elements had become separated. The found objects were also cleaned, while others removed over the years for exhibition displays were returned [fig.27]. Improvements were also made to the White and Yellow Brick Studios, particularly to the former which had become the main work-space for Copper, Muller and Woodward. Here they continued the programme of cleaning and restoring the remaining plasters and maintaining the surface patinations of the bronze casts. The other studio, no longer in use for restoration, remained a display area for a few late carvings and plasters. The Aisled Barn also received attention, with improvements to its outward appearance and the provision inside of eight purpose-built showcases to display a range of printed fabrics and textile designs. These had been produced in the late 1940s and early 1950s by David Whitehead and Zika Ascher,[131] and over the years the Foundation had been collecting samples and swatches of the various colour-ways and materials. Now for the first time came the opportunity to put them on display in proximity to the tapestries. Although regarded as derivative by the purists, the ten tapestries remain an accessible art medium to the public who continue to enjoy their presence in the Aisled Barn.

Only one vital facility was still missing. The Foundation had nowhere to display works on paper or small and medium-sized sculpture, including the pre-war carvings, and the staff at Perry Green were aware of frequent observations from the public that it was disappointing that these aspects of Moore's work remained hidden. Picking up an idea of John Scrope's, who had commented that if it was impossible for planning reasons to replace the Sheep Barn

with a purpose-built gallery perhaps a display space could be constructed inside it, Llewellyn, Mitchinson and Joint called in Hawkins and Brown to ask them to survey the building and prepare some options for the Trustees' consideration. It was suggested that as the storage conditions of the Collection had been radically improved over the previous five years, and the office facilities and library had been modernised, it was now time to think again about display since such a significant part of the Collection remained inaccessible. It was also the wish of those who worked at Perry Green to see the ongoing improvements completed in time for Moore's centenary in 1998. The Sheep Barn was clearly the most suitable building on the estate for conversion, since it was under-used, provided plenty of space, was ideally positioned in close proximity to the studios and with easy access for visitors. In addition it was not overlooked by any of the Foundation's neighbours. The space needed to be adaptable enough to take displays of works on paper or three-dimensional works, or a combination of both. As the curatorial staff intended to present a series of small changing exhibitions, generally from the Foundation's Collection but also augmented by loans from other institutions, the brief called for the building to include international conservation and security standards. A minor complication was the presence inside the barn of most of the large sculpture crates and a considerable amount of fodder for the sheep, but these potential difficulties were speedily overcome, with the farmer finding alternative storage nearby and Hawkins/Brown submitting a plan for a new storage barn in the farmyard site on the other side of Perry Green.

After considering a number of preliminary proposals, the Trustees agreed that a scheme should be developed maintaining the barn's exact proportions but rebuilding it entirely save for its existing metal structure. The reconstruction divides the interior one-third the way down its length, the first third on two floors for works on paper and maquettes, leaving the remaining two-thirds to open out into a full-height space for medium-sized sculptures. Details of the building and the way it would operate were discussed with local planning officers and the blueprints and scale model made available for inspection by local residents. After these consultations and others with interested parties in Much Hadham had resulted in no objections and a

considerable amount of support, a planning application based on the proposal was drawn up and submitted to the local District Council. Planning permission to go ahead was granted and work begun on site in the autumn of 1997. Exciting opportunities await to show and explain whole areas of the Foundation's Collection of Moore's work seldom or never previously seen at Perry Green.

During the 1990s a policy towards exhibitions evolved whereby a long touring retrospective one year was followed and balanced by shorter didactic or more specific shows the next, often chosen to bring forward areas of the Collection less suitable for inclusion in the full surveys. Since Leningrad/Moscow/Helsinki in 1991, the touring retrospectives have followed in the 'odd' years, with Budapest/Bratislava/Prague in 1993, Krakow/Warsaw/Venice in 1995 and Latin America in 1997. These were interspersed in the 'even' years with the single-venue retrospective in Sydney and the outdoor exhibition of bronzes in Paris during 1992; the exhibitions solely of bronzes in Pforzheim and Bad Homburg in 1994, plus the two very different shows in Wakefield; and the carvings, plasters and drawings show in Nantes/Mannheim during 1996. This schedule left room for loans to mixed exhibitions and for smaller touring shows such as *Henry Moore: Mutter und Kind* in 1992; *Henry Moore and the Sea* in 1993-94; *Henry Moore: oeuvre gravé, sculptures*, a selection of seven sculptures and fifty graphics seen first at the Musée du Touquet in 1993-94 and then in the Burton Museum and Art Gallery, Bideford, the following year; *Henry Moore: Shelter Drawings* in 1994; *Henry Moore: gli ultimi 10 anni* in 1995; and *Interno-Externo: Henry Moore Bronces y Obra Gráfica* in 1996. Between them, these exhibitions presented specific areas of Moore's work to a wide audience, in many cases away from the major cities – an arrangement which met the continuing demand, was fairly straightforward to plan and budget, and avoided the accusation that the Foundation, because of its large Collection, was over-emphasising the case for Henry Moore. No doubt this carefully considered programme will evolve and become even more varied and exciting in the future, not just because today's policy is tomorrow's heresy, but because the arrival of the Foundation's own display area at Perry Green will mean a new appraisal of how the Collection is used, and what its role should be in the Foundation's overall policy towards conservation, education and display.

1

Seated Male Nude 1921
HMF 5
pencil on cream lightweight wove
164 × 125mm
signature: pencil u.r. *Moore/21*
Gift of the artist 1977

publications: Wilkinson 1984, p.11, pl.7;
Henry Moore: Complete Drawings, vol.1
1916-29, AG 21.16

At the age of twenty-three Moore won a
scholarship to the Royal College of Art and
left the isolated environment of the Leeds
School of Art, where he had been the sole
student in their recently formed sculpture
department, for the stimulating atmosphere
of London. Although Moore eventually
found the Royal College inflexible and
unsupportive of his exploration of non-
Western art forms, he remained with the
institution for a decade, finally resigning
from a teaching position there in 1931.

This work, a rare depiction by Moore of
a male nude, is one of the earliest surviving
examples of his life drawings, created
during his first term at the Royal College. It
was later in this year that Moore would first
visit Stonehenge and begin sketching
ethnographic material in the British
Museum. He was evidently pleased with the
sketch as he clipped it out from the sheet of
paper and carefully saved it, to be
rediscovered years later in a folder under
his bed at Hoglands. Out of five known
drawings by Moore of this model, this is the
only one in which he uses a fluid free line,
and has been quickly drawn to express
movement. Although seated, the figure has
a pent-up energy, and seems to be turning
his head, lifting his arms and capable of
rising to his feet. Moore has captured the
essence of the figure at a particular fleeting
moment.

The figure's left eye extends over the
edge of his face, increasing the sense of
motion and visually breaking the inherent
restriction of the outline. Moore later
explained: 'An outline represents a
boundary and this you must begin by
destroying if you want to place an object
fully in space'.[1] Circular lines cut across the
chest, stomach and thighs of the figure,

1

suggesting volume without the use of light
and shade, anticipating Moore's 'sectional
line drawings' of 1927-28 in which he
defined the shape of a solid object with
lines drawn down and across the form.

Anita Feldman Bennet

1. *Auden Poems/Moore Lithographs*, British Museum
Publications, London 1974.

2

Small Animal Head 1921
LH 1a
boxwood
height 11.4cm
unsigned
Gift of the artist 1977

exhibitions: Nantes 1996 (cat.1); Mannheim
1996-97 (cat.1)
publications: Strachan 1983, pl.113

Here, at the outset of Moore's carving
career, is a modest yet fascinating
interpretation of a subject that would later
generate some of his most original,
disconcerting images. The young sculptor's
willingness to let the head's identity remain
ambiguous is remarkable. Although hints of
different animals are conveyed, Moore
clearly did not want it to be pinned down.

He may, in this early manifestation of
his interest in 'truth to materials', have let
the innate character of the boxwood
suggest the form it should take. He may
also have been intrigued by the mysterious
power of sculptural fragments, especially
during his visits to the British Museum, and
have decided to explore a similar sense of
enigma in a carving of his own. A more
specific springboard was available in the
work of Henri Gaudier-Brzeska, whose art
and writings Moore had encountered in the
pages of the Vorticist magazine *Blast*. For
Gaudier was preoccupied with animal
imagery throughout his short career; and
sometimes, as in the carving called *Stags*
illustrated in the first issue of *Blast*, he
deliberately frustrated the viewer's attempt
to decipher all the forms of a sculpture.

So does Moore in **Small Animal Head**.
Emboldened perhaps by working on an
almost miniature scale, he made the
carving far more difficult to 'read' than his
larger works of the same period. There can
be no doubt that, in a powerful suggestion
of pent-up energy, it embodies what Roger
Fry called 'an inner life'. Fry was here
describing the vitality of 'Negro sculpture'
in an essay admired by Moore, and in this
strangely mesmeric little carving the sense
of latent vitality is made palpable.

Richard Cork

3-6

Notebook No.2 1921-22
HMF 36-67
Maroon paper-covered boards quarter-
bound in red cloth 225 × 175mm; the book
probably contained 62 pages of cream
lightweight laid paper 224 × 170mm in five
signatures of ten and one of twelve,
including the inside covers and endpapers.
The front board is blind-stamped lower
right LAMLEY & CO./PUBLISHERS,/SOUTH
KENSINGTON. The pages were numbered in
pen and ink by the artist upper right on the
recto and upper left on the verso after some
had been removed. Many pages are now
missing and some others have become
detached.
Gift of the artist 1977

exhibitions: Toronto/Iwaki-Shi/Kanazawa/
Kumamoto/Tokyo/London 1977-78 (cat.73)

publications: Wilkinson 1984, pp.42-79;
Henry Moore: Complete Drawings, vol.1
1916-29, AG 21-22.1-33

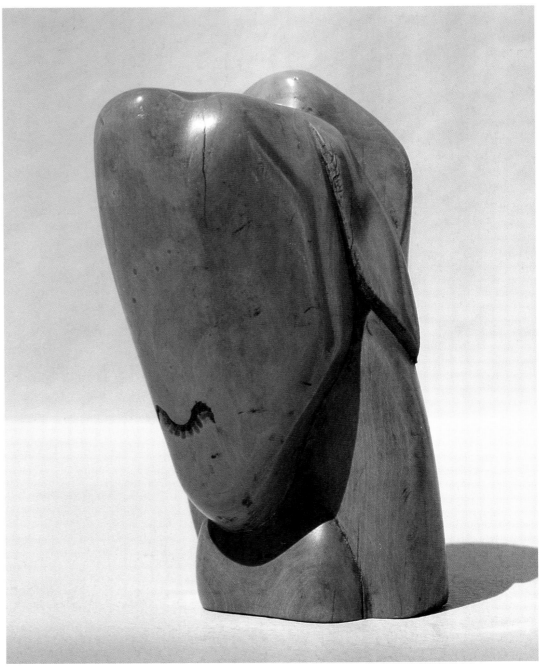

2

It is appropriate to call this 'The Royal College of Art Notebook' in that most of the sketches and lists of subjects relate to the 'monthly comps' (compositions) which were part of the academic curriculum at the Royal College. Many of the compositions and individual figures are for a series of architectural friezes which, both in terms of their narrative content and as studies for relief sculpture, could not have been more foreign to Moore's commitment to the non-literary, to shape for its own intrinsic interest, and to what he later called 'Full three-dimensional realisation. Complete sculptural expression is form in its full spacial reality', he added.[1] Subjects such as 'the auction', 'sheep shearing', 'frieze for decoration of emporium', 'fishing', 'agriculture', 'hunting scene' reflect the demands of the purely academic side of Moore's training, which was at odds with his taste in sculpture, his interest in the work of Gaudier-Brzeska and in the rich collections of tribal art in the British Museum.

Scattered throughout the notebook are sketches and written notes that establish at the outset of Moore's career sculptural motifs and concepts which dictated the direction of his art throughout his life. None is more telling than the note 'Carving with unsymetrical [sic] design', which appears on the inside front cover, along with a grocery list of twelve items totalling six shillings and sixpence. Moore, in the tradition of Gauguin, Brancusi, Gaudier-Brzeska, early Modigliani, Epstein and Dobson, was as committed to carving in stone and wood as Rodin, Lipchitz and Giacometti were committed to modelling in clay. 'Asymmetry' was one of the key concepts in Moore's approach to form, in his desire to create sculpture fully realised in the round with no two points of view alike. 'Asymmetry', he wrote in *Unit One* (1934), 'is connected also with the desire for the organic (which I have) rather than the geometric.'[2]

Nowhere is one more enlightened about the formal aims and considerations that preoccupied the young student than in the notes that accompany a number of studies for sculpture in which Moore was working freely (from the academic programme laid down by the Royal College) at developing his own ideas. Some of the notations beside completed studies for sculpture are descriptive, others corrective: on page 25 (HMF 45 verso) 'upward / twisting / & strong; on page 41 (HMF 50 recto) 'better designing / of masses'; on page 55 [cat.4 recto] 'eye higher up & lower neck / more horizontal'. In other notes Moore considers the appropriate materials: on page 31 (HMF 48 verso), 'Mask in terracotta or bronze', below this, 'Stone rough into / big simple mass / & limbs etc . . . ', and on page 81 [cat.9 recto] beside the drawings for the 1924 marble **Snake** (LH 20) simply, 'Composition in stone'.

At this early stage in his career, Moore's art reflects a total lack of interest in depicting on a psychological level the range of human emotions – joy, sorrow, pain, erotic ecstasy – that inform, for example, much of Rodin's sculpture. Rather, as the notes quoted above clearly indicate, his aim was 'to render the exact degree of relationship between, for example, the head and shoulders; for the outline of the total figure, the three-dimensional character of the body, can render the spirit of the subject treated.'[3] In this respect the word 'mass' – 'get better relation of masses' (page 83 HMF 62 recto) – is the one most often used in this and other notebooks of the 1920s in analysing and often correcting the 'shapes' of the sculptural ideas, as if the two-dimensional sketches were realised carvings that needed compositional alterations. It seems to me that in the repeated use of the word 'mass', Moore has paraphrased Gaudier-Brzeska's well-known dictum 'Sculptural energy is the appreciation of masses in relation.'[4]

Almost all Moore's early copies of sculptures, paintings and drawings from the Palaeolithic era to Picasso are to be found in Notebooks 2 to 6 (1921-26). **Notebook No.2** includes three individual figure studies taken directly from the work of Rubens, and a sketch based on a drawing by Gauguin [cat.3 verso]. Page 80 (HMF 60 verso) includes thumbnail sketches of individuals and groups of figures inspired by Cézanne's *Les Grandes Baigneuses* 1898-1905 (now in the Philadelphia Museum of Art) which Moore had seen in the Pellerin Collection on a visit to Paris in 1922.

If one were asked to preserve for posterity but one small corner of a page from **Notebook No.2**, I would choose without hesitation the two sketches of a reclining figure at lower right on page 93 [cat.6]. Moore himself commented when we discussed these two studies in April 1970 that they showed 'the first bit of influence of the Mexican reclining figure'. He was referring to the Toltec-Maya stone *Chacmool* reclining figure in the Museo Nacionale de Antropologia, Mexico City, which was unquestionably the most important, indeed overwhelming influence during Moore's formative years [cat.39]. **Notebook No.2** includes preparatory drawings for the following four early sculptures executed between 1921 and 1927: **Small Animal Head** 1921 [cat.2]; **Figure** 1923 (LH 8); **Snake** 1924 (LH 20); and **Duck** 1927 (LH 44). For a discussion of the crucial role of the drawings as a means of generating ideas for sculpture, see cat.5.

As the earliest surviving record of Moore's thoughts about sculptural form, of his obsession with the *Chacmool* reclining figure, of his interest in the work of Rubens, Cézanne and Gauguin, and of his use of drawing to generate ideas for sculpture, **Notebook No.2** is an invaluable document that mirrors, with the clarity and revealing psychological insights of dreams, the workings at the deepest, most spontaneous level of the sculptor's imagination.

Alan Wilkinson

1. James (ed.) 1966, p.69; 1992, p.72.
2. Ibid. 1966, p.70; 1992, p.73.
3. Ibid. 1966, p.117; 1992, p.119.
4. Ezra Pound, *Gaudier-Brzeska: A Memoir*, New Directions, New York 1970, p.20.

3 recto

3 verso

3

Studies of Female Nudes 1921-22
Page 51 from Notebook No.2
HMF 51
pen and ink
unsigned, undated
inscription: pen and ink top of page *Figure (Woman!) Climbing over rock. – /possibly with child/recompose*

verso
Standing Figures 1921-22
pencil, pen and ink
unsigned, undated
inscription: pen and ink c.l. *This/leg further/forward for standing/on./and this/more bent/at knee*; c.r. *Gauguin*

publications: *Henry Moore: Complete Drawings*, vol.1 1916-29, AG 21-22.17

One might be surprised by the title Moore has given the recto of this sheet, in which the idea seems to be more about a mother clasping and merging with her child, than a woman climbing over a rock. Earlier in the same notebook (HMF 46 verso) a woman almost crawls on the floor to tend her child; such compositions seem to be dealing with the horizontal, and with how to allow convincing compositions to grow upwards. This group of drawings can additionally be understood as a way of thinking about sculptural mass, and how to support a figure and allow it to relate to its own material. One wonders therefore whether that material might have been imagined as clay, or as stone? Stone necessitates more in the way of strategy, and one can see how this grouping of forms would be appropriate to a treatment in stone.

It is this approach which reminds me of Rodin's sculptures, in which figures emerge from the mass of the material, languorously floating on the rock. The touch is also reminiscent of Rodin's drawings, particularly the early ones, made around the time he was working at the Manufacture nationale de Sèvres. This fluid lingering line is like those figures which Rodin designed for ceramic vases, in which the nature of the glaze allowed the line to hover about the surface, both over and under. If one looks for a contemporary realisation in Moore's work of this theme, one comes up against **Mother and Child** 1922 (LH 3), which has none of the serpentine qualities of these sketches. Although it too finds a way of retaining the bulk of the stone, without too much excavation of the material, it has a jaunty air which may have helped to lead Moore away from Rodin and towards his own,

much more expressive characterisation, in which the figure does indeed become a mother, and the rock her child.

Penelope Curtis

Few artists have left such a detailed record as Moore has done of specific works of art that held their attention to the extent that they felt impelled to make visual records in the form of sketchbook drawings. In the 1920s there were, understandably, few copies of works by European artists, as Moore turned for inspiration to 'primitive' art – African, Oceanic, Peruvian and above all pre-Columbian art – as well as to prehistoric, Egyptian and Sumerian sculpture. In the 1920s, Rubens, Cézanne, Gauguin and Picasso were the only European artists whose work Moore copied, apart from those drawings done on a scholarship to Italy in 1925, the purpose of which was obviously to record and study Italian art. Almost all Moore's early copies of works of art appear in the sketchbooks of the 1920s.

Of Cézanne's work there is only one direct copy – **Studies of Figures from Cézanne's 'Les Grandes Baigneuses'** *c.*1922 (HMF 26 verso) – although there are several pages of figure studies that were almost certainly done from memory, with the painting, which Moore saw in Paris in 1922, still fresh in his mind [see cat.5].

The figure on the right of cat.3 verso is, as the inscription tells us, a copy of a Gauguin, with that unmistakable Gauguinesque pose which was based on sculptures from the frieze of the Javanese temple of Baraboudour, and on the heavy-limbed, broad-shouldered figure type characteristic of Tahitian women. As with many of Moore's copies of works of art in the 1920s and indeed throughout his life, a book, or possibly a photograph or reproduction, was the source for this drawing after Gauguin's 1892 charcoal *Femme Nue*, which was reproduced in Charles Morice's *Paul Gauguin* (Paris, 1911). As with the work of Rubens, the Gauguin drawing would have appealed to Moore because of the ample proportions of the figure.

In **Notebooks 2** and **3** of 1921-22 and 1922-24 respectively, I have with Moore's help identified four drawings that were directly copied from the work of Rubens. In the early 1970s, when we were leafing through the early notebooks, Moore pointed out 'the Rubens connection' by suggesting that the drawing at left of cat.3 verso 'might be a copy of Rubens' – a remarkable feat of visual memory fifty years on. It is indeed a copy of the partially draped female nude at the right of Rubens' *Diana and Nymphs Surprised by Satyrs* 1635-36. Whereas this copy was done from a reproduction, the standing female nude, back view, in HMF 47 verso, a sketch of the figure on the right of Rubens' *The Judgement of Paris* c.1632-35, in the National Gallery, London, may well have been done *in situ*. **Notebook No.2** also includes a copy in HMF 52 verso of one of the figures from Rubens' *The Judgement of Paris* in the Prado. In **Notebook No.3** (HMF 90 verso) there are several sketches of Rubens' *Venus Frigida* 1614, in the Musée Royal des Beaux-Arts, Antwerp. When I asked Moore what he admired about Rubens' female nudes, he said: 'The heavy, weighty figures were an obvious subject for stone sculpture, and one liked the compact poses.' That three of the four copies after Rubens depict back views of the female figure is of particular significance. They represent for the first time in Moore's work what was to become a life-long obsession with the strength and broad sweep of the female back, which the sculptor always related to the best-known and perhaps most vivid of his childhood 'tactile' experiences, that of relieving his mother's rheumatism by rubbing her back with liniment.

Alan Wilkinson

4
Studies of Animals 1921-22
Page 55 from Notebook No.2
HMF 53
pencil
unsigned, undated
inscription: pencil top of page *eye higher up & lower neck/more horizontal*;
u.r. *frightened look/not so many/angles*; c.r. *abstract/further*

verso
Study of a Caryatid 1921-22
[not illustrated]
pencil, charcoal offset
unsigned, undated

publications: Strachan 1983, pl.39; *Henry Moore: Complete Drawings*, vol.1 1916-29, AG 21-22.19

At first sight this makes one think of a horse, though perhaps it could be an ass or a donkey, or some ancient near-Eastern animal. I don't know whether it is a drawing after an antique prototype, or an idea for a sculpture, though one could probably argue that it is both. The various sketches on the page give us the impression that Moore is working hard to get the image right, in terms of the alignment of the head and neck and the arrangement of the legs. That returns us to the uncertainty as to whether he is copying from a museum exhibit, or delving into his imagination. The image is reminiscent of the Susian capital in the Louvre, but other pages in the notebook bring us more surely to Mexican amulets (and bookholders, see inscription on cat.6) in which birds and animals, including a horse, are fashioned out of and into their bases, almost like shadow puppets.

A number of other drawings focus on the upward lift of a form away from its base, whether this is in the twist of a snake, the poise of a lion, or the tension of a dancer or an athlete. Like cat.3, these animals offer a practical formula for bringing the legs into a compact base, so that the horse makes a block, neatly supported by the pedestal. Though these drawings suggest the museum, the image is also reminiscent of the *Pegasus* of Carl

4 recto

5 recto

Milles, which has a similar sense of energetic flight above, with the land-locked socle below. There is a horse sculpture of 1923 (LH 7) in Moore's work, but it too seems to be something of a rejection of these drawings. Though the sculpture has a similarly small base, with the rear legs brought in to meet the front, its neck is bowed. Its impression is of the bashful Chinese terracottas of the T'ang dynasty, rather than some Assyrian war-horse as in the drawing.

Penelope Curtis

5
Studies for Snake Sculpture 1921-22
Page 81 from Notebook No.2
HMF 61
pen and ink, chalk
unsigned, undated
inscription: pen and ink u.r. *Composition in stone*

verso
Studies of Birds 1921-22
[not illustrated]
pen and ink, chalk
unsigned, undated
inscription: chalk u.l. *Morceaus* [sic] *of figures*; u.l. *fragment of an/arm/etc etc*; part *of a/leg./etc*; c.l. *Heads of animals – / Grotesques*

exhibitions: Toronto/Iwaki-Shi/Kanazawa/ Kumamoto/Tokyo/London 1977-78 (cat.73)

publications: Strachan 1983, pl.2, 14; *Henry Moore: Complete Drawings*, vol.1 1916-29, AG 21-22.27

These studies for 'Composition in stone' are for the marble **Snake** 1924 (LH 20). The name of a Paris hotel on the previous page, and the Cézannesque studies beneath the drawings for **Snake** here, suggest that Moore took the notebook with him in 1922 on the first of many trips to the French capital.

In the four groups of studies for completed sculptures in this notebook, Moore has established the crucial role of drawing as a means of generating ideas for sculpture. From the earliest surviving carving, the **Small Animal Head** 1921 [cat.2], to the work of the early 1950s, almost all Moore's carvings and bronzes had their origin in the sketchbook pages. Sculpture, particularly carving in stone and

wood is, as he pointed out, 'a slow means of expression, and I find drawing a useful outlet for ideas which there is not time enough to realise as sculpture.'[1] It is interesting to compare Moore's working method with that of other masters of modern sculpture. Rodin and Lipchitz, for example, who modelled in clay, very rarely made sculptures based on preparatory drawings. The spontaneous clay sketch was, compared to carving, a relatively quick method of realising sculptural forms. Yet Brancusi and Hepworth, two of the twentieth century's greatest carvers, did not use drawing as an intermediate stage to explore ideas for sculpture; they envisaged the form within the material. Moore, on the other hand, always needed to work from *something*. From 1921 to the early 1950s it was the profusion of sculptural ideas in the notebooks. From the mid-1950s natural forms – flint stones, shells, bones – became the point of departure for sculptural ideas [see, for example, cat.174].

The drawings for the **Snake** on this page are unique among Moore's preparatory studies for sculpture in that he envisaged the work from so many different points of view. In most of the drawings for sculpture only one angle is shown. As he commented: 'I would often start a sculpture from an idea I'd produced in a single drawing and work out what was to happen at the sides and the back as I went along.'[2] This was more feasible for a subject such as a reclining figure than for the coiled, twisting, interlocking forms of a snake. It would be difficult to imagine a less frontal, more totally three-dimensional form. **Snake** is one of the earliest sculptures to reflect the influence of pre-Columbian stone carving, in this case the Aztec coiled serpents.

The figure studies below the drawings for **Snake** were, I would suggest, done in Paris in 1922 soon after, if not on the same day that Moore had seen Cézanne's *Les Grandes Baigneuses* in the Pellerin Collection. They have the immediacy and frenzied urgency of an attempt to recapture an overwhelming visual experience.

Alan Wilkinson

1. James (ed.) 1966, p.67; 1992, p.70.
2. Hedgecoe (ed.) 1968, p.269.

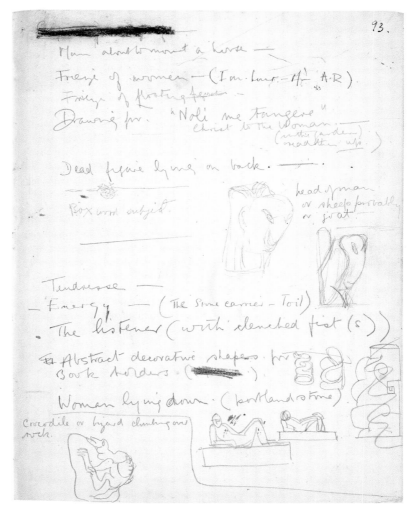

6 recto

6
Studies for Sculpture 1921-22
Page 93 from Notebook No.2
HMF 66
pencil
unsigned, undated
inscription: pencil covering most of page [. . .] [crossed through] *Man about to mount a horse –/Frieze of women – (I on horse – Mr. A.R)/Frieze of floating figures –/ Drawing for "Noli me Tangere"/Christ to the Woman –/) in the garden)/read this up.)/ Dead figure lying on back. –/Box wood subject; head of man/or sheep probably/or goat –/Tendresse –/– Energy – (The Stone carrier – Toil)/The listener (with clenched fist(s))/Abstract decorative shapes for/Book holders; (Maya)* [crossed through] *Woman lying down. (portland stone)/Crocodile or lizard climbing over/rock*

verso [not illustrated]
list of subjects for drawings and sculpture inscription: from top of page pencil *out of Verdi prato* [sic] *– small figure; Large head /small body arm/& legs;* crayon *Frieze for Emporium;* pen and ink *Hunting scene/ Fishing scene in boats/man carrying rabbits;* pencil *Subjects for Freize* [sic] *(Emporium)/ The Toilet. /Seated figure reading – or more than one –/Composition – (just decoration) (Allegory)/(El.G.)/Sports. (Tennis etc.)/Toy department –/Cafe scene. –;* pen and ink *furriers. –;* pencil *Group of work – (Taking produce to market etc);* pen and ink *– girls carrying fruit baskets etc. –/group of animals birds/etc.;* pencil *The Dancer/ Group of Girls singing/(Two men wrestling) –/(The Auction –)/An orgy –/History of merchandise – Procession/Panels of all the many products – agriculture – cloth – food/meat etc/sheep shearing –;* pen and ink

fruit gathering–/Man digging; pencil *March/The Sower – Wind/Pruning – fishing – & lambing –/The coming of Spring – Birds. sing/Generation of species – man & maid/Nature wakes from her sleep/The milkmaid & her beloved go to/market./Much work is done.*

publications: *Henry Moore: Complete Drawings*, vol.1 1916-29, AG 21-22.32

Reading this and the following page is as if we are back in the early 1920s looking over the shoulder of the young sculptor at work in his studio. Moore is rapidly itemising possible subjects for the 'monthly comps' (composition) projects set for sculpture students attending the Royal College of Art.[1] Some of the themes, with their narrative content, belong to the world of academicism which then still dominated English art education: 'Drawing for "Noli me Tangere" Christ to the Woman, Man about to mount a horse, Energy – (The Stone carrier – Toil)', and on page 94 'Group of Girls singing, The milkmaid & her beloved go to market, Sports. (Tennis etc.)'.

Already committed to Modernism, Moore summarily dismissed these worn-out genres. The two sketches centre right described as 'head of man or sheep probably or goat' relate to some of his earliest extant carvings, **Small Animal Head** [cat.2] and **Dog** [cat.10]. These sketches, and those of a 'Crocodile or lizard climbing over rock' lower left and the snake-like 'Abstract decorative shapes' lower right, though mundanely designated 'for Book holders', are early expressions of his lifelong enchantment with drawing animals.[2] The 'Frieze of floating figures' is perhaps the seed of the famous relief, **West Wind Relief** 1928-29 (LH 58, and see cats.36-41), on the St James's Underground headquarters in London.

The most remarkable item in the list is the pair of sketches lower right described as 'Woman lying down. (portland stone)'. The provision of material shows that Moore was already thinking of this subject as a sculpture which could be carved in three dimensions. Indeed, he was to develop the composition six years later in sketches entitled **Subjects for Garden Reliefs**

[cats.39, 40] and then in 1929 in one of his greatest works, the brown Hornton stone **Reclining Figure** (LH 59) now in Leeds City Art Gallery. Moore recollected having been inspired in 1925 by a photograph in a German magazine of the ancient *Chacmool* from Chíchén Itzá.[3] However, this sketch reveals that he had envisaged the essential pose and the monumental, volumetric treatment of the body as early as 1921-22. This is hardly surprising since by that time he was already looking hard at ancient and so-called primitive art, writing to a friend in October 1921: 'I spent my second afternoon in the British Museum with the Egyptian & Assyrian Sculptures – An hour before closing time I tore myself away from these to do a little exploring and found in the Ethnographical Gallery – the ecstatically fine negro sculpture – a joy to come . . . Cheerio (I'm trotting off again to the British Museum for the afternoon)'.[4]

Terry Friedman

1. Toronto/Iwaki-Shi/Kanazawa/Kumamoto/Tokyo/London 1977-78, p.73.
2. Strachan 1983, plates 1-2, 55-6, 79.
3. James Johnson Sweeney, 'Henry Moore', *Partisan Review*, March-April 1947, quoted in James (ed.) 1966, p.42; 1992, p.44.
4. Letter to Jocelyn Horner, Leeds City Art Gallery archives.

7

Reclining Male Nude 1922
HMF 72
pen and ink, pencil, crayon, charcoal, wash on cream medium-weight wove
382 × 555mm
signature: pencil l.r. *Moore/22*
Acquired 1979

exhibitions: Madrid 1981 (cat.D7); Lisbon 1981 (cat.D7); Barcelona 1981-82 (cat.D7); Columbus/Austin/Salt Lake City/Portland/San Francisco 1984-85 (cat.79); Paris 1989; Sydney 1992 (cat.1); Krakow/Warsaw 1995 (cat.1); Venice 1995 (cat.1); London 1996; Havana/Bogotá/Buenos Aires/Montevideo/Santiago de Chile 1997-98 (cat.3)

publications: Sotheby Parke Bernet, 20-22 March 1979 lot 297; *Henry Moore: Complete Drawings*, vol.1 1916-29, AG 22.5

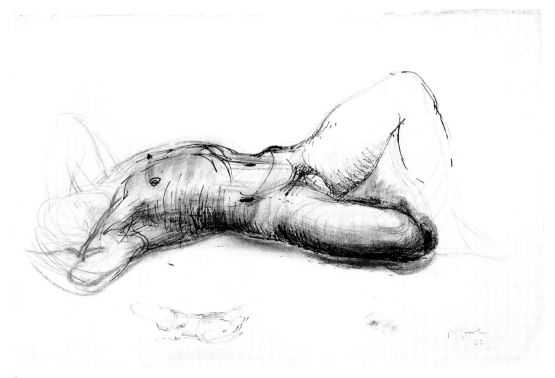

7

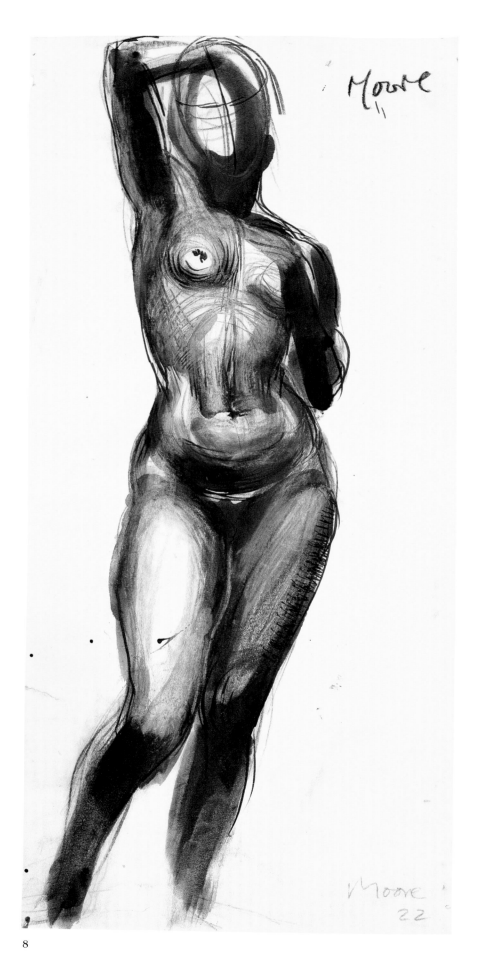

8

Standing Nude Girl, One Arm Raised
1922
HMF 78
chalk, pen and ink, crayon, wash on
off-white light to medium-weight wove
335 × 155mm
signature: crayon u.r. *Moore*; pencil l.r.
Moore/22
Gift of the artist 1977

exhibitions: Toronto/Iwaki-Shi/Kanazawa/
Kumamoto/Tokyo/London (cat.5) 1977-78;
Bonn/Ludwigshafen 1979-80 (cat.71); Hong
Kong 1986 (cat.D2); Tokyo/Fukuoka 1986
(cat.d2); Martigny 1989 (cat.p.78); Budapest
1993 (cat.2); Bratislava/Prague 1993 (cat.2)

publications: Clark 1974, pl.6; Wilkinson
1984, p.12, pl.9; Garrould 1988, pl.2; *Henry
Moore: Complete Drawings*, vol.1 1916-29,
AG 22.14, pl. III

Moore was still a student when this
drawing was made, in his second year at
the Royal College of Art. Unlike most
sculpture students at the time, he attended
life classes as he considered drawing the
human figure to be an essential training for
the practice of all forms of visual art.

Typically, the drawing is a mixture of
various media, and the head is reduced in
size and anonymous. Being a sculptor,
Moore is more interested in mass than in
personality. What he is noting is the
swelling and masses of his subject, the
tensions and slackness of its various parts.
Instead of the conventional use of outline
and shading, the artist fills in areas of
darkness from which the white of the paper
emerges to define volume and form. When
he draws a line it is to mark a contour or a
section rather than to define an edge.
Moore has already come to realise that, as
far as he is concerned, drawing should
work from the inside outwards. Outline
should suggest the edge of a form rather
than its sharp silhouette.

In 1922 Moore attended a lecture by
Roger Fry about Cézanne, and disagreed
with that critic's interpretation of Cézanne's
Bathers. According to Moore, Cézanne was
not interested in getting the anatomy right,
but wanted to give you the feeling of an arm

coming out at you like a telegraph pole that was falling on you. One year later Moore visited Paris and saw Cézanne's *Grandes Baigneuses* in Pellerin's collection. 'It was like seeing Chartres for the first time.'

By 1922 the revolutionary activities of Henri Gaudier-Brzeska, the Italian Futurists and Naum Gabo already belonged to the past. Jacob Epstein's *The Rock Drill* had been completed several years before, and Marcel Duchamp was about to give up the new art altogether. Despite his being denounced by his college professor for 'feeding on garbage', what is significant about Moore from his earliest days is his deep understanding of the expressive powers of sculpture made in previous ages and from different cultures. Though Moore felt that art must move from a period of decadence in England to a new future, he could not ignore what was to be discovered from the art of the past. This drawing sums up for me all these different ideas that were taking shape in Moore's mind, and shows his determination to make progress without revolution.

John Read

9

Reclining Nude and Five Studies of an Arm 1922
HMF 81
pencil, crayon, watercolour on cream heavyweight wove
443 × 368mm
signature: pencil l.r. *MOORE/22*

verso
Four Studies of a Seated Figure 1922
[not illustrated]
pencil, brush and ink, watercolour
unsigned, undated
Gift of the artist 1977

exhibitions: Toronto/Iwaki-Shi/Kanazawa/ Kumamoto/Tokyo/London 1977-78 (cat.6); Bonn/Ludwigshafen 1979-80 (cat.72); Salzburg 1981 (cat.8); Columbus/Austin/ Salt Lake City/Portland/San Francisco 1984-85 (cat.80); London 1988 (cat.45); Sydney 1992 (cat.2); Krakow/Warsaw 1995 (cat.2) Venice 1995 (cat.2)

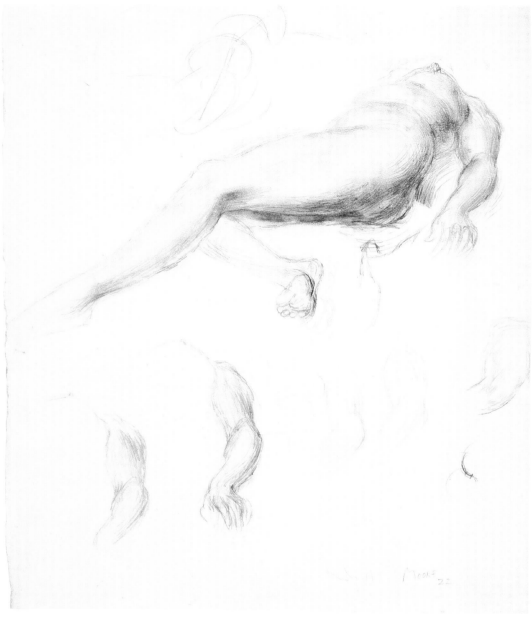

9 recto

publications: *Henry Moore: Complete Drawings*, vol.1 1916-29, AG 22.17

In the 1920s Moore made many carefully considered drawings from real life, predominantly of the female figure. In this work the model reclines in a daringly abandoned pose on floating drapery that vanishes in a few lines towards the lower part of the drawing. The piece has an almost classic solemnity, emphasised by shading used both to define volume and to give plasticity to the form: a sculptor's typical approach to drawing.

At the age of twenty-four Moore had not yet been to Italy, the country that would later reveal the works of Masaccio, Giotto and Giovanni Pisano. He had, however, been able to study the works of classical antiquity and the masters of the Renaissance at the British Museum. By contrast, the first seeds of awareness of modern art were sown during his visit to the Michael Sadler Collection in Leeds in 1920. By the time Moore came across the recumbent figure of an Aztec rain god in the pages of a German magazine (and consolidated this experience by a museum

10

10
Dog 1922
LH 2
marble
height 17.8cm
unsigned
Gift of the artist 1977

exhibitions: Bradford 1978 (cat.43); Mexico
City 1982-83 (cat.51); Caracas 1983
(cat.E118); Hong Kong 1986 (cat.72);
Tokyo/Fukuoka 1986 (cat.109); New Delhi
1987 (cat.1); Martigny 1989 (cat.p.87);
Sydney 1992 (cat.3); Budapest 1993 (cat.3);
Bratislava/Prague 1993 (cat.3); Krakow/
Warsaw 1995 (cat.3); Venice 1995 (cat.3);
London 1996; Nantes 1996 (cat.2);
Mannheim 1996-97 (cat.2); Havana/Bogotá/
Buenos Aires/Montevideo/Santiago de
Chile 1997-98 (cat.1)

publications: Strachan 1983, pl.79

Compared with the **Small Animal Head**
[cat.2] carved a year earlier, **Dog** is at once
easier to identify and crisper in execution.
Working in marble may have encouraged
Moore to cut his material with greater
sharpness, and his increasing technical
assurance is evident. So is his ability to charge
the animal with a compressed force far
removed from the charm of a domestic pet.

A photograph of Moore, taken in the
garden of his sister's Norfolk schoolhouse
in 1922, shows him standing next to **Dog**
and the larger **Mother and Child** 1922
(LH 3) in Portland stone. While the
offspring in the latter carving struggles to
emerge from the maternal body, the dog
seems poised to break out of its hunched
position. Seen from the side, its coiled legs
and shoulders are defined with a compact,
cubist-influenced muscularity. The heaped,
boulder-like forms suggest that Moore is
already seeking to invest limbs with the
grandeur of a rocky landscape.

There is nothing settled about their
compact strength. The animal appears
ready to leap out at a carefully observed
prey, just as a lion cub pounces on a bone
in Moore's contemporaneous notebook
drawing (HMF 129 verso). Alongside a
feeling for monumental stillness, the **Dog**
carving possesses a strain of implicit

visit), he had already discovered the Elgin
Marbles at the British Museum. For Moore,
the marbles were the initial inspiration
from which the archetype of the reclining
figures was born. The theme of the reclining
figure is a recurrent one in the history of
art, and can be found from the Aztecs to the
Greeks, from the Etruscans to the Roman
river deities, right up to the allegories of the
Medici tombs by Michelangelo. Moore was
to use the theme frequently in his art, in
both drawings and sculpture.

A feature of this particular drawing is
the attention to the angle of the figure's left
arm, repeated five more times in an
accurate rendering of outline and shadow,
proving yet again the young artist's attention
to real-life details.

Giovanni Carandente

opposite: cat.11

violence. It gives the image considerable tension, accentuated by the predatory power of the animal's paws. In the hands of another sculptor, the same subject might have amounted to nothing more than a tame celebration of canine cuteness. But Moore, refusing to rely on the animal's intrinsic appeal, transforms this bunched mass of sinew into a potential aggressor.

Richard Cork

11
Head of the Virgin 1922
LH 6
marble
height 53.2cm
unsigned
Acquired 1988

exhibitions: London 1988 (cat.1); Leningrad/Moscow 1991(cat.2); Helsinki 1991 (cat.2); Martigny 1989 (cat.p.89); Sydney 1992 (cat.4); Budapest 1993 (cat.4); Bratislava/Prague 1993 (cat.4); Krakow/ Warsaw 1995 (cat.4); Venice 1995 (cat.4); London 1996; Nantes 1996 (cat.3); Mannheim 1996-97 (cat.3); Havana/Bogotá/ Buenos Aires/Montevideo/Santiago de Chile 1997-98 (cat.2)

For a student exercise set at the Royal College of Art in 1922, which involved making a copy of a Renaissance head, Moore chose a fifteenth-century marble relief of the *Virgin and Child with Three Cherub Heads* by Domenico Rosselli in the Victoria and Albert Museum.[1] At that time Moore was somewhat diffident towards this sort of sculpture, remarking in a letter written during his first visit to Italy in 1924, ' . . . what I know of Indian, Egyptian and Mexican sculpture completely overshadows Renaissance sculpture – except for the early Italian portrait busts, the very late work of Michelangelo and the work of Donatello'.[2] He had already been profoundly moved by the 'intensity' of Michelangelo's conception of sculpture, his handling of 'monolithic masses' in which 'Outward forms were superfluous', and even noted that 'his Madonna has no halo'.[3]

The College exercise resulted in this

convincing replica of the Rosselli, which accurately recaptures the sensitive facial features and the delicate strands of hair lying under the Virgin's veil. However, the roughly cut edges of the block are a blatant expression of the fact that the stone had been carved direct, at that time an unconventional, Modernist technique advocated by a few rebellious sculptors. The Professor of Sculpture at the Royal College had insisted his students make the copy through a series of meticulously executed stages starting with a preliminary plaster model marked at regular measurable intervals and then laboriously transferred to the finished marble employing a mechanical pointing machine. Moore refused to do this, but audaciously peppered the finished head with tiny holes in imitation of the marks left by the pointing process.

Few early works are more demonstrative of his utter rejection of English academic methods of sculpture making. In the letter quoted above, which was written to William Rothenstein, the College Principal in 1924, Moore suggested that in 'the influence of Donatello I think I see the beginning of the end – Donatello was a modeller, and it seems that it is modelling that has sapped the manhood out of Western sculpture', adding prophetically: 'The only hope I can see for a school of sculpture in England . . . is a good artist working carving in the big tradition of sculpture'.

Terry Friedman

1. Leeds 1982, pp.13-37.
2. James (ed.) 1966, p.57; 1992, p.39.
3. Henry Moore, 'History of Sculpture Notes', 1920, pp.45v, 47v (Leeds City Art Gallery archives).

While it is often true that the best, most interesting works date from the very early years of an artist's working life, it always comes as a surprise to find works of such perception and inventiveness, and also that authority, which we see in Moore's copy of part of the *Virgin and Child with Three Cherub Heads* by Domenico Rosselli. It was a requirement for students in the sculpture school at the Royal College of Art that at some time during their two-year course they should make a copy from one of the

works in the Victoria and Albert Museum. I believe they began by modelling a copy in clay and then producing another carved in stone, enlarged by measurements through a process known as 'pointing' – a process Moore used all his life for enlarging maquettes and working models.

Head of the Virgin is one of Moore's first surviving works, and for the period one of the most remarkable, showing a strong portent in terms of the authority his work would display. His perception and understanding of sculpture other than his own was outstanding from his earliest years, and this copy, which adheres very closely to the original, is compelling evidence of a precision and awareness far in advance of most artists in their early twenties. Copies by young artists often display more about the limitations of the copier than an understanding of the original, but here we have a feeling that the part of the original Moore has chosen to copy has become his own – he uses that part and composes it as a separate composition in its own right, composing it in relationship to the shape of the original block of stone.

At the time of making this copy Moore was only a few years out of the army. He had served on the Western Front and been gassed during one of the German attacks, after which he was invalided out of active service and made a bayonet instructor,

11

teaching recruits how to kill others by the most brutal methods. It seems extraordinary that he was able to appreciate and record with a high degree of sensitivity and control a range of characteristics which would so recently have been completely alien to him.

Some time after **Head of the Virgin** was completed Moore gave it as a wedding present to his great friends, Raymond Coxon and Edna Ginesi, who owned it from then until 1988 when it was acquired for the Foundation's Collection. As the Coxons kept it in their house, it remained relatively unknown outside the circle of their friends, and was rarely lent for inclusion among the works selected for exhibitions of Moore's sculptures.

Bernard Meadows

12
Head of a Girl 1923
LH 15
clay
height 17.5cm
unsigned
Gift of the artist 1977

exhibitions: Bradford 1978 (cat.48); London 1981-82; Durham 1982 (cat.2); Mexico City 1982-83 (cat.79); Caracas 1983 (cat.E20); Hong Kong 1986 (cat.25); Tokyo/Fukuoka 1986 (cat.130); Martigny 1989 (cat.pp.90,91); Leningrad/Moscow 1991 (cat.3); Helsinki 1991 (cat.3); Sydney 1992 (cat.8); Budapest 1993 (cat.5); Bratislava/Prague 1993 (cat.5); Kracow/Warsaw 1995 (cat.6); Venice 1995 (cat.6); London 1996; Nantes 1996 (cat.4); Mannheim 1996-97 (cat.4)

12

This is an un-Moore-like Moore. The piece reminds one of an amalgam of influences, ancient and modern. The dominant ones appear to be contemporary German and ancient Egyptian. The delicacy of the modelling resembles New Empire Egyptian portraits, with particularly similar treatment of the lips. (An example, from the Berlin Museum, may be found in Elie Faure's *Ancient Art*,[1] a book which Moore might well have seen.) But the veiled, grieving nature of the inclined head brings to mind Wilhelm Lehmbruck, or Georg

Kolbe, or even Ernst Barlach's carvings in wood. It is clear from his **Notebook No.2** that Moore was not only culling his sources – he actually named Underwood, Gauguin and apparently Schiele – but was attracted to a more muscular way of working. This sculpture suggests to me that Moore was still entertaining the possibility of making his way forward by modelling, and that he made this head after a number of much rougher carvings. To find a way of modelling that was not utterly *retardataire*,

Moore has here rather successfully mixed a sensitive naturalism with stylisation. The unseeing – even blind – aspect of the head is unusual for Moore, and brings additionally to mind carved African masks.

Penelope Curtis

1. Elie Faure, *History of Art: Vol.I: Ancient Art*, John Lane, The Bodley Head, London; Harper & Brothers, New York 1921, p.54.

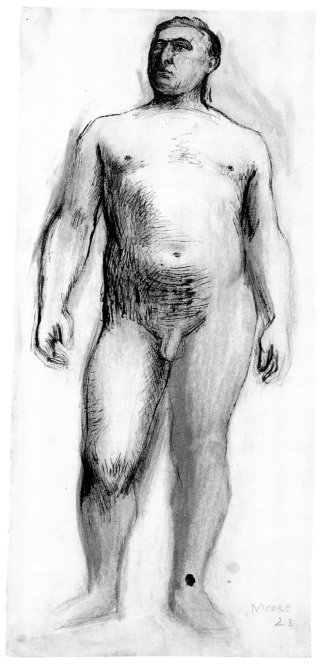

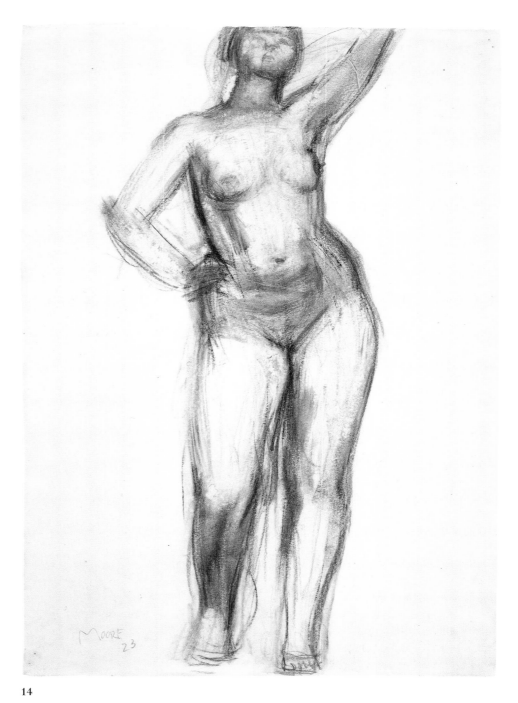

13

14

13

Standing Male Nude 1923
HMF 170
pencil, chalk, pen and ink, wash on cream
medium-weight wove
502 × 228mm
signature: pencil l.r. *MOORE/23*
Gift of the artist 1977

publications: *Henry Moore: Complete
Drawings*, vol.1 1916-29, AG 23.7

Moore executed this life study while he was
a student at the Royal College of Art. It is a
drawing of great authority and maturity for
such a young artist. As a sculptor Moore's
interest in life studies lay mainly in the
articulation of volume and the relationship
of parts. The male figure is an unusual
subject in his oeuvre, re-emerging most
notably with the Warriors of the 1950s.
The sense of detachment evoked by
viewing this drawing derives from the low
viewpoint and perhaps from the artist's

lesser feelings for the male form.

At this stage of his development Moore
was concerned almost exclusively with the
'primitive' sculpture he found in the British
Museum, to the disapproval of his tutors at
the Royal College. After a period when he
considered leaving the college, Moore
realised that both the academic discipline
and a diploma would be invaluable to his
career. He therefore decided to set aside his
own interests during term-time, and to
concentrate on obtaining the diploma by

complying with his tutors' wishes. However, he has attacked the pose – the ubiquitous *contrapposto* of antique statuary – with strong pen strokes, giving the figure presence and vitality. The emphasis on volume and the indication of fragmentation (possibly taken from Rodin) that leaves the legs merely sketched in, indicate interests at odds with the languid classicism of the post-Victorian art schools.

Clare Hillman

14
Standing Woman 1923
HMF 180
pencil, crayon, charcoal (rubbed), wash on cream light to medium-weight wove
483 × 335mm
signature: pencil l.l. *MOORE/23*
Gift of the artist 1977

exhibitions: Bradford 1978 (cat.132); London 1988 (cat.46); Paris 1989; Sydney 1992 (cat.5); Budapest 1993 (cat.6); Bratislava/Prague 1993 (cat.6); Krakow/Warsaw 1995 (cat.5); Venice (cat.5) 1995

publications: *Henry Moore: Complete Drawings*, vol.1 1916-29, AG 23.17

This drawing is of remarkable importance for what it tells us of schoolboy ambitions to be a sculptor. Moore had been something of a late starter because of the war. Here we have him already twenty-five but still a student at the Royal College of Art, with a year or so still to do. Yet already we see him beginning to come to himself as an artist, teasing out of himself works of authentic and creative authority. Works of this period show us just how fast he was developing. This is no student exercise or technical demonstration, but a mature work of art, even though the forms and rhythms through the drawing are as yet a little clumsy and less fluent in the execution than they would so soon become.

The fact that he is still a student is important, for clearly he is looking closely and unselfconsciously beyond any purely personal vision, such as it is, to other sources of reference and inspiration. He

may have later become more jealous of his personal originality – a vanity by no means uncommon among artists – but here the debt, not only to the African and Oceanic carvings he knew from the British Museum, but to the engagement in the work of other artists with the same sources, that had been current since before the war, is open and obvious. We think particularly of Epstein, Dobson and Gaudier-Brzeska. Clearly the young Henry Moore did not appear out of a clear blue sky.

Yet this drawing could only be by Henry Moore. Indeed it is one of the earliest statements of an image to which he would constantly return throughout his long creative life. Here is the female figure, his central theme, but here too, if only in anticipation, are the abstracted columns of the 1930s, pierced and wired, the piled, sliced, interlocking forms of the 1950s and 1960s. There could be no more succinct a prologue to the work of an entire career.

William Packer

15-18
Notebook No.3 1922-24
HMF 86-163
Black moiré paper-covered boards quarter-bound in black leather 225 × 173mm; the book originally contained 120 pages of cream lightweight laid paper 224 × 172mm in uneven signatures, two of fourteen, seven of twelve and one of eight with endpapers bound in between the first and second and the ninth and tenth signatures. The back board is blind-stamped upper left upside down LAMLEY CO./PUBLISHERS./SOUTH KENSINGTON. The pages were numbered in pencil by the artist upper right on the recto and upper left on the verso with one fragmentary page unnumbered between pages 47 and 49; many pages are missing, some are fragments and others have become detached. The notebook has always been dated 1922-24 although pp.179-193 HMF 146-153 were drawn in 1925 while Moore was in Italy.
Gift of the artist 1977

exhibitions: Toronto/Iwaki-Shi/Kanazawa/Kumamoto/Tokyo/London 1977-78 (cat.63);

New York/Detroit/Dallas 1984-85

publications: Wilkinson 1984, pp.79-144; *Henry Moore: Complete Drawings*, vol.1 1916-29, AG 22-24.1-79

'The Primitive Art Notebook' includes an extraordinary visual record of Moore's discovery of tribal sculpture in the early 1920s. In **Notebook No.2**, the only evidence of his awareness of 'primitive' art are the two sketches at the bottom of page 93 [cat.6], which were undoubtedly inspired by a pre-Columbian *Chacmool* reclining figure. We know from a letter Moore wrote to a friend on 29 October 1921 that within a month of his arrival in London he had discovered the ethnographical galleries at the British Museum, but based on the copies in **Notebook No.3**, he did not begin recording what he had seen and particularly admired until 1922.

This is for me the most varied and fascinating of early sketchbooks, not only as an invaluable record of the sources and of the impact of 'primitive' art on Moore's imagination, but also as a record of the creative process itself, of the way in which he assimilated and transformed the art of the past. For example, on page 3 (HMF 88) is a study of a squatting male figure which Moore told me was inspired by an Egyptian sculpture he had seen in the British Museum. On page 10 (HMF 90 verso) and again on page 88 (HMF 114) he combines this figure with a seated female nude based on Rubens' *Venus Frigida* to form a composition he entitled 'Adam and Eve'. Both sources represent heavy-set, compact figures ideal for carving in stone. Even more revealing is the way in which Moore transformed the objects he drew, as he was later to transform natural forms into figurative shapes. On page 89 (HMF 116) which includes a sketch of a Peruvian bird, the inscription reads: 'Abstract composition – developed from /naturalistic(?) animal or human – /form'. On page 106 [cat.16 verso] Moore has written 'abstraction' on this sheet of studies in which he is *abstracting from* (not making abstract drawings of) the thin, elongated *Stone Pestle* from Papua New Guinea, in the British Museum.

As there are many pages missing from

Notebook No.3 it is impossible to know the full range of the subjects explored. Moore's admiration for the work of Rubens, which was first in evidence in Notebook No.2, resurfaced near the beginning of this sketchbook. On page 10 (HMF 90 verso) are two sketches after Rubens' *Venus Frigida*; and the figure study on page 41 (HMF 100 verso) is remarkably similar to the partially draped nude in Rubens' *Pan and Syrinx*. The studies of hands on page 25 (HMF 95) were, Moore told me, probably influenced

by Rodin. A number of pages include figure compositions which, like those on page 81 of Notebook No.2 [cat.9], ultimately derive from Cézanne's *Les Grandes Baigneuses* in the Pellerin Collection, Paris. Of particular interest are two sheets (pages 74 and 137, HMF 113 verso and 134 recto) which document the earliest evidence of Moore's awareness of the work of Picasso. Of the standing female nude inscribed 'Picasso' in HMF 134 recto, Moore told me: 'I had seen the big, fat Picasso figures', a reference to

the massive, heavy-limbed figures of the early 1920s.

The dozens of copies of tribal art found between pages 89 and 221 (the inside back cover) of Notebook No.3 represent what is probably the most comprehensive and concentrated record in the history of 'Primitivism' in twentieth-century art of an artist's awareness of and interest in known sculptures and artefacts. Most of the copies derive from the British Museum, and from illustrations in the following books: Carl Einstein's *Negerplastik* (1920); and Ernst Fuhrmann's *Reich der Inka* and *Afrika*, both published in 1922.[1] That almost all the copies are of African, Oceanic, Eskimo, North American and Peruvian sculptures and artefacts is somewhat surprising, given Moore's statement that 'it was the art of ancient Mexico that spoke to me most'.[2]

Although this notebook was dated in Moore's hand '1922-24' on the inside front cover, the series of drawings on pages 183-193 were almost certainly executed in Italy in 1925, based on Italian art Moore was studying at the time.

Alan Wilkinson

1. For a detailed discussion of copies by Moore of works of art from all sources, see Toronto/Iwaki-Shi/Kanazawa/Kumamoto/Tokyo/London 1977-78, pp.19-20, 67-72, 147-50.
2. James (ed.) 1966, p.33; 1992, p.35.

15 recto

15
Study of Standing Figure 1922-24
Page 103 from Notebook No.3
HMF 122
pencil, chalk
unsigned, undated
inscription: pencil top of page *Stomach/Beak/of bird/legs*; u.l. *Woman*; u.c. *birds head*; u.r. *mother/& child*; u.c.l. *for piece of slate/birds head –*; *wider border*; c. *fledgling*; *head/larger*; l.c.l. *Wooden/or plaster form/covered with/linen or elastic/cloth & tarred/or painted. –*; l.r. *abstraction/for/mass/composition*; l.c.r. *go back/form/Cone*

verso
Studies of Seated Man 1922-24
[not illustrated]
pencil
unsigned, undated
inscription: pencil u.r. *Seated figure of man*;
u.c. *Try abstraction/from this*; u.r. *See page
117*; *head*; *for/head/or power*; l.c.r. *body
of/man*

publications: *Henry Moore: Complete
Drawings*, vol.1 1916-29, AG 22-24.38

The discovery of primitive art and the
expansion of his frame of reference beyond
the European tradition was one of the great
opportunities to occur once Moore came to
London to begin the diploma course at the
Royal College of Art in September 1921.
This was mediated by the influence of
Roger Fry's *Vision and Design* of 1920 that
Moore read early in the following year,
including essays on 'The Art of the
Bushman', 'Negro Sculpture' and 'Ancient
American Art', by the varied ethnographical
literature on African and pre-Columbian art
that he devoured through the libraries and
bookshops to hand in the capital, and by the
collections in the British Museum. Here, by
the end of 1921, he was already acquainted
with the Egyptian and Assyrian sculptures,
'the ecstatically fine Negro sculptures'[1] in
the Ethnographical Gallery and 'the
Japanese things' in the Print Room. The
example of Henri Gaudier-Brzeska, Leon
Underwood, Moore's drawing tutor in the
early 1920s, and above all, Jacob Epstein,
who had begun to amass a formidable
collection of his own, were before him in
his exploration of primitive and archaic
sculpture in a quest for an alternative
aesthetic to the classical ideal.

The vast array of disparate cultures
cohabiting in promiscuous profusion within
the Ethnographical Gallery at the British
Museum are reflected in the mixture of
references in this drawing. A small carving
of a woman and child from the Nootka
Indians of Vancouver Island upper right
was to have echoes in many of Moore's
later studies for sculpture; the two images
below the inscription 'fledgling' in the
centre of the page are thought to emanate
from a spear thrower of the Tlingit in

Alaska; at bottom centre in profile is a male
figure from the top of a column made in
German New Guinea, which reappears in a
contemporary drawing (HMF 121 verso)
and on the fly leaf of **Notebook No. 6** 1926
(HMF 427 verso); while to the right of this is
the standing figure of a man from Jukun,
southern Nigeria. (The identification of the
items from the British Museum's collection
in this sketchbook was made by Alan
Wilkinson together with the then Keeper of
Ethnography, William Fagg.)

Frances Carey

1. Packer 1985, p.54.

16
Studies of Sculpture in the British Museum 1922-24
Page 105 from Notebook No.3
HMF 123
pencil
unsigned, undated
inscription: pencil u.r. *Twisted/form*; crayon
Negro –/sculpture; pencil u.c. *bad drawings*;
twist/in/arms; *curved/arm*; c. *badly/drawn*;
c.r. *more pointed*; *from front*; l.c.l. *light*;
angles; l.r. s*mall abstract carving*; *masses/
redesigned*

verso
Studies of Sculpture in the British Museum 1922-24
pencil
unsigned, undated
inscription: pencil u.c. *abstraction*;
directions/& poising of weights; c. *Too thin*
publications: *Henry Moore: Complete
Drawings*, vol.1 1916-29, AG 22-24.39

The principal subject of the recto is a
Mumuye standing figure of a woman from
northern Nigeria which caught Moore's
attention again in 1951 when it was shown
in the exhibition of tribal art that formed
part of the Festival of Britain. To the right of
the page are a profile and frontal view of a
club of the bird-headed type from New
Caledonia, accompanied by the inscription
'small abstract carving'; lower left is a
sketch of what may be a wood carving of a
human head from the Baga of French New

Guinea; to the right is a carving possibly
from the Solomon Islands.

The constant thread running through
these sketches, and the artist's annotations,
is his desire to come up with sculptural
solutions through drawing, to bring forth
from the flat page an expression of solid
form which he described as one of the
achievements of Leon Underwood's
approach to drawing. Underwood's own
involvement with primitive art, which he
was already collecting in the early 1920s in
the form of African carving, led to an
exhibition in 1932 to demonstrate the
affinities across time and space between
work from Polynesia, Africa, Mexico, India
and China with that of the modern
sculptors he admired: Gaudier-Brzeska,
Modigliani, Hepworth and Moore.

Frances Carey

In his article 'Primitive Art', published in
The Listener on 24 August 1941, Moore
described his frequent visits to the British
Museum in the early 1920s: 'At first my
visits were mainly and naturally to the
Egyptian galleries, for the monumental
impressiveness of Egyptian sculpture was
nearest to the familiar Greek and
Renaissance ideals one has been born to.'
Indeed, the earliest identified copy of a
sculpture in the British Museum is a sketch
of an Egyptian wooden standard in the
shape of the wolf-god Ophoris, which
appears on page 85 of **Notebook No.2**
(HMF 63 verso).[2] Having then worked his
way through the collections of Assyrian,
Archaic Greek, Etruscan, Sumerian and
prehistoric sculpture, Moore discovered the
collection of tribal art: 'And eventually to
the Ethnographical room, which contained
an inexhaustible wealth and variety of
sculptural achievement (Negro, Oceanic
Islands, and North and South America), but
overcrowded and jumbled together like
junk in a marine store, so that after
hundreds of visits I would still find carvings
not discovered there before.'[3]

The concentration of copies of tribal
sculpture and artefacts in the British
Museum that appears between pages 90
and 107 of **Notebook No.3** represents the

16 recto

16 verso

earliest surviving evidence that Moore sketched *in situ* in the Ethnographical Gallery. From a letter, we know that he had in fact seen 'the ecstatically fine negro sculpture'[4] on his second visit to the British Museum on 29 October 1921, but he does not appear to have recorded his enthusiastic response to tribal art until 1922.

The studies on HMF 123 verso are based on the thin, tubular *Stone Pestle* in the form of a bird, from Papua New Guinea, in the British Museum. On the following page (HMF 124 recto) there are two straightforward sketches of the pestle, as well as a less elongated, more compact depiction of the bird-like form similar to the one at lower centre here. In the larger studies on this page, Moore has used the New Guinea carving as a point of departure to create, as the inscription indicates, an 'abstraction' from the original. Whereas the drawings of tribal art on pages 103 and 105

in this notebook [cats.15 and 16] were little more than an attempt to make fairly hasty but faithful copies, the sketches here have an extraordinary significance as the earliest example of Moore's transforming an object with the intention of creating a sculptural form of his own. As such, this page anticipates the first transformation drawings of natural forms of the early 1930s, as well as the way in which Moore, from the mid-1950s, began to work directly with flint stones, shells and bones, and by adding bits of clay or plaster to them, to transform inanimate objects into human or animal forms.

Alan Wilkinson

1. James (ed.) 1966, p.157; 1992, p.159.
2. See Toronto/Iwaki-Shi/Kanazawa/Kumamoto/Tokyo/London 1977-78, figs.108, 109, p.145.
3. James (ed.) 1966, p.157; 1992, p.159.
4. Packer 1985, p.54.

17
Figure Study 1922-24 [not illustrated]
Page 119 from Notebook No.3
HMF 127
pencil
unsigned, undated
inscription: pencil top of page *The bather?*; u.l. *put head – arms & legs in 97 –*; *figure of man in pain –*; u.c.l. *mother & child –/ wrestling pair./seated figure –8 & 10 & 117.*; c.l. *wounded man./reclining man./crawling man.*; l.c.l. *And abstractions – 106 – .107. – 104. – 100 – 99 – 88 – 102 & 113. –*

verso
Studies of Heads 1922-24
pencil, pen and ink
unsigned, undated
inscription: pencil u.r. *Composition in spheres* [crossed through]; *head/of child*

publications: *Henry Moore: Complete Drawings*, vol.1 1916-29, AG 22-24.43

If in the early 1920s the British Museum was the major source of Moore's first-hand knowledge of tribal sculpture, it was supplemented by several important books on African, Mexican and Incan art. From the outset of his career, and indeed throughout his life, books on the history of art were a constant source of pleasure and inspiration. He has described the excitement and sense of discovery during his first year in London when, in the evenings, 'I could spread out the books I'd got out of the library and know that I had the chance of learning about all the sculptures that had ever been made in the world.'[1]

In **Notebook No.3**, interspersed with the copies of tribal sculpture done *in situ* at the British Museum, are a number of

drawings based on illustrations in Carl Einstein's *Negerplastik* (1920) and Ernst Fuhrmann's *Reich der Inka* and *Afrika* (both 1922). On the verso here the small, crisp sketch of the single head, copied from the Congo (?) carving reproduced on plate 15 in *Negerplastik*, is no more than a straightforward record of a sculpture which had caught Moore's attention. The largest of the two studies of heads is, on the other hand, like the studies on cat.16 verso of the *Stone Pestle* from Papua New Guinea, a 'transformation drawing' based on the two heads on the neck of a pot from Trujillo (reproduced on plate 15 in *Reich der Inka*). By simplifying and isolating the two heads from the neck of the pot, Moore has gone far beyond a literal representation of his source and created an independent study for a mother and child sculpture.

By 1923-24, Moore's obsession with the mother and child theme had clearly taken

hold. On page 141 of this notebook (HMF 136 recto) is one of the exploratory drawings, and on page 155 (HMF 139) the definitive study for the Hornton stone **Mother and Child** 1924-25 (LH 26) in the Manchester City Art Galleries.[2] The way in which Moore perceived the two heads on the Inca pot as representing the mother and child relationship reinforces a comment he made many years later: 'I was conditioned, as it were, to see it in everything.'[3]

Alan Wilkinson

1. James (ed.) 1966, p.33; 1992, p.35.
2. Page 155 was removed from the notebook, which is now in the Art Gallery of Ontario, Toronto, gift of Henry Moore 1974.
3. Hedgecoe (ed.) 1968, p.61.

17 verso

18 recto

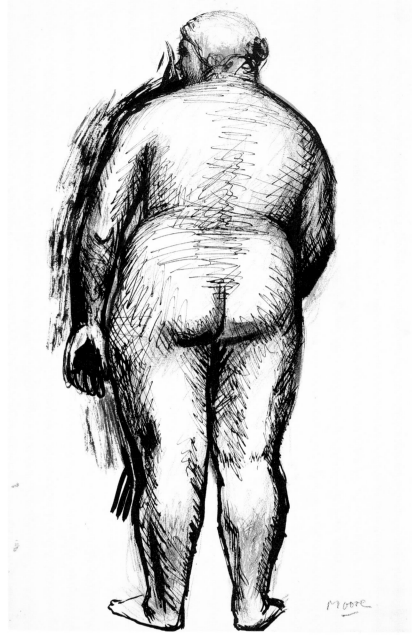

19

20 recto

18
Studies of African Sculptures 1922-24
Page 143 from Notebook No.3
HMF 137
pencil
unsigned, undated
inscription: pencil top of page *Do figure
with legs apart where joins body*;
c.r. *in black/material*

verso
Figure Studies 1922-24 [not illustrated]
pencil
unsigned, undated

publications: *Henry Moore: Complete
Drawings*, vol.1 1916-29, AG 22-24.53

19
Standing Girl 1924
HMF 214
pen and ink, crayon, wash on cream
medium-weight wove
509 × 195mm
signature: pencil l.r. *Moore/24*
Gift of the artist 1977

exhibitions: Toronto/Iwaki-Shi/Kanazawa/
Kumamoto/Tokyo/London 1977-78 (cat.13);
Martigny 1989 (cat.p.92); Sydney 1992
(cat.6); Budapest 1993 (cat.8); Bratislava/

Prague 1993 (cat.8); Havana/Bogotá/
Buenos Aires/Montevideo/Santiago de
Chile 1997-98 (cat.4)

publications: *Henry Moore: Complete
Drawings*, vol.1 1916-29, AG 24.2

20
Standing Figure: Back View *c.*1924
HMF 228
pen and ink, brush and ink, chalk, wash on
off-white medium-weight wove
451 × 279mm
signature: crayon l.r. *Moore*

verso
Figure Studies *c.*1924 [not illustrated]
pencil
unsigned, undated
Gift of the artist 1977

exhibitions: Toronto/Iwaki-Shi/Kanazawa/
Kumamoto/Tokyo/London 1977-78 (cat.16);
Madrid 1981 (cat.D18); Lisbon 1981
(cat.D18); Barcelona 1981-82 (cat.D15);
Mexico City 1982-83 (cat.D1); Caracas 1983
(cat.D1); Hong Kong 1986 (cat.D4); Tokyo/
Fukuoka 1986 (cat.d4); London 1988
(cat.48); Paris 1989

publications: *Henry Moore: Complete
Drawings*, vol.1 1916-29, AG 24.18

In this quick sketch, Moore has employed a
fabric of lines, not so much defining three-
dimensional form by their shape as building
up a pattern of light and shade, thus
suggesting modelling. In this way, the
figure is thrust towards the viewer, its
whiteness contrasted with the dark
silhouette that surrounds it and the cross
formed by the shadow between the legs and
buttocks. Life drawing for Moore was both
an exercise in observation and an
opportunity to experiment with style and
technique. **Woman Seated on a Stool**
[cat.35], for instance, is the opposite of this
drawing in terms of style, reliant on broken
line, and with the modelling suggested by a
light wash. Such drawings should be seen
less as finished pieces than as rapid
exercises in technique and pose.
 The concentration in **Standing Figure:**

Back View is on the bulk of the figure, seen
from a low viewpoint which gives it great
apparent weight. Moore told Alan Wilkinson
that in broadening the figure, making it
'more sturdy and weighty', he was expressing
his attitude towards working figures in
stone.[1] This preference for weighty females
may have been in part a quirk of Moore's
character but, much more importantly, it
was required by the 'truth to materials'
ideal, which demanded resistant working
materials to assert their presence as bulk,
as sheer matter, in the final sculpture.
 When looking at many of the life
drawings there is a tendency for the viewer
to be pulled in two directions; these are
firstly *life* drawings, and are about the
observation and recording of a particular
body, but they are also the drawings of a
sculptor attached to truth to materials and
the monumental stone forms of 'primitive',
particularly Mayan, work. The result is
frequently figures which raise limbs of
great weight, and turn their small heads to
one side, occupying a position somewhere
between flesh or stone. In these works,
academic observation and a liberal
enthusiasm for the primitive collide.

Julian Stallabrass

1. Wilkinson 1984, p.15.

21
Seven Studies of a Female Nude
*c.*1924
HMF 240
pencil, chalk, wash on cream medium-
weight wove watermarked [M]*ONTGOLFIER
FRANCE*
316 × 481mm
unsigned, undated

verso
Two Standing Figures *c.*1924
[not illustrated]
pencil, crayon,
unsigned, undated
Gift of the artist 1977

exhibitions: Hong Kong 1986 (cat.D5);
Tokyo/Fukuoka 1986 (cat.d5); Martigny
1989 (cat.p.93); Sydney 1992 (cat.7);
Budapest 1993 (cat.10); Bratislava/Prague
1993 (cat.10)

publications: *Henry Moore: Complete
Drawings*, vol.1 1916-29, AG 24.30

Before Moore's repertoire extended to
include 'primitive' art – knowledge of which
was strengthened by his reading Roger
Fry's essay *Vision and Design* (1920)[1] – the
most obvious influences on him were
Cézanne's *Baigneuses* and the

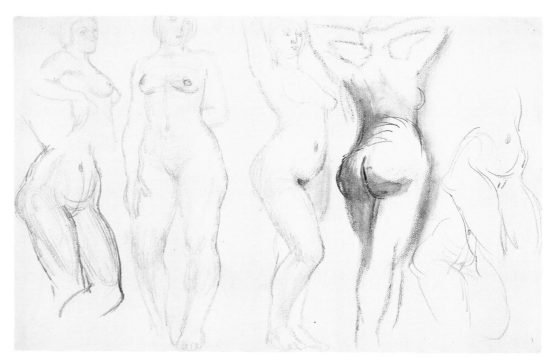

21 recto

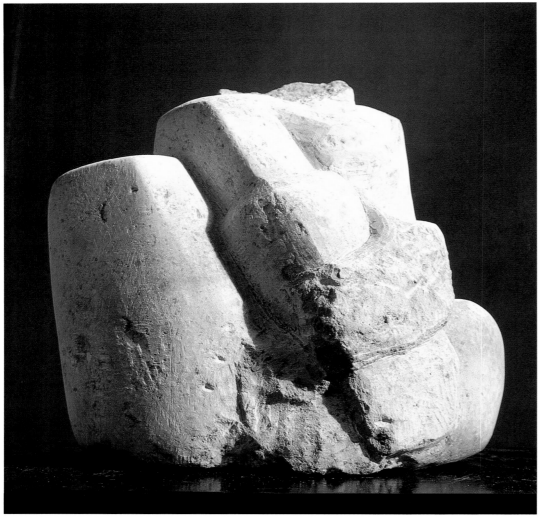

22

22
Seated Figure 1924
LH 19
Hopton Wood stone
height 25.4cm
unsigned
Gift of the artist 1977

exhibitions: Bradford 1978 (cat.60); Madrid
1981 (cat.14); Lisbon 1981 (cat.17); New
York 1983 (p.20); 1986 (cat.130); Leningrad/
Moscow 1991 (cat.6); Helsinki 1991(cat.6);
Kracow/Warsaw 1995 (cat.9); Venice 1995
(cat.9); Nantes 1996 (cat.6); Mannheim
1996-97 (cat.6)

23
Woman with Upraised Arms 1924-25
LH 23
Hopton Wood stone
height 43.2cm
unsigned
Gift of the artist 1977

exhibitions: Bradford 1978 (cat.16); Madrid
1981 (cat.15); Lisbon 1981 (cat.18);
Barcelona 1981-82 (cat.14); Leeds 1982-83
(cat.16); New York 1983 (p.19); Hong Kong
1986 (cat.1); Tokyo/Fukuoka 1986 (cat.155);
London/Stuttgart 1987 (cat.193); New Delhi
1987 (cat.2); Leningrad/Moscow 1991
(cat.8); Helsinki 1991 (cat.8); Sydney 1992
(cat.9); Budapest 1993 (cat.13); Bratislava/
Prague 1993 (cat.13); Krakow/Warsaw 1995
(cat.10); Venice 1995 (cat.10); London 1996;
Nantes 1996 (cat.8); Mannheim 1996-97
(cat.8)

contemporary works of Picasso, centred
around *Retour à l'ordre*.[2] Although this was
a short-lived phase, it released Moore from
a tendency towards Art Nouveau which had
begun during his early studies, first in
Leeds and then in London at the Royal
College of Art. It also freed him from a self-
confessed 'too much Beardsley' style.

With these full-length studies of a
standing female figure, seen in profile, front
and back, it is possible to picture the model
in the studio, varying her pose with a
succession of turning movements in front of
the artist. In his youth Moore alternated
between life drawing and numerous
sketches in notebooks which included
studies both from Cézanne and Picasso and
from the Old Masters – Giotto, Mantegna,
Masaccio and Rubens – which he made
during his weekly visits to the British

Museum. Interviewed by John and Véra
Russell for the *Sunday Times* in 1961,
Moore explained, 'I went to the British
Museum on Wednesday and Sunday
afternoons and saw what I wanted to see.'[3]

Giovanni Carandente

1. 'Actually Roger Fry's *Vision and Design* was the most
lucky discovery for me,' Moore confessed to James
Johnson Sweeney in 1947. 'I came on it by chance while
looking for another book in the Leeds Reference
Library. Fry in his essay on Negro sculpture stressed the
"three-dimensional realisation" that characterised
African art and its "truth to material".' James (ed.) 1966,
p.49; 1992, p.51.
2. Mitchinson 1971, p.24.
3. James (ed.) 1966, p.33; 1992, p.35.

We do not associate Moore with strong
emotional expression by representational
means. His primary aim was to
communicate feelings through the forms,
masses and spaces of his sculptures, not, so
to speak, to have his images perform
emotions for us. **Woman with Upraised
Arms** is a rare exception. Were it a
German piece we might well label it
Expressionist. The figure's solid, ungraceful
anatomy is characteristic of Moore's early
independent carvings, but the strained pose
and distorted face are not.

To carve stone so as to show its
character in the finished form was, of

course, to demonstrate a distance both from what polite taste looked for in sculpture and from what the Royal College of Art taught. The emphasis there was on modelling, though Moore's interest in carving was noted; a good result was one in which a head or figure resembled the model while making it aesthetically pleasing. Moore recognised other priorities in the ancient and primitive art he was studying in the British Museum; in 1924 he spent some months in Italy and was surprised to find that some early and pre-Renaissance art, and the sculpture of Michelangelo, eschewed elegance in favour of emphatic forms and expression. It is possible that the expression of anguish on the face of this carving starts from memories of Masaccio's Eve in the *Expulsion from Paradise* fresco.

Moore was also aware of anti-academic tendencies in English art. Gaudier-Brzeska's feeling for mountainous and faceted masses finds echoes in Moore's carvings of the 1920s. Epstein's over life-size stone carving *Maternity* (1910) was still in his studio when Moore first visited it in 1921. The example and perhaps advice of Epstein encouraged Moore to explore the British Museum and other collections for alternative sculptural traditions. *Maternity* appears as theme and title in Moore's work in 1924, in a small but assertively archaic-looking sculpture. Mother and child sculptures soon follow, starting with **Mother and Child** 1924-25 (LH 26), massive and much larger (though still only 57cm high) but less dramatically ancient. Though his drawings up to 1922-23 often show slender figures of both sexes, from 1923 on Moore drew his female nudes as full-bodied creatures. Awareness of Picasso's mighty nudes of 1922 and after may have contributed to this; interest in Gauguin's and Rubens' nudes certainly did. In 1922 or 1923 Moore was in Paris looking at Cézanne's large *Bathers* (now in the National Gallery) with its boldly simplified female torsos. Other English artists were also in these years opting for strong rather than elegant figures in their paintings and sculptures, among them Frank Dobson, Ben Nicholson and Leon Underwood. Underwood taught drawing at the Royal College of Art from 1920 until his sudden

cat.23

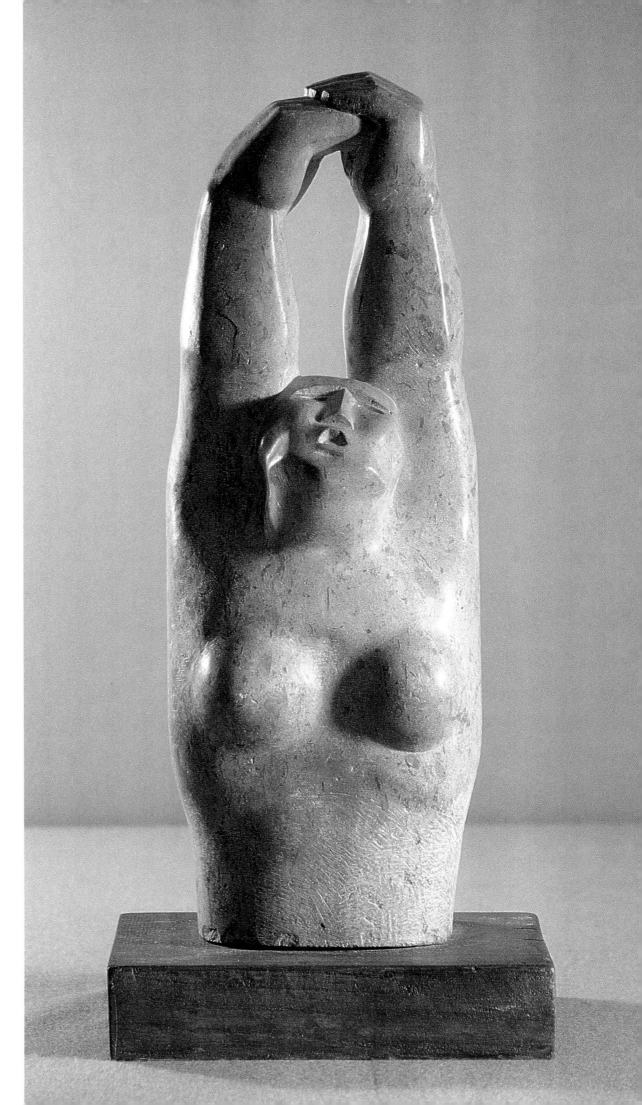

resignation in 1923, when Moore and other students persuaded him to give drawing classes at his studio. Underwood was at this time primarily a painter – a nude full-bodied woman appears among dressed people in his *Venus in Kensington Gardens* (1921; exhibited May 1924) – but by spring 1925 he was engaged on his first large stone carving, the headless three-quarter nude *Torso* in powerfully rounded forms. Moore saw this piece in progress and gave Underwood advice about carving tools.[1]

Moore's **Notebook No.5**, ascribed to 1925-26, contained many drawings of very solid nudes, including a sequence of ten drawings of a standing woman looking upwards with elbows bent so that her hands are close to her neck and cheek (HMF 397-406). A photograph shows Moore apparently at work on an over life-size stone half-figure that relates to these drawings; another shows this half-figure placed on a separate block roughed out so as to suggest the lower half of a squatting figure. Moore appears to have abandoned this sculpture. In the second photograph, evidently a prepared shot of the young sculptor's studio with selected work informally displayed, we glimpse the **Woman with Upraised Arms**, bottom left. The difference of scale between these two works is marked, but so is their similarity in theme and form.[2]

Norbert Lynton

1. See Christopher Neve, *Leon Underwood*, Thames and Hudson, London 1974, pp. 77-8.
2. Both photographs are in Berthoud 1987, plates 24 and 23. Berthoud dates the former to 1928; of the latter he says that it shows 'Moore aged about 29', implying a date of about 1927-28. While all the dating remains tentative, it seems likely that the ten drawings in the notebook of '1925-26' preceded but were close in date to the destroyed carving of '1928'. The studio photograph is reproduced, slightly trimmed and dated 1926-27, in the catalogue of the 1987 Leeds and Whitechapel exhibition *Jacob Epstein, Sculpture and Drawings*, p.43. It also appears in Allemand-Cosneau, Fath, Mitchinson 1996, p.66 where it is dated '*c*. 1927'.

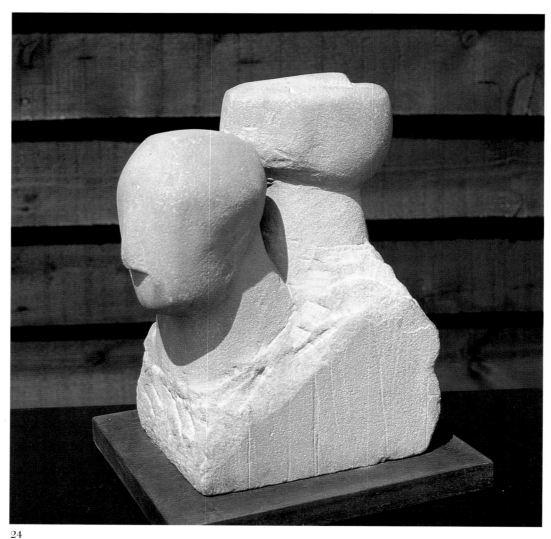

24

24
Two Heads 1924-25
LH 25
Mansfield stone
height 31.7cm
unsigned
Gift of Irina Moore 1977

exhibitions: Madrid 1981 (cat.152); Lisbon 1981 (cat.19); Durham 1982 (cat.4); Leeds 1982-83 (cat.9); Hong Kong 1986 (cat.2); Tokyo/Fukuoka 1986 (cat.156); Sydney 1992 (cat.17); Nantes 1996 (cat.7); Mannheim 1996-97 (cat.7)

Although **Two Heads** may appear unfinished, it was probably taken as far as Moore wished at the time. Like many other twentieth-century sculptors before him, he became fascinated by the notion of letting the material help him to shape the final image. Uncovering the form, and releasing it from the block of stone or wood, was a cardinal aim. In **Two Heads** the process of emergence is forcefully dramatised.

The lump of Mansfield stone serving as a base has been left rough. One side is striated with lines, like fissures in a rock-face. Above them, Moore's chisel-marks are left as raw evidence of his belief in 'carving direct'. The heads themselves seem to grow out of this inchoate matter, and their smooth surfaces contrast with the ruggedness below. All the same, Moore has stopped some way short of refining them into flawlessness. They still display evidence of the act of cutting, and neither possesses anything more than the most simplified of facial features.

The higher of the two heads is thrust upwards, at a still more extreme angle than the backward-tilting head of **Woman with**

Upraised Arms [cat.23] carved during the same period. Her expression is clearly anguished, whereas the heads in this sculpture remain emotionally enigmatic. They are hardly more informative, in physiognomic terms, than the faces crowning Cycladic figures. Moore admired the British Museum's carvings from the Cycladic era, and **Two Heads** shows unmistakable signs of their influence. The piece testifies to Moore's fascination with stripping the human form of anything that might detract from its primordial power.

Richard Cork

25

Recumbent Figure 1925
HMF 336
pen and ink, chalk on off-white
medium-weight wove
384 × 492mm
signature: pencil l.r. *Moore/25*
Gift of the artist 1977

exhibitions: Bradford 1978 (cat.123); London 1982 (cat.1); Mantua 1981(cat.60); Martigny 1989 (cat.p.95); Sydney 1992 (cat.10); Havana/Bogotá/Buenos Aires/Montevideo/ Santiago de Chile 1997-98 (cat.6)
publications: *Henry Moore: Complete Drawings*, vol.1 1916-29, AG 25.74

It is most unusual, in Moore's early drawings, to come across one such as this, distinguished by its thin linear stroke. The simplicity and physical characterisation of the model make it a highly surprising life drawing.

In conversation with Herbert Read in 1944, when Read was compiling the first volume of the Moore catalogue published by Lund Humphries, Moore declared: 'Every few months I stop carving for two or three weeks and do life drawing. At one time I used to mix the two, perhaps carving during the day and drawing from a model during the evening . . . Drawing and carving are so different that a shape or size or conception which ought to be satisfying in a

25

drawing will be totally wrong realised as stone. Nevertheless there is a connection between my drawings and my sculpture.'[1]

Thus it does seem to be the case that Moore on occasion derived the first idea for a sculpture from the study of a model standing in front of him. In this drawing the artist uses a thin uninterrupted line, like Modigliani, adding a light green pastel to the pen and ink. In this way Moore renders the fullness of the feminine form by combining a linear profile with a light contrasting shadow.

Giovanni Carandente

1. *Henry Moore, Sculpture and Drawings 1921-1944*. The fourth edition, revised and enlarged as *Henry Moore: Complete Sculpture* vol.1 1921-48, was edited by David Sylvester in 1957, with Herbert Read's essay republished as an introduction. The above mentioned passage also appears in James (ed.) 1966, p.146; 1992, p.149.

26
Reclining Nude *c.*1925
HMF 339
chalk on cream lightweight wove
269 × 411mm
signature: pencil c.r. *Moore* l.r. *Moore*, undated
Gift of the artist 1977

exhibitions: Bradford 1978 (cat.125); Madrid 1981 (cat.D12); Lisbon 1981 (cat.D12); Columbus/Austin/Salt Lake City/Portland/San Francisco 1984-85 (cat.81); Martigny 1989 (cat.p.96); Leningrad/Moscow 1991 (cat.4); Helsinki 1991 (cat.4); Budapest 1993 (cat.7); Bratislava/Prague 1993 (cat.7); Krakow/Warsaw 1995 (cat.8); Venice 1995 (cat.8); London 1996

publications: *Henry Moore: Complete Drawings*, vol.1 1916-29, AG 25.77

27-29
Notebook No.6 1926
HMF 426-469
Maroon paper-covered boards quarter-bound in red cloth 223 × 173mm; the book probably contained 60 pages of cream lightweight laid paper 223 × 170mm in three signatures of twelve, and one each of six, eight and ten, including the inside covers and endpapers. The front board is blind-stamped lower right LAMLEY & CO./PUBLISHERS,/SOUTH KENSINGTON/No. 9047. The pages were numbered in pencil by the artist upper right on the recto and upper left on the verso starting on the verso of the first page. In 1975 the artist altered the page numbers to run consecutively, ignoring any pages which were missing or had become detached. Page 18 therefore became p.16, p.22 became p.18, p.68 became p.62, p.96 became p.74, and p.108 became p.84.

26

Gift of the artist 1977

exhibitions: Toronto/Iwaki-Shi/Kanazawa/
Kumamoto/Tokyo/London 1977-78 (cat.69)

publications: Wilkinson 1984, pp.204-29;
Henry Moore: Complete Drawings, vol.1
1916-29, AG 26.1-43

I have called this 'The Prehistoric Art
Notebook' because the most powerful
drawings and the most influential in terms
of Moore's vision of the female nude are the
studies on pages 67-69 based on
reproductions in Herbert Kühn's *Die Kunst
der Primitiven* (1923) of the massive
proportions of the *Venus of Grimaldi*
(Musée de Saint Germain, Paris), and of a
bas-relief of a female figure from the
shelter of Laussel in the Dordogne (HMF
460 verso). On the inside front cover and on
the page opposite, Moore continues the
practice established in **Notebooks 2** and **3**
of jotting down subjects for sculpture, and
more importantly of commenting on the
nature of sculpture and on the formal
relationships he was trying to achieve in his
own work.

*Stay on the big design & play of masses until
power of form is achieved/opposition of
swellings & balance (not symetry) [sic]/
remember pebbles on beach*

*[. . .] Developement [sic] of Sculpture from
now not back to Maillol & archaic Greek
and modelling [. . .]/Disposition of masses
with opposition thrust; opposition of
swellings [. . .]/Sculpture [carving] is relative
[i.e. relation?] of masses etc etc/modelling is
undulation of surfaces/Write out thesis of
fact present beliefs./What I am attempting to
express [. . .]/Keep ever prominent the big
view of sculpture/The World Tradition*

Thematically, apart from the drawings of
prehistoric art based on reproductions in
Kühn's book *Die Kunst der Primitiven*, the
subjects of the drawings in **Notebook No.6**
seem somewhat disparate and disjointed.
On the third page (HMF 427 verso) there is
a sketch of the profile view of a carving of a
standing male figure from German New
Guinea, which first appeared at lower

27

centre on page 103 of **Notebook No.3**
[cat.15].[1] There are only two other drawings
of tribal sculpture in this notebook. The
study of a llama on page 26 (HMF 439) is
based on the reproduction in plate 109 of
Walter Lehmann's *The Art of Old Peru*
(1924); the 'Head of Christ' on page 74
[cat.29] derives from the alabaster head of a
man reproduced on page 10 of Ernst
Fuhrmann's *Mexico III* (1922). Moore's love

of the circus is reflected in four pages of
drawings of circus scenes. As in the earlier
notebooks, Moore continued to generate
ideas for sculpture. On page 8 (HMF 430
recto) are three studies for the stone
Standing Woman 1926 (LH 33). The single
sketch on page 82 (HMF 467 verso) near the
end of this notebook is the only surviving
record of a carving of a half-figure. When
looking at the notebook with me, Moore

said of the preparatory study: 'I did a sculpture in Corsham [stone] from this drawing, but it got broken.'

Notebooks Nos. 2 to 6, in the collection of the Henry Moore Foundation, were as close as Moore came to keeping a diary. Just as Virginia Woolf's journals shed a unique light on her development as a novelist, so Moore's early notebooks offer an intimate and detailed account of the sources and influences, from prehistoric fertility goddesses to Picasso, that shaped his vision during his formative years in London.

Alan Wilkinson

1. The source for the copy of the New Guinea carving was a loose page from an as yet unidentified early German publication on tribal art which I found among Moore's books and papers in the early 1970s.

27
Study of a Torso 1926
Page 14 from Notebook No.6
HMF 433
chalk, charcoal (rubbed)
unsigned, undated
inscription: chalk top of page *Sculpture*; *Bursting breasts*; u.c.l. *Torso/Fecundity*

publications: *Henry Moore: Complete Drawings*, vol.1 1916-29, AG 26.8

'Not young girls but that wide, broad, mature woman. Matronly.'[1] Moore's description of the female nudes in the Cézanne oil he owned, *Les Trois Baigneuses* 1873-77, applies equally well to his own work. To say that he had a preference for what he described to me as 'bulky models, sturdy wide figures rather than thin ones', is an understatement. So strong was Moore's need to represent the Rubenesque figure type that if confronted with a thin model in the life classes, he told me: 'I used to fatten them up in the drawings.'

Just as **Notebooks 2 to 6** reveal, like brief, isolated images in a dream, the gradual emergence of Moore's life-long obsession with the reclining figure and the mother and child motifs, so they also document images of women as

representing fertility and fecundity. That **Notebook No.2** includes three studies after Rubens and a sketch based on a Gauguin drawing of a heavily proportioned Tahitian nude needs no explanation. On page 85 (HMF 63 recto) of this notebook are the first representations of a little fertility figure, possibly copied from a prehistoric sculpture in the British Museum. The rather blunt caption beside these two sketches of a torso of a woman reads: 'middle aged – fat'. On page 135 of **Notebook No.3** (HMF 133 recto) the word 'fecundity' appears for the first time, beside a sketch of a very plump female torso, and on page 17 of **Notebook No.4** (HMF 273), the caption above the massive reclining figure reads: 'Woman fecundity – fertility'. The most potent images of fertility, however, are the three drawings in **Notebook No.6** of the well-known Palaeolithic *Venus of Grimaldi* [see cat.28].

The torso of 'fecundity' illustrated here fills and dominates the page like those huge boulders that occupy an entire room in the paintings of Magritte. As in Maillol's bronze *Chained Action* of 1906, this torso, like the breasts, is 'bursting' with energy, as if there are great forces from within pressing out. The drawing embodies one of Moore's most fundamental beliefs about the nature of sculpture: 'it should make the observer feel that what he is seeing contains within itself its own organic energy thrusting outwards . . . It should always give the impression, whether carved or modelled, of having grown organically, created by pressure from within.'[2]

Alan Wilkinson

1. James (ed.) 1966, p.193; 1992, p.208.
2. Ibid. 1966, p.58; 1992, p.60.

28
Miscellaneous Studies 1926
Page 66 from Notebook No.6
HMF 459
pencil
unsigned, undated
inscription: pencil u.r. *Big bird form/Form as shape/meaning by shape/not feature.*

verso
Study after 'Venus of Grimaldi' 1926
pencil (rubbed)
unsigned, undated
inscription: pencil top of page *Figure – wide across –*

publications: *Henry Moore: Complete Drawings*, vol.1 1916-29, AG 26.34

The series of sketches of prehistoric sculptures and rock drawings, which appear on seven pages towards the end of **Notebook No.6**, represent the most concentrated group of copies from a single source, apart from those drawings in **Notebook No.3** done *in situ* in the British Museum [see cats.15-18]. They were all based on reproductions of Palaeolithic and Neolithic art in Herbert Kühn's *Die Kunst der Primitiven* (1923), underlining once again the importance of books as one of the primary and most influential sources of Moore's knowledge of the history of art.

Without Moore's detailed account of his visits to the British Museum during his first year in London, one might assume that the drawings made five years later in **Notebook No.6** herald his sudden 'discovery' of prehistoric art. His description of the collection in the British Museum is worth quoting in full, as it describes what he particularly admired about the earliest known works of art: 'In the prehistoric and Stone Age room an iron staircase led to gallery wall-cases where there were originals and casts of Paleolithic sculptures made 20,000 years ago – a lovely tender carving of a girl's head, no bigger than one's thumbnail, and beside it female figures of very human but not copyist realism with a full richness of form, in great contrast with the more symbolic two-dimensional and inventive designs of Neolithic art.'[1] The description 'very human but not copyist realism with a full richness of form', might just as well be applied to Moore's own work.

There are two copies on this page based on reproductions in Kühn's *Die Kunst der Primitiven*. Directly beneath the horse's head is a sketch of a Neolithic rock drawing from Douth, a prehistoric burial mound west of Drogheda in the Republic of

28 recto

28 verso

Ireland. The pattern of rayed suns or wheels, which was carved on one of the kerbstones, could easily be mistaken for a drawing by Miró enticing tourists to sunny Spain. Moore was obviously very taken with the illustration in Kühn of the Neolithic-period amber horse, now in the Museum für Vor und Frühgeschichte, Berlin. It is the most meticulous and detailed of all Moore's early copies of sculpture. The light and shade modelling of the head corresponds to the lighting in the photograph. Considerable care was taken with the outline of the head and with details such as the ear, eye, nose and mouth. Even the rows of dots from the mouth to the neck have been included. One of Moore's earliest animal sculptures was the little bronze **Horse** (LH 7) made in 1923; one of his last was the 1978 bronze **Horse** (LH 740).

'A carving might be several times over life size and yet be petty and small in feeling – and a small carving only a few inches in height can give the feeling of huge size and monumental grandeur, because the vision behind it is big.'[2] Surely no group of works in the history of sculpture better illustrates Moore's comment about scale and monumentality than the small, prehistoric fertility goddesses, such as the steatite *Venus of Grimaldi* in the Musée de Saint Germain in Paris. Such was the impact on Moore of this little carving when he came across the illustration of it in *Die Kunst der Primitiven* that it became the subject of three pages of studies in **Notebook No.6**. (Rarely did Moore make more than a single sketch of a work of art that caught his attention.) On cat.28 verso, the first of the three sheets of studies, the drawing at upper right began, like most of Moore's copies, as a

straightforward sketch of the original object. Then, with a view to creating a sculptural form of his own, he altered the proportions of the *Venus of Grimaldi* by broadening the figure above the waist. I suspect that he intuitively felt that the relatively narrow upper torso should be 'wider across', as the caption indicates, to offset or balance the massive, broad bulk of the pelvis and legs. This transformation is even more clearly delineated in the much larger study. Faint pencil lines define an almost square right shoulder, in contrast to the sloping, nearly non-existent shoulders of the original. With the addition of the two arms, the upper part of the torso has also been broadened.

Neither the *Venus of Grimaldi*, nor the bas-relief of a female figure from the shelter of Laussel in the Dordogne – of which there is a drawing, also copied from

29 recto

29 verso

Kühn's book, on page 69 of this notebook (HMF 460 verso) – seems to have had any immediate impact on Moore's sculpture. Some thirty years later, however, when he made the armless **Woman** 1957-58 (LH 439), with the enormous breasts and swollen belly and the legs truncated above the knees, Moore was surely consciously creating a mid-twentieth-century equivalent of the prehistoric fertility goddesses he had sketched in his notebook in 1926.

Alan Wilkinson

1. James (ed.) 1966, p.157; 1992, p.159.
2. Ibid. 1966, p.66; 1992, p.69.

29
Circus Drawings 1926
Page 74 from Notebook No.6
HMF 463
pencil
unsigned, undated
inscription: pencil u.r. *Circus drawings/Horses*

verso
Circus Drawings and Study of a Mexican Head 1926
pencil
unsigned, undated
inscription: pencil *Head of Christ in Alabaster/Mexican*

publications: *Henry Moore: Complete Drawings*, vol.1 1916-29, AG 26.38

Moore's love of the circus is documented in four pages of drawings in **Notebook No.6** of tightrope walkers and acrobats, subjects one associates more with the work of Toulouse-Lautrec and of Degas, such as the latter's 1879 *LaLa at the Cirque Fernando* in the National Gallery, London. The body in motion or precariously balancing on a tightrope was the antithesis of the way in which Moore, in his life drawings and sculpture, represented the human figure in repose, whether standing, seated or reclining. He was not, he told me, attracted to what he called 'the gesture school of poses'.

The circus drawings on the verso include a study of two figures on a trapeze, and five drawings of tightrope walkers, one of whom balances with the aid of an umbrella. Although the circus drawings do not relate in any way to Moore's sculptural

preoccupations, these lively little sketches, like the studies of boxers in **Notebook No.2** (HMF 57 verso) and **Notebook No.5** (HMF 412 verso and 414 verso), record, like entries in a journal, his keen interest in these two very physical activities.

The 'Head of Christ in Alabaster Mexican' (with the sketchbook turned 180 degrees) is the last direct copy of a work of art in this notebook and, as far as I can determine, the last surviving one from the decade of the 1920s. It was based on the illustration on page 10 in Ernst Furhmann's *Mexico III* (1922) of the alabaster *Head of a Man* in the Naturhistorisches Museum, Vienna. Apart from the copies of religious subjects done in Italy in 1925, this is the only drawing with a 'visual affinity' to Christianity, until Moore began the preparatory studies in 1943 for the Hornton stone **Madonna and Child** (LH 226) for the Church of Saint Matthew, Northampton. He obviously saw the striking resemblance between the facial features of the pre-Columbian head and any number of representations of Christ, such as the shroud of Turin.

Alan Wilkinson

30
The Artist's Mother 1927
HMF 488
pencil (rubbed), pen and ink, wash on cream wove
277 × 191mm
signature: pencil l.l. *Moore*, undated
Gift of Mary Moore Danowski 1979

exhibitions: Madrid 1981 (cat.D1); Lisbon 1981 (cat.D1); Barcelona 1981-82 (cat.D1); Beijing/Shenyang/Hong Kong 1982 (cat.96); New York 1983 (p.8); London 1988 (cat.55); Sydney 1992 (cat.12); Havana/Bogotá/ Buenos Aires/Montevideo/Santiago de Chile 1997-98 (cat.8)
loans: London, Government Art Collection, for 10 Downing Street 1987

publications: Wilkinson 1984, p.20, pl.39; Packer 1985, p.15; Berthoud 1987, pl.1; Garrould 1988, pl.9; *Henry Moore: Complete Drawings*, vol.1 1916-29, AG 27.3, pl.IX

This is one of the few portraits amongst Moore's drawings, and is exceptionally realistic. He repeatedly told people about his childhood memory of rubbing his mother's back, and once admitted that he supposed he had a mother complex. Moore was not interested in psychological introspection. What mattered was his discovery of a human tactile experience. Though he is said to have regarded his father with awe and respect, his empathy for his mother is very evident in this granite-like portrayal.

His mother came from Staffordshire,

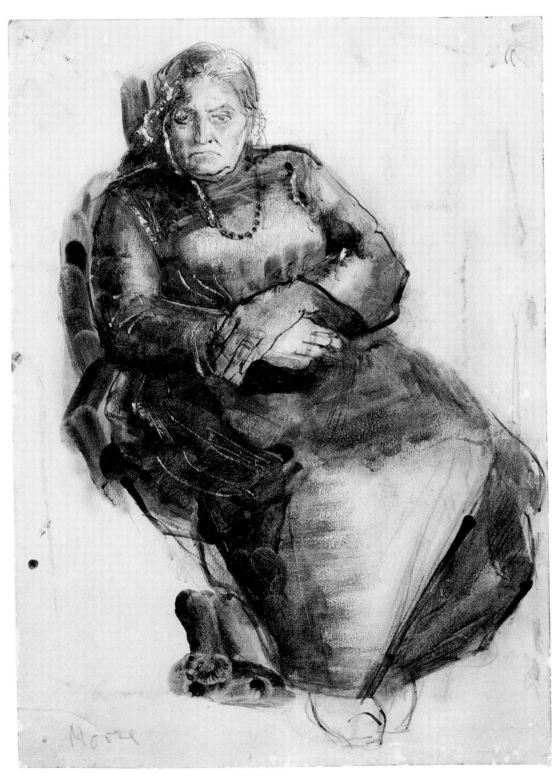

30

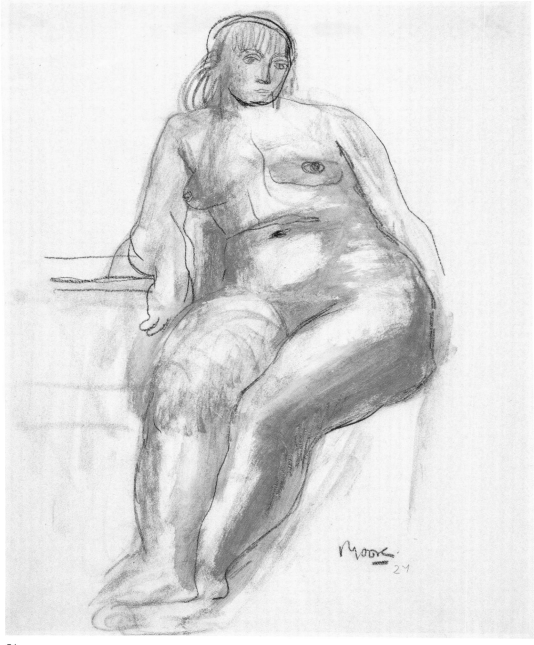

31

31

Seated Nude 1927
HMF 507
pastel, chalk, wash on off-white lightweight
wove
425 × 341mm
signature: crayon l.r. *Moore*/pencil *27*
Acquired 1980

exhibitions: Madrid 1981 (cat.D8); Lisbon
1981 (cat.D8); Barcelona 1981-82 (cat.D8);
Marl 1984 (cat.34); Martigny 1989
(cat.p.97); Leningrad/Moscow 1991 (cat.12);
Helsinki 1991 (cat.12); Budapest 1993
(cat.14); Bratislava/Prague 1993 (cat.14)

publications: *Henry Moore: Complete
Drawings*, vol.1 1916-29, AG 27.26;
Sotheby's, London 26 March 1980 lot 275

32

Seated Figure 1927
HMF 519
pen and ink, watercolour wash, charcoal on
off-white medium-weight wove
440 × 304mm
signature: pencil l.r. *Moore*/27
Gift of the artist 1977

exhibitions: Hong Kong 1986 (cat.D14);
Tokyo/Fukuoka 1986 (cat.d14); Martigny
1989 (cat.p.98); Leningrad/Moscow 1991
(cat.11); Helsinki 1991 (cat.11); Budapest
1993 (cat.15); Bratislava/Prague 1993 (cat.15)

publications: *Henry Moore: Complete
Drawings*, vol.1 1916-29, AG 27.39

This drawing of a brooding girl, rather less
heavy-limbed than many he portrayed,
shows Moore's sensitivity and may well
reflect his own, then fairly recent, travails.
In 1925 he had spent three unhappy months
on a scholarship in Italy, an experience
which disorientated him. For the past few
years he had been inspired mainly by the
powerful sculptures he found in the
ethnographic displays in the British
Museum. Intensive exposure to the cultural
glories of the Renaissance challenged his
loyalty to those gods. In addition he had
fallen in love with Edna Ginesi, who was
engaged to his best friend Raymond Coxon

but I suppose it is only my imagination that
sees in Moore's depiction of her legs and
her lap the sturdy forms of barrel or jug.
The drawing makes the most of the contrast
between black and glowing white. The
image comes off the paper with an almost
tangible power. He shows her wrapped in a
cloak of darkness, with minimal attention to
descriptive detail, yet the drawing tells us
everything we need to know about her age,
weight, character and dress. It gives me a
complete sense of the sitter's maturity,
stability, dignity and determination. As he

made this drawing the artist was also
making a portrait of himself.

Her presence can be felt haunting
much of his later work, in sturdy
Madonnas, broad-backed mothers and a
multitude of seated or reclining females
staring out the future. Just this once, Moore
has given us a piercing insight into an
individual personality within a monumental
form.

John Read

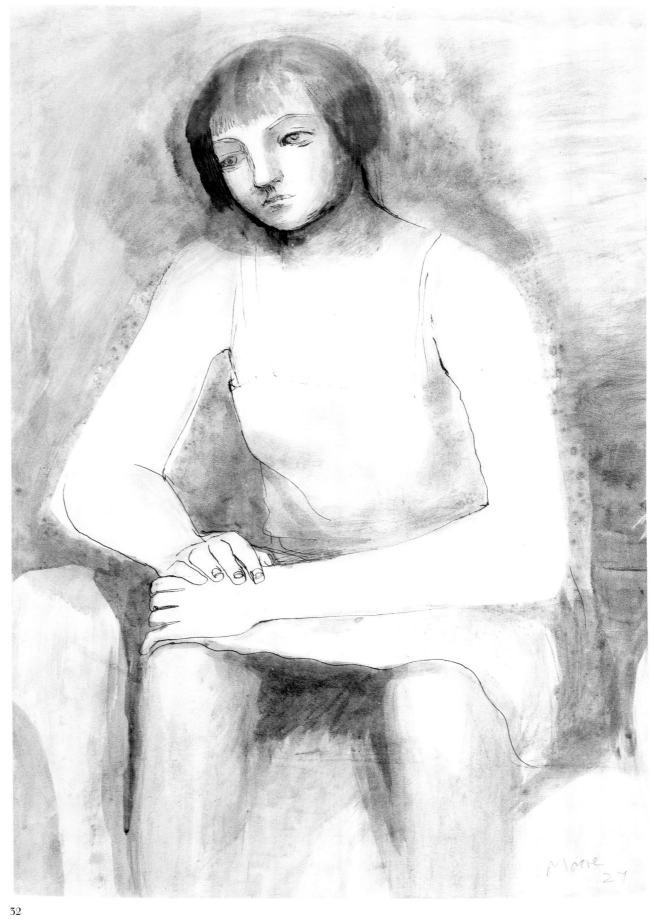

32

and did not reciprocate his feelings. There is a tenderness in these early drawings of young women that seems to reflect the conflicts and yearnings of the youthful and not yet famous Moore.

Roger Berthoud

33
Mask 1927
LH 46
stone
height 21cm
unsigned
Acquired 1997

publications: Sotheby's, New York
13-14 May 1997 lot 317

This mask is one of a series of masks, heads and relief heads of the 1920s in which Moore experimented with non-Western forms in a variety of materials including concrete, rock salt, lead, alabaster, slate, verde di Prato and African green stone.

Although Moore had written and performed in his own play,[1] this mask has little to do with the theatre. With a depth of over 12cm, the stone carving can be seen as a wall relief akin to those Moore would have known from local Norman and Gothic church architecture. Yet these factors are negligible compared with the overwhelming impact of non-Western art, which captivated Moore at this time. He explained: 'The most striking quality common to all primitive art is its intense vitality. It is something made by people with a direct and immediate response to life.'[2]

When Moore carved this mask in the autumn of 1927, he had already been exploring non-Western art forms for six years. First introduced to non-Western art through reading Roger Fry's *Vision and Design* in 1921, Moore soon began regular visits to the British Museum, where he could see and sketch these works at first hand. He recalled: 'Once you'd read Roger Fry the whole thing was there. I went to the British Museum and saw what I wanted to see . . . one room after another took my enthusiasm. The Royal College meant nothing by comparison.'[3]

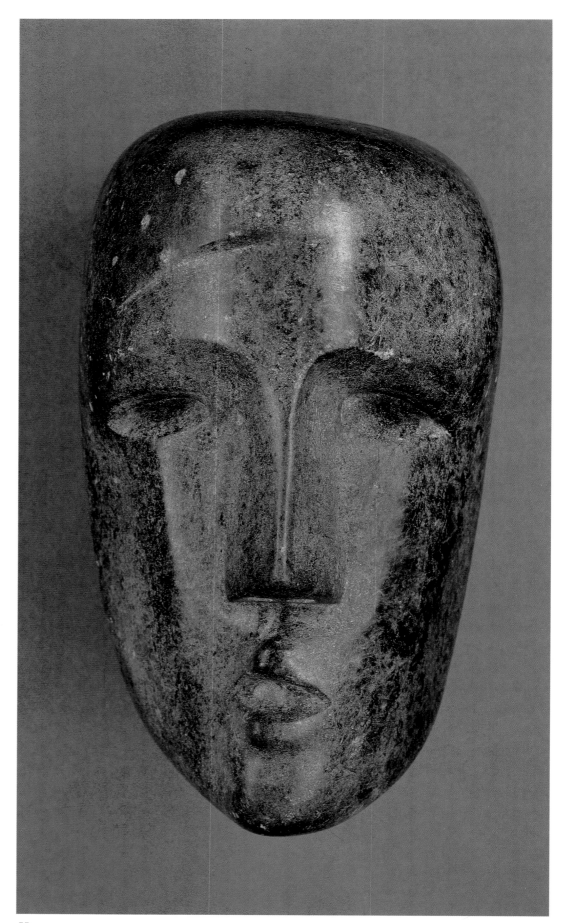

33

Moore, along with his contemporaries in Britain Jacob Epstein and Eric Gill, espoused the virtue (later recanted by Moore) of 'truth to material', a notion resurrected from the nineteenth-century Gothic revivalists by Henri Gaudier-Brzeska. In keeping with this ideology, the face seemingly emerges from the smooth organic shape of the stone, evoking an aura of mystery reminiscent of the Easter Island figures, one of which was on display in the British Museum at the time of this carving.

Manipulating the geometric purity of Cycladic art, a single arced line shapes the eyebrow and sweeps down to become the straight linear nose with a triangular base. Infused with the expressive intensity of African masks, the small open mouth is distorted, the eyes are asymmetrical and a gash streaks across one side of the forehead. Despite the surprising juxtaposition of non-Western influences, the mask retains a simplicity and directness which immediately engages the viewer.

Anita Feldman-Bennet

1. *Narayana and Bhataryan*, 1920, performed at Castleford Grammar School in 1920 and the Royal College of Art in 1922.
2. Henry Moore, 'Primitive Art', *Listener*, 24 August 1941, pp.598-9.
3. James Johnson Sweeney, 'Henry Moore', *Partisan Review*, March-April 1947.

34

Seated Figure 1928
HMF 594
pen and ink, crayon, wash on cream lightweight wove
425 × 264mm
signature: crayon l.r. *Moore/28*
Gift of the artist 1977

exhibitions: Martigny 1989 (cat.p.99); Krakow/Warsaw 1995 (cat.11); Venice 1995 (cat.11); Havana/Bogotá/Buenos Aires/Montevideo/Santiago de Chile 1997-98 (cat.9)

publications: *Henry Moore: Complete Drawings*, vol.1 1916-29, AG 28.110

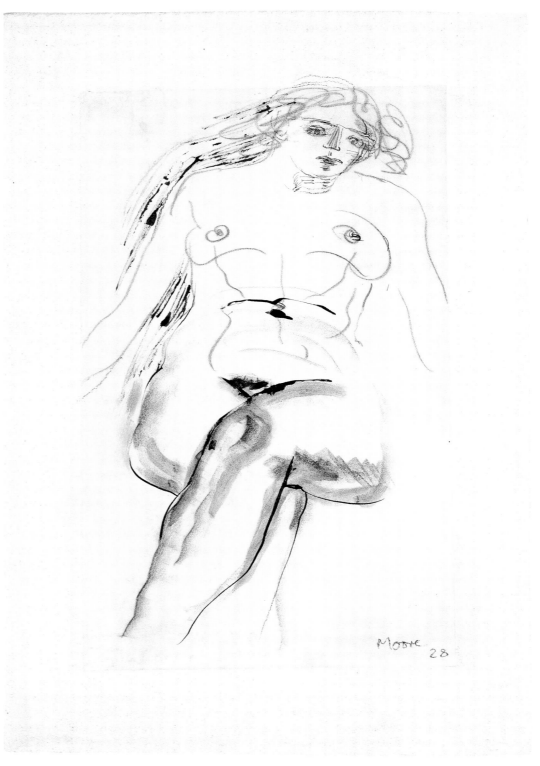

34

35

Woman Seated on a Stool 1928
HMF 596
chalk, brush and ink, wash on cream
lightweight wove
438 × 346mm
signature: pencil l.r. *Moore/28*
Gift of the artist 1977

exhibitions: Martigny 1989 (cat.p.100);
Havana/Bogotá/Buenos Aires/Montevideo/
Santiago de Chile 1997-98 (cat.10)

publications: *Henry Moore: Complete
Drawings*, vol.1 1916-29, AG 28.112

This is a very quick working sketch in
which the economical use of line indicates
the body, and a rapidly applied wash
defines its volume. In places there is some
conflict between the two. In addition,
Moore has changed his mind about the
dimensions of the figure, making double
lines in both the shading and the line of the
near leg and arm, and also in the breasts
and head – there are two pairs of eyes, and
two outlines describing hair.

Moore spoke of his enthusiasm for the
archaic Greek sculptures at the British
Museum, female figures 'seated in easy,
still naturalness'[1] and, indeed, in the life
drawings seated figures far outnumber
reclining figures, but their stillness is of a
very particular sort. If they are not exactly
animated by movement – although they
seem to exist in tension, as if about to raise
themselves, or as if perched rather than
resting on their stools and chairs – this is
because it is impossible to imagine them in
movement. All Moore's interest lies in bulk,
not anatomy, in masses rather than
muscles. So the figures exist in a strange
and uncertain balance, incapable of either
movement or repose.

As is common in Moore's life drawings,
here a low viewpoint gives great weight to
the legs and lower torso, and much less to
the girlish head. The heaviness of such
figures probably has various sources. In
part it comes from looking at Picasso's neo-
classical figure drawings made after the
First World War; their monumentality,
however, has a strong ironic component
quite lacking in Moore – Picasso depicts

ballet dancers pirouetting on elephantine
limbs, deliberately playing on the tension
between mass and animation which for
Moore remained a dilemma. It may also be
that Moore was looking at Renoir's late
paintings in which the torsos and limbs of
his female bathers grew ever broader.[2]

While the inert bulk of the figures in
Moore's life drawings may have been
necessary for his sculptural work, this did
not in itself withdraw the ideological sting
of these works in which feminine material
was made at least partially animate by the
sympathetic touch of (male) genius.

Woman is associated with the earth, a
fertile but passive receptacle. In such an
attitude, Moore was of course not alone. It
was a common motif of the period's avant-
garde sculpture, found not only in Moore's
work but in Hepworth and Dobson, and in
Epstein's pre-war carvings.

Julian Stallabrass

1. Cited in Wilkinson 1984, p.21.
2. Much later Moore praised these Renoir figures.
Statement on *La danseuse au tambourin* and *La
danseuse aux castagnettes*, 1962; reproduced in James
(ed.) 1966, pp.187-9; 1992, pp.195-7.

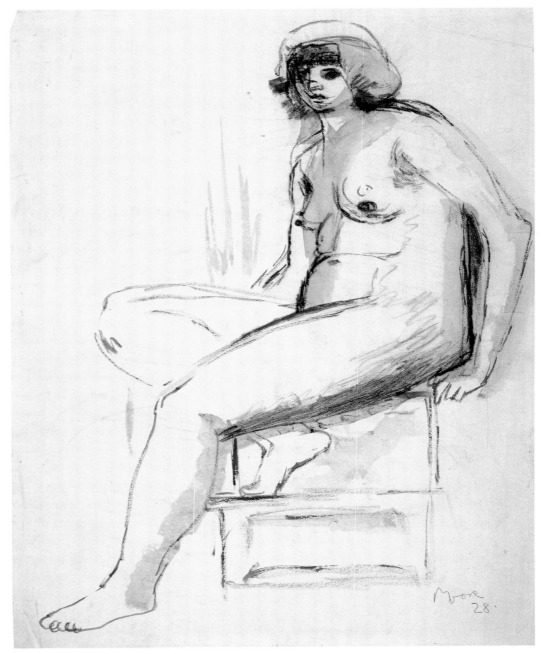

35

36-41

Sketchbook 1928: West Wind Relief

1928

HMF 610-643

Black paper-covered boards quarter-bound in black cloth 228 × 180mm; the book originally contained 52 pages of off-white lightweight laid paper 228 × 180mm in two signatures of eight and three signatures of twelve. The inside front cover is inscribed upper right in pen and ink *Henry Moore/13 Fitzroy Street/W.C.* with the *C* crossed through and *1* added in pencil. The pages are unnumbered but were ascribed numbers by Alan Wilkinson in the early 1970s.
Gift of Irina Moore 1977

exhibitions: Leeds 1984 (cat. 55)

publications: Farr 1978, pp.251-52; Moore 1982 (facsimile); Wilkinson 1984, pp.229-47; *Henry Moore: Complete Drawings*, vol.1 1916-29, AG 28.1-33

In 1928 the architect Charles Holden commissioned seven sculptors to make a series of carvings for the building he had designed for the new headquarters of London Transport at St James's Park Station, a quarter of a mile due west of Westminster Abbey. Jacob Epstein did two free-standing carvings entitled *Day* and *Night*. Eric Aumonier, A.H. Gerrard, Eric Gill, Moore, Frank Rabinovitch and Allan Wyon were asked to create eight relief carvings of horizontal figures representing the four winds for the central tower of the building. Gill carved three of the figures; the other five sculptors each did one.

Moore was somewhat reluctant to accept his first public commission. Relief sculpture was the antithesis of the fully three-dimensional, spatial richness he was striving to achieve in his own work. Holden was very persuasive, however, and Moore began what turned out to be by far the most numerous and concentrated series of preparatory studies for a single sculpture of his entire career – the drawings in this sketchbook and on a few larger sheets for the 1928 Portland stone relief carving **West Wind** (LH 58). In the first seven pages of studies, the static poses and simplified naturalism of the figures are reminiscent of

some of the life drawings of the period, and of the cast concrete **Reclining Woman** 1927 (LH 43). Not only was relief sculpture alien to Moore, so too was the representation of the human figure in movement. In **Two Flying Figures** on page 15 (HMF 617 verso) he tries to convey the theme of the commission by attaching swirling drapery to the figure, a motif that appears in a number of subsequent drawings.

None of the many studies of reclining figures in this sketchbook served as the definitive drawing for the **West Wind** carving. I suspect that there was such a drawing from which Moore worked when he did the preliminary carving in his studio at the Royal College of Art, but if so it has not survived. The more than one hundred individual variations of reclining figures realised in **Sketchbook 1928: West Wind Relief** and in the five separate pages of studies galvanised Moore's obsession with this motif. There are, it is true, a number of drawings of reclining figures in **Notebooks 2 to 6**, as well as five sculptures before **West Wind** on this theme, but it was with the profusion of studies in this sketchbook that the subject took hold. Moore later explained the importance of the reclining figure as the dominant theme in his work: 'The vital thing for an artist is to have a subject that allows [him] to try out all kinds of formal ideas – things that he doesn't yet know about for certain but wants to experiment with, as Cézanne did in his "Bathers" series. In my case the reclining figure provides chances of that sort. The subject-matter is *given*. It's settled for you, and you know it and like it, so that within it, within the subject that you've done a dozen times before, you are free to invent a completely new form-idea.'[1]

Sketchbook 1928: West Wind Relief also includes a number of studies for sculpture that are unrelated to the **West Wind** carving commissioned by Charles Holden. On page 1 (HMF 611 recto and verso) are two designs for wall lights. Between page 45 and the inside back cover are a series of drawings for two outdoor projects, almost certainly commissions, about which virtually nothing is known. There are four pages of preparatory

drawings of standing and seated female figures for the carving **Six Reliefs** *c.*1928 (LH 36a). The title of this sculpture is somewhat misleading. It consisted of two blocks of Portland stone and on each block Moore carved figures in relief on three of the four sides. For some reason the two relief carvings, one of which appears to have been a fountain, were destroyed in the 1960s. The thirteen pages of studies for the second project consist of drawings of heads, seated and reclining figures, and snakes for relief carvings in wood for the backs of garden benches. Of the two carvings which have survived, both are of three female heads [see cat.41 verso]. Moore told me that he thought he also did a relief carving of a reclining figure for the back of a garden bench, but if so the sculpture was either lost or destroyed. What have survived are five pages of studies in this sketchbook for a 'single reclining figure', one of four subjects for garden reliefs listed on page 55 verso [cat.39]. They are the most important drawings for sculpture of the 1920s, with the same far-reaching impact on Moore's work that the preparatory studies for the 1906-7 *Les Demoiselles d'Avignon* had on Picasso's development. Although the drawings were conceived as studies for a garden relief, and may have been used as such, their greater significance is not only that they ultimately served as the preparatory drawings for the Leeds **Reclining Figure** 1929 (LH 59), but that they reflect the sudden re-emergence of the pre-Columbian *Chacmool* carving, whose influence on Moore's work for the next few years was comparable to the impact of tribal art on the work of Picasso during his early Cubist years.

Alan Wilkinson

1. Russell 1968, p.28; 1973, p.48.

36

Three Reclining Figures 1928
Page [13] from Sketchbook 1928: West Wind Relief
HMF 616
pen and ink, chalk
unsigned, undated

publications: Garrould 1988, pl.13; *Henry Moore: Complete Drawings*, vol.1 1916-29, AG 28.6

37

Two Reclining and Two Flying Figures 1928
Page [17] from Sketchbook 1928: West Wind Relief
HMF 618
pencil, pen and ink
unsigned, undated
inscription: pencil l.l. *8"/2"=1ft -/[?]/3*

publications: *Henry Moore: Complete Drawings*, vol.1 1916-29, AG 28.8

Charles Holden has come down to us as an architect who employed some of the most innovative sculptors of the time, and gave them special opportunities to collaborate on important new building projects. The Headquarters of the London Underground Electric Railways was one such scheme, and on it Holden re-employed Epstein – with whom he had worked years earlier on the British Medical Association building –

as his principal sculptor, and asked Eric Gill to head a team of younger sculptors, which brought together Moore with Eric Aumonier, A.H. Gerrard, Frank Rabinovitch and Allan Wyon. (However, when Holden asked Moore six years later to carve figures for his new Senate House building, Moore refused.) The project was loosely based on the octagonal Athenian Tower of the Winds; Gill carved a North, a South and an East Wind, and the other five sculptors each carved one of the remaining five. Though Gill's Winds are curvaceous – the male ones puckish and the female rather benign – those of the younger generation are quite different: less decorative and more muscular. Wyon and Aumonier chose to make their figures male, the former rather Blakeian in its representation of pent-up energy, the latter reminiscent of Metzner's treatment of façade sculpture, while Gerrard, Rabinovitch and Moore all made heavy-limbed, somewhat languid females.

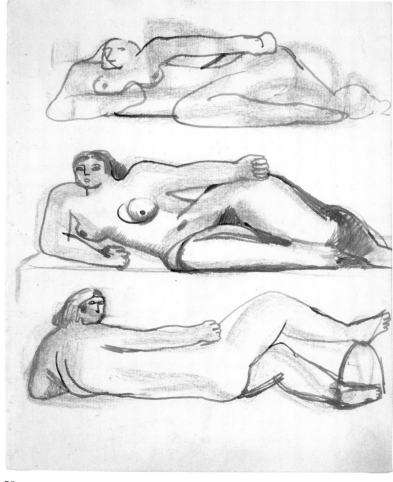

36

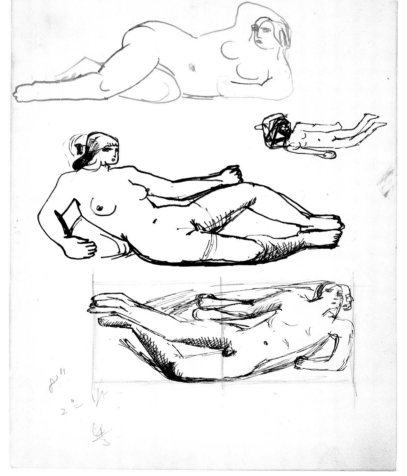

37

None of these greatly resemble winds; they all suggest water rather than air, and Moore's in particular looks like a swimmer. The notebook figures – weightless and balloon-like, reminiscent of classicising Cubism, and particularly Léger, only reinforce this impression; the drapery that wraps some of them at once suggests the stork's sling and the bather's towel. Moore's carving (LH 58) stands out for treating the face frontally, rather than in profile, and in general for the greater three-dimensional quality of the figure, which is realistic rather than decorative, shaped rather than delineated, and expressive rather than graphic.

Gill's North Wind was male, Gerrard's was female, and though both Rabinovitch and Moore made their West Winds female, this sketchbook shows Moore's Wind metamorphosing between the two sexes. Moore made over a hundred sketches in relation to this project; these pages show only a few, and of them, the smallest figure here is the closest to the carving as executed. Holden's commission forced Moore into finding a satisfactory way of fitting the figure into the horizontal. He had made only a few reclining figures up to this point: LH 24, in stone, now destroyed; three which were modelled (LH 30, 31 and 38); and one in cast concrete (LH 43), which served as his departure point for the drawings. Thus, though his **West Wind** itself is rather uncomfortable, its format and its material (Portland stone), and the drawings which accompanied it, must have been crucial in bringing Moore to this form. The sketchbook reveals how he had been trained to put his figures into architecture – whether on pediments, alongside doors and fireplaces, or in boxes, as here – and how he reduced that convention to the simple but resolute base line. The **West Wind** brought him to resolve the format, within the block, in **Reclining Figure** 1929 (LH 59), now in Leeds City Art Gallery, which he made immediately thereafter. The fact that Gill felt the need to re-carve his Winds in small scale for exhibition purposes, whereas Moore carried his experience into a new theme and format, perhaps points up the difference in what the project brought the two men.

It was not unusual for sculptors to collaborate with architects on the façades of buildings; this was in many ways a staple of both traditional and avant-garde practice. Moore had had to be persuaded that this project would be an example of the latter rather than the former. The newer buildings, which employed steel frames and reinforced concrete, offered to sculptors challenging possibilities for a real step forward. Sculpture would no longer be simply a secondary, additive decorative feature, but primary, integral to the architectonic structure of the building. The London Underground Building has often been talked of in such terms, but a return to contemporary accounts of the scheme, or even to panoramic views of the building, reminds us of the difference between theory and fact.

Herbert Maryon wrote: ' . . . the remaining figures seem incapable of forming an adequate relief to the acres of plain walling. The figures are not numerous enough; nor important enough in themselves, nor in their placing, to achieve any worthy object: they but declare the leanness of the land. Their sculptors, in the position chosen for them, and in the few feet and inches at their disposal, were set the impossible task of making something which would not look like a lost sheep on a mountain. That the task was impossible is apparent from the fact that we must look carefully at the building to find the sculptures at all, and must then wonder why they were so placed.'[1]

Maryon's criticisms accord with some of the sculptors' own misgivings about their role on the building, and remind us that this collaboration should not be taken as an unproblematic exemplar of modernist collaboration. Gill described the sculptures as 'big but unimportant'; 'architectural fal-lals merely but a valuable experience'[2]. Unlike the British Medical Association building, on this project Holden had the sculptors actually carry out the carving on the building's façade. Moore roughed out the stone in his Royal College studio, but completed the carving on scaffolding up on the seventh storey of the building. In principle this was the thorough realisation of all the demands of direct carving, and

would have squared with Gill's notion of the cathedral 'chantier', but in practice, as Gill himself continued, there was a 'revolting contrast between our (there are 5 sculptors on the job) attempts at "love-making" and the attitude of mind of the 1000 "hands" around us.'

Penelope Curtis

1. Herbert Maryon, *Modern Sculpture: Its Methods and Ideals*, Pitman, London 1933, p.40.
2. Fiona MacCarthy, *Eric Gill*, Faber and Faber, London 1989, p.230.

38
Three Flying Figures 1928
Page [21] from Sketchbook 1928: West Wind Relief
HMF 620
pen and ink
unsigned, undated
inscription: pencil u.r. *North wind man/ East wind man/south wind woman/west wind woman.*

verso
Flying Figure [not illustrated]
chalk
unsigned, undated

publications: *Henry Moore: Complete Drawings*, vol.1 1916-29, AG 28.10

In his discussion of the origin of the **West Wind** relief, Moore commented on the two very considerable problems which made him reluctant to accept the commission from the architect Charles Holden: 'At that stage in my career I did not (and still do not) like sculpture that represents actual physical movement – sculpture that appears to be jumping off its pedestal. I was also prejudiced against relief sculpture itself as being too much akin to painting.'[1] The first seven pages of studies of reclining figures in this sketchbook clearly indicate that when he made the first exploratory drawings, he was, in his own words, 'still fighting the idea of dealing with a figure in motion'.[2] Whether they are reclining on their sides, their backs or lying on their stomachs, the figures are firmly rooted to

38 recto

39 verso

the ground along almost their entire length. If these sheets had been removed from this sketchbook, I would connect them with the 1927 cast concrete **Reclining Woman** 1927 (LH 43) rather than the **West Wind** relief. Moore wrote: 'Slowly I realised that it might be wrong to give the title *West Wind* to a static figure and then I hit on the idea of a figure suggesting a floating movement'.[3] He also considered the character of the four winds: 'North being cold and hard – a male wind; South a warm female wind; East – hard, cutting wind [male] and West, a rainier and softer wind [female] – I made drawings, trying to express something of this character. You see the drawings are mainly of women.'[4]

On the three pages of studies preceding this page are Moore's first attempts at suggesting the figure in movement, with lines of force swirling about the body. In some of these and in later studies the

figures appear to be falling or tumbling through space, somewhat out of control. For me, among the most successfully resolved drawings for the **West Wind** relief are the three studies here. Drapery, a motif so often employed in classical Greek sculpture to convey movement, has replaced the abstract lines of force in the earlier studies. These floating rather than flying figures are beautifully poised and balanced, like three rather hefty ballerinas suspended in mid-air in full flight.

Alan Wilkinson

1. Moore 1982 (facsimile).
2. Ibid.
3. Ibid.
4. Ibid.

39

Ideas for Garden Bench Sculpture
1928 [not illustrated]
Page [55] from Sketchbook 1928: West Wind Relief
HMF 637
pen and ink, pencil, brush and ink
unsigned, undated

verso

Subjects for Garden Reliefs 1928
pencil
unsigned, undated
inscription: pencil u.l. *Subjects for Garden reliefs*. u.c.1 [circled] *Snake/2* [circled] *Two reclining figures in* – [sketch of a half circle]/3 [circled] *Two figures Adam & Eve. cut off at waist/4* [circled] *Single reclining figure.*

publications: *Henry Moore: Complete Drawings*, vol.1 1916-29, AG 28.27

The four subjects for garden reliefs listed at the top of this page relate to relief carvings for the backs of garden benches, rather than to the **Six Reliefs** *c.*1928 (LH 36a) carved on two blocks of Portland stone. From page 45 to the end of the sketchbook, almost all the drawings are preparatory studies for these two outdoor sculpture projects. Of the reliefs for garden benches only two carvings have survived, both of which are closely related to the studies of three heads on page 63 verso [cat.41].

If in several earlier notebook pages [see cat.6] there are hints and whispers of the pre-Columbian *Chacmool* reclining figure lurking in the background of Moore's imagination, these ten studies announce with a bang his sudden and overwhelming obsession with what he described to me as 'undoubtedly the one sculpture which most influenced my early work'. That Moore was aware of the *Chacmool* sculpture as early as 1922 was confirmed by the artist himself, who said, when I showed him the two little studies at the bottom of page 93 of **Notebook No.2** [cat.6]: 'Here is the first bit of influence of the Mexican reclining figure'.

These drawings are in a sense a continuation of numerous studies of reclining figures in this sketchbook for the **West Wind** relief. The most significant compositional differences are in the positions of the arms and legs as in, for example, the study at centre right, where the right leg is raised, with the foot resting on the left leg, and the right arm is raised and bent at the elbow, with the hand resting on the back of the head. In contrast to the almost symmetrical pose of the *Chacmool* carving, with the weight of the body resting on the buttocks, elbows and feet, Moore has turned the body on its side, which leaves the right arm and leg free to assume any number of positions. The head, turned sharply to left away from the line of the body, is a feature borrowed directly from the pre-Columbian sculpture. The more compact, angular forms of the limbs, very different from the plump naturalism of the studies for the relief, also reflect Moore's love of Mexican sculpture. As he wrote: 'I've always had a liking for squareness. The squareness of a right angle is a very

vigorous action. This may be one reason why I appreciate Mexican and particularly Aztec sculpture.'[1]

On page 59 from this sketchbook [cat.40], in the study of a reclining figure for the back of a garden bench, Moore has established the pose which he would use the following year for the Leeds **Reclining Figure** 1929 (LH 59), the first of the two great carvings inspired by the *Chacmool*. When, in the early 1970s, Moore read my comment that it was 'the pose' of the pre-Columbian carving that attracted him, he made a little matchstick drawing which captured the pose of the Mexican sculpture but nothing of its weight and massiveness. Yes, he said, it was the pose, but equally, 'its stillness and alertness, a sense of readiness – and the whole presence of it, and the legs coming down like columns.'

Alan Wilkinson

1. Hedgecoe (ed.) 1968, p.55.

40
Idea for Garden Bench Sculpture 1928
Page [59] from Sketchbook 1928: West Wind Relief
HMF 639
pencil, pen and ink, brush and ink, wash
unsigned, undated

verso
Ideas for Garden Bench Sculpture 1928 [not illustrated]
pencil, pen and ink, brush and ink
unsigned, undated

publications: *Henry Moore: Complete Drawings*, vol.1 1916-29, AG 28.29

40 recto

41

Ten Ideas for Garden Bench Sculpture 1928 [not illustrated]
Page [63] from Sketchbook 1928: West Wind Relief
HMF 641
pen and ink, brush and ink, wash
unsigned, undated

verso
Ideas for Garden Bench Sculpture
1928
pen and ink, brush and ink, wash
unsigned, undated
inscription: pen and ink c. *Size of this shape*

publications: *Henry Moore: Complete Drawings*, vol.1 1916–29, AG 28.31

Of the various subjects which Moore considered for relief carvings for the backs of garden benches, he focused most of his attention in making preparatory drawings of two motifs: a single reclining figure [cats.39 and 40], and three female heads side by side. These are the two subjects of most of the drawings in the last twenty pages of this sketchbook. Other preliminary studies for the garden bench project include two sketches of two intertwining snakes [cat.40] and one of two reclining women [cat.39].

Stylistically, the series of drawings of the three heads, with their flat noses and small mouths, are closely related to the cast concrete **Head of a Woman** 1926 (LH 36). In the 1928 drawings, however, Moore has incorporated an additional feature, a sort of double, cubic bun of hair, which is clearly visible on the head at the right in each of the two small compositions here. These two-tiered, geometric forms, which also appear on the left side of the head of the Leeds **Reclining Figure** 1929 (LH 59), are almost certainly derived from the rectangular projections on each side of the head of the *Chacmool* carving. In 1929–30, Moore again employed the cubic bun of hair in a number of life drawings of his wife Irina.

The only surviving carvings from the garden bench project are the two teak panels, both depicting three heads, now owned by the Moore Danowski Trust. Moore told me that he thought he also did a relief carving of a reclining figure, but if this was the case it was either lost or destroyed. Regrettably, nobody seems to have asked the artist about the origin of the garden reliefs. One assumes, like the **West Wind**, that they were an early commission.

Alan Wilkinson

42

Two Studies of a Female Nude *c.*1928
HMF 649a
charcoal (washed), watercolour wash, chalk, brush and ink on Japon
342 × 428mm
signature: pencil l.l. *Moore/28*; l.r. *Moore/28*
Acquired 1982

exhibitions: Sunderland/Swansea/Leeds 1983–84 (cat.p.124); Martigny 1989 (cat.p.101); Sydney 1992 (cat.13); Nantes 1996 (cat.10); Mannheim 1996–97 (cat.10); Havana/Bogotá/Buenos Aires/Montevideo/Santiago de Chile 1997–98 (cat.11)

publications: Christie's, London 30 March 1982 lot 352; *Henry Moore: Complete Drawings*, vol.1 1916–29, AG 28.53

'From 1922 on', Moore told me, 'I went once or twice a year to Paris – until 1932 or 1933 I didn't miss a year.' During his student years the trips were usually made with friends from the Royal College of Art – Barbara Hepworth, Raymond Coxon, Edna Ginesi and Vivian Pitchforth. As a form of relaxation after visiting museums and galleries, Moore enjoyed drawing from life at the free (no instruction) classes at the Colarossi and Grande Chaumière Academies. In the afternoon classes the models posed for several hours, which enabled him to complete fully worked drawings similar to the very sculptural, densely modelled life studies he had done at the College and would continue to do until the mid-1930s. In the evening classes the rhythm changed. The first sitting might last an hour, with subsequent poses becoming progressively shorter: twenty minutes, five minutes and finally several of one minute each. Moore spoke of his excitement at completing a drawing within the allotted time of one minute.

41 verso

42

The hastily executed Paris drawings, which include these two studies, are readily identifiable in terms of both style and technique. The outlines of the figures were usually drawn with pen and ink or brush and ink, often using sweeping, unbroken lines to depict, as here, for example, the left shoulder and arm of the nude at right. Moore's frequent use of wash or watercolour, both on and around the figure, is reminiscent of Rodin's late pencil and wash drawings.

Of particular interest in this unusual study, which includes two different poses on a single sheet, are the chalk lines which define the raised left arm of the nude at left. If isolated from the figure, the left arm becomes an abstract passage with a greater affinity to balanced rocks at Stonehenge than to human anatomy. A single, unbroken line runs down the raised left arm, cuts across the figure at the armpit, and then continues down the torso until it curls under and around the left breast, ending with a little flourish at the nipple. Here and in other life drawings of 1928, Moore has begun to experiment with what he called 'the two-way sectional line method of drawing', a highly original means of representing three-dimensional form. This he described to me as drawing by the use of line 'both down the form as well as around it, without the use of light and shade modelling'. By drawing in two directions, both horizontally across the form and vertically down it, the contours of the body within the outlines of the figure are defined, in much the same way that we are able to 'read' from the air the contours of a freshly ploughed, hilly field by the lines of the furrows. Likewise, on the face of the same figure in this drawing, a continuous line

43 recto

runs from the raised left arm across the forehead, dips down to the right eye and curves across to the left eye. Another line runs down the nose, then under it, and continues around the mouth. Although in the 1930s Moore continued to refine the two-way sectional line method of drawing, the technique was not fully developed until the mid-1940s.

Alan Wilkinson

43
Reclining Figure with Child 1928
HMF 682
pen and ink, watercolour wash on off-white lightweight wove
327 × 424mm
signature: crayon c.r. *Moore/*brush and ink *28*
inscription: brush and ink l.l. *Drawing for/sculpture.*

verso
Singing Girl 1928 [not illustrated]
pencil
unsigned, undated
inscription: pencil u.r. *No 36/Girl singing/6 gns*; c. *Singing Girl*
Gift of the artist 1977

exhibitions: Toronto/Iwaki-Shi/Kanazawa/Kumamoto/Tokyo/London 1977-78 (cat.78); Slovenj Gradec/Belgrade 1979/80 (cat.1); Madrid 1981 (cat.D42); Lisbon 1981 (cat.D42); Barcelona 1981-82 (cat.D37); Mexico City 1982-83 (cat.D9); Caracas

(cat.D9) 1983; Hong Kong 1986 (cat.D17); Tokyo/Fukuoka 1986 (cat.d18); Martigny 1989 (cat.p.102); Leningrad/Moscow 1991 (cat.13); Helsinki 1991 (cat.13); Sydney 1992 (cat.14); Budapest 1993 (cat.16); Bratislava/Prague 1993 (cat.16); Nantes 1996 (cat.12); Mannheim 1996-97 (cat.12); Havana/Bogotá/Buenos Aires/Montevideo/Santiago de Chile 1997-98 (cat.12)

publications: Wilkinson 1987, p.242; *Henry Moore: Complete Drawings*, vol.1 1916-29, AG 28.167

At a time when Moore modelled and carved many isolated female figures, reclining or vertical, he drew several women with children, seated and reclining. This is one of six drawings (HMF 680, 680a, 681, 681a, 682, 683) devoted to a reclining figure with baby, in which the woman is raised up, as here, on her right elbow and lying on her right hip and thigh, on which the baby sits as it sucks at her left breast. All show the group at different angles, suggesting the sculptor inspecting one model, or imagining one group, before embarking on

his carving. The inner relationships of the group are much the same in this sequence of drawings: for instance the woman looks in a similar direction throughout. The major variation shown is in the positioning of the left leg. Here it is lowered on to the right leg; in other drawings it is half or fully raised, leaving the planes of the two legs forming a right-angled space between them, and echoing the right angle presented by the woman's left elbow, sensed like a corner stone in the composition – and realised shortly afterwards in the Leeds **Reclining Figure** 1929 (LH 59).

Here Moore recognises the seated baby as a central right-angled element, emphasising this by means of additional scribbles and a brush dipped in the same ink. One senses his excitement at this discovery. It is possible also that he was in some doubt as to how to place the woman's left arm, holding the child, and the child in relation to the breast: he outlines the head in various positions. The right-angle idea required the child to be seated upright rather than leaning forward. In this drawing Moore accompanies the centred

large image with much smaller sketches of the same group, seen from different viewpoints. He was often to do this, echoing a central image with smaller marginal ones; this seems to be the first clear instance.

Given the unity of theme, it is remarkable that each of the six sheets of reclining women with children is drawn in a different manner. The media used are mostly ink and wash, sometimes with watercolour, but one drawing is done in crayon and another in chalk. Given also Moore's maturing taste for what in a drawing of 1929 (HMF 740) he calls 'Big powerful forms', it is striking that in these 1928 drawings, as in the 1929 carving, he achieves a total harmony, leaving no sense of exaggeration, least of all of violence. In 1926 he had instructed himself to 'Keep ever prominent the world tradition – the big view of sculpture'. The guiding vision behind his work at this stage, before he was to embark on a dizzying series of experiments in the early 1930s, brings together his awareness of Mexican, Egyptian, Greek and Renaissance sculpture, with Michelangelo's name and example

44

45

exhibitions: Madrid 1981 (cat.D38); Lisbon 1981 (cat.D38); Barcelona 1981-82 (cat.D33); Mexico City 1982-83 (cat.D14); Caracas 1983 (cat.D14); Martigny 1989 (cat.p.102); Leningrad/Moscow 1991 (cat.14); Helsinki 1991 (cat.14); Sydney 1992 (cat.15); Budapest 1993 (cat.17); Bratislava/Prague 1993 (cat.17); Krakow/Warsaw 1995 (cat.12); Venice 1995 (cat.12); Havana/Bogotá/Buenos Aires/Montevideo/Santiago de Chile 1997-98 (cat.13)

publications: Sotheby's, London 26 March 1980 lot 273; *Henry Moore: Complete Drawings*, vol.1 1916-29, AG 28.174

This drawing is reminiscent of the shelves of the maquette studio at Perry Green, with their rows of both related and unrelated objects and models. Usually Moore's drawings of sculptural ideas present rows of isolated forms inhabiting some kind of imaginary beach or undefined space. This drawing is rather more light and elegant, as his studio might be on a sunny day. The colouring is untypical and reminds me of the shimmering insides of some of the shells Moore collected.

By 1928 he was beginning to develop his reclining figure motif in stone and plaster, with small alert heads and rolling hill-like forms. It was also the year of his first one-man show in London. He sold thirty drawings for a pound each and was delighted when Epstein and Augustus John each bought one.

The famous holes that opened up the human figure had not yet appeared, so this drawing suggests the mountainous association of the figure and landscape rather than the cavernous aspects that were to develop later. The artist has used almost every possible graphic technique to help to separate the individual masses and to give depth as well as space to this surreal assembly of giants.

How wonderful it would be to be able to walk into this picture and to explore the secret passages behind these cool rocks and hills. Perhaps a virtual reality graphic computer could make this possible. It would be fun to try.

John Read

always as his lodestar. We are in the period that saw also the completion of Moore's first public commission, the **West Wind** (LH 58) figure in relief on the façade of the London Underground building at St James's, his first solo exhibition and his marriage to Irina Radetzky.

Norbert Lynton

44
Montage of Reclining Figures 1928
HMF 689
pencil, oil paint, watercolour, brush and ink, chalk, collage on white lightweight wove mounted on marbled brown-grey paper
303 × 567mm
signature: crayon l.l. *Moore*; l.r. *Moore*
Acquired 1980

45

Seated Nude 1929
HMF 702
pen and ink, brush and ink, charcoal, wash
on off-white lightweight wove
489 × 355mm
signature: chalk l.l. *Moore*; *Moore 29*; *Moore*
Acquired 1980

publications: Sotheby's, London 2 July 1980
lot 386; Wilkinson 1984, p.24, pl.50; *Henry
Moore: Complete Drawings*, vol.1 1916-29,
AG 29.15

46

Seated Woman 1929
HMF 707a
pencil, pen and ink, brush and ink, crayon,
wash on off-white heavyweight wove
430 × 372mm
signature: crayon u.l. *Moore/29*
Acquired by exchange 1991

exhibitions: Budapest 1993 (cat.18);
Bratislava/Prague 1993 (cat.18); Krakow/
Warsaw 1993 (cat.13); Venice 1993 (cat.13)
loans: London, Government Art Collection,
for 10 Downing Street 1997

publications: *Henry Moore: Complete
Drawings*, vol.1 1916-29, AG 29.24

Henry taught me about drawing, about the
way to draw. When I was with him I had
already been at the Royal Academy Schools
for about four years but I used to go into the
Royal Academy one day each week and
draw from the life model. Henry was very
keen about drawing; he said that one could
say so much in a drawing, one could
express ideas quickly, much more quickly
than making a sculpture. I never
understood what drawing for a sculptor
could really be. I worked in the old-
fashioned Drawing School at the Royal
Academy where we would sit on benches
raised in tiers around the sides of the
model. There was always a model posing. I
used to take the drawings back and the next
day Henry would criticise them. He taught
me in a very matter-of-fact way how to
realise a three-dimensional figure on a flat
sheet, how to give it weight.

His methods are evident in this
drawing. You can't draw the left side of a
rib-cage without drawing the right side as
well; you've got to realise the whole three-
dimensionally. That's true of Matisse's
drawings, even his line drawings. Moore's
way involved three laws to facilitate
expressing the solid on the flat surface of
the paper. First, perspective works when
drawing a figure just as it does in drawing a
landscape. What is closer to you is bigger.
You can see how he's made the leg and
hand big because they're closer to him.
Then also, just the same as with landscape,
what is closer is more intense, the blacks
blacker, the whites whiter. What is further

away is grey, the same as with a landscape
where the distant hills are grey, not sharply
black and white. Thirdly, and by far the
most difficult to grasp and realise, the
direction the light comes from is
exceedingly important and imposes a logic
to the drawing. There is a law of light, a
clear law of light, which says that whatever
is at right angles to the light source is going
to appear white and whatever is turned
away, in whatever direction, is going to be
dark. So if any part is turned away
completely it's going to be registered black,
just as whatever faces the source will be
white. In order for me to grasp this clearly
in my head he suggested that rather than

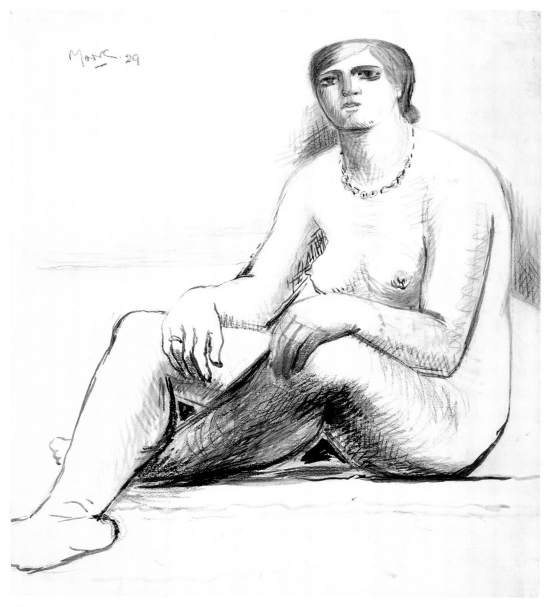

46

just taking where the light was coming from in nature I should invent a source of light for each drawing. He would say, 'Let's see, where is your light coming from?' and I'd answer, 'It's coming from forty-five degrees above my head on the right-hand side.' Then he'd say, 'Well, that hand will be white, that shoulder will be white, but this part must have been turned away more; so it doesn't make sense at present, it needs to be dark here.' You can see in this drawing he's drawing in just that way.

At the start drawing this way is quite difficult. It involves both understanding the body and what's happening within the model, and then understanding how to express that on the flat sheet. It's a good way for a sculptor to begin to get the grasp of drawing. One might ask why in this drawing does he make that black behind

the shoulder; the reason is that it forces the shoulder out from the background.

Before I went to Henry's, drawing for me was a pain, a dead worry because I couldn't visualise it in relation to sculpture. I thought I'll never enjoy drawing, but now even though I almost never draw this way any more, I love drawing. Before my time at Henry's I didn't like drawing because I didn't know what I was doing, trying to put this round thing on a flat surface. He taught me that.

Anthony Caro

47

Reclining Figure 1929
HMF 730
brush and ink, charcoal, chalk, collage
285 × 405mm
signature: pencil l.r. *Moore/29*
Gift of the artist 1977

exhibitions: Madrid 1981 (cat.D44); Lisbon 1981 (cat.D44); Barcelona 1981-82 (cat.D39); Columbus/Austin/Salt Lake City/ Portland/San Francisco 1984-85 (cat.88); Martigny 1989 (cat.p.103); Sydney 1992 (cat.16); Budapest 1993 (cat.19); Bratislava/ Prague 1993 (cat.19); Krakow/Warsaw 1995 (cat.16); Venice 1995 (cat.16)

publications: Garrould 1988, pl.16; *Henry Moore: Complete Drawings*, vol.1 1916-29, AG 29.55

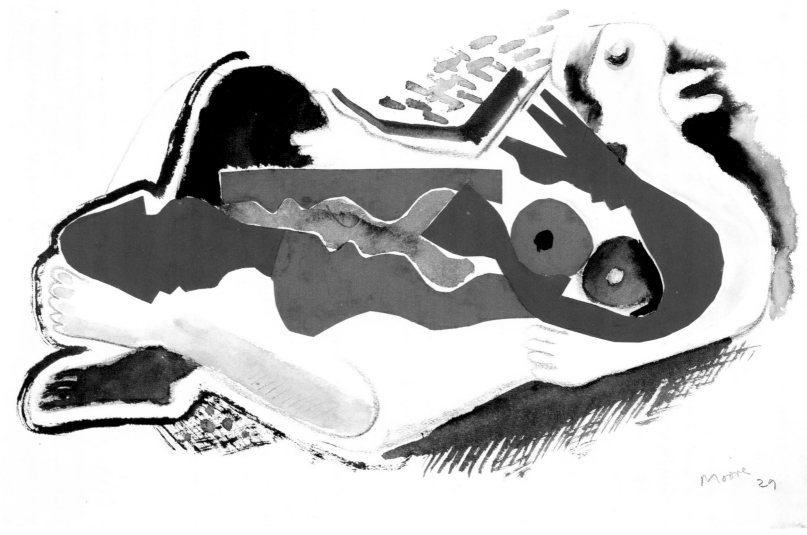

47

opposite: cat.48

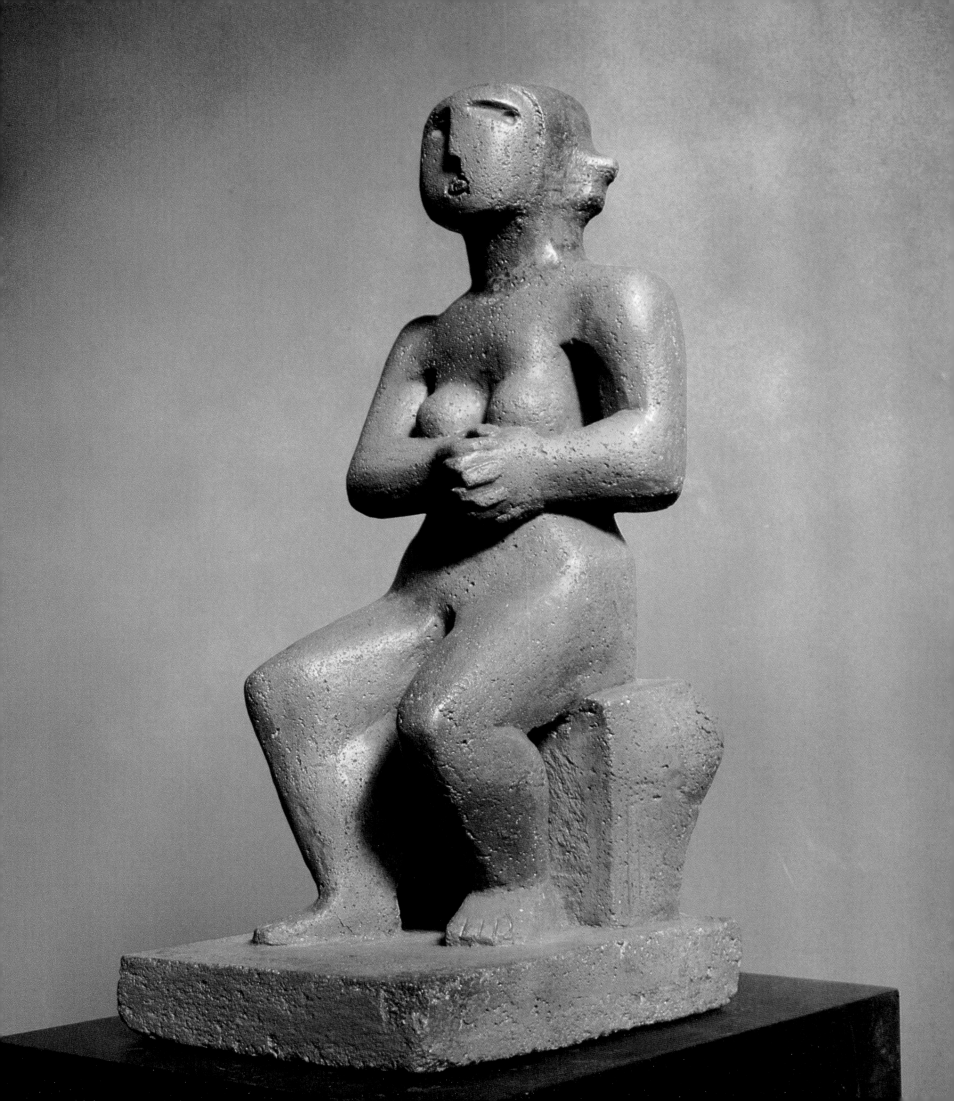

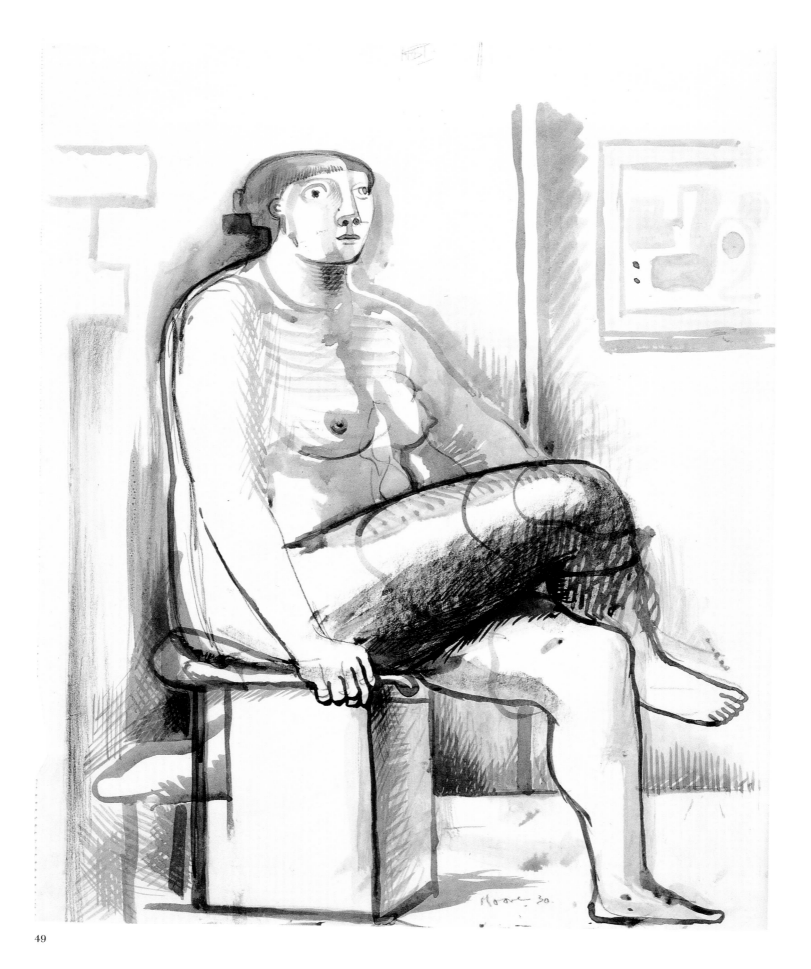

49

48

Seated Figure 1929
LH 65
cast concrete
height 44.5cm
unsigned
Gift of Irina Moore 1979

exhibitions: Madrid 1981 (cat.18); Lisbon 1981 (cat.22); Barcelona 1981-82 (cat.16); Mexico City 1982-83 (cat.4); New York 1983 (p.23); London 1984 (cat.2); New Delhi 1987 (cat.3); Budapest 1993 (cat.20); Bratislava/ Prague 1993 (cat.20); Krakow/Warsaw 1995 (cat.15); Venice 1995 (cat.15)

The numerous life studies Moore made in the 1920s of large-limbed, supple, seated females [cat.32, HMF 642, cat.45] soon evolved into a series of austere, stony statuettes of which this is one of the first and most powerful. The sculptor later spoke of striving continually 'to think of, and use, form in its full spacial completeness. He gets the solid shape, as it were, inside his head', just as 'the sensitive observer of sculpture must also learn to feel shape simply, not as description or reminiscence'.[1]

In the 1920s the changes needed to transform figure drawing into sculptural form were inspired by Moore's persistent study of Egyptian, archaic Greek and so-called primitive sculpture. As a student in Leeds in 1920 he had already noted the 'magnetised stillness' and 'hypnotic trance . . . giving an air of unchangeable, unchallengeable sovereignty' characteristic of Egyptian figure sculpture.[2] Of a Twelfth Dynasty limestone figure of Inyotef seen in the British Museum, similarly posed to the present work, he observed perceptively: 'The whole figure has the stillness I particularly associate with the Egyptians, a stillness of waiting, not of death'.[3] The powerfully clasped hands are like those found in Mesopotamian statues, such as the one illustrated on the cover of the June 1935 issue of *The Listener* accompanying Moore's review of Christian Zervos's *L'Art de la Mésopotamie*. He turned this occasion to good use as propaganda for his own Modernist approach: Sumerian sculpture 'has a bigness and simplicity with no

decorative trimmings . . . Their sculpture in the round is still and static, no physical movement or action is attempted, for one of the essential facts about a block of stone is its weight and immovability.'[4] On the other hand, the multiple viewpoints of the head, with eyes and mouth frontal, nose profiled and hair-bun repositioned as an outcrop on the left temple, a device Moore used in several other sculptures of about the same date, was recognised at the time for what it was: 'curious Cubistic heads, curiously fascinating'.[5]

Moore's choice of an unconventional material, cast concrete – a building construction technique here turned to the resources of Modernist sculpture – allowed him to exploit his innovative ideas in new, unheard of ways. Dark brown pigment was mixed in the wet concrete, giving the sculpture a decisively unclassical look and isolating it from the unblemished whiteness of marble so beloved by his hidebound contemporaries.

Terry Friedman

1. 'The Sculptor Speaks', *Listener*, 18 August 1937, quoted in James (ed.) 1966, pp.62-3; 1992, pp.65-67.
2. Henry Moore, 'History of Sculpture Notes', 1920, p.45v (Leeds City Art Gallery archives).
3. Moore 1981, p.35.
4. Henry Moore, 'Mesopotamian Art', *Listener*, 5 June 1935, p.945; reproduced in *Henry Moore: Complete Sculpture*, vol.1, Lund Humphries, London 1990, pp.xxxi-xxxiii.
5. *Home Notes*, London, 3 March 1928.

49

Seated Nude 1930
HMF 771
brush and ink, charcoal, wash on cream lightweight wove
426 × 340mm
signature: crayon l.c. *Moore 30*
inscription: pencil u.c. *NOT* [crossed through]
Gift of the artist 1977

exhibitions: Toronto/Iwaki-Shi/Kanazawa/ Kumamoto/Tokyo/London 1977-78 (cat.48); Madrid 1981 (cat.D26); Lisbon 1981 (cat.D26); Barcelona 1981-82 (cat.D22); Martigny 1989 (cat.p.104); Leningrad/ Moscow 1991 (cat.18); Helsinki 1991

(cat.18); Budapest 1993 (cat.22); Bratislava/ Prague 1993 (cat.22); Krakow/Warsaw 1995 (cat.17); Venice 1995 (cat.17); Nantes 1996 (cat.14); Mannheim 1996-97 (cat.14); Havana/Bogotá/Buenos Aires/Montevideo/ Santiago de Chile 1997-98 (cat.16)

publications: Wilkinson 1984, p.24, pl.49

Once or twice I tried Henry's idea of contouring the lines, making contours go round the body or round a leg or an arm. It helped I think to identify the figure in a sculptural way. This is an example of that technique. That leg is really sculptural, three-dimensional. I didn't want to do it in the end, but it certainly expresses what is going on in the figure. I've got a lot of student drawings of mine where he's drawn at the side, little drawings showing me how I should have done it. He grasped the pose and showed me how to express it even though he hadn't seen the model. He took immense trouble with me; he'd say, 'This is obviously what the model is doing; why isn't your drawing showing that? This is what it should look like, this space should be dark in there, mysterious.'

When I think back I'm amazed by how much time and trouble Henry took over me. I wanted to learn, I really wanted to learn from him. I learned more in the two years I was there than in the five years I spent at the Royal Academy Schools. Henry took trouble with me because he could see I was there in order to learn everything I could. Sculpture was beginning to flow through my veins. I listened hard to Henry. I really paid attention to him in a way I hadn't felt justified in paying attention to the professional sculptors, the Royal Academicians, who came to teach at the Royal Academy. Here was somebody who talked about things in sculpture, in art, in life in a way that struck a chord, rang a bell.

That's the really important aspect of Henry as my first real teacher of art. I wasn't sure that I liked all his work, but it wasn't easy like, say, Charles Wheeler's or Hardiman's. There was something compelling in Henry's conviction, maybe even the fact that I didn't like all his work and some of it gave me trouble, that made me look all the harder. I felt more

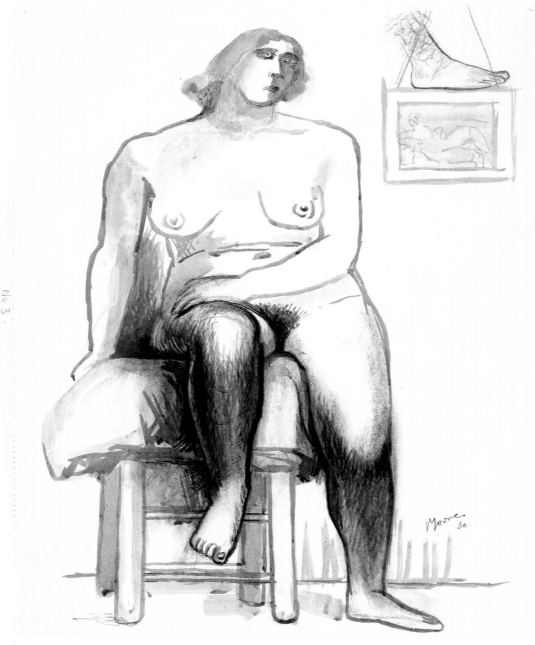

50

Seated Figure 1930
HMF 778
pen and ink, brush and ink, charcoal, wash
on off-white wove
427 × 399mm
signature: pen and ink l.r. *Moore/30*
Gift of the artist 1977

exhibitions: New Delhi 1987 (cat.9)

publications: Wilkinson 1984, p.25, pl.55

This is a largely monochrome drawing in
which a greyish-brownish wash is
overdrawn with finer, darker lines floating
over the wash and making it descriptive.
The use of a variety of media in drawing
was important to Moore, who asserted that
the sculptor should be as concerned with
space in a drawing as the painter: the
drawn subject should appear to have a 'far
side' to it. 'Any wash, smudge, shading,
anything breaking up the tyranny of the flat
plane of the paper opens up a suggestion, a
possibility of SPACE.'[1] This attitude is
apparent most clearly in the substantial
shadows, behind the left arm and under the
seat, which have a degree of modelling. To
try to model shadow is also to model space,
very much the device of a sculptor.

As with some other life drawings in the
Foundation's collection, it is important to
see these pieces as working drawings. This
is apparent in the quick study of a foot,
comically perched on the picture frame. Yet
even so, when Moore's life figures take on a
more realistic and individual air, the
disturbance of the viewer is likely to
increase. In this drawing a domestic space
is indicated, particularly with the picture
containing a crude pencil drawing of a
female reclining figure. In the seated figure
itself fragility, not stoniness, is suggested in
the uncertainty of the line and the sketchy
modelling created by the wash, especially
in the area of the shoulders and breasts.
Although the head is turned as if in a ʻ
gesture, the face is a total blank with the
eyes fixed dead ahead. Moore's main
interest is evidently elsewhere, however, as
is easily judged by the variability in density
and detail of the lower and upper parts; his
focus is on the legs and the area between

challenged around Moore than I ever had
before. Throughout life one goes on trying
to find the next challenge, and my time at
Much Hadham came at exactly the right
moment for me. Nothing in the studio was
mechanical. And when we broke for tea and
went into the house or when I drove him to
London or back to Hadham, Henry would
talk about his experiences, or what he
liked, or ask me questions about what I
liked in art. It was always stimulating. It
was just as if my mind were starting, as if
the wheels were starting to grind. I think

Henry saw me as somebody who wanted to
grow from being around him and he was
very willing to open the doors of his
experience, his knowledge to me.

Anthony Caro

them, and such an emphasis is seen again and again in his life drawings.

Since Moore's concerns are in large part formal, the female figure's display as spectacle, certainly as a creature of flesh or as a sexual object, is limited. This outlook is in conflict with the slight signs that we are dealing here with the portrayal of an individual, seated in a particular space, with a particular hairdo and physiognomy. The tension was frequently felt by Moore's later and wider public who insisted on reading his figures literally, as if he were distorting and disfiguring actual flesh, actual persons, in his drawings and sculpture. Such readings were not simply stupid or ill-informed, but had fixed on a genuine ambiguity which runs throughout the work.

Julian Stallabrass

1. Cited in Felix H. Mann, *Eight European Artists*, London 1954; reproduced in James (ed.) 1966, p.149; 1992, p.151.

51
Seated Figure 1930
HMF 782
brush and ink, oil paint, pastel, charcoal, wash on white lightweight wove mounted on marbled brown-grey paper
513 × 367mm
signature: pencil l.r. *Moore/30*
Gift of the artist 1977

exhibitions: Madrid 1981 (D27); Lisbon 1981 (cat.D27); Barcelona 1981-82 (cat.D23); Martigny 1989 (cat.p.104); Nantes 1996 (cat.15); Mannheim 1996-97 (cat.15); Havana/Bogotá/Buenos Aires/Montevideo/Santiago de Chile 1997-98 (cat.17)

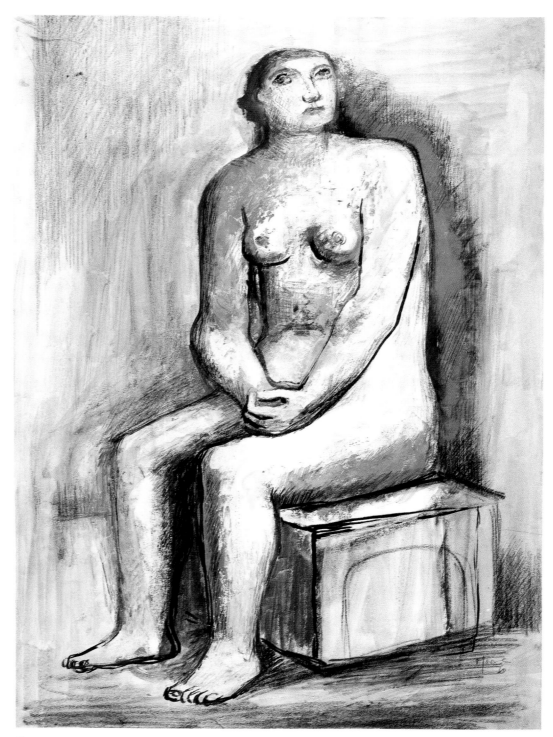

51

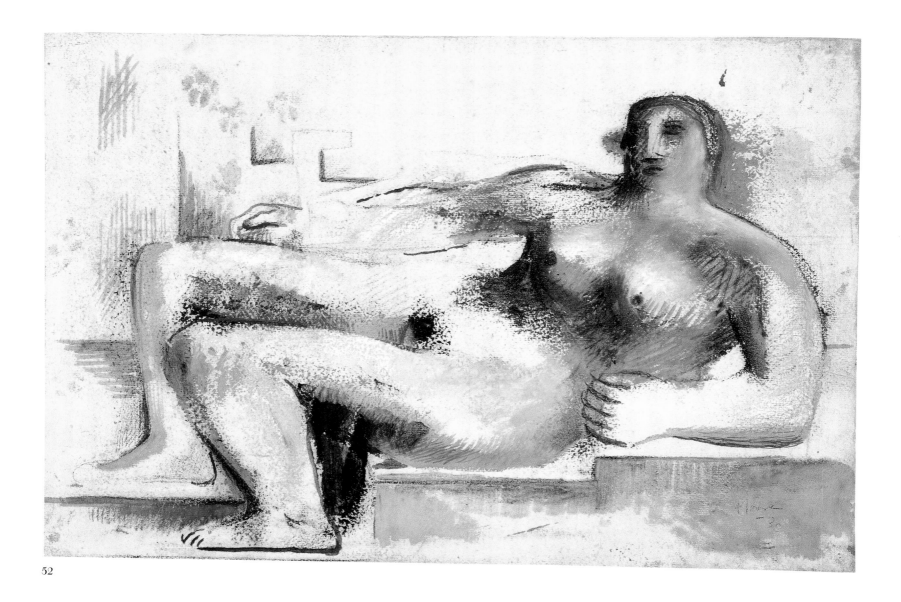

52

52
Figure on Steps 1930
HMF 784
oil paint, chalk, watercolour, wash on
cartridge
372 × 549mm
signature: chalk l.r. *Moore/30*
Acquired 1980

exhibitions: Madrid 1981 (cat.D43); Lisbon
1981 (cat.D43); Barcelona 1981-82
(cat.D38); Mexico City 1982-83 (cat.D13);
Caracas 1983 (cat.D13); London 1988
(cat.67); Paris 1989

publications: Sotheby's, London 5 March
1980 lot 167

53-54
No.1 Drawing Book 1930-31
HMF 823-833
Grey-green paper covered notebook
originally containing one signature of
cream lightweight wove paper attached to
the cover by two staples. The cover has the
words THE JUNIOR /DRAWING BOOK/NAME:/
PHILIP & TACEY, LTD., LONDON, S.W.9 printed
in dark grey within a square cartouche
across the centre of the front and *KM/1930-
31* in pencil in the artist's hand upper right.
The pages, measuring 162 × 201mm, are
unnumbered and many are missing; nine
pages HMF 824-HMF 832, remain intact and
two others HMF 823 and HMF 833 have
been allocated to the notebook.
Gift of the artist 1977

53
Study of a Suckling Child 1930-31
Page from No.1 Drawing Book
HMF 831
pencil
unsigned, undated
inscription: pencil u.c. *Child suckling/&
Animal/& portion of figure/reclining*

verso
Animal Form 1930-31 [not illustrated]
pencil
unsigned, undated

publications: Wilkinson 1984, p.270, pl.162

This is the third of five studies which Moore used in preparation for his sculpture **Composition** (LH 99) carved in green Hornton stone in 1931. These five sketches marked a breakthrough for the artist in that for the first time he opened up his biomorphically condensed use of forms, which he discovered after 1928, to produce a phantasmagorical world of expression. In the metamorphic interworld that exists in the portrayal of man and beast, his mother and child theme is loaded with a new and startling energy. That is not all, however: in **Composition**, Moore responds to Picasso's 'biomorphic designs' (Alfred Barr) from 1928-31 with his astonishing compression of shape. With its enigmatic exoticism this piece enabled him, like Picasso, to present a perfect example of a biomorphic organism seen from all angles.

The gift of this compression did not just come to Moore in a sudden flash of inspiration, however, it was worked into his drawings in stages. This shaping process seems – both from behind and from the front – to be concentrated in important components in the third sketch: here we can see the motif of the ever-present torso, its legs depicted like pegs, and the hypertrophied breasts, dominated by the portrayal of the suckling child in two fragmented views. Although this theme is not incorporated in the sculpture in this manner, the artist intended it to express its true vitality. This is also evident from the order in which the words in the title appear: 'Child suckling & Animal & portion of figure reclining'. He was clearly fascinated by the interaction of the little head greedily suckling at the breast of the mother, that is to say the giving and receiving in the encounter between two spherical forms as a living, three-dimensional motif *par excellence*.

For Moore, this dialogue of forms is not abstract. Indeed, he sees the act of the mother giving milk and the child receiving it as a fundamental event which forms the basis of all life. In order to give expression to this encounter, he raises and transposes it, lending it an 'animal' character by allowing a sort of bird's head to envelop the breasts on the left, and so preparing the groundwork in the unequal tête-à-tête between the beak-shaped head and the

53 recto

54 recto

head of the mother for his future sculptures in stone. Having worked with metamorphosis in this sense, Moore (in the moral tradition of drawing) uses *e contrario* to portray extensions of the human *figure*. His 'Transformation drawings' later channelled this interest into the pure content of transformations which are autonomous in form.

This drawing confirms what Moore was to make clear three years later when he said: 'It might seem from what I have said of shape and form that I regard them as ends in themselves. Far from it. I am very much aware that associational, psychological factors play a large part in sculpture . . . Each particular carving I make takes on in my mind a human or occasionally animal, character and personality, and this personality controls its design and formal qualities, and makes me satisfied or dissatisfied with the work as it develops.'

Christa Lichtenstern

54
Ideas for Composition in Green Hornton Stone 1930-31
Page from No.1 Drawing Book
HMF 832
pencil
signature: pencil l.l. *Moore/30*

verso
Ideas for Sculpture 1930-31
[not illustrated]
pencil
unsigned, undated

exhibitions: Toronto/Iwaki-Shi/Kanazawa/Kumamoto/Tokyo/London 1977-78 (cat.88); Madrid 1981 (cat.D66); Lisbon 1981 (cat.D66); Barcelona 1981-82 (cat.D54); Mexico City 1982-83 (cat.D23); Caracas 1983 (cat.D23); London 1988 (cat.70)

publications: Wilkinson 1984, pl.163, 164

Moore added a signature and date to this study[1] to draw attention to the sketch for **Composition** 1931 (LH 99). A clue to the interpretation of this apparently non-representational sculpture is Moore's

evident fascination with infants clamped to the breast, for this drawing itself includes three, and cat.53 two more. On another sheet in the same sketchbook (HMF 836) Moore tried out more conventional ideas, though the resulting Burgundy stone **Mother and Child** 1930 (LH 100) shows that he rejected the example of nineteenth-century precursors such as Dalou[2] who had sentimentalised the mother nursing her baby.

Moore approached the subject in essence rather than concentrating on the literal appearance; he preferred to draw out the complex psychology of the relationship. In both this and cat.53 he omitted the mother's head and most of her body, reducing the maternal torso to a freely shaped, pliable form with an infant attached to a nipple – its unformed body like a thin encrustation on the rounded breast.

These strange half-human babies seem freely derived from Moore's sketches in early notebooks, such as a bird swallowing an egg (HMF 129) which inspired the top element of the drawing for **Composition** (LH 99), a bird's head. Although in the finished sculpture such detail has gone, the juxtaposition of drawings of suckling infants on the same sheet does suggest that Moore

found inspiration in the natural world for his unusually non-representational sculpture.

Susan Compton

1. HMF 832 was originally shown the other way up: see the reproduction of the unsigned drawing in the exhibition catalogue *Henry Moore*, Otterlo/Rotterdam 1968 (unpaginated).
2. Aimé-Jules (Jacques) Dalou (1838-1902), *Peasant Woman Nursing a Baby*, terracotta, h.125cm, in the Victoria and Albert Museum, London. This popular sculpture was no doubt known to Moore, as students at the nearby Royal College of Art were expected to copy works of art in the museum.

55
Reclining Figure 1930
LH 85
bronze edition of 1 + 1
cast: 1962
length 17.1cm
unsigned, [0/1]
Gift of the artist 1977

exhibitions: Paris 1977 (cat.6); Bradford 1978 (cat.45); Madrid 1981 (cat.117); Lisbon 1981 (cat.51); Barcelona 1981-82 (cat.97); Mexico City 1982-83 (cat.99); Caracas 1983

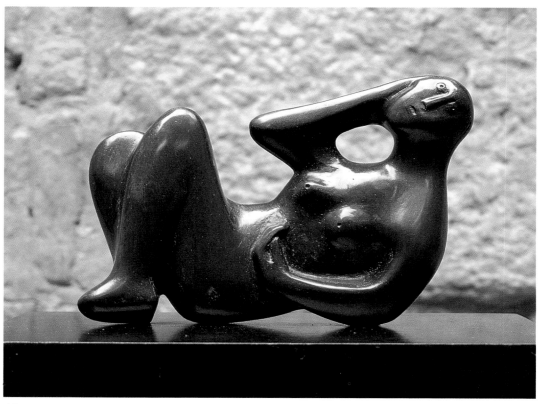

55

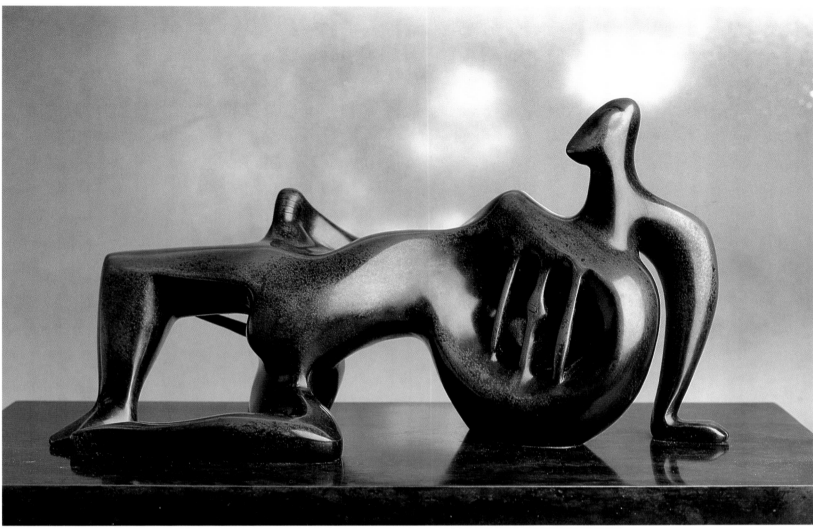

56

(cat.E84); Columbus/Austin/Salt Lake City/Portland/San Francisco 1984-85 (cat.2); London 1987 (cat.22); New Delhi 1987 (cat.6); Martigny 1989 (cat.p.105); Leningrad/Moscow 1991 (cat.22); Helsinki 1991 (cat.22); Sydney 1992 (cat.19); Budapest 1993 (cat.26); Bratislava/Prague 1993 (cat.26); Krakow/Warsaw 1995 (cat.16); Venice 1995 (cat.16); London 1996; Havana/Bogotá/Buenos Aires/Montevideo/Santiago de Chile 1997-98 (cat.14)

The reclining figure, essentially the female figure, half-reclining with knees raised and upper body turned and resting on one or both arms, emerged as a staple of Moore's sculpture at some point in the later 1920s. The initial stimulus, or at least the experience that had released it from the latent imagination – for there is a drawing as early as 1921 that hints at the idea – had been his seeing in reproduction the *Chacmool* rain god [see cat.6].

By 1930, when this small figure was carved, Moore had already made several substantial essays upon the theme, all of them also carvings, for he was to take to modelling only much later in his career. Most notable of these was the brown Hornton stone version of 1929 (LH 59), now at Leeds, one of his largest works to date. Already the character was set. These were never to be masculine figures. The implacable male god had been immediately and intuitively transformed into an image more general, unhieratic and benign, as a simple function of the softer, rounded forms that came with the change of sex, and the humanising informality of the relaxed and turning body. These self-same qualities are to be found in all Moore's drawings of this period.

Barely one year on, this particular figure marks yet a further shift in character, at once more improvisatory and experimental. Even when cast in bronze, the image, especially in its constriction about its lower half, still carries the sense of being adapted to a given piece of stone rather than ordered and designed. There is a playfulness to it and an inconsequentiality, as though the point was simply to see what would come out of it, or what could be made of it.

Here we have the artist, unconstrained by the responsibilities of any larger mass and weight of stone, playing openly with the Surrealist ideas of exaggeration and distortion that were so much the avant-garde currency of the day. At the same

time, and perhaps for the very first time, we find him making more formal and abstract experiment with the piercing and opening out of the form. Here indeed we are with him when, almost by the by, and with but a small and handy piece of stone, he reaches a most critical point in his development, of the most far-reaching consequence. Such are the factors and creative tensions that give this small object its peculiar imaginative force.

William Packer

56
Reclining Figure 1931
LH 101
bronze edition of 6
cast: 1963
length 43.2cm
signature: stamped *Moore, 6/6*
Gift of the artist 1977

exhibitions: Bradford 1978 (cat.17); Madrid 1981 (cat.13); Lisbon 1981 (cat.80); Barcelona 1981-82 (cat.98); Mexico City 1982-83 (cat.91); Caracas 1983 (cat.E103); Columbus/Austin/Salt Lake City/Portland/San Francisco 1984-85 (cat.4); Leeds 1986 (cat.140); New Delhi 1987 (cat.10); Paris 1989; Strasbourg 1989-90; Mexico City 1990; Leningrad/Moscow 1991(cat.23); Helsinki 1991 (cat.23); Sydney 1992 (cat.21); Budapest 1993 (cat.28); Bratislava/Prague 1993 (cat.28); Krakow/Warsaw 1995 (cat.22); Venice 1995 (cat.22)

Surrealism was one of the most important stimuli, besides primitive cultures, for the young Moore. In 1931, the year that he created this sculpture (cast originally in lead and about thirty years later in bronze), he also held his second London exhibition, at the Leicester Galleries. It is interesting to note that Jacob Epstein, in his introduction to the catalogue, predicted without reservation that Moore would become a seminal figure for British sculpture.

With his new wife Irina Radetzky, Moore moved to a small house in Parkhill Road in Hampstead, near the studios of Barbara Hepworth and Ben Nicholson. This trio of artists, later joined by the art critic

Herbert Read, shared many of the emergent ideas about Modernism infiltrating British culture at the time: not oniy Primitivism and Surrealism, but also the art of antiquity, the subsequent desertion of the neo-classical tradition, and then the first signs of abstraction. The resulting tumultuous but fertile union was to trigger an extraordinary phenomenon in the history of British twentieth-century art.

For the first time, with this sculpture, Moore engaged in the technique of thinning out one part of the figure in a game of philiforms and parallels. This process was to ripen into the stringed figures common to both himself and Hepworth. In the stringed figures Moore produced between 1937 and 1940 there were times when the ropes and strings used during casting appeared to have been incorporated into the bronze.

It may be that the stringed figures idea was associated with musical instruments, but the theme was linked to the scientific models seen by Moore in the Science Museum in South Kensington,[1] and perhaps also to the works of the Russian Constructivists Antoine Pevsner and Naum Gabo. Gabo, who had moved to London in 1936, greatly admired the first of the stringed relief pieces made in beechwood [see cat.93] which he saw in Moore's studio.

This **Reclining Figure** is one of Moore's first abstract–organic compositions, showing the artist's gradual transformation from realistic figuration to a style embodying a formal, free profile, partly indebted to Brancusi and Arp, but at the same time sensitive to the anthropomorphic mimesis of Surrealism. Interestingly, the work of Alberto Giacometti was undergoing the same process at the time.

Giovanni Carandente

1. Moore admitted this himself when talking of his visits to the Science Museum and of his admiration for the hyperbolic parabolas of the mathematical models by Joseph Luis Lagrange (1736-1813). See Carlton Lake, 'Henry Moore's World', *Atlantic Monthly*, Boston, January 1962, reproduced in James (ed.) 1966, p.209; 1992, p.223.

57
Composition 1931
LH 102
Cumberland alabaster
length 41.5cm
unsigned
Gift of Irina Moore 1979

exhibitions: Madrid 1981 (cat.154); Lisbon 1981 (cat.26); Barcelona 1981-82 (cat.20); Mexico City 1982-83 (cat.8); Caracas 1983 (cat.E5); Hong Kong 1986 (cat.8); Tokyo/Fukuoka 1986 (cat.162); London/Stuttgart 1987 (cat.194); New Delhi 1987 (cat.13); London 1988 (cat.16); Martigny 1989 (cat.p.109); Leningrad/Moscow 1991 (cat.26); Helsinki 1991 (cat.26); Sydney 1992 (cat.22); Budapest 1993 (cat.29); Bratislava/Prague 1993 (cat.29); Krakow/Warsaw 1995 (cat.23); Venice 1995 (cat.23); Nantes 1996 (cat.18); Mannheim 1996-97 (cat.18); Havana/Bogotá/Buenos Aires/Montevideo/Santiago de Chile 1997-98 (cat.18)

Moore's **Reclining Figure** (LH 59) in Leeds, widely regarded as his first masterpiece, was made in 1929. There followed years of experiment, stylistic and technical, taking him into abstraction and Surrealism, and bringing him some success though times were hard after the 1929 crash. In 1931 he had his second solo exhibition – his first at the prestigious Leicester Galleries – which Epstein backed with an intelligently supportive statement, ending: 'For the future of sculpture in England, Henry Moore is vitally important.' The Museum für Kunst und Gewerbe in Hamburg bought a stone **Head**, Moore's first museum purchase. Herbert Read, a new voice in English art writing, reviewed the exhibition in *The Listener*, placing Moore at 'the head of the modern movement in England', and reiterated his praise the same year in *The Meaning of Modern Art*. Also in 1931 Moore became an integral part of two artistic circles by joining the staff of Chelsea School of Art and by moving into south Hampstead, close to Ben Nicholson and Barbara Hepworth in a creative enclave that soon included Read himself, as well as the artists F.E. McWilliam and Roland Penrose, the writers Adrian Stokes and Geoffrey Grigson, and such

opposite: cat.57

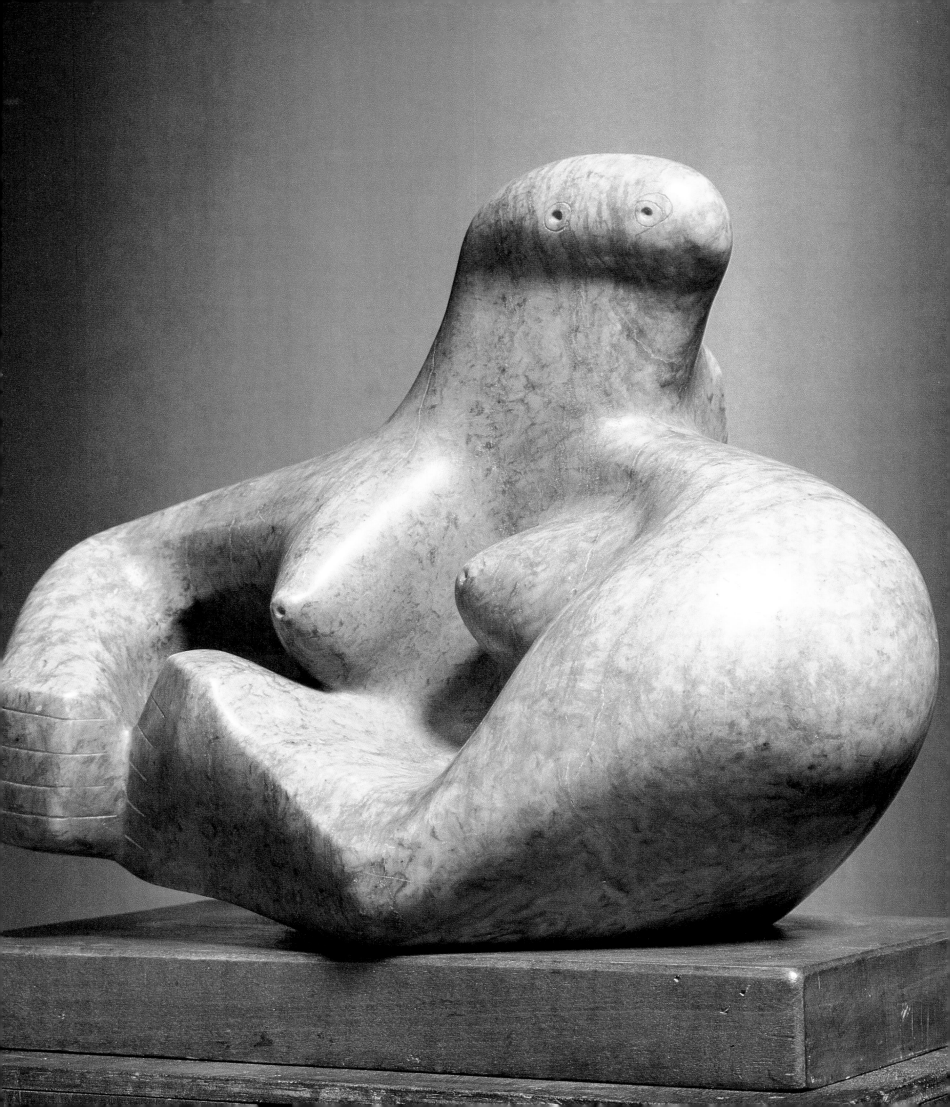

eminent foreigners as Walter Gropius, László Moholy-Nagy, Naum Gabo and Piet Mondrian. Moore also joined the Seven and Five Society which Nicholson was shortly to reform into an avant-garde group, and the short-lived and small but significant group of painters, sculptors and architects, Unit One, formed by Paul Nash.

Moore was thus launched into a turbulent stream of artistic adventure with close links to the Continent. The advance of Fascism would soon give a political edge to its activities. For the moment he was still wrestling with artistic issues and their everyday human connotations. **Composition**, carved in the soft alabaster so important to sculptors in medieval and Renaissance England, is exceptionally fluent in form. The vertical nude female half or three-quarters figure had of course been a central theme for Moore in the 1920s. The female nude, represented for a wide range of purposes and in styles ranging from naturalism to near-abstraction, dominated Western sculpture in the 1920s to what can now seem a ludicrous extent, in terms of both output and public reception. Stanley Casson[1] tacitly draws attention to this. None of the sculptors discussed by Casson chose to call figures 'Composition', not even those, such as Archipenko, intent on radical abstraction. Moore's use of this title, repeatedly in 1931-33 but not before, may well have come out of discussions with his Hampstead friends, since Nicholson used it in 1933. It emphasises 'the relation of masses' which, according to Epstein,[2] was the true concern of sculpture, implying a desire in Moore to distance his work from more directly representational sculpture. After 1931 the reclining figure becomes dominant, and his vertical figures tend to be severely abstracted.

Here we have a moment of balance. The delicate breasts recall those which the Leeds **Reclining Figure** presents between her massive arms. Here too masses enshrine these softer forms, shoulders and arms forming a sort of harbour and giving a marked sense of enclosed space though the left arm remains attached to the torso. A child might rest there . . . and does so in other Moore sculptures around that time,

as for example in the tiny **Mother and Child** 1929 (LH 75), which in formal respects is a clear precursor of this **Composition**. Hands are indicated by means of incised lines, very rare in Moore's previous work but a major element in Nicholson's and then also in Hepworth's work of this time. The tilt of the figure gives it an air of spontaneity. Incised lines surround drilled eyes, the only facial features in the minimal head. Moore's heads shrink dramatically around 1931. There is no stated reason. He had the example of Picasso[3] and perhaps also of Max Ernst to take him this way, but probably also some doubt about the role of the head in his own work – and perhaps in the work of his contemporaries, such as Dobson, whose figures tend to show appealing bodies or dynamic grouped masses topped by vacant, even inane faces. The masks and heads Moore had been carving tend to an effect of alertness, often reinforced by the turn of the head. This can carry too much significance and detract from the impact of the whole. As his ability to communicate feeling through what he would later call 'universal forms' became clearer to himself, he needed to avoid distractions and force attention on the general play of masses and voids. The motif of clasped hands appears repeatedly in Moore's carvings of 1929 and 1930, suggesting sometimes the pose of a singing woman. A drawing ascribed to 1925 **Ideas for Sculpture: Standing Nudes with Clasped Hands** (HMF 361) shows seven such figures, heads turned to the right and hands clasped in front of their middles in what I will call the praying manner, meeting symmetrically, with the fingers entwined. Other positions include that of the **Girl with Clasped Hands** 1930 (LH 93) whose two hands meet at right angles to each other and one hand lies across the other, and that of the concrete **Half Figure** 1929 (LH 67) whose hands meet fingertips of one to heel of the other. In both these instances the elbows are some distance from the body and the torso is open for deep, controlled breathing, which is why this reminds me of a time-honoured position taken by singers. It always emphasises the breasts and it can give arms

an active role, including that of sheltering a child; perhaps it calls for a child where there is none.

Norbert Lynton

1. Stanley Casson, *XXth Century Sculptors*, Oxford University Press, 1930. Of its thirty-four illustrations twenty-six are of female nudes, mostly by themselves, sometimes as Europa plus bull, as a dryad plus centaur, etc. Many of these are vertical figures, whole or partial, and generally they are girlish. Casson was neither frivolous nor a reactionary. His judgements come from experience and study, including study of Greek sculpture. His preference for carved over modelled sculpture is striking. So is his simple association of the female nude, even when radically abstracted, with beauty, and his basic assumption that art's prime purpose is to deliver beauty. This theme is stated most clearly when he opposes Jagger's war memorial at Hyde Park Corner to Maillol's monument to Cézanne: the former will be 'meaningless' soon, 'in those happy years of the future, when guns and howitzers are forgotten', whereas Maillol's mighty nude will always be beautiful and admired. This arises out of discussion of Dobson's plaster sketch of a large and a small nude proposed for a Welsh National War Memorial and rejected in 1923.
2. *Catalogue of an Exhibition of Sculpture and Drawings by Henry Moore*, Leicester Galleries, London 1931.
3. It has been said more than once that **Composition** reflects the influence of a Picasso sculpture illustrated in a 1929 issue of the Paris journal *Cahiers d'Art*. See Manfred Fath in Allemand-Cosneau, Fath, Mitchinson 1996, p.25.

58
Seated Figures 1931
HMF 874
pen and ink, crayon, watercolour on cream medium-weight wove
374 × 273mm
signature: pencil l.r. *Moore/31*
Gift of the artist 1977

exhibitions: Toronto/Iwaki-Shi/Kanazawa/ Kumamoto/Tokyo/London 1977-78 (cat.90); Bonn/Ludwigshafen 1980 (cat.35); New York 1983; Hong Kong 1986 (cat.D25); Tokyo/Fukuoka 1986 (cat.d27)

publications: Read 1979, p.57

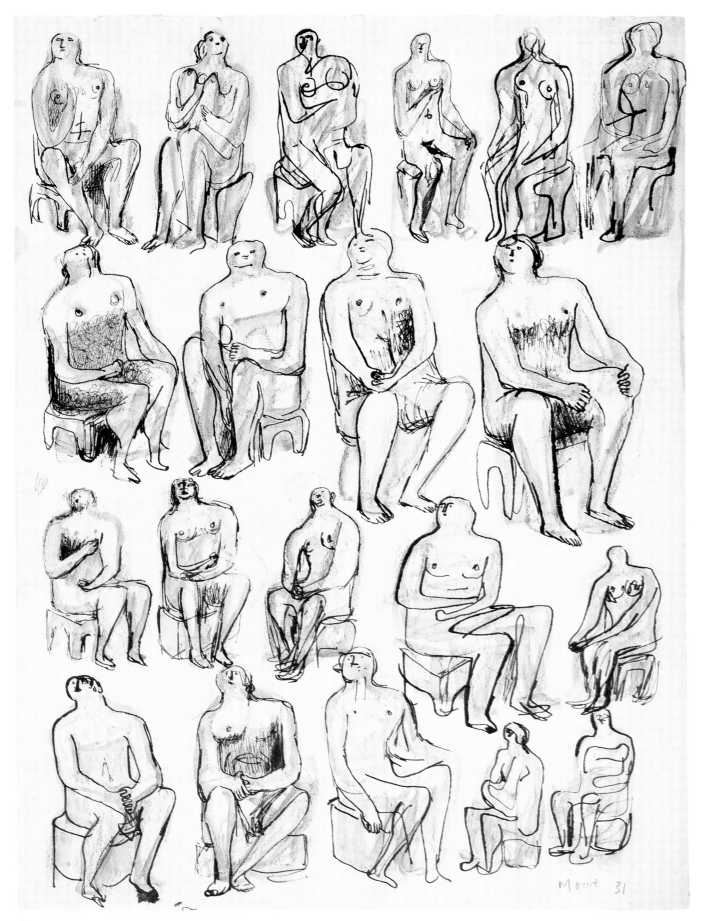

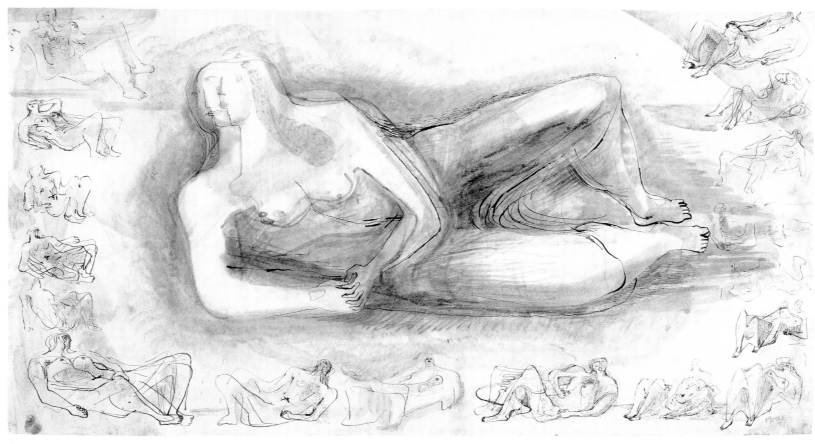

59

59

Reclining Figure 1933
HMF 995
pen and ink, charcoal, wash on
medium-weight off-white wove
310 × 559mm
signature: pencil l.r. *MOORE/33*
Acquired by exchange 1981

exhibitions: Madrid 1985 (cat.D39); Lisbon
1981 (cat.D39); Barcelona 1981-82
(cat.D34); Columbus/Austin/Salt Lake
City/Portland/San Francisco 1984-85
(cat.92); Paris 1989

60

Seated Mother and Child 1933
HMF 1001
pen and ink, brush and ink, charcoal,
pastel, watercolour, wash on cream
medium-weight wove
556 × 374mm
unsigned, undated
inscription: pencil u.c. *Page of seated
mother & child/*; c.r.vertically *New* [crossed
through]/*2" cream mount all round 2¼ at
bottom/New frame Thin ½ plain wood
frame*
Gift of the artist 1977

exhibitions: Martigny 1989 (cat.p.111);
Leningrad/Moscow 1991 (cat.24); Helsinki
1991 (cat.24); Sydney 1992 (cat.27);
Budapest 1993 (cat.30); Bratislava/Prague
1993 (cat.30); Krakow/Warsaw 1995
(cat.24); Venice 1995 (cat.24); Nantes 1996
(cat.23); Mannheim 1996-97 (cat.23);
Havana/Bogotá/Buenos Aires/Montevideo/
Santiago de Chile 1997-98 (cat.21)

The mother and child theme was a
fundamental obsession throughout Moore's
life. The austere, frontal poses
characteristic of his first forays, in the
1920s, loosened up in the following decade
as he came to realise that it was 'no longer
necessary to close down and restrict
sculpture to the single (static) form unit.
We can now begin to open out. To relate
and combine together several forms of
varied sizes, sections and directions into
one organic whole.'[1]

In this moving and elegant drawing,
with its rhythmically curving forms
softened by warm tones of washed pastel,
the delicately drawn baby is cradled in its
mother's tenderly encircling arms as if still
ensconced unborn in her womb. Moore had
experimented with this idea in an earlier
drawing [cat.43], but here there is 'a great
feeling of maternal protectiveness', to use
his own, compelling description of a tiny,
carved wood North American Nootkan
mother and child group he had admired in
the British Museum and sketched in

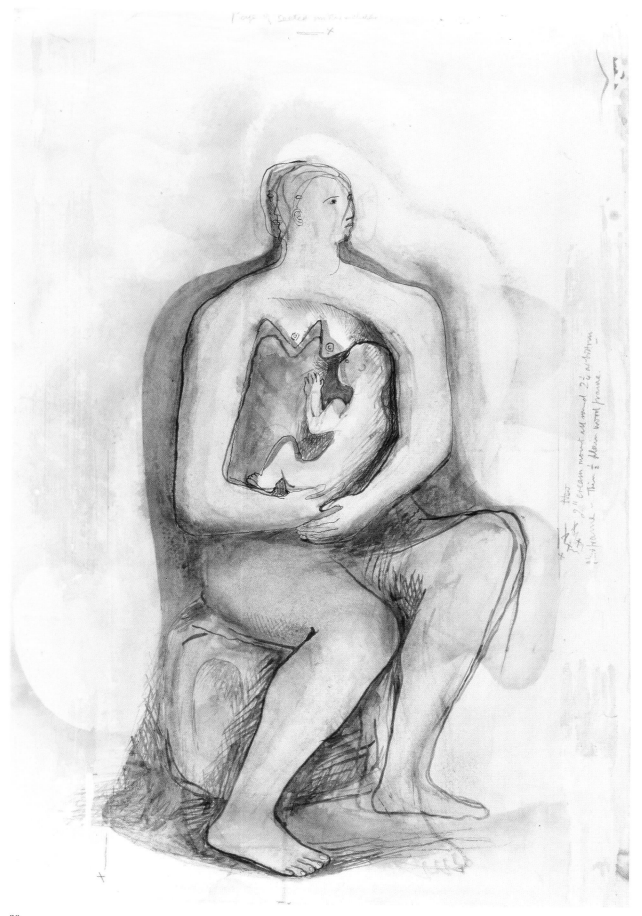

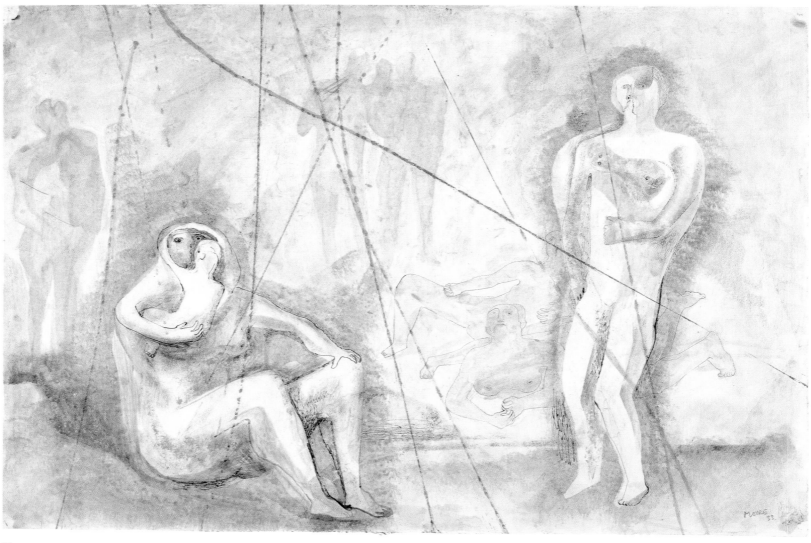

61

1922-24.[2] Notice how in the present drawing Moore explores the various turns of the mother's head, first to the left, which is partly erased, then to the right, and finally back to the left side. Or, is the right head attached to its ghostly body hovering behind the father, foreshadowing the compassionate series of post-war family groups?

Terry Friedman

1. 'The Sculptor Speaks', *Listener*, 18 August 1937, quoted in James (ed.) 1966, p.64; 1992, p.67.
2. Moore 1981, p.125.

61
Figure Studies: Seated Mother and Child, Standing Man 1933
HMF 1015
pencil, charcoal, pen and ink, wash on cream medium weight wove
378 × 558mm
signature: pencil l.r. *MOORE/33*
Gift of the artist 1977

At first glance the crossing lines on this drawing may look as though it had been 'excised' by Moore from his oeuvre. However, similar dotted lines are found in several drawings of groups from 1933: the relationship to the similarly sized HMF 1014 is especially close. Unusually for Moore, these drawings seem to suggest a story. Here the foreground figures are

accompanied by ghostly ideas for a family group appearing between them, as well as outlines of the three figures of the main group reclining half-hidden behind the standing man. The most sculptural is the surreal shadowy figure standing on the left which derives from a new way of working which Moore developed in 1930. He began to draw pebbles, bones and shells and play with the resulting shapes by adding heads, arms and legs, eyes and nipples, in order to transform them into ideas for sculpture. In this way he bypassed his former process of basing sculpture on direct studies of other works of art and humans (still present here in the reclining figures). Bones in particular gave him the protuberances and hollows of his sculpture – here suggested by wash. He added images from his unconscious mind

and his memories to the basic shapes that he culled from nature, thus vastly extending his range of images without resorting to the dreams and hallucinations which many Surrealists were using in the 1930s to generate pictorial and sculptural ideas.

Susan Compton

62
Figure Studies 1933
HMF 1016
pen and ink, charcoal, watercolour, wash on off-white medium-weight wove
375 × 560mm
signature: pencil l.l. *Moore/33*
Gift of the artist 1977

exhibitions: Bradford 1978 (cat.137); Madrid 1981 (cat.D68); Lisbon 1981 (cat.D.68); Barcelona 1981-82 (cat.D56); London 1984 (cat.7); Tokyo/Fukuoka 1986 (cat.d32); Paris 1989; London 1992 (cat.37); Budapest 1993 (cat.31); Bratislava/Prague 1993 (cat.31)

63
Seated Figure 1933
HMF 1042
pencil, brush and ink , pen and ink, watercolour on off-white lightweight wove
582 × 394mm
signature: pencil l.r. *Moore/33*
Acquired 1995

In July 1929 Moore married Irina Radetzky, a beautiful Russian student whom he had met the previous autumn at the Royal College of Art, where she was enrolled in the Painting School. For the next six years she became his principal model and the subject of a remarkable series of life drawings that represent the culmination of a decade devoted to studying the human figure. Exactly when Irina began posing for Moore is unclear. On one occasion I showed

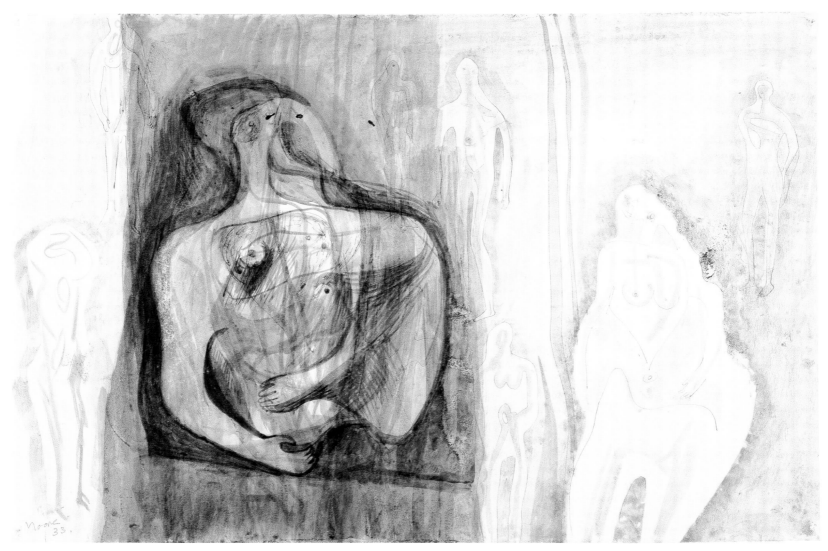

62

combined with chalk and wash or charcoal and wash. In the second series, executed between 1932 and 1935, Moore used various combinations of pencil, pen and ink and wash to create drawings of great delicacy and refinement.

This is one of the finest of the latter series of fourteen known drawings of Irina, of which all but three depict the model seated in or on the arm of a chair. The most striking features of the studies of seated figures are the low viewpoint and the way in which the legs, darker and more heavily worked than the rest of the body, project forward. As Moore commented: 'I wanted the legs to come forward from the pelvis – the closer parts were drawn more strongly.' Although he obviously set the pose and chose the low viewpoint, the extraordinary sense of immediacy has a delightfully simple explanation. As Moore explained to me, in the small sitting-room where Irina posed in their flat at 11a Parkhill Road, Hampstead, he was unable to draw from any distance, and his model seemed to loom up in front of him as he worked. In this study, the remarkable sense of depth and perspective, Moore suggested, allows one to read the composition in terms of landscape, with the legs as foreground, the head and torso the middle distance, and the back of the chair and the faintly indicated wall as background.

No better account exists of the serenity and quiet dignity of the life drawings of Irina than Moore's own description of the carvings of life-size female figures he had first seen in 1921 in the archaic Greek room in the British Museum, 'seated in easy, still naturalness, grand and full like Handel's music'.[1]

Alan Wilkinson

1. James (ed.) 1966, p.157; 1992, p.159.

63

him a life drawing dated 1928 which I said looked to me like a number of accepted studies of 'Mrs Moore', and he agreed, until he saw the date. 'No, no', Henry said indignantly, 'Irina would never have posed in the nude before we were married . . . '

The life drawings of Irina divide into two groups, both chronologically and in terms of technique. The drawings of 1929-31, the most sculptural and densely worked of all the life studies, include five or six experiments with oil paint, usually

64

Composition 1934
LH 140
cast concrete
length 44.5cm
unsigned
Gift of the artist 1977

exhibitions: Paris 1977 (cat.17); Bradford 1978 (cat.18); Madrid 1981 (cat.26); Lisbon 1981 (cat.31); Leeds 1986 (cat.107); London 1988 (cat.21); Sydney 1992 (cat.31)
loans: Leeds City Art Gallery 1986-88, 1988-91, from 1993

Composition is one of a sequence of sculptures made up of separate elements placed on long, flat bases. This and **Four-Piece Composition: Reclining Figure** 1934 (LH 154) are the most readable as single figures; the others are rather dialogues between separate, abstracted elements. Both this sculpture and **Four Piece Composition** are composed of a tall torso-like element at one end, pieces which might indicate splayed limbs, and a ball which in surrealistic manner may stand in for a variety of organs all at once – as indeed does the hole through the taller element in **Composition** (in **Four Piece Composition**, by contrast, an eye and a nipple are incised, Miróesque fashion, into the torso element). The reading of this sculpture as a figure becomes more apparent when it is compared with drawings of the same period, for instance **Reclining Figure** 1933 (HMF 984) where similar elements are built into a coherent and readable figure, and the torso element has a protrusion attached to signify a head.

The influence of Giacometti is very evident in **Composition**, especially when it is compared to *Woman with her Throat Cut*;[1] but the bony, naturalistic forms are used here in a manner quite different to Giacometti's overtly violent piece. They suggest something more in the way of an eroded ruin than a fresh corpse. Nevertheless, the ghostly white of the concrete, not just a register of formal purity, and the suggestions of figuration do

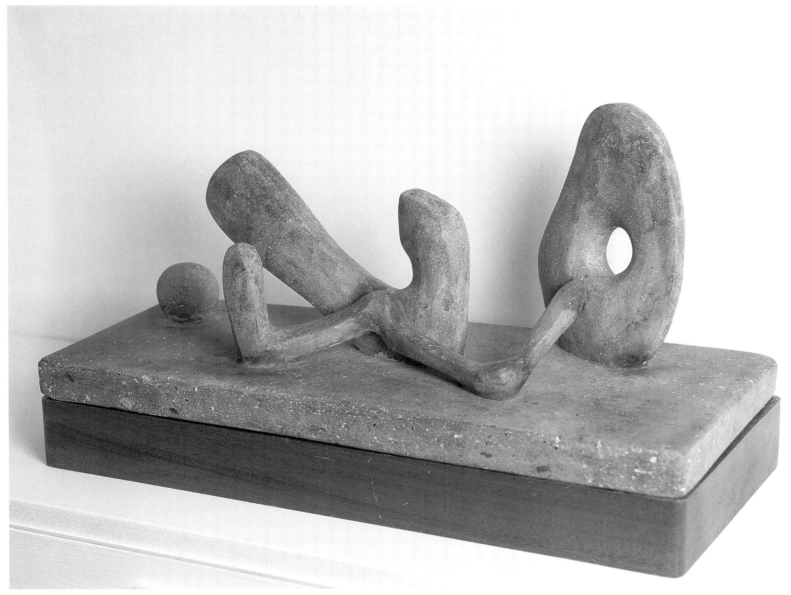

64

serve to add a surrealistic disturbance to its otherwise Constructivist-inspired forms.

The British avant-garde had an odd relationship with its counterparts on the Continent, certainly in the years before émigrés began to settle in Britain, imparting first-hand knowledge. With few exceptions, the engagement of monoglot British artists' with the new European art was largely visual – sometimes gained by travel, more frequently by looking at magazines such as *Cahiers d'Art* and *Minotaure*. There were few critics who attempted to explain European avant-garde movements to a British public – hence the great importance of those who did. Surrealism, in any case, was not taken

seriously by most people in Britain until after the International Surrealist Exhibition held in London in 1936 (to which Moore contributed). Even then, it was explained eccentrically by its British theorists, Herbert Read and David Gascoyne, and often seen merely as a destructive prelude to a truly meaningful art. Yet before 1936, as can plainly be seen in **Composition**, Surrealism had been adopted at least as a *style*. Given this, Moore's later attitude to the dispute between the Constructivist and Surrealist wings of the British avant-garde – that he could not see what the argument was about, and that the two should simply coexist – is logical enough. In 1934, in his statement for *Unit One*, the publication of

the group formed in an attempt to promote and unify the British avant-garde, Moore wrote of his attachment to the observation of 'nature' – stones, bones, trees and shells. Again, this stands in marked contrast with European Surrealism, that resolutely urban movement for which nature, when considered at all, was a chaotic and violent force linked with the unconscious. The result of this situation in **Composition** is a curiously ambivalent and defanged piece (especially when compared with the Giacometti from which it sprang) in which Surrealism improbably meets a very English Romanticism.

Julian Stallabrass

1. *Woman with her Throat Cut* was reproduced in *Minotaure*, December 1933, pp.46-7; we know that Moore looked carefully at this Surrealist publication and drew on its illustrations for his own work. He also met Giacometti in Paris in 1931-32. See Christa Lichtenstern, 'Henry Moore and Surrealism', *Burlington Magazine*, November 1981, pp.652-7, 645. David Sylvester made the comparison between *Composition* and *Woman with her Throat Cut* in his Arts Council catalogue, *Henry Moore*, London 1968, p.93.

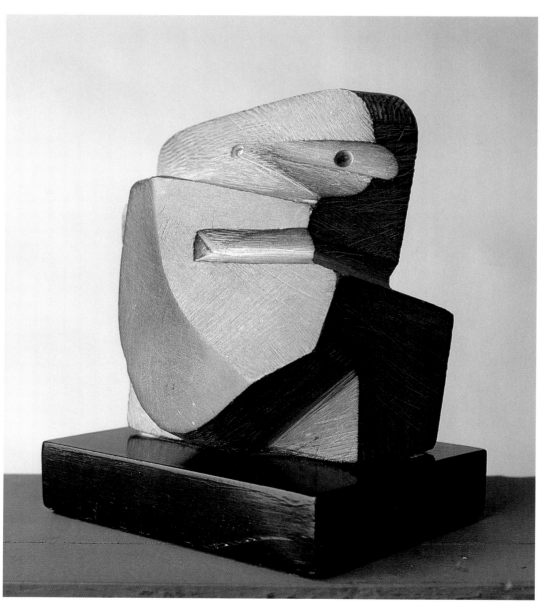

65

65
Carving 1934
LH 142
African wonderstone
height 9.8cm
unsigned
Gift of Irina Moore 1977

exhibitions: Madrid 1981 (cat.185); Lisbon 1981 (cat.193); Mexico City 1982-83 (cat.81); New York 1983; Hong Kong 1986 (cat.28); Tokyo/Fukuoka 1986 (cat.133); New Delhi 1987 (cat.20); Leningrad/ Moscow 1991 (cat.27); Helsinki 1991 (cat.27); Martigny 1989 (cat.p.116); Sydney 1992 (cat.52); Krakow/Warsaw 1995 (cat.26); Venice 1995 (cat.26); London 1996; Nantes 1996 (cat. 27); Mannheim 1996-97 (cat.27); Havana/Bogotá/Buenos Aires/ Montevideo/Santiago de Chile 1997-98 (cat.22)

As its title indicates, this small carving flouts any attempt to saddle it with a clear figurative identity. By this time, Moore's deepening interest in abstraction meant

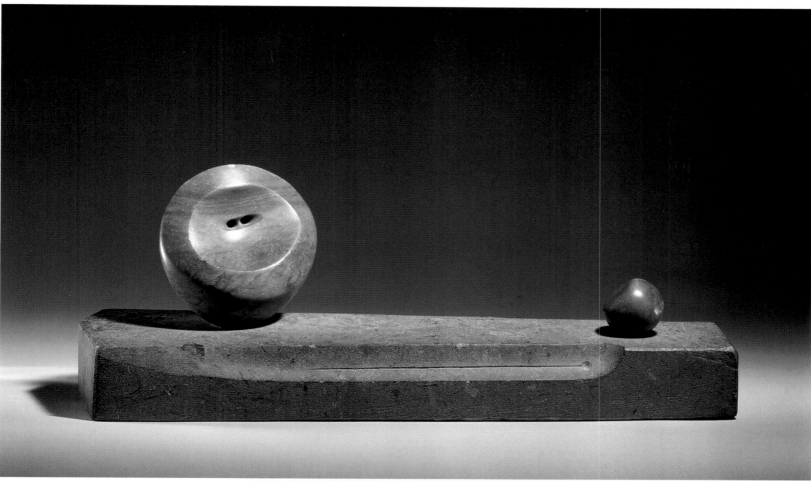

66

that he was prepared, on occasion, to move away from his former, all-absorbing involvement with the female body. The rounded, fruitful forms dominating so many of his earlier carvings have given way here to a taut and thrusting angularity. Moore gives his carving an architectonic character. At the same time he cuts deep into his material in several places, evoking the cave-like spaces and projecting ledges of a rocky outcrop. Ambiguity reigns, inviting us to see this deceptively modest sculpture as much in terms of a building as of a rugged landscape.

Moore compounds the mystery by retaining vestiges of corporeal form, too. The small circular incisions in the upper part of the African wonderstone resemble eyes, suggesting that the entire image might still be affected by his profound attachment to the human body. Although harsher and more rigid in structure than the swollen fulfilment of his earlier female

figures, it persists in evoking the tense, compressed energy of a vigilant human presence.

For all its toy-like size, **Carving** is ambitious in metamorphic scope. Refusing to set a narrow limit on its range of references, Moore relishes his growing ability to endow a single work with a rich and tantalising multiplicity of meanings.

Richard Cork

66
Head and Ball 1934
LH 151
Cumberland alabaster
length 51cm
unsigned
Acquired 1992

exhibitions: Budapest 1993 (cat.36); Bratislava/Prague 1993 (cat.36); Paris 1996 (p.107 and cover)

publications: Sotheby's, New York 14 May 1992 lot 292

Related in date, material and formal enquiry to the more celebrated **Four-Piece Composition: Reclining Figure** 1934 (LH 154), this **Head and Ball** carving is among the most purged Moore sculptures of the period. It is also audacious, leaving a markedly large amount of empty space where the conventional centre of the

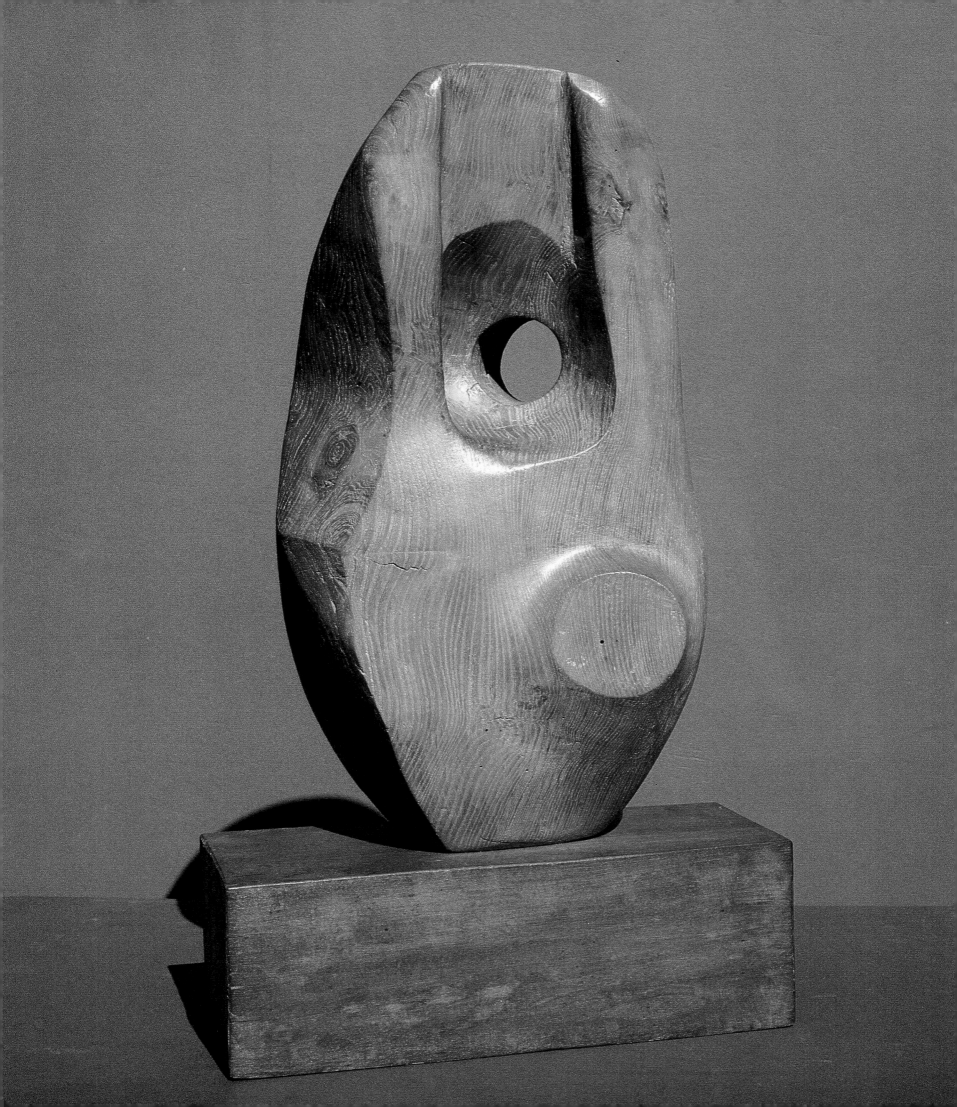

carving should be. The forms employed here suggest an awareness, on Moore's part, of Arp and Giacometti, both of whom, taking as their springboard the dislocated yet balancing forms explored by Picasso at Dinard in 1928, were prepared to incorporate ball-like components in their work of the early 1930s.

So was Barbara Hepworth, whose kinship with Moore reached its most intense pitch during this period. In 1933, she had carved several multi-part pieces before he began to pursue a related course the following year. Moreover, Hepworth and Moore shared a preoccupation with the mother and child theme. In her 1933 exhibition with Ben Nicholson at the Reid and Lefevre Gallery, she exhibited an alabaster work where the child is reduced to a pebble nestling in the mother's arms. Since the 'ball' in Moore's alabaster carving is similar, it may initially have been seen by him as an offspring guarded by the maternal bulk of the larger form. The fact remains that he eventually distanced **Head and Ball** from such an overt intention. The title alone removes the work from the straightforward mother and child subject he had explored so many times before. No longer willing to be quite as explicit, he moves towards a more enigmatic alternative.

Moore always had a more turbulent and disturbing imagination than Hepworth. The intimacy between parent and infant celebrated in her carving is replaced, here, by tension and displacement. In opening up such a startling gap between the head and the ball, Moore implies that each of them is isolated. The eyes bored so arrestingly in the centre of the head still seem capable of monitoring the ball with attentive concern; but any closeness they may once have enjoyed is now severed. Although a thin line has been incised in the plinth where they rest, it serves only to accentuate their separation. The ball looks vulnerable in its marooned state, and the head powerless to bring about a reunion. They are left confronting each other, uneasily exposed on a narrow base where shelter is nowhere to be found.

Richard Cork

67
Hole and Lump 1934
LH 154a
elmwood
height 68.6cm
unsigned
Gift of the artist 1979

exhibitions: Leeds 1982-83 (cat.26); Hong Kong 1986 (cat.10); Tokyo/Fukuoka 1986 (cat.164); London 1988 (cat.16); Nantes 1996 (cat.28); Mannheim 1996-97 (cat.28), Paris 1997 (p.298)
loans: Leeds, City Art Gallery 1983-85; Manchester, Cornerhouse Gallery 1985

By including the word 'hole' in the title of this work, Moore emphasised the importance he attached to his latest sculptural initiative. Three years before, Barbara Hepworth had cut through the centre of *Pierced Form*, an alabaster carving admired by Moore in her studio. It was the first time in her work that she had created a hole with its own abstract autonomy, free from overt anatomical references. Moore himself began making similar holes in 1933, ensuring in his walnut wood **Composition** (LH 132) that they had no identifiable role in representational terms.

By the time he carved **Hole and Lump** the following year, his attitude had become even more defiant. Lacking **Composition**'s rhythmic suavity and smooth finish, **Hole and Lump** evokes the sturdiness of the elm tree from which it derives. The wood-grain is openly proclaimed, as are the occasional imperfections in the material. The projecting circular mass beneath the hole is redolent of a branch, cut off near its base yet still able to convey a surprising amount of innate strength. As for the hole, its prominent position near the centre of the carving shows Moore's growing determination to treat it as an abstract space with a life of its own.

He later recalled his determination to regard 'holes in sculpture as forms in their own right'. They were for him a revelation, making the work more three-dimensional and proving that a hole could be as sculpturally eloquent as a solid mass. At certain moments in the later 1930s he would cut more radically into his material,

opening out his reclining figures until they disclosed an entire sequence of caves and tunnels. The cavity piercing **Hole and Lump** may seem, when compared with these later carvings, modest in both size and ambition; but its peculiar merit lies in a stubborn directness, asserting Moore's determination to move away from any reliance on representation and literary concerns. Commenting on **Hole and Lump** in later life, he explained: 'I was consciously concerned with simple relationships of form: here is the hole which is the opposite to the lump. I was putting an emphasis on this consciousness of form – of sculpture not being just an imitation of nature, but also an expression with three-dimensional form.'

Richard Cork

68
Square Form 1934
LH 154b
Burgundy stone
height 31.7cm
unsigned
Gift of Irina Moore 1979

exhibitions: Madrid 1981 (cat.27); Lisbon 1981 (cat.32); Barcelona 1981-82 (cat.22); Mexico City 1982-83 (cat.9); Caracas 1983 (cat.E6); Hong Kong 1986 (cat.11); Tokyo/Fukuoka 1986 (cat.165); New Delhi 1987 (cat.21); Martigny 1989 (cat.p.118); Sydney 1992 (cat.33); Budapest 1993 (cat.37); Bratislava/Prague 1993 (cat.37); Krakow/Warsaw 1995 (cat.27); Venice 1995 (cat.27); Nantes 1996 (cat.30); Mannheim 1996-97 (cat.30); Havana/Bogotá/Buenos Aires/Montevideo/Santiago de Chile 1997-98 (cat.23)

While exploring his fascination with pierced and hollowed-out forms, Moore began stressing squareness in other carvings of the period. Although his perpetual involvement with the human body may still inform this work, it simultaneously evokes awesome buildings and the grandeur of the quarry from which the Burgundy stone was hewn. Unlike his more rounded and organic carvings, where he worked against

the squareness of the original block, this notably compact and sturdy piece is the outcome of a different attitude.

Based at this time in the five acres of land attached to his newly acquired house at Burcroft, near Canterbury in Kent, Moore was able to appraise the uncarved stones in a new way. They took their place within the landscape stretching beyond his own plot of land, encouraging him to think in terms of boulder-like presences occupying space with something of the immemorial certainty he admired in Stonehenge. **Square Form** is modest in size, but its implications are monolithic. It looks like a maquette for a monument, capable of dwarfing anyone who approaches; and the recessed areas generate shadows that intensify the aura of primordial mystery. 'Stone for me has a blunt squareness', Moore explained later, 'a squareness where you round off the corners. This seems a natural form for a stone.'

In **Square Form** he was careful to ensure that any deep cuts in the material honoured the overall rectilinear character of the work. Only in the surface incisions did he depart from this stern principle. A circle is introduced, and almond-shaped lines enclosing pin-prick marks reminiscent of eyes. These give the sculpture a vigilant air, accentuating its human associations. They may also reflect Moore's interest in the work of his friend Ben Nicholson, who had just started making his white reliefs. Painting in oil on carved board or wood, Nicholson favoured the unadorned circles and rectilinear contours cut so precisely on the side of **Square Form**.

If Moore's overall feeling for weight and mass distinguishes his work from Nicholson's more ethereal vision, the two men did share a feeling for delicate incisions which derive, in turn, from ancient Peruvian stone-carving. In **Square Form** these lines alleviate the ponderousness, proving that Moore could combine gravity and the lightest of touches within a single, complex work.

Richard Cork

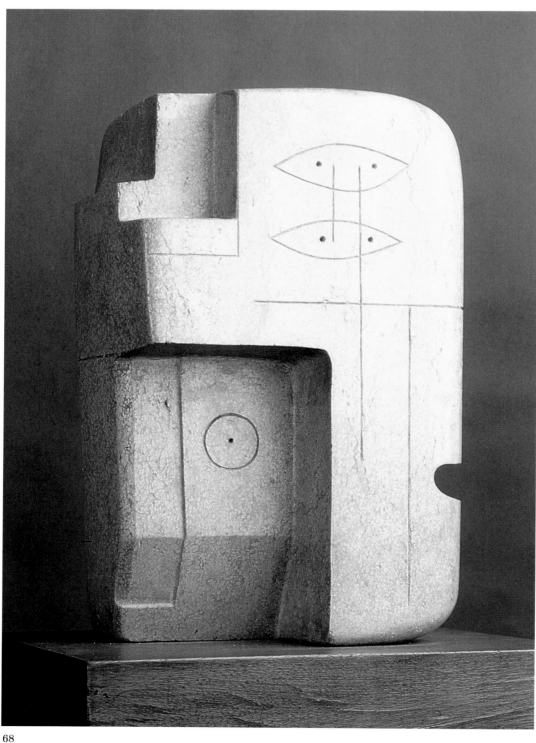

68

69
Two Seated Women 1934
HMF 1077
pen and ink, charcoal, crayon, watercolour, wash on off-white lightweight wove
370 × 553mm
signature: pen and ink l.r. *Moore 33*
Acquired 1983

exhibitions: Martigny 1989 (cat.p.114); Leningrad/Moscow 1991 (cat.25); Helsinki 1991 (cat.25); Sydney 1992 (cat.29); Nantes 1996 (cat.24); Mannheim 1996-97 (cat.24); Havana/Bogotá/Buenos Aires/Montevideo/ Santiago de Chile 1997-98 (cat.24)

publications: Christie's, London 22 March 1983 lot 177

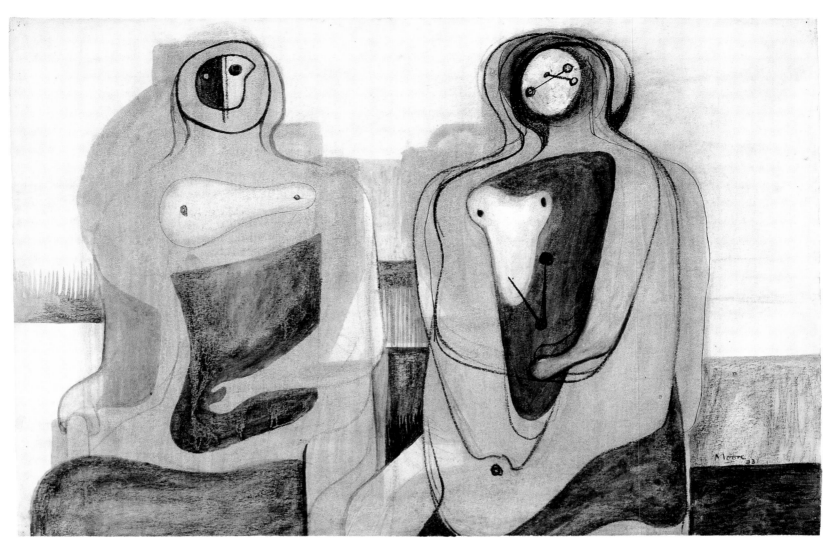

69

My first impression of this drawing was of an assured work, clearly defined and carefully planned. My second brought a realisation that beneath the sense of Moore's authority of line, the figures themselves have a shadowy presence that cannot be contained. They consist of overlaid lines and planes, using tonal values to give them vague volume. The resulting effect of movement is elusive, like an apparition. The motifs, although conflated from a variety of earlier sketches, have a singular coherence as if they indeed came in one inspired moment from the 'shadowy ante-room of his mind'.[1]

In a sense it is a very open and warm drawing. The concentration on the form of the breasts continues a run of experiments Moore was making around this time. Although greatly abstracted, the breasts are

not as flat as they first appear, for the shaded planes leave them as tactile peaks that attract the eye, the only truly sensual part of this nervy image. In this way the drawing anticipates his 1980 bronze **Working Model for Seated Woman** [cat.182].[2] The element of time indicated by the Cubist-style clock hands on both the face and belly of the right-hand woman, and the way in which the other woman is looking at her, strongly suggest an element of waiting, of expectation. The woman on the right may be pregnant, as she has a greater sense of volume and a stronger presence than the other, due to the multiple black lines around her form. She is presented as an incubator, a symbol of destiny and sacrifice, shivering with an uncontainable *raison d'être* that her friend appreciates but cannot feel. The woman

seems to have lost all identity, thrown into limbo by this process. I increasingly feel that, far from being derogatory, this is Moore sharing with the viewer his reverence for woman and for one of nature's greatest and most rewarding achievements.

Clare Hillman

1. Clark 1974, p.64.
2. Lynton 1991, p.54.

70

**Studies for Several-Piece
Compositions and Wood Carvings**
1934
HMF 1102
pencil, chalk on white lightweight wove
213 × 271mm
unsigned, undated
inscription: chalk u.l. *Sheet of several piece
carvings*; u.r. *Sheet of wood carvings*
Gift of the artist 1977

exhibitions: Madrid 1981 (cat.D69); Lisbon
1981 (cat.D69); Barcelona 1981-82
(cat.D57); Martigny 1989 (cat.p.113); Nantes
1996 (cat.25); Mannheim 1996-97 (cat.25)

publications: Wilkinson 1984, p.280, pl.186

71

Studies for Square Forms 1934
HMF 1103
pencil, chalk on white lightweight wove
200 × 274mm
unsigned, undated
inscription: chalk u.c.l. *Sheet of* [*square*
altered to *squarish*] *forms*
Gift of the artist 1977

exhibitions: Madrid 1981 (cat.D69); Lisbon
1981 (cat.D69); Barcelona 1981-82
(cat.D57); Martigny 1989 (cat.p.113); Nantes
1996 (cat.26); Mannheim 1996-97 (cat.26)

The years before the outbreak of the
Second World War was a time in which
British artists were unusually close to
artists on the mainland of Europe. These
years, from around 1934, the date of this
sheet of drawings, also reveal particularly
close relations between Moore, Hepworth
and Nicholson. The forms here exemplify
this closeness, and show that fertile land
between the drawing and the form, the line
and the mass, the carved and the modelled.
This point was made in my text for *Un siècle
de sculpture anglaise*.[1] This seems to me to
suggest the interest which contemporary
artists had in the developing language of
abstraction, and which these sculptors, in
particular, had in the pictorial language of
Continental painters such as Mondrian,
Miró, Herbin and Helion.

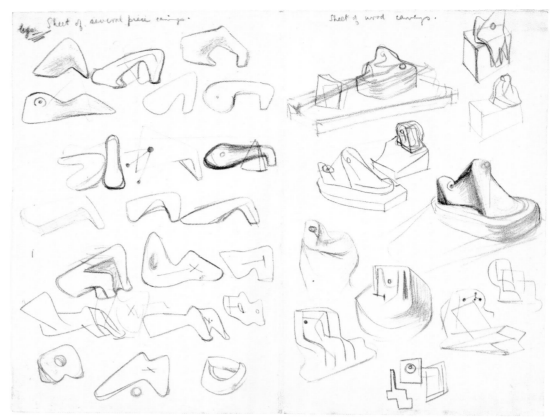

70

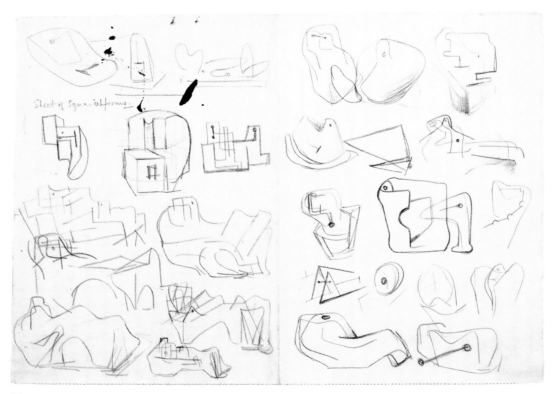

71

These drawings put forms together in groups, a practice which had become standard for painters but which was still new within sculpture. They also attempt either to map form, or to give volume to lines, in the manner of mathematical or statistical models, reminiscent of Tony Cragg's recent sculpture and drawings. They bring together the convex and the concave, straight lines and curves, by scooping out certain portions. These channels suggest erosion, or the more decisive action of a tool in soft material, and invite the eye to roll along, or play within the work's grooves. Within a few years Moore was to deploy these raised sections and link them over and above the concave passages by threading string from bridge to bridge.

Despite the seemingly functional nature of these sheets (prescribing variations on set themes: 'squarish forms', 'several piece carvings', 'wood carvings', etc.), they do not exactly relate to the contemporary sculptures, though parallels can be found in LH 139, 140 [cat.64], 141, 147, 150 and 154, while LH 167 and 178 from 1936 and 1937 also appear to be prefigured. At any rate, these drawings are peculiarly close to the sculptures, because they are as much about what the sculptures are about as the sculptures themselves.

Penelope Curtis

1. Paris 1996, pp.79-80.

72
Monoliths 1934
HMF 1127
pencil, crayon, pen and red ink,
watercolour, wash on medium-weight
cream wove
278 × 183mm
signature: pen and ink l.l. *Moore/34*
inscription: pencil u.l. *Form in architectural
setting*/*do more*/*finished*/*drawing*;
c.r. *straight with hole through*; l.c.r. *cylinder/
cone/cube/egg*
Acquired 1996

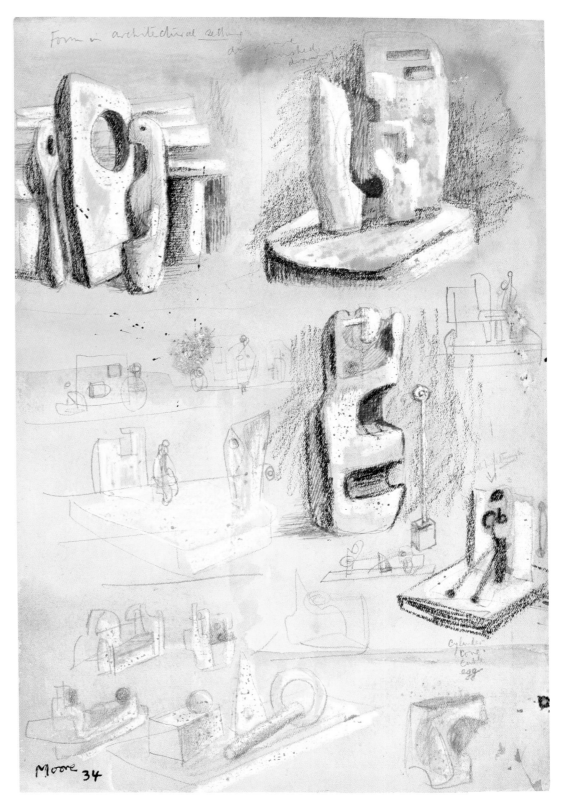

72

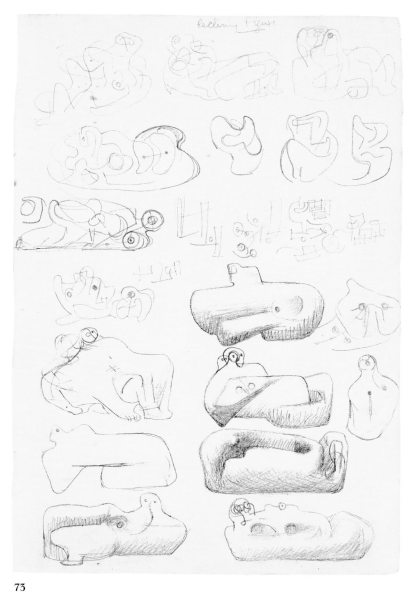

73

74

73-76

Sketchbook 1934–35
HMF 1128-1134
Grey-green paper covered notebook
originally containing one signature of
medium-weight cream wove paper
attached to the cover by two staples. The
cover is inscribed in pencil *PROMÉTHÉE*
[crossed through]/*1934 or 35* in the artist's
hand. The pages, measuring 272 × 183mm,
are unnumbered and some are missing;
seven pages, HMF 1128-1134, remain intact.
Gift of the artist 1977

73

Ideas for Sculpture 1934–35
Page from Sketchbook 1934–35
HMF 1128
pencil
unsigned, undated
inscription: pencil top of page *Reclining
Figure*

The aim of this sketch is clear: without any
pretences whatsoever, it acts as a melting
pot for 'ideas for sculpture'. Motif follows
motif. The past is played out. New elements
loom. As the annotation suggests, Moore
deals with his most liberated theme of the
reclining figure.

If we look more closely, the top row of
the faint line of reclining figure sketches

harks back to the first biomorphically
condensed reclining figure sculptures and
their preparatory studies after 1928. Ideas
follow on from this – ideas thrown on to
paper with an even lighter touch, moving
playfully in experimentation between the
additional fragmented compositions and the
lineaments of the 1934 carvings.

On the bottom half of the page, the line
gets bolder once more. At this stage, Moore
seems to be thinking of reclining figures
more as massive forms in stone. Only in the
bottom right-hand corner of the last
drawing – astonishingly enough – is there
any reference to the holes of the third
reclining figure in wood from 1939 (LH 210,
currently at the Detroit Institute of Art).

In the middle of the page centre right a

75

76

female nude attracts our attention, reminiscent of something else: in its outline, the upright posture of the head and arms the wrong way round, Moore has modified the austere female semi-nude of his 1931 **Composition** [cat.57].

Overall, the page is carefully filled in, line by line in free composition. Is it based entirely on an unconscious arrangement of forms? Within the top and bottom portions of the page, can we see a repetitive rhythm in the reclining figure which increasingly leads the forms away from unity into decomposition (top) and holes (bottom)? Moore's economical approach is well known. Sometimes his consistency of thought works with the unconscious ease befitting a good teacher. Moore himself was

happy to let it be known that he spent much time studying. In this example, he seems to have left behind a thoroughly didactic page. *Semper aliquid haeret.*

Christa Lichtenstern

74
Ideas for Sculpture 1934-35
Page from Sketchbook 1934-35
HMF 1132
pencil
unsigned, undated

75
Ideas for Sculpture 1934-35
Page from Sketchbook 1934-35
HMF 1133
pencil
unsigned, undated

76
Ideas for Sculpture 1934-35
Page from Sketchbook 1934-35
HMF 1134
pencil
unsigned, undated
inscription: pencil u.l. *Construction*

77

Eleven Ideas for Sculpture: Reclining Figures 1935
HMF 1150
pencil, charcoal (rubbed and washed),
crayon, pen and ink, brush and ink,
watercolour wash on cream lightweight
wove
376 × 274mm
signature: pen and ink l.r. *Moore/35*

Acquired by exchange 1981

exhibitions: Columbus/Austin/Salt Lake
City/Portland/San Francisco 1984-85
(cat.94); Martigny 1989 (cat.p.119)

In the mid-1930s Moore exhibited in a
number of Surrealist shows. He remained,
however, on the periphery of the
movement, taking only certain principles
that could enhance his own work, most
notably the importance of the imagination
and of subconscious and dream imagery.

The background of faint green and pink
wash, a combination of colours that appears
in his Shelter drawings of sleepers, lends an
other-worldly, dream-like atmosphere.
Moore has gone on to experiment here, as
in other multiple figure drawings of this
time, with the ambiguous relationship, and
integral function, of form and space which
occurs in dream vision. The background
that supposedly gives 'more of an
appearance of reality'[1] is here equivocal.
Behind each of the upper figures is a
'negative shadow', a related shape
seemingly cut from the background, leaving
a hole. This simultaneously acts as the
colour on the overdrawn sculptural
recliners that enhances the appearance of
solidity of these line drawings. The white
areas could also be read as spotlights on the
forms and background, thereby combining
the two on the same plane.

The larger two figures at the bottom
manipulate space in a different way, with
their own enclosed, solidifying colour and
'positive shadows'. However, the upper
more organic figure seems to cast a shadow
all around the circumference of its form,
flattening it almost totally and pinning it to
the background. The bottom figure, on the
other hand, emerges from the shadowy
depths that almost conceal its true form and
add an eerie reality. Finally the horizontal
lines on the background that could be read
as perspective planes are rendered futile by
the lack of relatively sized figures. Moore
has demonstrated the interdependence of
form and space in sculpture by the creation
and negation of depth that derives from
Surrealism, adapting this to his own
purpose.

Clare Hillman

1. New York 1979-80, p.28.

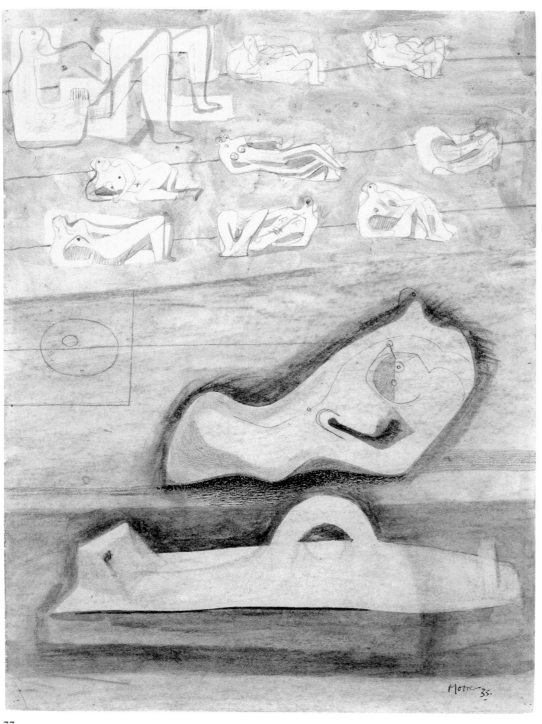

77

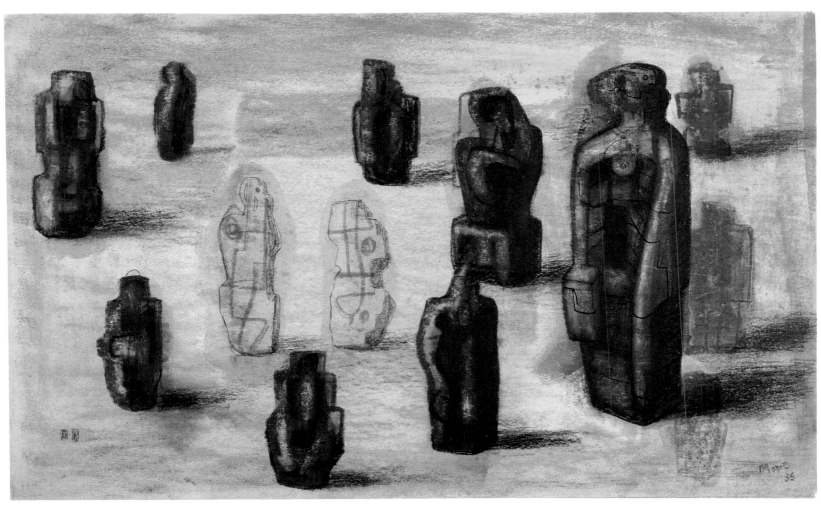

78

78

Stone Figures in a Landscape Setting
1935
HMF 1163
pencil, wax crayon, pen and ink, charcoal,
pastel on cream lightweight wove mounted
on board
92 × 466mm
signature: crayon l.r. *Moore/35*
Gift of the artist 1977

exhibitions: Madrid 1981 (cat.D79); Lisbon
1981 (cat.D79); Barcelona 1981-82
(cat.D67); Mexico City 1982-83 (cat.D15);
Caracas 1983 (cat.D15); London 1988
(cat.82); Paris 1989

publications: Garrould 1988, pl.40

Moore first saw the prehistoric monoliths at
Stonehenge one moonlit night in 1921:
'Moonlight, as you know, enlarges

everything, and the mysterious depths and
distances made it seem enormous . . . I was
alone and tremendously impressed.'[1] In the
1930s the sculptor worked part of each year
at Burcroft, his cottage near Canterbury,
where he had five acres of ground that 'ran
down into a valley with hills on the other
side. Any bit of stone stuck down in that
field looked marvellous, like a bit of
Stonehenge, but not so big.'[2] Thus there
was gradually born in Moore's mind the
revolutionary idea of making sculpture
inspired by natural forms and of placing
upright carvings, free of museum display
pedestals, directly in the landscape.

These ideas were put into words in the
seminal year of 1934. The painter and critic
Adrian Stokes, who was then Moore's
neighbour in Hampstead, wrote in *Stones of
Rimini*, published in January 1934: 'I write
of stone . . . Used, carved stone, exposed to
the weather, records on its concrete shape

in spatial, immediate, simultaneous form,
not only the winding passages of days and
nights, the opening and shutting skies of
warmth and wet, but also the sensitiveness,
the vitality even, that each successive
touching has communicated.'[3] Soon after,
in *Unit One*, Moore wrote that 'The
observation of nature . . . enlarges [the
sculptor's] form-knowledge, keeps him
fresh . . . and feeds inspiration . . . I have
found principles of form and rhythm from
the study of natural objects such as pebbles,
rocks, bones, trees, plants, etc. Pebbles and
rocks show nature's way of working stone
. . . Rocks show the hacked, hewn treatment
of stone, and have a jagged nervous block
rhythm.'[4] Another neighbour and close
friend, the critic Herbert Read, echoed
these ideas in the first monograph on the
artist, also published in 1934: 'Rocks show
stone torn and hacked by cataclysmic
forces, or eroded and polished by wind and

rain. They show the jagged rhythms into which a laminated structure breaks; the outlines of hills and mountains are the nervous calligraphy of nature.'[5] In this drawing some of the monoliths possess human attributes, lonely sentinels in a deserted country.

Terry Friedman

1. Berthoud 1987, p.61.
2. Quoted in James (ed.) 1966, p.52; 1992, p.54.
3. Chapter I, 'Stone and Water', p.15.
4. Quoted in James (ed.) 1966, p.70; 1992, p.73.
5. Herbert Read, *Henry Moore, Sculptor: An Appreciation*, Zwemmer, London 1934 , p.15.

79
Simple Shapes 1935
HMF 1182
pencil on cream lightweight wove
273 × 181mm
signature: pencil l.l. *Moore*
inscription: pencil top of page *write to Mrs. Chase/Big powerful sculptures & drawings*; c.l. *Try to get out of simple/shape the effect of/power & human intensity*

verso

Ideas for Sculpture 1935 [not illustrated]
chalk
unsigned, undated
inscription: pencil top of page *Do some two form ones like black chalk series./[Do some] like red & black reclining figure.*; chalk *Do some head ones.*
Gift of the artist 1977

exhibitions: Martigny 1989 (cat.p.120); Leningrad/Moscow 1991 (cat.28); Helsinki 1991 (cat.28); Budapest 1993 (cat.38); Bratislava/Prague 1993 (cat.38); Nantes 1996 (cat.33); Mannheim 1996-97 (cat.33); Havana/Bogotá/Buenos Aires/Montevideo/ Santiago de Chile 1997-98 (cat.25)

80
Ideas for Sculpture 1935
HMF 1187
pencil on cream lightweight wove
272 × 183mm
signature: pencil l.l. *Moore*
inscription: pencil c.l. *Drawing*

79 recto

verso

Ideas for Sculpture 1935 [not illustrated]
chalk (rubbed and washed), pencil
unsigned, undated
Gift of the artist 1977

exhibitions: Martigny 1989 (cat.p.120); Leningrad/Moscow 1991 (cat.29); Helsinki 1991 (cat.29); Budapest 1993 (cat.39); Bratislava/Prague 1993 (cat.39); Nantes 1996 (cat.34); Mannheim 1996-97 (cat.34); Havana/Bogotá/Buenos Aires/Montevideo/ Santiago de Chile 1997-98 (cat.26)

publications: Wilkinson 1984, p.280, pl.191

81
Ideas for Sculpture 1935
HMF 1188
pencil on cream lightweight wove
272 × 183mm
signature: pencil l.l. *Moore*
Gift of the artist 1977

exhibitions: Martigny 1989 (cat.p.120); Leningrad/Moscow 1991 (cat.30); Helsinki 1991 (cat.30); Budapest 1993 (cat.40); Bratislava/Prague 1993 (cat.40); Nantes 1996 (cat.35); Mannheim 1996-97 (cat.35); Havana/Bogotá/Buenos Aires/Montevideo/ Santiago de Chile 1997-98 (cat.27)

80 recto

81

These drawings immediately reminded me of those by Barbara Hepworth which were first exhibited at the 1994 Tate Gallery Liverpool retrospective, and reproduced on page 49 of the catalogue as *Standing Mother and Child c.*1932. Certainly the treatment of the standing figure here suggests that it is more than just a simple shape, and that there is another form within, protected, struggling or symbiotic. Their relationship is rather more ambiguous than that embodied in Hepworth's figures. Some of these forms seem almost divided, as if one form is attempting to separate from another. The struggle appears to shift its location from head and heart to stomach, and then to become total. The line conveys a combination of control and an almost subversive automatism. Such schizophrenia might almost be borne out in the way Moore moved from splitting his forms at their top, to cupping out their heads, allowing one part to watch the other, as if one were listening and the other hearing.

These drawings find surprisingly few realisations in Moore's sculpture of the time; **Figure** 1935 (LH 157) is perhaps the only example of the single standing figure. Nevertheless, the split form which we associate with Moore as a head can be seen here to have a more mixed genesis, as in **Sculpture** 1935 (LH 161) and **Two Forms** 1936 (LH 170), both abstract, and shows the complex conversation which is being held within this seemingly simple form.

Penelope Curtis

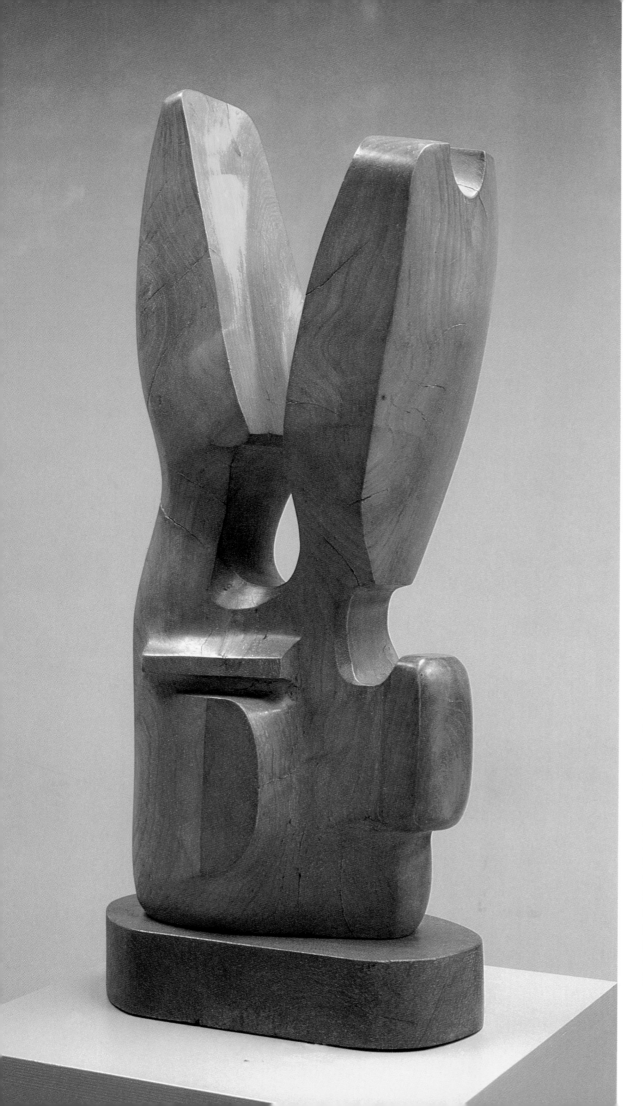

82
Family 1935
LH 157a
elmwood
height 101.6cm
unsigned
Gift of the artist 1977

exhibitions: Bradford 1978 (cat.19); Leeds
1982-83 (cat.34); Leeds 1984-85 (cat.8);
London/Stuttgart 1987 (cat.204); Nantes
1996 (cat.29); Mannheim 1996-97 (cat.29);
Paris 1997 (p.533)
loans: Leeds, City Art Gallery 1983-84

At first glance an unusually abstract piece
for Moore, this carving soon suggests two
heads and two partial figures. In 1924-25
Moore had carved **Two Heads** [cat.24] in
stone, and this was still in his studio. It
represents, in summary terms, a mother
carrying her child on her back; she looks
ahead, the child looks up. Their bodies
merge in what is in effect the classical
shaped base of a portrait bust. In **Family**
the lower part of the sculpture is shaped to
suggest the child's arms on the sides and,
possibly, the mother's clasped hands in
front. Its bifurcation comes as a surprise at
this stage of Moore's work. Later he would
make reclining figures in two or more
parts, implying nature's action in separating
them. In 1934 he had made two multi-part
sculptures, **Composition** [cat.64] and **Four-
Piece Composition: Reclining Figure**
(LH 154), in which the harmony achieved
by their elements, derived from pebbles and
bones, modifies the disquiet given by
fragmentation. The two heads here do not
seem to have been proposed by the block of
wood – though perhaps some flaw made
Moore want to remove at least part of what
became the gap.

The date 1935 would seem to be when
Moore started this work. According to
Bernard Meadows, Moore's assistant at the
time, it was worked on over a period and
not finished until the beginning of the
Second World War. Photographs taken
during the 1940s show the sculpture almost
finished, with a rising bar bracing the two
heads, presumably to strengthen it while he
worked on it. No trace of this remains, yet
Moore represented it in the 1937 drawing

cat.82

Sculpture in a Setting [cat.87] as if it were a necessary part of the piece. This appears to have been removed in the 1960s.[1] Moore was keenly aware of the properties of different timbers and stones, and he probably felt by this time that the elmwood had matured enough not to need this tie, even though cracks had formed in both neck areas.

The two heads are nearly geometrical and without facial features. The larger head, which we take to be the mother's, shows the beginnings of another kind of bifurcation, a curved notch cut out of its top. This is a feature developed to more dramatic effect in Moore's modelled work of 1938-39 and again in the Festival of Britain **Reclining Figure: Festival** 1951 (LH 293) and subsequent pieces. In 1960 Stephen Spender asked the sculptor about 'these heads with great clefts down the whole of the centre', and Moore told him of how, as a boy, he had seen animals killed in a slaughterhouse by having their heads broken with a mallet – 'a terrible experience that had haunted him all his life'.[2] They were looking at a study for a head associated with Moore's **Warrior with Shield** [cat.171], an extreme instance in which a deep cleft runs from the top of the head to where a mouth would be. The notch in **Family** is much less dramatic and affecting: it lends an air of life and intelligence to what is in fact a subtly shaped form.

Norbert Lynton

1. Allemand-Cosneau, Fath, Mitchinson 1996, p.88, and Berthoud 1987, p.89.
2. Stephen Spender, *Journals 1939-1983*, Faber 1985, p.225.

83
Carving 1935
LH 158
walnut wood
height 96.5cm
unsigned
Gift of Irina Moore 1977

exhibitions: Cambridge 1982 (cat.21); Leeds 1982-83 (cat.33); Hong Kong 1986 (cat.12); Tokyo/Fukuoka 1986 (cat.166); Nantes 1996

cat.83

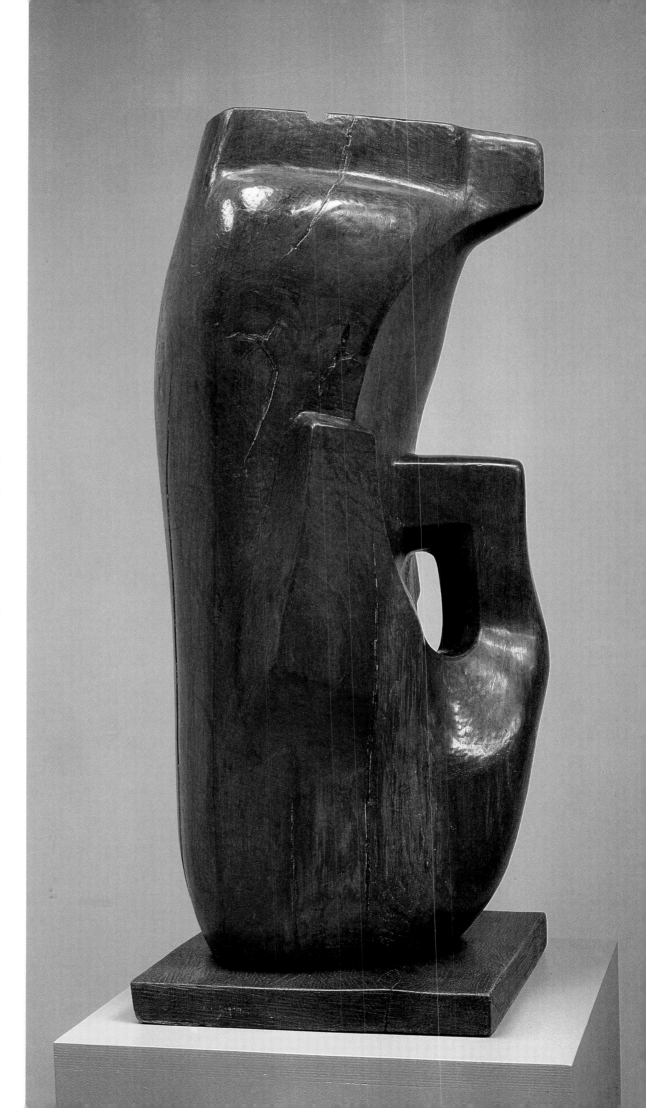

84

To judge by its resolutely unrevealing title, Moore had no desire to give the work a straightforward identity. He no longer wanted his sculpture to rely on associations with human, animal or landscape forms. 'For me a work must first have a vitality of its own', he had insisted in his *Unit One* credo a year earlier. 'I do not mean a reflection of the vitality of life, of movement, physical action, frisking, dancing figures and so on, but that a work can have in it a pent-up energy, an intense life of its own, independent of the object it may represent.' Hence the overriding sense of compressed, knotted strength in this carving. At either side of the main mass, two 'arms' appear but stay very close to its flanks. Echoes of Moore's old obsession with the maternity theme are stirred here: the top of the sculpture pushes outwards and seems to hang over the convoluted form below. The latter juts out, bends and rejoins the larger mass. Its movement is suggestive of a child asserting independence only to hurry back to parental shelter.

Any such interpretation is bound to remain speculative, however. Moore does not allow the viewer to pin this elusive sculpture down, alive though it may be with suggestions of tense, fiercely protective movement.

Richard Cork

84
Square Form Reclining Figures 1936
HMF 1242
chalk, wash on cream medium-weight wove
555 × 392mm
signature: pencil l.r. *Moore/36*
Gift of the artist 1977

exhibitions: Paris 1977 (cat.148); Toronto/ Iwaki-Shi /Kanazawa/Kumamoto/Tokyo/ London 1977-78 (cat.109); London 1988 (cat.83); Martigny 1989 (cat.p.121); Leningrad/Moscow 1991 (cat.31); Helsinki 1991 (cat.31); Sydney 1992 (cat.34); Krakow/ Warsaw 1995 (cat.28); Venice 1995 (cat.28); Nantes 1996 (cat.36); Mannheim 1996-97 (cat.36); Havana/Bogotá/Buenos Aires/ Montevideo/Santiago de Chile 1997-98 (cat.29)

(cat.31); Mannheim 1996-97 (cat.31)
loans: Leeds, City Art Gallery 1983-85

The formal variety of Moore's work in the mid-1930s is prodigious. At one moment preoccupied with holes, at the next with uncompromising solidity, he moved from organic rhythms to geometric rigidity in a

restless, continually enquiring spirit. During the course of 1935 the possibilities offered by wood became a major concern. Walnut, which had already led him to the pierced ripeness of **Composition** (LH 132) two years before, now became the raw material for an altogether more ungainly carving.

opposite: cat.85

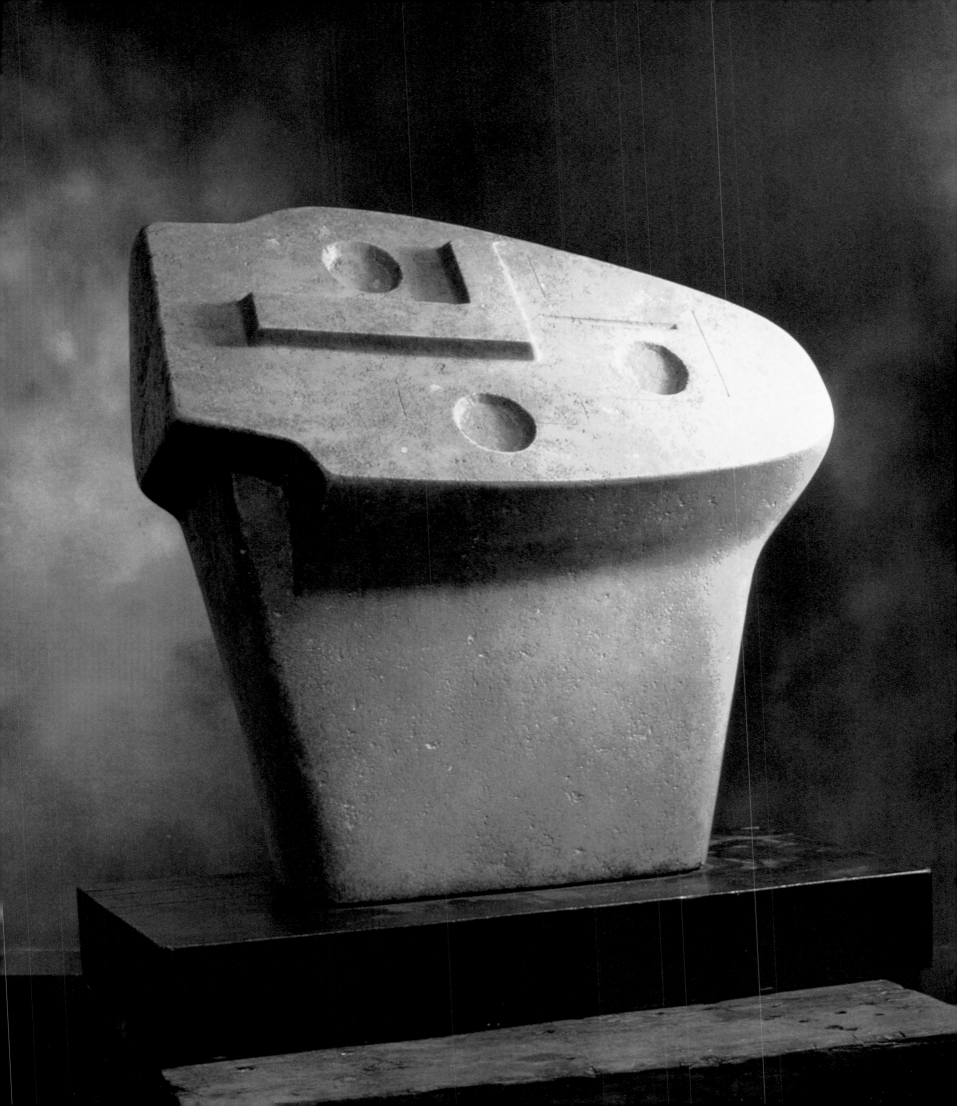

85

Carving 1936
LH 164
travertine marble
height 45.7cm
unsigned
Gift of Irina Moore 1977

exhibitions: Madrid 1981 (cat.29); Lisbon 1981 (cat.34); Cambridge 1982 (cat.22); New York 1983 (p.37); Southampton/ Bradford/Stoke-on-Trent/Sheffield 1983-84 (cat.9); Hong Kong 1986 (cat.15); Tokyo/ Fukuoka 1986 (cat.169); Leningrad/ Moscow 1991 (cat.32); Helsinki 1991 (cat. 32); Sydney 1992 (cat.35); Budapest 1993 (cat.42); Bratislava/Prague 1993 (cat.42); Leeds 1993-94 (cat.141); Krakow/Warsaw 1995 (cat.30); Venice 1995 (cat.30); Nantes 1996 (cat.32); Mannheim 1996-97 (cat.32)

Just over a decade earlier, Moore made **Woman with Upraised Arms** [cat.23] whose head is pushed back with a force reminiscent of the face in this carving. The woman's expression was, however, openly anguished. With eyes shut and lips parted in an apparent yell, she conveys unequivocal suffering. By the time Moore returned to the upturned head theme in 1936, he adopted a far more guarded and oblique approach.

The title of the work is deliberately uninformative, shying away from any admission that the sculpture is crowned by a face at all. It could, on one level, be seen as an abstract carving. After all, the L-shaped projection is as geometrically severe as the sunken circles around it, and the lines leaving their faint trail across the rest of the upturned surface might easily have been incised with the aid of a ruler.

In their taut and refined interplay, the marks made on the top of this travertine marble block are as close as Moore ever came to the language employed in Nicholson's contemporaneous carved reliefs. In 1936 the latter reached the height of his involvement with the possibilities offered by sculpture. He produced his first fully three-dimensional pieces early in the year, and found himself stimulated by Hepworth's 'free movement of carving' when they worked in the same studio.

Moore, by contrast, stayed at a certain remove. However sympathetically disposed he may have been to Nicholson's current work, he ensured that the 1936 **Carving** proclaimed his own obstinate fascination with the human body.

Unlike Nicholson, Moore signed the Surrealist manifesto in 1936 and thereby associated himself with its call for an end to the policy of non-intervention in Spain. Since this carving can be seen as a head with staring eyes and a mouth gaping in helpless consternation, its emotion might reflect Moore's awareness of the accelerating Spanish conflict. In the same year he visited Barcelona, Toledo and Madrid for the first time. Keenly conscious of the gathering international tension, he may well have wanted **Carving** to convey uneasy expectation – even as its cool organisation of form upholds his continuing interest in the abstractionist cause.

Richard Cork

86

Two Forms 1936
LH 166
brown Hornton stone
length 64cm
unsigned
Gift of Irina Moore 1979

exhibitions: Madrid 1981 (cat.30); Lisbon 1981 (cat.35); Barcelona 1981-82 (cat.24); Durham 1982 (cat.14); Mexico City 1982-83 (cat.12); Caracas 1983 (cat.E8); Hong Kong 1986 (cat.14); Tokyo/Fukuoka 1986 (cat.168); New Delhi 1987 (cat.22); Martigny 1989 (cat.p.124); Sydney 1992 (cat.57); Budapest 1993 (cat.43); Bratislava/Prague 1993 (cat.43); Krakow/Warsaw 1995 (cat.31); Venice 1995 (cat.31); Nantes 1996 (cat.38); Mannheim 1996-97 (cat.38); Havana/Bogotá/Buenos Aires/Montevideo/ Santiago de Chile 1997-98 (cat.28)

Moore produced a number of sculptures in the 1930s which are considered abstract and associated with contemporary tendencies in English art and design that placed unprecedented emphasis on what was often called 'pure art'.[1] Having concentrated on the female body radically transformed away from both naturalism and the academic idealisation, he now appeared to be investigating the two poles towards which Modernism was tending: pure abstract form and Surrealistic imagery intended to reveal human desires and fears normally censored in accord with social mores. In 1934 he carved two 'compositions' which we are encouraged to received as fragmented body images (in both senses of the phrase): **Composition** [cat.64] and **Four-Piece Composition: Reclining Figure** (LH 154), distantly related to recent works by Giacometti and Picasso. We could also see them as groups of abstract forms. This suggests that Moore did not wish to attain either pole, but welcomed associative factors even when he came close to so-called pure abstraction and clear formal statements in his carved pieces, and even when he approached the suggestive and fantastic realms opened up by the Surrealists.

We have the option of reading his **Two Forms** as just that, two rounded and partly penetrated shapes carved from and into a kind of stone which, with its natural richness of colour and markings, invited him to interfere relatively little with its own beauty. We may also incline to see a (much simplified) head in the larger stone and hence another head (even more simplified) in the smaller, and wonder whether this is another exploration of the mother and child theme. Moore's **Two Forms** 1934 (LH 153), in Pynkado wood, consist of a larger and a smaller form, the larger leaning over the smaller in a protective manner and, even though wholly undescriptive in its general shape and its parts, giving an extraordinarily powerful evocation of maternal love. It may be significant that Moore and his wife wished for children but long failed to produce one.

His friends and colleagues Ben Nicholson and Barbara Hepworth produced not only triplets in 1934 but also, around that time, some of their most abstract work. Certain Hepworths ask to be seen as pure abstracts; others in their grouping and forms evoke human beings and relationships while coming close to being solid geometry. Nicholson's contemporary

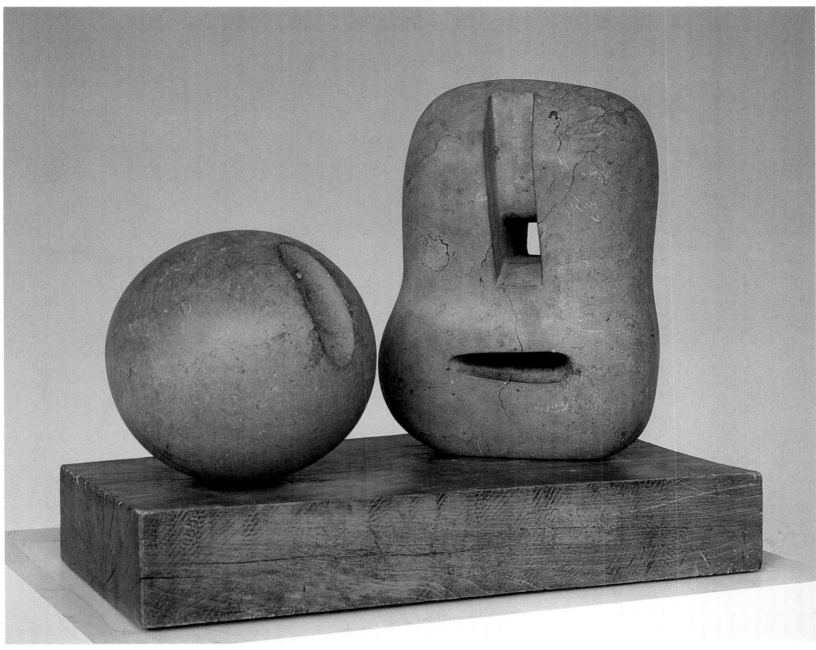

86

carved and painted white reliefs are also purely geometrical, though they carry still-life connotations. That many of the reliefs, and of Hepworth's carvings, are white adds to the sense of distance from life without quite cancelling out these associations. Moore did not go so far: he neither painted wood white nor worked in white marble (a significant exception being **Sculpture** 1935 (LH 161), which is indeed one of his most convincingly abstract pieces, though it is possible to see a hint of mother and child in it). Even when during 1937-40 he made the

stringed sculptures inspired by mathematical models in the Science Museum, he tended to see associative meanings in them, sometimes emphasising these in his titles, such as **Bird Basket** (LH 205) and **The Bride** (LH 213), lest they be mistaken for inventions remote from human experience.

Norbert Lynton

1. Unit One's chief aim was to demonstrate the close relationship between aspects of English art and design, even though the art presented in its exhibition and the accompanying book *Unit 1*, both of 1934, varied widely. The quarterly art review *Axis* was published during 1935-37 to promote abstract art in Britain in response to the journal of the international group Abstraction-Création working in Paris, and the exhibition *Abstract and Concrete*, sponsored by *Axis*, was seen in Oxford, London, Liverpool and Cambridge in 1936. Moore was involved in these ventures, other than the Paris group, of which Nicholson and Hepworth were members.

87

Sculpture in a Setting 1937
HMF 1318
chalk on heavyweight off-white wove
560 × 380mm
signature: l.l. pencil *Moore/37*
Gift of the artist 1977

exhibitions: Martigny 1989 (cat.125);
Sydney 1992 (cat.38); Krakow/Warsaw 1995
(cat.32); Venice 1995 (cat.32); Nantes 1996
(cat.41); Mannheim 1996-97 (cat.41);
Havana/Bogotá/Buenos Aires/Montevideo/
Santiago de Chile 1997-98 (cat.30)

Many sculptors use drawing as a means of
letting their imaginations roam without the
constraints imposed by sculptural materials
and methods. Moore did many drawings of
this sort, 'as a means of generating ideas for
sculpture, tapping oneself for the initial
idea; and as a way of sorting out ideas and
developing them', he said in a radio talk in
August 1937.[1] **Sculpture in a Setting** is a
drawing of another sort. It shows an
existing sculpture, **Family** [cat.82], begun
two years earlier, presenting it
dramatically, like an actor on a stage. Lit
from the side, it stands in front of a blue
backdrop. On the right is a wall, drawn
softly in several colours but dark in effect
and not a little oppressive, its position in
space as uncertain as its scale and thus its
relative size. Moore has added details to the
heads of **Family** that add to their
strangeness, especially the little circles in
the notched top of what we take to be the
mother's head, which recall Picasso's
disconcerting use of teeth and hair in
drawings and paintings of around 1930.

Moore is here coming close to
Surrealism. Surrealism had become a
public issue in England in the summer of
1936 with the arrival of the International
Surrealist Exhibition and the scandals and
amusement it occasioned. Individual
members and precursors of the Surrealist
movement in Paris had been showing in
London galleries since the late 1920s, and
Moore and his friends were in personal
touch with Paris and keeping their eyes on
French art journals. While Nicholson,
Hepworth and others were moved to assert
their distance from Surrealism by various

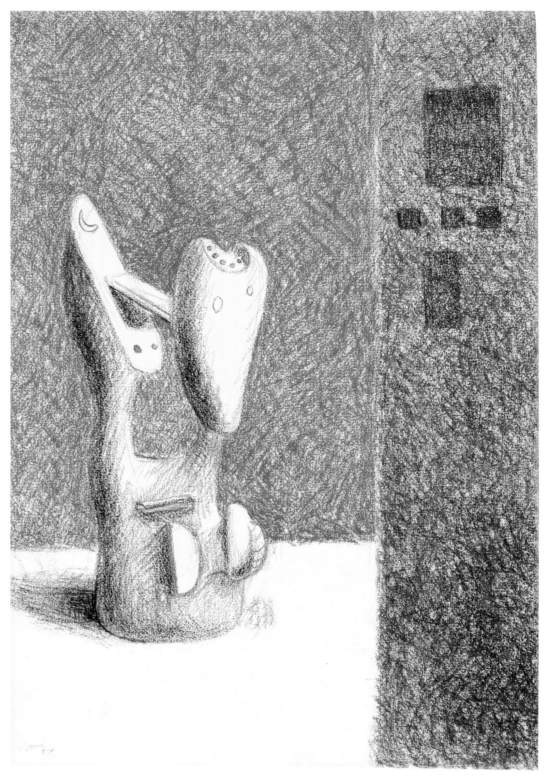

87

means including the publication of *Circle:
International Survey of Constructive Art* in
1937, Moore contributed to the activities of
both groupings while keeping slightly aloof:
'All good art has contained both abstract
and surrealist elements', he said that same
year.[2] His own work could come close to
the abstraction and clarity that
characterised 'constructive art', and he was
included in *Circle*, but he was seeing art
more and more as the business of evoking
multiple experiences through forms

156

attracting ambiguous associations, and thus as to some degree Surrealist. It was not in his nature to contribute to anything intended to disrupt society and denounce common sense, but he could respond to the thrills offered by particular Surrealist images, particularly De Chirico's semi-real figures and nightmarish settings and Picasso's way of building human presences out of all sorts of bits and pieces. It is significant that he never made 'Surrealist objects', surprising and suggestive combinations of found objects.

In 1937 Moore did another drawing of sculpture on stage, **Five Figures in a Setting** (HMF 1319), in which the 'figures' are seen before a backdrop representing a wall. Others followed in 1938, referring to actual sculptures and also to otherwise unused ideas for sculpture. In the 1950s he began to model walls, steps and other such elements to create an environment for modelled figures. Though in his drawings he often gave his figures and abstract forms some sort of setting, however generalised, an additional impulse came from his exploratory work for a large brick relief on the Bouwcentrum in Rotterdam, commissioned in 1955.[3]

Moore's pleasure in seeing his sculpture in a natural setting is well documented and supported, but many of his finest pieces have found their home amid buildings. The 1929 relief for the London Underground (LH 58) was for a long time his only sculpture for architecture, and he tended to think of true sculpture as being free-standing and conceived in the round. So one wonders whether his urge to place his sculptural forms in a constraining, man-made setting does not at least unconsciously relate to news of the Spanish Civil War and the response to political oppression that it aroused among many British artists and writers.

Norbert Lynton

1. 'The Sculptor Speaks', *Listener*, 18 August 1937, quoted in James (ed.) 1966, p.67; 1992, p.70.
2. Ibid.
3. On his work towards the Bouwcentrum relief, see Allemand-Cosneau, Fath, Mitchinson 1996, pp.134-6.

88
Drawing for Stone Sculpture 1937
HMF 1320
pencil, chalk, watercolour, wash on cream heavyweight wove
495 × 604mm
signature: conté crayon l.l. *Moore/37*
Bequeathed by Gerald Cramer 1991

exhibitions: Sydney 1992 (cat.39); Budapest 1993 (cat.44); Bratislava/Prague 1993 (cat.44); Nantes 1996 (cat.42); Mannheim 1996-97 (cat.42)

Moore made this drawing while he was living and working at Burcroft, the cottage at Kingston near Canterbury which he and Irina had bought in 1935. The days in Kent were entirely devoted to carving in stone or wood and it was only in the evenings, after it was too dark to work outside, that Moore would turn to drawing. According to Bernard Meadows,[1] who worked as an assistant to Moore from 1936 until the outbreak of the Second World War, Moore would work on up to twenty drawings at a time, exploring sculptural ideas and forms,

covering large sheets of paper, as opposed to sketchbooks, with these drawings.

This drawing is clearly inspired by blocks of stone which Moore had standing around in the gardens at Burcroft. He would order a consignment of stone from a quarry, for example from the Hopton Wood quarries in Derbyshire, and have it delivered to Burcroft where he and Meadows cast concrete bases on which the stones would stand until Moore needed them. The blocks of stone obviously inspired ideas, and in this drawing it is easy to see how he is allowing forms to grow out of the stone, some more completely finished than others. The holes in the stone in the drawing are particularly interesting as they do exist in the original blocks, probably mechanically made during removal from the quarry. However, Moore has chosen to interpret the holes as features in the drawing, and he went on to use similar holes in the architectural backgrounds for his sculptures and lithographs during the 1950s.

In the top left-hand corner of the drawing are two forms which relate directly

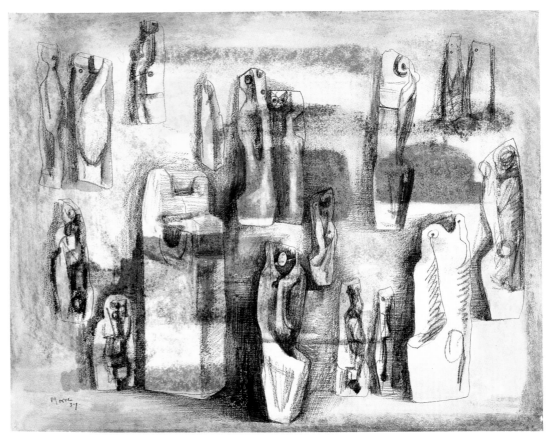

88

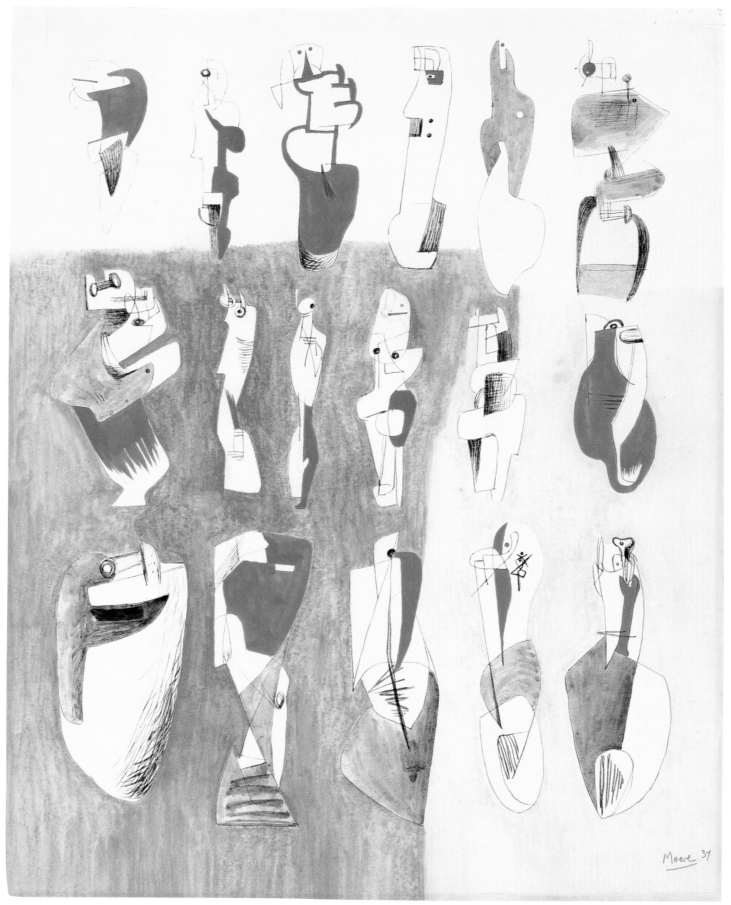

to four sculptures he made in 1952 entitled **Mother and Child: Corner Sculpture Nos. 1-4** (LH 307-310). Moore never wasted a sculptural idea, and sometimes years, even decades, elapsed between the idea originating in his mind and completion of the final sculptural form.

The use of watercolour and ink wash in this drawing helps to provide a three-dimensionality and a depth to the drawing which could not have been achieved otherwise. Even when drawing such abstract shapes as blocks of stone, Moore treated forms in a very sculptural way, highlighting certain faces which caught the light and accentuating the shadows to bring the forms forward. With the use of minimal strokes of his pen or chalk, such as in the form bottom right here, he would give the shape a surface which might approximate to his treatment of a sculptural surface. The forms in this drawing seem to be moving out of the background into the foreground. They have about them something of the quality and light of Stonehenge, a subject to which Moore devoted a great deal of time in the 1960s, having first visited Stonehenge while at the Royal College of Art in the 1920s. The blocks of chalk colour seem to be used to give added atmosphere and perspective to the drawing, almost to hint at the landscape background against which the stones would have been standing in Kent.

Julie Summers

1. Bernard Meadows in conversation with Julie Summers, May 1995.

89

Seventeen Ideas for Metal Sculpture
1937
HMF 1321
pencil, pen and ink, pastel (washed), gouache, watercolour on cream medium-weight wove
666 × 517mm
signature: pencil l.r. Moore 37
Gift of the artist 1977

exhibitions: Martigny 1989 (cat.p.126); Sydney 1992 (cat.40); Budapest 1993 (cat.45); Bratislava/Prague 1993 (cat.45); Krakow/Warsaw 1995 (cat.33); Venice 1995 (cat.33); Havana/Bogotá/Buenos Aires/ Montevideo/Santiago de Chile 1997-98 (cat.31)

90

Drawing for Sculpture 1937
HMF 1325
watercolour, gouache, chalk on cream heavyweight wove
483 × 546mm
signature: l.l. pen and ink *Moore/37*
Gift of the artist 1977

exhibitions: Martigny 1989 (cat.p.127); Leningrad/Moscow 1991 (cat.34); Helsinki 1991 (cat.34); Budapest 1993 (cat.46); Bratislava/Prague 1993 (cat.46); Krakow/ Warsaw 1995 (cat.34); Venice 1995 (cat.34)

91

Drawing for Sculpture: Two Forms
1937
HMF 1326
chalk, watercolour on cream heavy weight wove
381 × 445mm
signature: l.r. *Moore/37*
Gift of the artist 1977

exhibitions: Martigny 1989 (cat.p.128); Budapest 1993 (cat.47); Bratislava/Prague 1993 (cat.47); Krakow/Warsaw 1995 (cat.35); Venice 1995 (cat.35); Nantes 1996 (cat.43); Mannheim 1996-97 (cat.43); Havana/Bogotá/Buenos Aires/Montevideo/ Santiago de Chile 1997-98 (cat.32)

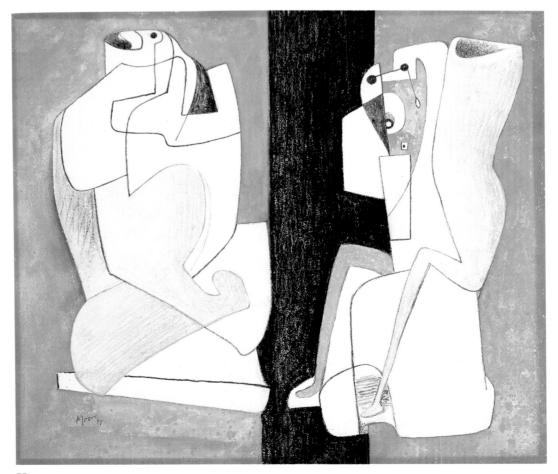

90

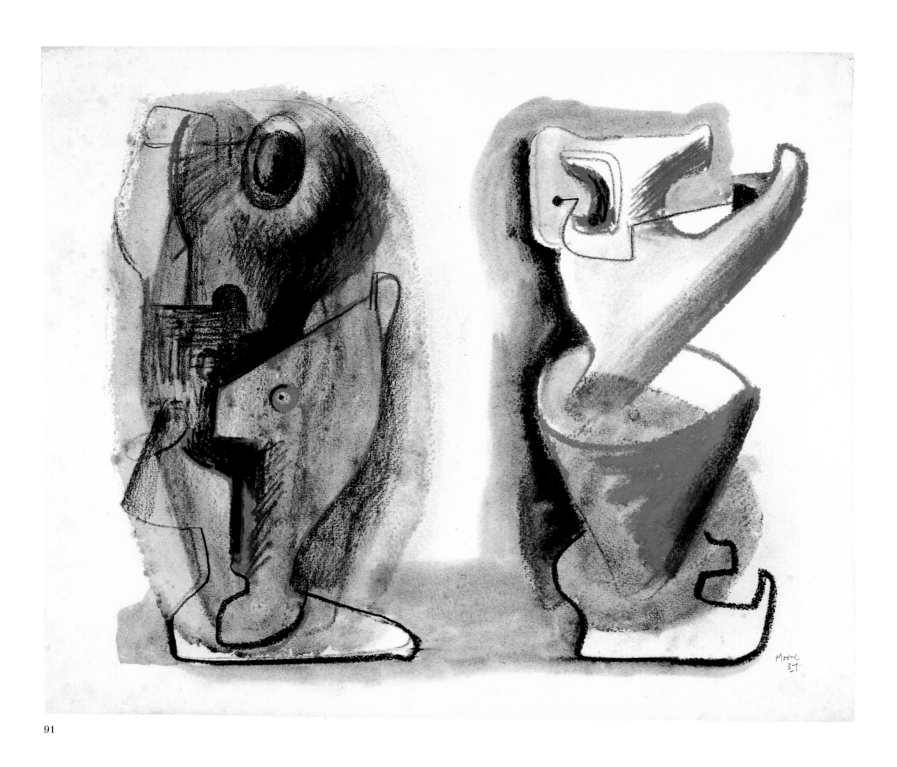

91

92
Ideas for Sculpture 1937 [not illustrated]
HMF 1340
pencil on cream medium-weight wove
273 × 179mm
signature: pencil l.c. *Henry Moore*
inscription: l.r. *C* [circled]/*on Reverse/Ideas
for/drawings/1937*

verso
Ideas for Drawings 1937
pencil, chalk, wash
signature: l.r. *Moore/1937*
inscription: pencil u.c. *Figure in a tunnel Do
drawings of setting for figure*; u.c.r. *Do
another drawing of two/monuments*; chalk
c.r. *Three/boys./helping/each/other/up a
tree*; pencil *apple/stealing*; chalk c. *see page
517/Frobenius/A big picture with a lot of*

little/figures/or with large monuments
Gift of the artist 1977
exhibitions: Madrid 1981 (cat.D92); Lisbon
1981 (cat.D92); Barcelona 1981-82 (cat.D74)

Like the three boys 'helping each other up a
tree . . . apple stealing' depicted here, the
viewer feels a buzz of excitement looking at
a page from a notebook. Surreptitiously we
peer straight into the working mind of the

artist, although by signing the page, Moore has – so to speak – invited us into the orchard of his imagination.

The 1930s was a golden age of Moore sketchbooks. They are brim-full of ideas, some of which would rest dormant for decades before emerging as sculptures. Almost all the radical departures of the remainder of Moore's career turn out to have been anticipated in some postage-stamp-sized vignette in a pre-war sketchbook. These sketchbooks are thus to art historians like the diaries or intimate correspondence of a great writer are to literary scholars. The first image on this page, reading from top left, which depicts (and is denoted as) 'figure in a tunnel', presages by somewhat bizarre coincidence a theme drawn not so much from the artist's imagination as from life, his Shelter drawings of people sleeping in the London Underground. The idea in miniature seems to have been worked up into his celebrated **Figures in a Cave** 1936 (HMF 1260), according to Alan Wilkinson, who proposes 1936 as the date for this drawing despite Moore's dating of 1937. Inspiration for the cave figures, in turn, derives from a photograph of a tomb in Southern Rhodesia (Zimbabwe) in a book on African culture by Leo Frobenius, which is cited in a note to himself by the sculptor on this page. This really is 'back of envelope' stuff. Unguarded and unconcerned by 'appearances', ideas oscillate from the monumental to the whimsical. The space between conscious and unconscious is fluid, as suggestive doodles vie with specific references to source materials and designated future projects. Quite probably Frobenius and other authors were open on his table as ideas were jotted into his sketchbook.

Disparate elements of Moore's aesthetic jumble on top of one another, suggesting that, in their originating mind at least, they are not so disparate. Allusions to primitive art, whether directly drawn from reference works or freely improvised in the artist's own dainty scenarios, nestle cheek-by-jowl with automatic doodles which in turn lead into approximations of highly abstract compositions.

David Cohen

92 verso

161

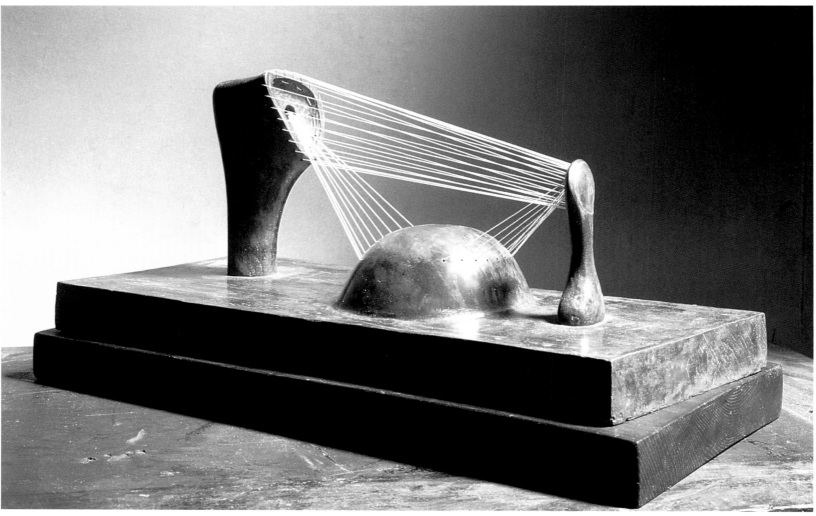

93

93
Stringed Relief 1937
LH 182
bronze and nylon edition of 2 + 1
cast: Fiorini, London 1976
length 49.5cm
unsigned, [0/2]
Gift of the artist 1977

exhibitions: Budapest 1993 (cat.48);
Bratislava/Prague 1993 (cat.48)

By 1932 Moore's sculptures had become
increasingly abstract. Prompted by the
increased activities of the Surrealist artists,
exhibitions on Surrealism, and numerous
articles in *Cahiers d'Art*, the influence of
Surrealism began to appear in Moore's
work. He experimented with new shapes
and devices for bridging forms, and at the
Science Museum in South Kensington he

was intrigued by 'some of the mathematical
models; you know, those hyperbolic
paraboloids and groins and so on,
developed by Lagrange in Paris, that have
geometric figures at the ends with coloured
threads from one end to the other to show
what the form between would be. I saw the
sculptural possibilities of them . . . '[1] These
mathematical configurations which
contained string prompted Moore to
experiment with the possibilities of how
string could show lines in space, but even
more important to his oeuvre was the idea
that one form could be seen through the
other. The shifting, hidden, organic forms
would be a constant, particularly in Moore's
more abstract works.

Stringed Relief was created in wood
and twine in 1937. Reminiscent of a mother
and child image, as in the other stringed
works of the period, the smaller form

stands away from the major one yet is
physically linked and intimately connected
by the string. The stringed cross-beams
from the top to the centre emphasise the
bond between the forms. The string
visualises in concrete terms Moore's
conceptual base, and works both
aesthetically and psychologically. Erich
Neumann aptly noted: 'It is, in fact, an
archetypal idea that the unconscious bond
between people in a state of participation
mystique has its seat in the solar plexus
("sun web"), which is located in the center
of the body . . . The solar plexus is the
center of the "sympathetic" nervous system,
whose function is to mediate the
"sympathies," the participation of living
beings with one another.'[2] Here again one
can only marvel at the profound intuition of
the artist, who in his visionary grasp of
these archetypal relationships made 'visible

the invisible'. Made at a time when Moore was contributing to *Circle* and interested in Constructivism and Surrealism, these stringed sculptures create a dynamic equilibrium between opposing inner and outer forces, an interplay of internal and external energies.

Gail Gelburd

1. James (ed.) 1966, p.81; 1992, p.84.
2. Erich Neumann, *The Archetypal World of Henry Moore*, Pantheon Books, New York 1959, p.35.

94
Head 1937 carved 1968
LH 182a
green serpentine
height 33.7cm
unsigned
Gift of the artist 1977

exhibitions: Bradford 1978 (cat.44); Toronto 1981-82 (cat.127); Nantes 1996 (cat.40); Mannheim 1996-97 (cat.40)

'Since the Gothic, European sculpture had become overgrown with moss, weeds – all sorts of surface excrescences which completely concealed shape. It has been Brancusi's special mission to get rid of this overgrowth, and to make us once more shape-conscious. To do this he has had to concentrate on very simple direct shapes, to keep his sculpture, as it were, one-cylindered, to refine and polish a single shape to a degree almost too precious. Brancusi's work, apart from its individual value, has been of historical importance in the development of contemporary sculpture. But it may now be no longer necessary to close down and restrict sculpture to the single (static) form unit. We can now begin to open out . . . The first hole made through a piece of stone is a revelation. The hole connects one side to the other, making it immediately more three-dimensional. A hole can itself have as much shape-meaning as a solid mass.'[1]

Moore's statement, which appeared in *The Listener* on 18 August 1937, coincided with the creation of this little sculpture and explained it perfectly. Thirty years later, the

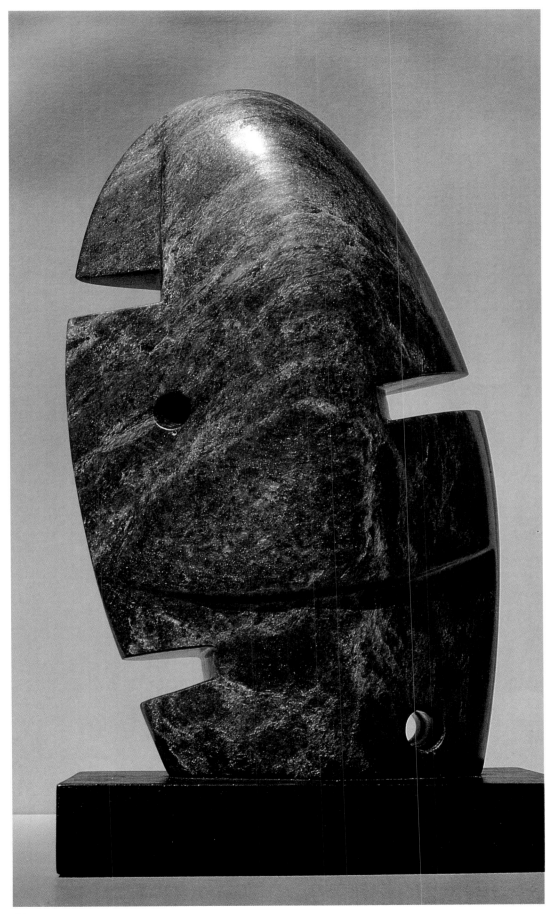

94

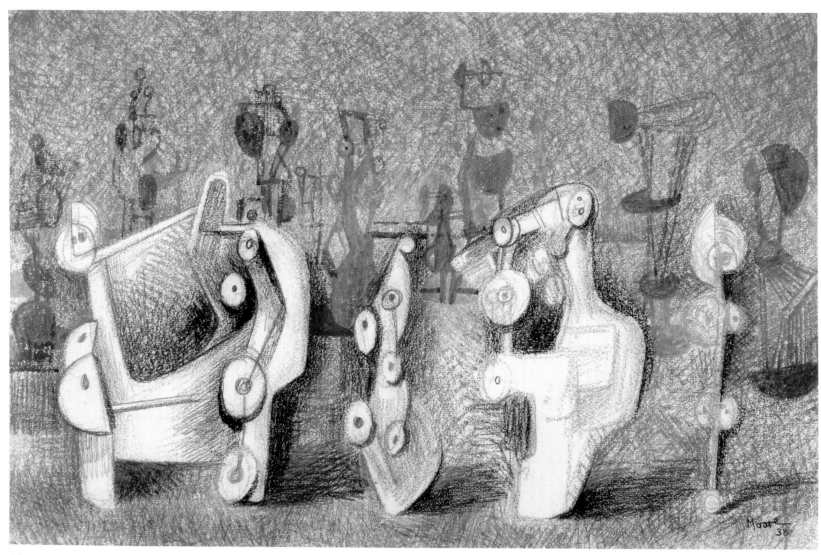

95

plaster was to appear in a beautiful translucent green serpentine marble. In 1968 Moore rediscovered the plaster, forgotten in his studio, and decided to carve the piece in marble.

The cottage Moore bought in Kingston, near Canterbury, in 1935 provided him with a huge open-air space where he could make sculpture. The ambition which was to have such a profound effect on his art had come true: at last he could make sculpture that was meant to be shown in the open, in direct contact with landscape, sky and architecture.

Giovanni Carandente

1. 'The Sculptor Speaks', *Listener*, 18 August 1937, pp.338-40, quoted in James (ed.) 1966, pp.64-66; 1992, pp.67-69.

95
Mechanisms 1938
HMF 1367
chalk, wash on cream heavyweight wove
397 × 572mm
signature: chalk l.r *Moore/38*
Acquired 1988

exhibitions: Martigny 1989 (cat.p.129); Sydney 1992 (cat.41); Krakow/Warsaw 1995 (cat.36); Venice 1995 (cat.36); Nantes 1996 (cat.44); Mannheim 1996-97 (cat.44)

In certain ways, this is an unusual drawing for Moore, both in its technique of little coloured lines densely forming a fabric from which the figures emerge, and in its subject matter. In part, this is because it is one of Moore's most Surrealist works. It

owes much to Ernst and Tanguy who both depicted crowds or hordes of weird hybrid beings. Formally, the debt is to Picasso, both in the modified line-and-dot technique of the figures in the foreground (which Moore elsewhere pursued more directly)[1] and in the background figures which owe much to Picasso's Anatomy drawings; Moore was to revive these spiky, skeletal objects in **Standing Figure** (LH 290) 1950.

Yet, peculiar as some of the forms seem, they do bear a relation to Moore's other work. The odd foreground objects are derived from more traditional pieces where eyes and nipples become nodes in a complex network of lines within the outline of a figure, or where (as in the third figure from the left) the face is transformed into a striated plateau elevated on a neck of

almost equal thickness.[2] The pram-like form far left is derived from drawings of reclining figures placed on raised plinths, seen at an angle and from above to form a trapezoid, with their centres hollowed out.

The meaning of this drawing is not easily arrived at – it certainly cannot be straighforwardly read off from its Surrealist sources. In Ernst, the horde was a collective force in which individual figures were merged into and borne along by the mass. It had strong suggestions of the loss of consciousness and civilisation in some violent impetus. Tanguy's bizarre hybrid forms, by contrast, float in deep space and painful isolation. In this drawing the meaning is more equivocal; the individual figures are distinct, and the drawing is more plainly an exploration of sculptural form. Yet this is not to rule out other readings of what is, after all, not merely a collection of graphical thoughts about sculpture but a highly finished drawing.

How then to explain these oddities? Surrealism was much associated with political commitment at this time, and Moore was participating in anti-fascist and pacifist events and exhibitions, including benefits for the Republican side in the Spanish Civil War.[3] **Mechanisms** may perhaps be seen as a parade or procession watched by a crowd. In this way it can be read as a premonition of war – a common concern in the late 1930s. In other similar drawings of this period there are sometimes indications of truly vast crowds beyond the main figures, standing or marching in open landscapes. These mechanical and primitive objects or beings, comprising awkward, ill-fitting shapes, may stand both for the disfigured and the displaced, and for the mechanisms, human and technological, that were the cause of their plight.

Julian Stallabrass

1. See for instance **Page from Shiny Notebook 1933-35: Ideas for Reliefs**, *c*.1934 (HMF 1059).
2. See **Ideas for Sculpture** 1932 (HMF 973 verso).
3. Various sources note Moore's participation that year in a charitable exhibition in aid of the Spanish Medical Aid Committee at Whistler's House in Cheyne Walk, London. See *Eastern Daily Press*, 8 June 1937, and 'Art Aids Spain', *Yorkshire Post*, June 1937. Moore was involved in various anti-fascist activities from 1935 onwards.

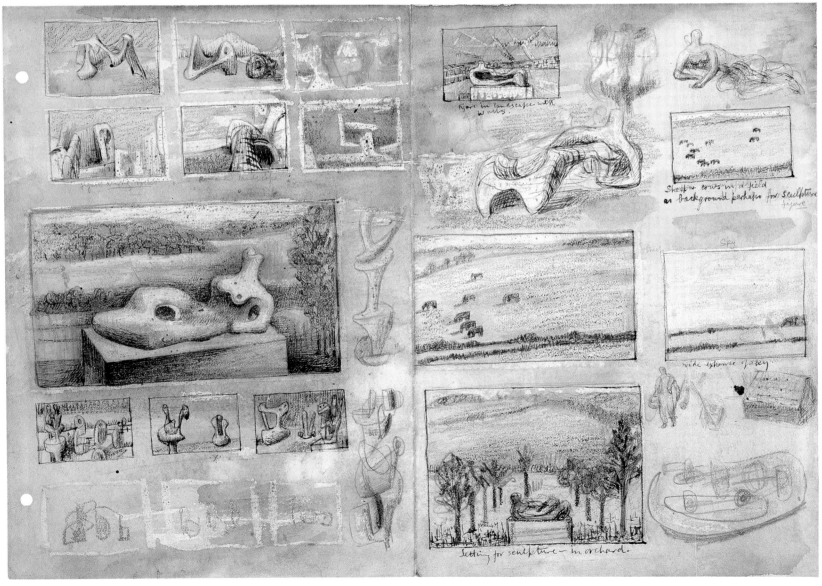

96 recto

96

Ideas for Sculpture in Landscape 1938
HMF 1391a
pencil, watercolour, wax crayon, pen and
ink, crayon on cream medium-weight wove
277 × 381mm
unsigned, undated
inscription: pen and ink u.c. *Figure in
landscape with/Walls*; u.c.r. *Sheep & cows in
a field/as background perhaps for sculpture*;
pencil *figure*; c.r. *Sheep Sky*; pen and ink
l.c.r. *wide expanse of sky*; l.c. *Setting for
sculpture-in orchard*; pencil u.c.l. *Figure
among rocks, Romantic landscape*

verso
Ideas for Sculpture 1938 [not illustrated]
pencil
unsigned, undated
inscription: pencil u.r. *Keep concentrated
and all the time trying to improve the/
drawing and conception*; *Grey mount*;
u.l. *Do a deep, dark red picture/rather like
the one of mine/Sutherland bought/3 forms/
& a much coloured one/like Geoff's*
Acquired 1990

exhibitions: Sydney 1992 (cat.43); Budapest
1993 (cat.49); Bratislava/Prague 1993
(cat.49); Krakow/Warsaw 1995 (cat.37);
Venice 1995 (cat.37); Havana/Bogotá/
Buenos Aires/Montevideo/Santiago de
Chile 1997-98 (cat.34)

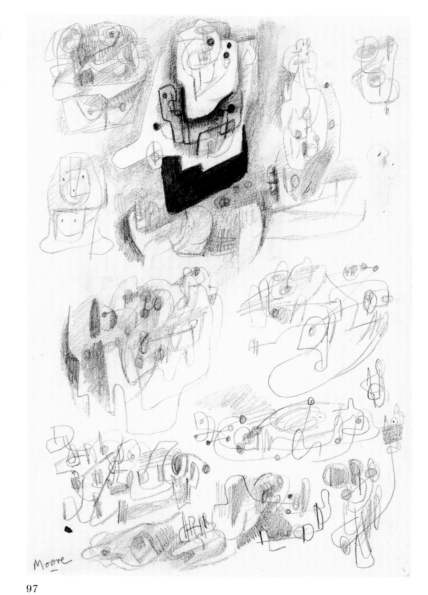

97

In this composition Moore is exploring the
use of landscape not only as possible sites
for sculpture, but as a potential for
metamorphosis with the figure. He has
taken the Surrealist imagery of the 1930s a
step closer towards his eventual realisation
of a sculpture of the sublime – a domain
previously only occupied in the visual arts
by painting. The figures are depicted within
imaginary landscapes, merging with the
surrounding terrain. Holes penetrate the
figures, activating the internal space, thus
creating vistas through the sculpture and
enabling the landscape physically to enter
the interior of the figure.

This fusion of woman and nature is
continued in the way the sculptural forms
mirror their environment. The holes in the
reclining figure on the left are repeated in
the circular patterns of the surrounding

foliage; the legs of the reclining figure in
the orchard shoot up towards the sky,
echoing the limbs of the surrounding trees.
Strange Surrealist shapes fit together like
vertebrae, similar to the bone-white wax
reclining figure in a sea of red crayon, and
the hollow space of the 'figure in a
landscape with walls' recedes mysteriously
into the darkness.

The potential to imagine the fluctuation
of light and shadow on a two-dimensional
surface is assisted by Moore's use of white
wax and his washing over the composition
with watercolour, illuminating the 'wide
expanse of sky' and heightening the
sculptural quality of the drawing. The

figures are in varying stages of emerging
from the natural found objects which
inspired them – whether they be bits of
flint, bone, or driftwood – and in a reversal
of Moore's sculpting methods, they gradually
fuse with the nature surrounding them.

Anita Feldman Bennet

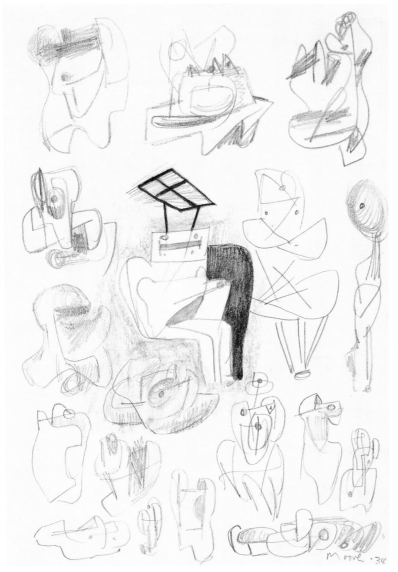

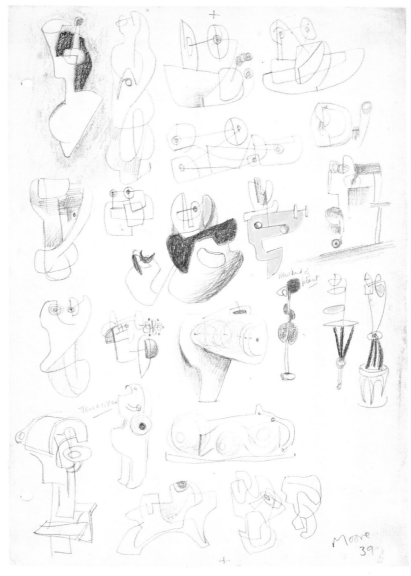

98 recto

99

97
Ideas for Sculpture 1938
HMF 1410
pencil, conté crayon, charcoal, watercolour
wash on cream medium-weight wove
277 × 183mm
signature: pencil l.l. *Moore*
Gift of the artist 1977

exhibitions: Paris 1989; Sydney 1992 (cat.44)

98
Ideas for Sculpture 1938
HMF 1411
pencil, conté crayon on cream medium-
weight wove
277 × 183mm
signature: pencil l.r. *Moore 38*

verso
Ideas for Sculpture 1938 [not illustrated]
pencil
unsigned, undated
inscription: pencil l.r. *2* [circled]
Gift of the artist 1977

exhibitions: Paris 1989; Sydney 1992 (cat.45)

99
Ideas for Sculpture 1938 (misdated
1939)
HMF 1412
conté crayon, pencil on cream medium-
weight wove
278 × 190mm
signature: pencil l.r. *Moore/39*
inscription: pencil c.r. *New kind of/plant*;
l.c.l. *Terracotta*
Gift of the artist 1977

exhibitions: Paris 1989; Sydney 1992 (cat.46)

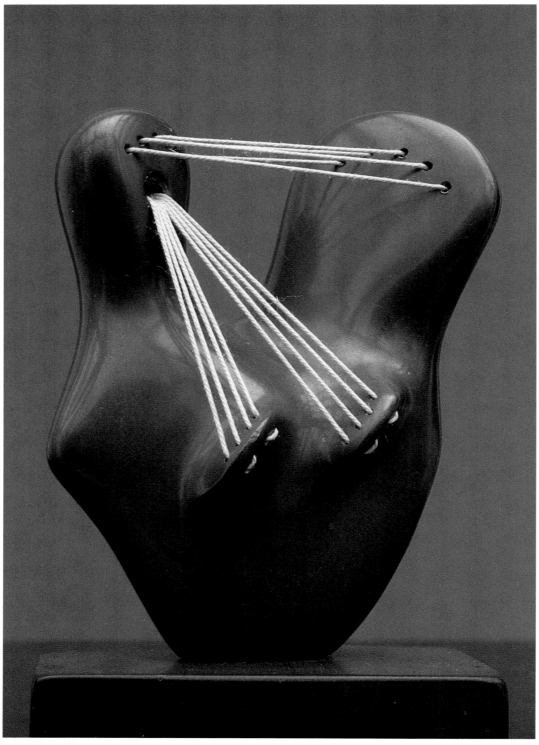

100

100
Mother and Child 1938
LH 186
lead and string
height 19.5cm
unsigned
Acquired by exchange 1996

This stringed figure stands out from the sixteen or so stringed pieces of 1938-39 because of its human qualities. While there are a couple of reclining figures within the group, the majority are unusually non-figurative, and primarily pictorial. This piece, however, being two figures, allows

the strings to enact a conversation, and to underscore the relationship between mother and child. Their eyes are drawn together, while the infant's mouth is attached to the mother's breasts. Perhaps the piece is unique precisely because Moore was nervous about its very literalism. One can find a closer parallel in the **Mother and Child** (LH 165) of 1936, which links this stringed piece with the evolution of the same sheet of 'Simple Shapes' [see cat.79]. The possible triteness of the conceit is, for me at least, softened by its realisation in lead, which seems to slow it down. Nevertheless it is a work which seems inherently bound to the small scale.

Penelope Curtis

101
Stringed Figure: Bowl 1938
LH 186c
bronze and string edition of 9 + 1
cast: The Art Bronze Foundry, London 1967
height 54.6cm
signature: stamped *Moore*, [0/9]
Gift of the artist 1979

exhibitions: Madrid 1981 (cat.33); Lisbon 1981 (cat.38); Barcelona 1981-82 (cat.27); Mexico City 1982-83 (cat.14); Caracas 1983 (cat.E10); Hong Kong 1986 (cat.17); Tokyo/Fukuoka 1986 (cat.147); Sydney 1992 (cat.51); Krakow/Warsaw 1995 (cat.38); Venice 1995 (cat.38); Havana/Bogotá/Buenos Aires/Montevideo/Santiago de Chile 1997-98 (cat.33)

The series of stringed figures made during the late 1930s while Moore was working in Kent comprise stringed wood carvings, lead casts with wire, and a number of bronzes with string which were generally cast later, as is the case with this work. It has always been a subject of debate as to whether Barbara Hepworth was the first to string her sculptures or whether Moore originated the idea. Whatever the truth, drawings of stringed sculptures appear in Moore's sketchbooks from 1937 onwards, and the technique afforded him a completely new dimension for his work.

 Moore claimed that his source for the

stringed figures was the mathematical models which he saw at the Science Museum in London during his student days at the Royal College of Art. He explained that the particular interest lay not in the mathematical calculations but in the fact that a square at one end of a figure leading to a circle at the other, joined by strings, produced forms which were very difficult to draw on a flat surface. They also had the added attraction of being see-through in the same way that a bird's cage is, and this intrigued Moore. The stringed figures soon lost their allure, however, and he said later: 'I could have done hundreds. They were fun, but too much in the nature of experiments to be really satisfying. That's a different thing from expressing some deep human experience one might have had.'[1] I feel pretty confident that this comment was made with the benefit of hindsight and that in fact he was incredibly excited by the stringed figures when he first made them in 1937-38.

In this figure the stringing is complex, following a straight vertical descent in one direction and a circular horizontal in the other. The exterior form is abstract but could be construed as representing a head or a helmet – a subject with which Moore became involved a year or so later. He said to Hedgecoe in 1968[2] that the great appeal of the stringed figures was that he was able to see one form inside another, which is why I think this figure foreshadows the internal/external forms of the 1950s. The external figure here is the hard, solid, defensive surface of the bronze, the interior is the frail stringed figure vulnerable and pale in comparison to the dark, strong bronze of the outer form.

Julie Summers

1. Carlton Lake, 'Henry Moore's World', *Atlantic Monthly*, Boston, January 1962, pp.39-45.
2. Hedgecoe (ed.) 1968, p.105.

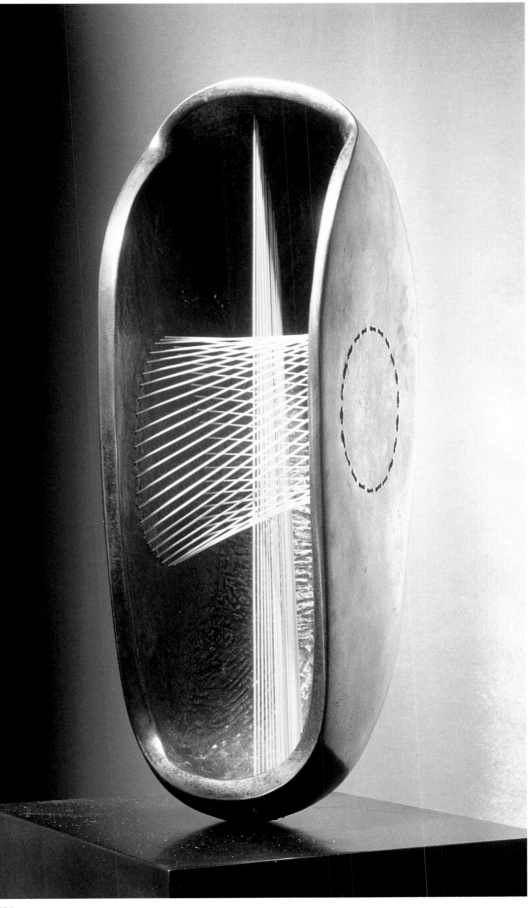

101

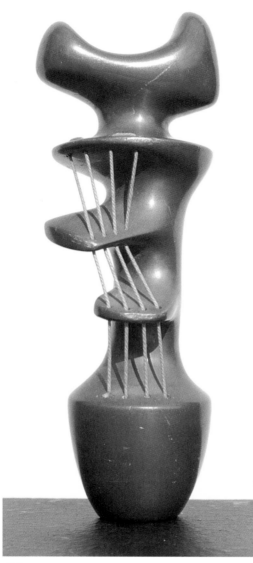

102

102
Stringed Figure 1938
LH 186e
lead and string
height 17.1cm
unsigned
Acquired 1994

A group of sculptures with which I was very concerned dates from the period 1937-39 when Moore and I were experimenting on casting works in lead. These included a number of stringed figures, such as this, as well as some reclining figures, standing figures, and several abstract works. From the middle of the 1930s until the end of the decade Moore had made a lot of drawings for sculpture whose final form was intended to be in metal. These drawings enabled him to develop his ideas by experimenting in the direction of thinner forms or by concentrating on the interplay of thinner and more solid forms. It also freed him from the confining influence of always having to think in terms of stone or wood sculpture.

This period was a very fertile one, as many works in wood and stone, in addition to lead, were being made at the same time. During the 1930s Moore had no large studio accommodation, or equipment which would enable him to move large works inside to continue working in bad weather. Larger sculptures were carved outside while the weather was good, but when rain made working in the open air impossible we moved indoors to work on small pieces in lead. Stimulated by the high cost of having maquettes and small works produced in bronze, we experimented and began ourselves to make casts in lead, a material which could be melted relatively easily, was fairly easy to get and as a process did not differ radically from that of bronze casting nor did it require a technical set-up such as is needed for bronze. We melted lead in a saucepan on a primus stove, because at that time we were living in the depth of the country in a cottage without gas or electricity. All castings were made by the lost wax process, which meant that for every cast Moore had to make an individual wax model, or alternatively a plaster mould from which another copy of the original could be taken in wax. Because this was a long, labour-intensive process no editions were made at this time – it was only by the early 1940s that Moore began to have bronze editions made by commercial foundries.

Lead is a very fragile medium but it can be easily worked, taking on a high and very seductive polish, much like polished silver. This deteriorates after a few weeks to a slightly dull grey tone and is always susceptible to damage by scratching and other abrasions and is easily bendable. Lead can be worked on with carpenters' tools or wood-carving tools and can be rubbed down with abrasives, although we soon found out that carborundum dust became embedded in the surface of the cast, preventing it from taking a good polish. We had to work on the raw castings first with carving tools, then with rasps and files and finally with the only thing we found satisfactory – sharkskin, which was still being used by carpenters for the same reason that it left the surface free of carborundum dust.

There are very few lead casts in the Foundation's Collection, probably due to the fact that the originals were either damaged, or sold, since lead is such a seductive medium, but many of the originals were subsequently cast in bronze and these may be found in the Collection.

Bernard Meadows

103
Large Reclining Figure 1984
LH 192b
bronze edition of 1 + 1
cast: Morris Singer, Basingstoke
length 900cm approx.
unsigned, [0/1]
Acquired 1986

publications: Spender 1986, pp.110,112

This is the big sculpture which I.M. Pei, the architect, commissioned Moore to make for Singapore. (You can see its size from the photograph and it is, I believe, the largest sculpture Henry ever made.) I remember the small lead maquette for this work which Henry made at the end of the 1930s. It was cast in lead by Henry and Bernard Meadows in 1938 and the famous photograph of it against the landscape was taken in Kent the same year. I like the little lead piece very much – it is alive, vital. The rolling movement of the lower part of the body is steadied by the head and the arms. However the top part of the body which gives this steadiness and scale does not seem to me to match up with the inspired treatment of the lower half. I sometimes find myself in doubt about the heads of Henry's figures; they are not always felt but a touch forced.

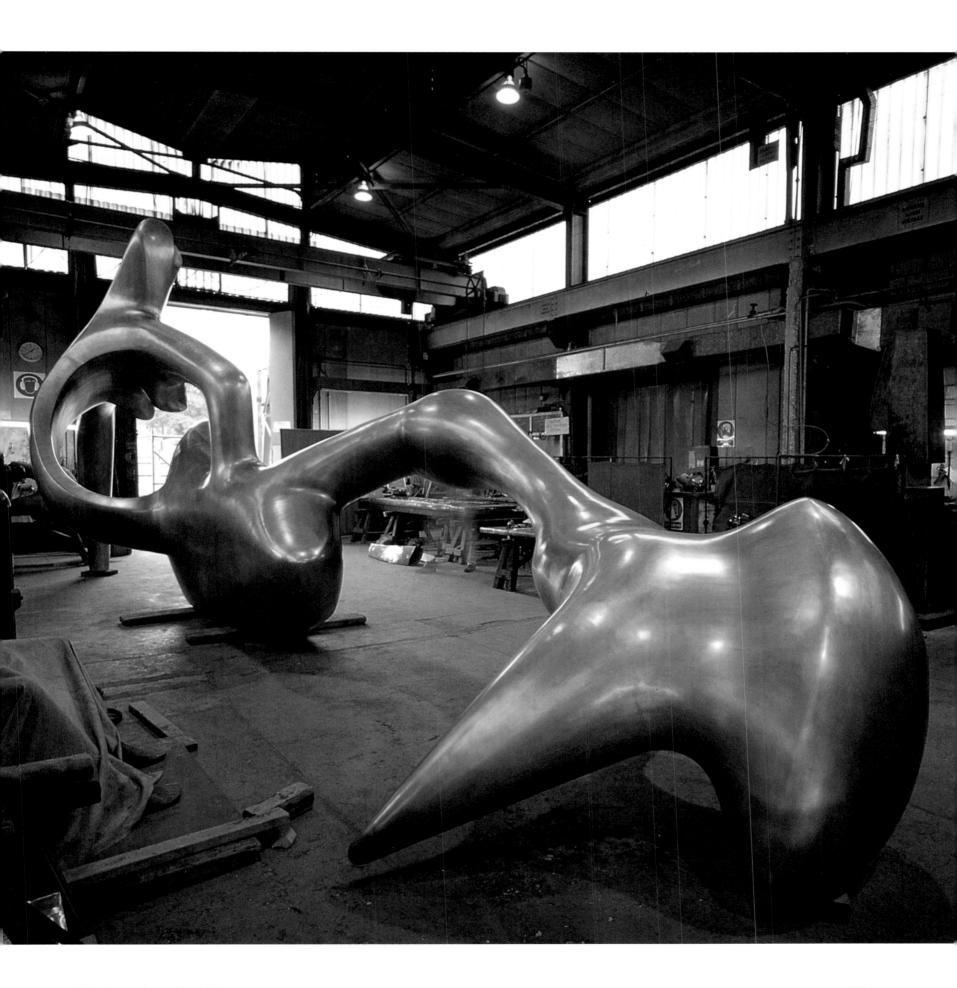

cat.103 after casting at Morris Singer

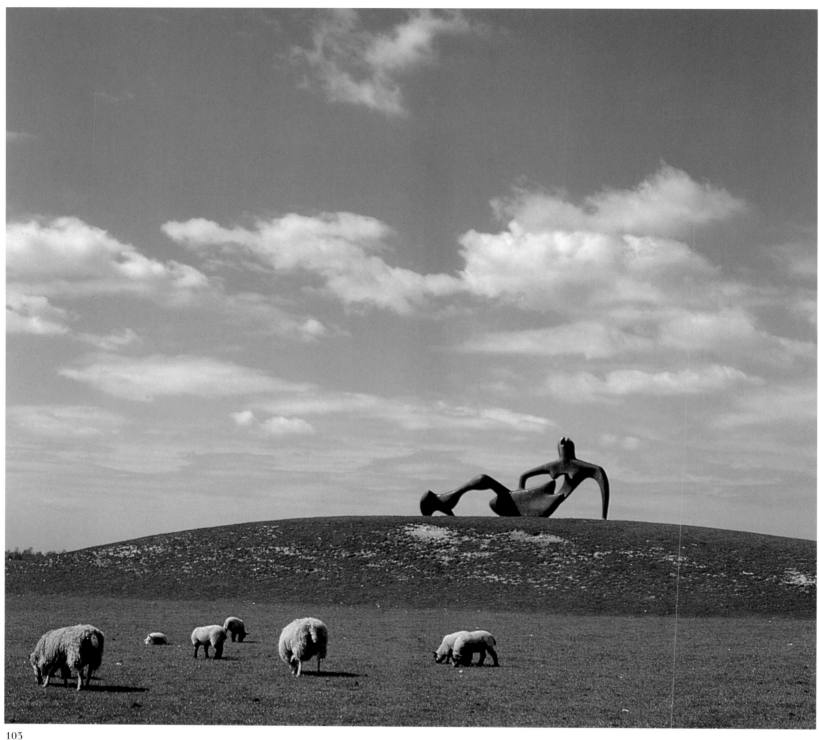

103

This is not to say that Moore was really an abstract sculptor; nor was he a cold, unfeeling artist. Quite the reverse. Unlike the sculptures of some of his contemporaries, Henry's work always has human warmth to it. It was this that attracted me to it from the first, and I am sure that he was conscious of the human aspect of his work whether it was figurative, abstract or surrealist. In conversation his whole attitude to his work stressed his humanistic side.

Henry's first big commission for a building was the Time-Life carving (LH 344) which he started and finished while I was there. By the time he made this **Large Reclining Figure** thirty years later he had gained tremendous confidence. There wasn't anything provincial about Henry's sculpture. If it hadn't have been for him I don't believe English sculptors would have had half the confidence which is apparent today, half a century after Henry. Henry gave English sculptors who followed him

the confidence to feel they could be as good as the best, could take themselves seriously and be taken seriously. When we were students we looked up to local artists, people like Augustus John; we simply weren't aware of what was going on in Paris. We were looking at Epstein's portraits – his portraits, not his wonderful early carvings, not Gaudier-Brezska, let alone Picasso, Lipchitz. Then along comes Henry Moore and he is in there talking the same language as Picasso or Miró and he asks to be judged alongside them. There's no doubt Henry gave us that in this country. At the time of the Jeu de Paume British sculpture show in 1996 I was interviewed by a French journalist. 'Tell me, what is it that gives that edge to English sculpture? Is there a shared style?' I replied, 'No, it's the atmosphere.' The confidence was set by Moore's own certainty. Then the revolution in sculpture at St Martin's which came about by my calling some sculptural assumptions into question, mounted up and

became an explosion. An atmosphere was created here which made advanced sculpture and good sculpture possible. I don't say all the sculpture that's done here now is good but to my amazement sculpture has become the leading visual art – something that was out of the question twenty or thirty years ago. Furthermore there's no doubt London is where sculpture is right now, just as New York in the forties, fifties and sixties and before that Paris was where the best painting could be found. Sculptors here feel they have the bit between their teeth. If it hadn't been for Moore it probably wouldn't have happened. Henry was the first one to see himself as a world artist, not a local artist. And in my time he did it in a very human way, with proper pride in his sculptural merit. There was no side to him; he was never arrogant.

Anthony Caro

104
Ideas for Sculpture 1939 (misdated 1938)
HMF 1431
pencil, wax crayon, pen and ink, crayon, watercolour wash on off-white lightweight
254 × 432mm
signature: pen and ink l.r. *Moore/38*
inscription: pencil u.r. *S.P.*; c.l. *drawing of this kind/and/this/kind*
Acquired 1981

exhibitions: New York 1983; Martigny 1989 (cat.p.131); Sydney 1992 (cat.49); Budapest 1993 (cat.53); Bratislava/Prague 1993 (cat.53); Krakow/Warsaw 1995 (cat.40); Venice 1995 (cat.40) Havana/Bogotá/ Buenos Aires/Montevideo/Santiago de Chile 1997-98 (cat.38)

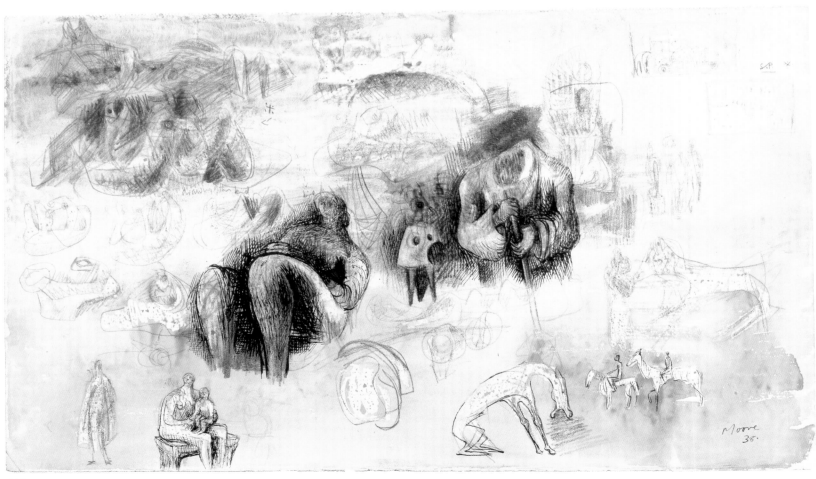

104

105

**Studies for Sculpture in Various
Materials** 1939
HMF 1435
pencil, wax crayon, pen and ink, crayon,
watercolour wash on off-white lightweight
wove
254 × 432mm
signature: pen and ink l.r. *Moore/39*
Acquired 1983

exhibitions: London 1988 (cat.98); Martigny
1989 (cat.p.132); Leningrad/Moscow 1991
(cat.40); Helsinki 1991 (cat.40); Sydney 1992
(cat.50); Budapest 1993 (cat.54); Bratislava/
Prague 1993 (cat.54); Krakow/Warsaw 1995
(cat.41); Venice 1995 (cat.41); Havana/
Bogotá/Buenos Aires/Montevideo/Santiago
de Chile 1997-98 (cat.39)

publications: Garrould 1988, pl.58

Prior to the Shelter drawings of the early
war years, Moore was executing some of

his most highly worked studies for
sculpture, such as this, one of a number of
similar assemblages of ideas on sketchbook
sheets of uniform size. Within the page are
condensed the results of his sculptural
preoccupations of the preceding decade,
from the Transformation drawings of the
early 1930s, in which bones, pebbles and
shells assumed sculptural and figurative
characteristics representing his
assimilation of a biomorphic Surrealism, to
the relationship between internal and
external forms that had emerged in 1935
with his studies after a malangan figure
from New Ireland in the British Museum.
The density of forms, range of invention
and brilliant use of colour, involving what
Moore came to describe as his wax-resist
technique, impart a visionary quality to the
sheet that perfectly encapsulates the notion
of the artist's fertile mind teeming with
possibilities for the future.

Frances Carey

106

**Two Heads: Drawing for Metal
Sculpture** 1939
HMF 1462
chalk, watercolour, wash, pen and ink on
cream heavyweight wove
275 × 383mm
signature: pen and ink l.r. *Moore/39*
Acquired 1997

publications: Sotheby's, New York 13-14
May 1997 lot 327

105

106

107
Spanish Prisoner *c.*1939
CGM 3
lithograph in five colours proofed at
Chelsea School of Art on English cartridge
paper
365 × 305mm
unsigned, undated, unnumbered
Gift of the artist 1977

exhibitions: Paris (Bibliothèque Nationale)
1977 (cat.3); Zug 1978; Leeds 1982-83
(cat.42); Leeds 1986 (cat.186); Martigny
1989 (cat.p.133); Bilbao 1990 (p.59);
Budapest 1993 (cat.55); Bratislava/Prague
1993 (cat.55); Krakow/Warsaw 1995
(cat.42); Venice 1995 (cat.42); Havana/
Bogotá/Buenos Aires/Montevideo/Santiago
de Chile 1997-98 (cat.41)

Many artists made works related to the
Spanish Civil War, and one could look at
Moore's in relation to earlier pieces by
Picasso, González or Hepworth. This piece
also reminds us of a period when there was
a broadly based alliance among many kinds
of British artists against the rise of Fascism,
and when Moore was unusually politically
involved. The membership of the Artists
International Association (to which Moore
had belonged since shortly after its
foundation in 1933), which was pledged to
fight Fascism and Imperialist War, swelled
with the outbreak of the Spanish Civil War.

Moore's name featured prominently on
their campaign literature; he designed and
signed the broadsheet attacking the British
government's stance of non-intervention in
Spain, did some work on behalf of the
International Peace Campaign, and was
even invited to Spain by the Republicans in
1938. (This was a war in which both sides –
Republicans and Nationalists – cared about
and used artists and art.)

However, one could equally look at this
piece in relation to Moore's sculptural
interests, and ask whether the title was
developed before or after the image itself,
and whether the subject made any real
difference (though this is a study for a
lithograph originally intended to raise

107

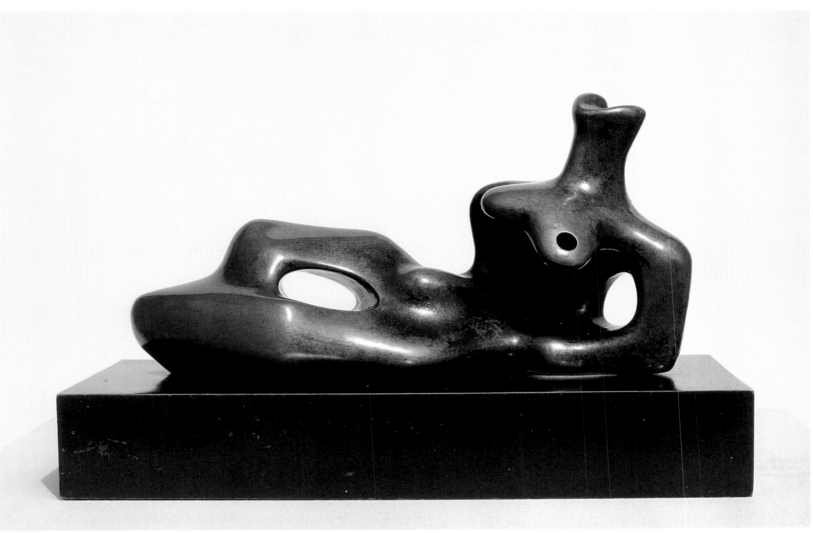

108

money for Republican internees in France). Moore's drawing relates to the stringing in his sculptures, which was at its height in 1938 and 1939, and similarly acts as a kind of *repoussoir* to keep forms in the background, and one might well read this drawing in a primarily formal manner, rather than as a prisoner behind bars. However the fear is there, if latent, rather than overtly as in González' work of this time. Indeed Moore's world in the years around the outbreak of the war seems to be peopled with shadowy forms and inner erosion, and it is this very sense of repression which gradually asserts its unsettling effect.

Penelope Curtis

108
Reclining Figure 1939
LH 202
bronze edition of 3
cast: not recorded
length 27.9cm
signature: stamped *Moore*, unnumbered
Acquired by exchange with the British Council 1991

exhibitions: Leningrad/Moscow 1991 (cat.38); Helsinki 1991 (cat.38); Krakow/Warsaw 1995 (cat.44); Venice 1995 (cat.44)

Of what Moore identified as 'the three fundamental poses' of the human figure, the reclining figure was 'an absolute obsession' with him: 'if you like to carve the human figure in stone, as I do, the standing pose is no good. Stone is not so strong as

bone, and the figure will break off at the ankles and topple over . . . The seated figure has to have something to sit on. You can't free it from its pedestal. A reclining figure can recline on any surface. It is free and stable at the same time . . . the reclining figure gives the most freedom, compositionally and spatially.'[1]

Moore may have based the pose of this bronze statuette on the monumental, heroic, nude figure of Dionysus (438-423 BC), one of the Elgin Marbles from the east pediment of the Parthenon at Athens, which is among the greatest treasures of the British Museum and a work which, he said, 'always attracted' him.[2] Though Moore's figure is female, a similar prominence is given to the broad chest cage, the knees and the outspread legs, while the absence of hands and feet in the Greek sculpture,

broken off and lost in the mists of time, became an essential element in Moore's association between the partial human figure and water-worn, punctured rock. In 1937 he wrote: 'The first hole made through a piece of stone is a revelation. The hole connects one side to the other, making it immediately more three-dimensional. A hole can itself have as much shape-meaning as a solid mass . . . The mystery of the hole – the mysterious fascination of caves in hillsides and cliffs.'[3] **Reclining Figure**, like its many related sculptures by Moore, is both human and geological, both figure and landscape.

Terry Friedman

1. J.D. Morse, 'Henry Moore Comes to America', *Magazine of Art*, March 1947, and John and Véra Russell, 'Conversations with Henry Moore', *The Sunday Times*, 17, 24 December 1961, quoted in James (ed.) 1966, pp.264-65; 1992, p.283.
2. Moore 1981, p.60.
3. 'The Sculptor Speaks', *Listener*, 18 August 1957, quoted in James (ed.) 1966, p.66; 1992, p.69.

109
Stringed Figure 1959
LH 206
lead and string
length 25.4cm
unsigned
Gift of Irina Moore 1977

exhibitions: Madrid 1981 (cat.39); Lisbon 1981 (cat.44); Barcelona 1981-82 (cat.33); Mexico City 1982-83 (cat.20); Caracas 1983 (cat.E16); Hong Kong 1986 (cat.23); Tokyo/ Fukuoka 1986 (cat.153); London 1988 (cat.38); Paris 1996 (p.111); Paris 1997 (p.304)

This work is one of the latest of a series of stringed sculptures which Moore created over two years from 1957 to 1959. As with his carvings, he is claiming the interior space of the object as the sculptor's domain. In addition to providing a way of seeing into the form like a transparent skin, the delicate strings link the soft lead curves of the figure which has been reduced to twisting circular planes.

Although initially inspired by mathematical models at the Science Museum in London, Moore was less interested in the mechanics of the structures than in the way the strings revealed the object's interior. He explained: 'I was fascinated by the mathematical models I saw there, which had been made to illustrate the difference of the form that is half way between a square and a circle . . . One end could also be twisted to produce forms that would be terribly difficult to draw on a flat surface . . . It wasn't the scientific study of these models but the ability to look through the strings as with a bird cage and to see one form within another which excited me.'[1]

The title exploits the Surrealist notion of shock by the provision of the unexpected – an experimental reworking of the theme of the reclining figure through biomorphism and abstraction. Moore's relationship with the avant-garde in the 1930s was tentative; nevertheless, he selectively appropriated the forms and aesthetic ideas of the various movements which contributed towards the development of his own sculptural vision. Naum Gabo arrived in Hampstead in 1935 – a decade after he and his brother Antoine Pevsner issued the Constructivist Manifesto in Russia, dedicated to the exploration of space through the manipulation of new forms and materials. Moore and Gabo exhibited together in 1936, in *Abstract and Concrete* which toured Oxford, London, Liverpool and Cambridge and also featured the work of Nicholson, Piper, Mondrian, Léger and Calder. The short-lived journal *Axis*, which sponsored the exhibition, published Moore's 'Notes on Sculpture' the following year in a collection of essays titled *The Painter's Object*, which also included the writings of Léger, Kandinsky and Moholy-Nagy.

Anita Feldman Bennet

1. Hedgecoe (ed.) 1968, p.33.

110
Three Points 1939-40
LH 211
cast iron
length 20cm
unsigned
Gift of Irina Moore 1977

exhibitions: Madrid 1981 (cat.41); Lisbon 1981 (cat.46); Barcelona 1981-82 (cat.35); Leeds 1982-83 (cat.41); New York 1983; Leeds 1986 (cat.188); London/Stuttgart 1987 (cat.205); New Delhi 1987 (cat.29); Düsseldorf 1987-88 (cat.75); London 1988 (cat.40); Martigny 1989 (cat.p.135); Bilbao

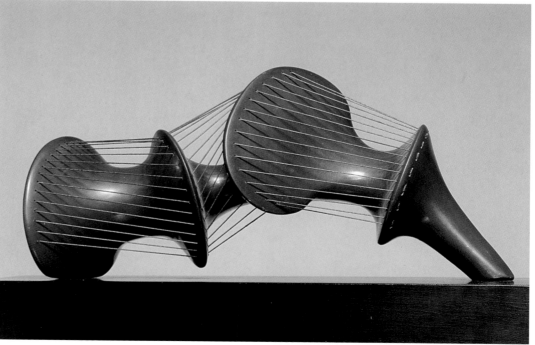

109

The 1938 **Drawing for Sculpture with Points** (HMF 1417) is the earliest example of Moore's interest in the abstract tension, devoid of figurative references, that is created by 'points practically touching', as the inscription states above the sketch which clearly anticipates the 1939-40 **Three Points**, but which does not include a central, conical spike.

In 1939, the motif of pointed forms practically touching was again explored in two highly finished drawings: **Seated Figure and Pointed Forms** (HMF 1497, private collection), and **Pointed Forms** (HMF 1496, Graphische Sammlung Albertina, Vienna). Although the latter drawing is dated 1940, it was almost certainly executed in the previous year, as it includes the study for the 1939-40 **Three Points**.

Three Points has provoked more disparate interpretations as to the possible sources of inspiration, conscious or unconscious, than any other sculpture by Moore that I can think of. With its highly charged tension and varied, evocative associations, the piece has much in common with Giacometti's sexually explicit Surrealist sculptures of the late 1920s and early 1930s, such as the 1929 bronze *Three Figures Outdoors* (Art Gallery of Ontario, Toronto), which includes two phallic, spike-like forms within the cage-like structure. David Sylvester, in the catalogue of the 1968 Henry Moore exhibition at the Tate Gallery (Moore read and approved Sylvester's manuscript before publication), suggested that 'it is possible that Moore unconsciously derived the spike from Picasso',[1] specifically from the thrusting, conical tongues of the horse and of the woman at the left in *Guernica* of 1937. The exact source of inspiration, however, Moore told Sylvester, was the sixteenth-century School of Fontainebleau painting *Gabrielle d'Estrées and One of Her Sisters* (Louvre, Paris). 'The fastidious pinching of Gabrielle's nipple

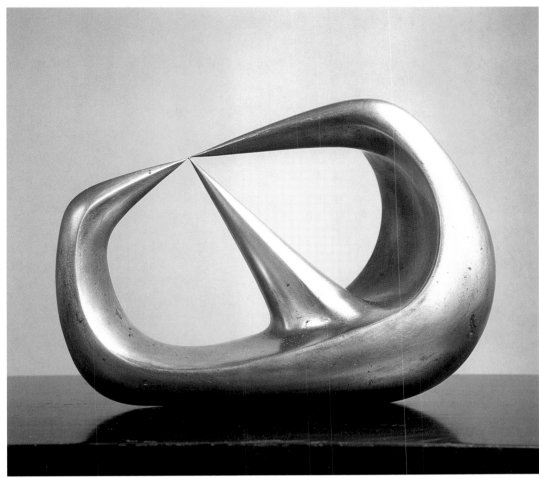

110

between her sister's pointed forefinger and thumb gave Moore the idea of making a sculpture in which three points would converge so that they were only just not touching'.[2] Yet in the early 1970s, when I mentioned this 'source' to Moore, he rather indignantly denied any direct influence of the School of Fontainebleau painting. The ideas in the pointed forms drawings and in the 1939-40 **Three Points** were, he told me, based on the memory of many things, including spark plugs.

Of the sources discussed above, I find the spike-like tongues found in Picasso's *Guernica* the most visually convincing. However, given Moore's intense interest in Oceanic art from the middle to late 1930s – as reflected in the internal/external form drawings inspired by figures from New Ireland, and in the 1939 **Bird Basket** (LH 205) which in my opinion was based on New Ireland friction drums – a more direct and plausible source may be found in tribal art. In the 'hook' figures or Yipwons from the East Sepik Province, Papua New Guinea, the pointed, horizontal form of the penis is protected above and below by two sharp, pointed, rib-like forms which practically touch. If the penis and the two arched forms were removed from the New Guinea carving and seen in isolation, they could very easily be mistaken taken for a wooden version of **Three Points**. If one of the Yipwon figures did not inspire Moore's sculpture, their striking similarities must rank as one of the most remarkable, fortuitous affinities between the tribal and the modern.

Alan Wilkinson

1. David Sylvester, *Henry Moore*, Arts Council of Great Britain, London 1968, p.36.
2. Ibid.

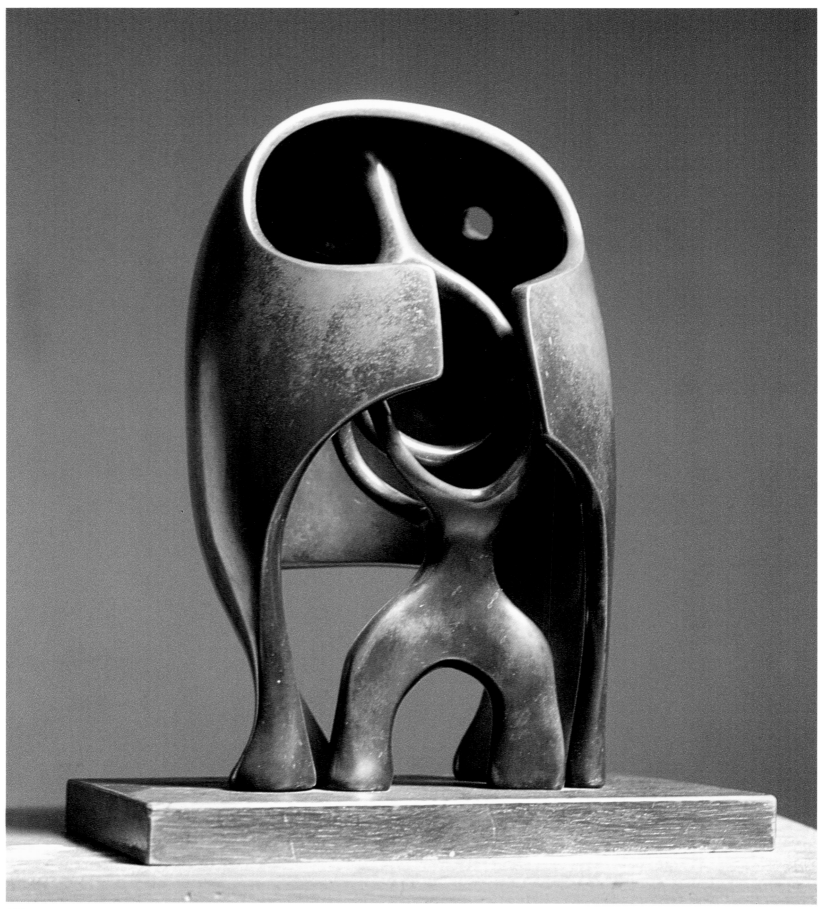

111

111
The Helmet 1939-40
LH 212
bronze
height 29.2cm
unsigned
Gift of Irina Moore 1977

exhibitions: Madrid 1981 (cat.186); Toronto 1981-82 (cat.129); Durham 1982 (cat.15); Mexico City 1982-83 (cat.82); Caracas 1983 (cat.E22); Leeds 1986 (cat.187); Hong Kong 1986 (cat.29); Tokyo/Fukuoka 1986 (cat.134); New Delhi 1987 (cat.30); London 1988-89; Bilbao 1990 (p.63); Leningrad/ Moscow 1991 (cat.41); Helsinki 1991 (cat.41); Sydney 1992 (cat.56); Ittingen 1994; Salzburg 1994; Buenos Aires/Rosario/Mar del Plata/Córdoba/Montevideo 1996; Berlin 1997 (cat.373)

Moore's interest in the internal/external form motif dates from a group of drawings of the mid-1930s, such as **Forms inside Forms** of 1935 (HMF 1225), a page from **Sketchbook B**, which includes a sketch of a malangan figure from New Ireland in the South Pacific. Moore was greatly impressed by the inner and outer framework of these intricate carvings, and by the extraordinarily skilled craftsmanship required to create forms within forms from a single block of wood.

The Helmet, the first of the internal/external form sculptures, was based on one of the six studies in **Heads: Drawing for Metal Sculpture** 1939 (HMF 1463). If the initial concept of a form within a form was suggested by the Oceanic sculptures Moore had sketched in 1935, the shape of the helmet itself, with the two holes at the back, derives from the pierced, helmet-like forms of two prehistoric Greek implements or utensils illustrated in *L'art en Grèce des temps préhistorique au début du XVIIIe siècle*[1] and copied by Moore in **Ideas for Sculptures and Artist's Notes** (HMF 1341 recto), a sketchbook page of 1937.

Alan Wilkinson

1. Christian Zervos, *L'art en Grèce des temps préhistorique au début du XVIIIe siècle*, Cahiers d'Art, 1934, plates 4 and 5. Moore owned a copy of the book.

112

112

Studies of Reclining Figures 1940
HMF 1478
pencil, pen and ink, conté crayon, crayon,
pastel, wax crayon, gouache, watercolour
wash on cream heavyweight wove
380 × 560mm
signature: crayon l.l. *Moore/40*
Acquired 1984

exhibitions: London 1987 (cat.4); Martigny
1989 (cat.p.138); Leningrad/Moscow 1991
(cat.43); Helsinki 1991 (cat.43); Sydney 1992
(cat.57); Krakow/Warsaw 1995 (cat.47);
Venice 1995 (cat.47); Nantes 1996 (cat.46);
Mannheim 1996-97 (cat.46); Havana/
Bogotá/Buenos Aires/Montevideo/Santiago
de Chile 1997-98 (cat.40)

113

**Seated Figures: Ten Studies of
Mother and Child** 1940
HMF 1513a
pencil, wax crayon, pen and ink, gouache,
watercolour on cream medium-weight wove
276 × 381mm
signature: pen and ink l.r. *Moore/40*
Acquired 1985

exhibitions: Martigny 1989 (cat.p.139);
Sydney 1992 (cat.58); Budapest 1993
(cat.58); Bratislava/Prague 1993 (cat.58);
Krakow/Warsaw 1995 (cat.49); Venice 1995
(cat.48); Nantes 1996 (cat.47); Mannheim
1996-97 (cat.47)

publications: Garrould 1988, pl.68

Among Moore's drawings are many larger,
finished presentations intended for
exhibition and sale on which he devoted
more time than on the jottings of ideas for
sculptures that he usually made in
sketchbooks. In this carefully set-out
drawing Moore returned to a more
representational approach to the subject of
mother and child, while incorporating some
of the formal explorations of the past
decade which had led to more abstracted
forms. These may be seen in the mothers'
tiny heads, which barely suggest human
features; the suckling baby on the left of the
lower rank, which is more like an
excrescence from its mother's body than a
child; the legs of this and another of the
mothers, which are close to the ones he had

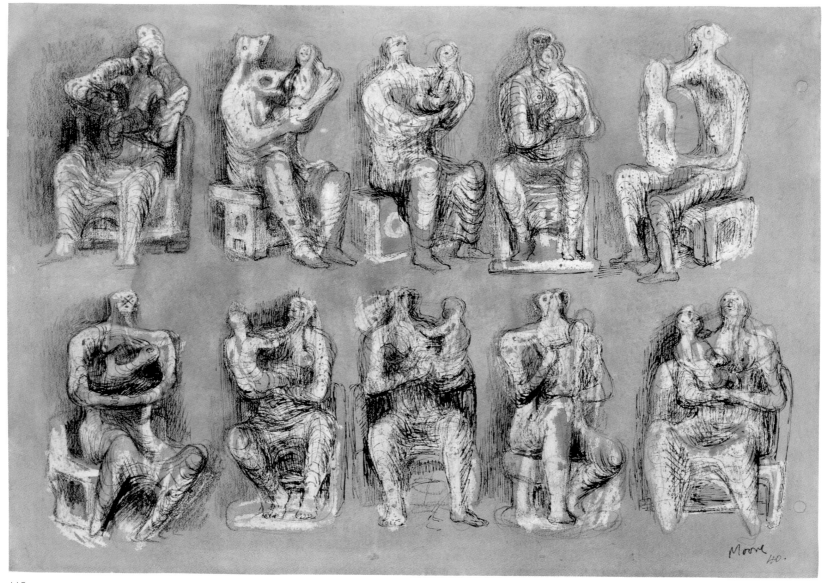

113

derived from bone formations [see cat.61].
In two of the groups Moore has used rays to
join the faces of mother and child,
emphasising the child's dependence on the
mother and giving a reminder of the strings
he had used in many sculptures in the
1930s.

On New Year's Day 1941 Moore was
appointed on the basis of his drawings as an
Official War Artist. This sheet antedates and
is outside the range of drawings of mothers
and children made in the London
Underground [see cat.115], and here he has
explored new combinations of materials to
create sculptural effects on a flat sheet of
paper, rather than record life around him.
Yet the ordered arrangement of detached
figures is unlike the colourful accretions of
multiple forms crowding the paper which
are typical of Moore's elaborate larger
drawings of 1939. Here he uses a
monochrome wash, pencil shading with
dry-brushed gouache highlights, and a final
layer of pen-and-inked detail for individual
groups that anticipate the Madonna and child
theme he explored in 1943 [see cat.141].

Susan Compton

114

**Studies for Sculpture: Reclining
Figures** 1940
HMF 1534
pencil, crayon, wax crayon. pastel, pen and
ink, watercolour on cream medium-weight
wove
274 × 181mm
signature: pencil l.r. *Moore/40*
Acquired 1980

exhibitions: Madrid 1981 (cat.D91); Lisbon
1981 (cat.D91); Columbus/Austin/Salt Lake
City/Portland/San Francisco 1984-85
(cat.99); London 1988-89

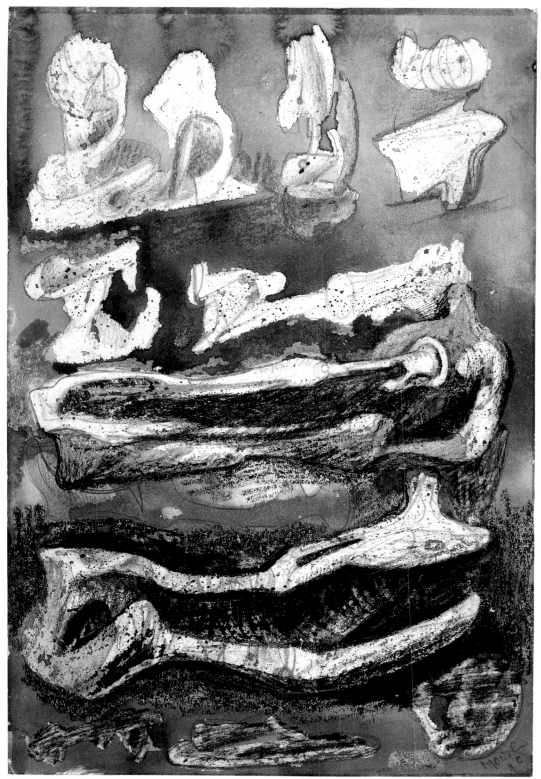

114

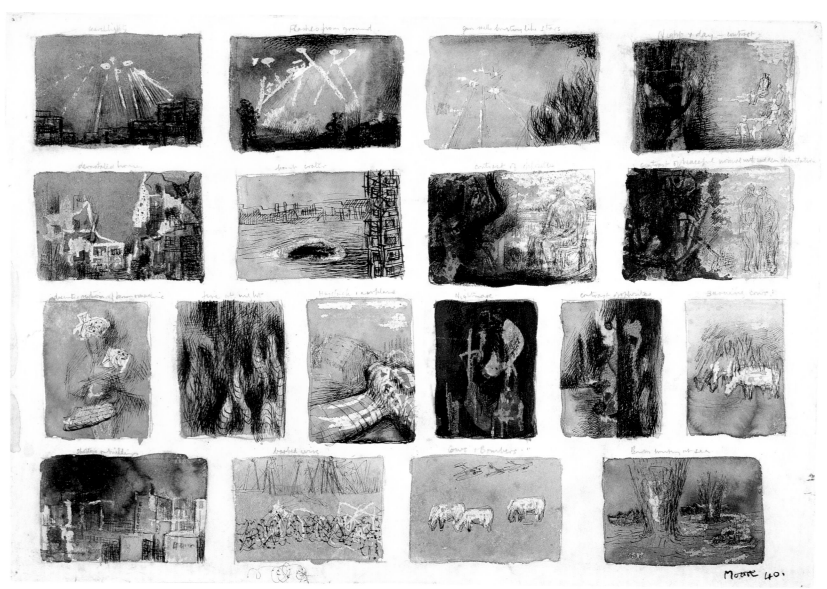

115

115

Eighteen Ideas for War Drawings
1940
HMF 1553
pencil, pen and ink, wax crayon, chalk,
watercolour, wash on cream medium-
weight wove
274 × 376mm
signature: pen and ink l.r. *Moore/40*
inscription: pencil u.l. *searchlights*;
u.c. *Flashes from ground*; *gun shells bursting
like stars*; u.r. *Night & day – contrast*;
u.c.l. *devastated houses*; *bomb crater*;
u.c.r. *contrast of opposites*; *contrast of
peaceful normal with sudden devastation*;
c.l. *disintegration of farm machine*; *fire at
night*; c. *Haystack & airplane*; *Nightmare*;
c.r. *contrast of opposites*; *Burning cows*;
l.c.l. *spotters on buildings*; *barbed wire*;
l.c.r. *Cows & Bombers*; *Bombs bursting at sea*
Gift of the artist 1977

exhibitions: Paris 1977 (cat.174); Toronto/
Iwaki-Shi/Kanazawa/Kumamoto/Tokyo/
London 1977-78 (cat.138); Madrid 1981 (cat.
D103); Lisbon 1981 (cat.D107); Barcelona
1981-82 (cat.D81); London 1982 (cat.2);
East Berlin/Leipzig/Halle/Dresden 1984
(cat.5); London 1988-89; Sydney 1992
(cat.59); Budapest 1993 (cat.59); Bratislava/
Prague 1993 (cat.59); Krakow/Warsaw 1995
(cat.48); Venice 1995 (cat.49); Nantes 1996
(cat.48); Mannheim 1996-97 (cat.48)

publications: Garrould 1988, pl.64

For almost the whole of the first year of the
war, up until June 1940 when Hitler's
invasion of England seemed imminent,
Moore was able to carry on working in a
relatively normal way at his sculpture. He
and Irina were living at their cottage,
Burcroft, in Kent, from where Moore used
to drive up to London twice a week to fulfil
his teaching commitment at Chelsea.
During this period he was invited by
Kenneth Clark to consider working for the
newly formed War Artists' Advisory
Committee, but turned the offer down,
feeling that he had no clear ideas for
suitable subjects.

This drawing, dated 1940 by the artist,
is sometimes referred to as 'Eighteen War

Sketches'. It holds an intermediary position in the corpus of Moore's wartime drawings, coming between **September 3rd, 1939** 1939 (HMF 1551), clearly sparked by the emotional impact of the outbreak of war, and the finished Shelter drawings. It is directly related to **War – Possible Subjects** (HMF 1603) page 45 of the **First Shelter Sketchbook** 1940-41, in which, below a drawing of ruined buildings against a background of flames, Moore has written a heading: 'War possible subjects'. The list of thirteen topics that follows includes a number of those which appear in this composite drawing. It is therefore clear that although Moore was by this time intensely occupied with the Shelter drawings he was still considering other war-related subjects.

The eighteen tiny images are laid out very precisely on the sheet, three rows of four horizontal subjects being separated by the third row of six vertical ones. This is very different from Moore's practice of packing a sheet with multiple versions of a single idea, and the drawing is clearly a carefully prepared and finished work.

The subjects, all titled by the artist, vary from literal depictions of searchlights and bombs bursting between warships at sea, through the highly surreal image of cows in flames, to images in which ideas are expressed in a more symbolic manner. 'Night & day – contrast' in the top row, 'contrast of opposites' and 'contrast of peaceful normal with sudden devastation' in the second row are all metaphors for the destructive effect of war on ordinary lives, showing normal figures against scenes of fire and destruction; these become more abstracted, and more emotional, in 'Nightmare' and 'contrast of opposites' in the third row. At the same time several of the studies of bombed buildings, with dramatic outlines and strong colours, are similar to versions of the same subjects carried out by Graham Sutherland and John Piper, while 'Haystack & airplane', in which Moore has made use of his two-way sectional line technique, resembles images by another war artist, Paul Nash.

These tiny drawings are interesting also for the media used. Even on this small scale Moore is using mixtures of pen and ink, pencil, chalk and watercolour wash, as he did in his much earlier figure studies, together with the wax crayon resist that he had recently discovered and used for the first time in some important standing figures. He would evolve this technique even further in the Shelter drawings that followed.

Julian Andrews

116-129
Second Shelter Sketchbook 1941
HMF 1626-1720
Paper covered notepad originally containing 96 pages of off-white lightweight wove paper 204 × 165mm stapled to cover at upper edge above a perforated line 42mm from the top. The cover is inscribed by the artist in pencil *Irina Moore*/*March 1941*/*to Oct 1941*. The 95 pages in the collection of the Henry Moore Foundation are numbered in pen and ink lower right on the verso; one page was removed prior to numbering and is owned privately. None of the pages are signed or dated. The notepad was taken apart on a number of occasions and has remained unbound since 1981.
Gift of Irina Moore 1977

Moore's discovery of the subject that was to occupy him for almost a year of intense work took place, almost certainly, on 11 September 1940. On that night the first major anti-aircraft barrage of the war opened up throughout the London area, so that passengers alighting from Underground trains were advised by wardens to remain below ground in the Tube stations until it was over. Moore and his wife, who were returning from an evening out in the West End, stayed for about an hour on the platform of Belsize Park station, where Moore had the opportunity to observe the people, and the atmosphere of the place, for longer than would normally have been the case. His own evocative descriptions of the scene have often been quoted, particularly his comparison of the sleeping figures on the platform to his own reclining figures, and the train tunnels resembling the holes in his sculptures.

Within a day or two of this experience he had begun his first drawings based on shelter subjects. These were not, however, in a sketchbook but on larger size paper, similar to other drawings of war subjects he had already carried out: **Women and Children in the Tube** (HMF 1726) of 1940, now in the Imperial War Museum, is 280 by 380 millimetres, the same size as two other drawings known to predate the shelter experience, **Standing, Seated and Reclining Figures against Background of Bombed Buildings** (HMF 1556) and **Gash in Road: Air Raid Shelter Drawing** (HMF 1557). By contrast the sketchbook pages measure only 204 by 165 millimetres. Moore completely filled two sketchbooks with shelter subjects, both of which have survived. The first was given to Jane Clark, wife of Moore's patron and friend Sir Kenneth Clark, who bequeathed it to the British Museum in 1977. Moore partially filled two others, which were broken up, the separate sheets being sold. The precise total of sketchbook drawings made by Moore is uncertain. Approximately seventy-five larger 'finished' Shelter drawings were made, derived directly from the subjects in the sketchbooks. Seventeen of these were acquired by the War Artists' Advisory Committee for subsequent presentation to museums and galleries all over Britain.

Moore's use of the sketchbooks clearly resulted from his decision to make a series of visits to the Underground with a view to collecting ideas for drawings. Confusion has sometimes been caused by the varying use of the words 'sketch' and 'drawing', leading some people to assume that Moore carried out sketches actually in the Tube stations. This was not the case: he realised that it would have been a tactless intrusion into the privacy of the shelterers if he had attempted to draw them directly. Instead he limited himself to discreet but intense observation of the scenes, sometimes finding a quiet corner in which he could scribble down a note or reminder to himself, on a scrap of paper, about a figure or a position. Similar reminders also occur on a number of the sketchbook pages. Moore would then work from these notes (none of which he apparently kept) when he came to re-create the scenes from memory. After two or three nights'

observing in the Underground he would spend several days working intensively on the drawings at home – first in London and then, from October 1940 (after his Hampstead studio had suffered bomb damage) at Perry Green, where he and Irina had managed to rent part of Hoglands.

The sketchbook drawings are not, therefore, simply sketches, but intense works of the imagination, in many cases finished works in their own right. The fact that Moore squared up a number of pages in the sketchbooks in order to produce other versions of certain drawings, on a larger scale, in no way reduces the importance or the power of the smaller images. He applied to these scenes all the complex mixed-media techniques that he had evolved in his pre-war drawings [see cat.115], to obtain extraordinary richness of texture combined with a sense of depth.

Although immense numbers of essays and articles have been written about the Shelter drawings, few writers have analysed the differences between the **First** and **Second Shelter Sketchbooks**, the exception being Alan Wilkinson in the 1977 Tate Gallery catalogue. In his pre-war drawings Moore had been concentrating on the development of ideas for sculpture, three-dimensional forms, many of them quite abstract. The sight of the huddled, muffled figures on the Tube platforms was, in Kenneth Clark's words, 'visible confirmation of the world of form that he had been extracting from his inner consciousness for the last ten years'.[1] Yet at the same time the emotion of the scenes turned Moore towards far more naturalistic, almost classical representations of the human figure. The contrast between these two approaches shows up particularly in the first twenty pages of the **First Shelter Sketchbook**, where beautifully gentle, figurative drawings of women and girls alternate with totally abstract forms – together, also, with scenes of buildings, barbed wire, even crashed aircraft.

At this early stage the War Artists' Advisory Committee was quite unaware of what Moore was doing. It is not known precisely when he first showed some of his Shelter drawings to Clark, nor is it known when he finished the first sketchbook and

moved on to the second, but Clark is on record in the minutes of the Committee's meeting of 5 December 1940 as reporting that Moore 'had done outstandingly good drawings of shelter subjects'. Less than a month later, at their meeting on 1 January 1941, the Committee recommended that four of Moore's shelter subjects should be acquired for a total of thirty-two guineas. These were obviously 'finished' drawings, not sketchbook pages, showing that in the three months since he had started on this theme Moore had already produced a remarkable quantity of work.

Comparison between the two sketchbooks is difficult, not only because they are located in different places (and have both been dismantled with their pages all individually framed) but because it is evident, as they progress, that Moore returns from time to time to themes – and to actual places – that he has treated earlier, sometimes after long intervals when he has been working on other subjects. **Tube Shelter Perspective** [cat.130], for example, inspired by the unfinished tunnel extension at Liverpool Street, appears as early as page 21 of the **First Shelter Sketchbook**, being elaborated in a number of versions in the second. Scenes in the Tilbury warehouse shelter, in Commercial Road, Whitechapel, also appear in both. Each of the sketchbooks also contains above-ground scenes, some of which may be imaginary (or drawn from memory), while others have clearly been inspired by press photographs. When Wilkinson points out that 'sculptural ideas with the exception of two or three drawings, do not appear in the Second Shelter Sketchbook'[2] he means references by Moore to 'his earlier brain-children' (as Clark describes them), his concerns with problems of form. But in fact the **Second Shelter Sketchbook** contains many drawings of individual figures which contain the seeds of some of Moore's most important sculptures of the post-war period. These include the Northampton **Madonna and Child** (LH 226), the family groups, the draped reclining figures and the **Three Standing Figures** (LH 268) in Battersea Park, as well as a number of the seated figures. The second sketchbook also

includes certain subjects that are barely developed in the first: notably the figures and faces seen from a very low perspective angle, which are often compared to figures in Mantegna's *Agony in the Garden* in the National Gallery, London, and to his *Dead Christ* in the Brera, Milan. Another innovation in the second sketchbook is very dramatic use of the two-way sectional line to create figures that appear ghostly, even skeletal.

The two Shelter Sketchbooks were felt by Clark to be 'among the most precious works of art of the present century'.[3] The influence of the shelter experiences on Moore's subsequent development is a major subject which cannot be pursued here, but in the following pages a number of images from the **Second Shelter Sketchbook** are analysed in greater detail.

Julian Andrews

1. Clark 1974, p.149.
2. Alan Wilkinson, in Toronto/Iwaki-Shi/Kanazawa/Kumamoto/Tokyo/London 1977-78, p.31.
3. Clark 1974, p.150.

116
Sleeping Figure and Figure Pinned under Debris 1941
Page 2 from Second Shelter Sketchbook
HMF 1627
pencil, wax crayon, pen and ink, watercolour wash
inscription: pen and ink c. *Figure sleeping/ in shelter*; c.l. *Figure pinned/under debris.*

exhibitions: East Berlin/Leipzig/Halle/ Dresden 1984 (cat.25); London 1988-89; Ittingen 1994

publications: Garrould 1988, pl.69

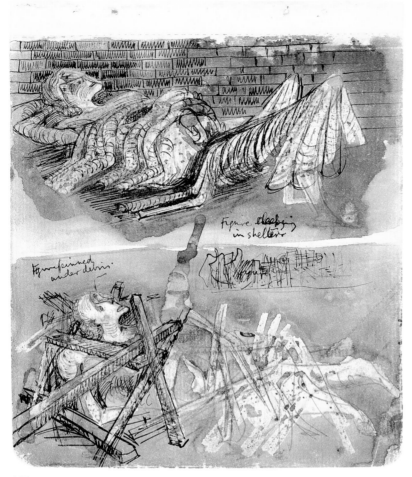

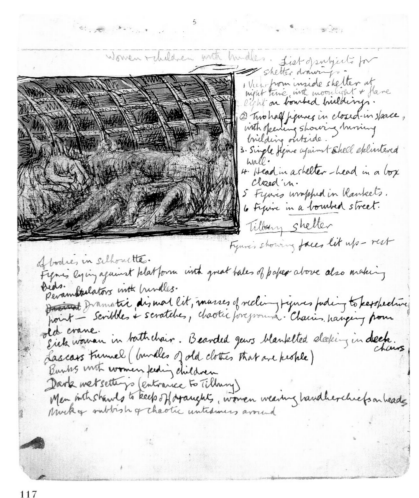

116

117

117
Women and Children with Bundles
1941
Page 6 from Second Shelter Sketchbook
HMF 1631
pen and ink, wax crayon, gouache,
watercolour wash
inscription: pencil u.c. *Women & children
with bundles.*; pen and ink u.r. *List of
subjects for/shelter drawings./1 View from
inside shelter at/night time, with moonlight
& flare/light on bombed buildings./2
[circled] Two half figures in closed-in
space/with opening showing burning/
building outside./3. Single figure against
shell splintered/wall./4. Head in a shelter –
head in a box/closed in./5 Figures wrapped
in blankets./6 Figure* in a bombed *street./
Tilbury Shelter/Figures showing faces lit up
– rest/of bodies in silhouette./Figures lying
against platform with great bales of paper
above also making/beds./Perambulators
with bundles./Dismal* [crossed through]

*Dramatic, dismal lit, masses of reclining
figures fading to perspective/point –
Scribbles and scratches, chaotic foreground.
Chains hanging from/old crane./Sick
woman in bathchair. Bearded jews
blanketed sleeping in deck./chairs/Lascars
tunnel (bundles of old clothes that are
people)/Bunks with women feeding children/
Dark wet settings (entrance to Tilbury)/Men
with shawls to keep off draughts, women
wearing handkerchiefs on heads/Muck &
rubbish & chaotic untidiness around*

exhibitions: Colorado Springs 1982; East
Berlin/Leipzig/Halle/Dresden 1984 (cat.9);
London 1988-89; Ittingen 1994; Salzburg
1994

During the early years of the Second World
War Moore spent most of his time drawing,
and created a monumental series of
drawings of the Underground bomb
shelters. 'It's curious how all that started,'
he wrote. 'The official shelters were
insufficient. People had taken to rolling
their blankets about eight or nine o'clock in
the evening, going down into the tube
stations and settling on the platforms . . . It
was like a huge city in the bowels of the
earth. When I first saw it quite by accident –
I had gone into one of them during an air
raid – I saw hundreds of Henry Moore
Reclining Figures.'[1]

Moore began to travel by train from
station to station specifically to see the
differences between the stations, and the
some hundred thousand people sheltered
there from the bombings. He could not
actually make the drawings while in the
station, that would have been 'like making
sketches in the hold of a slave ship. One
couldn't be as disinterested as that.'[2] He
would sometimes just jot a few notes to
remind him of the scene, and then from
memory he would use a wax-resist
technique which included quick strokes of

crayon with a watercolour wash on top to add colour. The drawings that Moore created in these bowels of the earth show the pathos and yet the stoicism of the times. 'I had never seen so many rows of reclining figures,' he wrote, 'and even the holes out of which the trains were coming seemed to me to be like the holes in my sculpture. And there were intimate little touches. Children fast asleep, with trains roaring past only a couple of yards away. People who were obviously strangers to one another forming tight little intimate groups.'[3]

On this page Moore wrote, 'bundles of old clothes that are people'. This simple note, scribbled as he walked through the shelter, led to the actual drawing. The clothing seemed to provide an added shelter for the family and it created an integral rhythm of internal and external forms. The drapery became an important aspect of the imagery depicted, almost the subject itself: the figures were bundled up, as their clothed bodies were covered with blankets and children huddled next to them. The drawings cumulatively present a narrative of man's quest for survival, his need for warmth and the ability to create a shelter for himself and his family in the face of adversity. This pursuit of nourishment goes beyond physical survival to a psychological quest.

Gail Gelburd

The drawing on this page, which can justifiably be classified as a sketch, occupies less than a quarter of the sheet, the remainder being filled with written notes. There are two headings: 'List of subjects for shelter drawings' at the right, and 'Tilbury Shelter' for the lower part of the sheet. In addition a separate heading in pencil at the top appears to be a title for the drawing: 'Women & children with bundles'.

This drawing shows the formal curved girder structure of an unfinished tunnel, and is probably based on a scene in the extension at Liverpool Street Tube station. The figures are seated on the ground, where the rails have not yet been laid, against the curved wall. A chaotic group of people are huddled together. Neither set of

notes bears any relation to this drawing. The list of subjects seems to refer to possible scenes at the doorway of a surface shelter, not a Tube station, since Moore is clearly interested in the effects of silhouettes against the light from flares and burning buildings outside. By contrast the scenes at Tilbury Shelter, probably recollections from the previous night, are claustrophobic, with a dramatic background of industrial equipment and fittings against which people are desperately trying to make a temporary life for themselves. The references in these notes to Lascars and Jews, and to dark, wet settings at the entrance, make an interesting commentary on the social background of the East End of London at this time.

Julian Andrews

1. James (ed.) 1966, p.212; 1992, p.226.
2. Moore 1988, p.9.
3. Ibid.

118
Study for 'Group of Shelterers during an Air Raid' 1941
Page 17 from Second Shelter Sketchbook
HMF 1642
pencil, wax crayon, pen and ink, watercolour
inscription: pencil u.c. *Black bearded jews, men with shawls, women handkerchiefs on heads, women in/aprons*

exhibitions: Madrid 1981 (cat.D108 l.l.); Lisbon 1981 (cat.D112 l.l.) Barcelona 1981-82 (cat.D85 l.l.); Mechelen 1982 (cat.217); East Berlin/Leipzig/Halle/Dresden 1984 (cat.42); London 1988-89; Ittingen 1994; Salzburg 1994

A drawing which divides into two utterly distinct sections. In the lower part four female figures, one cradling a baby, are seated against the receding curves of a tunnel perspective. This is drawn with very fine pen and ink lines, giving the illusion that we are within the funnel of a tornado. The figures are massive, but sketchily drawn. This section of the sheet has been squared up, and is clearly the study for the large drawing **Group of Shelterers during**

an Air Raid 1941 (HMF 1808), now in the collection of the Art Gallery of Ontario.

The upper part of the sheet contains a drawing of two reclining figures which are entirely sculptural in conception, one of the very few drawings in this sketchbook which refers directly back to Moore's pre-war subjects. There is some ambivalence, however: the raised knees of both figures – particularly of the distant one – are uncomfortably representational against the upper sections, which are highly abstract. The nearer figure seems related to several of the reclining figure sculptures of 1938-39, particularly to LH 202 [cat.108]. At the same time the taller seated figure in the lower drawing looks forward to the series of seated figure sculptures of the late 1940s. This drawing is therefore an interesting example of the way in which the Shelter drawings are simultaneously informed by Moore's earlier practices while sowing the seeds of future developments.

Julian Andrews

During the period 1940-41 Moore executed virtually no independent studies for sculpture, but what was at first an involuntary fascination with the human drama of the underground shelters during the Blitz from September 1940 to the spring of 1941 provided him with an enormous range of possibilities, in which as Herbert Read wrote in *Art in Australia* in September 1941, 'the whole meaning and substance of his past work is implicit in this new work'. His method of working was to make notes rather than drawings, which he felt would have been too intrusive, on the spot, then work up these ideas into drawings in his studio at Much Hadham. Although the experience ultimately propelled him towards a more naturalistic treatment of the human figure, all his observations were shot through with his preoccupation as a sculptor, emulating Gauguin's precept: 'Art is an abstraction; as you dream amid nature, extrapolate art from it and concentrate on what you will create as a result.'

This tiered sheet from the second sketchbook, that he began towards the end

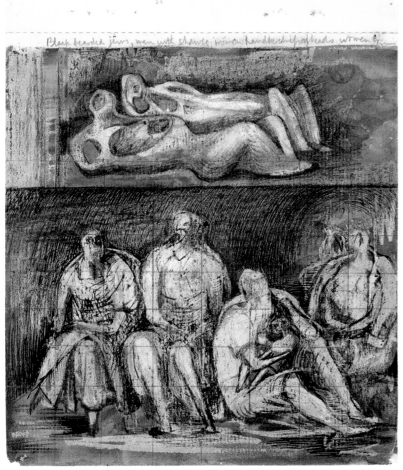

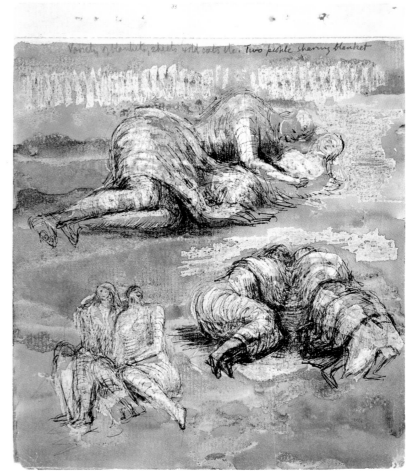

118

119

of 1940, shows the softening of his pre-war abstraction above into the semblance of draped reclining figures, with the evidence below of Moore's new-found interest in family groups prompted by the shelter scenes. The inscription at the top of the page, 'Black bearded jews, men with shawls, women handkerchiefs on heads, women in aprons' refers to the huge Tilbury shelter, the basement of a warehouse in Commercial Road, Stepney, whose nocturnal invasion by a chaotic multi-racial population gripped the artist's imagination. The figures below, located in the penumbra of an underground tunnel, have been squared for the purposes of enlargement for one of the approximately seventy-five drawings worked up from the pages of the Shelter Sketchbooks. Eighteen were acquired by the War Artists' Advisory Committee, from whom Moore received his official commission on 1 January 1941, but the others were freely sold by the artist; in

this case the finished drawing was acquired by the Contemporary Art Society and then presented to the Art Gallery of Ontario in Toronto in 1951.

Frances Carey

119
Figure Studies: People Sharing Blankets 1941
Page 22 from Second Shelter Sketchbook
HMF 1647
pencil, wax crayon, pen and ink, watercolour
inscription: pencil u.c. *Variety of blankets, sheets & old coats etc*; pen and ink *Two people sharing blanket*

exhibitions: London 1982 (cat.3); Mantua 1981 (cat.63); London 1988-89; Ittingen 1994

How the figure is set in its space was important for Henry when he drew. He would tell me that 'you need to kill the tyranny of the white sheet of paper'. I hate photographs of sculptures which are cut out and pasted on to a page. You see a lot of that in catalogues and books. If you photograph a sculpture against a white bed-sheet then the slight shadow indicates an environment for the sculpture, makes it look real; a cut-out photo or a drawing with hard edges on a white sheet looks artificial, without scale. That's the reason why Henry broke up the backgrounds of his drawings, sometimes rubbing wax across and painting a watercolour wash over them to alleviate the dead anonymous white. He's done that in this one, and it sets it within the paper and within its space.

When I was working for him he drew not in the studio during the day but in the evenings in his sitting-room. He would draw in little sketchbooks. He let me have

189

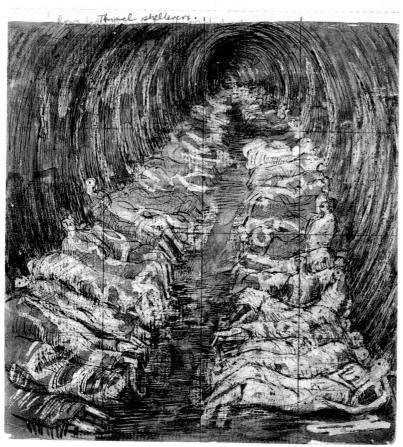

120

121

sight of the sketchbooks at that time. I was trying to get into his head, understand the way he was thinking and find out how his mind was working, and the sketchbooks really helped.

Anthony Caro

120
Study for 'Tube Shelter Perspective':
The Liverpool Street Extension 1941
Page 24 from Second Shelter Sketchbook
HMF 1649
pencil, wax crayon, pen and ink,
watercolour wash
inscription: pen and ink u.c. *Tunnel shelterers*; over pencil *Rows* [. . .]

exhibitions: Madrid 1981 (cat.D108 u.c.);
Lisbon 1981 (cat.D112 u.c.); Barcelona
1981-82 (cat.D85 u.c.); Mexico City 1982-83
(cat.D34); Caracas 1983 (cat.D38); East

Berlin/Leipzig/Halle/Dresden 1984 (cat.6);
London 1988-89; Bilbao 1990 (p.67);
Ittingen 1994; Salzburg 1994

This drawing is the second of three versions of the 'Tube Shelter Perspective' that appear in the second sketchbook, and is the preparatory study for the large version owned by the Tate Gallery (HMF 1801). At least two further 'finished' versions are known; all were inspired by the Liverpool Street extension tunnel, in which the rails were still to be laid, so that people could lie down in rows on either side of the tunnel.

This has rightly been seen as one of the most profound and symbolic images to have emerged from the Second World War. The colour variations that Moore has used in his different versions of this subject are interesting: in his first study, a few pages earlier, a gentle pink is used in the foreground, against which many of his

figures seem to be sitting up, alert. The grey of the tunnel is also relieved, in that version, by extensive use of white, with touches of blue. Here, however, the colour is an almost uniform grim grey, touched only with a dingy yellow, the effect being much more one of weary resignation, perhaps even hopelessness. While the figures in the earlier version may well have been interpreted as larvae that will eventually bring forth life and emerge from the ground, those here and in the finished Tate drawing seem to be wrapped not in blankets but in winding-sheets or shrouds.

The atmosphere of this strange, subterranean world was perfectly captured by Moore in words, as well as in his drawings, when he wrote of people being 'cut off from what was happening above, but they were aware of it. There was tension in the air.'[1] He compared these shelterers to 'people who were having

things done to them that they were powerless to resist'.[2]

The photographer Bill Brandt recorded this scene in an image strikingly similar to Moore's. The two images, together with juxtapositions of other works by photographer and artist, were published side by side in the popular magazine *Lilliput* in December 1942. Regularly included in exhibitions of Moore's works, reproduced continually in books and magazines, the tunnel perspective has become one of Moore's best-known drawings, symbolising as it does the plight of humanity in an age of conflict.

Julian Andrews

The tunnel of the Liverpool Street extension to the Central Line, stretching as far as Leytonstone in East London, became one vast elongated shelter holding an estimated ten thousand people. Because there was no compulsion to leave as trains could not pass through, some people did at first stay below for long periods of time, feeding official fears of a 'deep-shelter' mentality that would become irreversible. The impact of this tunnel on Moore was apparent from a sketch, **Underground Sheltering** (HMF 1579) on page 21 of the **First Shelter Sketchbook**. This resulted in seven other drawings of varying degrees of finish whose culmination was the version now in the Tate Gallery (HMF 1801). These studies are perhaps the most compelling aspect of Moore's subterranean world, which disturbed some contemporaries who recognised in the figures 'a static life more intense than ours, that is devoid of incident. Their clothes are cerements. They have the Lazarus look; they are brought like Alcestis from the grave.'[3]

The extraordinary power of this 'tunnel vision' affected subsequent compositions by Moore such as **Odysseus in the Naiads' Cave** 1944 (HMF 2502), one of six illustrations to the published version of Edward Sackville-West's verse drama *The Rescue* (1945). In more recent times, it has been one of the sources of inspiration for the 'Time Tunnel' created by the designer Peter Sykora for Gotz Friedrich's production

of Wagner's Ring Cycle that was first performed for Deutsche Oper in Berlin 1984-85.

Frances Carey

1. Moore 1967, introduction.
2. James (ed.) 1966, p.218; 1992, p.232.
3. Frederick S.Wight, 'Henry Moore: The Reclining Figure', *Journal of Aesthetics and Art Criticism*, December 1947, p.103.

121
Sleeping Positions 1941
Page 45 from Second Shelter Sketchbook
HMF 1670
pencil, wax crayon, pen and ink, watercolour wash

exhibitions: Colorado Springs 1982; London 1988-89; Ittingen 1994

The pages of the **Second Shelter Sketchbook** are sprinkled with the artist's comments on the positions of the figures, who were often denied any proper repose; Moore noted their 'distorted twistings' and 'disorganised angles of arms and legs covered here and there with blankets', sometimes adding the injunction 'Try positions oneself'. These all contributed to the accumulation of visual information that he was later to put into practice in a different context. 'The angular, attenuated, blanketed figures' reappear in the sketchbook studies and one of the larger drawings, **The Death of the Suitors** 1944 (HMF 2305) for *The Rescue*, which in turn anticipated the warrior sculptures of the 1950s with their apparently precarious sense of equipoise.

Frances Carey

122
Shelter Drawing 1941
Page 46 from Second Shelter Sketchbook
HMF 1671
pencil, wax crayon, pen and ink, watercolour wash

exhibitions: Madrid 1981 (cat.D112 l.r.); Lisbon 1981 (cat.D116 l.r); Barcelona 1981-82 (cat.D88 l.r.); Mechelen 1982 (cat.219); East Berlin/Leipzig/Halle/Dresden 1984 (cat.64); London 1988-89; Ittingen 1994; Salzburg 1994

A multiple drawing, showing nine lying and seated figures, all swathed in blankets or shawls, the two half-figures at bottom left being only very roughly sketched. The remainder are all variations on sitting and lying positions, and all are female figures, apart from the top left pair who appear to be a couple. The two figures in the centre are nursing children.

The impression is of a series of poses, almost as though drawn for an art school exercise since, with the exception of the couple, all the figures are clearly quite distinct from each other. They do not form a group or crowd as in so many of the other shelter studies, their apartness being emphasised by the dark grey wash that forms the background to the whole sheet. Against this, Moore has used green wash on wax crayon resist as the predominant colour for most of the figures, offset by strong reds, pinks and occasional orange. Alan Wilkinson has pointed out that the colours used by Moore were freely invented, rather than precise descriptions of what he had seen, and this is obviously the case here. Moore, too, stated that he used colour for its emotional effect, not its decorative or realistic effect.

Moore's interest is clearly in the varied shapes of the human body as partially revealed beneath drapery, the centre right figure hinting at his post-war mother and child theme, while the one at bottom right, in red and pink, stresses the outline of the knees in a pose that would become familiar in his seated figure sculptures of 1948-49.

Julian Andrews

122

123

123
Study for 'Morning after the Blitz'
1941
Page 60 from Second Shelter Sketchbook
HMF 1685
pencil, wax crayon, pen and ink,
watercolour wash
inscription: pen and ink u.c. *Sightseers among debris*

exhibitions: Madrid 1981 (cat.D104 u.c.);
Lisbon 1981 (cat.D108 u.c.); Barcelona 1981
(cat.D82 u.c.); Mexico City 1982-83
(cat.D36); Caracas 1983 (cat.D.40);); East
Berlin/Leipzig/Halle/Dresden 1984 (cat.2);
London 1988-89; Ittingen 1994; Salzburg
1994

124
Falling Buildings: The City
30 December 1940 1941
Page 61 from Second Shelter Sketchbook
HMF 1686
pencil, wax crayon, pen and ink,
watercolour wash
inscription: pen and ink u.c. *Falling buildings*; pencil [. . .] *drawings & enclosed drawings against walls etc/*[. . .] *of black & white Mayor gallery drawings*

exhibitions: Madrid 1981 (cat.D104 u.r.);
Lisbon 1981 (cat.D108 u.r.); Barcelona
1981-82 (cat.D82 u.r.); Mexico City 1982-83
(cat.D37); Caracas 1983 (cat.D41); East
Berlin/Leipzig/Halle/Dresden 1984 (cat.3);
London 1988-89; Ittingen 1994; Salzburg
1994

Moore gave a typically vivid description of
his feelings on emerging from the shelters
after a night below ground: 'It was strangely
exciting to come out onto the street in the
early hours of the morning after a big raid,
and I used to go down the back streets to
see what damage had been done.'[1] He went
on to describe seeing the girl with plaster in
her hair depicted in HMF 1714, but at no
time did he ever mention seeing a building
collapsing, as in cat.124. It is scarcely likely
that he would not have mentioned such a
dramatic event – indeed it is probable that
he would have made a number of drawings
of the scene. The assumption must be that
he did not see either of the scenes from
which these images are drawn, except in
photographs. They thus stand alone in the
corpus of Shelter drawings, although Moore
made an enlarged version of the 'sightseers'
scene (HMF 1558) which is now in the
Wadsworth Atheneum, Hartford,
Connecticut. We do know, of course, that he
was still considering other ideas for war
subjects at this time.

The first drawing, of the people in the

124

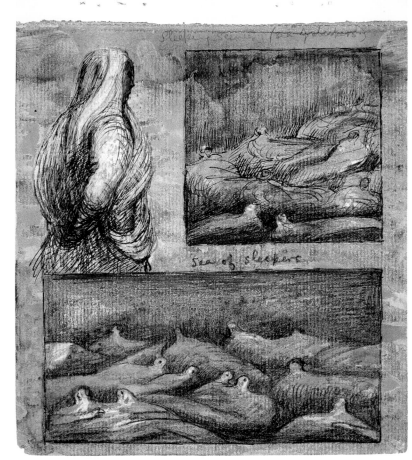

125

debris, is a view from a high angle. For reasons already explained Moore did not have his sketchbook with him when he took his early morning walks, and in any case he would never have been allowed to climb up into a building in a blitzed street. Furthermore he would not have been allowed to sketch such scenes at all unless – like his friend Graham Sutherland – he had a permit to do so. Almost certainly he saw the dramatic photographs of these scenes which appeared in magazines and newspapers, and decided to re-create them for himself.

The Imperial War Museum holds copies of many press photographs taken during the blitz, including two which perfectly match these two drawings by Moore.[2] The first shows a devastated street from a similarly high angle, with groups of dark figures standing in the wreckage of the buildings. There is a curious, motionless quality about these figures which one also

feels in Moore's drawing and which, on reflection, seems a little odd. The reason is that the people in the photograph are not sightseers at all, but ARP wardens and Civil Defence rescue workers, dressed in their dark boiler-suits, standing absolutely still in order to listen for sounds from possible survivors under the debris.

The other photograph, also very well known, shows the collapse of No.23 Victoria Street on 11 May 1941. Moore's drawing shows a street from exactly the same angle, the buildings on the left, through to No.23, being identical to those in the photograph. Moore has simply added the ruined building on the right and the debris on the ground – probably features he noted on one of his walks. Interestingly, when a selection of Shelter drawings toured East Germany in 1984, including the cities of Berlin and Dresden, it was this image that the authorities chose for the cover of their exhibition catalogue, since it symbolised

the kind of war with which they could most closely identify.

These two drawings, the second in particular, are executed in a detached, objective manner, far removed from the emotion that infuses so many of the studies of shelterers. Were they to be seen outside their sketchbook context it is doubtful whether they would necessarily be recognised as being by Moore. Nevertheless they are of importance as an indication of his interest in the effects of the war on the population of London, and his urge to seek new subjects covering this theme.

Julian Andrews

1. Moore 1967, introduction.
2. Imperial War Museum numbers H 0680 and H 0650.

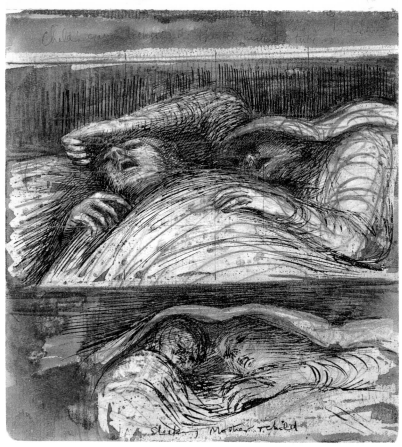

126

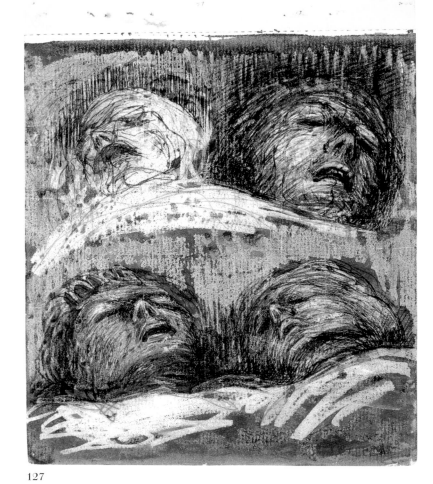

127

125
Sea of Sleepers 1941
Page 62 from Second Shelter Sketchbook
HMF 1687
wax crayon, pen and ink, watercolour wash
inscription: pencil u.c. *Sleeping scenes. (sea of sleepers.)*; crayon c. *sea of sleepers*

exhibitions: Madrid 1981 (cat.D117 u.l.); Lisbon 1981 (cat.D121 u.l.); Barcelona 1981-82 (cat.D92 u.l.); Mexico City 1982-83 (cat.D38); Caracas 1983 (cat.D42);); East Berlin/Leipzig/Halle/Dresden 1984 (cat.77); London 1988-89; Ittingen 1994; Salzburg 1994

This is one of the few drawings in the **Second Shelter Sketchbook** which refer directly to Moore's pre-war sculptural forms. Entitled 'Sleeping scenes (sea of sleepers)' by Moore, with the words 'sea of sleepers' repeated above the lower image, this drawing shows the evolution of the shelter imagery into a new metaphor, the masses of huddled figures turning into an anonymous, amorphous expanse, like the waves of the sea. Throughout this sketchbook we see Moore becoming increasingly fascinated by the effect of huge numbers of draped and wrapped figures cramped together: sequences of studies, showing these seas of bodies receding into the darkness of the tunnels, light just catching occasional upraised knees or elbows. What makes this drawing different is that the figures here are almost totally abstracted, with no hints of the body shape concealed beneath the covering.

The smooth blank forms of the reclining figures, heads represented by a blob with one hole, are very similar to the **Reclining Figure** 1934-35 (LH 155) in Corsehill stone, which has itself often been likened to a mummy or a sarcophagus. The funereal atmosphere is emphasised by the overall grey of the drawing, executed mainly in pen and pencil on a dark wash background.

The top right section is clearly a preliminary sketch for the lower drawing, but the female figure at top left is very different, probably drawn on a different day. Poised and controlled, this wrapped figure could almost be a robed Afghan tribeswoman, the fall of the shawl around her head and shoulders, also hoisted up at the waist, executed in confident, sweeping curved lines.

Julian Andrews

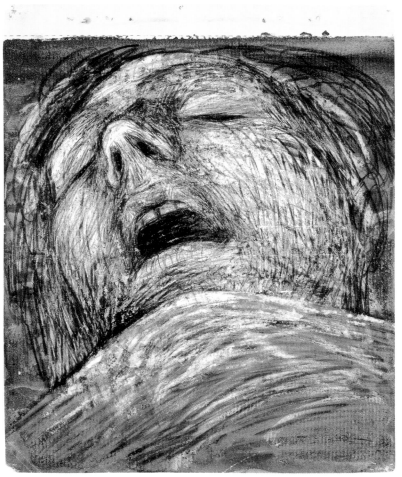

128

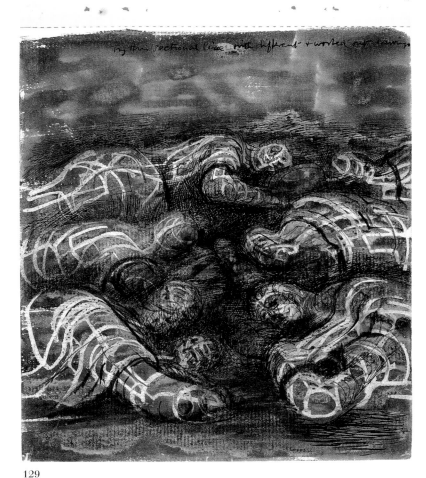

129

126
Study for 'Pink and Green Sleepers'
1941
Page 67 from Second Shelter Sketchbook
HMF 1692
pencil, wax crayon, pen and ink,
watercolour wash
inscription: pencil u.c. [. . .]/[. . .]/*Child's
crayon background & pencil instead of* [. . .];
pen and ink (over an inscription in pencil)
l.c. *Sleeping Mother & child*

exhibitions: Madrid 1981 (cat.D114 l.r.);
Lisbon 1981 (cat.D118 l.r.) Barcelona 1981-
82 (cat.D90 l.r.); East Berlin/Leipzig/Halle/
Dresden 1984 (cat.51); London 1988-89;
Bilbao 1990 (p.69); Sezon/Kitakyushu/
Hiroshima/Oita 1992-93 (cat.Fo-57);
Ittingen 1994; Salzburg 1994

A double drawing, again executed entirely
in black and white, though in this case
Moore has also used wax crayon for the
open curves of the blankets covering the
pairs of figures in each section.

One cannot tell whether the upper
figures are man and woman or of the same
sex, but the lower pair is a mother and
child. It is in this kind of drawing that we
feel Moore's increasing interest in the
intimate relationships that exist between
people, even when they are caught in such
bare, anonymous surroundings. This is the
first of a sequence of drawings which show
Moore's fascination with the effect of
foreshortening that results from looking at
a subject from a very low perspective angle.
He develops this theme further in
succeeding pages.

Julian Andrews

127
Sleeping Figure Studies 1941
Page 68 from Second Shelter Sketchbook
HMF 1693
pencil, wax crayon, pen and ink,
watercolour wash

exhibitions: Madrid 1981 (cat.D114 u.c.);
Lisbon 1981 (cat.D.118 u.c.); Barcelona
1981-82 (cat.D90 u.c.); Mexico City 1982-83
(cat.D39); Caracas 1983 (cat.D.43); East
Berlin/Leipzig/Halle/Dresden 1984 (cat.52);
London 1988-89; Sezon/Kitakyushu/
Hiroshima/Oita 1992-93 (cat.Fo-58);
Ittingen 1994; Salzburg 1994

publications: Garrould 1988, pl.76

128
Sleeping Shelterer 1941
Page 69 from Second Shelter Sketchbook
HMF 1694
pencil, wax crayon, gouache, watercolour
wash

exhibitions: Madrid 1981 (cat.D114 l.c.);
Lisbon 1981 (cat.D118 l.c.); Barcelona 1981-
82 (cat.D90 l.c.); Mexico City 1982-83
(cat.D40); Caracas 1983 (cat.D.44);); East
Berlin/Leipzig/Halle/Dresden 1984 (cat.55);
London 1988-89; Ittingen 1994; Salzburg
1994

publications: James 1992, pl.83

Cats.127 and 128 show the preliminary
drawings for what became, with the **Tube
Shelter Perspective** [cat.130], Moore's best-
known subject from the whole corpus of his
Shelter drawings: the 'Sleepers'. At least ten
large 'finished' drawings of sleepers are
known, almost all of them being pairs of
heads, sometimes with arms and clawlike
hands just showing above the blankets that
shroud them.

Whereas sleeping figures are usually
associated with calm and repose, Moore's
shelterers seem disturbed, even tortured by
nightmares, echoes perhaps of the violence
and chaos taking place above their heads.
With their gaping mouths, eyes closed in
expressions which come close to pain, and
death-like pallor, they seem more like
corpses than living beings.

The realism and the intensity of these
studies is in marked contrast to the more
abstracted forms in previous drawings. At
the same time the use of a pink wash
against the wax crayon resist as
background to the four heads here gives
them a sense of being remote, almost
literally disembodied in their sleep. It is in
these drawings, above all, that we see
Moore harking back to his own early
experiences of life drawing, and to the
influence of his trip to Italy in 1925 when he
had his first opportunity to study the
Renaissance masters at first hand.

Julian Andrews

129
Study for Shelter Drawing 1941
Page 77 from Second Shelter Sketchbook
HMF 1702
pencil, wax crayon, pen and ink,
watercolour wash
inscription: pen and ink u.c. *Try this
sectional line with different – & worked out
drawings*

exhibitions: Madrid 1981 (cat.D108 l.c.);
Lisbon 1981 (cat.D112 l.c.); Barcelona 1981-
82 (cat.D85 l.c.); East Berlin/Leipzig/Halle/
Dresden 1984 (cat.71); London 1988-89;
Bilbao 1990 (p.71); Ittingen 1994; Salzburg
1994

This drawing shows the first version of
what became one of the most dramatic of
Moore's large shelter drawings, the
Shadowy Shelter 1940 (HMF 1735), owned
by Sheffield City Art Galleries. A chaotic
group of people are sprawled together on a
station platform or shelter floor, resting
their heads on bundles, one figure in the
foreground protecting her child with her
arm.

The special interest in this drawing is
Moore's use of his two-way sectional line
technique. This has the effect of
emphasising the curves and volume of his
figures while, paradoxically, also giving an
eerie, skeletal effect. In this drawing the
impression of a world of ghosts is
heightened by the colours used: against a
dark wash background, combined with
intense black ink hatching, the forms of the
figures are outlined in white, yellow and a
few deep black sectional lines. This is
another sea of sleepers but – like the
figures in the **Tube Shelter Perspective**
[cat.130] – they can also be read as chrysalis
forms, pupae which are dead to the world
but which yet contain the seeds of life, to be
resuscitated once the conflict above them
has abated. Moore's note to himself at the
top of this drawing, 'Try this sectional line
with different – & worked out drawings' is
presumably what prompted him to create
the Sheffield version.

Julian Andrews

130
Tube Shelter Perspective 1941
HMF 1773
pencil, wax crayon, gouache, watercolour
wash on off-white light weight wove
292 × 242mm
unsigned, undated
Gift of the artist 1977

exhibitions: Toronto/Iwaki-Shi/Kanazawa/
Kumamoto/Tokyo/London 1977-78
(cat.159); Bonn/Ludwigshafen1979-80 (cat.
62); Beijing/Shenyang/Hong Kong 1982
(cat.97); London 1988 (cat.149); Martigny
1989 (cat.p.140); Bilbao 1990 (p.73); Sydney
1992 (cat.60); Ittingen 1994; Salzburg 1994;
Havana/Bogotá/Buenos Aires/Montevideo/
Santiago de Chile 1997-98 (cat.42)

The power of art as prophecy is a well-
rehearsed trope of romanticism. The
anticipation of war in the art of the 1930s,
however, is a matter of historic fact. No
recourse to mysticism is necessary to
explain the phenomenon, as the war clouds
were gathering. In the second half of the
decade, in Abyssinia and Spain, conflict was
already raging. By the time artists were
commissioned or inspired to record its
ravages in the early 1940s, the sensibilities
of those who had already experimented
with Surrealism were primed for such
pictorial oddities as bombed-out buildings
(John Armstrong) and aerial conflict (Paul
Nash).

There was little by way of impending
doom in Moore's art of the 1930s. As it
turned out, however, his war work went to
the very heart of his aesthetic
preoccupations. Both his elected subjects as
a commissioned War Artist took him
underground: first to record the stoic
suffering of Londoners sheltering in the
Tube, later to draw Britain's 'underground
army', the coalminers, in his native
Yorkshire. Moore's legendary 'holes' could
be understood, in the context of his pre-war
sculpture, as a strategy for opening out his
forms; but at the imaginative level at which
his reclining woman equates with
landscape, the hole is a burrowing into
form, suggesting caves, tunnels, submerged
secrets.

The war brought out the romantic in

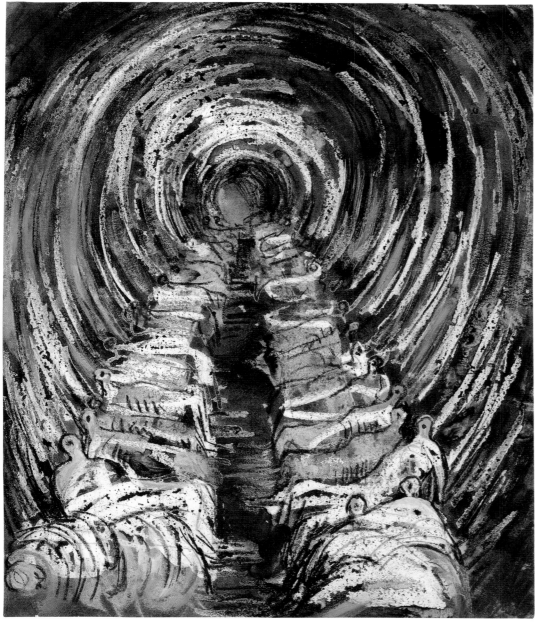

130

Moore, and the symbolist too. His distinctive graphic technique of washing over water-resistant wax lends chiarascuro to dark, brooding interiors. The Tube tunnel protects like the womb, but in the way it is depicted here it also recalls the menacing pulsations of Munch's scream – only the angst is shared among a sleeping mass, rather than hounding the lonely individual, as if the moral is that a shared burden is a lessened one.

David Cohen

131

Mother and Child among Underground Sleepers 1941
HMF 1798
pencil, wax crayon, pen and ink, gouache, watercolour wash on cream medium-weight wove
485 × 439mm
signature: pen and ink l.r. *Moore/41*
Acquired 1977

exhibitions: Slovenj Gradec/Belgrade 1979-80 (cat.2); Mechelen 1982 (cat.225); East Berlin/Leipzig/Halle/Dresden 1984 (cat.35);

London 1988-89; Martigny 1988 (cat.p.141); Bilbao 1990 (p.79); Leningrad/Moscow 1991 (cat.49); Helsinki 1991 (cat.49); Sydney 1992 (cat.64); Budapest 1993 (cat.60); Bratislava/Prague 1993 (cat.60); Krakow/Warsaw 1995 (cat.50); Venice 1995 (cat.50); Paris 1996-97 (p.608)

In the foreground of this cavernous setting Moore has chosen to focus on the mother and child, picked out from the otherwise undifferentiated mass of sleepers whom he described as being a 'bit like the chorus in a Greek drama telling us about the violence we don't actually witness'.[1]

The tenderness and immediacy of the depiction of mother and child are a vivid reminder of both the artist's versatility of expression and his search for new types of sculptural relationship. It was the dignity and three-dimensional quality of some of the large Shelter drawings exhibited in the National Gallery in 1942 that prompted Walter Hussey to offer Moore the commission that gave him his first opportunity for monumental sculpture since the outbreak of war, the **Madonna and Child** 1943-44 (LH 226) carved in Hornton stone for Hussey's church of St Matthew in Northamptonshire.

Frances Carey

1. Moore 1988, p.9.

152

Group of Draped Figures in a Shelter 1941
HMF 1807
chalk, crayon, pen and ink, gouache, watercolour on cream medium-weight wove
324 × 565mm
signature: pen and ink l.r. *Moore/41*
Acquired 1982

exhibitions: East Berlin/Leipzig/Halle/Dresden 1984 (cat.39); London 1988-89; Martigny 1989 (cat.p.142); Bilbao 1990 (p.81); Leningrad/Moscow 1991 (cat.47); Helsinki 1991 (cat.47); Budapest 1993 (cat.61); Bratislava/Prague 1993 (cat.61); Krakow/Warsaw 1995 (cat.51); Venice 1995 (cat.51); Paris 1996-97 (p.608)

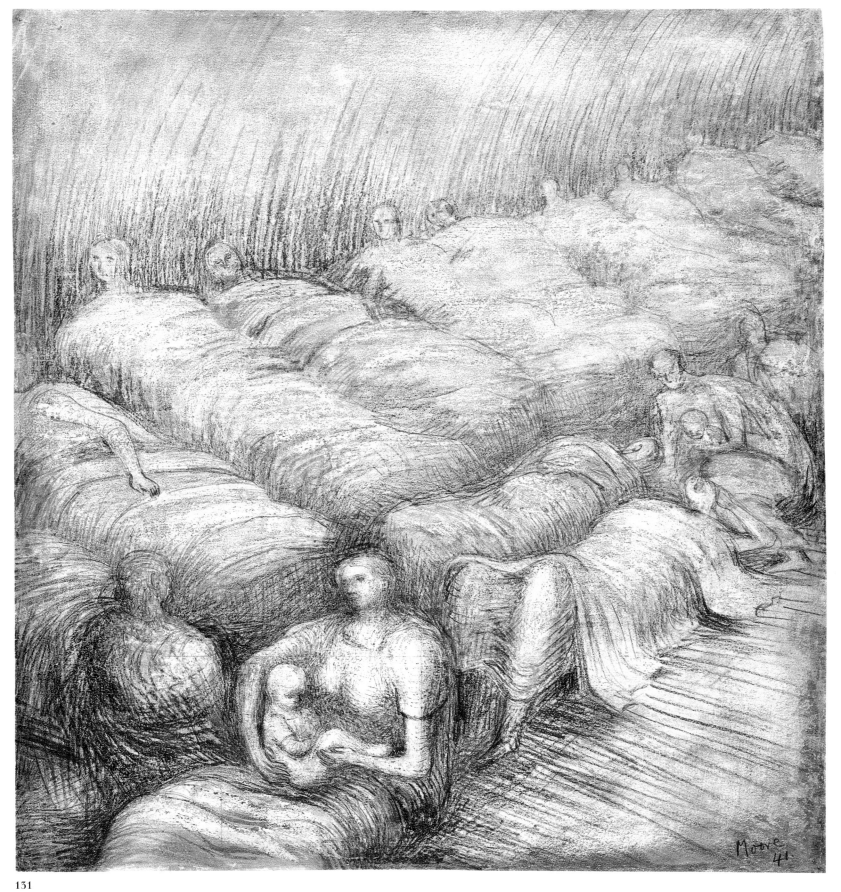

131

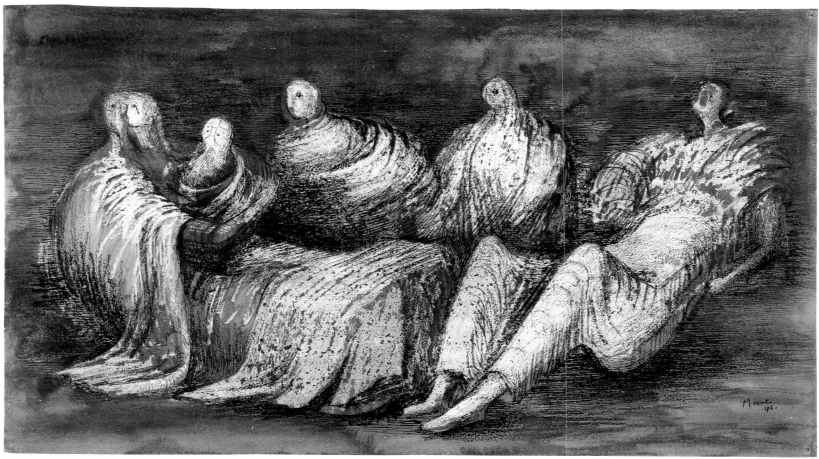

132

publications: Sotheby's, London
1 December 1982 lot 178

As already explained, the larger 'finished'
Shelter drawings were made by Moore
mainly with a view to being sold, initially to
the War Artists' Advisory Committee, and
then, as people gradually became more
aware of their importance, to private
collectors and to other museums and
galleries. Moore kept very few himself, and
one must remember that because he was
unable to work on sculpture at this stage
these drawings were an important element
in the exhibitions he was offered by dealers,
not only in London but even in New York.
For his exhibition for Curt Valentin at the
Buchholz Gallery in 1943 a number of
Shelter drawings were included.

Group of Draped Figures in a Shelter
was acquired by the Henry Moore
Foundation in 1982, having previously been
in a private collection. It is one of a number
of majestic studies of groups of draped and
shawled women, related to similar works in
the art galleries of Manchester, Leeds,
Wakefield and Toronto, and to yet other
versions still in private hands.

The figures, mainly in ghostly white,
touched with pink and yellow, emerge from
the darkness of the shelter, their unearthly
quality emphasised by the use of wax resist
under the pale wash. The heads of the three
central and right-hand figures are turned to
gaze at the child held by the woman on the
left, whose own head looks to the right, out
beyond us. In this and in the related
drawings, Moore's figures – referred to by
Clark as 'dramatis personae'[1] – take on a
resonance and a monumental power that
rises above the specific context of the
shelters; like characters in a Greek tragedy
they sit, stoically, awaiting the outcome of
events that they cannot influence. They
were to reappear, after the war, in two
books for which Moore was commissioned
to provide illustrations: a verse play for
broadcasting called *The Rescue* by
Edward Sackville-West, and *Prométhée* by
J.W. Goethe, translated by André Gide.

Julian Andrews

1. Clark 1974, p.150.

133
Shelter Drawing: Sleeping Figures
1941
HMF 1816
pencil, wax crayon, pen and ink,
watercolour wash on off-white medium
weight textured wove
303 × 308mm
signature: pen and ink l.r. *Moore/41*
Acquired 1983

exhibitions: Martigny 1989 (cat.p.143);
Bilbao 1990 (p.83); Leningrad/Moscow 1991
(cat.48); Helsinki 1991 (cat.48); Sydney 1992
(cat.66); Budapest 1993 (cat.62); Bratislava/
Prague 1993 (cat.62); Krakow/Warsaw 1995

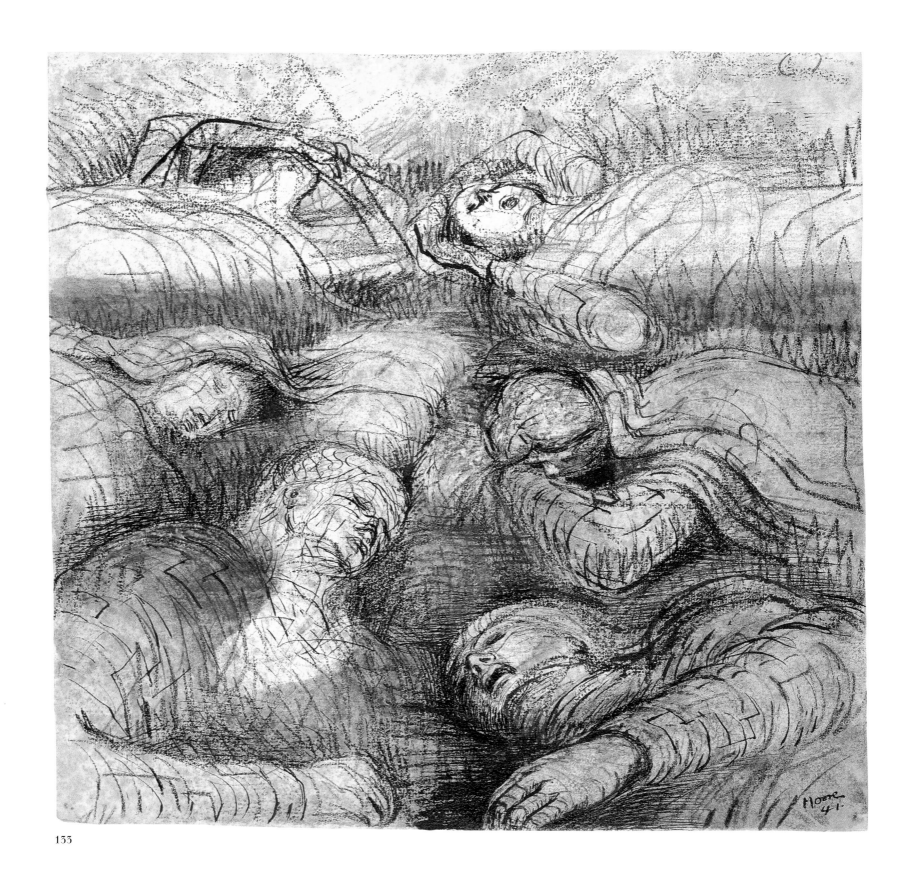

133

(cat.52); Venice 1995 (cat.52): Paris 1996-97 (p.608)

publications: Sotheby's, London 23 March 1983 lot 179

This fine drawing is related to a number of drawings in the **Second Shelter Sketchbook,** and to the series of 'finished' drawings of sleepers which have already been referred to. In the foreground figures, particularly the woman at lower left, Moore has given very literal representations of heads and faces through careful, detailed draughtsmanship, while the other figures are only roughly sketched in. Considerable use of pencil, initially, is still visible, with ink hatching, outline and some sectional line drawing making this a very rich, worked image. The overall tonality, in varying shades of brown crayon and watercolour, is warm in comparison to the dark greys and blacks used as background in so many of the Shelter drawings: this is a particularly intimate study. Unlike the figures of the later sleepers who are haunted by nightmares, these people are sunk in a sleep of exhaustion, with which we ourselves can readily empathise.

Julian Andrews

134-138
Coalmining Subjects Sketchbook 1942
HMF 1926-1945
Grey-green Kraft paper covered notebook which probably contained 24 pages of lightweight cream paper 203 × 162mm in one signature of twelve. The front cover bears an off-white label with *London County Council/CLAPHAM CENTRAL SCHOOL FOR BOYS,/ARISTOTLE ROAD S.W.1/Name/ Subject/Form* printed in black and partially crossed through. The word *Meadows* in pen and ink and crossed through is written next to *Name.* In pencil, across the label in the artist's hand is *KM/1941/42; Henry Moore/ Coalmining subjects.* Twenty-two pages are known, numbered in pen and ink by the artist 2 to 44 upper left on the verso, additionally the first and second pages are numbered 1 and 3 upper right on the recto. None of the pages are signed or dated. The

notebook remained bound until 1981 when it was taken apart for the Madrid exhibition. Gift of the artist 1977

The suggestion that Moore should carry out a commission to draw scenes in a coalmine came originally from his friend and fellow Yorkshireman Herbert Read, probably some time during the summer of 1941. By then Moore had begun to find his interest in the shelters was waning, as the authorities began to tidy up the scenes of chaos that had so fascinated him initially. Given his family background in the Yorkshire mining district it was natural that the proposed subject should appeal to him – particularly since he had never been down a mine before.

The War Artists' Advisory Committee not only offered Moore the commission but also obtained the necessary permits and organised facilities for him to carry out the project. He arrived in Castleford in early December 1941 and at once spent several days underground, observing conditions and studying possible subjects for drawings.

Altogether Moore spent about a fortnight in Castleford at the Wheldale Colliery, where his father had worked. His vivid description of his first day down the pit, in the care of a deputy manager (who became the subject for a number of his sketches), has often been quoted. It parallels the well-known essay by George Orwell, written some five years earlier, which also emphasised the exhausting distances the miners had to cover below ground, before they even began their work at the coal-face.

With none of the inhibitions about drawing from life that he had felt in the shelters, Moore took a small notebook down with him in which he made a large number of preliminary sketches, mainly in pencil. He was accompanied on one occasion by a photographer from the weekly journal *Illustrated*, who recorded him at work for a feature published in the magazine on 24 January 1942. From initial sketches in the **Coalmining Notebook A** (HMF 1864-1920) he filled another small, and two larger sketchbooks with worked-up and 'finished' drawings. As with the Shelter drawings, this secondary stage of work was carried out at his studio back in Hertfordshire, not on the spot in Castleford.

The Coalmining sketchbooks were subsequently dismembered, twenty-one pages of the **Coalmining Subjects Sketchbook** being held by the Foundation. A further thirty-nine drawings from the **Coalmine Sketchbook** (HMF 1946-1984) are known to exist, fifteen of which are owned by museums, and five pages remain from the small sketchbook (HMF 1921-1925). In addition twelve larger 'finished' Coalmine drawings were acquired by the War Artists' Advisory Committee, subsequently being allocated to public galleries around Britain.

Moore's own statement that 'the coalmine drawings were more in the nature of a commission coldly approached'[1] led to their being, for a long time, somewhat underrated within the corpus of his work. But Kenneth Clark thought highly of them from the start, while the critic John Russell went so far as to say that 'there is very little else in Moore's work to compare with them for directness and intensity of observation – or, for that matter, for power and economy of design.'[2]

Julian Andrews

1. James (ed.) 1966, p.216; 1992, p.230.
2. Russell 1968, p.115; 1973, pp.135f.

134
Miner with Truck 1942
Page 9 from Coalmining Subjects Sketchbook
HMF 1928
pencil, wax crayon, pen and ink, watercolour wash
inscription: pencil top of page *old man with white eyes, when conveyer belt stopped*

Moore has made two studies which emphasise the solid lines and forms of the heavy wooden pit-props between which the miners have to squat or crouch to wield their tools. In the upper section the limbs and arms of a miner emerging from behind the props, beyond a section of rails with an empty truck, resemble solid baulks of timber; in the lower part the light of a lamp shines on the back of a miner who is kneeling, stripped to the waist, among a

134

135

confused mass of props and timbers. This is
probably the first of a series of studies of
the male back, a theme which came to
preoccupy Moore during this assignment,
and which is featured in many of the
'finished' Coalmine drawings. Moore
himself was well aware that in tackling
these tough masculine figures he was
making a break from his pre-war practice:
'I had never willingly drawn the male figure
before – only as a student in college.
Everything I had willingly drawn was
female. But here, through these coalmine
drawings, I discovered the male figure and
the qualities of the figure in action. As a
sculptor I had previously believed only in
static forms, that is, forms in repose.'[1]

Julian Andrews

1. James (ed.) 1966, p.216; 1992, p.230.

135
Miner with Pit Pony 1942
**Page 11 from Coalmining Subjects
Sketchbook**
HMF 1929
pencil, wax crayon, watercolour, wash
inscription: pencil top of page [illegible]

exhibitions: East Berlin/Leipzig/Halle/
Dresden 1984 (cat.93)

The upper half of this drawing shows a
miner's back beside a pit pony, the animal's
mood of patient resignation being tenderly
conveyed. (A photograph showing Moore
sketching this scene appears in the
Illustrated article referred to above.) The
lower section shows two men working beside
trucks which they are presumably filling
with coal, backs glistening in the darkness.

Julian Andrews

136
Miners Pushing Tubs 1942
**Page 19 from Coalmining Subjects
Sketchbook**
HMF 1933
pencil, wax crayon, pen and ink,
watercolour wash
inscription: pencil top of page *Colliers down*
[. . .] *pits (pushing tubs)*

exhibitions: Madrid 1981 (cat.D126); Lisbon
1981 (cat.D130); Barcelona 1981 (cat.D100);
Colorado Springs 1982; East Berlin/Leipzig/
Halle/Dresden 1984 (cat.87)

This shows two of several studies that
Moore made for the well-known finished
drawing **At the Coal Face: Miner Pushing
Tub** 1942 (HMF 1991), in the collection of
the Imperial War Museum. Again the
figures are framed between the massive
geometric forms of the pit-props, light

136

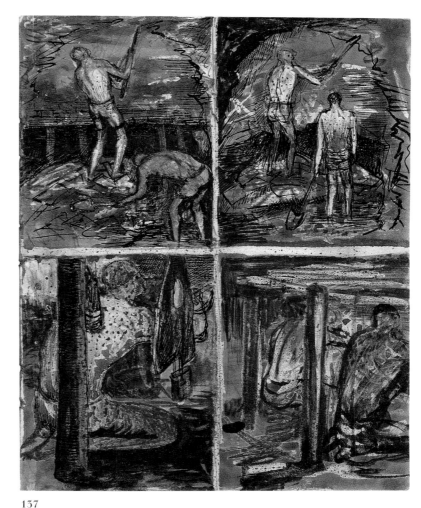

137

gleaming on their bodies and on the sides of the tubs, from a source we cannot easily see. In the finished version, the light appears to be coming from the floor of the tunnel, perhaps where a miner has put his lamp down.

Julian Andrews

137
Four Studies of Miners Working 1942
Page 29 from Coalmining Subjects Sketchbook
HMF 1938
pencil, wax crayon, pen and ink, watercolour wash

Francis Bacon liked to say that Moore's Shelter drawings looked like knitting with the needles pulled out: unfair, of course, but one knows what he meant. He could never have said the same about Moore's subsequent drawings of coalminers, which deserve to be better known. They have, to me at least, a sombre, gritty dignity that is in some ways more touching than the overt pathos and pretty tints of the scenes in the London Underground.

Despite the gruelling experience of spending two weeks down the pit where his father had worked, Henry never felt as emotionally involved in the miners' privations as he had in those of the shelterers. His diffidence about the resulting drawings was not shared by the War Artists' Advisory Committee, which commissioned them and received them with acclamation.

Roger Berthoud

138
Miners Walking into Tunnel 1942
Page 39 from Coalmining Subjects Sketchbook
HMF 1943
pencil, wax crayon, pen and ink, watercolour wash, brush and ink

exhibitions: London 1988-89

Obvious comparisons have been made between the claustrophobic, subterranean

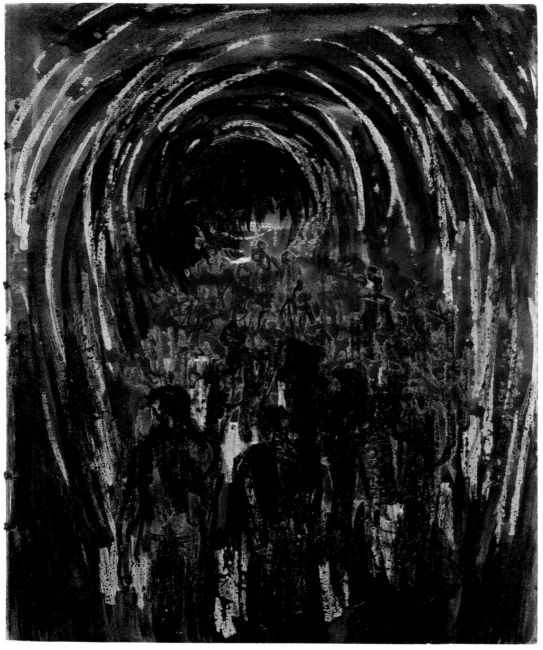

138

139
Miner at Work 1942
HMF 1999
pencil, crayon, pen and ink, watercolour,
wash on cream medium-weight wove
311 × 267mm
signature: pen and ink l.r. *Moore/42*
Gift of the artist 1977

exhibitions: Paris 1977 (cat.200); Toronto/
Iwaki-Shi/Kanazawa/Kumamoto/Tokyo/
London 1977-78 (cat.174); Bonn/
Ludwigshafen 1979-80 (cat.64); Madrid
1981 (cat.D118); Lisbon 1981 (cat.D122);
Barcelona 1981 (cat.D93); Colorado Springs
1982; East Berlin/Leipzig/Halle/Dresden
1984 (cat.91); Martigny 1989 (cat.p.144);
Bilbao 1990 (p.85); Sydney 1992 (cat.68);
Budapest 1993 (cat.63); Bratislava/Prague
1993 (cat.63); Krakow/Warsaw 1995
(cat.53); Venice 1995 (cat.53); Havana/
Bogotá/Buenos Aires/Montevideo/Santiago
de Chile 1997-98 (cat.46)

If the Shelter drawings had a direct and
obvious influence on Moore's sculpture in
the immediate post-war period, the
Coalmine drawings can be said to have had
a more pervasive influence on his later
graphic work. In these subjects Moore
found himself confronting the problem of
how to delineate forms which were
emerging from almost complete darkness.
Facing this challenge forced him to explore
aspects of draughtsmanship which he had
not tackled before, but which he was later
to develop for himself in several important
sets of graphics, notably the Stonehenge
sequence and lithographs he made to
accompany a selection of poems by
W.H. Auden. Moore himself was to admit,
much later, that the coalmine experience,
which he had slightly denigrated at the
time, had been of great importance to him:
'I now believe that the effort of making
these drawings was of great value for my
later "black" drawings and graphics.'[1]

Julian Andrews

1. Henry Moore in *Auden Poems/Moore Lithographs*,
British Museum Publications, London 1974.

world of the mine and that of the shelters,
this being in effect a reworking of the 'Tube
Shelter Perspective' theme. Here a mass of
miners, presumably moving on to or away
from a shift, are seen from behind as they
walk down into a tunnel. Heavy use of wax
crayon under the dark wash, with pen and
ink and chalk, gives a slightly 'raised'
appearance to the figures when the page is
examined closely. Silhouettes of caps on the
heads of the first row of figures are just
distinguishable, while a bright yellow
gleam from the lamps they are carrying is
reflected on the curved wall of the tunnel,
drawn mainly in white chalk against the
black background. This drawing powerfully
conveys the atmosphere of the mine,
whereas in the others described here
Moore concentrates on the actual tasks
being carried out, and on the forms of the
male human figures bent and twisted in
their cramped positions.

Julian Andrews

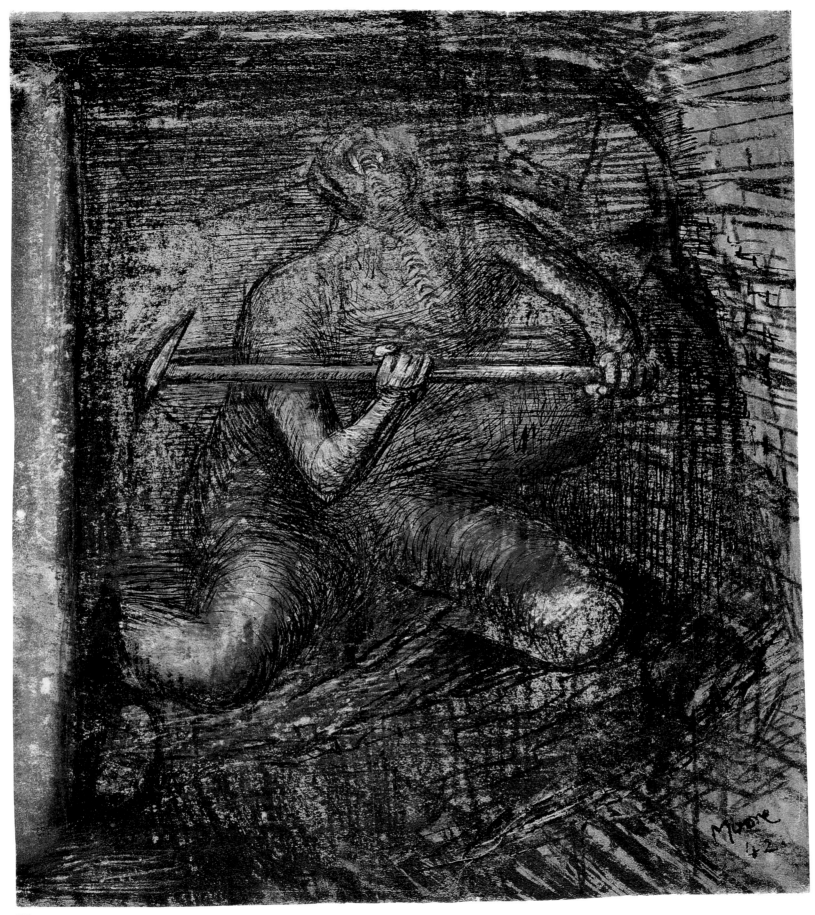

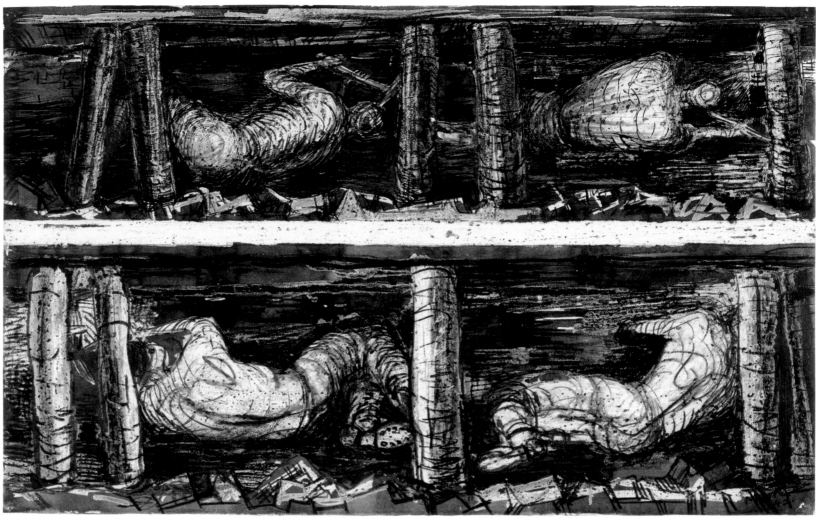

140

140

Four Studies of Miners at the Coalface 1942
HMF 2000a
pencil, wax crayon, pen and ink,
watercolour, wash on off-white
medium-weight wove
365 × 562mm
signature: pen and ink l.r. *Moore/42*
Acquired 1984

exhibitions: London 1987 (cat.8); London
1988 (cat.159); Martigny 1989 (cat.p.145);
Bilbao 1990 (p.87); Sydney 1992 (cat.69);
Budapest 1993 (cat.64); Bratislava/Prague
1993 (cat.64); Krakow/Warsaw 1995
(cat.54); Venice 1995 (cat.54); Havana/
Bogotá/Buenos Aires/Montevideo/Santiago
de Chile 1997-98 (cat.47)

Instead of the static forms in repose Moore had found in the Underground shelters, he was here confronted with the problems of capturing figures in action whose positions had to be accommodated within severely confined spaces. He made rough sketches as well as notes *in situ*, later working up the ideas into more highly finished studies in two further sketchbooks from which some twenty large drawings were developed.

The Coalmine drawings were less obviously related to Moore's sculptural interests than the Shelter studies, but they had an heroic quality; the lessons he learned from the constraints of this subject matter can also be detected later on in the warrior figures of the 1950s, subsumed within his renewed appreciation for the sculpture of the Parthenon frieze, as well as in the black and white graphics of the 1970s.

Frances Carey

141

Madonna and Child 1943
LH 216
bronze edition of 7
cast: The Art Bronze Foundry, London
height 14cm
signature: stamped *MOORE*, unnumbered
Gift of the artist 1977

exhibitions: Madrid 1981 (cat.187); Lisbon
1981 (cat.160); Barcelona 1981-82 (cat.135);
Mexico City 1982 (cat.127); Caracas 1982-83
(cat.E63); Hong Kong 1986 (cat.43); Tokyo/
Fukuoka 1986 (cat.44); London 1987
(cat.24); New Delhi 1987 (cat.35); London
1988-89; Martigny 1989 (cat.p.148);
Coventry/Huddersfield/Wrexham/Bristol/
Eastbourne/Exeter/Sterling 1990-91 (cat.4);
Leningrad/Moscow 1991 (cat.53); Helsinki
1991 (cat.53); Sydney 1992 (cat.70);
Budapest 1993 (cat.65); Bratislava/Prague
1993 (cat.65); Krakow/Warsaw 1995
(cat.55); Venice 1995 (cat.55); Havana/
Bogotá/Buenos Aires/Montevideo/Santiago
de Chile 1997-98 (cat.48)

This bronze was cast from one of the
preliminary terracottas which Moore made
when he was commissioned to carve a
Madonna and child to mark the fiftieth
anniversary of the consecration of St
Matthew's Church, Northampton. He said
he was aware that a Madonna and child
should differ from a secular mother and
child by having 'austerity and nobility and
some touch of grandeur (even hieratic
aloofness)'[1] and this group is less playful
than the mothers with children he had
drawn in 1940, such as cat.113; it has a
touching sense of seriousness and stillness.
But, like two other trial terracottas[2] he
made, it breaks with a long tradition of
Church art in that the child Jesus faces
Mary rather than the viewer, who would
have been confronted with the child's back
when the sculpture was placed against the
church wall. In the version finally chosen
(by Kenneth Clark, Director of the National
Gallery, and Canon Hussey, vicar of St
Matthew's), the child is turned to the front,
and the eventual siting of the group
determines that, as the artist wanted, 'the
Madonna's head is turned to face the
direction from which the statue is first seen,

in walking down the aisle, whereas one
gets the front view of the Infant's head
when standing directly in front of the
statue.'[3]

Susan Compton

1. The artist's words are found in the anonymous article
'Henry Moore's Madonna and Child', *Architectural
Review*, May 1944, p.139.
2. Eight models are reproduced in the *Architectural
Review* article, ibid.
3. Ibid.

142

Madonna and Child 1943
LH 222
bronze edition of 7
cast: The Art Bronze Foundry, London
height 18.2cm
signature: stamped *MOORE*, unnumbered
Acquired in honour of Sir Alan Bowness
1994

exhibitions: Krakow/Warsaw 1995 (cat.56);
Venice 1995 (cat.56)

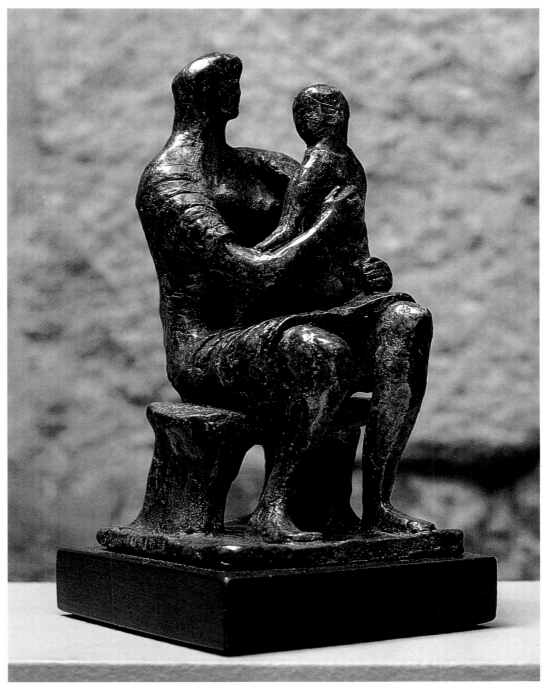

141

In 1942 the Reverend Walter Hussey was so moved by an exhibition of Moore's Shelter drawings at the National Gallery that he approached the artist about a commission in commemoration of the fiftieth anniversary of St Matthew's Church in Northampton, for which Benjamin Britten had already agreed to write a cantata. Initially reluctant to accept the proposal, Moore felt that the era of great ecclesiastical art projects had long since passed, and moreover that religious art of the past century tended to be saturated in sentimentality and of very poor quality.

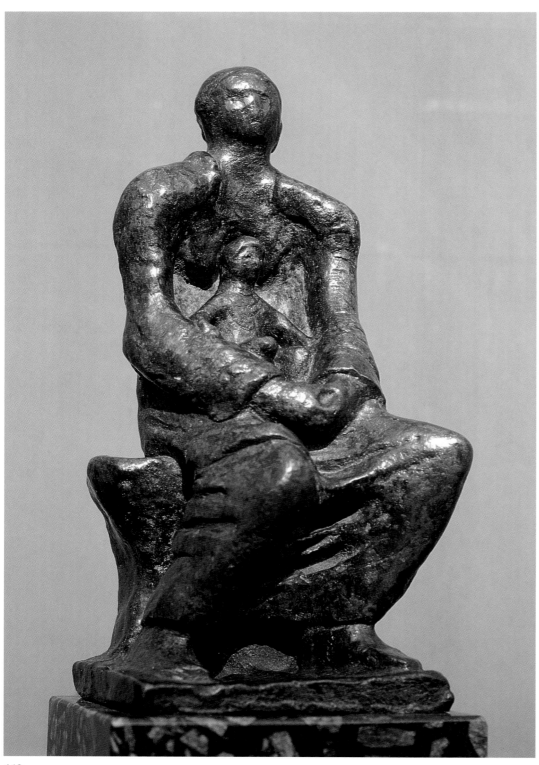

142

Moore elaborated: 'Religion no longer seems to provide inspiration or an impetus for many artists. And yet all art is religious in the sense that no artist would work unless he believed that there was something in life worth glorifying.'[1]

The resulting stone carving, **Madonna and Child** (LH 226), would become the artist's first true public commission, in that the subject had been predetermined, unlike the relief above St James's Park Underground station in 1928, for which Moore had used his own idea. Working through subtle variations, he created a number of preparatory sketches and twelve terracotta maquettes, out of which five – one of which was used to cast this **Madonna and Child** – were shortlisted by Kenneth Clark, Director of the National Gallery. Moore described how he grappled with the subject: 'It was a real worry and gave me many problems. There were all sorts of implications other than sculptural ones. One problem lay in trying to make the child an intellectual looking child that you could believe might have more of a future than an ordinary baby.'[2]

With this series of maquettes Moore's rejection of the avant-garde was complete. The shock here is what Peter Fuller described as 'the shock of the old',[3] the past returning. Unlike his contemporaries, Moore has temporarily shelved the Surrealist forms he appropriated before the war in search of a new humanism, one which would eventually contribute to his own sculptural vision independent of any post-war art movement. Critics such as Clement Greenberg, busily promoting the New York art scene, were openly hostile: 'Truly new and modern sculpture has almost no historical associations whatsoever at least not with our own civilisation's past, which endows it with a virginity that compels the artist's boldness and invites him to tell everything without censorship or tradition. All he need remember of the past is Cubist painting, all he need avoid is naturalism . . . I have had my fill of Henry Moore and artists like him.'[4]

Embracing the traditions of Byzantine and Renaissance Madonnas which he admired as early as 1925 during his first visit to Italy, Moore has placed the Virgin on

a low bench, her knees slightly raised and angled, cradling the infant in her lap and creating strong lines of drapery. With her shoulders dropped and her face gently tilted, the Madonna evokes a relaxed yet ethereal quality.

Anita Feldman Bennet

1. Hedgecoe (ed.) 1968, p.164.
2. Ibid. p.160.
3. Fuller 1993, p.16.
4. Clement Greenberg, *Collected Essays and Criticism*, vol.2, *Arrogant Purpose 1944-49*, Chicago, University of Chicago Press, 1986, pp.126-7.

143
Family Group 1944
LH 231
terracotta
height 15.6cm
unsigned
Gift of the artist 1977

exhibitions: Madrid 1981 (cat.189); Lisbon 1981 (cat.162); New York 1983; Hong Kong 1986 (cat.45); Tokyo/Fukuoka 1986 (cat.46); Sydney 1992 (cat.72); Budapest 1993 (cat.67); Bratislava/Prague 1993 (cat.67); Krakow/Warsaw 1995 (cat.57); Venice 1995 (cat.57); Nantes 1996 (cat.49); Mannheim 1996-97 (cat.49)

The ideal of a secure family in a secure community was central to the thinking behind the emergence of the Welfare State in Britain after the war. Looking ahead, people spoke of 'The Century of the Common Man'. As an artist, Moore was as much committed to the aesthetic development of modern art as anyone, but was also aware of the artist's duty to the society in which he lived. His experiences working out his ideas for a Madonna and child for a church in Northampton had led him to think profoundly, as a sculptor, about the difference between sacred and religious art, about human relationships in art, and about the nature of public monuments.

These concerns fitted in neatly with ideals that lay behind the building of new schools and the planning of new towns in England. Originally he had been

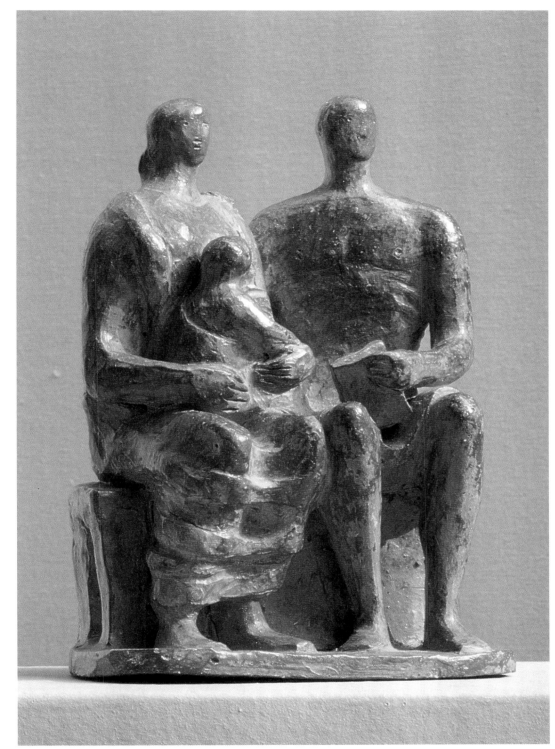

143

approached to devise a piece suitable for a community college in Cambridgeshire. When that project failed to find enough support, he was asked to consider a piece for one of the New Towns in Hertfordshire, and eventually sculptures were commissioned for both Stevenage and

Harlow, one in bronze and one in stone [cat.156 and LH 364].

This small-scale terracotta is one of the most realistic yet monumental of his original ideas. It has the direct textural appeal of something made entirely by his own hands. Moore's family groups exist in

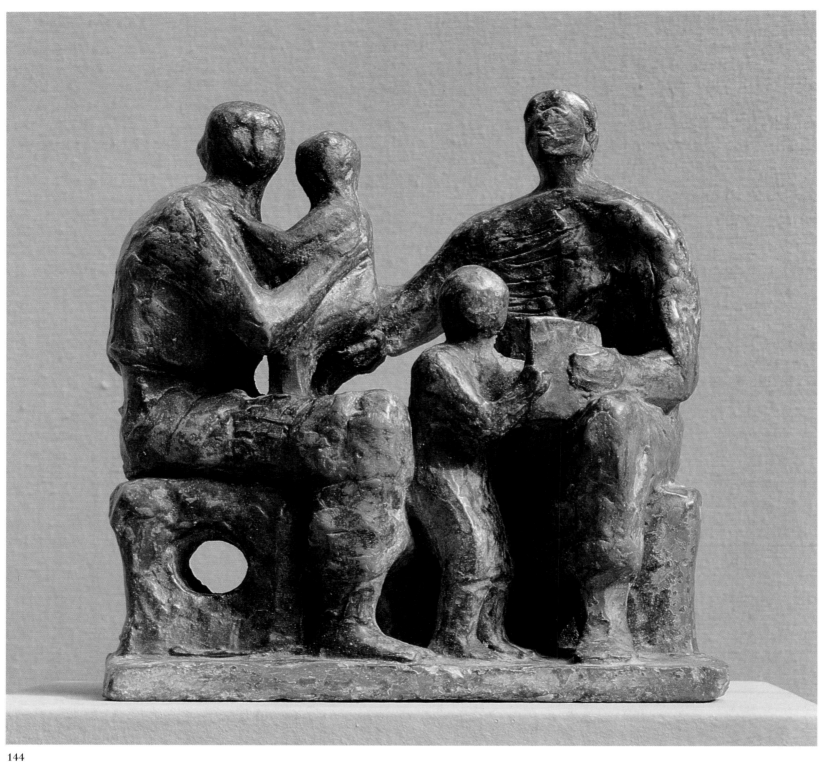

144

profusion in many sizes and forms and editions. Some seem to me to become too complex to suit his usual mastery of mass and solidity, as he fussed over who should hold the child and where it should be put. It could not have been easy to find a satisfactory way of combining father, mother and infant into a single mass that had a perfect visual unity. This version has all the calm symbolic dignity and sheer beauty of form that I also see in his later carving for Harlow in 1954-55.

Moore produced such a stream of variations on this theme that it would be possible to combine photographs of them all into an animated film which would make explicit the workings of his mind as he searched for an ideal aesthetic solution to the problem.

John Read

144
Family Group 1944
LH 232
terracotta
height 16.2cm
unsigned
Gift of the artist 1977

exhibitions: Madrid 1981 (cat.190); Lisbon 1981 (cat.163); New York 1983; Martigny 1989 (cat.p.149); Sydney 1992 (cat.73); Budapest 1993 (cat.68); Bratislava/Prague 1993 (cat.68); Krakow/Warsaw 1995 (cat.58); Venice 1995 (cat.58); Nantes 1996 (cat.50); Mannheim 1996-97 (cat.50)

When, just before the outbreak of the Second World War, the renowned architect Walter Gropius asked Moore to consider creating a sculpture for a local community college, Moore decided to create a family group for this venue. Although funding was not immediately forthcoming, he created drawings and maquettes for the eventual project. The recent birth of his own child after sixteen years of marriage was surely an impetus to this work. The addition of a male figure in Moore's sculptures constituted a radical change in his usual compositional structure. As he once aptly noted, 'In my work, women must outnumber men by at least fifty to one. Men get brought in when they are essential to the subject, for example in a family group.'

Despite the addition of a male figure, and of another child in the work, Moore continued to strive to avoid symmetry, and of necessity the formal problems became more complicated. The artist created a wide variety of maquettes and working models of the family in an effort to resolve issues such as the unification of the figures. In some versions drapery joins the arms or knees, in others, limbs are connected. In this piece Moore connects them by engaging the figures – there is a direct interaction between the parent and child both physically and psychologically. The adult and child forms are connected by their actions while the two large figures are physically linked by an arm. The large forms also continue to provide a protective niche for the children, who are subtly bracketed by two adult figures who turn toward one another. Even the leg and foot of the adult figures extend past the position of the standing child, as if to assure its containment. The piece also embraces the negative spaces for which Moore has become well known. The space between the figures is activated by the arm reaching out, while the space beneath the stool becomes a window to the surrounding vista.

Gail Gelburd

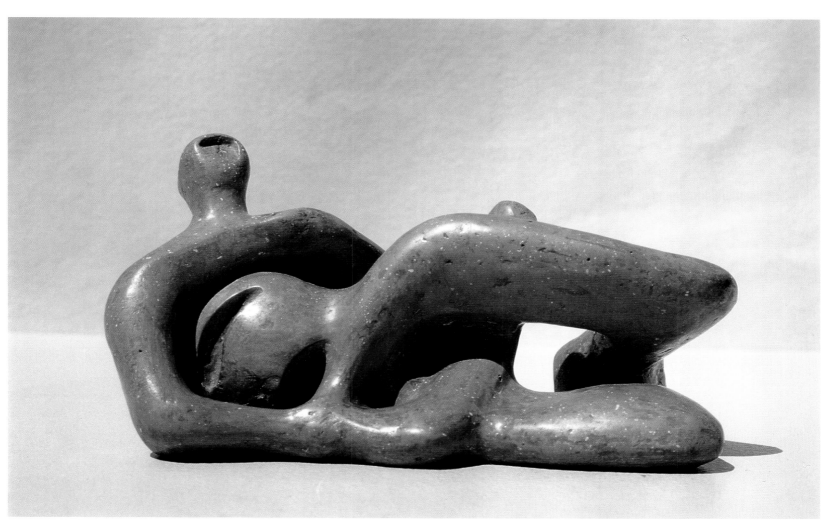

145

145

Reclining Figure 1945
LH 247
terracotta
length 15.2cm
unsigned
Gift of the artist 1979

exhibitions: Madrid 1981 (cat.193); Lisbon
1981 (cat.166); London 1988 (cat.104);
Nantes 1996 (cat.52); Mannheim 1996-97
(cat.52)

This is one of three famous terracotta
maquettes which Moore used when
preparing his fourth major reclining figure
in elmwood (LH 263). At the end of the war,
he had begun to carve with a new burst of
enthusiasm. The large work was finished
by October 1946 and immediately sold to
Moore's American colleague, the gallery
owner Curt Valentin in New York.

The maquette takes pride of place in
the way in which Moore approached his
work. Talking to Erich Steingräber, director
of the Munich Pinakothek, he said in 1978:
'Working with the maquette is a more
creative period and it is the part that I like
immensely because, in a day, I can
probably make two maquettes, or in a
week, I can make six, and I enjoy it
enormously. Because one is being more
creative. So, for me it is the most exciting
time . . . the maquette stage, doing the idea
is a great, great enjoyment and pleasure.'[1]

Anyone looking at this maquette also
gets a little of this 'doing the idea' pleasure.
It is almost as if it came from a cast, even
though all parts have been handled
lovingly, right down to the last careful
rounding. In it, Moore is thinking of work in
wood. The future flow of forms is already
clarified in the two basic directions of his
work. Thus, the chest curves protectively by
adopting a movement of shape which,
rising from the feet, allows the wide forked
motif of the legs to evolve into a spherical
form, ending up beneath the broad bridge
of the breasts. Moore has carved another
wide notch above this spherical shape
which is reminiscent of the space-opening
energy of the leg section.

It seems to me that these two thrusts in
direction involve two fundamentally
different forms of movement which Moore
ultimately wanted to bring into balance. For
him, the most important thing was the
drama of what was happening to the shape
per se, the contextual psychological
interpretation of the figure being irrelevant.
On this point, Clare Hillman has
commentated on the relevance of the
biographical background, since Moore
became a father at the time he was making
the carving (Mary was born on 7 March
1946): 'both mother and foetus have only
deep grooves for eyes . . . The mother looks
towards the sky and her body is literally
knotted up with anxiety for her child'.[2]
About the content of this, his most
expensive reclining figure in wood, Moore
said on the occasion of its auction in 1983:
'For me it had great drama with its big
heart like a great pumping station.'[3]

Christa Lichtenstern

1. From an interview in Erich Steingräber, 'Henry Moore
Maquetten. Zum Wandel des Arbeitsprozesses in seinem
Werk', *Pantheon*, July/August/September 1978, p.257.
2. Allemand-Cosneau, Fath, Mitchinson 1996, p.114.
3. *Courier-Journal*, 6 February 1983.

146

Three Standing Figures 1945
LH 258
plaster with surface colour
height 21.6cm
unsigned
Gift of the artist 1977

exhibitions: Nantes 1996 (cat.54);
Mannheim 1996-97 (cat.54)

In this maquette Moore prepares his group
Three Standing Figures, carved during
1947-48 in Darley Dale sandstone and
erected in 1948 in Battersea Park, London.

The idea for a three-figure group (a
familiar theme in sculpture since the Three
Graces configuration) dates back to the
Shelter drawings and meanders through
Moore's graphic oeuvre from 1942. Moore
himself placed his sculpture next to the
well-known high archaic seated figures
from Didyma near Miletus, which had
fascinated him in the British Museum since
the 1920s. They convey a strong impression
of dense corporeality. In the very useful
book *Henry Moore at the British Museum*
(1981) the artist confronts the head and
shoulder section on the left of his Battersea
group with the only remaining *Branchidae*
figure with a head. His comparison shows
how he picks out the shallow relief carving
of the seated figure and then, over the right
shoulder, gradually deepens this. Moore
explicitly pointed out on his archaic model:
'Look how poised yet relaxed that simple
head is, it's the very essence of a head on a
neck and shoulders.'[1] He tried to retain in
his figures this impact of the dense, gently
curved handling of volume, while
dramatising the masses in his own way. His
heads do not, however, from a
psychological viewpoint, look exactly
relaxed but seem to be filled with a
dignified alertness. Moore makes them look
tensely upwards: a frightened communal
glance from six piercing eye-sockets. The
pose of each figure makes them appear
somewhat perplexed.

John Russell may have correctly
interpreted the message intended here. He
saw the **Three Standing Figures** as
guardians or witnesses, and so remarked
on the relevant *Zeitgeist*: 'The man or
woman who watches the skies has a
particular emotional meaning for anyone
who, from the Spanish Civil war onwards,
has looked on the skies primarily as a
potential source of catastrophe, and in
carving this group Moore drew, whether
consciously or not, on the stored memories
of millions.'[2]

Christa Lichtenstern

1. Moore 1981, p.50.
2. Russell 1968, p.115; 1973, pp.135f.

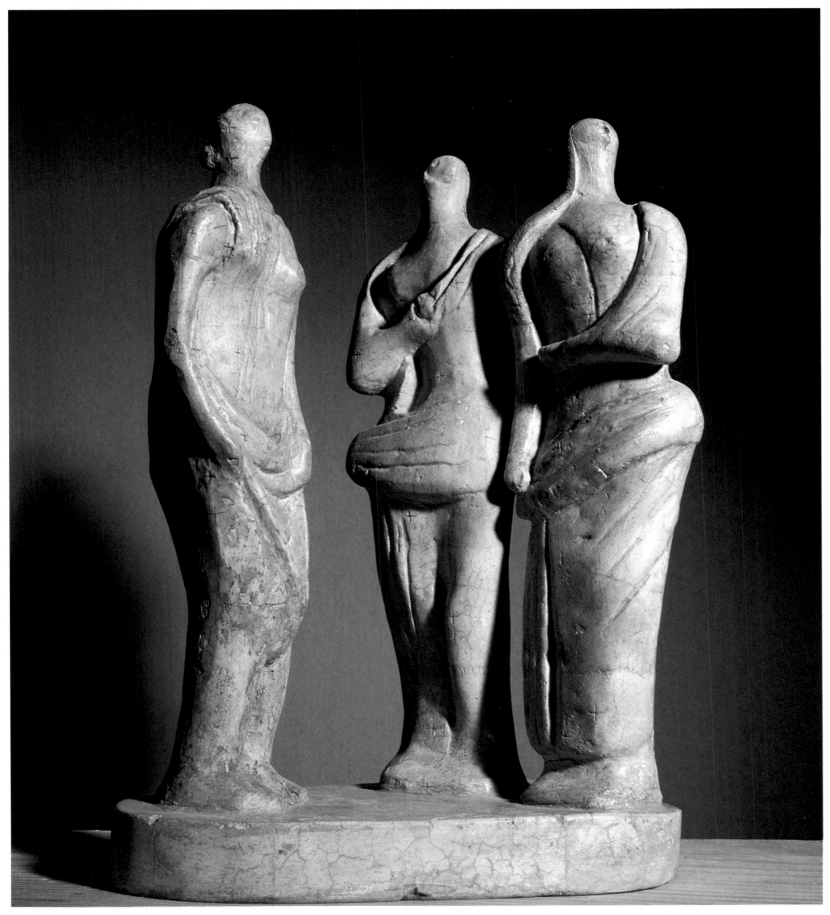

147

148

147
Mother Nursing Child 1946
HMF 2340
pen and ink on thin off-white laid
203 × 163mm
signature: pen and ink l.r. *Moore/46*
Gift of the artist 1977

exhibitions: Madrid 1981 (cat.D6 u.l.);
Lisbon 1981 (cat.D6 u.l.); Barcelona 1981-82
(cat.D6 u.l.); Sydney 1992 (cat.77)

148
Mother and Child Studies 1946
HMF 2353
pen and ink on thin off-white laid
204 × 164mm
signature: pen and ink l.l. *Moore/46*
Gift of the artist 1977

exhibitions: Madrid 1981 (cat.D6 u.r.);
Lisbon 1981 (cat.D6 u.r.); Barcelona
1981-82 (cat.D6 u.r.); Sydney 1992 (cat.78)

149
Child Studies 1946
HMF 2355
pen and ink on thin off-white laid
204 × 163mm
signature: pen and ink l.r. *Moore/46*
Gift of the artist 1977

exhibitions: Toronto/Iwaki-Shi/Kanazawa/
Kumamoto/Tokyo/London 1977-78 (cat.58);
Madrid 1981 (cat.D6 l.l.); Lisbon 1981
(cat.D6 l.l.); Barcelona 1981-82 (cat.D6 l.l.);
Sydney 1992 (cat.79)

publications: Wilkinson 1984, p.27, pl.64

149 150

150

Child Studies 1946
HMF 2356
pen and ink on thin off-white laid
204 × 161mm
signature: pen and ink l.r. *Moore/46*
Gift of the artist 1977

exhibitions: Madrid 1981 (cat.D6 l.r.);
Lisbon 1981 (cat.D6 l.r.); Barcelona 1981-82
(cat.D6 l.r.); Sydney 1992 (cat.80)

In 1946, with the birth of his daughter,
Mary, Moore was able to study at first hand
the motif that was always one of his
principal preoccupations, and the effects of
the natural observation continued to
revitalise his subsequent art. Whereas
earlier drawings – such as cat.113 – had
been drawn from anonymous models and
his own memories, in this year he was able
lovingly to observe the movements of his
wife and their baby daughter. Hour by hour

his model was close by, to be drawn
feeding, or exploring the space around her,
naked after a bath.

In cat.147 Moore contrasts the baby in
repose, peacefully suckling, with the
intensity of expression on the mother's face.
Her look of uncertainty is explained by lines
suggesting the baby's head raised on to her
shoulder – a shorthand observation of the
ritual of 'bringing up baby's wind' – though
added bands of wash emphasise the
essential placidity of the scene. In the other
drawings, Moore has captured a baby's
typical movements with his quickly moving
pen. He omits the mother's face, exploring
the disparity in scale between a tiny baby's
head and the adult hand which he had
noted on a page of **Notebook No.3** of 1923
(HMF 159): 'Mother and Child – mother
large hands, head and breasts and child
across knee – poise and action intensified
for expression'. He is fascinated here by the
disproportionate size and weight of the

baby's head to its trunk and limbs as he
draws her from back view and from front,
using the sheet of paper effectively with
one diagonal view balancing another. In
cat.148 he has caught the way a baby relies
on its mouth to make contact with its
restricted world – using it to find the nipple
and to emit those piercing cries that elicit
the desired response of comfort from the
mother.

Susan Compton

151
Drawing for Wood Sculpture 1947
Page from Sketchbook 1947-49
HMF 2403
pencil, wax crayon, pen and ink, gouache,
watercolour, wash on off-white medium-
weight wove
292 × 242mm
signature: ball point pen l.l. *Moore/47*
inscription: pen and ink u.c. *Wood figures*
Acquired 1985

exhibitions: Martigny 1989 (cat.p.150);
Sydney 1992 (cat.83); Graz 1994 (p.37);
Nantes 1996 (cat.56); Mannheim 1996-97

(cat.56); Havana/Bogotá/Buenos Aires/
Montevideo/Santiago de Chile 1997-98
(cat.50)

publications: Sotheby's, New York 15 May
1985 lot 231

In this major sketchbook drawing, fortune
transmits a rare understanding. Everything
agrees, and yet is full of tension. The
skeletal figures in the foreground contrast –
not without scenic flair – with the 'intact'
male figure in the background: a ghostlike
rendezvous.

Moore makes an express comment in
the top margin of his drawing: 'Wood
figures'. As long ago as 1933, he wrote this
highly informative comment about the
background to the origins of his wood
carvings: 'Trees (tree trunks) show
principles of growth and strength of joints,
with easy passing of one section into the
next. They give the ideal for wood
sculpture, upward twisting movement.'[1]

The construction of these figures
sketched in 1947 did not, however, merely
reflect Moore's observations of tree trunks
and their 'upward twisting movement', but
also his extensive study of bones. Both
factors unite in bringing together the
'feeling of what has grown'[2] with the
structural beauty and vigour of bones,
supported in the drawing by the two-way
sectional line method. Thus equipped,
Moore pits the familiar image of the man
top left against another by revealing the
internal form. Here, as in comparable
sketches for wood sculptures from 1948, he
gradually develops the theme of the upright
internal form which – after countless
preparatory stages of drawing – is
ultimately integrated into the composition
Upright Internal/External Form 1953-54
(LH 297).

What do we mean by 'revealing the
internal form'? Colour plays a telling role in
this context, the dominant orange lending a
special warmth. The fact that it is precisely
this harmony of colour which serves as an
'exterior' for the imagined wood figures
seems confirmed by Moore's repeated
emphasis on the warm tones of wood. If we
were to do a cross-check and, for example,
consult drawings in watercolour from the
early 1930s from which one of his
sculptures in lead gets its appropriate,
unevenly colder, ghost-like colour
background, we might find an explanation:
Moore develops his colours not merely as
some kind of atmospheric accident or
situational additional extra, but primarily
through his empathy with the character of
the material. This aspect certainly
contributes to his use of colour.

Christa Lichtenstern

1. James (ed.) 1966, p.70; 1992, p.73.
2. Quoted in Mitchinson (ed.) 1981, p.98.

151

152
Reclining Figures 1948
Page from Sketchbook 1947-49
HMF 2428
pencil, wax crayon, pen and ink, wash on
off-white medium-weight wove
292 × 242mm
signature: pen and ink l.r. *Moore/48*
Gift of the artist 1977

exhibitions: London 1982 (cat.9); Mantua
1981 (cat. 62); Columbus/Austin/Salt Lake
City/Portland/San Francisco 1984-85
(cat.100); Martigny 1989 (cat.p.151); Graz
1994; Havana/Bogotá/Buenos Aires/
Montevideo/Santiago de Chile 1997-98
(cat.51)

publications: Garrould 1988, pl.137

The drawing looks back in a certain way to
the war drawings from the beginning of the
1940s, but the predominant interest for
Moore in this work are the poses of the
reclining figures. The top figure has her
head upturned towards the sky or ceiling in
a gesture relatively uncharacteristic of
Moore but one which he used in a sculpture
from 1924-25 entitled **Woman with
Upraised Arms** [cat.23] and later in
Reclining Figure 1930 [cat.55] and 1931
[cat.56]. The figure appears to be resting on
a bundle (of clothes, perhaps), whereas the
two lower figures are propped up on their
elbows. The depiction of the feet in the
central and lower figure is quite different
but Moore used both these treatments in
later sculptures, the pointed feet appearing
in sculptures in the mid-1950s, the
broader, more naturalistic feet in works of
the 1960s and 1970s, most notably **Draped
Reclining Figure** 1978 [cat.248] in
travertine marble.

It was not unusual for Moore to place
more than one figure in a drawing, and
here he has given each an environment
with a base on which to recline. He said in
1970: 'There is a general idea that a
sculptor's drawings should be
diagrammatic studies, without any sense of
background behind the object or of any
atmosphere around it. That is, the object is
stuck on the flat surface of the paper with
no attempt to set it in space – and often not

even to connect it with the ground, with
gravity. And yet the sculptor is as much
concerned with space as the painter.'[1] The
background here is dark and heavily
hatched to give the figures three-
dimensionality, with the light source for
each figure coming from a very slightly
different direction, rendering them
independent of one another in the space.
This technique facilitates the reading of the
individual figures and makes sense of the
different focus of their gazes. Of the three
figures the central one is the most
sculptural and massive, her heavy legs in
contrast to her lighter torso. The belly of
this figure, with its dominant navel, seems
to bely the slender waist, attributable
perhaps to her youth.

Moore never wearied of experimenting
with and exploring the female form, and
these drawings, unrelated as they are to a
particular sculpture, look both back to his
reclining figures of the 1930s and forward
to those of the 1950s onwards.

Julie Summers

1. *Henry Moore: Drawings, Watercolours, Gouaches*,
exhibition catalogue, Galerie Beyeler, Basel 1970
(unpaginated).

153

Seated Figure 1948
HMF 2488
pencil, wax crayon, gouache, watercolour,
wash on cream heavyweight wove
555 × 587mm
signature: pen and ink l.r. *Moore/48*
Acquired 1985

exhibitions: Martigny 1989 (cat.p.152);
Sydney 1992 (cat.82); Budapest 1993 (cat.69);
Bratislava/Prague 1993 (cat.69); Krakow/
Warsaw 1995 (cat.60); Venice 1995 (cat.60)

publications: Christie's, New York
13 November 1985 lot 184

At first it seems odd that Moore executed
this rather awkward, experimental drawing
on such a large scale, which indicates that
it is a considered and finished piece of
some significance.

The figure, flattened by the Cubist-style
drawing, has then been crudely modelled
and made to cast a shadow on the wall and
floor to give her presence and volume. Yet
she seems to have no weight. Her breasts
are like eyes set in armoured plating, while
over the rest of her misshapen body she
wears heavy drapery, perhaps for
protection. She is a transient apparition in a
cell-like room, the exaggerated perspective
and the use of watercolour and wax adding
to its empty, bleak aspect. The green panel
(perhaps significantly the colour of nature)
at the back of the room is possibly a
handleless door by which the figure has
entered but cannot exit.

The image has a powerful and
uncomfortable ambience – silent and eerie.
Many of the drawings Moore completed in
1948 have the same quality. This, and the
element of human choice and responsibility
suggested by the 'door', brings it close to
the existentialism of Samuel Beckett's
plays. The drawing embodies a general
angst in the wake of the Second World War,
brought on by the revelation of the atom
bomb and the realisation of the power of
man to destroy everything, including
himself. This figure is perhaps living in an
inescapable nuclear winter; nothing of our
environment remains, and the survivor has
no reason to live, no reason to protect
herself any longer, for in a dead world life
is futile. The awkward style has surely been
adopted to these ends.

Clare Hillman

154

Six Studies for Family Group 1948
HMF 2501a
pencil, wax crayon, pen and ink, gouache,
watercolour wash on cream heavyweight
wove
525 × 384mm
signature: pen and ink l.r. *Moore/48*
Acquired 1984

exhibitions: London 1987 (cat.20); Martigny
1989 (cat.p.153); Leningrad/Moscow 1991
(cat.65); Helsinki 1991 (cat.65); Sydney 1992
(cat.85); Budapest 1993 (cat.70); Bratislava/
Prague 1993 (cat.60); Graz 1994 (p.41);

153

Krakow/Warsaw 1995 (cat.61); Venice 1995 (cat.61); Nantes 1996 (cat.57); Mannheim 1996-97 (cat.57)

publications: Garrould 1988, pl.144

In 1946 Moore noted in a letter that he had not thought his Shelter drawings of 1941 would have a direct influence on his future work. He admitted that he might do sculpture using drapery, or do groups of two or three figures rather than one, but never imagined that the Shelter drawings would serve as the impetus for his next masterpiece, the Northampton **Madonna and Child** 1943-44 (LH 226) and the later family groups.[1] Indeed, very few drawings of the mother and child were dated before 1940-41, but this theme, which was to become his 'fundamental obsession', took root in the Shelter drawings and then led to his images of the family. Like the earlier drawings, these of the family are created with crayon and a watercolour wash. They portray small forms protected by large forms: individual family groups pulled out of a shelter to be monumentalised.

The birth of Moore's daughter in 1946 led him to create an extraordinarily rich array of drawings of the child with her mother. Now he could study the relationship between a mother and child in a more intimate way. These drawings show the artist struggling with thematic decisions of whether to include one child or two, or how to incorporate the protective spirit of the parent over the child.

Gail Gelburd

1. James (ed.) 1966, p.218; 1992, p.232.

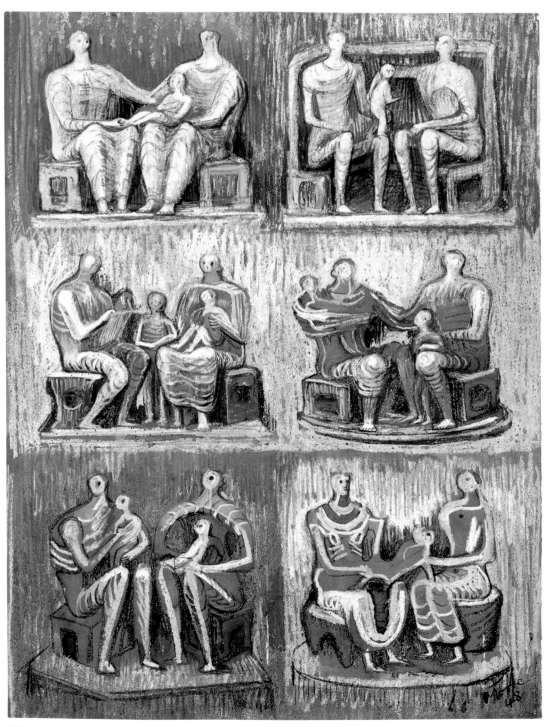

154

155
Family Group 1948-49
LH 259
bronze edition of 7
cast: The Art Bronze Foundry, London
height 24.1cm
unsigned, unnumbered
Acquired by exchange with the British Council 1991

exhibitions: Sydney 1992 (cat.74); Budapest 1993 (cat.71); Bratislava/Prague 1993 (cat.71); Krakow/Warsaw 1995 (cat.62); Venice 1995 (cat.62); Havana/Bogotá/ Buenos Aires/Montevideo/Santiago de Chile 1997-98 (cat.52)

Moore's family groups have a complicated history, with fourteen original maquettes and several full-scale enlargements, of which two [cat.156 and LH 364] came to fruition as public commissions. However, all the works might be traced back to Moore's interest in the ideas of Henry Morris, who had originally wanted a family group sculpture for his new model college of education, at Impington, near Cambridge. Morris's vision of the village college was of a resource which would provide for the family unit as it grew and developed, and this rhythmic sense of

change and continuity is expressed in Moore's development of the theme of parent and child groups. This maquette is a particularly felicitous arrangement, having a unified resolution that brings with it both alertness and balance.

One can also read this series, which spanned a decade from 1944, as being Moore's own answer to the new ethos in British sculpture after the war, which returned to a much more recognisable human figure, and responded to the new opportunities for public sculpture arising out of state support for the arts within a culture of reconstruction. Moore was a generation older than the new wave of British sculptors who took the stage after him at the Venice Biennale, whose style was angular and anxious, and it is likely that Moore's comparative wholeness accorded better with people who wished to celebrate the arts of peace, rather than those of the cold war.

Penelope Curtis

156
Family Group 1948-49
LH 269
bronze edition of 5 + 1
cast: Morris Singer, Basingstoke
height 152cm
unsigned, [0/5]
Acquired 1992

exhibitions: Paris 1992 (cat.1); Budapest 1993 (cat.72); Bratislava/Prague 1993 (cat.72); Krakow/Warsaw 1995 (cat.63); Venice 1995 (cat.63)
loans: Buenos Aires, Museo Nacional de Bellas Artes 1997; Montevideo, Museo de Artes Visuales 1997; Santiago de Chile, Museo Nacional de Bellas Artes 1997-98

publications: Cohen 1993, pls.XXII, XXIII

This is a famous sculpture. In my early days at Perry Green it came back from the bronze foundry. Henry used to say, 'The foundries get a commercial look to their patinas. They don't do it right at the foundry.' I had been colouring quite a lot of his smaller bronzes and I was given the

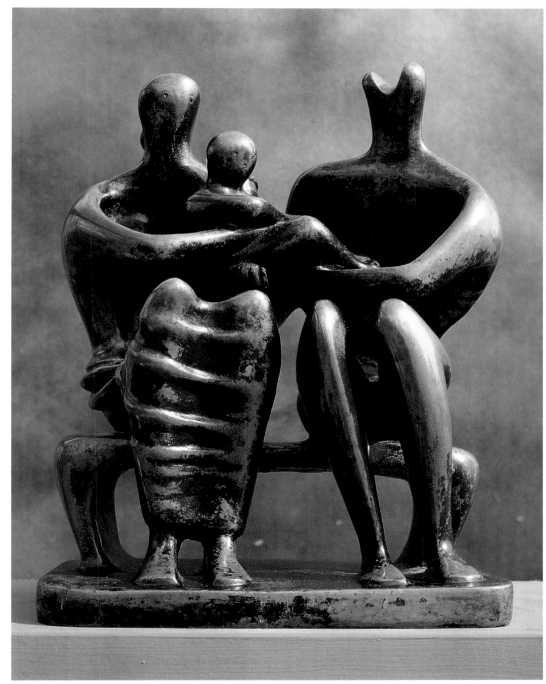

155

task of patinating this one. However, patinating can cause problems, especially on big sculptures where the bronze is different in one part from another, in places like joints; anyway this one went patchy. Finally I had to take off all the acid and go back to the raw metal. I used nitric acid not the usual caustic soda. It was in the summer and I worked outside. You have to start at the bottom when you are colouring bronze so you don't get any runs of acid appearing on the surface. In the end it worked out fine and we got a wonderful colour. I got to know the sculpture intimately, working on it so long. That's the best way of learning, working right there on a sculpture, in physical contact with it.

The entire matter of bronze casting was something fresh, new to us all. We didn't rely on handbooks or technical textbooks; we were all going back to the beginning, we had to learn everything from scratch. Henry

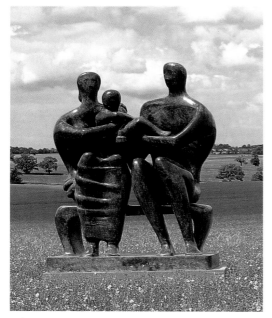

156

didn't know the technical stuff either. Alan Ingham was the most proficient – perhaps he had acquired some knowledge of the technique at art school in Christchurch, New Zealand. Anyway he had a natural understanding of how to make things work, he was an excellent technician. We built a bronze foundry in the garden at Hoglands. Unfortunately we did it wrong, it was too big for the crucible and we couldn't keep the bronze sufficiently hot. By the time we'd heated the bronze the coke would go cold, then when you put in more coke it would cool the bronze! Nevertheless we cast maybe a couple of dozen smallish pieces. The largest piece we cast was a sculpture of about 20 kilograms – the **Working Model for Reclining Figure: Internal/External Form** 1951 (LH 298) – which was not at all bad for amateurs. I remember us staying down in the field until about 2am, each taking turns on the big hand-bellows. It wasn't like nowadays with electric blowers; it was really makeshift. Henry came down and lent a hand, it was like a party but it was hard work. Henry wasn't rich then and he certainly couldn't afford to get everything cast. So doing it in the garden ourselves was not a bad idea. I cast a few things of my own, my first sculptures in bronze, and so did Alan. All the waxes – Henry's, mine and Alan's – went in together: it was a shared thing. Henry had

done lead casting before but not bronzes. In fact that was the reason Henry took me on; when I first went to Hoglands he said, 'We're not ready for you yet but we're making a bronze foundry so we'll want an extra person. Ring me in six months.' When I rang he remembered me and said, 'OK, we're ready now; start on Monday.'

For the first six weeks or so – Sheila had just had our first baby, Tim, and she wasn't well and had to stay with her mother – Alan Ingham and I stayed at Mrs Gaylor's in Perry Green. Mrs Gaylor was about eighty and she had had twenty-one children in that same council house. Walking across the fields to work we'd sometimes pick up flints or pebbles with the right look to them; then we'd drop them casually on the path we knew Henry would use. 'Look what I've found, lads!' he'd say. We never let on.

When Sheila returned with Tim we rented Woodham Cottage in Much Hadham. Later the lady who owned the cottage came back and wanted it herself so we had to find another place. We stayed for the second year in Westbury House, right near the Red Lion. We liked Much Hadham. When I decided to stop working for Henry we seriously thought of living in Hadham permanently and even started looking at houses there. But you have to get away from strong influences, you have to be on your own. I think for me, things broke open when I came to live in London. To have been a sculptor working under Henry's shadow would have been very difficult.

The two years I was 'apprenticed' to him were wonderful. Working beside him was the best thing. We'd have the wireless on, we'd talk. Henry enjoyed it, he liked being with the young assistants. He was very open to our asking him his opinions or why he did this or that. Each of us had a different relationship with him. Bernard Meadows was more his peer in age and I would think probably had more of a close working relationship. Don't forget, Bernard was working for Henry twenty years before I did. Bernard was in and out during the time I was there. Before I came there had been Oliffe Richmond from Australia. I was assistant at the same time as Alan Ingham, and later also with Peter King and Peter Atkins. After I left Phillip King took my

place. There was quite a high turnover of assistants after that.

Family Group I have always thought very authoritative, very strong. I find it difficult to make judgements about Henry's work. I was so close to him. I find it easier to make judgements about my own work. The experience of seeing these and working on them was my first real contact with modern art – you felt it represented so much. However I do feel that Henry was making extremely good work when I was there, becoming more and more comfortable with bronze. It was a fruitful and fresh moment in his long career.

Anthony Caro

157
Studies for Sculpture: Ideas for Internal/External Forms 1949
HMF 2540a
pencil, wax crayon, chalk, pen and ink, gouache, watercolour on cream heavyweight wove
584 × 398mm
signature: pen and ink l.r. *Moore/49*
inscription: pencil u.l. *sectional lines*
Acquired 1990

exhibitions: Leningrad/Moscow 1991 (cat.67); Helsinki 1991 (cat.67); Sydney 1992 (cat.88); Budapest 1993 (cat.73); Bratislava/Prague 1993(cat.73); Graz 1994 (p.39); Krakow/Warsaw 1995 (cat.64); Venice 1995 (cat.64); Nantes 1996 (cat.58); Mannheim 1996-77 (cat.58)

publications: Sotheby's, New York 17 May 1990 lot 207

This drawing is a significant landmark in the evolution of one of Moore's great sculptural ideas, the internal/external form. Scholars have traced the idea back to the 1930s, the fulcrum decade of his development; Alan Wilkinson, for instance, has pinpointed a 1935 sketchbook drawing of an Oceanic carving as the first expression of interest in this form, while other critics cite **The Helmet** 1939-40 [cat.111], with its interchangeable interior elements, as the forebear. However, what is

opposite: cat.156

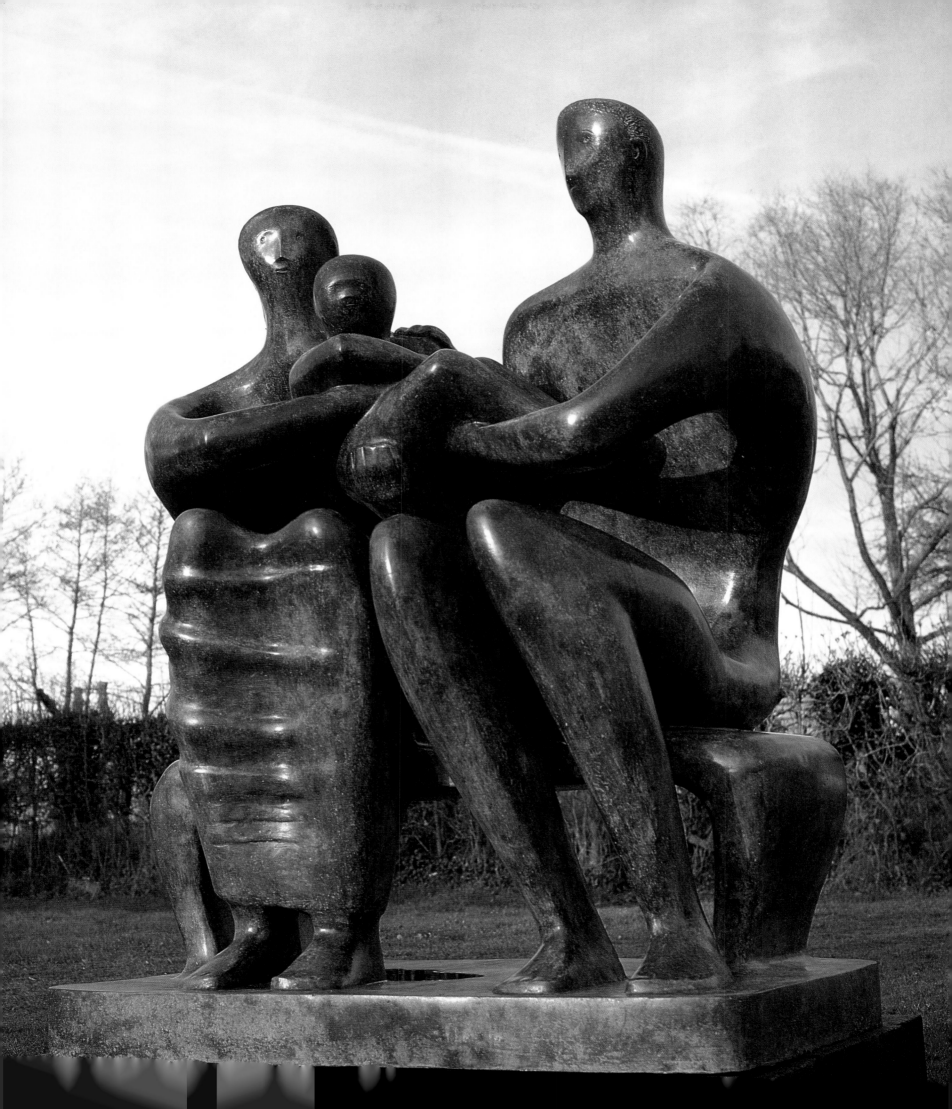

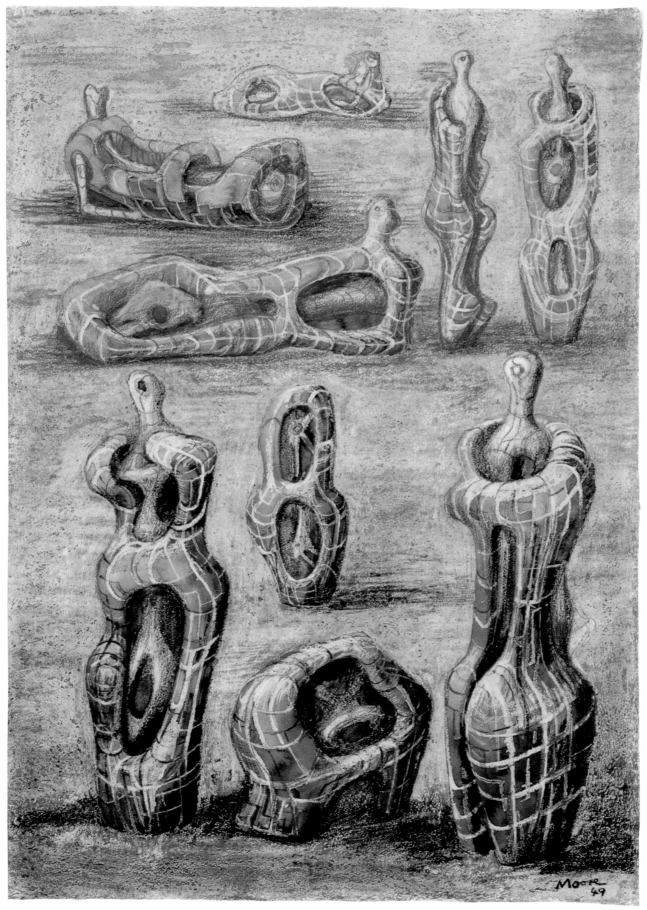

157

going on in these nine figures is, phenomenologically, of a different order even from the **Large Upright Internal/ External Form** [cat.162] which the drawing anticipates. In that sculpture, the sense is of a kernel protected by its pod – an extension, in a way, of the mother and child theme. While the same can be said of some of the nine figures in this drawing, in others there is much more of a 'pre-natal' sense of one form alive within another. Or else we are to think of some creature shedding its skin, like a snake, or sliding around uneasily within its shell, like a tortoise – only neither of those animals quite catches the amazing fluidity of form in a Moore invention, where the growth laws of animal, vegetable and mineral merge into one vitalistic urge.

David Cohen

158
Helmet Head No.1 1950
LH 279
lead
height 34cm
unsigned
Gift of Irina Moore 1977

exhibitions: Durham 1982 (cat.16); Mexico City 1982-83 (cat.76); Caracas 1983 (cat.E31); Hong Kong 1986 (cat.30); Tokyo/Fukuoka 1986 (cat.121); New Delhi 1987 (cat.44); London 1988 (cat.114); Martigny 1989 (cat.pp.162,163); Bilbao 1990 (p.91); Leningrad/Moscow 1991 (cat.68); Helsinki 1991 (cat.68); Sydney 1992 (cat.89); Budapest 1993 (cat.77); Bratislava/Prague 1993 (cat.77); Ittingen 1994; Salzburg 1994; Krakow/Warsaw 1995 (cat.69); Venice 1995 (cat.69); Havana/Bogotá/Buenos Aires/ Montevideo/Santiago de Chile 1997-98 (cat.56)

Henry Moore made no fewer than eight separate sculptures on the theme of the helmet, or the helmet head, but precisely what led him to take up this subject is uncertain. His own descriptions of his first helmet pieces emphasise his fascination at seeing one form enclosed by another, and the notion of protectiveness, a soft

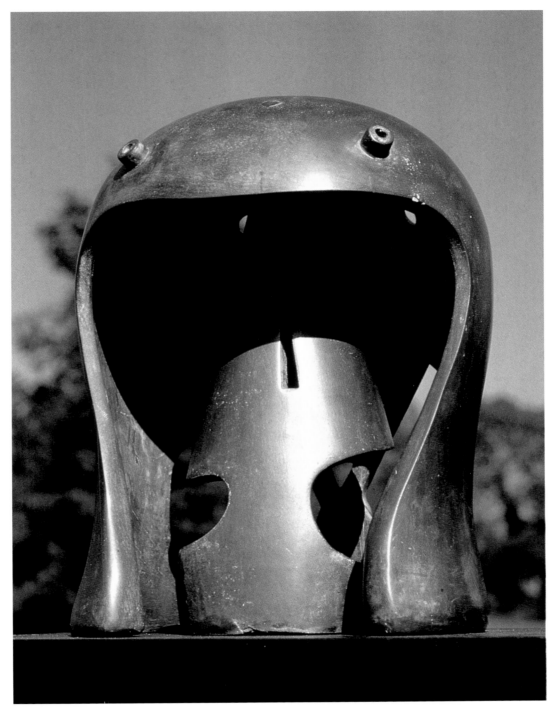

158

vulnerable form being sheltered by a hard, surrounding carapace.

Helmets are, traditionally, seen as threatening objects, from the powerful shapes of Greek and Roman military headgear, through the horned Viking helmets, to the grim visors used in medieval European armour. The shape of a prehistoric Greek cooking utensil (apparently copied by the sculptor from a

magazine) has also been suggested as an influence, but Moore's helmets – and particularly this one – do set up a frisson of fear that is not quite consonant with a simple domestic object. Moore himself, speaking about the different casts of this piece, appears to support a more sinister reading of the subject when he says: 'The lead version, I think, is more expressive because lead has a kind of poisonous quality'.[1]

Far more likely as an influence, surely, is the sculptor's own direct experience of confrontation with helmets during the German counter-attack at Bourlon Wood, Cambrai, on 30 November 1917, when the nineteen-year-old Moore was serving with the 15th battalion of the 47th (London) Division, the Civil Service Rifles. **Helmet Head No.1** does, in fact, bear strong similarities to the classic German 'coalscuttle' helmet – Stahlhelm M16 designed by Professor Schwerd of Hanover – which had come into service with the German army just a year earlier and which was already an object of awe to the British troops, much sought after as a souvenir. In Moore's piece the sides come right down and then open slightly outwards, rather as the German helmet protects the ears and neck of the wearer. More remarkable, however, are the two prominent lugs that Moore has placed into the dome of his piece to act as 'eyes'. These holes in the work would originally have been sprues, small vents or channels through which surplus metal, wax and air were expelled from the casting-mould, but rather than conceal them (as in so many of his other cast works) Moore has chosen to emphasise this rather stark shape, by making them precisely the same size and shape as the lugs on each side of the M16 helmet, originally intended to hold a protective steel plate for use by snipers.

Within the outer shell the interior form of this helmet is also hard and aggressive, like an inverted nose protector of an ancient Greek helmet, totally different from the small humanoid figure that appears, protected (or imprisoned?) by a curved wall in Moore's first version of the subject, **The Helmet** 1939-40 [cat.111], and which he would repeat in variant forms when he came to make **Helmet Head No.2** 1950 (LH 281). After continuing to experiment with a series of 'Openwork Head and Shoulders' pieces, he then abandoned the theme for ten years.

In 1960 he produced **Helmet Head No.3** [cat.193] in which the interior form consists of mainly abstract shapes with a suggestion of eyes, held within a highly surreal, head-like outer form which has often been compared to a diver's helmet.

This comparison is strengthened when one looks at **Helmet Head No.4: Interior-Exterior** of 1963 [cat.202], considerably taller thanks to the addition of a long, craning 'neck', which bears some resemblance to a person wearing a snorkel diving-mask. At the time he made this sculpture Moore had just acquired his summer retreat in Italy, so it is quite possible that he might have seen these relatively new inventions on the beaches of Forte dei Marmi. Once again the interior section consists of abstract forms.

These last two helmets – No.4 particularly – also hark back to the extraordinary drawing Moore produced at the outbreak of the Second World War, which he called simply **September 3rd, 1939** (HMF 1551). Several of the figures half-submerged in the sea, against a backdrop of stark cliffs, have strange mask-like shapes around their heads that seem to be extensions of their bathing costumes, similar to the rubber wet-suits worn by modern scuba-divers. The shapes of gas-masks are another obvious echo at this moment of apprehension, and this drawing clearly prefigures the sense of menace and foreboding we find in the later series of helmet heads.

The three versions in the Foundation's collection illustrated here are all quite small – between 30 and 50 centimetres high – related to the scale of the human head. This relatively modest size means, however, that it is difficult to see, or 'read', the internal elements of the pieces, and it is notable that these works can appear entirely different when photographed from different angles. Thus the sense of mystery, of something secretive, concealed from view, is heightened. It has also been pointed out that helmets and masks actually change the human face into something disembodied, even ruthless, and that the whole theme can be read as symbolic of the dehumanisation of mankind in an increasingly technological society.

Certainly the earlier helmet heads enabled Moore to experiment with the theme of internal/external forms that he was to develop in such important ways in his later work. Versions of them have been included in almost all important displays of

Moore's works. They have always been popular sculptures, arousing in the viewer a sense of slightly nervous fascination.

Julian Andrews

1. Henry Moore, quoted in Durham 1982, p.18.

159
Standing Figure 1950
LH 290b
white marble, carved 1971
height 221cm
unsigned
Gift of the artist 1977

The surreal geometry of this dummy-like figure had been anticipated not only in previous sculptures characterised by open and spatial forms, but also by certain drawings made between 1939 and 1948. In **Projects for Sculpture** 1939 (HMF 1470 recto) the figure seen top left of the page is clearly stylistically linked with this **Standing Figure**. The same stylistic link is to be found in **Sculptural Object in Landscape** 1939 (HMF 1441) even though this differs in shape and content. However, the closest anticipatory drawing is a page from **Sketchbook 1947-49, Ideas for Standing Metal Figures** 1948 (HMF 2417). Here, ten sculptural ideas analyse the theme of the figure with its different spatial implications. The central figure occupying the lower part of the page is an exact model for this sculpture. The complete set of these studies of an erect figure, skeleton-like and singularly articulated, can be compared with the *Anatomie* by Picasso, which appeared in the first issue of *Minotaure* in 1933. The latter aims to study the standing figure as an object, a surreal symbol, a structure of cartilage, tendon and muscle, a counterpoint of physical elements representing tension and strength in space.

Four bronzes of this abstract **Standing Figure** were originally cast in 1950. When, in 1971, Moore decided to carve the only existing version in white Carrara marble, he opted to work with the Stabilimento Henraux of Querceta di Seravezza in Tuscany. He made this choice with a view to showing the piece at the exhibition of his

work due to be held at Michelangelo's Forte di Belvedere in Florence the following spring. The work reached the show still supported by buttresses to protect the fragile marble; but at the last moment Moore substituted a cast in fibreglass since he considered the marble unstable. This he placed on one of the outer sloping banks of the Forte where it was to be seen in direct, daring and unforgettable competition with the Brunelleschi Dome and the Giotto Bell Tower.

Giovanni Carandente

160
Working Model for Reclining Figure: Festival 1950
LH 292
bronze edition of 7 + 1
cast: not recorded
length 43cm
signature: stamped *Moore*, unnumbered
Gift of the artist 1977

exhibitions: Bradford 1978 (cat.23); Madrid 1981 (cat.129); Lisbon 1981 (cat.63); Barcelona 1981-82 (cat.107); Mexico City 1982-83 (cat.106); Caracas 1983 (cat.E91); New Delhi 1987 (cat.49); St. Etienne 1987-88 (p.102); London 1990; Leningrad/Moscow 1991 (cat.70); Helsinki 1991 (cat.70); Sydney 1992 (cat.92); Ittingen 1994; Salzburg 1994; Barcelona/Vienna 1995 (cat.188); Havana/Bogotá/Buenos Aires/Montevideo/Santiago de Chile 1997-98 (cat.57)

During 1950-51 I made a number of visits to Moore's studio in the course of a film which followed the development of this sculpture through all its stages. The main subject for the camera was the full-scale plaster working model from which the bronze would be cast. The ivory smooth surface of the plaster was most seductive, but I was puzzled by the linear ridges which Moore made by fixing lengths of string to the clear expanses. I never dared to ask why! A similar technique can be seen in some of his drawings when he makes lines that form imaginary contours in depth, indicating the distance of the subject from

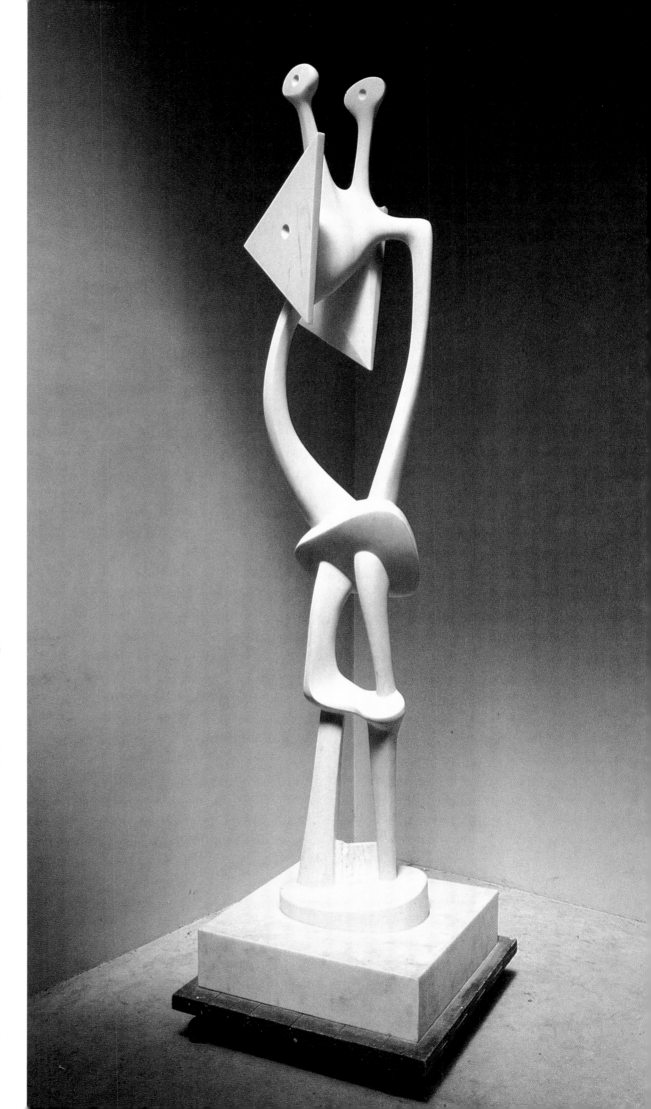

cat.159

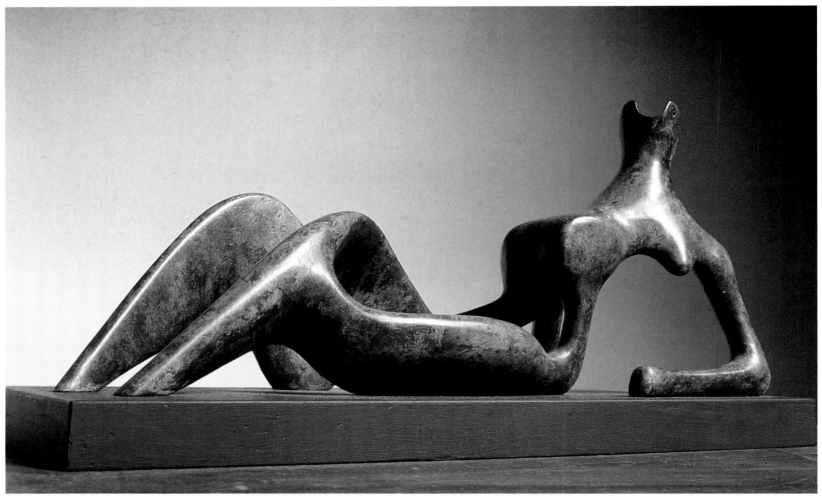

160

the viewer's eye at various points. I think Moore found it fun to play with this kind of illusion, as though in his mind he was making an imaginary three-dimensional jigsaw puzzle.

By 1950 the sculptures had opened out so that their effect depended as much on the spaces created by the forms as it did on the forms themselves. The full grace of this particular sculpture became apparent in the open air when the piece revolved in front of the camera. The strong shadows cast by the sun slipped over the flowing surfaces just as the shadows of clouds drift across hills and moors, following their undulations.

In the case of the full-scale version of this piece it was possible to make the camera glide inside the sculpture, revealing another world of arches and caverns. It made a beautiful cinematic image which created quite a stir at the time. After all, no one had seen inside a sculpture before.

Plaster and stone can suffer from the attentions of sticky fingers, but bronze can be handled with greater safety. My fingerprints must be on quite a lot of Moore's sculptures as I helped to move them around in front of the camera. When the final full-scale bronze version of this work was displayed in the grounds of the Festival of Britain, many adults stopped to look, but their children often reached out to touch it as well.

Moore's figures, seated, standing or reclining, all have this capacity to make one feel physically what it is like to be alive within one's own body. One wants to reach out and take possession of them with one's own hands.

John Read

161
Two Women and a Child 1951
HMF 2727
crayon, pastel, wash on cream heavyweight wove
334 × 314mm
signature: pen and ink l.r. *Moore/51*
Gift of the artist 1977

exhibitions: Graz 1994

Moore was interested in the family group at this time as a subject for both drawings and monumental sculpture. Here, however, the father is replaced by a second woman, destroying the usual feeling of harmony and serenity. The women are lean, their lines not pleasing, and the whole lacks authority. Thus it is odd that three versions of the drawing exist, suggesting that this is an important motif and the style very much deliberate.

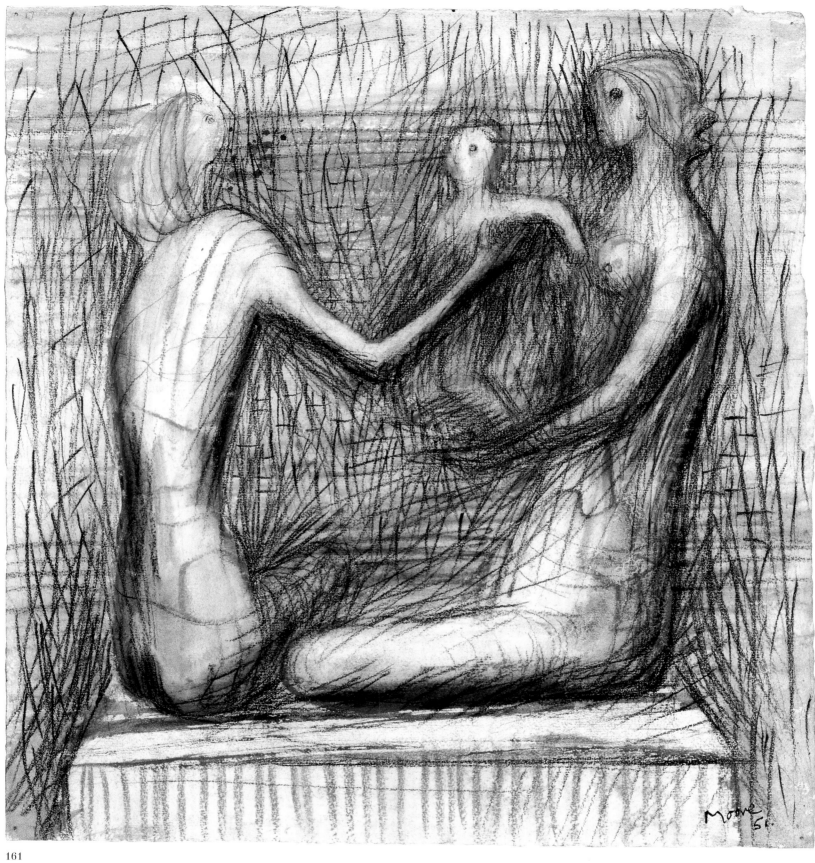

161

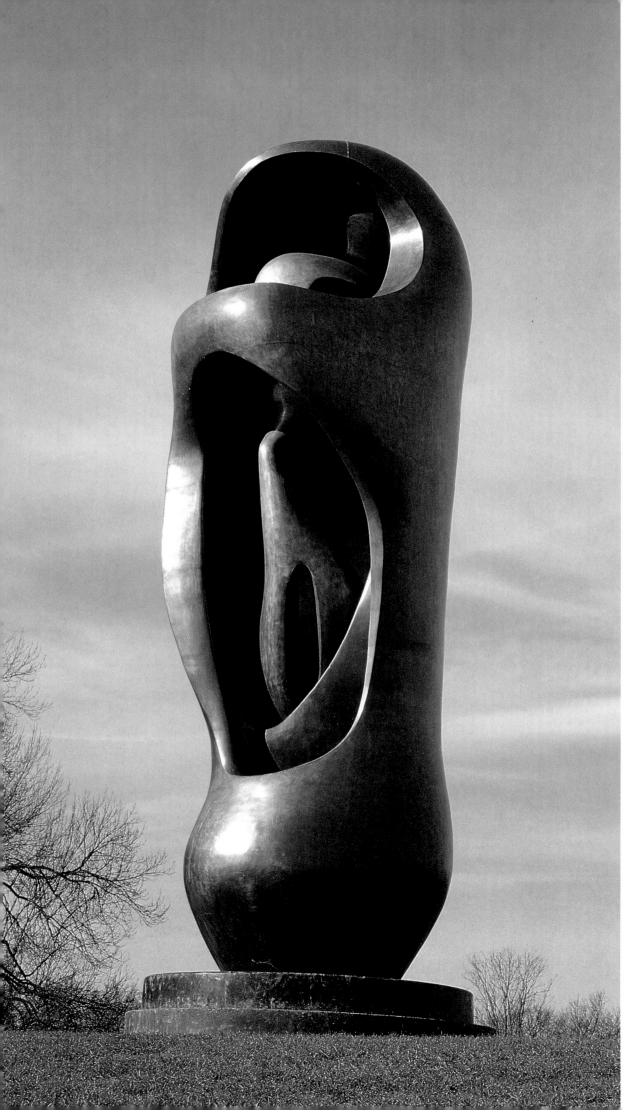

It is a self-consciously composed image without warmth or sentimentality. The women are physically and psychologically opposed, locked in an emotional battle. The black stabbing lines that encroach upon their forms almost diagrammatise this negative atmosphere. Consumed with the action, these lines, their poses and the fence-like stripes on the shared seat, unite the women on a single plane with all pictorial depth imprisoned beyond it. The spectator is totally excluded. Moore's interest in the bond between mother and infant seems here to have extended to the loss felt by a woman unable to have children. Although such overt symbolism in Moore's work is rare, the green aura around the child may perhaps here indicate jealously. The figures stare past each other, neither looking at the child, as the woman on the left takes him back without tenderness, from the other whose expression betrays her. Such blatancy is not to its credit. The drawing must, however, be seen as a bold experiment with composition and technique as expressive tools in the handling of a difficult and poignant subject.

Clare Hillman

162
Large Upright Internal/External Form 1981-82
LH 297a
bronze edition of 1 + 1
cast: Morris Singer, Basingstoke
height 673cm
unsigned, [0/1]
Acquired 1986

exhibitions: Wakefield 1994-95 (cat.1)

publications: Spender 1986, p.82

In the 1950s and 1960s Moore made very few sculptures that were specifically 'mother and child'. Although he developed a wide range of ideas that would be the impetus for most of his oeuvre during the next twenty-five years, he spent a significant amount of time exploring possibilities for the reclining figure and for a new series of internal/external forms.

cat.162

The new sculptures suggest the presence of an unborn child within the womb. Moore wrote that the idea was of '[an] embryo being protected by an outer form, a mother and child idea, or the stamen in a flower, that is, something young and growing being protected by an outer shell.'[1] The child struggling to emerge from the block of stone has now returned to the security of the womb. Moore declared that the idea of one form inside another owed some of its beginnings also to an interest in armour. 'I spent many hours in the Wallace Collection, in London, looking at armour . . . an outside shell like the shell of a snail which is there to protect the more vulnerable forms inside, as it is in human armour which is hard and put on to protect the soft body. This has led sometimes to the idea of the Mother and Child where the outer form, the mother, is protecting the inner form, the child, like a mother does protect her child.'[2]

The figure is also reminiscent of an Egyptian mummy or the archetypal mother in primitive cultures in which the process of birth is a critical component, embracing the very continuity of society. The image of the mother and child and of the mother, or womb, and embryo, or of giving birth, can be found in the tribal art of Ireland, Africa and the art of the Aztecs of Mexico. There is also in these forms a spirit of sheltering and of protecting the nascent form. Moore readily appropriated images from a broad range of cultures. This appropriation of styles and cultures, and the openness with which he interspersed them, is surely not in keeping with the reductivist spirit that permeated Modernism. His quest was not for the new and radical, rather he sought to reinterpret the universal. Moore went to Greece and embraced Classicism, while relishing pre-Columbian imagery. He wrote: 'Art is a universal activity with no separation between past and present.'[3] Moore's free use of contextual formats suggests that his work is in fact precursory to the aesthetics of Post-Modernism.

Gail Gelburd

1. James (ed.) 1966, p.247; 1992, p.263.
2. Mitchinson (ed.) 1981, p.228.
3. HMF archive.

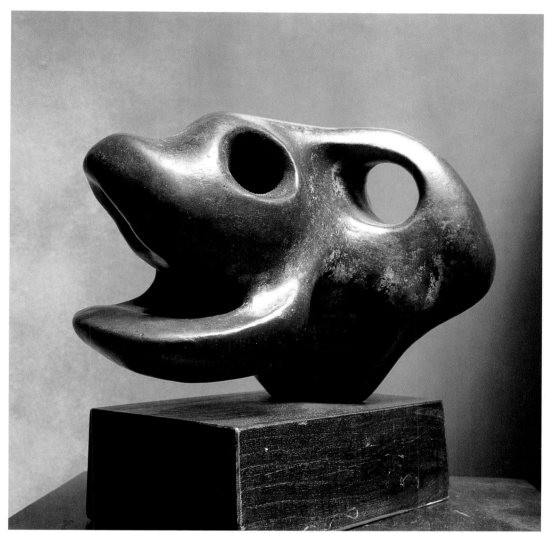

163

163
Animal Head 1951
LH 301
bronze edition of 8 + 1
cast: not recorded
length 30.5cm
unsigned, unnumbered
Gift of the artist 1977

exhibitions: Madrid 1981 (cat.95); Lisbon 1981 (cat.213); Barcelona 1981-82 (cat.71); Durham 1982 (cat.19); Mexico City 1982-83 (cat.55); Caracas 1983 (cat.E120); Hong Kong 1986 (cat.74); Tokyo/Fukuoka 1986 (cat.111); New Delhi 1987 (cat.46); St. Etienne 1987-88 (p.171); Sydney 1992 (cat.94); Barcelona/Vienna 1995 (cat.189); Bremen/Berlin/Heilbronn 1997-98 (p.105)

Despite Moore's life-long obsession with the female figure, his work does not convey any sense of overt sexuality, nor does it thrive on inherent aggressiveness (unlike that of his contemporary Jacob Epstein, who was a master at combining both these elements in his sculpture). **Animal Head** is an exception: although small in scale, the piece projects a predatory energy found in few other of Moore's pieces. It is an abstracted fusion of a human head, bird, fish, reptile and mammal, jaws agape and eye sockets wide open. The cranial cavity has a circular opening, echoing the radical gouging of the eye socket.

This opening of a solid form, which Moore referred to as a 'formal contrast to the solid part', is evident in his work from the late 1920s. His studies of Mayan, Aztec, Olmec, Inca and other pre-Columbian art at

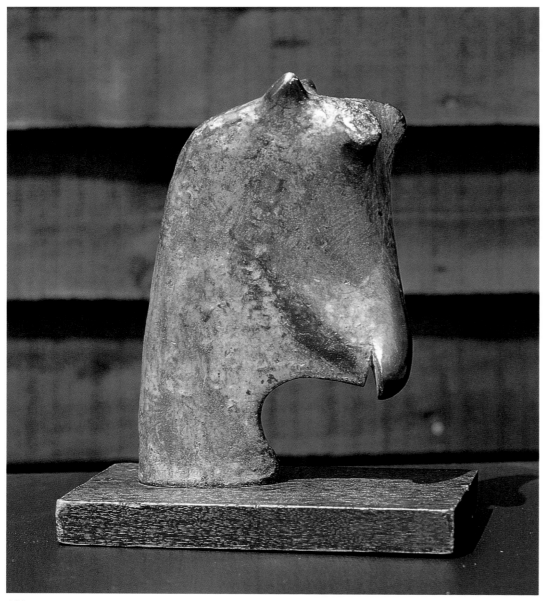

164

164
Goat's Head 1952
LH 302
bronze edition of 10 + 1
cast: The Art Bronze Foundry, London
height 20.5cm
unsigned, unnumbered
Gift of Irina Moore 1977

exhibitions: Madrid 1981 (cat.96); Lisbon
1981 (cat.214); Barcelona 1981-82 (cat.72);
Durham 1982 (cat.20); Mexico City 1982-83
(cat.54); Caracas 1983 (cat.E121); Hong
Kong 1986 (cat.75); Tokyo/Fukuoka 1986
(cat.112); New Delhi 1987 (cat.47)

'What makes me interested in bones as
much as in flesh [is] because the bone is the
inner structure of all living form. It's the
bone that pushes out from inside; as you
bend your leg the knee gets tautness over it,
and it's there that the movement and the
energy come from. If you clench a knuckle,
you clench a fist, you get in that sense the
bones, the knuckles pushing through,
giving a force that if you open your hand
and just have it relaxed you don't feel. And
so the knee, the shoulder, the skull, the
forehead, the part where from inside you
get a sense of pressure of the bone
outwards – these for me are the key
points.'[1]

Goat's Head is a sculpture which
renounces intrinsic monumentality, and it
is significant that it was never enlarged
beyond maquette size. It is one of the most
intimate and delicate of Moore's animal
representations. Its genesis is a bone
fragment, its original shape easily
discernible when one looks at the piece
frontally: an elongated form ending in a
smooth triangle with lamellar
fragmentations at the top of the head. The
plaster model of **Goat's Head** clearly shows
the working method employed by the artist.
Layers of plaster were applied around the
bone, which served as a natural armature –
and the basic shape of the head evolved.
The overall texture reveals the combination
of Moore's finger imprints (rough in the
neck and temple area, soft around the
cheeks and muzzle) and delicate toolmarks
which score the surface of both sides of the
sculpture. Little horns, almost

the British Museum in London during the
decade between the 1920s and early 1930s
consolidated this artistic concept. In
particular, the works of the Mexican
Tlatilco culture which is thought to have
evolved about 800 BC appear significant.
Those craftsmen created extraordinary
pottery masks, showing human or animal
faces, natural or grotesque, often divided
vertically into human and animal form, the
human half frequently in the shape of a
bare skull with large, circular eye-holes cut
through the clay. These masks appear to
have been a major influence on Moore in
his definition of 'negative space', and his
early sketchbooks show that he noted his

impressions and analysed the formal issues
of these works, which were to remain a
preoccupation throughout his life.

Although not specifically referring to
Animal Head, the following quotation
demonstrates that Moore, when working on
an animal theme, would never disassociate
his artistic thoughts from the human figure:
'Animals for me have characters similar to
many human beings, though sometimes I
feel freer when working on an animal idea
because I can invent an imaginary animal.
I would find it less natural to try to alter a
human.'

Reinhard Rudolph

mischievously added, justify the title. A precisely carved incision at the bottom of the modified bone fragment defines the goat's mouth, and the seam on the left side, joining the bone to the sculpted neck, renders perfectly the jaw-line of the beast.

This transformation of bones, as well as other organic objects such as flints, pebbles and driftwood, utilising their original form and shaping them by means of the addition of plaster or plasticine into autonomous works of art, was a working method Moore had been developing since the early 1930s. In 1940, he moved to a house significantly named 'Hoglands' which had been the site of a pork butcher's yard since the sixteenth century, and therefore offered rich pickings for the bone and skull section of the artist's 'library of natural objects'. Moore was to utilise these found objects in his artistic production throughout his creative life.

In the artist's own words: 'Pebbles and rocks show nature's way of working stone. Smooth, sea-worn pebbles show the wearing away, rubbed treatment of stone and principles of asymmetry. Rocks show the hacked, hewn treatment of stone, and have a jagged, nervous block rhythm. Bones have a marvellous structural strength and hard tenseness of form, subtle transition of one shape into the next and great variety in section . . . '[2]

Reinhard Rudolph

1. Warren Forma, *Five British Sculptors: Work and Talk*, Grossman, New York 1964, p.59.
2. Herbert Read (ed.), *Unit One*, Cassell, London 1934, pp.29-30.

165
Maquette for Mother and Child 1952
LH 314
bronze edition of 9 + 1
cast: The Art Bronze Foundry, London
height 21.6cm
unsigned, [9/9]
Gift of Irina Moore 1977

exhibitions: New Delhi 1987 (cat.50); Sydney 1992 (cat.95); Budapest 1993 (cat.82); Bratislava/Prague 1993 (cat.82); Krakow/Warsaw 1995 (cat.74); Venice 1995 (cat.74); Havana/Bogotá/Buenos Aires/Montevideo/Santiago de Chile 1997-98 (cat.59)

Not many Moore sculptures have a nickname, but when someone around the studio asked if or why this baby was trying to bite its mother's breast, Moore replied, 'No, not bite her, gnaw her.' Thus the inadvertently proletarian name stuck: Nora!

All joking aside, this is a strange, dark sculpture. Although he was hardly ever sentimental in his treatment of the mother and child theme, the relationship generally elicited gentle, placid, even serene images from Moore. The mother and child are bonded in varying degrees of consciousness of one another. Here however there is a terrible struggle, as the infant lurches viciously at the proffered erect breast and is staved off by the gridlocked arm of its terror-stricken mother. What an infant and what a mother!

Paul Nash, when showing some new paintings to a friend, is reputed to have said, 'This will provide jam for the psycho boys.' Moore provided as much 'jam' as any modern artist: books and essays have been devoted to him from the perspectives of competing schools of psychoanalysis.

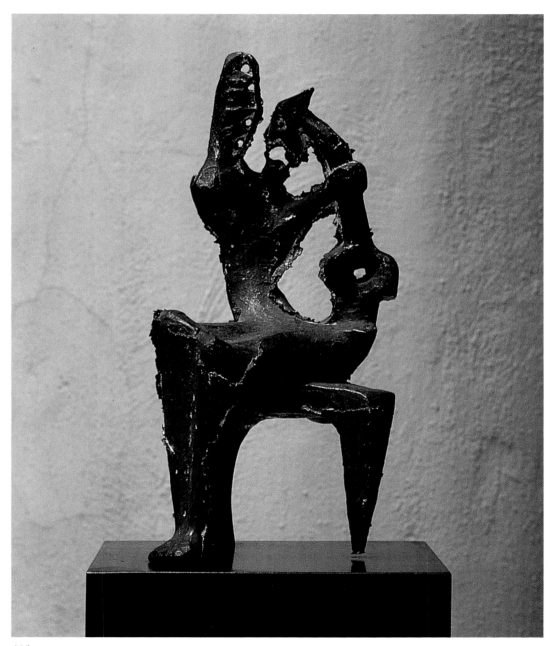

165

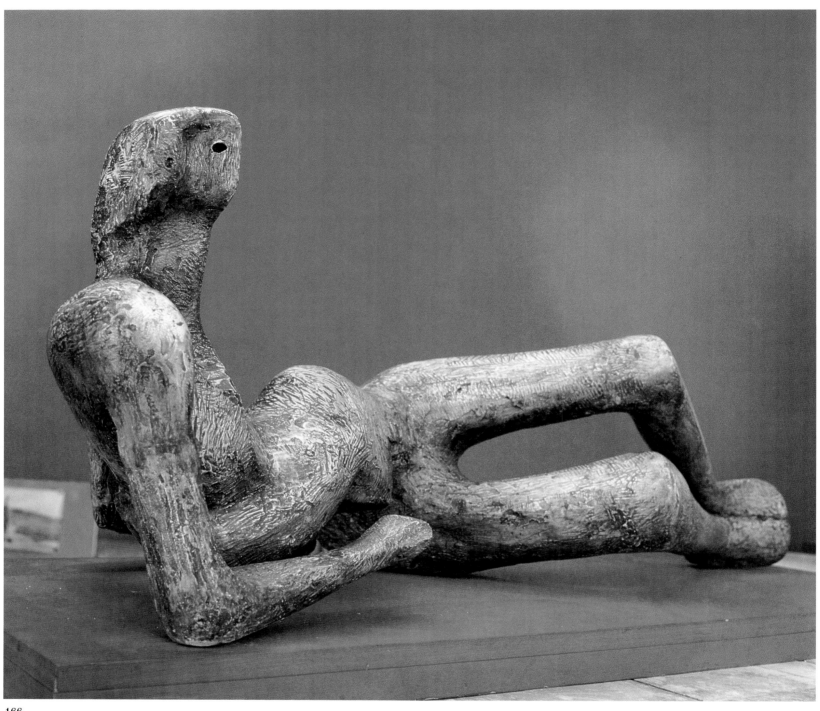

166

Naturally, Nora has gained plenty of attention. To the Jungian Erich Neumann, she is the 'Terrible Mother'; the archetype of Tantalus is unleashed in the sculpture. Moore actually stopped reading Neumann's book on him – *The Archetypal World of Henry Moore* (1959) – when the psychologist sent him a copy. He maintained that if he knew the unconscious source and motivation of his art, the inspiration would inevitably dry up, and he did not want to stop being an artist.

Neumann knew of Moore's work through Herbert Read, a devoted Jungian and editor of the English edition of Jung's collected works. Read, however, was ever an eclectic in the history of ideas. He related the image to the theories of Melanie Klein, who introduced the notions of infant envy and aggression, and of the splitting of the mother in the child's mind into a good breast and a bad breast, depending on when and whether mother is there to satisfy his needs. The way in this work one breast projects and the other caves in provides food for Kleinean thought.

The art historian Alan Wilkinson has rather poured cold water over such portentous readings of this **Mother and Child**. The image, he insists, 'derived

neither from the psychoanalytical theories of Klein nor from the artist's unconscious', but from a Peruvian pot. He has discovered a link, in the sketchbooks, to an illustration in a book Moore owned which does indeed show a couple engaged in some strange ritual. One holds up a totem pole or bird-cum-animal with a head just like Nora's infant's to what looks to be the gaping jaw of a second figure. The latter's teeth are just like the jagged edge of Nora's head, and she holds the stick figure by the 'throat', although not especially in contained fear, perhaps even in appreciation. It seems to me that Dr Wilkinson's scepticism is misplaced, and even shares Moore's own rather quaint attitude towards consciousness and motivation. The fact that automatism and free association can provide access to the unconscious need not

mean that they are prerequisites for such access. Form consciousness is a rich, multilayered cultural–personal process; drawing out forms from the depth of one's being need not preclude actually wanting to find them, or being turned on by related forms and phenomena out in the world.

The collective unconscious, 'envy and gratitude' and Peruvian pottery aside, Nora also relates keenly to the *Zeitgeist* and to contemporary developments in sculpture. This was the year that a group of young British sculptors exhibiting at the Venice Biennale alongside Moore, including Kenneth Armitage, Reg Butler, Lyn Chadwick, Eduardo Paolozzi, and Moore's first assistant Bernard Meadows, were dubbed by Herbert Read the 'Geometry of Fear' generation, for their spiky, angular, angst-ridden imagery, brutalised by the

cold war and by post-war malaise. 'Moore is father of them all', claimed Read. Nora adds another dimension to that allusion to parenting.

David Cohen

166
Reclining Figure No.2 1953
LH 329
plaster with surface colour
length 91.5cm
unsigned
Gift of the artist 1977

exhibitions: Barcelona/Vienna 1995
(cat.191)
loans: London, Victoria and Albert Museum
until 1982; Leeds, City Art Gallery 1982-95

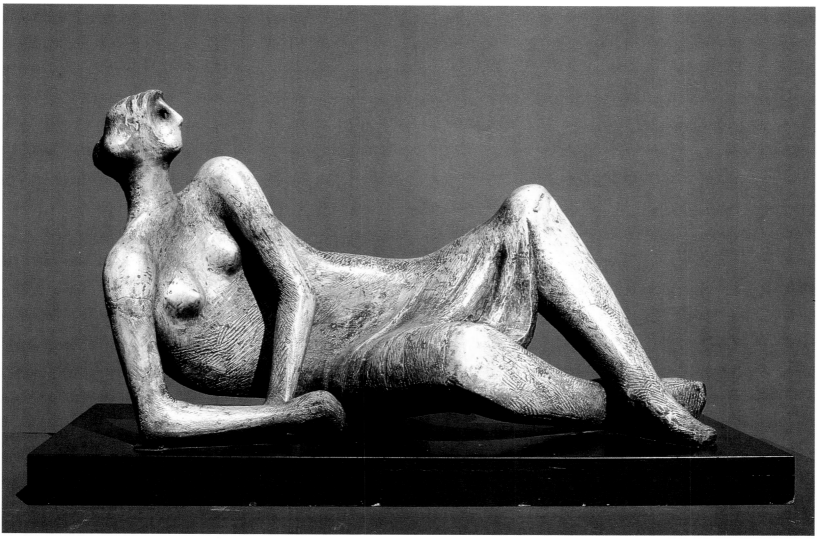

167

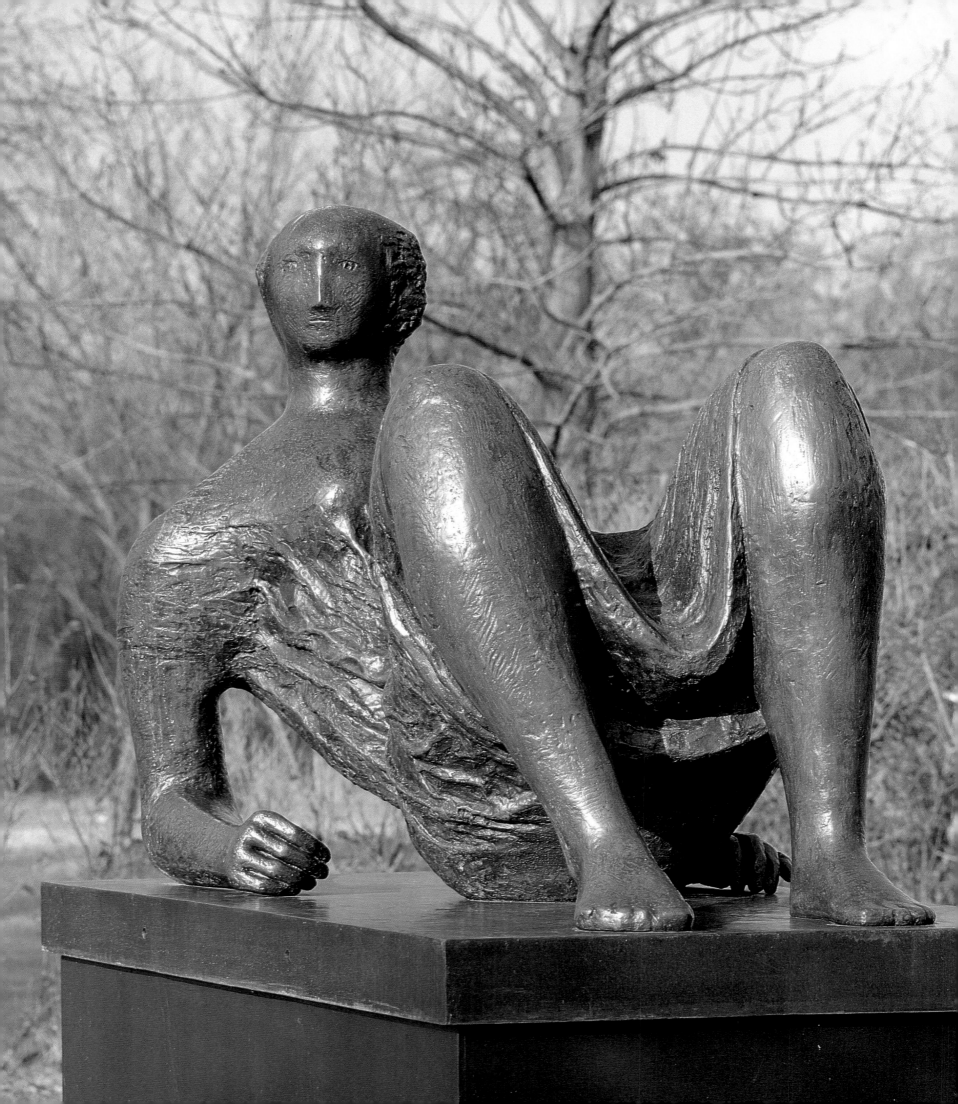

167

Reclining Figure No.4 1954-55
LH 332
plaster with surface colour
length 58.5cm
unsigned
Gift of the artist 1977

exhibitions: Nantes 1996 (cat.61);
Mannheim 1996-97 (cat.61)
loans: London, Victoria and Albert Museum
until 1982; Leeds, City Art Gallery 1982-95

168

Draped Reclining Figure 1952-53
LH 336
bronze edition of 3 + 1
cast: Fiorini, London
length 157.5cm
signature: stamped *Moore*, [0/3]
Gift of the artist 1977

exhibitions: Rome 1981 (front cover);
Madrid 1981 (cat.111); Lisbon 1981
(cat.209); Barcelona 1981-82 (cat.5); Mexico
City 1982-83 (cat.140); Caracas 1983
(cat.E106); Hong Kong 1986 (cat.124);
Tokyo/Fukuoka 1986 (cat.4); Wakefield
1987 (cat.5); London (not Stuttgart)1987
(cat.207); New Delhi 1987 (cat.53); London
1988 (cat.127); Martigny 1989
(cat.p.166,167); Milan 1989-90 (p.13);
Glasgow 1990; Sydney 1992 (cat.98);
Ittingen 1994; Salzburg 1994; Santiago de
Compostela/Oporto 1995 (p.96)

publications: Spender 1986, pp.69, 71

I remember this sculpture very well indeed
because I made the plaster for it. Henry and
Irina were off on a trip to Greece, I believe
it was his first trip to Greece. He gave me
the little model, the maquette to enlarge – it
was eight or nine inches (20-23cm) long.
He said make it nine times bigger, no make
it ten times bigger. That was certainly
outside my range as a young sculptor to
think so boldly about size! You feel close to
a sculpture you are making when you've
been working on it continuously, no matter
if it is someone else's piece or your own.
Henry clearly was ready for his trip to
Greece – he made the maquette for this

sculpture before he went, and as soon as he
came back he worked on it directly. The
main things he worked on were the head,
which he made infinitely better, and the
drapery which he made very Greek, like the
Parthenon figures in the British Museum. I
know he had that idea before he went to
Greece, he was thinking about it being
draped. His new excitement about Greek
art was confirmed by the trip to Greece – he
was going that way and kept going that
way. Nevertheless, the trip was obviously
important to him. Everybody is bowled over
when they go to Greece and see the art in
the flesh and in the Greek light. The
sculptures don't read truly from
photographs. Students from the eighteenth
century onward used to be fed on casts
from the Greek, but plaster casts or
photos don't make much sense – they're
simply reminders, no more than that. When
you go there it is real, it knocks you out.
You have to be ready to receive it though.
Henry was absolutely ready and when he
came back the fact that he went straight
into this sculpture confirmed it had been
maturing in his head and the trip to Greece
was the spark that set it alight. The
sculpture had nothing to do with the Time-
Life building, it was just put on the terrace
of the building. Making it was very
enjoyable. It was one of the few I enlarged
from the start from the maquette into the
large size. Henry knew I was very excited
by the art and that's why we got on
together.

I must have worked on this sculpture
for about a month. I took the little model
and placed it on a plaster block which I
divided into half or quarter-inch squares.
Then I made the full-size armature and the
whole thing got going. I used a wooden
armature with chicken wire; then I would
find each relative position on the large
piece and mark it with a matchstick. To do
that you would get the plaster maquette and
put a little black spot on it with a pencil,
then take the right-angle set square up
against it, and stand it upright in each
dimension. You clamp a little pointer on to
that, and by registering the position of the
point both upright and on the ground and
multiplying it by ten – working in inches of
course – you can find the position on the big

piece. You use a similar big set square and
make that equivalent point with the
matchstick on the enlarged piece. Actually
it's a crude form of pointing machine, but
the whole idea of a pointing machine was
something that Henry resisted for the whole
of his life. He went back to do-it-yourself
ways just as with the bronze casting, and so
you'd have these quite clumsy ways of
doing things because of his resistance to
automatic mechanical enlargement. The
Victorian academy pointing machine was
what the worst sculptors in Paris used in
the last century. I had worked with a
pointing tool in Charles Wheeler's studio
(the one and only time in my life) and you'd
see a small sculpture become a big monster
in no time at all using a pointing machine;
it was totally mechanical, awful! Henry
didn't want to do that, so even when we
were carving the **Time-Life Screen** 1952-
53 (LH 344) we constructed a complicated
box-type arrangement with a wooden pole
dropping down vertically with a point
attached to it: once again it was a confused
way of doing three-dimensional
enlargement. Nevertheless he was probably
right to escape from the Victorian enlarging
methods. It was makeshift but somehow
exciting and the sculpture came to life.

Henry was very keen about the way a
sculpture sits on the ground; it mustn't sink
down into the ground or collapse as if it
were on a cushion – to give it life it had to
bounce up from the ground. I remember
him saying that to me very early on; he was
criticising a sculpture I had made as a
student. A figure, in fact any sculpture, he
would say, has to come alive, so make it lift
off the ground. That's also true of siting
sculptures. If I were to place my sculpture
in a cobbled courtyard, for example, I
would want its legs to rest on the stones
not in the hollow between them; in that way
it looks buoyant, not depressed. These
things I learnt from Moore and they have
become second nature, you forget
completely how you came to do them that
way. I don't know whether Henry taught
himself these things or whether he was
taught them. He was very intelligent –
intelligent in a way that a sculptor or an
artist is intelligent. By that I mean he was
visually aware and listened to what his gut

instinct told him and he used his brain to develop that. But he could also talk well to people and explain things. He knew how the world worked. He had a real gift for explaining things, he enjoyed explaining things – he did to me, anyway.

Henry was pleased by the fact that I was so focused on sculpture, he liked that. I always speak of him and David Smith as my fathers in sculpture, but they were very different. My relationship with Henry was personal, very human. David was doing his own work, he wasn't really interested in what you did except perhaps out of the corner of his eye. Henry was always interested. After I'd left him and moved to London he called at my studio to see my work and he bought two sculptures. He used to be interested in what young people were doing. It was very encouraging.

Anthony Caro

169
Working Model for Time-Life Screen
1952
LH 343
bronze edition of 9 + 1
cast: The Art Bronze Foundry, London
length 101cm
unsigned, [0/9]
Gift of Irina Moore 1977

exhibitions: Madrid 1981 (cat.8); Lisbon 1981 (cat.14); New Delhi 1987 (cat.54); St. Etienne 1987-88; London 1988 (cat.125); Martigny 1989 (cat.p.169); Milan 1989-90 (p.16); London 1990; Sydney 1992 (cat.100); Budapest 1993 (cat.83); Bratislava/Prague 1993 (cat.83); Leeds 1993-94 (cat.147); Krakow/Warsaw 1995 (cat.75); Venice 1995 (cat.75)

Early in the 1950s Moore agreed to provide two sculptures for the London headquarters of Time-Life International. Designed by the London-based, Austrian-born architect Michael Rosenauer, the new building (1951-53) is in the form of two Portland stone cubes, the larger of six storeys with long, horizontal windows, in the reception area of which Moore placed a cast of the bronze **Draped Reclining Figure** [cat.168].

This he enlarged in plaster to working model size and had a bronze edition cast. On the open-air terrace above the two-storey wing he created a quartet of life-size Portland stone carvings, each set in individual frames forming a screen facing directly on to New Bond Street. Here both sculptor and architect rejected the idea of pictorial or symbolic references in favour of an unambiguous abstract approach.

In a letter of 10 March 1952 to Rosenauer, Moore warned of the dangers of merely using the site 'as a hoarding for sticking on a stone poster'. Meticulous consideration was given to the problems of light, 'the most important element of sculptural as well as architectural effect'. For the final carving of the pieces Rosenauer built a wall in Moore's Perry Green studio 'exactly in the same orientation as at Bond Street, sufficiently elevated to study their future appearance when seen from the pavement opposite. We adjusted the shape of the openings to allow for penetration of light from the Western sun and to place each of the carved abstracts into an opening as a three dimensional sculpture and not as a relief'.[1] Moore wanted the screen to 'look as though it was part of the architecture', 'a continuation of the surface of the building', but having both a front and back which would be pierced to give 'an interesting penetration of light'.

He prepared four maquettes in plaster with the aim of giving 'a rhythm to the spacing and sizes of the sculptural motives'. Three he rejected for being too regular, vertical and monotonous, approving the fourth because it was 'more varied'.[2] Further subtle adjustments were made during the carving process. The stone blocks were worked on turntables which, Moore explained, allowed each to be 'turned, say, on the first of each month, each to a different view, and project from the building like some of those half animals that look as if they are escaping through the walls in Romanesque architecture. I wanted them to be like half-buried pebbles whose form one's eye instinctively completes.'[3] This marvellous kinetic experiment, however, proved too costly and the carving remained stationary. The finished work was

unveiled in June 1953 during the week of Queen Elizabeth II's Coronation.

Terry Friedman

1. Peyton Skipwith, 'Abstract Sculpture and Modern Architecture' in London (F.A.S.) 1988.
2. Henry Moore, *Sculpture in the Open Air*, London County Council Third International Exhibition of Sculpture, London 1954, quoted in James (ed.) 1966, p.231; 1992, p.235.
3. *Sculpture in the Open Air. A Talk by Henry Moore on His Sculpture and its Placing in Open-Air Sites*, edited by Robert Melville and specially recorded with accompanying illustrations, British Council, London 1955, quoted in James (ed.) 1966, p.235; 1992, p.251.

170
King and Queen 1952-53
LH 350
bronze edition of 5 + 2
cast: Morris Singer, Basingstoke
height 164cm
unsigned, [00/5]
Acquired 1991

exhibitions: Leningrad/Moscow 1991 (cat.71); Helsinki 1991 (cat.71); Sydney 1992 (cat.101); Budapest 1993 (cat.84); Bratislava/Prague 1993 (cat.84); Leeds 1993-94 (cat.148); Graz 1994; Salzburg 1994; Paris 1996 (p.149); Stade 1997 (cat.4)

It was a natural progression to move from sculpture on the theme of 'Everyman and his family' to a sculpture involving the idea of royalty and kingship. Moore began thinking about his **King and Queen** when Britain was in the grip of a patriotic fervour stimulated by the Coronation and what was often called the beginning of a New Elizabethan Age. Once again the artist is involved in a public theme to be stated in the terms of his own vision. The initial purchaser of the final bronze was the Open Air Sculpture Park at Middelheim in Belgium.

When he began this piece Moore had recently returned from his first visit to Greece, where he experienced the light and the landscape that had inspired a culture whose products he had only, until then, seen in museums. His ideas were no doubt influenced by Greek sculptures from the thirteenth to the fifteenth century BC.

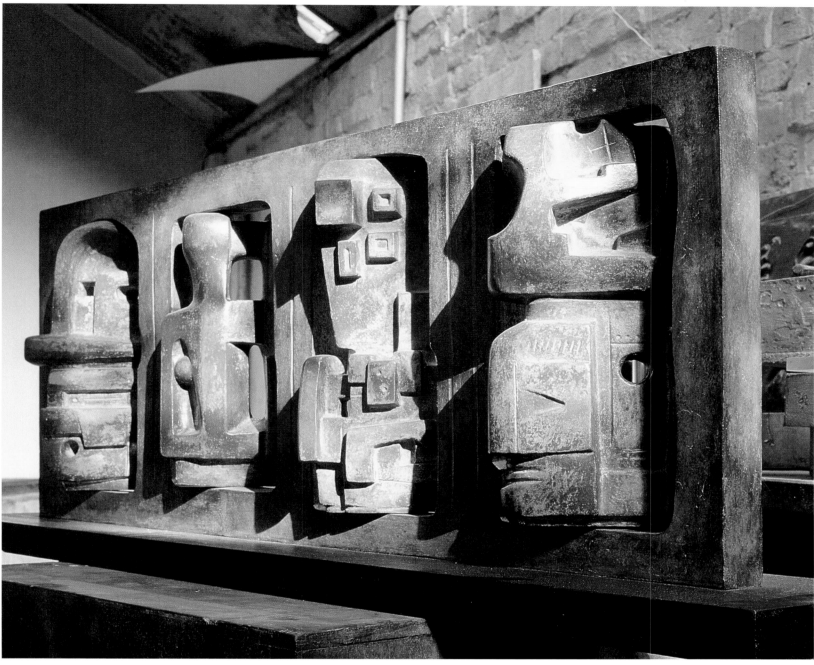

169

Moore also tells us that he was showing his six-year-old daughter how to make figures with strips of wax, and that the shape of the King's head was suggested by a piece that fell accidentally into a bowl of water. Both heads approximate to the shape that is made by pressing a soft piece of clay or wax between finger and thumb. The rather bird-like appearance of the King's head is in accord with ancient symbols of royalty used in painting and sculpture. Moore certainly intended to evoke the tribal and hieratic

nature of monarchy rather than the more sentimental feelings that were part of the popular celebrations taking place at the time.

Though seated on a very rudimentary throne, this royal couple convey a feeling of authority, in spite of their bare feet. They seem rather isolated on their bench and, in the case of the Queen, her dignity is tempered by a slight touch of homeliness. I rather wish that they could face an assembly of their loyal subjects, perhaps a

crowd created by another sculptor, Antony Gormley.

The version of this work that I got to know best stood alone on a Scottish hillside facing a deserted loch. I filmed the couple once on a grey day, in black and white, and years later in a more sunny mood, in colour. The spell they cast remains vividly in my memory. Moore has made an artistic unity of a variety of styles. The transitions from the group's realistic human features to more abstracted forms is imperceptible,

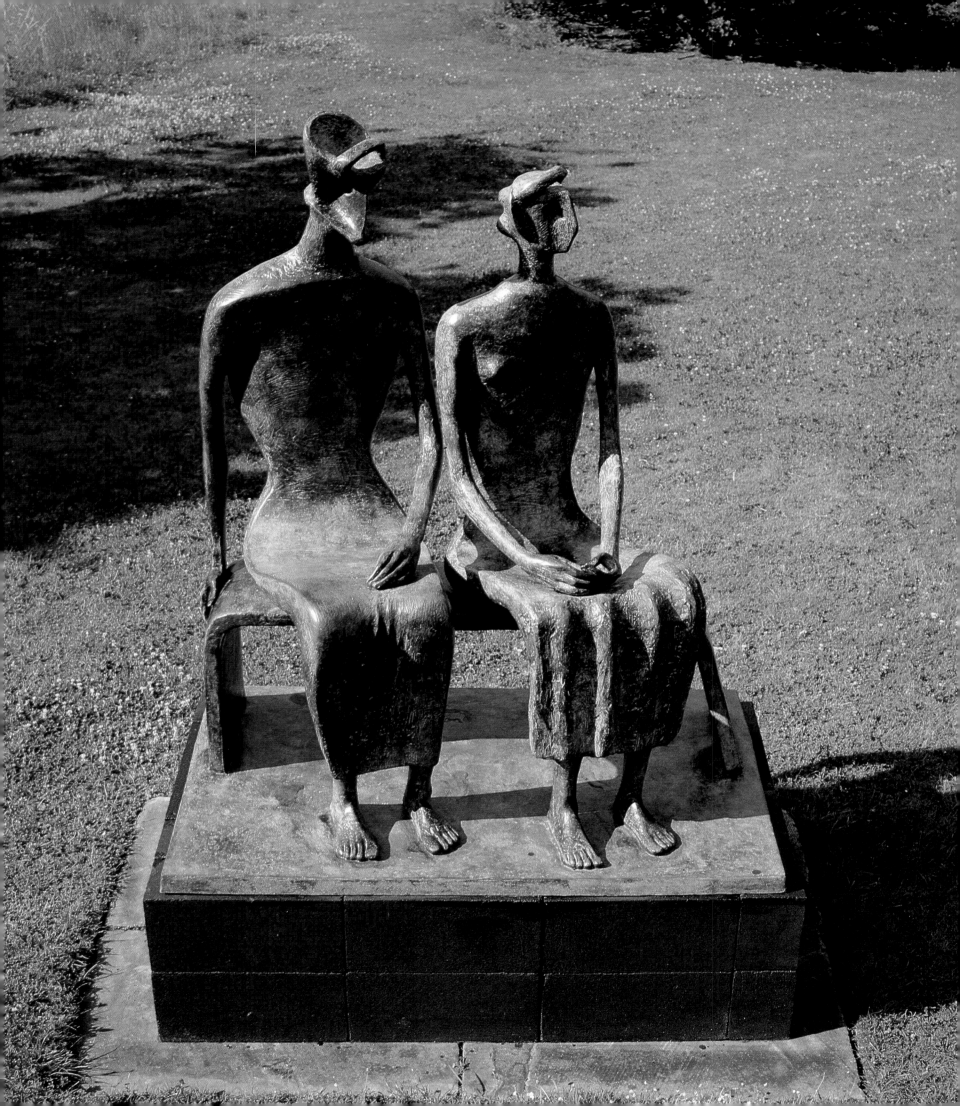

just as it is impossible to tell where naked flesh ends and drapery begins.

Wherever this group is placed, its lean silhouettes take command of the territory they survey. A sense of history, a knowledge of cultural tradition, a chance accident whilst playing with a child, have combined in the sculptor's imagination with a contemporary event, and produced one of his most widely respected masterpieces.

John Read

I remember watching Henry making the **King and Queen** maquette. The way he worked in wax intrigued me. He got attracted to working in wax while I was there. He set up a situation whereby we all partook in parts of his process. Alan Ingham and I were helping him in the big studio, the old cow shed. He only had one studio at that time and we all worked together.

First we boiled up the wax and poured it out on to flat sheets, so he'd got wax roughly the thickness of a casting. Then he'd cut it out, he'd cut out the shape of the figure he wanted – in this case the bodies of the **King and Queen** – and he did it exactly like a tailor cutting cloth into shape. He worked on a very small scale, he was comfortable working very small, the whole figure about six or eight inches (15-20 cm) high. He'd get this little figure and bend the warm wax into a seated position, then he'd make a little wax seat for it and give it legs and arms made up of thin elements of wax which he'd model. He was good at modelling hands or feet on a tiny scale. When it came to the head he'd make the head out of small wax parts, weld them together and dip the whole head into hot water, so the shapes would melt a little and cohere and the parts of the head would run together. That's how the heads of those maquettes and the rocking chair sculptures were made. Of course the rocking chairs with their delicate slats couldn't be made in plaster: the rockers and the slats had to be made in wax which is firm and quite strong when cold. He made the rocking chair figures in exactly the same way; he'd weld the slats on to the rocking chairs and sit the figures on them.

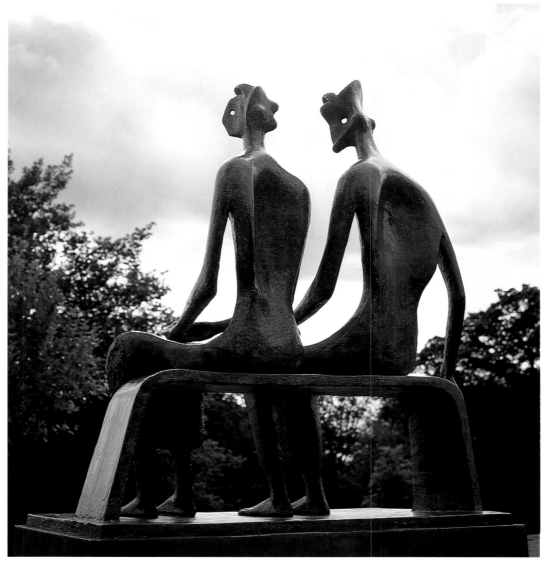

170

He did a lot of this sort of work when I was there and it was fascinating to watch him working. I had this little open Morris car and I'd go into London with the back of the car full of Henry Moore waxes. I'd take them to the bronze foundries – Gaskin (The Art Bronze Foundry) or Fiorini – and bring them back for him to check.

Henry was good on really small detailed things and I think that meant he could visualise these works big – monumental in scale. You can go from the very small to the large much more readily than you can go from a biggish maquette. It's a more natural jump, more direct, because you see the unity of the piece and don't get caught up with inessentials. It's rather like an architect working from a drawing or a

small model to a big building, the concept stays complete. Henry did sometimes make intermediate sized maquettes, but in the tiny sketch the sculpture was already there, even the detail, eyes and hands.

Henry was really happy working in wax with us all three in the studio together. I guess working direct in the wax came from having to correct the waxes that had gone to the foundries to be cast. After that I suppose it was natural to start working in wax direct. Of course this way is utterly different from the sort of modelling in wax that Degas did. I have never understood how Degas managed it because he seems to have stuck one piece of wax on to another just like clay. Perhaps it was a very soft wax, I don't know, but getting it to adhere is

difficult. Also Degas had a lot of trouble with his armatures. But these maquettes of Henry's weren't done like that at all, they had no armatures, the pieces adhered to one another by using a heated tool, a spatula. Anyway, it was the same sort of wax that the bronze casters used, and of course it made direct casting easier too.

I enlarged the Queen in terracotta for Henry. When I had been at the Royal Academy of Art Siegfried Charoux and Arnold Machin had taught me the technique of working in terracotta. I said to Henry, 'Would you like me to enlarge it to three-quarters size in terracotta?' and he said, 'Yes, good idea, go ahead.' I don't know why we never did the King, as he was pleased with the Queen. It is slow working in terracotta: you have to wait for the clay to harden and dry to a leathery consistency before you can go on to the next stage. Again, he would do a bit with it, he would push it here and there in the thorax for example, but by and large he mostly worked on the hands, feet and head.

Anthony Caro

171
Warrior with Shield 1953-54
LH 360
painted plaster on wire support, shield detached
height 155cm
unsigned
Gift of the artist 1977

exhibitions: Nantes 1996 (cat.64); Mannheim 1996-97 (cat.64)

Male figures are rare in Moore's art. As a student he had often drawn and modelled men's heads and figures. After 1923 they almost disappear even from his drawings, whereas his obsession with the female body is patent. The first major exception to this comes with the war. The Shelter drawings show women and children almost exclusively, but in 1941 he was commissioned to make drawings of coalminers, and thus found himself drawing half-naked men at work, not posed like models. In and after 1945 he made male figures as part of the family groups and **King and Queen** [cat.170], employing some of the formal discoveries he had made down the mines.

Late in 1952 or early in 1953 Moore started work on what became **Warrior with Shield**. In a letter of 1955 he gave an unusually full account of the sculpture's genesis from a pebble which suggested to him 'the stump of a leg, amputated at the hip'. He added the torso, one leg and one arm, 'and it became a wounded warrior' – a reclining warrior at first, but then he raised him and gave him a shield, 'and so it changed from an inactive pose into a figure which, though wounded, is still defiant.' He added: 'This sculpture is the first single and separate male figure that I have done in sculpture and carrying it out in its final large scale was almost like the discovery of a new subject matter; the bony, edgy, tense forms were a great excitement to make.'[1]

Commentators readily associated this figure with memories of the recent war, but Moore had made his first visit to Greece in 1951 and thought that his **Warrior** was perhaps stimulated by that. He had admired the power of Michelangelo's sculpture in Florence and Rome, male and female. He had discovered for himself the Mayan *Chacmool* figure, adapting his pose for his own reclining female figures. The Elgin Marbles in the British Museum, which he knew well, could have given him impulses towards making his own carved or modelled male figures. The visit to Greece may well have made him more aware of the dominant role of the male nude figure in classical Greek art and enhanced his feeling that, as he wrote the same year, 'sculpture is an art of the open air. Daylight, *sunlight* is necessary to it, and for me its best setting and complement is nature.'[2]

Moore must have been aware of the tendency in contemporary European art to express 'the human condition' through images of suffering and fear, as in the work of the French sculptor Germaine Richier and many lesser artists. In 1952 Herbert Read had associated the work of a group of younger British sculptors, exhibiting at the Venice Biennale, with 'the iconography of despair, or of defiance . . . excoriated flesh, frustrated sex, the geometry of fear'. These words now seem excessive; at the time they resonated memorably. Read was then at the height of his international fame as a writer on art, most particularly as a champion of 'a renaissance of sculpture in England' stemming from Moore's leadership.[3]

The early 1950s also found Moore beset by personal anxieties. The large bronze **Reclining Figure** (LH 293) he had made for the 1951 Festival of Britain show on London's South Bank, placed there as a work of exceptional importance, had met with harsh criticism and little praise. When it was lent to Leeds and offered for purchase at a nominal price, abuse was showered on it and him by councillors and others who might by this time have taken some pride in their famous local artist. Other attempts in the early 1950s to buy or commission work from Moore for public consumption met with untiring attacks. In 1951 he was at long last given a major exhibition at the Tate Gallery, yet praise from a few critics produced a backlash of mockery, as did John Read's film about Moore when it was shown on television that April. These were distressing experiences for an artist who by this time had achieved high fame outside his own country and, especially during and just after the war, seemed to have found his way to the British public. There was also an extended crisis at and around the Tate Gallery, where Moore was a trustee, which found him sharply at odds with fellow trustees such as Graham Sutherland, all accompanied by press attacks and by questions in Parliament. There was the fuss over the international competition for a sculpture of *The Unknown Political Prisoner*, which Moore had helped launch and therefore did not compete in but was pleased to see the little known Reg Butler win in early 1953. The event produced a swarm of hostile responses. Moore, usually of robust health, fell ill with a kidney infection in May 1953 and required an operation that June. He had reasons for picking up a pebble and seeing a broken human being in it.

He considered his **Warrior with Shield** a particularly important work. Casts of it were quickly bought by public bodies in Toronto, Mannheim, Minneapolis and Arnhem, but Birmingham had to fight off an

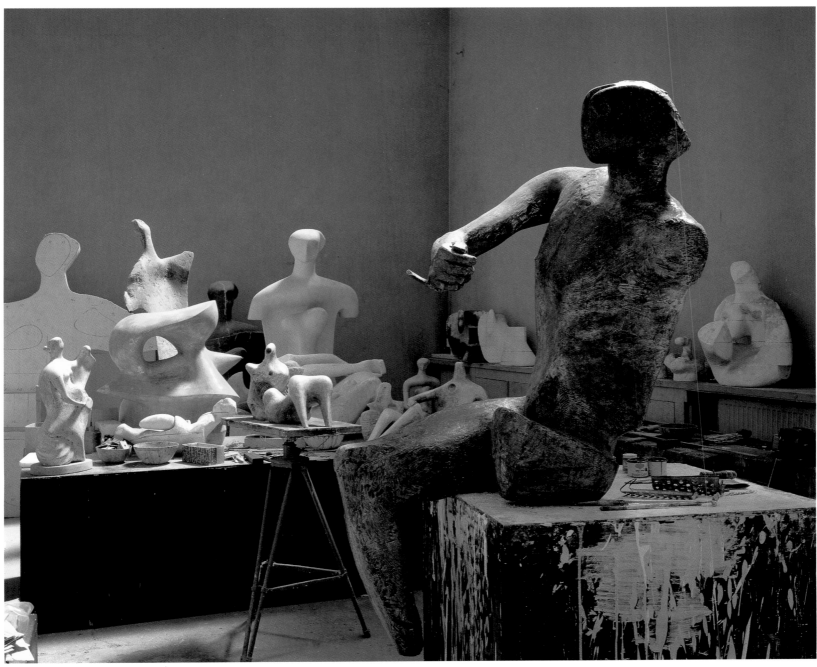

171

extraordinary swell of uninformed criticism when one was bought for the Central Art Gallery in 1955.[4] Moore, always reluctant to interpret his work too specifically, spoke of it in slightly guarded terms in the letter of 1955 quoted above: 'The figure may be emotionally connected (as one critic has suggested) with one's feelings and thoughts about England during the crucial and early part of the last war', when Britain faced German forces in command of the Continent and seemed helpless against

almost daily bombing raids; but its image is timeless. The theme of the truncated figure had been refreshed for Moore by his visit to Greece, and of course the shield suggests Homer rather than modern warfare. Only the split and drilled face suggests the twentieth century, and this attracted the sharpest criticism. A more naturalistic head would surely have weakened the sculpture's total impact.

Norbert Lynton

1. James (ed.) 1966, p.250; 1992, p.267; also Allemand-Cosneau, Fath, Mitchinson 1996, p.128, and p.127 where a small plaster study for this sculpture is illustrated and discussed as **Reclining Warrior** 1953 (LH 358b).
2. Quoted in Robert Melville, 'Henry Moore and the Siting of Public Sculpture', *Architectural Review*, February 1954.
3. Herbert Read, 'New Aspects of British Sculpture', *The XXVI Venice Biennale, The British Pavilion*, exhibition catalogue, British Council, London 1952. Also shown in the Pavilion were paintings by Wadsworth and by Sutherland, the latter at least also inviting interpretation in terms of fear and danger.
4. Berthoud 1987, p.243.

172
Seated Torso 1954
LH 362
bronze edition of 9 + 1
cast: Susse Frères, Paris
length 49.5cm
unsigned, unnumbered
Gift of the artist 1977

exhibitions: Bradford 1978 (cat.31); Madrid 1981 (cat.164); Lisbon 1981 (cat.154); Barcelona 1981-82 (cat.129); Mexico City 1982-83 (cat.120); Caracas 1983 (cat.E75); Honolulu 1983; Hong Kong 1986 (cat.133); Tokyo/Fukuoka 1986 (cat.32); Leningrad/Moscow 1991 (cat.73); Helsinki 1991 (cat.73)

173
Wall Relief: Maquette No.1 1955
LH 365
bronze edition of 12 + 1
cast: Fiorini, London
length 57cm
unsigned, [0/12]
Gift of Irina Moore 1977

exhibitions: Leeds 1984-85 (cat.19); London 1988 (cat.129); Milan 1989-90 (p.20); Coventry/Huddersfield/Wrexham/Bristol/Eastbourne/Exeter/Sterling 1990-91 (cat.17)

I have never been to Rotterdam to see Moore's 63 foot (1920cm) long mural at the Bouwcentrum, but the available photographs detail a remarkable *tour de force* on the part of the artisans who translated **Wall Relief** into its intended medium, brick. There were no holds barred in Moore's maquettes for this project, as he evidently took the commissioning architect J.W.C. Boks at his word when the latter promised that Rotterdam's master bricklayers could rise to any challenge.

Moore once professed to dislike reliefs because of the way they betoken sculpture's subservience to other art-forms – conceptually to painting and practically speaking to architecture. For one reason or another, though, he relented to this particular appeal. His mural is a modernist inflection of a uniquely northern Gothic–Renaissance tradition of ornate brickwork. The relief is rich in compositional incident and texture; the artfully distressed surface of the plaster, which registers in the bronze edition of which this cast is an unnumbered proof, anticipates the textures of brick, especially as it weathers.

Moore apparently worked his ideas straight into maquette form, without the intermediary of drawings, producing ten compositions. It is ironic that he eschewed drawing on this occasion, as the result is closer than any of his sculptural works to a page from his sketchbooks, or a worked-up drawing composition. There is a rigorous asymmetry in its schematic lay-out. The five human–animal figures roughly at the centre of the composition are highly distinctive, as they emerge from or are submerged within the picture plane – as ambivalently within the ground and aloof from it as the sculptural ideas in wax that populate imaginary landscapes in his drawings are locked into the page by the colour but stand apart from it in their resistant material. There is another, incidental similarity between the realised mural and Moore's drawing technique, although probably unanticipated, and that is the way the grouting recalls his characteristic jigsaw-puzzle detailing (sectional line) – see for example cat.157.

David Cohen

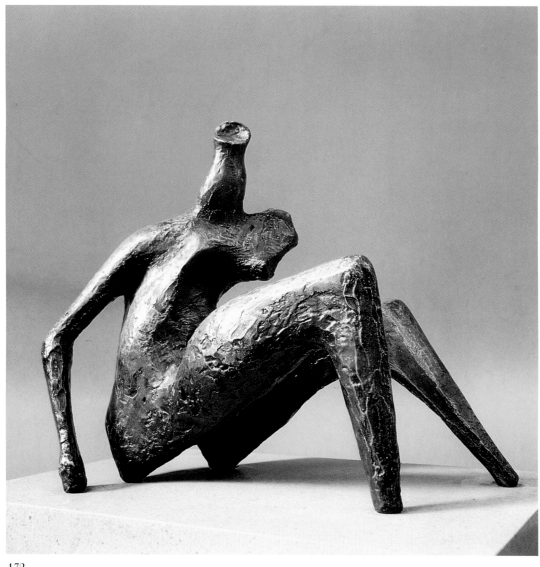

172

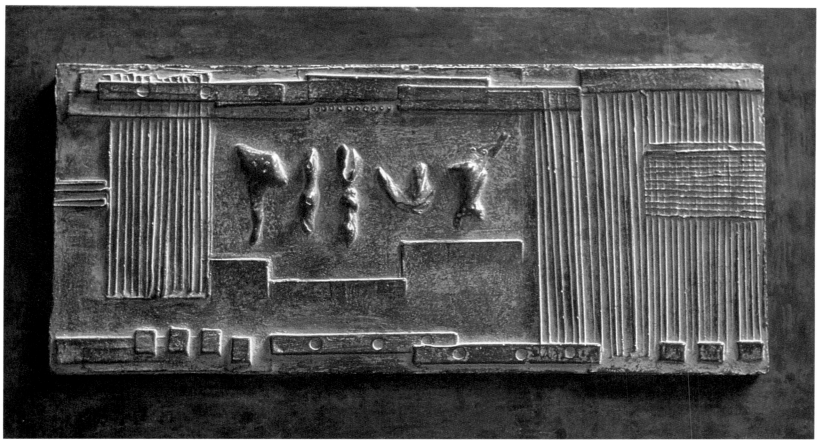

173

174

Upright Motive: Maquette No.1 1955
LH 376
bronze edition of 10 + 1
cast: Fiorini, London
height 30.5cm
unsigned, unnumbered
Gift of the artist 1977

exhibitions: New Delhi 1987 (cat.56);
Martigny 1989 (cat.p.175); Milan 1989 -90
(p.22); Budapest 1993 (cat.85); Bratislava/
Prague 1993 (cat.85); Krakow/Warsaw 1995
(cat.76); Venice 1995 (cat.76); Havana/
Bogotá/Buenos Aires/Montevideo/Santiago
de Chile 1997-98 (cat.62)

In 1954 Moore was asked to create a
sculpture for the courtyard of the new
Olivetti office building in Milan. When he
visited the site, 'A lone Lombardy poplar
growing behind the building convinced me
that a vertical work would act as the correct
counterfoil to the horizontal rhythm of the
building. This idea grew ultimately into the

Upright Motives.'[1] Moore produced thirteen
upright motive maquettes in 1955. Of the
five which were subsequently enlarged,
undoubtedly the most powerful and
evocative is **Upright Motive No.1: Glenkiln
Cross**, 1955-56 (LH 377), which was named
after Sir William Keswick's estate near
Dumfries, Scotland, where the first bronze
cast was sited on a hillside high above the
reservoir.

Upright Motive: Maquette No.1 is one
of a group of works from the mid-1950s that
illustrates the profound change in Moore's
working method at this time. Instead of
using drawing as a means of generating
ideas for sculpture, he began to work
directly in three dimensions in the form of
small maquettes modelled in plaster and
then carved. As his sculpture became less
frontal and began to have an organic
completeness from every point of view, he
found that working from a drawing
representing a sculptural idea from a single
view was contrary to his aims. It is no
longer in the sketchbook pages, but among

the hundreds of natural forms in the artist's
studio – bones, shells, pebbles and flint
stones – that one can discover the genesis
and point of departure of many sculptures
from the last thirty years of Moore's career.

This maquette is composed of three
distinct units. In the top section, which was
directly based on a flint stone I saw in
Moore's maquette studio, the small orifice
suggests the eye of some primeval Cyclops,
while the truncated arms and shoulders are
what connect the sculpture with a cross and
the Crucifixion. Below this is the smooth,
sensuous form of the torso, which was
almost certainly based on a flint stone or
possibly a bone. The rounded protuberance
at the bottom of this section resembles
waist and hip. Moore has described the less
organic, lower part of the sculpture as 'the
column and on it are little bits of drawing
which don't matter sculpturally, which
represent a ladder and a few things
connecting it with the Crucifixion'.[2] The
front of the column was in fact directly
based on a drawing done in 1955 (HMF 1256)

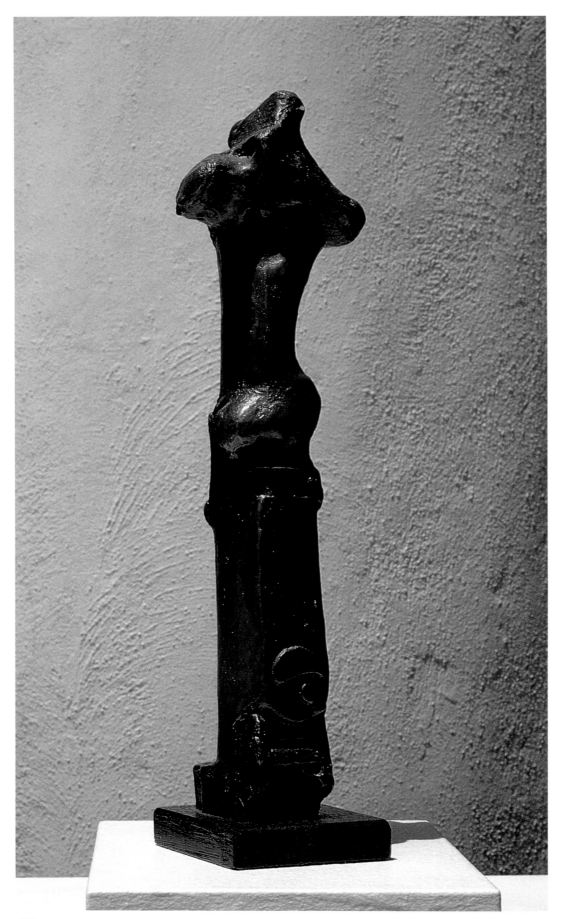

174

of an Oceanic carving from New Ireland, possibly a shield, which has not as yet been identified. In the **Glenkiln Cross** Moore, whose work is as closely associated with the reclining figure as that of Brancusi and Hepworth is with soaring, vertical forms, has produced one of the great totemic images in twentieth-century sculpture.

Alan Wilkinson

1. James (ed.) 1966, p.253; 1992, p.270.
2. *Henry Moore Looking at his Work with Philip James*, sound and filmstrip unit, sound editor John Yorke, Visual Publications, London 1975.

175
Upright Motive No.5 1955-56
LH 383
bronze edition of 7 + 1
cast: The Art Bronze Foundry, London
height 213.5cm
signature: stamped *Moore*, [0/7]
Gift of the artist 1977

exhibitions: Winchester 1983; Martigny 1989 (cat.p.176); Wakefield 1994-95 (cat.5)

Moore's upright motives are often discussed in terms of the influence of various types of 'primitive' sources, be it Celtic crosses or totem poles. Such comparisons have provided a convenient prop for those writers who have been concerned to present Moore, not as a product of history, but as a great artist standing outside of time. Herbert Read viewed the upright motives, 'apparitions' he called them, with terror, asserting that they were 'primordial images projected from the deepest level of the unconscious, and they illustrate the truth that the artist is essentially the instrument of unconscious forces.'[1]

While it is true, as Alan Wilkinson claims, that there are no specific preparatory drawings for the upright motives,[2] we can find a source for them in drawings Moore made, presumably at the National Army Museum, in 1941-42 (HMF 1854, 1855 and 1856). The drawings show bombs which had been cut in half lengthways to reveal their workings, and displayed standing upright. This gave a

long, smooth, rounded shape at the back, and a complex series of mechanical forms jutting out at the front, particularly protruding ledges which divide the sections of many of the upright motives. In these drawings Moore can already be seen anthropomorphising the bombs – for instance, by adding eyes. The importance of this source is that it suggests that the concerns of the upright motives are closer to Moore's response to the war than to the ahistorical matters which solely primitive influences and associations would imply.

There are other ways in which the upright motives are very much products of their time. **Upright Motive No.7** [cat.176] is the left-hand component of **Three Upright Motives**, as it stands at the Kröller-Müller Museum, Otterlo, with No.1 (the **Glenkiln Cross**, LH 377) in the middle, and No.2 (LH 379) to the right. In this arrangement, the Crucifixion motif implicit in the **Glenkiln Cross** is thus made explicit, and No.7 becomes one of the thieves. There is surely a dialogue established with Bacon's *Three Figures at the Base of a Crucifixion* which had been acquired by the Tate Gallery in 1953 while Moore was a trustee.[3] From some points of view, No.7 can be read as a figure with its head thrown right back and its open mouth pointed at the sky. The raised head and open mouth were a common motif in Bacon's painting, derived from Georges Bataille's theories about how in moments of pain and passion, human bodily hierarchies were overturned in a regression to animal nature. There is also a strong similarity with Sutherland's slightly earlier paintings of part-mechanical, part-organic standing figures. Sutherland represented these figures as sculptures placed in gardens and erected on plinths. Like Moore, he grouped them in threes.

As with many of Moore's sculptures, the upright motives are highly ambivalent. Read may have been terrified by them, and in the 1950s people often read in Moore's work references to the Holocaust or to nuclear destruction, yet to see them in this way only is to deny their status as monuments, and the redemptive aspect implied by the Crucifixion. Such deliberate ambivalence was certainly not confined to Moore's often quoted work, and instead of

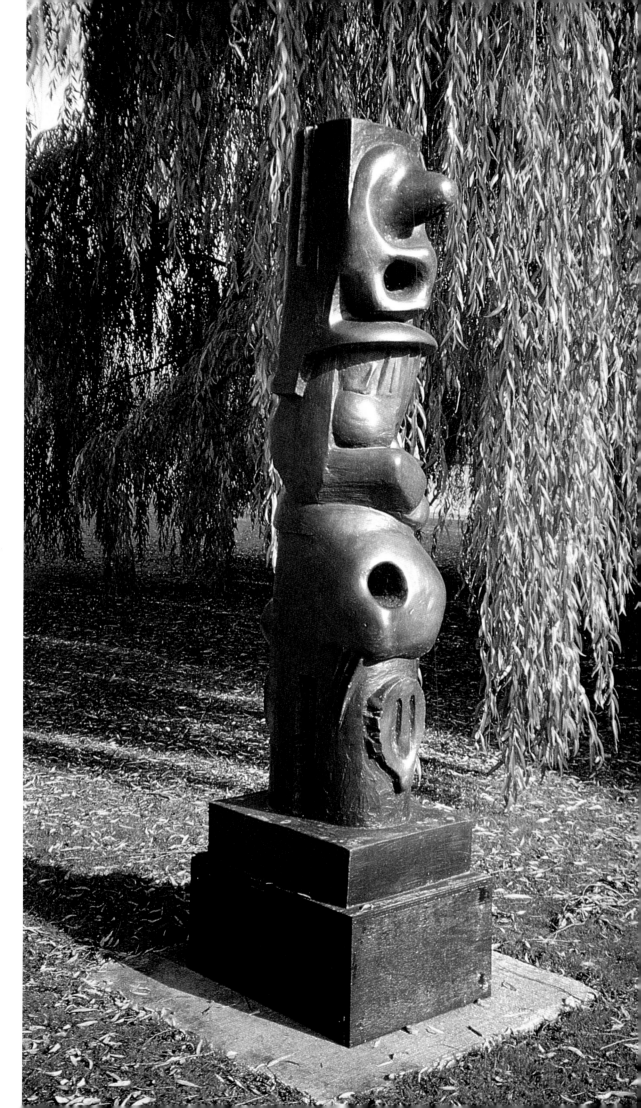

cat.175

using Moore's words to illuminate these sculptures, we may just as well use those of Sutherland. He wrote of those who saw his images as being only 'dark and pessimistic': 'That is outside my feeling ... the precarious tension of opposites – happiness and unhappiness, beauty and ugliness, so near the point of balance – are capable of being interpreted according to the predilections and needs of the beholder – with enthusiasm or delight, or abhorrence, as with the taste of bitter-sweet fruit.'[4] It is just this tension which is found in the upright motives.

Julian Stallabrass

1. Read 1965, p.208.
2. Wilkinson 1987, p.160.
3. London 1988, p.237.
4. Sutherland, *Listener*, 1951; cited in Tate Gallery, *Graham Sutherland*, London 1982, p.120.

176
Upright Motive No.7 1955-56
LH 386
bronze edition of 5 + 1
cast: H.H. Martyn, Cheltenham
height 320cm
unsigned, [0/5]
Gift of the artist 1977

exhibitions: Bradford 1978 (cat.7); Vienna/Munich 1983-84 (cat.1); Herning 1984 (cat.1); Le Havre 1984 (cat.1); Wakefield 1987 (cat.7); Martigny 1989 (cat.p.177); Paris 1992 (cat.3)

publications: Cohen 1993, pls.XXVIII, XXIX

177
Upright Motive No.8 1955-56
LH 388
bronze edition of 7 + 1
cast: Corinthian, London
height 198cm
unsigned, [6/7]
Gift of the artist 1977

exhibitions: Paris 1977 (cat.82); Winchester 1983

publications: Spender 1986, p.64

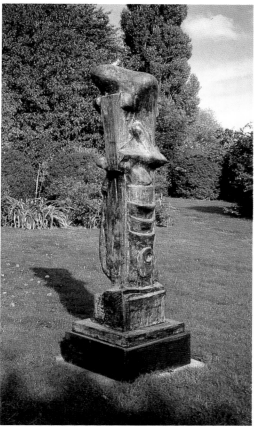

177

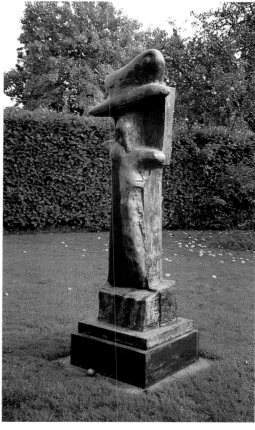

177

Moore's excitement on first seeing prehistoric stone monoliths at Stonehenge and Avebury in the 1920s and 1930s [see cat.78] resurfaced after the Second World War in a series of dramatic monumental sculptures. The catalyst was the commission in 1954 to make a sculpture for the courtyard of Olivetti's new offices in Milan [see cat.174].[1] The form was explored further during 1954-56 in a group of six plaster maquettes (now in Leeds City Art Gallery) for colossal stone sculptures attached to the façade of the proposed, but never built, English Electricity Company headquarters in London,[2] in a brick wall relief for the Bouwcentrum at Rotterdam [see cat.173], and finally in a series of thirteen maquettes for upright motives, five of which were carried out and measure between ten and eleven feet (305-335cm) high.

Moore explained: 'I started by balancing different forms one above the other – with results rather like the Northwest American totem poles'. The first 'took on the shape of a crucifix – a kind of worn-down body and a cross merged into one'. This and two other **Upright Motives** grouped together assumed in Moore's mind 'the aspect of a Crucifixion scene, as though framed against the sky above Golgotha.'[3]

Upright Motive No.8 merges several different forms: on one side the Glenkiln Cross shape, now having taken on vaguely human references, stands against the taller, noduled totem. Moore later associated this with a wood carving of an Arawak bird man from Jamaica: 'What I liked about this was the way the sculpture was built up in divisions, lump upon lump, as though it were breathing in matter, up from the toes along the arms from the fingers, into the great swelling chest.'[4]

Terry Friedman

1. *Henry Moore. Drie staande motieven*, Rijksmuseum Kröller-Müller, Otterlo 1965, quoted in James (ed.) 1966, p.253; 1992, p.270.
2. London (F.A.S.) 1988.
3. James (ed.) 1966, p.253; 1992, p.257.
4. Moore 1981, p.117.

opposite: cat.176 exhibited in Wakefield, 1987

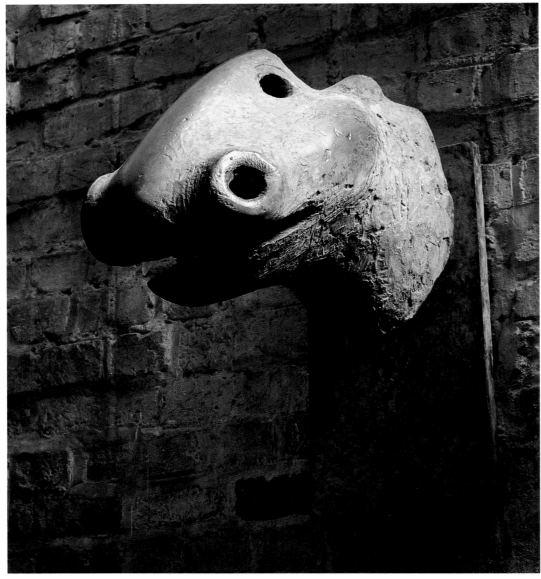

178

artist as a wall-mounted object. Moore's dictum was always that a sculpture had a front, two sides and a back. Complete three-dimensionality of form was his essential artistic concern. The only other sculptural pieces exempt from this credo, coming from the 1950s, are the wall reliefs (LH 365-373a), the **Three Forms Relief** 1955 (LH 374), and the large brick construction for the Bouwcentrum in Rotterdam, also executed in 1955 (LH 375).

There is a great degree of aggression in the image; the animal's mouth is gaping open, not enough to be thoroughly menacing, but subtly implying a latent threat. This impression is heightened by the tool marks, which here are are rough, extremely pronounced and expressive.

Reinhard Rudolph

179
Maquette for Fallen Warrior 1956
LH 404
bronze edition of 10 + 1
cast: The Art Bronze Foundry, London
length 22.9cm
unsigned, [0/10]
Gift of the artist 1977

exhibitions: Bradford 1978 (cat.117); Mexico City 1982-83 (cat.85); Caracas 1983 (cat.E26); Hong Kong 1986 (cat.34); Tokyo/Fukuoka 1986 (cat.141); New Delhi 1987 (cat.59); Martigny 1989 (cat.p.180); Milan 1989-90 (p.28); Bilbao 1990 (p.99); Sydney 1992 (cat.103); Budapest 1993 (cat.86); Bratislava/Prague 1993 (cat.86); Krakow/Warsaw 1995 (cat.77); Venice 1995 (cat.77); Havana/Bogotá/Buenos Aires/Montevideo/Santiago de Chile 1997-98 (cat.63)

With this maquette Moore returned to the theme of the warrior. A large **Falling Warrior** (LH 405) followed in 1956-57, significantly different in form as in title, and subsequently the **Goslar Warrior** 1973-74 [cat.233], again a different invention. None of them is idealised, let alone heroic. Moore's exploration of the subject reminds us that though he is associated with benign sculpture that speaks often of the comfort of

178
Animal Head 1955
LH 396
bronze edition of 10
cast: Fiorini, London
length 55.9cm
signature: stamped *Moore, 10/10*
Gift of the artist 1977

exhibitions: Bradford 1978 (cat.32); Mexico City 1982-83 (cat.65); Caracas 1983 (cat.E132) Tokyo/Fukuoka 1986 (cat.100); London 1988 (cat.137); Bremen/Berlin/Heilbronn 1997-98 (p.104)

Moore visited Paris for the first time in 1922 with his friend Raymond Coxon. On this visit they particularly wanted to see the works of Cézanne, an artist whom Moore respected and drew inspiration from throughout his life. After Moore had married Irina Radetzky more visits followed, continuing throughout the 1930s, often in the company of Coxon and his wife Edna. **Animal Head** was not executed until 1956, but has a striking resemblance to the famous gargoyles on the outside of the spires of Notre Dame. Although there is no conclusive evidence of a visit by Moore to the cathedral, it seems highly unlikely that he would not have been aware of these carvings during the earlier visits.

Animal Head is an unusual sculpture as it appears to have been perceived by the

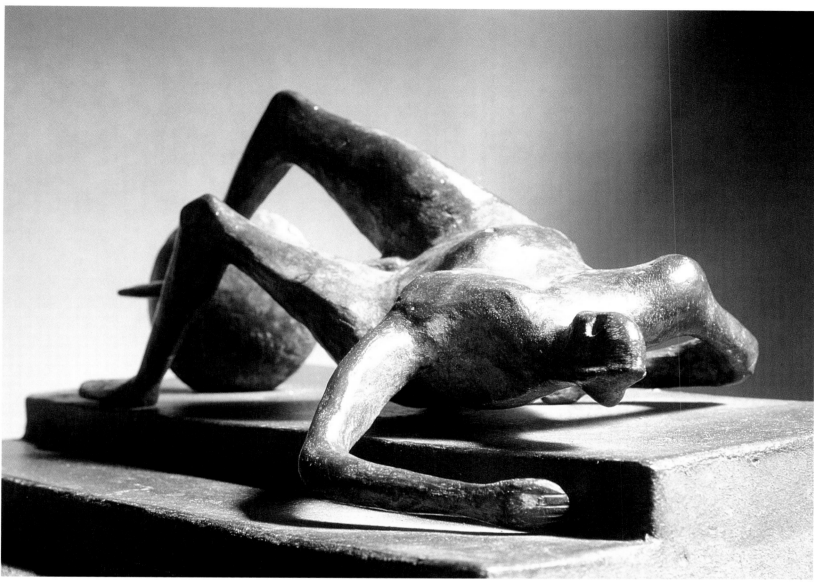

179

human contact, he did also address situations of pain and even despair. This needs stressing because Moore's 'good guy' image, especially during his last years, damaged his reputation by making his art appear much more limited than it is. His range of theme and expression is remarkably wide and is matched only by that of Picasso.

This warrior is physically complete but, as the title hints, the most abject. The shield has fallen from the man's right arm and he has fallen on to his back. Just fallen: his arms press down to break his fall, his left arm descending below the general level of the base to give added force to that gesture. One foot is on the ground; the other still

descends. His head has not yet touched the ground. It will. This motion feels more final here than in the **Falling Warrior**, where the shield, the right arm and the left foot press on the ground, keeping the rest of the man's body off it. Such clear accounts of movement have been rare in sculpture since Rodin, especially in the work of consciously avant-garde sculptors who have tended to opt for stillness or for kinetic works. One is tempted to assert that kinetic sculpture was outside Moore's range – though his abstract stringed works of the 1930s took him towards it – and it seems likely that it was the experience of classical sculpture in Greece, added to familiarity with the Elgin Marbles, that made the

theme of a fighting but vanquished man important to him in the 1950s.

Perhaps because of this, Moore's 1950s warriors are conceived more naturalistically than most of his post-student work and any of his sculptures of that decade. (I say this in spite of the **Harlow Family Group**, carved in soft limestone in 1954-55, naturalistic in its all-over disposition but generalised in all particulars.) Not that everything is delivered in naturalistic terms, especially not in the terms we call naturalistic but which are those of idealised naturalism as invented and refined by the Greeks and both honoured and devalued in nineteenth-century academic sculpture. The torsos of

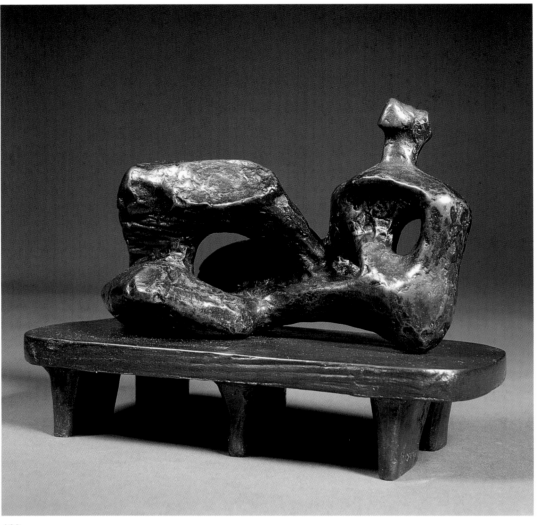

180

180
Maquette for Unesco Reclining Figure 1956
LH 414
bronze edition of 6 + 1
cast: not recorded
length 21.6cm
signature: marked *Moore*, [0/6]
Gift of the artist 1977

exhibitions: Bradford 1978 (cat.75); Seoul 1982 (cat.7); Columbus/Austin/Salt Lake City/Portland/San Francisco 1984-85 (cat.38); London 1988 (cat.139); Milan 1989-90 (p.30); Coventry/Huddersfield/Wrexham/Bristol/Eastbourne/Exeter/Sterling 1990-91 (cat.24); Leningrad/Moscow 1991 (cat.76); Helsinki 1991 (cat.76); Sydney 1992 (cat.105); Budapest 1993 (cat.88); Bratislava/Prague 1993 (cat.88); Krakow/Warsaw 1995 (cat.79); Venice 1995 (cat.79); Havana/Bogotá/Buenos Aires/Montevideo/Santiago de Chile 1997-98 (cat.65)

The sculpture for the forecourt of the new Unesco headquarters in Paris was one of Moore's first major international commissions, and remains his most important public work in Paris, if not in the whole of France. It is a great reclining figure, abstracted and simplified to a degree, pierced and hollowed, carved in travertine marble and completed in 1958. It was a commission that occupied all his creative faculties for something over two years and, one way and another, resulted in more than twenty works, as ideas were tested and discarded, or developed alongside the major piece.

This small maquette, originally worked up in clay and plaster, is perhaps the earliest in this group, the first provisional statement of the image upon which Moore settled. Though he tried other formats, it is as though he always knew it had to be indeed a reclining figure. Already it has the same hole established through arm and shoulder, the same raised, thrusting, vestigial head, and the same mass of thigh poised so lightly in mid-air. It carries too, at least in prospect, much of the required weightiness and humane dignity of the larger scheme.

Moore's warriors are full of tension, the limbs taut with exertion or limp in collapse, the heads full of life though much transformed.

Moore has equipped both his **Fallen** and **Falling Warrior** with genitals. Generally he eschewed sexual motifs in his sculpture, though his use of thrusting forms, as in the **Two-Piece Reclining Figure No.1** 1959 (LH 457) [see cat.190], sometimes even a pairing of thrusting and receiving forms, cannot have been wholly unconscious. His general instinct was against exciting thoughts of sexual activity or potentialities in his sculpture, although his drawings often reveal his desire for women. His upbringing provided the basis for this reticence, while his growing up in a family of ten living in close proximity must have militated against any long ignorance of physical functions. Gill and Epstein were often accused of obscenity, sometimes because of depicting male genitals in their work, and this gave them the false fame of notoriety. Moore certainly did not want anything like that for himself.

Norbert Lynton

What makes it so particular, however, gives it such life, is its essential quality not in relation to the carving by which the image would eventually be realised, but still as very much a modelled figure. Here there is nothing yet of the character of stone, with its careful surfaces and static, monumental authority. Rather it is pinched and prodded, squeezed and smoothed into shape between the artist's active, exploratory fingers. It is malleable, experimental, alive.

William Packer

181
Working Model for Draped Seated Woman: Figure on Steps 1956
LH 427
painted plaster, paper, hessian on metal support
height 65cm
unsigned
Gift of the artist 1977

exhibitions: Nantes 1996 (cat.72); Mannheim 1996-97 (cat.72)

This working model belongs to a series of sculptures which Moore was working on during the latter half of the 1950s in his attempt to find a solution to the problem of placing a sculpture against a building. The commission to make a work for the Unesco headquarters in Paris occupied Moore for over four years, during which time he filled notebooks with sketches and ideas as well as completing eleven maquettes on the subject. This led to his biographer, Roger Berthoud, dubbing the group 'the daughters of Unesco'.

This particular work is significant in that it bridges the gap between the draped

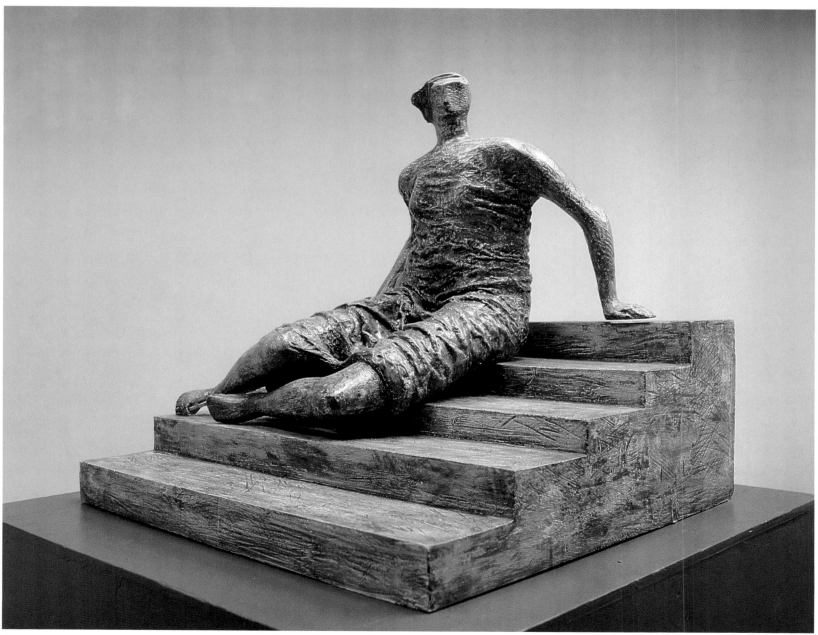

181

figures of two or three years earlier, which had resulted directly from Moore's first visit to Greece in 1951, and the later figures set against architectural backgrounds. The use of steps gave him the possibility to explore placing a figure on an architectural feature without wholly obscuring the background. In the final monumental version of this sculpture the steps have been quite dramatically reduced to give the figure prominence, which shows, I feel, Moore's great sensitivity to the importance of considering each stage of an enlargement as a sculpture in its own right.

The importance to Moore of his visit to Greece cannot be underestimated. Until 1951 he had spurned Greek sculpture, preferring to take as his model the primitive sculpture of Africa, Mexico and pre-Cycladic Greece. The idea of using drapery appears to have been born out of the war studies, when he was drawing figures bundled up in blankets, either sitting or lying in the Underground, and confirmed after his Greek sojourn. Moore said of drapery: 'Drapery can emphasize the tension in a figure, for where the form pushes outwards, such as on the shoulders, the thighs, the breasts, etc., it can be pulled tight across the form (almost like a bandage), and by contrast with the crumpled slackness of the drapery which lies between the salient points, the pressure from inside is intensified.'[1] In this figure he has minimised the drapery, using it to fulfil his sculptural requirements, making it very much his own, and it is only the heavy skirt which looks back to such pieces as **Draped Reclining Figure** [cat.168], where the influence of Greek sculpture can be most clearly recognised.

Julie Summers

1. Russell 1968, p.132; 1973, p.156.

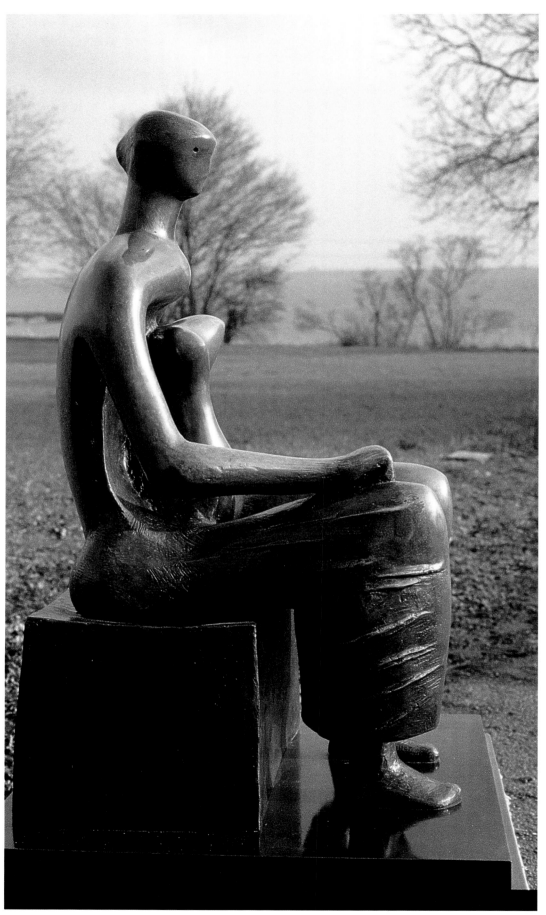

182

182
Working Model for Seated Woman
1980
LH 433b
bronze edition of 9 + 1
cast: Hermann Noack, Berlin
height 76cm
signature: stamped *Moore, 0/9*
Acquired 1986

exhibitions: Hong Kong 1986 (cat.136);
Tokyo/Fukuoka 1986 (cat.39); Florence
1987 (cat.8); New Delhi 1987 (cat.66);
Martigny 1989 (cat.pp.186-188); Milan
1989-90 (p.32); Milngavie/Ayr/Paisley/
Kilmarnock/Dumfries 1990; Leningrad/
Moscow 1991 (cat.81); Helsinki 1991
(cat.81); Sydney 1992 (cat.109); Budapest
1993 (cat.90); Bratislava/Prague 1993
(cat.90); Krakow/Warsaw 1995 (cat.83);
Venice 1995 (cat.83); Havana/Bogotá/
Buenos Aires/Montevideo/Santiago de
Chile 1997-98 (cat.67)
loans: Newport, Free Grammar School 1988

Moore returned to this motif many times in
different sculptures. He made the maquette
for this piece in 1956 and a final
enlargement in 1986 (incomplete at his
death). The visual centre is the fused form
of the woman's breasts and stomach, this
appendage being the only sensual and
tactile part of the lithe figure.[1] What it
represents is surely an intended ambiguity.
Moore made a number of maquettes on the
theme of pregnancy around 1956. The
swollen breasts and belly simultaneously
take on the form of a foetus, indicating that
a life inside this woman is relying on her
for sustenance and protection. Moore's
works exploring internal and external
forms reached their most monumental with
Large Figure in a Shelter [cat.237], also
enlarged in 1985-86, just before his death.
The shape of the 'sheltered' bears a
resemblance to the appendage of this
Seated Woman, suggesting that the theme
of protection was in his mind when making
both pieces. A similar shape also appears in
another work relating to the theme of
pregnancy, **Reclining Connected Forms**
1969 [cat.225]. These links also strengthen
the argument that this piece is in fact a
mother and child.[2] The appendage, though

exaggerated by patination, remains not
quite detached, as a child is not quite
independent.

There are many drawings and
sculptures by Moore of seated women and
children dating from around 1956 and 1980,
nearly all concentrating on the intense
mother and child bond. In some the two are
literally fused together and often,
particularly in drawings, this involves the
child taking the place of the breasts and/or
belly, whence it came and received
nourishment.

There is something jarring about this
woman, however. She is draped from the
waist down and sits tensely with one fist
clenched. She has an impenetrable air of
cold resignation and maintains a certain
aloof regality seen also in the **King and
Queen** [cat.170]. Her form and features are
almost androgynous, she has slightly gangly
bodylines, and her back is simply described,
functional more than sensual. Yet there is
great feminine and haptic sexuality in the
ambiguous 'lump'. Moore often
concentrated on the breasts and stomach,
as though these for him embodied 'woman'.

Clare Hillman

1. It is interesting to note that one of Giacometti's
Women of Venice, exhibited at the Venice Biennale in
1956, has similarly detached and fused breasts and
stomach. It is likely that Moore saw these figures, at
least in reproduction, and this may have influenced,
consciously or subconsciously, the original 1956
Maquette for Seated Woman (LH 433a).
2. Lynton 1991, p.107.

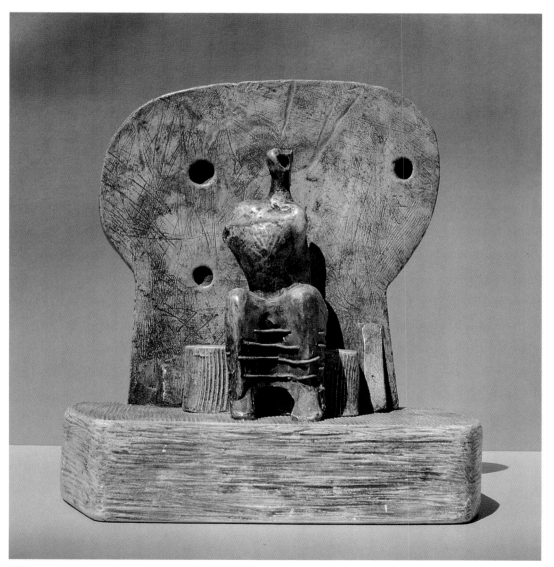

183

183

Armless Seated Figure against Round Wall 1957
LH 438
plaster with surface colour
height 28cm
unsigned
Gift of the artist 1977

exhibitions: Paris 1977 (cat.88); Madrid 1981 (cat.207); Lisbon 1981 (cat.177); New York 1983; Hong Kong 1986 (cat.90); Tokyo/Fukuoka 1986 (cat.66); London 1988 (cat.143); Sezon/Kitakyushu/Hiroshima/Oita 1992-93 (cat.Fo-16); Nantes 1996 (cat.74); Mannheim 1996-97 (cat.74)

184

Seated Woman 1958-59
LH 440
bronze edition of 6 + 1
cast: Hermann Noack, Berlin 1975
height 190.5cm
signature: stamped *Moore, 0/6*
Acquired 1987

exhibitions: Wakefield 1987 (cat.9); Martigny 1989 (cat.pp.190,191); Milan 1989-90 (p.37); Paris 1992 (cat.4); Wakefield 1994-95 (cat.11)
loans: Prague, British Embassy 1996-97

publications: Cohen 1993, pls.XLVI, XLVII

I first went to work for Henry in late 1958 or early 1959 and worked for him for about a year and a half. I had just finished at St Martin's, and Tony Caro had suggested my name to Henry and I went to see him for an interview. Since I lived in London I travelled every day to Much Hadham by car. I think there were two other people there, but I can't remember their names.

We produced small works and large works in the studio next to his house and sometimes down in the gardens where he had built other studios. I remember him once or twice bringing me into his little inner sanctum where he made his maquettes and asking me which one I would like to enlarge. The **Seated Woman** is one I chose from there. The sort of funny cut on her skirt, I wouldn't be surprised if it

came from a bit of coal – you know, that sort of mark you get in certain kinds of coalite. It was an unusual shape for Henry.

He would discuss his work in general terms – what sculpture was about, perhaps. I do remember him talking about the head, and the twist of the head being the most important aspect of a figure for him. I noticed that he would work on that as the crucial part of the figure. He would change the slight angle of the head or do something to the head and the neck to get the right angle, and I think it was particularly so in the piece which is like a sitting figure,[1] rather like **Seated Woman** but earlier, where the feet are dangling loose in space. It looks as though she is looking out at the side with a rather alert look.

I think the kind of sculptures that I worked on seemed to lie around in the studio for quite a while without being cast. Henry seemed unable to get rid of them, finish them or quite assimilate them. I don't know whether I put anything of my own in the work that was foreign to him. Certainly he worked a lot on the **Relief No.1** [cat.187] and it took him many, many years to complete. **Seated Woman** is perhaps less surprising as I chose it from a number of things he had on the studio shelves after he had asked me to do so. Both pieces were lying about for a long time and I wondered why he never cast them. Every time I went to see him I noticed it was my work that didn't get cast, everybody else's did!

Sometimes I patinated bronzes there but I don't remember colouring the plasters unless they came back from the foundry for siting in the gardens. He sometimes put plasters out in the grounds and then he would colour them, either to look like bronze or just to give them a bony look by putting a wash on them.

Henry looked at my own work about every six months. He asked me what I was up to and I would bring in my photographs. He would look and criticise in a positive way which I found useful. I think I got a lot out of it. Being in the landscape as well was interesting. I'd been a fairly urban person until then. I think being at Perry Green was my first contact with working in that kind of open air environment and I enjoyed it. When I did eventually get a studio in the

late 1960s out in Dunstable, which meant driving outside London, it was like going back to something I already knew. For many years I had worked indoors in a sort of studio set-up and that was my first experience of working out of doors, in that kind of setting.

Phillip King

1. **Woman** 1957-58 (LH 439).

185

Three Motives against Wall No.1 1958
LH 441
bronze edition of 12 + 1
cast: The Art Bronze Foundry, London
length 106.7cm
unsigned, unnumbered
Gift of the artist 1977

exhibitions: Budapest 1993 (cat.93); Bratislava/Prague 1993 (cat.93); Krakow/Warsaw 1995 (cat.85); Venice 1995 (cat.85)

This was one of a sequence Moore made of figures against walls while trying to work out how to place a sculpture before the intrusive fenestration of the Unesco building in Paris. Each of the sculpture's elements is related to the ideas he was exploring for this large, outdoor figure, although none of them was, in fact, used and Moore eventually fixed upon a conventional reclining figure. In this piece he was also experimenting with different bases for each of the figures. The technique of lining elements up to let them formally bounce off one another was quite a common technique in Moore's work – among early examples are **Four Forms** 1936 (LH 172) and the drawing **Mechanisms** [cat.95].

The middle figure of **Three Motives against Wall No.1** is closely related to the Lincoln Center piece (LH 519), and is based on a bone. The other figures also appear to have their origin in found objects, while the wall, too, has something of this status, bearing the imprint of wood grain. Each figure is a distinct but rough, half-formed or broken object, struggling as if with its incompleteness.

opposite: cat.184 exhibited in Wakefield, 1987

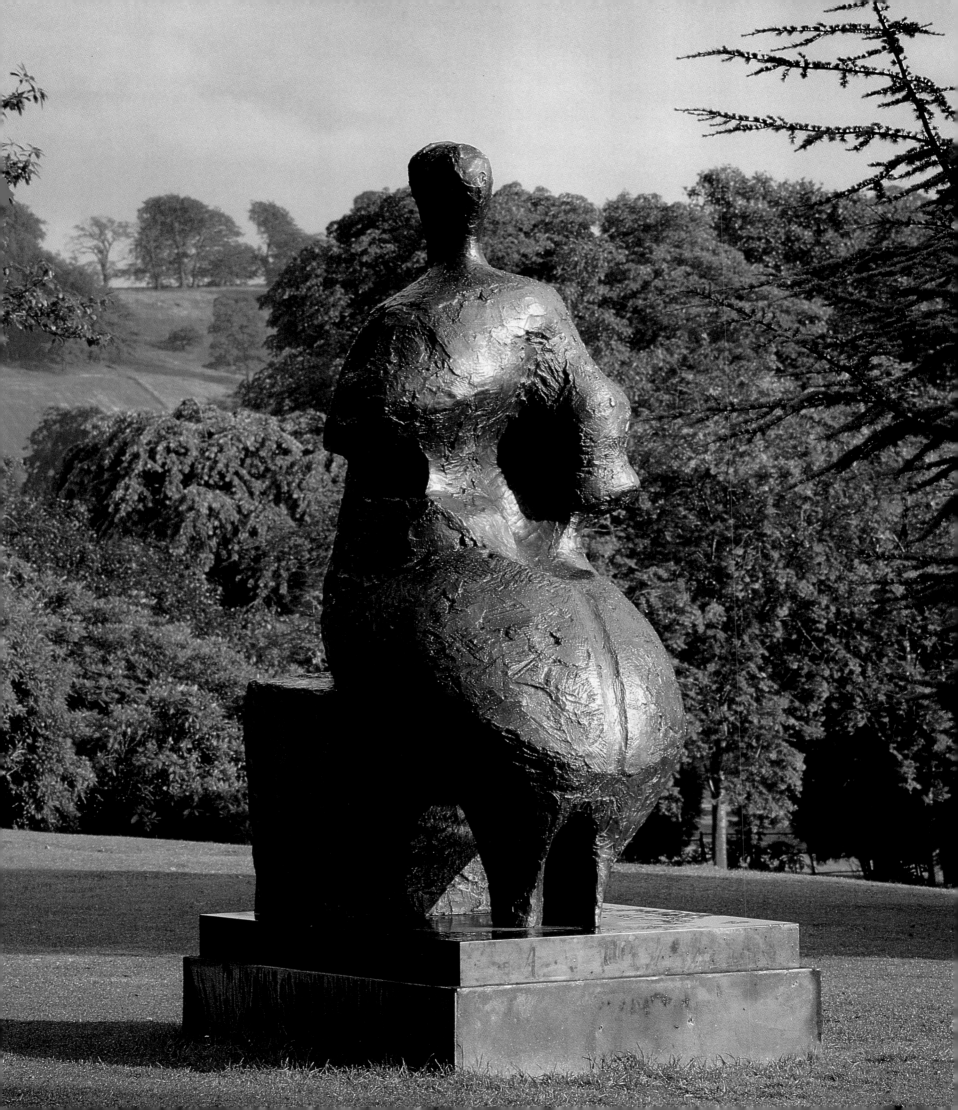

The motif of figures in architectural settings is seen in drawings of the 1930s in which the figures inhabit claustrophobic spaces – one example is **Ideas for Sculpture in a Setting** 1938 (HMF 1372).[1] The walls in those drawings have the same narrow slots as in this sculpture, though there they could represent openings rather than mere depressions. It was only in the late 1950s that these slotted walls began to appear in sculpture.

At first sight, it is peculiar that Moore was ready to place his thoroughly three-dimensional forms against a wall, forcing the viewer to see them from a restricted viewpoint. The specific difficulties of the Unesco commission were one consideration, but Moore's insistent concern in drawing and sculpture with figures in confined settings goes well beyond it. There are actually many works which could be described as deep pictures or shallow sculptures, which attempt to control the viewer's position by their largely frontal emphasis. These include the early masks, the reliefs of the 1950s, and the Upright Motives. Most of these sculptures have in common some relationship to architecture, meant to be displayed on walls, or seen in contrast to them. Moore remarked of **Relief No.1** [cat.187] that the relief form can be treated in a sculptural rather than a pictorial fashion, exploiting hollows and bumps to give three-dimensional interest from a single point of view.[2] Thus a hybrid, a free-standing relief, is created, and it may be that this is also the way to think of **Three Motives against Wall No.1**.

Julian Stallabrass

1. Wilkinson 1987, p.177.
2. James (ed.) 1966, p.275; 1992, p.294.

186

Three Motives against Wall No.2 1959
LH 442
bronze edition of 10 + 1
cast: The Art Bronze Foundry, London
length 107.3cm
unsigned, unnumbered
Gift of the artist 1977

exhibitions: New Delhi 1987 (cat.68); Havana/Bogotá/Buenos Aires/Montevideo/ Santiago de Chile 1997-98 (cat.69)
loans: Salford, University of Salford 1974-87

In this bronze, and its pendant **Three Motives against Wall No.1** 1958 [cat.185], Moore has arranged three sculptural forms in front of a rectangular, slotted wall. The idea was first developed in 1936 in, for example, **Drawing for Sculpture** (HMF 1255) showing six sculptural ideas lined up in front of a slotted, rectangular wall similar to the one in this 1959 bronze. The first appearance of the wall motif in sculpture was in **Maquette for Girl against Square Wall** 1957 (LH 424).

In **Three Motives against Wall No.1**, the earlier of the two versions, the three sculptural forms have much more obvious figurative references. In both bronzes, the three motives were undoubtedly based on flint stones, whose extraordinarily varied shapes were a constant source of inspiration during the last thirty years of Moore's working life. We know from a photograph of six stones in Moore's very large collection of natural forms that the central form in **Three Motives against Wall No.2** was directly based, with little alteration, on a bulbous flint stone. For many years it reminded me somewhat of the head of a hippopotamus, until a more perceptive young schoolboy gleefully exclaimed: 'Look Mummy, Snoopy from Peanuts.' As Anita Brookner observed in her novel *Look At Me*: 'Once a thing is known, it can never be unknown.'

Alan Wilkinson

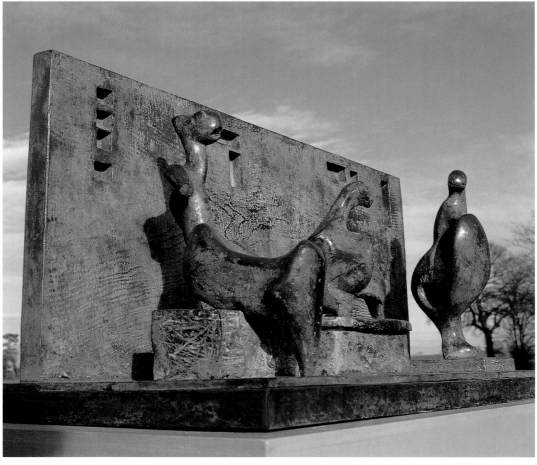

185

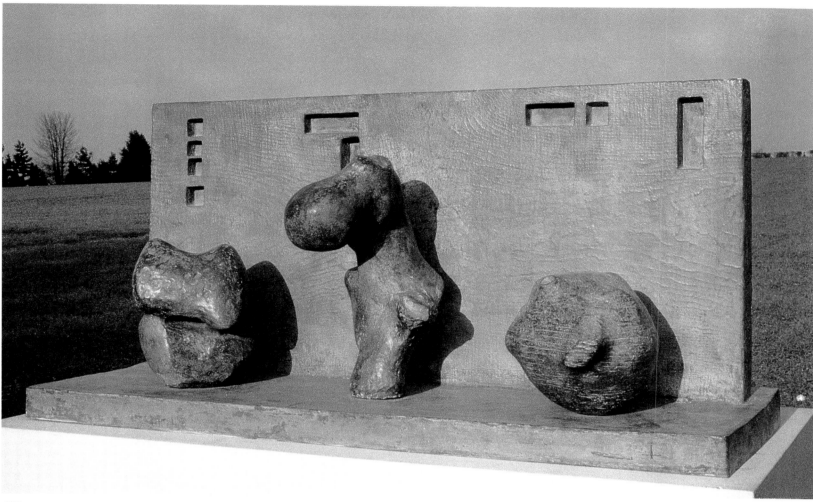

186

187
Relief No.1 1959
LH 450
bronze edition of 6 + 1
cast: Hermann Noack, Berlin
height 223.5cm·
signature: stamped *Moore* [6/6]
Gift of the artist 1977

exhibitions: Wakefield 1987 (cat.10); Paris
1992 (cat.5); Wakefield 1994-95 (cat.3)
loans: Wakefield, Bretton Country Park
from 1995

publications: Cohen 1993, pl.XXXV

By the time Moore completed this piece in
1959 he had already made three large-scale
relief sculptures. These works, **West Wind**
1928-29 (LH 58), the **Time-Life Screen**
1952-53 (LH 344) and the Bouwcentrum
Wall Relief 1955 (LH 375), in Rotterdam,

were all architectural in nature. **Relief No.1**
differed from these inasmuch as it was a
free-standing sculpture.

In 1962 Moore expressed his thoughts
on the importance of working in relief.
'Renaissance sculptors used relief
pictorially. They reduced depth almost
mathematically. They had the same use of
perspective as painters. For some time I've
thought one might use relief in its own way,
to exploit the projection and recession of
form and make it more powerful in relief
than in a realistic rendering of compressed
representation. To make the chest more
strong, to make it come out more, you send
it back underneath. You bring the hips out
more, and the umbilicus. One has made the
projections and recessions for their own
sakes rather than for a pictorial use of relief
. . . But then there's more than one way of
doing a relief. You can take the Renaissance
way, the way of Ghiberti or Donatello,

where you have a fundamentally pictorial
attitude, or you can use relief sculpture as a
form in itself – and that's what I've tried to
do.'[1]

Herbert Read wrote in 1965 that **Relief
No.1** was an enlargement of one of the
motifs in the maquettes for the Rotterdam
Wall Relief.[2] Later, Alan Wilkinson
surmised that Read was referring to a motif
in **Wall Relief: Maquette No.3** 1955 (LH
367), and noted the figure on the bottom
row, second from left which has a distinct
tripartite construction. Wilkinson went on
to suggest **Wall Relief: Maquette No.6**
1955 (LH 370) as yet another possible
source for **Relief No.1**, pointing out the
motif to the left of centre which is less
abstract and even more recognisably
related to the figure in **Relief No.1**.[3]

Moore seems to have liked this piece.
Writing in 1968, he compares it to **Relief
No.2** 1959 (LH 451) which remained in

259

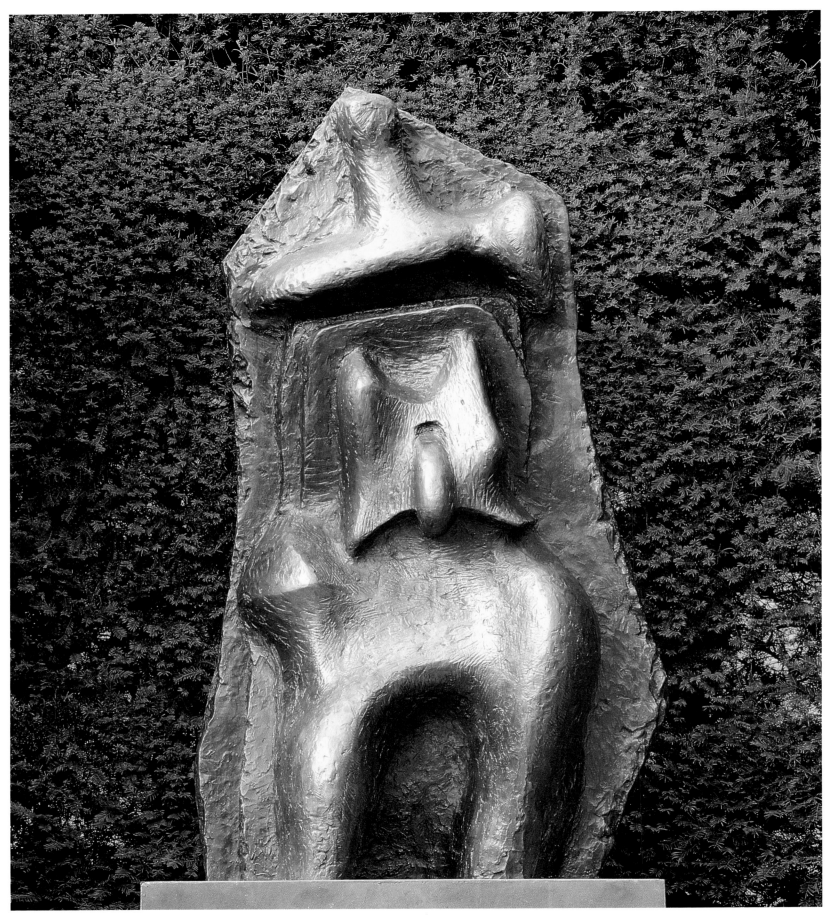

cat.187 exhibited in Wakefield, 1987

plaster since he was never satisfied with it enough to cast it into bronze. 'In the bronze sculpture **Relief No.1** you know the middle and you know where the shoulder is. It has a centre, a kernel, and an organic logic.'[4]

The piece has a commanding presence with three distinct sections, the head and shoulders, the torso, and the hips and limbs. Tension is created as the female figure appears to emerge section by section from its matrix only to be frozen in place. Whether poised to take a step forward or relaxed in a *contrapposto* position, the work is a peculiar mixture of grace and gusto that exemplifies Moore's desire to exploit the going in and the coming out, the projections and recessions to give the forms a bigger richness and bigger power.[5] The figure is broad, strong and determined. As John Russell notes, 'the human body seen as something robust as a rhino; with

something, in fact, of a rhino's armoured hide, and something of its power to trample and thrust when and where we least expect it.'[6]

Ultimately, however, it is Moore using the female figure, simplifying it, and stressing its most recognisable elements, the head and shoulders, the centre or the womb, and the legs. The work is sensuous and undulating as our eye discovers contour after contour, nook and cranny, and bumps and bulges that seem to all but bubble to the surface.

Deborah Emont-Scott

1. James (ed.) 1966, p.275, 277; 1992, p.294, 296.
2. Read 1965, p.223.
3. Wilkinson 1987, p.187.
4. Hedgecoe (ed.) 1968, p.391.
5. James (ed.) 1966, p.277; 1992, p.296.
6. Russell 1968, p.178; 1973, p.198.

188
Reclining Figure 1959-64
LH 452
elmwood
length 261.5cm
unsigned
Gift of Irina Moore 1977

exhibitions: Bradford 1978 (cat.3); London 1978 (cat.1); Winchester 1983; London (Tate)1984 (cat.103); London 1985 (p.2); Tokyo/Fukuoka 1986 (cat.5); Stuttgart 1987; Nantes 1996 (cat.79); Mannheim 1996-97 (cat.79)

At the end of the 1950s, Moore decided to resume his involvement with carving recumbent figures. Most of that decade had been taken up with monumental work in bronze, and only a few carved pieces of the period were executed in wood. Moore's

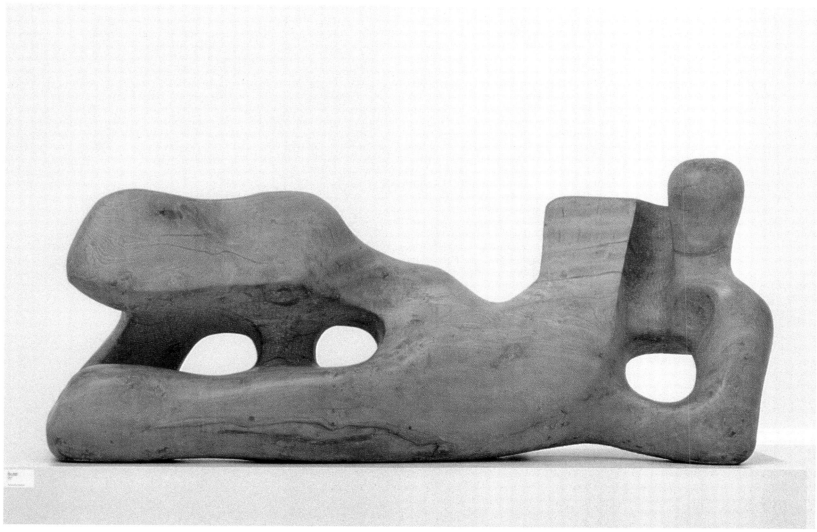

cat.188 exhibited in Nantes, 1996

decision in 1959 to tackle a large block of elm, supplied by the local timber merchant in Bishop's Stortford, indicated his desire to continue the great sequence of reclining female figures he had carved from the same material between 1936 and 1946.

He had no desire simply to ape his work of that previous period. Instead, the starting-point for this new carving was a maquette made in 1954. With the help of his assistant Isaac Witkin, who was responsible for most of the 'roughing out' on the sculpture, Moore set about turning his small yet potent model into one of his most grandly satisfying later carvings.

Unlike the earlier elmwood figures, this one took five years to complete. Part of the reason for such a prolonged gestation was technical: Moore later recalled that 'in the early stages there was a crack in the lower part of it which hadn't shown itself in the original tree trunk. I got somewhat disheartened when I found that this crack was getting bigger, and for a period I stopped working on it.' Luckily, however, the splitting did not worsen and he eventually took the carving up again. In the end, he concluded that 'the sculpture gained by having a slow evolution.'[1]

This can certainly be ranked among his most complex achievements, coupling stateliness with the capacity to surprise. The figure's legs, one raised high above the other and yet echoing its horizontal thrust, have some kinship with Moore's handling of the lower limbs in his **Reclining Figure** 1945-46 (LH 263). They are far less smoothly finished, however, and reflect the sculptor's apprehension of bony, tensile strength. This preoccupation with hardness reaches its most provocative point where the body rises towards the right shoulder. Instead of honouring anatomical expectations, as he does in the left arm, Moore presents us with an expanse of square, blunt wood.

It is a defiant form, brazenly manifesting the sculptor's right to flout corporeal propriety whenever he wishes. As bare and awesome as a cliff-face, it intensifies the figure's toughness and suggests that she is set to endure. It also contrasts with the nobly rounded left arm, where Moore allows himself to carve the most sensual part of the entire sculpture.

A similar duality informs his approach to the head. Viewed from the front, the woman appears to be a blank. Devoid of facial features, she is anonymous and lacking in any specific female characteristics. Seen from the side, though, her impersonality drops away. For Moore has allowed himself to make her hair billow outwards, transforming her into a far more alluring presence. As if to accentuate his engagement with this luxuriant mane, the chisel-marks are left here in a loose and broken state. They heighten the tactile sensuality of a proud figure who, more than any of his recumbent women, appears to revel in her own physical magnificence.

Richard Cork

1. Levine 1983, p.134.

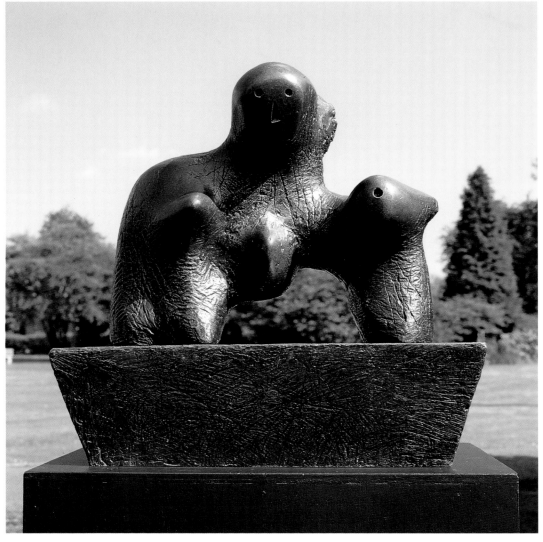

189

189
Mother and Child: Arch 1959
LH 453a
bronze edition of 6 + 1
cast: The Art Bronze Foundry, London 1967
length 49.5cm
signature: stamped *Moore*, *0/6*
Gift of the artist 1977

exhibitions: Madrid 1981 (cat.168); Lisbon 1981 (cat.148); Sunderland 1982-83 (cat.1); Folkestone 1983 (cat.1); Marl 1984 (cat.4); Hempstead/University Park/Philadelphia/ Baltimore 1987-88 (pl.42); Cologne/Kreis Unna/Norden/Ratzeburg/Huddersfield 1992 (cat.5); Chiswell/Chichester/Wighton 1993 (cat.1); Scarborough/Aldeburgh/Stromness/ Canterbury 1994 (cat.1)

By the mid 1950s, Moore was no longer using drawings to visualise his ideas for sculpture, but had turned to creating plaster maquettes as a preliminary model. Many of these works were derived from shells, bones or stones that he had collected. **Mother and Child: Arch** was inspired by a found stone,[1] but Moore did not just copy rocks or stones or flints; he allowed the natural forms to evolve into a sculpture. He has written that he found the sources for his forms in the simplicity of the primitive ritual or natural object. His forms are reminiscent of those that Neolithic man created when he found the image of a bison in a stone. 'Eventually I found', wrote Moore, 'that form and space are one and the same thing. You can't understand space without understanding form.'[2]

Moore also explored the use of the hole, cave or arch-like shapes. The hole became as important as the solid negative spaces which define the positive forms. The holes made the space into a three-dimensional form. 'For me the hole', stated Moore 'is the penetration through from the front of the block to the back. This was for me a revelation, a great mental effort. It was having the idea to do it that was difficult, and not the physical effort'.[3] The sculpture gained a life and vitality of its own. He created a pushing and pulling effect within the form so that it seemed as if the form had grown from within. These pushing forces maintained an internal organic rhythm. By studying nature, Moore created forms which have a vital rhythm, sympathetic to trees, flowers or a stream. In his work, he has gone beneath the flesh to the bones, beneath the bark to the essence of the tree. The external space pushes while the internal force breaks out. The exterior reveals the possibilities from within and seeks to strike a harmonic balance between the two forces.

Gail Gelburd

1. Wilkinson 1987, p.190.
2. Mitchinson (ed.) 1981, p.112.
3. Columbus/Austin/Salt Lake City/Portland/San Francisco 1984-85, p.38.

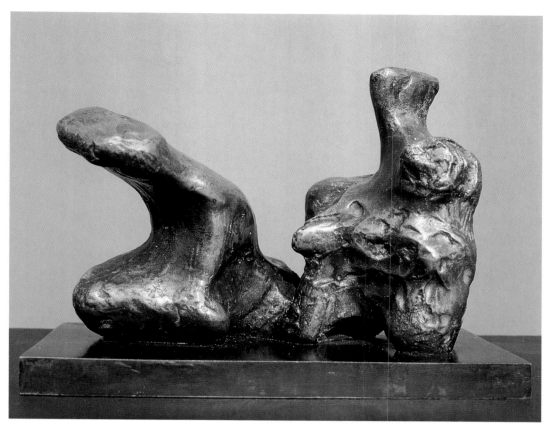

190

190
Maquette for Two Piece Reclining Figure No.1 1959
LH 457a
bronze edition of 7 + 3
cast: Hermann Noack, Berlin 1974
length 16cm
signature: stamped *Moore, 00/7*
Acquired 1987

exhibitions: New Delhi 1987 (cat.70); Milan 1989-90 (p.38); Coventry/Huddersfield/Wrexham/Bristol/Eastbourne/Exeter/Sterling 1990-91 (cat.27); Sydney 1992 (cat.110); Budapest 1993 (cat.94); Bratislava/Prague 1993 (cat.94); Pforzheim/Bad Homburg 1994 (cat.1); Krakow/Warsaw 1995 (cat.86); Venice 1995 (cat.86)

191
Two Piece Reclining Figure No.2 1960
LH 458
bronze edition of 7 + 1
cast: Hermann Noack, Berlin
length 259cm
signature: stamped *Moore, 0/7*
Gift of the artist 1977

exhibitions: Bradford 1978 (cat.11); Wakefield 1987 (cat.11); New Delhi 1987 (cat.71); London 1988 (cat.178, not cast from Tate Gallery as published); Martigny 1989 (cat.pp.192,193); Milan 1989-90 (pp.40,41); Paris 1992 (cat.6); Wakefield 1994-95 (cat.2)
loans: Cambridge, Churchill College 1979-87; Wakefield, Bretton Country Park from 1995

publications: Cohen 1993, pls.XXXIII, XXXIV

By numbering these reclining figures, Moore himself uncovered a remarkable relationship. **Two Piece Reclining Figure No.1** 1959 (LH 457) and the bronze we see here appear as two sisters from a race of

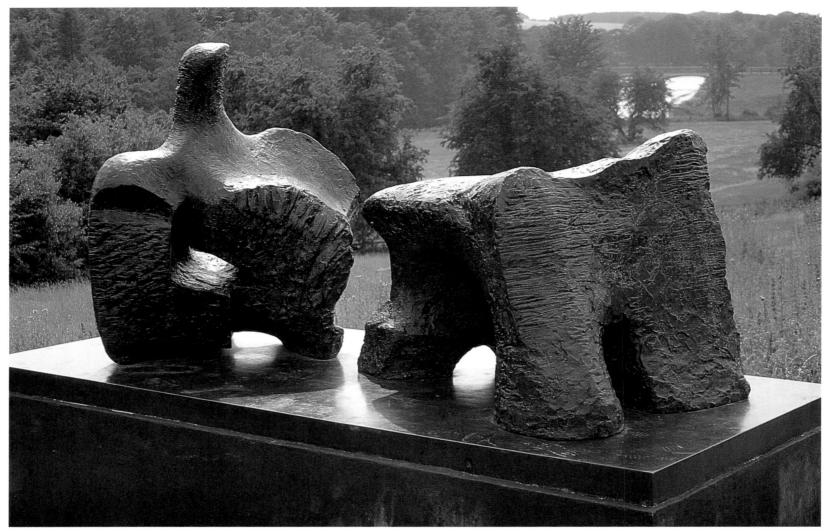

cat.191 exhibited in Wakefield, 1994-95, on loan from 1996

giants. That they are both in two pieces and larger than life is indicative of their family likeness. Yet, in terms of character – as is often the case among siblings – they are completely different. The first, taller, sister has, on the whole, a 'human' quality. The second sister, further engrained into the horizontal, appears to be more attached to the elements, particularly stone and the landscape.

Moore said that he came across the idea of a sculpture in two pieces in his first version rather by accident. 'But after I'd done it, then the second one became a conscious idea. I realised what an advantage a separated two-piece composition could have in relating figures to landscape. Knees and breasts are mountains. Once these parts become separated you don't expect it to be a

naturalistic figure; therefore you can justifiably make it like a landscape or a rock. If it is a single figure, you can guess what it's going to be like. If it is in two pieces, there's a bigger surprise, you have more unexpected views; therefore the special advantage over painting – of having the possibility of many different views – is more fully exploited.'[1]

At 259 centimetres, **Two Piece Reclining Figure No.2** is clearly longer than its predecessor at 193 centimetres dating from 1959. Moore separated the two parts and drew them more in line with the horizontal. The figurative parts still dominant in No.1 were withdrawn. They now appear as if submerged in the coarse elementarism of 'rocks' and 'cliffs' on which Moore clearly depended. In it, he was able fully to exploit the traits of the sculpture,

'the possibility of many different views'. Nevertheless, the sculptor was aided in this by a known painting, namely his recollection of Monet's *Cliff at Etretat* dated 1883: 'I kept thinking of this arch as if it was coming out of the sea'.[2] Thus, we see the *raised* arch motif of the Etretat rock on the one hand and the moving motif of the 'coming out of the sea' on the other hand which he wanted specifically to introduce into the landscaping of this sculpture. In their attempt at limitation and analogy, both pieces hark back to the legacy of romanticism which lives on in Moore's work with particular vitality.

Christa Lichtenstern

1. James (ed.) 1966, p.266; 1992, p.285.
2. Hedgecoe (ed.) 1968, p.325.

I feel personally about the sculptures when I see them nowadays. I remember working on them very well. The plaster of this one was at the British Sculpture Exhibition at the Jeu de Paume in 1996.[1] I was surprised to see it there and I remembered working on it. Some of the texture I remember doing. Henry seemed to encourage you to go quite a long way towards the finish in many ways, although there was a sort of unspoken rule that you were only supposed to go two inches below the surface and he would finish the last two inches. But of course it never worked out like that because you can't really do it that way. When you're doing a measurement you're measuring from the model so you have to go almost to the limit. Well, I found it difficult to imagine it without doing that. So you would more or less finish the work and then Henry would come in, after hours (I think I'd finish about four thirty) and he'd work in the evening. In the morning you'd come in and see something altered. But very often he wouldn't do anything until right at the end when you'd finished enlarging it.

I remember him working on pieces that had been made by other people who were there before me. He must have liked to work with an axe or a sort of rather heavy-bladed knife of some sort. You could see the hack marks of the instrument, and a depression would suddenly make a lot of sense. He would sort of cut into something and bring something out as a result. That was a discovery for me, that he didn't work on the outer surface of the form. He liked to talk about sculpture being like a closed fist, and your knuckles push out and so forms push out. So one would imagine he would work on the bits which were pushed out, but he actually managed somehow to work on the indentations to give a three-dimensional quality to the work by working around it rather than directly on it. That I remember noticing. It was a very good experience for me. Henry worked at the models very carefully and of course sometimes he went through a series of enlargements so he would work on two or three different scales. But not on any of the pieces I worked on. They went straight from maquette to enlargement. I learnt a lot

about scale, then suddenly I was confronted with having to do large plasters and the techniques of enlarging were new to me. It gave me a lot of confidence about working on a larger scale. I found it exciting. I didn't really notice the importance of landscape to Moore when I was there nor that he was suddenly increasing his sculptures in size. Of course there was another jump in scale quite a bit later on, where the pieces became really enormous, like **Sheep Piece** 1971-72 [cat.230]. I think when he started working in polystyrene the figures got larger. The way I was working was really enlarging with fairly traditional techniques in plaster. We worked usually with wire mesh, but at one point we stopped using it because if you cut up a work in the foundry you don't want wire mesh. I think I worked on **Two Piece Reclining Figure** for a while, and built up the form out of that. Obviously you don't want to make it too heavy either, so it was a question of bulking out in any way you could using quite a lot of scrim and plaster, and things like bits of wood. You would put a bit of wood sticking out in the right point according to the enlargement you were doing and then you'd build up to that point. Then as you built up the form, when you got towards the end, you'd have to provide the texture, as it were.

Henry was a very good boss, he never interfered very much. He was always friendly and jolly, let you get on with it. He would never comment in a negative way about what you'd been doing, well he never did to me at any rate. He was always very pleased at what you'd been doing.

Phillip King

1. Now in the collection of the Art Gallery of Ontario, Toronto.

192
Working Model for Seated Woman with Arms Outstretched 1984
LH 463a
bronze edition of 9 + 1
cast: Fiorini, London
height 61cm
signature: stamped *Moore, 0/9*
Acquired 1986

exhibitions: Manchester 1987 (cat.2); Chandigarh/Bombay/Baroda/Bhopal/ Madras/Bangalore/Calcutta/Jaipur 1987-88 (cat.1); Budapest 1993 (cat.95); Bratislava/ Prague 1993 (cat.95); Pforzheim/ Bad Homburg 1994 (cat.3); Krakow/Warsaw 1995 (cat.88); Venice 1995 (cat.88)

'You see, I think a sculptor is a person who is interested in the shape of things. A poet is somebody who is interested in words; a musician is someone who is interested in or obsessed by sounds. But a sculptor is a person obsessed with the form and the shape of things, and it's not just the shape of any one thing, but the shape of anything and everything.'[1]

This exuberant figure has its origins in a flint stone and was originally conceived as a maquette in 1960. It was frequent practice for Moore to take a flint and incorporate it in a plaster as the basis for a figure. The arms, hip and leg section of this sculpture are all formed from one flint stone and the head has been added and interpreted to give the sculpture its final female form. Moore said: 'Heads are the most expressive part of a human being',[2] and certainly in adding a head to this flint he has succeeding in interpreting an organic form and translating it into a human form with the minimum of alteration. The figure rests gently on her buttocks and has a lively and energetic feeling about her.

In this work the smooth areas on the surface accentuate the parts of the body such as the shoulders, breasts, elbows and knees, whereas the areas with a rougher surface represent the softer forms where, in a draped figure, there might be folds of drapery. This figure always strikes me as being related to the draped figures and to be the most extreme form of minimalism in drapery that Moore achieved.

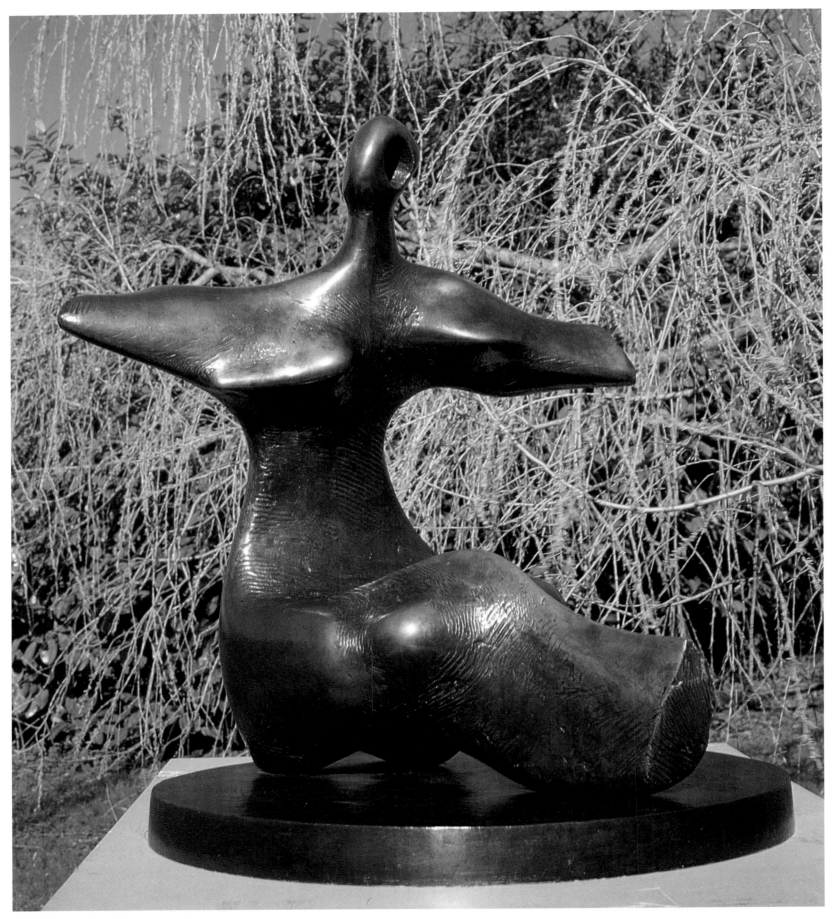

192

The working model was cast in 1983 in bronze, and work was under way at the time of Moore's death to enlarge this sculpture to a monumental scale. Unfortunately it was not completed and exists only as a half-finished enlargement in the studios at Perry Green.

There are only a small number of sculptures by Moore placed on a round base, something he did during the 1960s [see cat.219], but it certainly serves in this case to accentuate the three-dimensionality of the figure. As a result the sculpture has no 'front' and can be successfully sited and viewed from almost any angle.

Julie Summers

1. Quoted in Warren Forma, *Five British Sculptors: Work and Talk*, Grossmann, New York 1964, p.59.
2. New York 1979-80, p.65.

193

Helmet Head No.3 1960
LH 467
bronze edition of 14
cast: The Art Bronze Foundry, London
height 29.5cm
unsigned, [11/14]
Gift of the artist 1977

exhibitions: Bradford 1978 (cat.77); Madrid 1981 (cat.180); Lisbon 1981 (cat.208); Mexico City 1982-83 (cat.77); Caracas 1983 (cat.E32); Johannesburg/Pretoria/Johannesburg (second venue)/Durban/Bloemfontain/Kimberley/Pietermaritzburg/Port Elizabeth/Cape Town 1984-85 (cat.40); New Delhi 1987 (cat.74); Bilbao 1990 (p.101); Sydney 1992 (cat.112); Buenos Aires/Rosario/Mar del Plata/Córdoba/Montevideo 1996
loans: Birmingham, City Art Gallery 1986

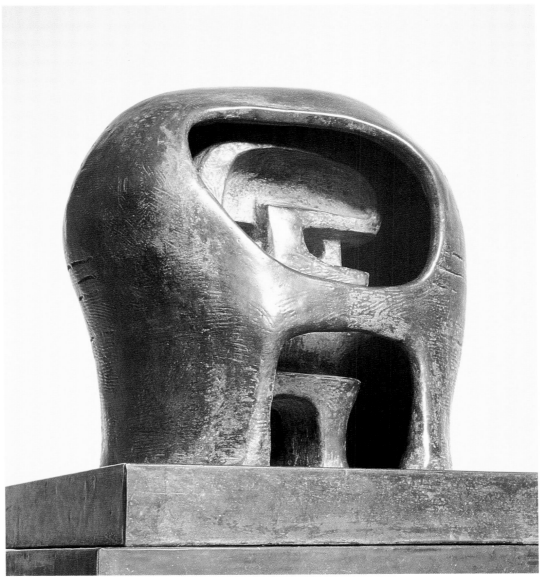

193

194

Large Standing Figure: Knife Edge
1976
LH 482a
bronze edition of 6 + 2
cast: Hermann Noack, Berlin
height 358cm
signature: stamped *Moore, 0/6*
Acquired 1986

exhibitions: Hong Kong 1986 (cat.141); Tokyo/Fukuoka 1986 (cat.11); London (not Stuttgart) 1987 (cat.208); Wakefield 1987 (cat.15); New Delhi 1987 (cat.75); Milan 1989-90 (p.42,43); Paris 1992 (cat.7); Pforzheim/Bad Homburg 1994 (cat.5); Bellinzona/Naples/Bologna 1995-96 (cat.1)

loans: London, Guildhall 1993

publications: Cohen 1993, pls.XXX, XXXI

Henry Moore once described **Standing Figure: Knife Edge** as a means 'to direct the viewer to experience'.[1] At a time when Modernism was demanding the now familiar elevation of formal experiment over direct and powerful communication, Moore created a literally and spiritually uplifting piece using the impact of personal and shared experience from the eternal shapes of our natural world.

The form is in fact a bird's breast bone implanted in a wedge of clay with small additions to create a figure. At one time

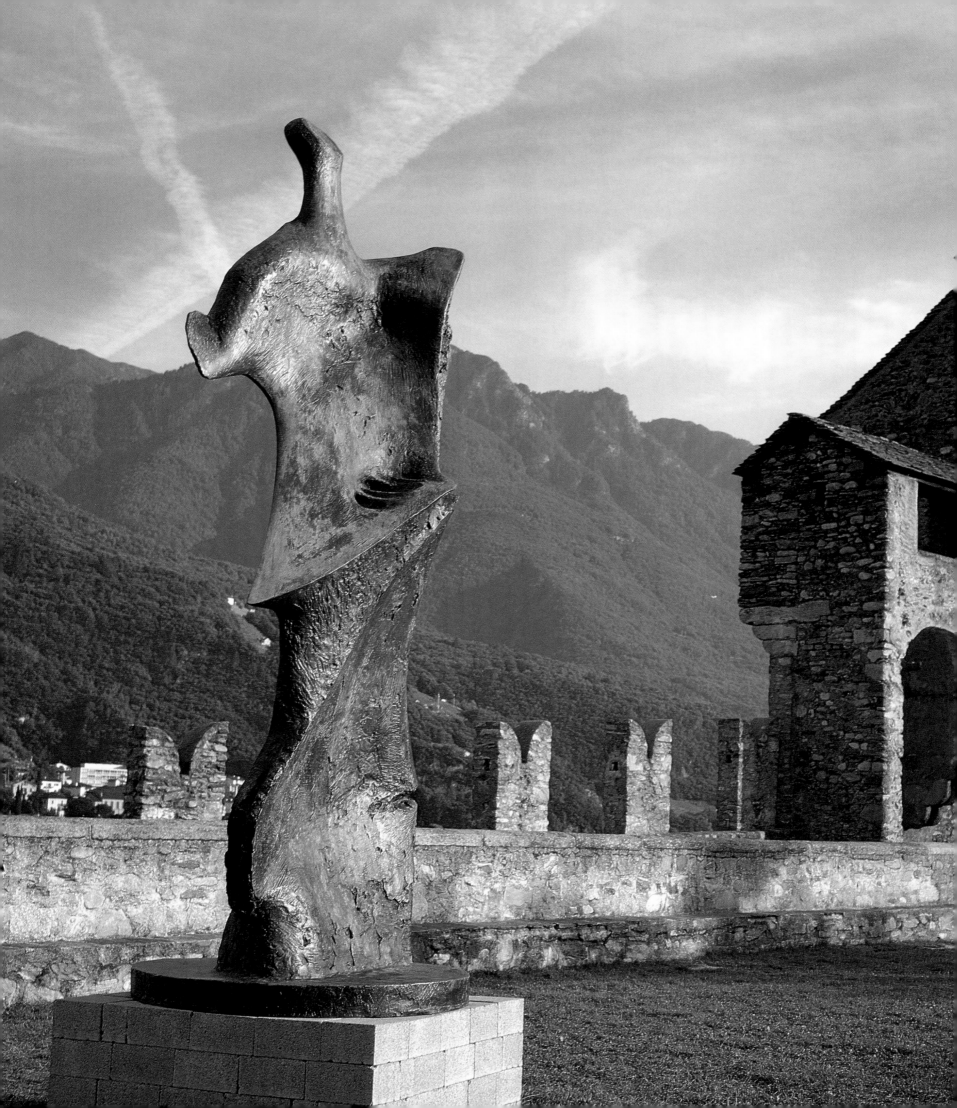

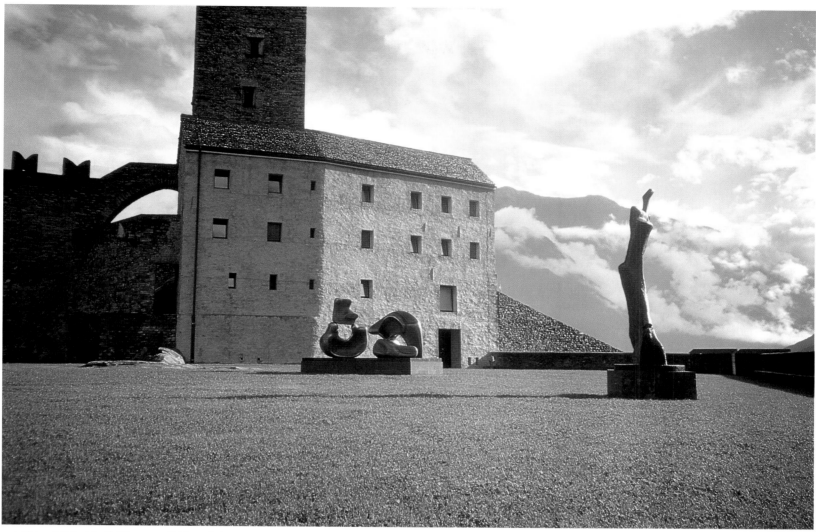

cat.194 exhibited in Bellinzona, 1995, with **Large Four Piece Reclining Figure** 1972-73 [cat.231]

named 'Winged Figure', the sculpture has an ethereal feeling of weightlessness and soaring verticality through the associated lightweight strength of the bone. A cut in the lower part of the sculpture indicates the join of bone and clay, but from side view the cut seems to attempt to release the figure from the base that grounds it. The spiritual quality is heightened in combination with the totemic quality, and the image of a berobed figure. It recalls the Louvre's *Nike of Samothrace* or a biblical angel, so tapping into the viewer's experience of spiritual energy through religion, the wonders of nature and indeed, sculpture. Calling upon his own understanding of man in this capacity, Moore has also imparted great humanism, for by being rooted as it is to the earth, both literally and metaphorically, the figure

exudes unwavering confidence in man's potential for goodness and greatness. It is this quality that made the piece so apt as a memorial to W.B. Yeats erected in 1967, prompting many equations with the great poet's character that could not possibly have been intended by the sculptor in 1961. Of course the experience upon which Moore draws first and foremost, and of which he is master, is that of form.

Moore loved the changing aspect of **Standing Figure: Knife Edge** as he walked around it, and it is this activity of looking that begins to reveal the multi-faceted identity of the anonymous figure. Contrasting with the knife-edge sharpness, the front plane opens out into comparative earthly solidity before dissolving once again. Susan Compton noted that the figure may have been inspired by Edward

Sackville-West's epic poem *The Rescue* that Moore illustrated in 1945.[2] The hero is Phemius, a Homeric character described in the preamble as possessing 'something of a mysterious timelessness, the knife edge balance between being and not being, which only the poetic imagination seems able to achieve'.[3] How aptly this describes the powerful impact upon the viewer created through Moore's deep understanding of the articulation of form.

Clare Hillman

1. Pforzheim/Bad Homburg 1994, p.51.
2. London 1988, p.260-1.
3. Edward Sackville-West, *The Rescue*, Secker and Warburg, London 1945, p.13. It is worth noting that Phemius' closing speech also approaches the essence of **Standing Figure: Knife Edge**.

opposite: cat.194 exhibited in Bellinzona, 1995

195

196

195
Two Reclining Figures 1961
Page from Sketchbook 1961-62
HMF 3029
pencil, wax crayon, pastel, felt-tipped pen,
chalk, watercolour wash on cream
medium-weight wove
292 × 242mm
signature: pen and ink l.r. *Moore/61*
Gift of the artist 1977

exhibitions: Toronto/Iwaki-Shi/Kanazawa/
Kumamoto/Tokyo/London 1977-78
(cat.228); Bonn/Ludwigshafen 1979-80
(cat.53); London 1988 (cat.176); Sydney
1992 (cat.115); Budapest 1993 (cat.96);
Bratislava/Prague 1993 (cat.96); Nantes
1996 (cat.77); Mannheim 1996-97 (cat.77)

196
Square Reclining Forms 1961
Page from Sketchbook 1961-62
HMF 3039
pencil, crayon, watercolour, wash, ballpoint
pen, pen and ink, with felt-tipped pen bled
through from verso on cream medium-
weight wove
292 × 242mm
signature: pen and ink l.r. *Moore/61*
inscription: pencil top of page *Square
reclining figures*
Gift of the artist 1977

197
Two Reclining Figures 1961
Page from Sketchbook 1961-62
HMF 3052
pencil, crayon, watercolour, wash,
charcoal, felt-tipped pen on cream
medium-weight wove
292 × 242mm
signature: felt-tipped pen l.r. *Moore/61*
Gift of the artist 1977

exhibitions: Sydney 1992 (cat.116)

publications: Garrould, Power 1988, p.58

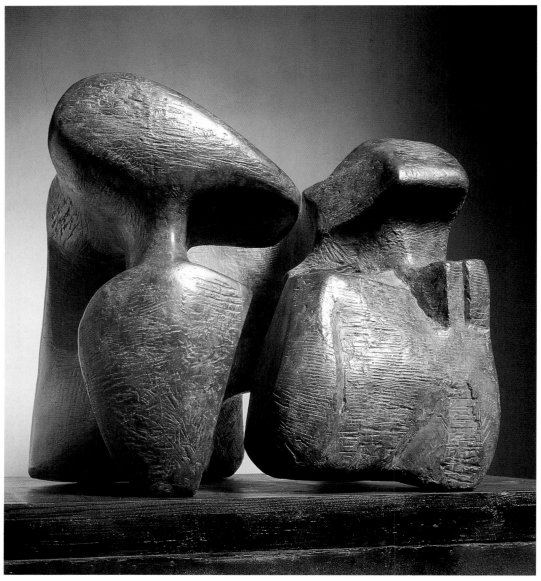

198

his earliest work, even as a student.

So too with the forms which, though quite abstract, remain still highly suggestive of the human form – shoulders as it were arched back upon the arms: a thrust here of what might just be a head or neck: here the weighty lift of a thigh or the cross of a knee. In this again the piece stands for so much else in the oeuvre, from first to last, for no matter what the particular interest might be at any given moment, or flirtation with purely abstract or formal considerations, Moore's work is never entirely remote from a human, or at least a humanising reference.

Yet it is emphatically an abstract work, anticipating the interest that was to be more fully explored in other pieces, in the twist and conjunction of a joint, perhaps, whether mechanical or physical, or the interlocking intricacies of a Chinese puzzle.

It is not a huge piece but is, rather, a perfect example of Moore's own dictum, that a true sculpture establishes its own scale, and may register in the imagination at any scale whatsoever. In this it calls to mind the practice he developed before the war at his studio in Kent, when by raising a work against the sky, all things became possible. Others may be larger and heavier, but there is no work of Moore's that is more truly massive and, in its essential self, more monumental.

William Packer

198
Working Model for Stone Memorial
1971
LH 491a
bronze edition of 9 + 1
cast: Fiorini, London
length 61cm
unsigned, [0/9]
Transferred from the Henry Moore Trust
1978

exhibitions: Bonn/Ludwigshafen 1979-80 (cat.7); Madrid 1981 (cat.93); Lisbon 1981 (cat.136); Barcelona 1981-82 (cat.63); Mexico City 1982-83 (cat.66); Caracas 1983 (cat.E133); Honolulu 1983; Hong Kong 1986 (cat.146); Tokyo/Fukuoka 1986 (cat.102);

New Delhi 1987 (cat.76); Milan 1989-90 (p.44); Pforzheim/Bad Homburg 1994 (cat.6); Krakow/Warsaw 1995 (cat.91); Venice 1995 (cat.91)

This nominally working model clearly stands as an autonomous and authentic work of art in its own right; and it brings together a complex of responses, almost as though it were a compendium or digest of Moore's work as a whole. Cast in bronze, it is yet a monument to his practice as a carver, with the gougings and hatchings of the rasp upon the raw plaster clear in evidence of the processes by which the form and image were realised. It is a character of surface that takes us back to

199
Large Slow Form 1968
LH 502a
bronze edition of 9 + 1
cast: The Art Bronze Foundry, London
length 76.8cm
signature: stamped *Moore, 0/9*
Gift of the artist 1977

exhibitions: Bradford 1978 (cat.33); Madrid 1981 (cat.92); Lisbon 1981 (cat.137); Barcelona 1981-82 (cat.64); Mexico City 1982-83 (cat.67); Caracas 1983 (cat.E134); Honolulu 1983; Hong Kong 1986 (cat.147); Tokyo/Fukuoka 1986 (cat.101); Chandigarh/Bombay/Baroda/Bhopal/ Madras/Bangalore/Calcutta/Jaipur 1987-88

(cat.2); Martigny 1989 (cat.p.200); Havana/
Bogotá/Buenos Aires/Montevideo/Santiago
de Chile 1997-98 (cat.73)

When I saw this piece in the Tate for the
first time, some time in the late 1970s, I got
a surprise: it didn't look like a Henry Moore.
I thought it was a marvellous piece. It's
untypical. I remember when I was there
Henry saying after he had made a small
piece, 'This one doesn't look like a Moore.'
Well, **Large Slow Form** is not immediately
recognisable as a Moore either. In this case
it's because he seems to have gone away
from using flints, stones or bones as a
starting point, but has invented his own
forms. And it has such unity, it feels like a
carving: it has that strength and weight.

I used to think that the difficulties I had
appreciating some of Moore's works were
the natural criticism a 'son' would have of a
'father' (because Henry was my father in
sculpture). But now I don't think that's
entirely the case. The problem in Moore's
work stems I think from its very
accessibility. Henry's sculptures are fairly
available. They aren't hard to reach, like
say Cubist paintings: they never offend the
eye. Henry's sculpture looks the way people
think modern sculpture should look. In one
way that's a great thing because they stand
in public places very well, and by doing that
they bring modern art into everyone's lives.
And some of the large public pieces are just
wonderful, for example the **Knife Edge
Two Piece** [cat.204] outside the Houses of
Parliament, a marvellous sculpture. But the
very fact of their general acceptance and
availability gives rise to doubts among
people in art, makes art people say perhaps
he's not so good after all. I don't think that's
right. On the other hand I don't think that
uncritical praise is right either and Henry
had a lot of that towards the end of his life,
which wasn't good for him or his work.
Nevertheless when Henry makes a work
like **Large Slow Form** it gives you a jolt; it
knocks your expectations awry. This work
confirms how good a sculptor he could be.
You can't box him into a corner. A piece
like the **Large Slow Form** defeats your
expectations.

Anthony Caro

200
The Arch 1969
LH 503b
bronze edition of 3 + 1
cast: Hermann Noack, Berlin
height 610cm
signature: stamped *Moore, 0/3*
Acquired 1989

Various versions of this massive sculpture
exist, made from fibreglass, bronze and
travertine marble. My preference is for the
original, full-scale fibreglass piece which I
saw in a field adjacent to Moore's studio.
First impressions are always the most
enduring, but I also remember it in
Florence where it dominated the view of
the city from the ramparts of the Forte di
Belvedere. Every day young couples would
pose for their wedding photographs in the
shelter of this gigantic sculpture.

In bronze it brings out the toughness of
Moore's vision when working on such a
large scale. For many years he had invited
the spectator's eye to enter and see through
his work. Now he could achieve a scale that
made a walk-through experience entirely
possible. Can you imagine yourself driving
through a sculptured Channel tunnel
linking the cultures of Britain and France?

The original full-scale bronze was
chosen by the architect I.M. Pei to stand
outside the library he was designing for
Columbus, Indiana. It was an imaginative
combination of technological building and
organic art, and of the spirit of modernity
with the forms of the eternal. To celebrate
the Millennium I would like to see an even
larger version of this awe-inspiring
sculpture spanning The Mall in London,
halfway between Admiralty Arch and
Buckingham Palace. It would give the
architect of La Grande Arche at La Défense
in Paris something to think about.

John Read

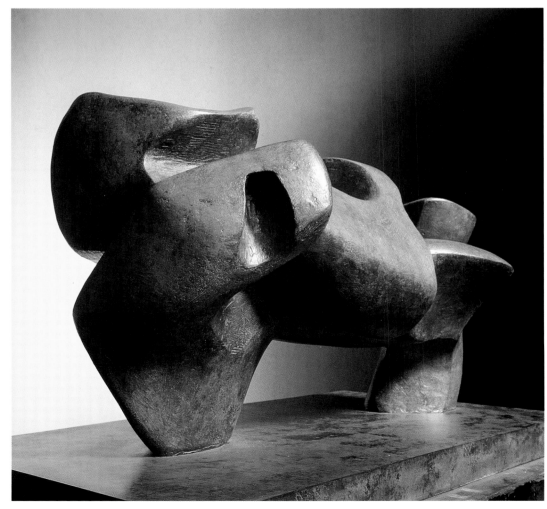

199

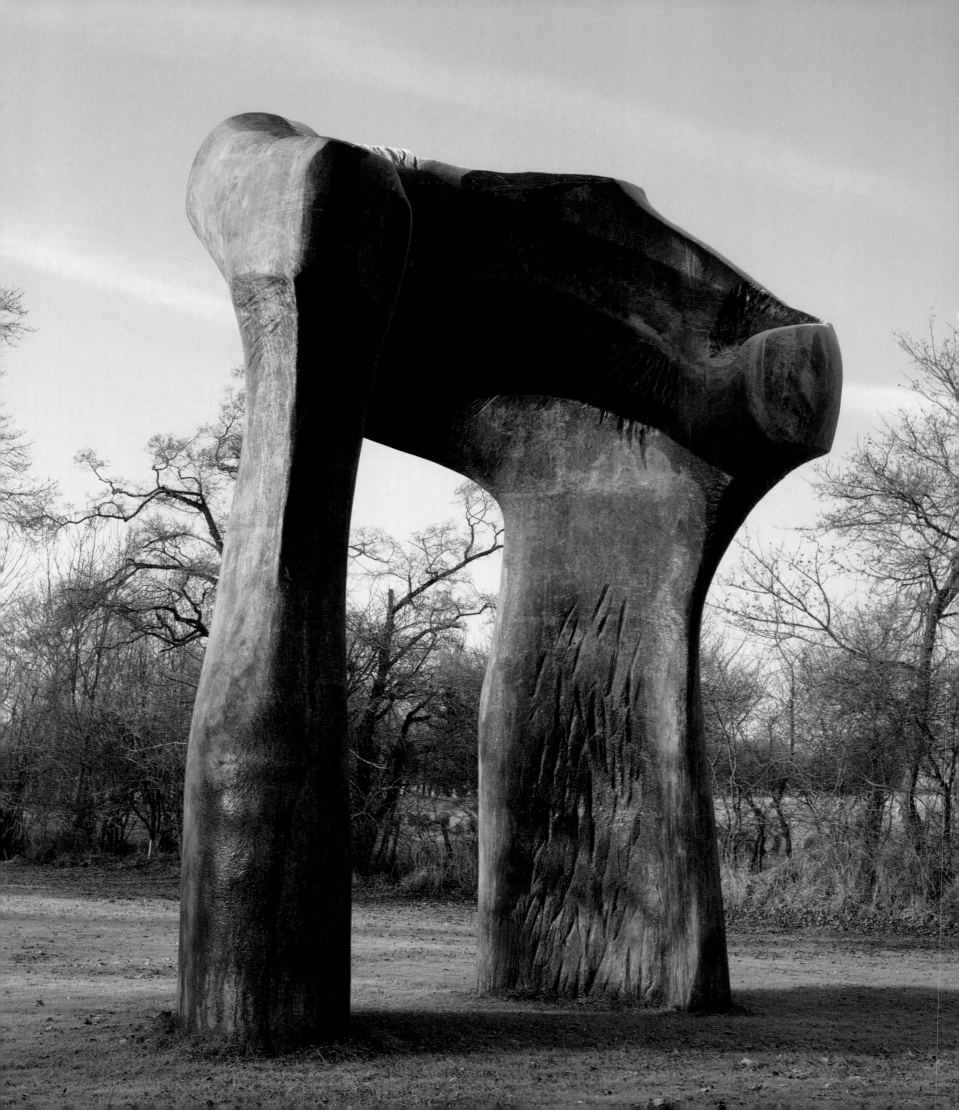

201

Divided Head 1963
LH 506
bronze edition of 9 + 1
cast: Fiorini, London
height 35cm
signature: stamped *Moore, 0/9*
Acquired 1987

exhibitions: Bilbao 1990 (p.103); Sydney 1992 (cat.122); Krakow/Warsaw 1995 (cat.96); Venice 1995 (cat.96); Buenos Aires/Rosario/Mar del Plata/Córdoba/Montevideo 1996

In most other Moore heads (the figure in a shelter sculptures and the helmet heads) two formally distinct elements take on different roles, one protecting or sheltering the other. In psychological terms it is tempting to read these pieces as illustrating the contrast between various dualities – body and mind, conscious and unconscious, mechanical and organic. Here, however, the head is split so as to give a more equal relationship between the parts, which are in any case joined at the neck. The image of the divided head is derived from Cubism, where it quickly passed from being a formal device to gaining psychological import. As in sculptures by Lipchitz, for example, and as in Moore's **Moon Head** 1964 (LH 521) [see cat.205], when the sculpture is turned the viewer gains a different impression of the unity or disunity of the parts, suggesting that identity and mental coherence is a matter of perspective, of a particular view at a particular time.

In an interview given to the London *News Chronicle*, Moore described a change in the way that he opened up the sculpture, so that where previously the focus had been on the shape of the opening hole, later 'I have attempted to make the forms and the spaces between them inseparable, neither being more important than the other, and this is why one sometimes distorts the forms of objects to make the spaces between the forms a more considered element.'[1]

Divided Head is a sculpture of the 1960s but its concerns date from the 1930s or even earlier. Like Renoir or Monet, artists associated with Impressionism but

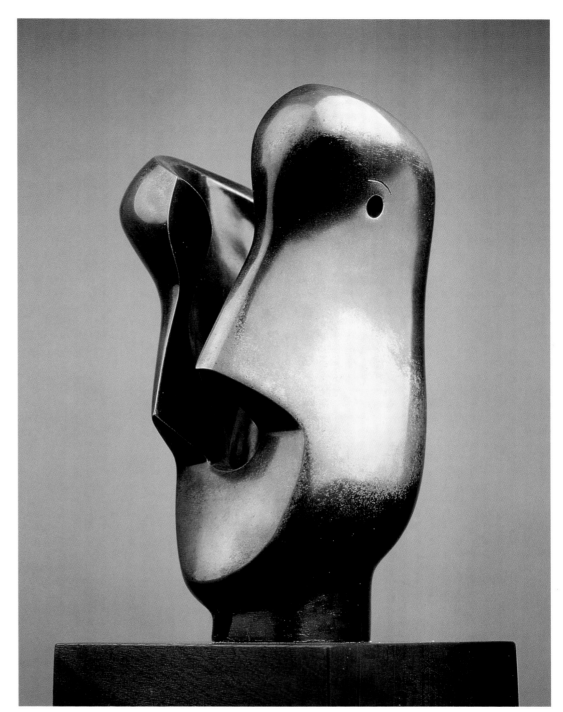

201

who lived and worked well into the twentieth century, Moore found himself working outside his time: his work appeared to drop out of history. Established artists often interweave themes, creating their own art history with elaborate internal references; this is not necessarily the artist's intention but rather a symbiotic relationship between artists, dealers and critics, each adjusting to the other, as form

is adjusted to space. In this process, a space is created around the oeuvre, isolating it from its surroundings, and it begins to engage above all with itself.

Julian Stallabrass

1. Ian Low, 'Let's Look at it this Way', *News Chronicle*, 26 March 1952.

202

Helmet Head No.4: Interior-Exterior
1963
LH 508
bronze edition of 6 + 2
cast: Fiorini, London
height 47.5cm
signature: stamped *Moore*, unnumbered
Gift of the artist 1977

exhibitions: Bradford 1978 (cat.36); Durham
1982 (cat.32); Mexico City 1982-83 (cat.78);
Caracas 1983 (cat.E33); Leeds 1984-85
(cat.27); Hong Kong 1986 (cat.149); Tokyo/
Fukuoka 1986 (cat.128); Bilbao 1990
(p.107); Buenos Aires/Rosario/Mar del
Plata/Córdoba/Montevideo 1996

203

Locking Piece 1963-64
LH 515
bronze edition of 3 + 1
cast: Hermann Noack, Berlin
height 290cm
unsigned, [0/3]
Acquired 1987

exhibitions: Paris 1992 (cat.8); Venice 1995
(cat.99); Paris (Champs Elyseés) 1996 (p.62)
loans: Basel, Merian Park 1984-92; Milton
Keynes, Campbell Park 1993-95

publications: Cohen 1993, pls.VI, VII

Locking Piece is to me the single most
characteristic example of all Moore's
nominally abstract sculpture, in that it
embodies within itself so many features of
his work in general throughout his career.

Although he made a number of
experiments with forms and images that
were entirely without any reference beyond
themselves, most especially in the 1930s, he
always found himself almost instinctively
moving back at least to some human or
organic suggestion or association. It was as
though he came to accept, in the end, that
creatively he couldn't live without it. Indeed
he eventually admitted as much quite
openly, stating in *Circle*, the critical
symposium published in 1937: 'Because a
work does not aim at reproducing the
natural appearance it is not therefore an
escape from life.'

Yet always, even when the figurative
aspect was openly declared in the work,
Moore would find himself ever drawn back
to the simplifications and open-ended
ambiguities and opportunities of
abstraction. With his stones and driftwood,
and most especially the bones he found on
the beach, weathered and hollowed by sea
and tide and bleached in the sun, he would
have it both ways. Here were forms that
were entirely natural, yet no less entirely
unspecific in their allusions.

A joint, a swivel, a bearing, whether
natural or man-made, was always a stimulus
and fascination to him: jaws, hips, knees,
axles, the grinding and working together of
two mill-stones, perhaps, one upon the
other, the turn and fall of a lock. There is
always the sense of one form working with
another, one within another, opening,
penetrating, hollowing out. He treasured an
elephant's skull that had been given to him,
and treasured no less a *forcola*, the
extraordinary rowlock of a gondola, worn to
its present formal subtlety by centuries of
adaptation and practical refinement.

Locking Piece is rich in all such
associations and suggestions, formal quite
as much as imaginative. It has the massive
monumentality of a mill, fraught with that
sense of the imminent, heavy horizontal
turn. It has the domed form of a skull, that
seems to clip and hinge together, jaw and
cranium. Here are the smoothed and
hollowed declivities and opportune points
of pressure of the Venetian rowlock, here
the deep cavity to hold the ball of hip or
shoulder.

It is manifestly a carved piece, for all

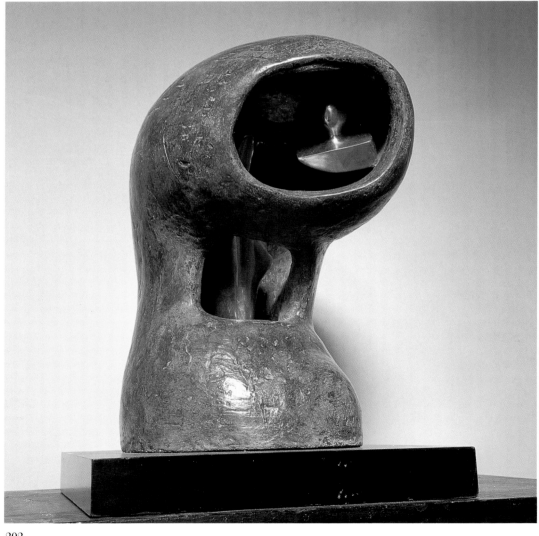

202

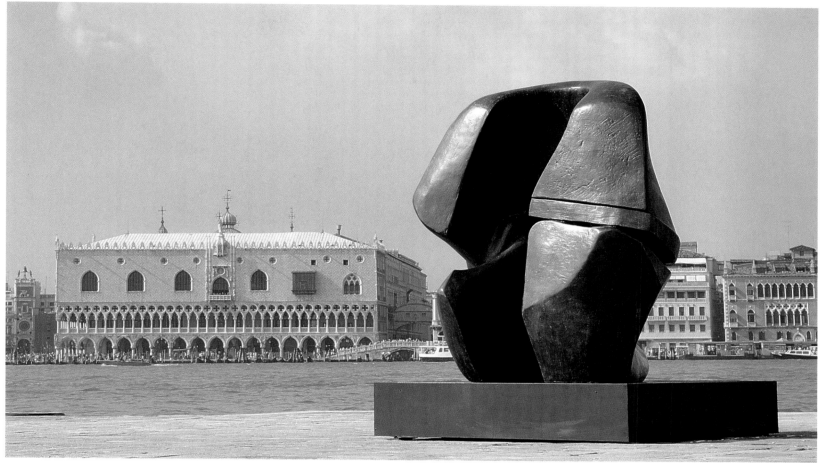

cat.203 exhibited in Venice, 1995

that it is cast in bronze, the surface scored, rasped and smoothed in the original plaster to match the long wearing of the natural form, whether by nature or man's own hand and use. This is the essential character of the whole of the work, and the whole of the man.

William Packer

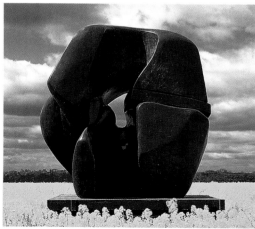

203

204

Knife Edge Two Piece 1962-65
LH 516
bronze edition of 3 + 1
cast: Hermann Noack, Berlin
length 366cm
signature: stamped *Moore, 0/3*
Gift of the artist 1977

exhibitions: Paris 1977 (cat.104); Bradford 1978 (cat.1); Wakefield 1987 (cat.20); London 1988 (cat.182)

publications: Spender 1986, pp.61, 84, 98

Embodying the feeling of a journey through a magnificent landscape, the gap between the two forms allows just enough space for passage between the narrow chasm walls. The shapes rise and fall unexpectedly; a sharp edge cuts across the sky. Smooth amber curves are relieved by roughly textured areas with traces of deep natural green patina.

The hollows and holes of previous work give way to the complete division of this sculpture into separate but integral parts. Moore explained: 'I realised what an advantage a separated two piece composition could have in relating [forms] to landscape . . . Once these two parts become separated, you can justifiably make it a landscape or a rock.'[1] The space created between the two forms not only permits vistas of the surrounding environment through the sculpture, contributing to the blending of art and nature, but invites one physically to enter the sculptural space. The viewer becomes not just a spectator but an active participant.

Moore has achieved a sense of equilibrium, a delicate balance between elegance of line and monumentality. The original inspiration came from a bone fragment. Moore admired the structural and sculptural properties of bones, their combination of lightness and strength, and referred to the bones of birds in particular

as having the 'the lightweight fineness of a knife-blade'.[2]

The Foundation's cast, which is also the artist's copy, can be found where Moore originally sited the sculpture, within view of his home on the edge of the gardens planted by Irina. Two of the other bronzes are in public collections: one, in Queen Elizabeth Park, Vancouver, and another, belonging to the City of Westminster, outside the Houses of Parliament.

Anita Feldman Bennet

1. Carlton Lake, 'Henry Moore's World', *Atlantic Monthly*, Boston, January 1962, pp.39-45.
2. James (ed.) 1966, p.278; 1992, p.299.

The enormity of Henry Moore's success and international acclaim sometimes masks his real artistic achievements, particularly his understanding of nature and his desire to place sculpture in the landscape. Many of the world's great museums and art galleries hold fine examples of Moore's work, and lone sculptures can be viewed against the metropolitan background of cities around the world. Rarely, however, is it possible to see a substantial body of Moore's sculpture in the landscape, apart from at his former home in Perry Green, and, to a lesser extent, at Yorkshire Sculpture Park, located within a few miles of Castleford, Moore's birth place. Moore was associated with the Park from its early days – offering advice, support, and the loan of sculpture. He also enjoyed the adjacent Bretton Country Park which he felt would provide an ideal setting for his sculpture.

cat.204 exhibited in Wakefield, 1987

In 1987 Yorkshire Sculpture Park organised what was possibly the largest exhibition of Henry Moore's sculpture in the landscape, when thirty-three sculptures were sited in approximately one hundred acres. The landscape varies enormously from domestic formal spaces enclosed by walls and balustrades, to wide rolling parkland punctuated by large mature trees. Beyond the lakes, the hillside provides a panorama of woodlands and distant views of the Pennines.

The exhibition *Henry Moore and Landscape* started on the long Formal Terrace, backed by a massive yew hedge. High above the formal garden, the terrace provided an opportunity to look down upon some of the sculptures. This is both a private and open space, and its lush green lawn, bordered by trees and bushes leading into further concealed areas, is an ideal place for sculpture. Never had **Reclining Figure: Festival** 1951 (LH 293) looked better as elevated views from the terrace revealed the inner space and complex structure of this elegant sculpture. It presented a startling contrast to the solid mass of the much later **Reclining Figure: Angles** [cat.274] with its piercing eyes asserting a watchful presence. The timeless quality of these reclining figures was severely disrupted upon entering the shrubbery and undergrowth beyond the lawn, where the gloom heightened the darker, brooding, almost sinister side of works such as **Seated Woman: Thin Neck** 1961 (LH 472), the flat shell-like back shielding the inner form of a strange creature sitting bolt upright with its periscopic head sniffing and searching the air. The temptation to impose a monumental sculpture on the hillside was resisted. Instead the **King and Queen** [cat.170] were allowed quietly to contemplate their Yorkshire domain. In Yorkshire there was an affectionate response to the near human size and warmth of this sculpture.

Much further away and sited on the large open grassland against the lakeside, **Three Piece Reclining Figure: Draped** [cat.238], **Goslar Warrior** [cat.233], **Oval with Points** [cat.220] had rarely found so much space. Downward from the hillside

and beyond, tucked away in intimate and open spaces, was a wide range of other sculptures including **Knife Edge Two Piece** [cat.204], **Large Totem Head** [cat.215] and less familiar works such as the uncharacteristic **Relief No.1** [cat.187] and the smaller **Three Part Object** 1960 (LH 470), all taking on new and vigorous forms within the landscape.

For many weeks Henry Moore Foundation and Yorkshire Sculpture Park staff toiled with cranes and with great physical perseverance to move and coax many tonnes of sculpture throughout the landscape, searching for the right locations. Moore often said that sculpture gains by finding a setting which suits its mood and, when this happens, there is great gain for both sculpture and setting. This was certainly true in 1987 when we all learnt a great deal more about the landscape and the sculptures. To site thirty-three sculptures spanning forty-five years without the works intruding upon each other was a demanding and exacting task. Vistas, mature trees, concealed and intimate spaces, and open grassed areas were all used to great effect, creating an exhibition full of surprises which did not detract from the integrity of the individual sculptures, or from the coherence of the exhibition.

Peter Murray

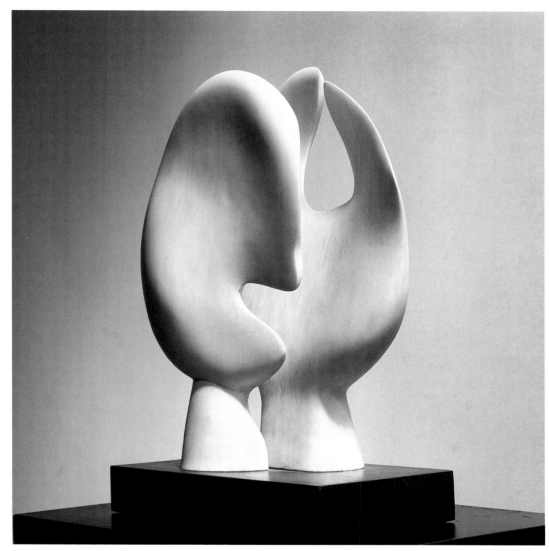

205

205
Moon Head 1964
LH 522
porcelain edition of 6 + 1
cast: Rosenthal, Selb
height 30.5cm
unsigned, [0/6]
Gift of the artist 1977

exhibitions: London 1988 (cat.183)

Of **Moon Head**, which was based on **Maquette for Head and Hand** 1962 (LH 505), Moore said: 'When I came to make it full size, about eighteen inches high, I gave it a pale golden patina so that each piece reflected a strange, almost ghostly, light at the other. This happened quite by accident. It was because the whole effect reminded

me so strongly of the light and shape of the full moon that I have since called it 'Moon Head'.'[1]

In **Moon Head**, the way in which the two closely related head and hand forms are fixed to the base parallel to each other but out of alignment – 'in echelon' – is reminiscent of one of Barbara Hepworth's favourite compositional arrangements which first appeared in the 1935 wood *Discs in Echelon* (Museum of Modern Art, New York). **Moon Head**, one of Moore's most refined and elegant works, has been compared to the thin, flat forms of Cycladic sculpture which he greatly admired. William Fagg suggested to me that the hand-shaped form derived from a Mama *Mask of a Buffalo* which is illustrated in his book *Nigerian Images* (1963). Harry

Fischer, Moore's friend and dealer, gave him a copy soon after the book was published. The comparison looked very convincing, and I illustrated the Nigerian mask with the **Moon Head** in my 1981 exhibition catalogue *Gauguin to Moore: Primitivism in Modern Sculpture* (Art Gallery of Ontario, Toronto). I failed, however, to take into account the 1962 **Maquette for Head and Hand**, on which it was based, made a year before Fagg's book was published. Did Fagg have another African mask in mind, or were the affinities between the 1964 **Moon Head** and the Mama *Mask of a Buffalo* so strong that he convinced himself that Moore must have been inspired by the African carving? If nothing else, Fagg's perception was indicative of rich and varied associations

and comparisons we make between works of art from different cultures and periods. That **Moon Head** reminds some viewers of Cycladic sculpture, and a great African scholar of a Mama mask, attests to the evocative resonance of Moore's art.

Alan Wilkinson

1. Hedgecoe (ed.) 1968, p.466.

206
Maquette for Atom Piece 1964
LH 524
bronze edition of 12 + 1
cast: Fiorini, London, 1970
height 15cm
signature: stamped *Moore, 0/12*
Gift of the artist 1977

exhibitions: Bradford 1978 (cat.109); Durham 1982 (cat.36); New Delhi 1987 (cat.83); Leningrad/Moscow 1991 (cat.92); Helsinki 1991 (cat.92); Martigny 1989 (cat.pp.208,209); Milan 1989-90 (p.50); Bilbao 1990 (p.111); Pforzheim/Bad Homburg 1994 (cat.9); Krakow/Warsaw 1995 (cat.99); Venice 1995 (cat.100); Havana/Bogotá/Buenos Aires/Montevideo/Santiago de Chile 1997-98 (cat.76)

In the early 1950s Moore had shown considerable interest in the shapes of armour and had produced some helmet head sculptures. In 1963 he was approached by Chicago University to consider a monument that would commemorate the first controlled splitting of the atom, achieved there in 1952 by Enrico Fermi.

So the seeds of a visual idea already existed. As a strong supporter of the Campaign for Nuclear Disarmament, Moore was well aware of the moral and political issues such a memorial might raise. This bronze casting is from the original small maquette he showed to the Chicago committee before they commissioned the 366cm high sculpture unveiled at the university in 1967.

Atom Piece is one of the most complex of Moore's works both in formal terms and in terms of its moral and intellectual

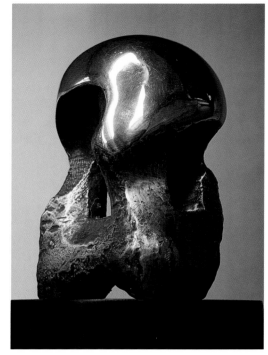

206

significance. There are many levels of meaning that can be deduced from considering this unified image. It can be seen as a sculptural metaphor for both physical and intellectual power. The seductive polished cranium emerges from a rocky base and is supported by sturdy pillars. These remind me of the sense of massive strength contained within a spiritual space that one feels on entering Durham Cathedral.

The swelling mushroom head, that can break a rock or paving stone in spite of its apparent fragility, presents a paradox paralleled with the implications of man's discovery of how to release atomic energy. The similarity to the lethal mushroom clouds that marked the bombs exploded over Hiroshima and Nagasaki is obvious. The sculpture does not shirk the ominous and sinister implications of its theme. The

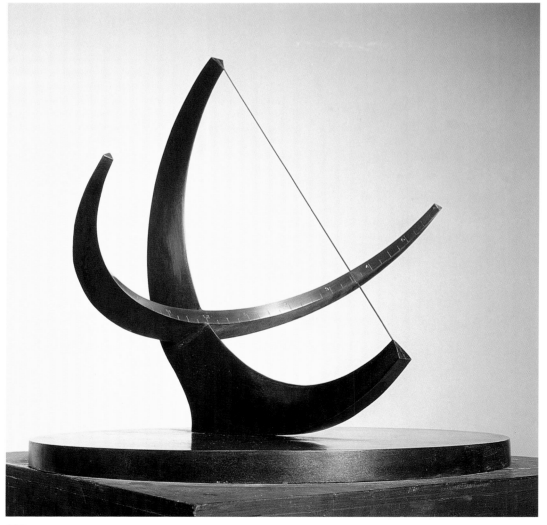

207

seductive beauty of perfect intellectual ideas, exemplified by perfect scientific experiments, is represented in the mirror-like surface of the skull without obscuring the fatal consequences of such achievements.

Atom Piece is a continuation in sculptural terms of the legend of Beauty and the Beast. It is a deeply thought through symbol for the moral dilemmas of the twentieth century.

John Read

207
Working Model for Sundial 1965
LH 527
bronze edition of 21
cast: Hermann Noack, Berlin
height 56cm
signature: stamped *Moore*, unnumbered
Gift of Sir Denis Hamilton 1986

exhibitions: New Delhi 1987 (cat.84)

Among the numerous sculptures at Perry Green which regularly came and went in a frenetic programme of world-wide exhibitions, a cast of **Working Model for Sundial** was one of the few which remained stationary, sited serenely on an expanse of green lawn, close by an apple tree, within view of the 'New Room', where Henry and Irina entertained or sat and talked.[1] The traditional function of this common, utilitarian garden apparatus – 'a contrivance for showing the time of day by means of a shadow cast by the sun upon a surface marked with a diagram indicating the hours'[2] – has been transformed by Moore into an elegant, kinetic dance. Lines of light following the sun's movement across the sky reflect on the sharp-edged, polished bronze surfaces of crescents and partial spheres. One is reminded of those monumental, abstract masonry buildings of the royal observatory (Jantar Mantar) built in the early eighteenth century at Jaipur in Rajasthan.[3] Moore's forms are if anything more tense, recollections of his **Three Points** 1939-40 [cat.110], about which he has observed: '. . . this pointing has an emotional or physical action in it where

things are just about to touch but don't . . . where one form is nearly making contact with the other.'[4]

Terry Friedman

1. Spender 1986, plates 65, 77, 102.
2. *Oxford English Dictionary*.
3. Christopher Tadgell, *The History of Architecture in India*, Architecture Design and Technology Press, London 1990, plate 45a.
4. Levine 1978, pp.28, 29.

Given Moore's dislike of commissions, it was odd that he should agree to execute this one for the forecourt of *The Times* building, then located near Blackfriars Bridge. The idea came from the chief architect Richard Llewellyn-Davies, who sat with Moore on the Royal Fine Art Commission. Sir Denis Hamilton, who later presented this working model to the Foundation, was then editor-in-chief of Times Newspapers, having previously been a great editor of the *Sunday Times*. Sir Denis and Moore became particularly close when Hamilton bought a house in Italy not far from Moore's bungalow in Forte dei Marmi. Hamilton's nearest neighbour there was the sculptor Jacques Lipchitz. Moore and Lipchitz sometimes came to dinner, along with Marino Marini, who had a studio in Forte dei Marmi. Hamilton saw himself as 'the lowly scribbler, trying to take part in argument with the three greatest sculptors in the world', as he described it to me.

The **Sundial**, a crisply elegant work, was installed on a – regrettably sunless – morning in November 1967, with Moore among those present and me peering down from my office in Printing House Square. When *The Times* sold the building to the

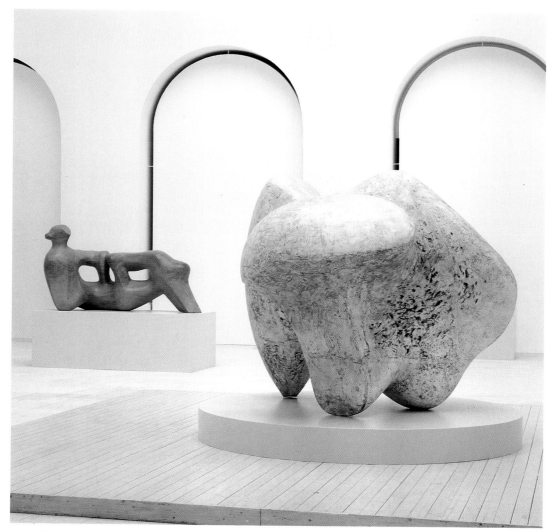

cat.208 exhibited in Nantes, 1996, with **Reclining Figure: Holes** 1976-78 [cat.239]

281

Observer in 1974, sculpture and all, the sundial was sold by a philistine management to IBM via a dealer, and ended up at the company's education centre on the outskirts of Brussels.

Roger Berthoud

208
Three Way Piece No.1: Points 1964-65
LH 533
plaster with surface colour, hessian on wood support
height 193cm
unsigned
Gift of the artist 1977

exhibitions: Nantes 1996 (cat.85); Mannheim 1996-97 (cat.85)

The source of inspiration for this mammoth plaster was a small flint which could be turned to rest on three different sides, increasing the potential to explore new perspectives of the object and at the same time creating a sense of weightlessness.

At only eight centimetres, the initial plaster maquette was small enough for the artist to hold in the palm of his hand and imagine on a much larger scale. Abandoning his pre-war attachment to the ideal of 'truth to material', Moore adopted plaster as his preferred sculpting medium, for it provided a freedom and flexibility of form which were limited in wood or stone carving. This working method also allowed for an innovative use of his massive collection of found objects. By adding plaster or plasticine directly to a piece of flint, bone, shell or other object, Moore could physically transform the source of inspiration into the desired sculptural form. He explained: 'Plaster is an important material for sculptors. Good quality plaster mixed with water sets to the hardness of a soft stone. I use plaster for my maquettes in preference to clay because I can both build it up and cut it down. It is easily worked, while clay hardens and dries, so that it cannot be added to.'[1] This sculpture was one of the last to be created using an intricate wooden armature encased with wire netting and canvas, a method Moore

discarded soon afterwards in favour of the simpler and more efficient use of polystyrene.

Although originally inspired by a flint, the shape of the sculpture closely resembles a gigantic knuckle bone or even a tooth, and it is revealing that Moore began working on this sculpture at the same time that he first came across the skull of an elephant in the garden of his friends Julian and Juliette Huxley (who later made him a gift of the skull). Moore was fascinated by the surprising contrasts the skull offered: the strong arc of the jaw, the fragile nasal membrane, the coarse flat teeth, the mysterious caverns of space receding from smooth planes of sunbleached bone. Heightening the stark juxtapositions of light and shade, Moore enlarged and carved his sculpture in an enormous clear plastic temporary studio which allowed the plaster to be worked in natural daylight. The monumental bulbous

forms defy the inherent fragility of the medium, the surface of which has been roughly grated and pitted while faintly coloured with warm organic tones.

Anita Feldman Bennet

1. Levine 1978, p.124.

209
Two Three-Quarter Figures on Base
1984
LH 539b
bronze edition of 9 + 1
cast: Fiorini, London
height 101.6cm
signature: stamped *Moore, 0/9*
Acquired 1986

exhibitions: Hong Kong 1986 (cat.157); Tokyo/Fukuoka 1986 (cat.99); Helsinki 1987 (cat.21); Florence 1987 (cat.13); Chandigarh/

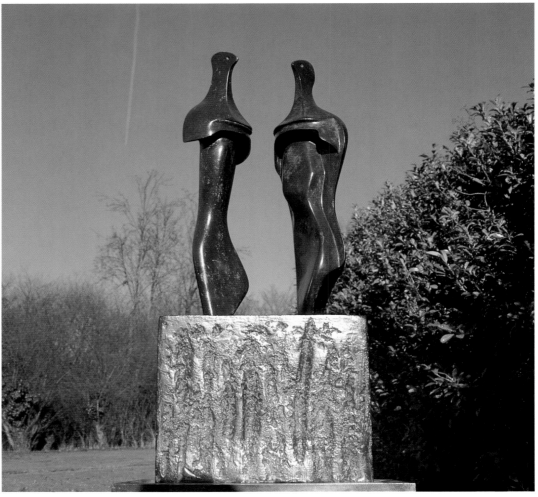

209

Bombay/Baroda/Bhopal/Madras/Bangalore/
Calcutta/Jaipur 1987-88 (cat.4); Harare/
Bulawayo 1988 (cat.2); Singapore/Kuching/
Kuala Lumpur/Penang/Bangkok/Manilla
1989-90; Sydney 1992 (cat.127); Krakow/
Warsaw 1995 (cat.101); Venice 1995
(cat.102); Havana/Bogotá/Buenos Aires/
Montevideo/Santiago de Chile 1997-98
(cat.78)

210
Three Way Ring 1966
LH 550
porcelain edition of 6 + 1
cast: Rosenthal, Selb
length 33cm
unsigned, [0/6]
Gift of the artist 1977

211
Large Two Forms 1969
LH 556
bronze edition of 4 + 1
cast: Hermann Noack, Berlin
length 610cm
signature: stamped *Moore, 0/4*
Acquired 1992

exhibitions: Paris 1992 (cat.9); Wakefield
1994-95 (cat.13); Paris 1996 (pp.388,389)
loans: Wakefield, Yorkshire Sculpture Park
1992-94; Wakefield, Bretton Country Park
1995-96

publications: Cohen 1993, pls.XII, XIII

This sculpture is familiar to the German
nation. As soon as the Federal Chancellor's
office in Bonn appears on the television
screen they jump out at you: Moore's **Large
Two Forms** – hotly coveted and fiercely
debated.

Moore did not create the piece for the
forecourt of the German Chancellor's office.
He was not used to working for architecture
in this way. He had to remain independent.
Rather, the **Large Two Forms** had been
sought out by experts on the orders of
Helmut Schmidt at the great exhibition to
celebrate the artist's eightieth birthday in
Kensington Gardens in the summer of 1978.
Moore agreed to this proposal even though

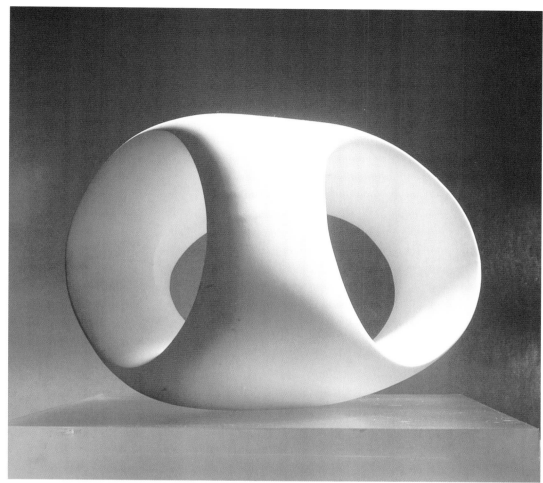

210

there were still a number of hurdles to
clear before one of only four bronze
castings was available. He generously
donated the work to Bonn, initially for two
years. As always, he stipulated where it
should stand and the required spacing from
other buildings. He also determined how
the two sculpted pieces should be
positioned. By 28 August, the mighty
sculpture was placed – in the presence of
the sculptor – on a beautifully mown grassy
hill that had been specially prepared for it.
When the piece was finished on time and in
line with his wishes, Moore was heard to
exclaim: 'I think you Germans are
wonderful.'

Of course, less wonderful was the fact
that at the time there was sharp criticism in
a number of newspaper articles and even in
a letter from a renowned sculptor about the
fact that no German artists had been
entrusted with this monumental order.
Cleverly, Helmut Schmidt took the wind

from the sails of these protests by using his
official opening speech to stress that 'art
does not grow on the ground of national
small-mindedness'. For him they were 'a
symbol of human solidarity and an
expression of humanity'.

In the context of the history of his work,
it is clear that Moore used two of his
discoveries from years back to develop
Large Two Forms. First the two-piece
approach and with it his aesthetics of 'unity
in multiplicity'. In this context, Alan
Wilkinson had already identified the
pynkado wood **Two Forms** 1934 (LH 153,
Museum of Modern Art, New York) as a
'distant relative.'[1] Secondly, in **Large Two
Forms** Moore again takes up his old
fascination dating back to 1933 for the
'hole', in other words a spatial opening
maintained by form. The many perspectives
into space which this sculpture gives when
one walks around it combine with the large
dimensions of the opposing forms to result

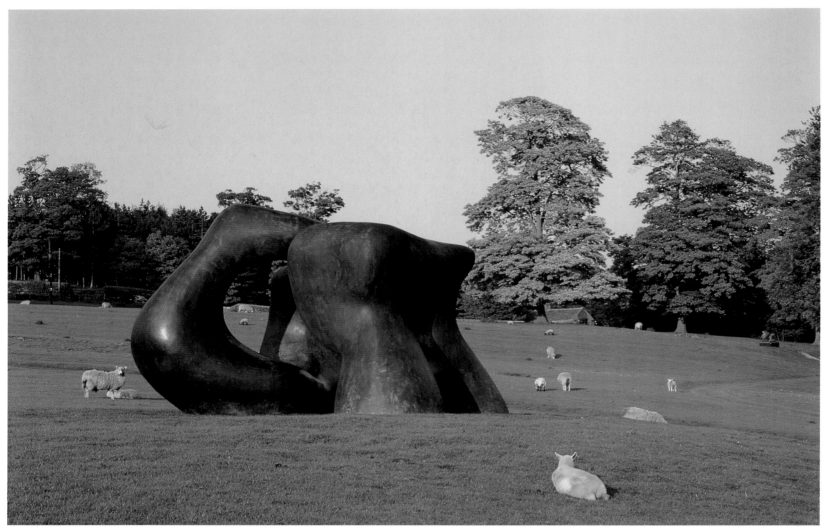

cat.211 exhibited in Wakefield, 1994-95

in a revolving rhythm which is uniform both internally and externally, a rhythm which stands out attractively from the monotone architectural framework of the Chancellor's office.

Last but not least, **Large Two Forms** reveals three exemplary achievements of the style of Moore's mature works: the spaciousness of the developing forms; the increased complexity of the mutual interdependence of form and space; and the quality of being viewed from all angles which Moore – in a new and exciting way – employed to comply with the theory dating back to the Renaissance that sculpture had to be 'equally attractive on all sides'.

Christa Lichtenstern

1. Wilkinson 1987, p.227.

212
Double Oval 1966
LH 560
bronze edition of 2 + 1
cast: Hermann Noack, Berlin
length 550cm
signature: stamped *Moore, 0/2*
Acquired 1992

exhibitions: Paris 1992 (cat.10)
loans: Hatfield, Hatfield Polytechnic 1991-92

publications: Cohen 1993, pls.XVIII, XIX

Double Oval is a feat of formal balance and harmony. Although essentially abstract, the shapes entertain visual association and implied meaning. It has a compelling tactility; the viewer feels the urge to reach out and touch the seemingly worn-smooth inside edges of the vast holes. In other parts it is scratched like an ancient fossil, while its angular parts recall the lightweight strength of a bone. The sweeping ovals suggest the romantic promise of eternity symbolised by the wedding ring. This accentuates the perceived duality of bulk and grace, as does the idea of protection indicated by the stouter, darker back form that appears to guard the other, akin to Moore's internal/external imagery. It has a natural, timeless feel that is the basis of so much of his work.

It has been suggested that **Double Oval** resembles the handles of a pair of scissors. The analogy has previously been cast aside, but a drawing of 1964 goes some way to proving it to be correct. **Heads** (HMF 3100) depicts two heads made out of the forms of

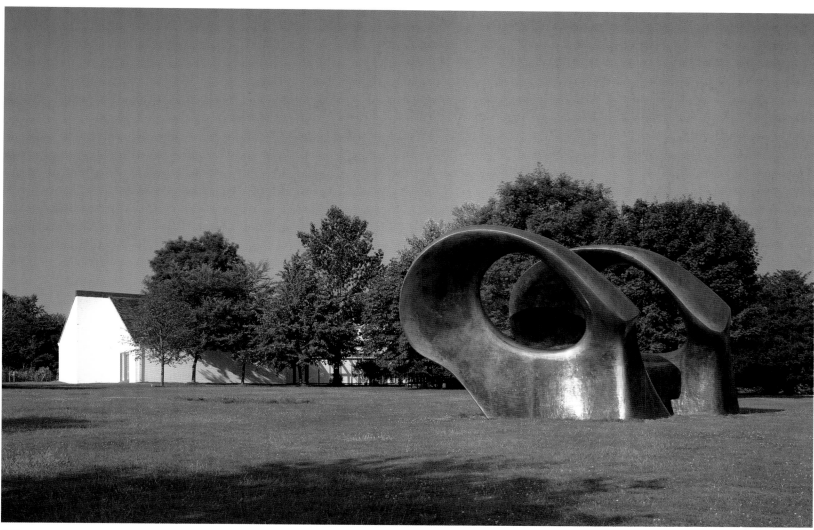

212

two pairs of scissor handles, the two finger holes of each becoming the eyes. Each head is a single entity, but comprising two distinct parts as in Moore's two-piece reclining figures. Each hole could therefore also be a single head with only one visible eye. This seemingly frivolous animation of a household object may have its roots in the contemporary Pop Art, but it seems more likely that it is a semi-automatic drawing tapping unconscious imagery and concepts. The ideas it explores may be involved in the evolution also of the two **Moon Heads** of 1964 (LH 521 and cat.205)[1] that investigate interdependence of form and space. By using the pierced forms in **Double Oval** that are more true to the original drawing, Moore has furthered this investigation. However he also spoke of the idea of the shadow, of one form echoing the other, that

thereby questions its solid reality. Beyond the emotional communication of both the abstract form and the suggestion of two heads, this piece could be seen as a formal experiment with the sculptural object as a three-dimensional presence negotiating space on different levels. This impression is only enhanced by our physical engagement with it due to its immense size.

Clare Hillman

1. These works also grew out of such pieces as **Maquette for Head and Hand** (LH 505) and **Divided Head** (LH 506), both 1962.

213

Working Model for Divided Oval: Butterfly 1967
LH 571a
bronze edition of 6 + 1
cast: Hermann Noack, Berlin 1982
length 91.4cm
signature: stamped *Moore, 0/6*
Acquired 1986

exhibitions: Bremen/Berlin/Heilbronn 1997-98 (p.127)

This work, conceived in 1967 and cast in 1982, is a solid horizontal form, highly abstracted and symmetrical in the sense of a three-dimensional Rohrschacht test. It would be ambitious for any sculptor to try to render the effortless grace and weightless nature of a butterfly in a

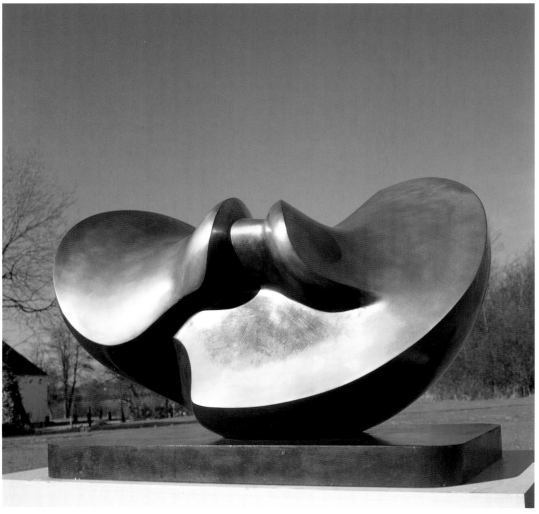

213

on the theme of helmet heads, internal/external forms and mother and child representations.

Moore's own words, although not specifically relating to the **Butterfly**, reflect upon the alliance between tension and enigma: 'One of the things I would like to think my sculpture has is a force, is a strength, is a life . . . It's as though you have something trying to make itself come to a shape from inside itself.'[1]

Reinhard Rudolph

1. Warren Forma, *Five British Sculptors: Work and Talk*, Grossman, New York 1964, p.59.

214
Mother and Child 1967
LH 573
rosa aurora marble
length 130.2cm
unsigned
Gift of Irina Moore 1977

exhibitions: London 1978 (cat.5); Madrid 1981 (cat.162); Lisbon 1981 (cat.151); Barcelona 1981-82 (cat.130); Mexico City 1982-83 (cat.121); Caracas (cat.E78); Hong Kong 1986 (cat.115); Tokyo/Fukuoka 1986 (cat.33); Wakefield 1994; Nantes 1996 (cat.88); Mannheim 1996-97 (cat.88)

Criticism is often levelled at Moore's late carvings because they were not done by the artist himself, and this can be seen as a contradiction of his early insistence on 'truth to material' and 'carving direct'. When, however, these carvings are seen alongside Moore's later bronzes, cast from enlargements made by assistants, the two processes are not dissimilar. Both were made from the tiny maquettes that Moore made himself, often out of plaster which he carved: in each case the final material – whether bronze or stone – is an integral part of the composition.

From 1964 onwards, each year Moore worked with the Henraux stonemasons in Querceta in Italy. While the family were on holiday at their house in Forte dei Marmi, the stonemasons made carvings following Moore's maquettes. Invariably the material

medium such as bronze unless it was executed in decorative metal lattice work, and Moore's approach could not be further from this. His 'butterfly' is solid and voluminous.

The title is a subtle misnomer, allocated to the piece by the artist applying the most tentative intellectual association to the idea of a central body section and two rounded ends reminiscent of the wings of an insect about to unfurl. The viewer's perception of the sculpture as a butterfly is created by means of semantics and form – title and visual presence – put into effect by Moore's intellect and absolute understanding of three-dimensionality. By means of this combination, and despite the sculpture's size, volume and weight, the piece appears lofty, and the viewer's tentative visual association with a butterfly is gratified. An insect's chitin body is hinted at in the

central part of the sculpture, the overall contained bronze shape indicating the wingspan.

This sculpture does not work on this level only, however; it triggers a number of other associative responses. The smooth surface and lusciously rounded shape conjure up notions of a chrysalis or a larva; questions about the inner content of an external form pose themselves, ideas about metamorphosis kick in. The strength of **Working Model for Butterfly** lies not only in its formal appearance but equally in the inherent mystery which is contained within the enclosed shell. The combination of associative enigma and physical tension of form contained within form had been a constant preoccupation of Moore's since the 1930s; drawings and comments in sketchbooks document this, as does a vast body of both graphic and sculptural works

was unusual. In this case the imported Portuguese rosa aurora marble, with its natural veining and translucent quality, inspired arcane imagery which challenges the viewer to remember all he has ever imagined about the relationship of mother and child. Moore drastically reduced natural appearances to leave an inner core of psychological truth to be conveyed by his suggestive shapes, which gain their significance from the special quality of the material.

The sculpture is closer to **Two Forms** 1934 (LH 153) than to any of Moore's contemporary and equally non-representational compositions cast in bronze. A drawing (HMF 1126) for the 1934 sculpture shows that its abstracted shapes are based on a mother's breasts and the head of a child – Moore even repeated the theme in a drawing of 1980, HMF 80(228). However, the marble two-piece of 1967 with its parts resting upon each other is more sensuous than the 1930s wood carving: the 'essence of child' is bonded to the 'essence of nurture'. Nurture is emotional as well as physical, and the precisely carved 'decapitation' on top of the torso suggests that the mother's intellect is superfluous; the child receives reassurance from the mother's fond touch as much as from her milk.

Susan Compton

215

Large Totem Head 1968
LH 577
bronze edition of 8 + 1
cast: Hermann Noack, Berlin
height 244cm
signature: stamped *Moore, 0/8*
Acquired 1987

exhibitions: Wakefield 1987 (cat.21); Milan 1989-90 (p.59); Paris 1992 (cat.12); Pforzheim/Bad Homburg 1994 (cat.11)

publications: Cohen 1993, pl.XL

This head has an all-encapsulating look, a hollow character and an exotic monumentality. Leaning forward, it would appear to hail more from the totem-head world of Easter Island than from our times.

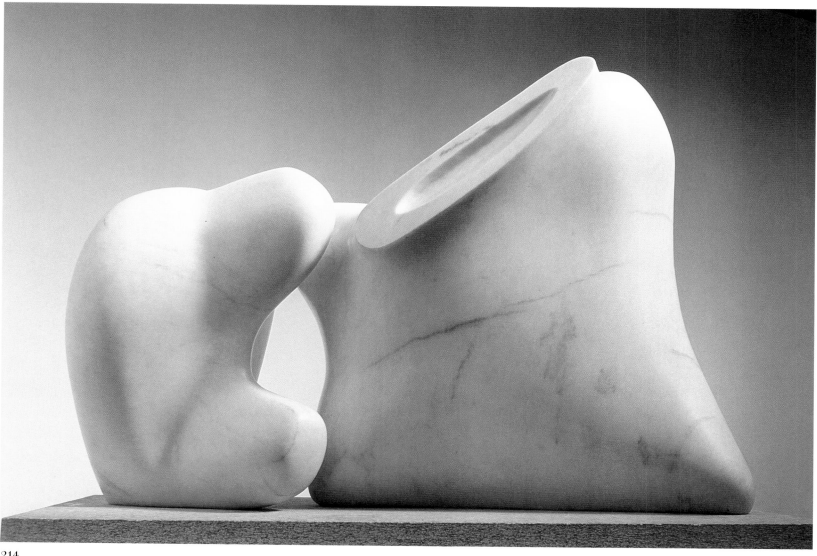

214

replaced the ridge of the mask's nose with three bars.

In 1963 he once again adopted the genre of the Dogon mask, this time – virtually unchanged – in bronze, which he laid horizontally and called **Head: Boat Form** (LH 509).

In 1968, this finally evolved into the **Large Totem Head**. Just by giving it this title, Moore comes as close as possible to his source of the Dogon mask. It is characteristic of the honesty of this artist that he did not conceal any relevant ideas. On the contrary, as in this case, he allows the observer to make his own discoveries. Everyone joins in – it is all part of the game.

Christa Lichtenstern

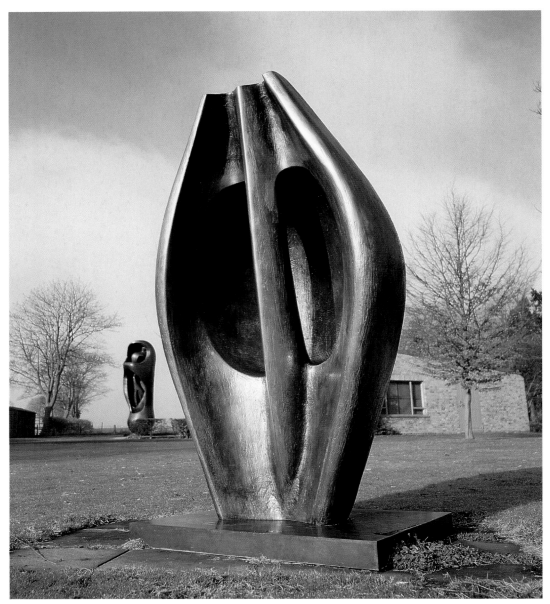

cat.215 with **Large Upright Internal/External Form** 1981-82 [cat.162]

216
Three Piece Sculpture: Vertebrae
1968
LH 580
bronze edition of 3 + 1
cast: Hermann Noack, Berlin
length 750cm
signature: stamped *Moore, 0/3*
Acquired 1989

exhibitions: Paris 1992 (cat.13)

publications: Cohen 1993, pls.IX, X, XI

This feeling is not deceptive. In fact, the origins of this head date back to the cultic past of non-European art. In the 1930s, when Moore – as a member of the group of English Surrealists – adopted a lot of surrealistic ideas without surrendering himself to them, he also appeared in the pages of the second edition of the first volume of the journal *Minotaure*. This was a special edition specifically devoted to African expeditions undertaken by the Ethnological Institute of the University of Paris from Dakar to Somalia. In a number of drawings from 1935 and 1936, it has been proven that Moore was inspired by certain reproductions featured in this report, which

became important launching pads for his later sculptures.

At the time, Moore was also said to have looked closely at numerous Dogon masks originating from Western Sudan that were depicted in this issue of *Minotaure*. These entailed the face being made up from two vertical indented rectangles which formed the oblong eyes; in between, a narrow vertical ridge marked the bridge of the nose. This matrix is supposed to have furthered Moore's artistic way of thinking for many years to come. In 1939, in his famous lithograph entitled **Spanish Prisoner** [cat.107], he pushed the face of the prisoner into a similar boxed space and

Moore's creative use of pebbles and bones goes back to about 1930. He spoke of it in 1934, in his statement for *Unit One*, and again, more fully, in 1964. He hoped that his sculpture had 'a vitality from inside it, so that you have a sense that the form is pressing from inside, trying to burst or trying to give off the strength from inside itself, rather than having something which is just shaped from the outside and stopped . . . This is, perhaps, what makes me interested in bones as much as flesh because the bone is the inner of structure of all living forms. It's the bone that pushes out from inside . . . and it's there that the movement and the energy come from.'[1]

Moore added to the vertebrae before enlarging them to produce the three units that are here juxtaposed, so that in titling his sculpture he was both naming his

source and drawing attention to his adaptation of it. The main transformations are those of size and individual shape, and then also the all-important one of positioning. We think of vertebrae in a line. Here they have been altered and regrouped, so that the resulting sculpture hovers between figuration and abstraction in a manner unusual even for Moore. It seems to consist of one form used three times but positioned to offer the greatest variety possible, thus approaching a composition of modular units. Closer looking shows that the three elements are similar but not identical, yet the experience offered is still one of variety within repetition. For example, Moore described his **Three Part Object** 1960 (LH 470) as consisting of 'three similar forms . . . balanced at angles to each

other'. They are stacked. The top two are almost identical but orientated differently; the bottom element is simpler but looks similar from most angles. He called it 'a strange work, even for me'.[2] Another piece that suggests a composition of similar or identical units is **Locking Piece** [cat.203]. This consists of two elements, derived, Moore said at different times, from a pair of pebbles that seemed to fit together or from a bone fragment he found in his grounds which included a socket and joint. The completed bronze, in two parts, calls for the upper part to be turned as it is lowered on to the other, almost clicking into place.[3]

The individual units are reminiscent of some of the two- and three-piece reclining figures Moore made from 1959. The result is a very large sculpture that at the same

time feels approachable and intimate while offering what seems like an infinity of alternative viewpoints. Moore collaborated with the architect I.M. Pei in siting a larger version of **Three Piece Sculpture: Vertebrae** close to Pei's new City Hall in Dallas in 1978 (known locally as *Dallas Piece*), placing the three elements to form an inward-looking group through which people can walk.

Norbert Lynton

1. Warren Forma, *Five British Sculptors: Work and Talk*, Grossman, New York 1964, p.59.
2. Hedgecoe (ed.) 1968, p.351.
3. Berthoud 1987, pp.307-8.

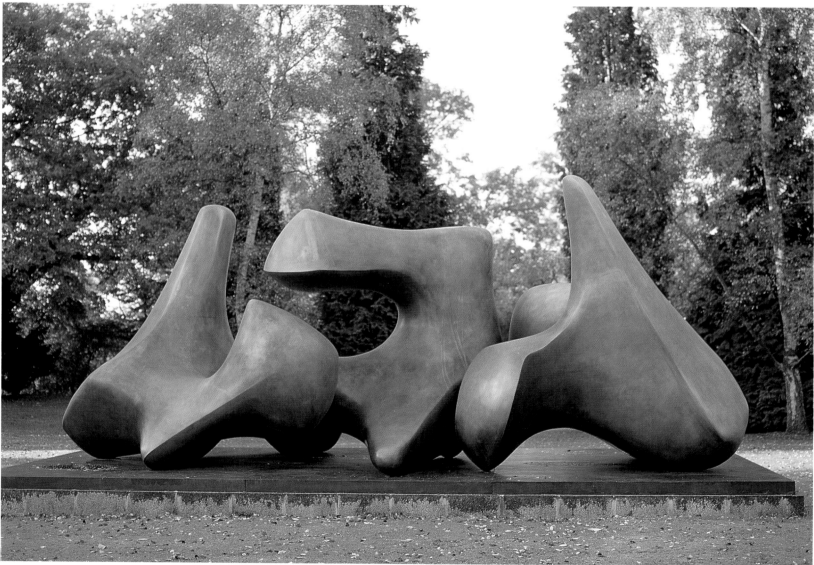

216

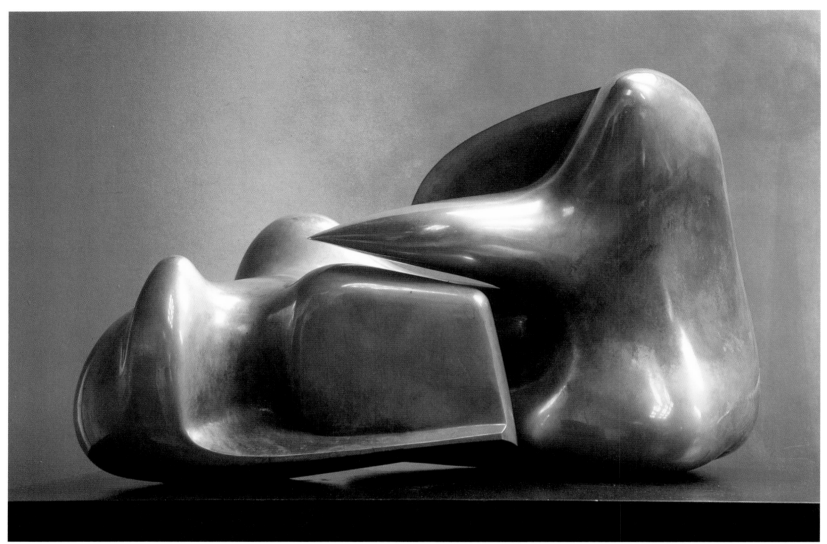

217

217
Two Piece Sculpture No.10:
Interlocking 1968
LH 581
bronze edition of 7 + 1
cast: Hermann Noack, Berlin
length 91.4cm
signature: stamped *Moore, 0/7*
Gift of the artist 1977

exhibitions: Buntingford 1980 (cat.5);
Madrid 1981 (cat.72); Lisbon 1981 (cat.108);
Barcelona 1981-82 (cat.67); Mexico City
1982-83 (cat.47); Caracas 1983 (cat.E114);
Honolulu 1983; Hong Kong 1986 (cat.152);
Tokyo/Fukuoka 1986 (cat.95); Chandigarh/
Bombay/Baroda/Bhopal/Madras/
Bangalore/Calcutta/Jaipur 1987-88 (cat.5);
Budapest 1993 (cat.106); Bratislava/Prague

1993 (cat.106); Krakow/Warsaw 1995
(cat.105); Venice 1995 (cat.106); Bremen/
Berlin/Heilbronn 1997-98 (p.54)
loans: London, Government Art Collection,
for 10 Downing Street 1992-93

For much of his career Moore was to
alternate between the techniques of carving
and modelling, exemplifying the ancient
principle of using both a *levare*
(subtraction) and a *mettere* (addition)
technique. The artist used this principle for
the making of plasters to be used
subsequently for casting. Towards the end
of the 1960s, however, before the great
Florentine exhibition of 1972, Moore was to
make greater exclusive use of the levare
technique, as he had done in his youth,
when most of his work was directly carved

in stone rather than cast in bronze.

Anthropomorphism and freely created
forms engage with each other in great
simplicity, engendering an element of
mystery in the work of the otherwise
pragmatic and rational Moore. Additionally
during this period Moore experimented
with the new theme of interlocking shapes
– generally two or three shapes at once. In
the earlier figures in several parts, shapes
were carefully dislocated from each other
on a flat plane in order to present a
succession of viewpoints where the voids
played as much a part of the composition as
the solids. 'There's a bigger surprise, you
have more unexpected views', commented
the artist.[1] In the series of 'interlockings',
however, forms are clenched to one
another with a sense of possessive

sexuality. Indeed, in the work shown here this synthesis of two shapes, with their smooth softness and their enveloping curves, can hardly fail to suggest the anatomy of a female body, while still maintaining an abstract metamorphosis from biomorphic to tectonic. Moore himself urged the reflection, 'Knees and breasts are mountains.'[2]

Giovanni Carandente

1. This statement appeared in Huw Wheldon, *Monitor: An Anthology*, Macdonald, London 1962, quoted in James (ed.) 1966, p.266; 1992, p.285.
2. Ibid.

218
Upright Motive No.9 1979
LH 586a
bronze edition of 6 + 1
cast: Morris Singer, Basingstoke
height 335.5cm
signature: stamped *Moore, 0/6*
Acquired 1986

exhibitions: Wakefield 1987 (cat.22); New Delhi 1987 (cat.96); Paris 1992 (cat.14); Wakefield 1994-95 (cat.10)
loans: Gland, World Wildlife Foundation Headquarters 1984-87; Wakefield, Bretton Country Park from 1995

publications: Spender 1986, p.80; Cohen 1993, pl.XLVIII

Each of the **Upright Motives** [see cats.175-177] that Moore created had an organic unity as the forms were piled on top of one another. The cruciform reference of the first (LH 377) was eliminated in the later pieces, and this, perhaps more than any of the others, resembles a female figure.

The piece is organic and the forms look weathered. When placed in an appropriate setting, it gives the impression of being an ancient figure which has weathered time. The bulbous figure is also reminiscent of fertility goddesses of prehistory such as the Venus of Willendorf. Moore's goddess is monumental and majestic; she grows from the earth as she gazes out over the landscape. Moore wrote: 'There are

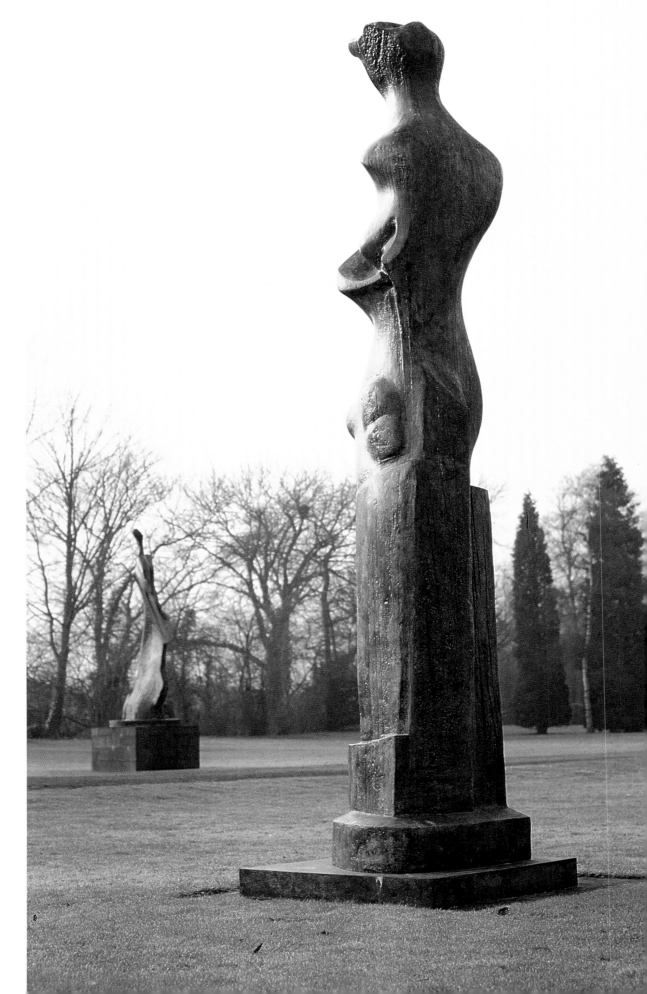

cat.218

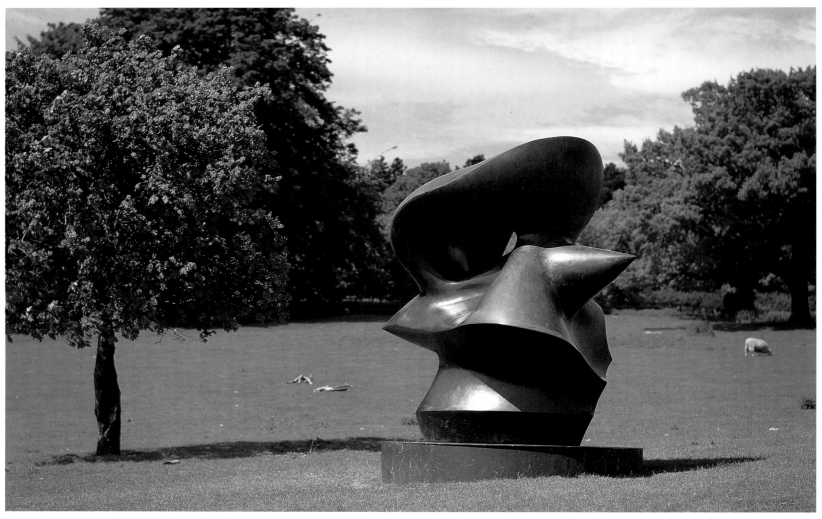

cat.219 exhibited in Wakefield, 1994-95, on loan 1996-97

universal shapes to which everyone is subconsciously conditioned and to which they can respond if their conscious control does not shut them off. The less articulate, the more mysterious the forms the better. Words, exactness, literal descriptions, when probing the mysteries are dangerous and, in the long run destructive.'[1]

The placement of the sculptures was also critical to Moore, and his sense of the environment and attention to placement and installation served as a model for many of the artists who were later to create environmental art projects.

Gail Gelburd

1. Quoted in Charles S. Spencer, 'The Phenomenon of British Sculpture', *Studio International*, March 1960, p.99.

219
Large Spindle Piece 1974
LH 593
bronze edition of 6 + 1
cast: Hermann Noack, Berlin
height 335cm
signature: stamped *Moore, 0/6*
Acquired 1986

exhibitions: Wakefield 1994-95 (cat.12)
loans: London, British Council, Spring Gardens 1981-94, 1998; Wakefield, Bretton Country Park 1995-97

publications: Spender 1986, p.94

Whoever came up with the title **Large Spindle Piece** could not have made a more inspired choice. The inherent rotational movement of a spindle describes equally the internal and external twisting of this

work. Thus, like hacked-out tips, the voids extend dynamically, at the same time seeming to screw into the interior opening. We are struck with wonder at how the external and the internal are able to maintain their balance despite the dynamic twisting.

This phenomenon conceals new findings: in 1968, Moore received an elephant's skull as a gift from Juliette Huxley. Elephants were seen as bearers of wisdom not only in the iconic tradition of contemporary art, but also literally if you look at them 'down to the bone'. Moore was able to use this skull to further his study of bones which he had been making with untiring enthusiasm for thirty-five years. This opened up new insights for him into the depths of an invisible 'architecture' in which every detail is in harmony with the whole. Among his 'elephant skull' sketches from 1970 are illustrations which, with their

similarly diversely guided movements of form and space twisting around and into each other, can be seen to coincide with **Large Spindle Piece**.

Christa Lichtenstern

220
Oval with Points 1968-70
LH 596
bronze edition of 6 + 1
cast: Morris Singer, Basingstoke
height 332cm
signature: stamped *Moore, 0/6*
Gift of the artist 1977

exhibitions: Hamburg 1980; Wakefield 1987 (cat.23); Martigny 1989 (cat.p.220); Milan 1989-90 (p.65); Glasgow 1990; Paris 1992 (cat.15); Wakefield 1994-95 (cat.8)
loans: Leicester, University of Leicester 1980-87; Croydon, Queens Gardens 1988-89; Wakefield, Yorkshire Sculpture Park 1992-94; Wakefield, Bretton Country Park from 1995

publications: Cohen 1993, pl.VIII

Tense, dramatic and bulging with energy, this sculpture represents one of the most successful abstract forms which Moore explored at the end of the 1960s. It has its origins in a sculpture of 1939-40 entitled **Three Points** [cat.110] which Moore had also explored in a drawing in 1938 on which he had noted 'points practically touching'.[1] He then went on to work up the idea in a further drawing of 1940 (HMF 1496) in which both **Three Points** and a shape which is extremely closely related to **Oval with Points** are to be found.[2] Alan Wilkinson notes that Moore was anxious not to look to a single source for the inspiration of his sculptures and told Wilkinson that the ideas in the pointed form drawings 'were based on the memory of many things, such as for example, sparking plugs'.[3] Wilkinson himself thinks that the idea for **Oval with Points** was suggested by a small stone he saw in Moore's studio showing two points touching at the centre of a hollowed-out form.[4]

Whatever the truth behind the source

for the sculpture, the germ of the idea was clearly in Moore's head as early as 1939, and it is quite remarkable that he could work on an idea and then leave it dormant for as long as thirty years before taking it up again and translating it into a sculpture. There are a number of works related to **Oval with Points**, including **Large Spindle Piece** [cat.219] and **Two Piece Points: Skull** 1969 (LH 600) which also have the combination of rounded, full forms and, in the case of the latter two, sharp points, although the points face outwards. Here the points strain towards each other but fail to meet, giving a dynamic tension to the voluptuous forms of the exterior of the sculpture. The difference between **Oval with Points** and the other closely related works mentioned is that here the dynamic harmony is absolutely successful; there is

no suggestion of aggression in the points, which grow out of the exterior towards the interior in a tense but organic movement. The unevenly weighted holes above and below the points seem to suggest the division between a head and torso.

This sculpture has been extremely successfully sited out of doors in both landscape and urban settings. Certain sculptures look better in either a landscape or an urban site, but this work – perhaps because of the organic origins of the form – succeeds in transcending the boundaries.

Julie Summers

1. **Drawing for Sculpture with Points** 1938 (HMF 1417).
2. **Pointed Forms** 1940 (HMF 1496).
3. Wilkinson 1987, p.232.
4. Ibid.

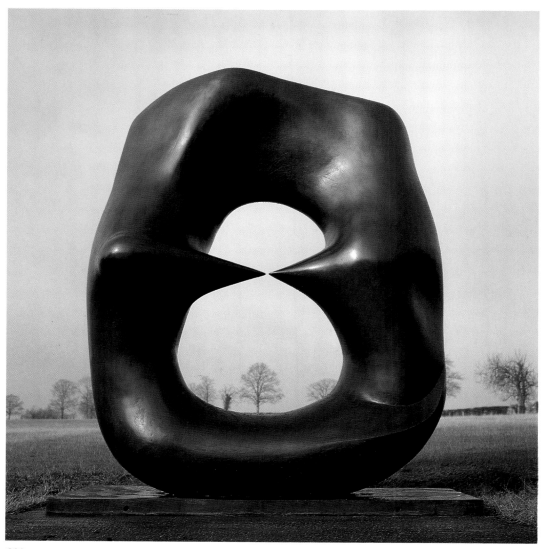

220

221

Maquette for Square Form with Cut
1969
LH 597
bronze edition of 9 + 1
cast: Fiorini, London
height 16.5
signature: stamped *Moore, 0/9*
Gift of Irina Moore 1977

exhibitions: Slovenj Gradec/Belgrade 1979-80 (cat.3); Selb/Amberg/Hamburg 1980 (cat.7); Madrid 1981 (cat.80); Lisbon 1981 (cat.100); Folkestone 1983 (cat.14); New Delhi 1987 (cat.105); Milan 1989-90 (p.66); Sydney 1992 (cat.131); Pforzheim/Bad Homburg 1994 (cat.16)

This is a maquette for the most monumental of the sculptures shown at the Forte di Belvedere exhibition in Florence in 1972. Even the modestly sized maquette clearly reveals the artist's intention of creating a work embodying square and architectural shapes.

The huge marble version of this piece, **Large Square Form with Cut** 1969-71 (LH 599), was realised after a trial version in expanded polystyrene was produced to test the volumetric impact of the sculpture. The work, supervised by the artist, was carried out at Henraux in Querceta. A white marble was chosen from the Cava Mossa in the Monte Altissimo, the same mountain that in the past had been the home of the now vanished caves used by Michelangelo as the source for the marble for his Julius II tomb.

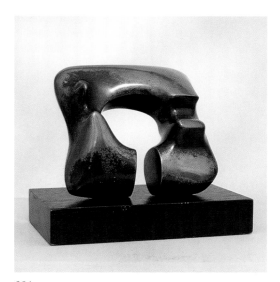

221

Consisting of thirty blocks, Moore's massive sculpture achieved the considerable weight of one hundred and seventy tonnes. After the exhibition, in which the sculpture was positioned on one of the bastions of the Forte in dramatic contrast with the cityscape below, it was acquired by the City of Prato, with financial help from local industry. There is also an intermediate version of this work, in black marble, now in a private collection in Spain.

Giovanni Carandente

222

Two Piece Reclining Figure: Points
1969
LH 606
bronze edition of 7 + 1
cast: Hermann Noack, Berlin
length 365cm
signature: stamped *Moore, 0/7*
Gift of the artist 1977

exhibitions: London 1978 (cat.10); Hong Kong 1986 (cat.161); Tokyo/Fukuoka 1986 (cat.6); Wakefield 1987 (cat.24); Paris 1992 (cat.16); Wakefield 1994-95 (cat.15)
loans: Aldeburgh, Aldeburgh Foundation, for Snape Maltings 1979-86, 1988-92; Cambrai, Musée de Cambrai 1987-88; Wakefield, Bretton Country Park 1995-97

publications: Cohen 1993, pl.XVII

Building upon the experience of the *Henry Moore and Landscape* exhibition in the Yorkshire Sculpture Park in 1987, it was possible in 1994 to use the adjacent Bretton Country Park for a display on a semi-permanent basis of a number of Moore's monumental sculptures. Designed as the Deer Park within the original Bretton Estate, it was planned as a grand and romantic entrance to Bretton Hall. This hundred-acre site is very different from the parkland setting of the main Sculpture Park. From the northern tip an acutely angled gradient sweeps down to the lake. There are hillocks and hollows, and the trees, although occasionally grouped, exist mostly in isolation, providing large open spaces with green waves of undulating rough pasture, textured by thistles, some nettles, the occasional tree stump and many sheep.

At first the Deer Park seemed unpromising. There was little cover, with few intimate or enclosed areas, normally considered to be essential ingredients to provide concealment and the element of surprise when planning open air exhibitions. From any given position many sculptures would be seen at a glance, so lengthy reconnaissance was important to gain an understanding of levels and vistas and a sense of place.

Frequently criss-crossing the hundred acres of land with Moore's assistants inevitably brought back memories of the artist's first visit to Yorkshire Sculpture Park, and reflections on his statements about sculpture and landscape became more meaningful as locations were gradually identified. As our understanding of the terrain unfolded it was possible to imagine the impact of this designed landscape on early travellers entering the Bretton estate. As horses and carriages negotiated the contours of the landscape, moving steadily forward through the Deer Park to the more cultivated land surrounding the mansion, views of distant fields and hills and the glint of lakes would have emerged and re-emerged. The spatial awareness of past landscape designers provided a context for some of Moore's statements: 'Sculpture is like a journey. You have a different view as you return. The three-dimensional world is full of surprise in a way that a two-dimensional world could never be . . . '[1]

The whole approach to exhibition planning had to be rethought. The space called for a limited number of sculptures, each capable of sustaining sculptural self-sufficiency in this less cultivated domain. Different levels, small hillocks, dells and miniature plateaux were discovered as sixteen sculptures[2] were plotted into the topography of the site.

The siting of sculpture on this scale and in this type of landscape reflects the pace and some of the practical problems connected with the making of monumental sculpture. The installation is a slow

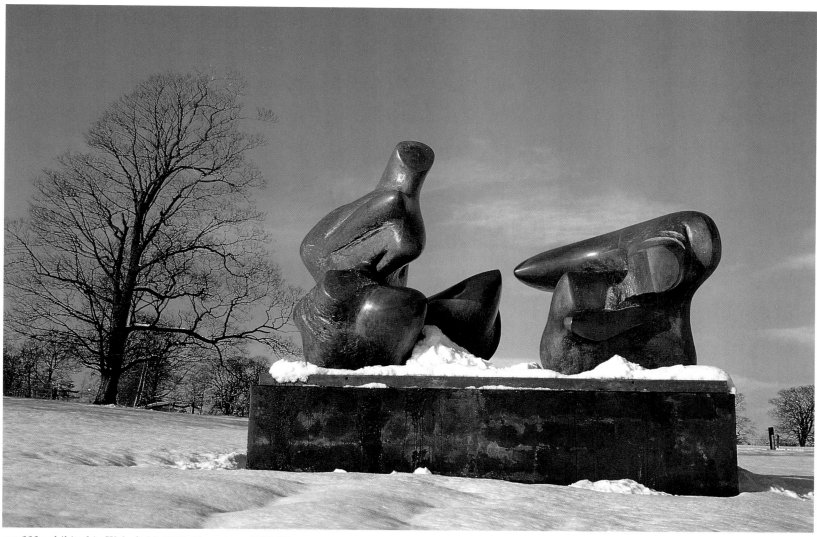

cat.222 exhibited in Wakefield, 1994-95, on loan 1996-97

business, requiring thoughtful solutions to the technical problem of moving large works across rough terrain. For the viewer this is an excursion into the landscape requiring time and patience, not only to deal with the intellectual demands of the work, but also the physical conditions of the site. Lack of shelter from the weather, few pathways and the feel of uneven pasture under foot all add to the experience. To view some sculptures requires a pleasant stroll, while others demand a more physical effort to clamber up the uneven inclines, particularly to reach works on the tip of the northern slope where **Two Piece Reclining Figure: Points** was sited. Like most of the sculptures it first came into view from a long distance. Initially perceived as two jagged rocks against the sky, the huge girth of the forms was revealed after a twenty-minute walk. The vastness of the surrounding space increased rather than diminished the volume of the sculpture, particularly when the work was explored from every angle. From the back the two forms seemed like large boulders imbued with a human presence, echoing the scale and lay-out of the panoramic landscape beyond. Lashed by wind and rain, the forms seemed to relish contact with the elements as a validation of their organic roots. They appeared to expand and grow in the wild open space of the landscape where it was possible to comprehend the gigantic achievement of Moore and his acute understanding of scale.

Two-Piece Reclining Figure: Points provided a bird's-eye view of the far-flung disposition of other sculptures. The vast sculpture **Large Two Forms** [cat.211] seemed to grow out of the landscape as the two separated forms like giant pelvic bones responded to one another with rhythmic harmony. To the west, some way away, **Large Spindle Piece** [cat.219] was perched on a ridge, surrounded by sheep and soft grass and appearing deceptively gentle. The distance masked the internal drama of this work, and a closer encounter was required to witness the spindle points bursting out of the centre. The almost ungainly side view of **Oval with Points** [cat.220] could also be glimpsed from here, but again a good walk was required to view the full frontality of this elegantly composed sculpture which was, and remains, sited to emphasise the perspective of the Dearne valley.

Dug into the hillside the Tate Gallery's **Three Piece Reclining Figure No.1** 1961-62 (LH 500) can be seen in the distance,

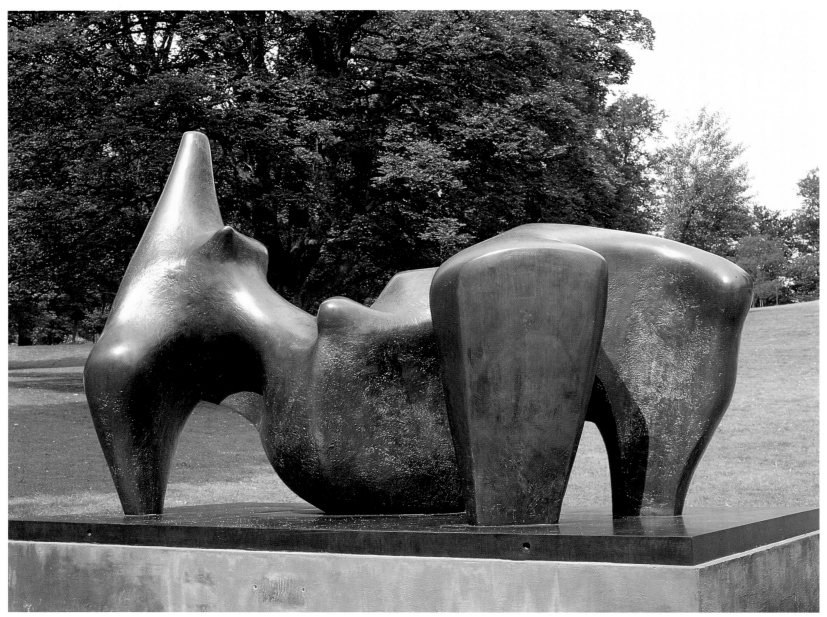

cat.223 exhibited in Wakefield, 1987

framed between two ancient oaks. The natural light plays upon the angular bony nature of the three forms, delicately posed on the base. As the sculpture is approached, the cragginess of the forms is revealed without distracting from the unity and balance of the composition. A twenty-minute walk eastward brings into view the smaller cliff-like forms of **Two Piece Reclining Figure No.2** [cat.191]; its darker patination is more reminiscent of coal, mined for many centuries from the earth beneath Bretton, than of bronze. Closer at hand is a fibreglass cast of **Locking Piece** 1963-64 [cat.203], glistening against the

woodland hills. Beyond this, and separated by a clump of trees, was the magnificent **Hill Arches** [cat.232] which, as described by David Sylvester, 'with its flamboyant energy, its superb symmetry, its coiled tension, its predatory menace, its formality and its sheer magnificence, is like an especially ritualistic and flashy mating display.'[3]

Although the exhibition *Henry Moore and Landscape* provided great insight into the development of the artist's work, the monumental sculptures sited in Bretton Country Park generate a much clearer understanding both of Moore's desire to

place sculpture in the landscape and of his awesome talent. The landscape at Bretton has been rediscovered and the sculptures revitalised. Its spaces, unlimited and uncultivated, enable the sculptures to draw strength from the natural environment, and both sculpture and landscape are enriched.

Peter Murray

1. Hedgecoe (ed.) 1968, p.266.
2. LH 297a, 383, 400, 450, 458, 489b, 500, 515, 556, 586a, 593, 596, 606, 610, 636, 822.
3. Wakefield 1994-95, p.25.

223
Reclining Figure 1969-70
LH 608
bronze edition of 6 + 1
cast: Hermann Noack, Berlin
length 343cm
signature: stamped *Moore, 0/6*
Acquired 1987

exhibitions: Wakefield 1987 (cat.25); Paris 1992 (cat.17)
loans: Wakefield, Yorkshire Sculpture Park 1988; Aldeburgh, Aldeburgh Foundation, for Snape Maltings 1993-97

publications: Cohen 1993, pl.XIV

Throughout his life Moore had been engaged in a continual search within the repertoire of shape: not only the natural and physical shape of the human body, but also the shape of a stone, a pebble, an animal's skeleton or an outline of rock. As a result of his never-ending search the artist has often broken the boundaries of each visual category, giving life to works like this monumental **Reclining Figure**. The sinuous figurative forms of the sculpture suggest the massive density of rock or architecture while retaining the sensual characteristics of a reclining female body. This ambiguity in Moore's work is shortlived, however. His later pieces are classical and reflective, rather than demanding psychological interpretation. In this piece the organic themes of sex and fertility unite with an architectural structure epitomised by the mechanical strength of the curve. A protruding breast points at the sky like the top of a mountain. The sculpture is imbued with vigour, monumentality and inner energy, and its form is posed within the fluctuating movement of its profile. The dialogue between empty and occupied space gives the piece dynamism and agility. Likewise there is a play of contrast where smooth and translucent planes alternate with porous or rougher surfaces, emphasising the duality of the unremitting opposition of the organic to the mechanical, of the senses to reason, of awareness to unconsciousness.

Giovanni Carandente

224
Reclining Figure: Arch Leg 1969-70
LH 610
bronze edition of 6 + 1
cast: Hermann Noack, Berlin
length 442cm approx.
signature: stamped *Moore, 0/6*
Acquired 1987

exhibitions: Milan 1989-90 (pp.68,69); Glasgow 1990; Paris 1992 (cat.18); Wakefield 1994-95 (cat.9); Venice 1995 (cat.110)

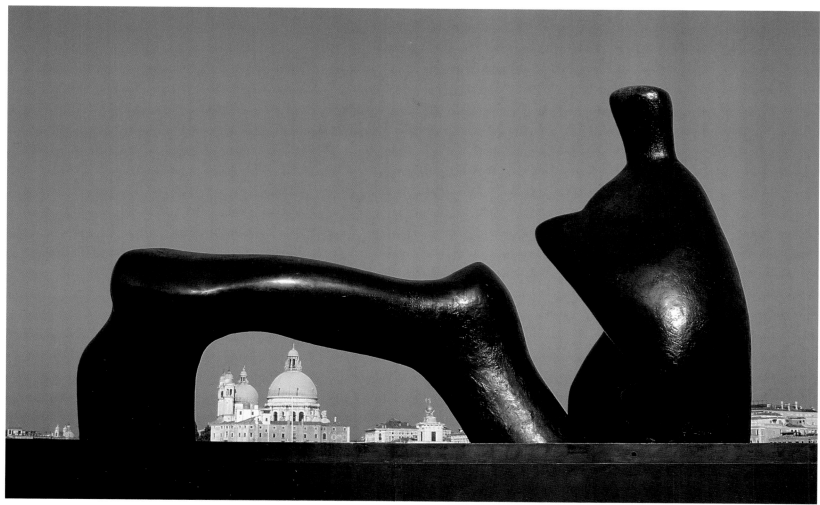

cat.224 exhibited in Venice, 1995

loans: Croydon, Queens Gardens 1987-89;
Wakefield, Yorkshire Sculpture Park
1992-94

publications: Cohen 1993, pls.XV, XVI

This reclining figure, one of the largest in
that extraordinary sequence that first began
to preoccupy Moore rather more than forty
years earlier, is in formal terms one of the
simplest and most abstract. Indeed, the
lower element, by which the piece gets its
name, would be entirely abstract were it to
be seen separate from the upper-body
element, which completes and defines the
image. That element too is reduced to a
degree, the head no more than a vertical
post or bollard on top of a larger lump, that
has but a single pendulous stump for arm
and elbow, with one thrusting fist that
doubles ambiguously as breast, in token of
femininity.

 This character it shares with Moore's
other dismembered figures in the oeuvre,
those compositions of discrete and abstract
elements that so curiously add up to rather
more than the sum of their parts. This
piece, for all its simplicity, is as remarkable
as any of them, a work of extraordinary
power and imaginative force. Indeed, as
much as anything, it is its very simplicity,
amounting almost to audacity, that makes it
so powerful.

 At one end we have the strongly
vertical, hieratic emphasis of the head and
torso, as near in the work as Moore ever
gets to the cold and brutal presence of the
old Mexican *Chacmool*. This, as far as it
goes, is the part of the work that declares
itself clearly as a figure. Yet, perversely, it is
the lower, abstract part, in itself but a
vaguely organic, bone-like arch, that gives
the work as a whole its softer, humanising
quality. There is a subtle twist along its
length, and a gentle swelling in and out that
might just be the fall and sag of relaxed
flesh away from bone. On its own it would
be no more than the barest of hints. So we
come to the knees: but are they knees? Only
the context tells us so, yet there is to them
the gentlest sway away from the vertical,
knees together off to one side, the legs and
feet together implicit within that shrouding
tubular case of bronze, leaning ever so

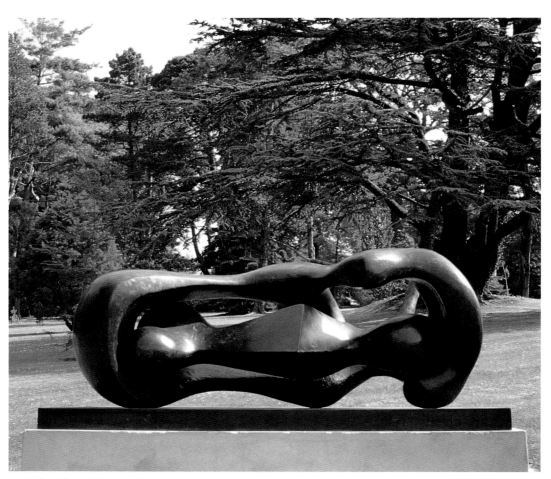

cat.225 on loan in Exeter from 1996

slightly. It is by just such nuances, such
delicacies, that the work comes alive as the
gently reclining figure it is. In a work so
self-consciously monumental, so simple
and apparently severe, such humanising
subtlety is all the more remarkable.

William Packer

225
Reclining Connected Forms 1969
LH 612
bronze edition of 9 + 1
cast: Morris Singer, Basingstoke
length 213cm
signature: stamped *Moore, 7/9*
Gift of the artist 1977

exhibitions: Wakefield 1987 (cat.26); New
Delhi 1987 (cat.112); Martigny 1989 (cat.pp
222,223); Milan 1989-90 (p.71); Paris 1992
(cat.19)
loans: Cambridge, Fitzwilliam Museum

1975-87, 1990-92, 1993-96; Exeter,
University of Exeter from 1996

publications: Cohen 1993, pl.XXXIX

Moore's initial interest in the internal/
external form was realised in a mid-1930s
series of drawings of a malangan figure
from New Ireland, Oceania. Moore wrote:
'. . . the carvings of New Ireland have,
besides their vicious kind of vitality, a
unique spatial sense, a bird-in-a-cage
form.'[1]

 Through the decades, Moore turned
from the vertical stance of his internal/
external forms to renderings of this motif in
a horizontal position, which now became a
reclining figure. In this highly abstracted
sculpture, the internal and external
sections look more like a landscape
element than a human figure. The
undulating external form appears cave-like,
its wall structure hollowed out through the
natural force of wind or water. The interior

element solidly rests in the embrace of the form that surrounds it. The reclining figure reads as a mother either with a foetus in her womb or with a child in her embrace. The child-like form is angular in contrast to the organic flow of the 'mother'. The diamond-shaped torso of the child differs sharply from the organic rhythms of the mother's form suggesting that it is still in the 'rough', not yet completely shaped, but rather emerging, still to find its form.

Deborah Emont-Scott

1. James (ed.) 1966, p.159; 1992, p.161.

226
Three Seated Mother and Child Figures 1971
HMF 3314
charcoal, pen and ink, wash on off-white heavyweight wove
302 × 430mm
signature: felt-tipped pen l.l. *Moore 71*
[*M* overwritten with ballpoint pen]
Gift of the artist 1977

exhibitions: Paris 1977 (cat.215); Toronto/ Iwaki-Shi/Kanazawa/Kumamoto/Tokyo/ London 1977-78 (cat.238); Bonn/ Ludwigshafen 1979-80 (cat.42); Madrid 1981 (cat.D183); Lisbon 1981 (cat.D182); Barcelona 1981-82 (cat.D146); Mexico City 1982-83 (cat.D80); Caracas 1983 (cat.D84); New Delhi1987 (cat.114); London 1988 (cat.207); Leningrad/Moscow 1991 (cat.94); Helsinki 1991 (cat.94); Budapest 1993 (cat.107); Bratislava/Prague 1993 (cat.107); Nantes 1996 (cat.93); Mannheim 1996-97 (cat.93)

This is the darkest and most sinister of a number of drawings of mothers and children that Moore made in 1971 (see for example HMF 3313) and it makes an interesting comparison with the ten studies of **Mother and Child** [cat.113] from 1940 discussed earlier. In that drawing the mother and child are given equal weight as sculptural forms; here the less-than-human children seem welded to the mothers. Though non-naturalistic, the heads of the earlier mothers appear concerned with

their offspring; the mothers here turn their bone-formation-heads upwards, as though terrified of some dreadful fate. Though reduced in colour, the early drawing is suffused with light; the later one depends on gradations of black from which the sculptural groups emerge.

Moore's exploration of degrees of black has been compared with drawings by Seurat which he collected in the early 1970s.[1] But the doom conveyed by these figures and their distorted babies may also relate to the generally felt apprehension for the future of humans in those years in view of the threat of radiation from nuclear weapons and the unexpected and terrible effects that the drug thalidomide had produced on babies in the womb. In the 1930s Moore had explored states of mind, attempting like the Surrealists to visualise emanations from the unconscious: by the 1970s internal fears had become externalised by sinister forces which lay beyond the control of conscious or unconscious mind.

Susan Compton

1. London 1988, p.274, cat.207 and pp.281-2, cat.221.

227
Classical Landscape with Temple
*c.*1972
HMF 3436
crayon, chalk, charcoal on medium-weight off-white wove
213 × 290mm
signature: ballpoint l.r. *Moore*; l.l. *Moore*
Gift of the artist 1977

exhibitions: New York 1979-80 (cat.36); London 1988 (cat.206); Sydney 1992 (cat.140); Havana/Bogotá/Buenos Aires/ Montevideo/Santiago de Chile 1997-98 (cat.91)

One of the hallmarks of Moore's aesthetic is the symbiosis he achieved of figure and landscape. The reclining female figure is, invariably, at some imaginative or formal level, a representation of hills, valleys, caves. A landscape setting was often crucial to his initial conception of a sculptural idea, as the drawings and sketchbooks attest. Famously, he defined sculpture as 'an art of the open air'.

Increasingly in his later career he made depopulated landscape drawings: studies of trees, fields with grazing sheep, cloudscapes, and imaginary geological

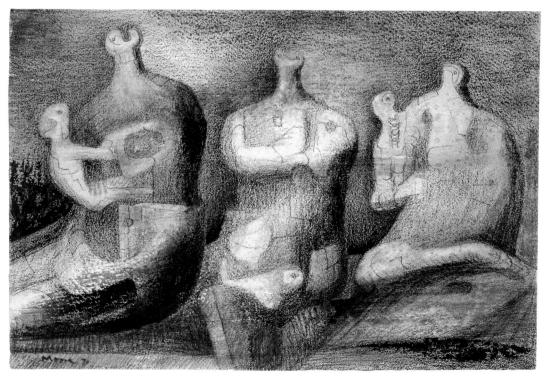

226

227

terrains like this one. This is billed as a 'classical landscape', but really it is only the temple that makes it such; with its crowd of irregular, writhing forms and its brooding tones it has all the attributes of a romantic, sublime landscape. The temple, according to Moore, was one of the devices he liked to use to humanise his landscapes – church steeples were another.

At one level, however, this landscape is already supremely human. Just as his reclining figures hold associations with the land, so that legs can appear to be eroded cliffs, in this drawing the geological forms are imbued with the erogenous qualities of limbs, as Moore superimposes one form consciousness upon another. The foreground rocks have some generalised qualities of arms and legs, but it is hard not to read the stretch of terrain in the background as a more specific depiction of a reclining woman. The temple rests on what would be the buttocks, while the dip to its right is like the small of her back giving way to the sharp rise of her upper back and shoulders. If anything, this part is more legible as a body than as landscape. We are enticed into reading the drawing as

John Ruskin looked upon mountain ranges, seeing there 'heaving bosoms and exulting limbs'.

David Cohen

228
Bird Form I 1973
LH 623
black serpentine
length 36.8cm
unsigned
Gift of the artist 1977

exhibitions: Madrid 1981 (cat.87); Lisbon 1981 (cat.140); Forte dei Marmi 1982; Spoleto 1982 (cat.1); Basel 1982 (cat.2); Paris 1983 (cat.4); Hong Kong 1986 (cat.117); Tokyo/Fukuoka 1986 (cat.105); New Delhi 1987 (cat.121); Wakefield 1994; Nantes 1996 (cat.94); Mannheim 1996-97 (cat.94); Bremen/Berlin/Heilbronn 1997-98 (p.124)

publications: Strachan 1983, pl.28

229
Bird Form II 1973
LH 624
black serpentine
length 34.3cm
unsigned
Gift of the artist 1977

exhibitions: Madrid 1981 (cat.88); Lisbon 1981 (cat.141); Forte dei Marmi 1982; Spoleto 1982 (cat.2); Basel 1982 (cat.3); Paris 1983 (cat.5); Hong Kong 1986 (cat.118); Tokyo/Fukuoka 1986 (cat.106); New Delhi 1987 (cat.122); Wakefield 1994; Nantes 1996 (cat.95); Mannheim 1996-97 (cat.95); Bremen/Berlin/Heilbronn 1997-98 (p.125)

publications: Strachan 1983, pl.27

As nature repeats form, not caring whether it is vegetable, mineral or animal matter, so too did Moore, utilising natural forms through his beloved found objects as an indispensable basis for the creation of many of his sculptures. He transformed the *objets trouvés* by means of artistic vision into sculpture, documenting the intellectual process of 'making' sculpture in his graphic work, although his work on paper must not be seen as the usual 'studies for sculpture'. His drawings are autonomous works of art, independent, having little to do with the notion of sculptors' drawings. They are often drawings of sculpture.

Moore's continuity in his artistic thinking is documented in **Bird Form I** and **Bird Form II**, both enlarged in marble from a small maquette **Fledglings** 1971 (LH 622). They have been described as expressing 'a quintessentially bird-like quality with their sharp pointed "beaks" and the compressed forms of a fledgling crouching in the nest.'[1] Both sculptures are voluminous pieces, highly abstracted, yet recognisable as 'birds' by means of Moore's ability to render his abstract works readable after his figurative approach to sculpture during the 1940s and 1950s.

The first drawings which relate to these bird forms appear in **Notebook No.6** 1926, for example **Studies of a Bird and Animal** (HMF 455 verso). On this sketchbook page, executed in delicate graphite and inscribed

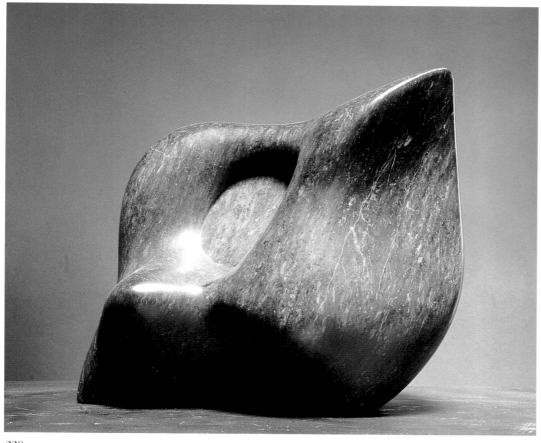

228

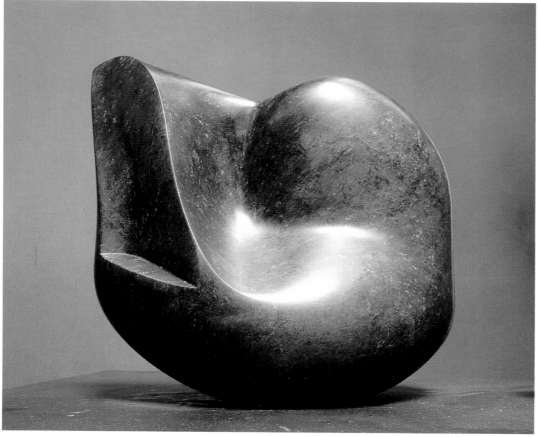

229

Fledgling along the top, the bird form is almost identical to the marble versions of 1973.

Moore kept repeating the intrinsic structure of the bird forms in other work, but modifying them by title. One of the last examples of this is a drawing of 1983 entitled **Sheep's Skull** (HMF 83 (111)). In this work, executed in charcoal, chalk and ballpoint pen, the skull assumes the same volume and shape as the drawing of 1926 and the sculptures of 1973, with the eye of the sheep echoing the eye of the bird, and the bone, pointedly protruding from the skull, identical to the birds' open, hungry beaks. Formally, in both his drawings and sculptures, Moore applied the principles he knew so well of volume, balance and light and shade to this particular image which remained throughout his artistic life.

Reinhard Rudolph

1. Allemand-Cosneau, Fath, Mitchinson 1996, p.157.

230
Sheep Piece 1971-72
LH 627
bronze edition of 3 + 1
cast: Morris Singer, Basingstoke
height 570cm
signature: stamped *Moore, 0/3*
Gift of the artist 1977

exhibitions: London 1977 (cat.34); London 1978 (cat.12); Bremen 1997 (pp.150,151)

publications: Strachan 1983, pls.XI, XII; Spender 1986, p.109

This is another piece which was done long after my time at Perry Green. I've always admired it; it's so certain, so grand, powerful. It's a very moving piece and it looks lovely in the countryside. It has huge presence. When I saw it at Perry Green there were sheep grazing round about it and in it; this enhanced the work. That's something I very much like in sculpture, that it's not just standing there but, especially on this scale, having a relationship with living activity. The forms of **Sheep Piece** are grand and rich, and it

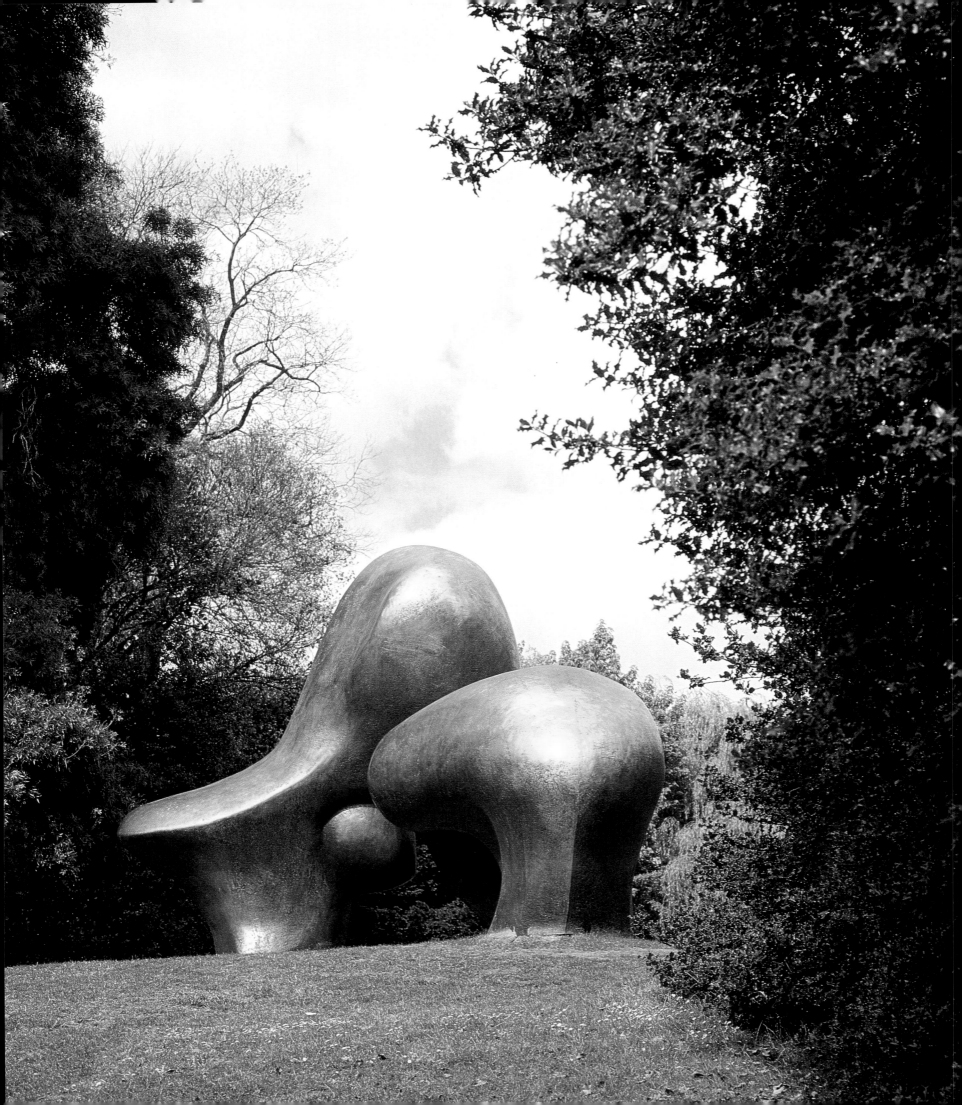

has naturally become part of the environment.

The fact that children have been playing on my big sculpture pleases me. That's one important side of public sculpture for me, that people want to and do interact with it. I think sculpture, to be expressive, has to have meaning in people's lives. If it's big, if it's public, it has to belong to its place.

When I was there Henry wasn't making sculptures specifically to go in the landscape. Soon after I left, he placed a white sculpture at the end of a field at Perry Green, a field with dark hedges: it looked wonderful. Henry really understood how to place sculpture, and he knew how it should sit in the landscape. He was never nostalgic or sentimental about landscape. I am sure he was less concerned with landscape than the Cornish painters: I never once heard him enthuse over landscape or views. The St Ives artists' work echoes their own landscape. Henry's doesn't, it's simply that his sculpture fits very well into a landscape setting. Unfortunately I feel that it's been allowed to become a given for all sculpture of all types – as if putting sculpture in a landscape setting, a park, a sculpture garden, will necessarily be a good way to display it. You can go with the landscape like Moore did or you can go against the landscape like architecture does. But that's no reason to place any piece of sculpture in nature – that misreading has come about in recent years largely I guess because Moore's work looks good in the landscape. You have to be much more

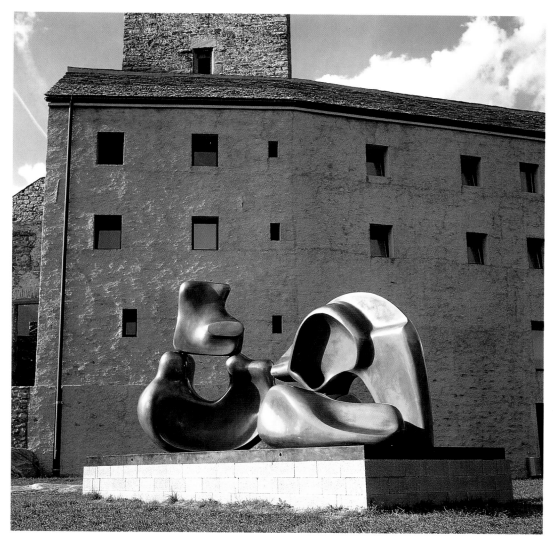

cat.231 exhibited in Bellinzona, 1995

careful. Against the sky large sculpture often visually blows away. Sculpture requires a setting to allow it to be looked at carefully and in peace; sculpture needs containment. It's got to be thoughtfully placed and it's got to be the right sculpture, the right size, the right material, the right colour for its position. Outdoor placement of sculpture requires just the same care and adjustment as setting up an exhibition in a gallery.

Anthony Caro

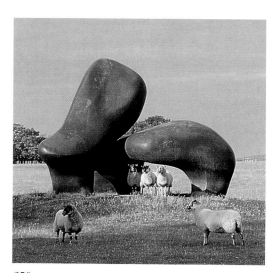

230

opposite: cat.230 exhibited in London, 1977

231
Large Four Piece Reclining Figure
1972-73
LH 629
bronze edition of 7 + 1
cast: Hermann Noack, Berlin
length 402cm
signature: stamped *Moore, 0/7*
Acquired 1987

exhibitions: London 1988 (cat.190); Bellinzona/Naples/Bologna 1995-96

The suave bumps and curves of this sculpture tempt the hand to offer a caress. It is an appeal to our sense of touch and all that implies. Though each section is independent, together they generate a communal life. It has become a nest of sculptures, but conceived on a gigantic

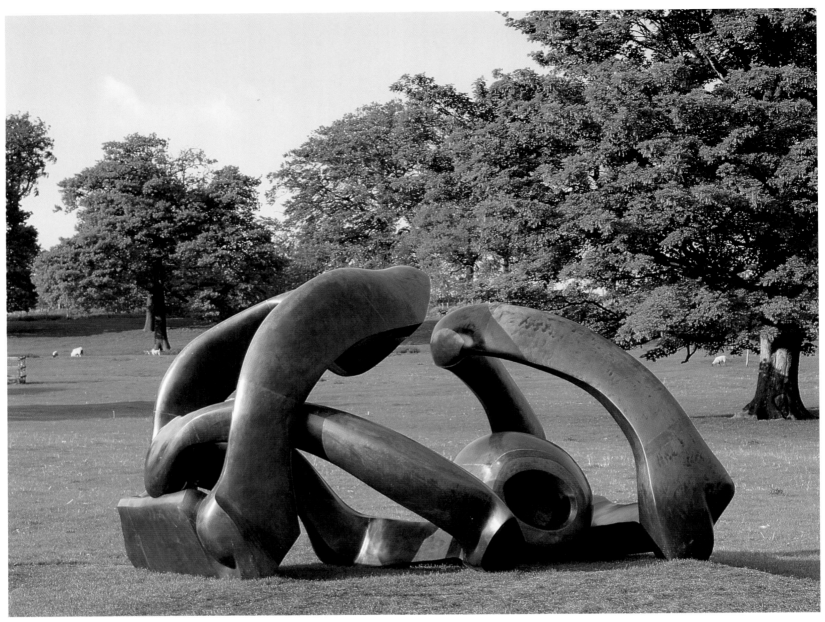

cat.232 exhibited in Wakefield, 1995-97

scale. That feeling of touching is very important as one becomes aware of the points of contact, where one form rests upon another.

The reclining figure has been the most enduring of Moore's themes, whether it be realistic and draped in a single piece or, more expressively, divided and identified with landscape. The mind is left free to fill in the spaces between each segment. The **Large Four Piece Reclining Figure** is one of Moore's most abstract inventions and almost Surrealistic in its effects. There is a wonderful tension between the tangible and the intangible. Moore never committed himself to the sectarian factions and arguments that disturbed the progress of the Modern Movement. His awareness of the whole range of effective sculptural statements was an innate and constant factor in his mind. His purpose was to invent and experiment as his imagination suggested.

I remember sitting with him one evening in the garden of an Italian hotel enjoying an aperitif. He wanted to explain to my wife and myself his reasons for working with multiple forms. He reached out for a plate of potato crisps. In a few moments they had been arranged into a variety of intriguing compositions. In a similar way I have watched him working with his assistants on the crest of a hill that he had built beyond his studios, trying out the separate parts of his multiple sculptures, this way and that way.

When reduced in size, versions of such pieces have the appeal of jewellery. We can see Moore the designer at work. On a full scale, with the impressive dimensions that this work has, the merely decorative becomes something else and is very powerful, elemental and overwhelming.

John Read

232

Hill Arches 1973
LH 636
bronze edition of 3 + 1
cast: Hermann Noack, Berlin
length 550cm
signature: stamped *Moore, 0/3*
Gift of the artist 1977

exhibitions: Paris 1977 (cat.116); London
1978 (cat.14); Hamburg 1980; Madrid 1981
(cat.4); Lisbon 1981 (cat.7); Wakefield 1987
(cat.27); Paris 1992 (cat.20); Wakefield
1994-95 (cat.4)
loans: Port Talbot, Welsh Sculpture Trust,
for Margam Park 1983-85; Wakefield,
Bretton Country Park 1995-97

publications: Spender 1986, p.79; Cohen
1993, pls.XLI, XLII

It is hard to get a handle on this work. One
could be persuaded, almost, that it's by
another sculptor: a perfectly talented artist,
for sure, as it's intriguing, graceful and
richly suggestive. But I feel it is highly
typical of Moore.

Although the equation of woman and
landscape was of fundamental concern to
him, **Hill Arches** is exceedingly difficult to
construe in figural terms. The best I can
manage to read are some thighs and
buttocks at the base of two of the elements,
and that is only from an angle that does not
make sense of any reclining posture. Yet
the title refers explicitly to landscape,
which makes the piece a 'landscape in
itself', a very rare thing in Moore's
sculpture (and common only in his late
drawings).

What I suppose it does relate to are
various abstract works with hints of
landscape or figuration in them, generally
with phenomenological or geometric titles:
Locking Piece [cat.203]; **Large Two Forms**
[cat.211]; **Double Oval** [cat.212]. The title
also directs us to **The Arch** [cat.200]. But all
these works have some sense of
evolutionary pattern, whether of animal or
plant growth, or of super-slow, geological
erosion. **Hill Arches** is a highly arcane
abstraction, and looks right back to work of
the 1930s when Moore's association with
the abstract camp of English Modernism

took him out of the way of his natural
proclivity, which was always to give form to
the life force.

The career of sculptures once they are
finished can sometimes patinate them with
new layers of meaning. A cast of **Hill
Arches** was selected for Moore's prestigious
commission to provide something for the
fountain outside Vienna's Karlskirche, a
Baroque church. Losing all pretence to
landscape, its curvaceous forms come to
relate to the ornate dome and the twisting
triumphal columns that flank the façade.
Ironically, this sculpture conceived in terms
of landscape has settled effortlessly into this
most urbane of settings.

David Cohen

233

Goslar Warrior 1973-74
LH 641
bronze edition of 7 + 1
cast: Hermann Noack, Berlin
length 300cm
signature: stamped *Moore, 0/7*
Gift of the artist 1977

exhibitions: Vienna/Munich 1983-84 (cat.3);
Herning 1984 (cat.3); Le Havre 1984 (cat.3);
Hong Kong 1986 (cat.130); Tokyo/Fukuoka
1986 (cat.129); Wakefield 1987 (cat.28);
New Delhi 1987 (cat.120); London 1988
(cat.191); Martigny 1989 (cat.pp.244-246);
Milan 1989-90 (p.77); Glasgow 1990; Paris
1992 (cat.21); Pforzheim/Bad Homburg
1994 (cat.20); Bellinzona/Naples/Bologna
1995-96 (cat.4)

publications: Cohen 1993, pl.XLV

In 1973-74, with **Goslar Warrior**, Moore
returned to a subject that had preoccupied
him some twenty years earlier. During the
1950s he had made four separate works on

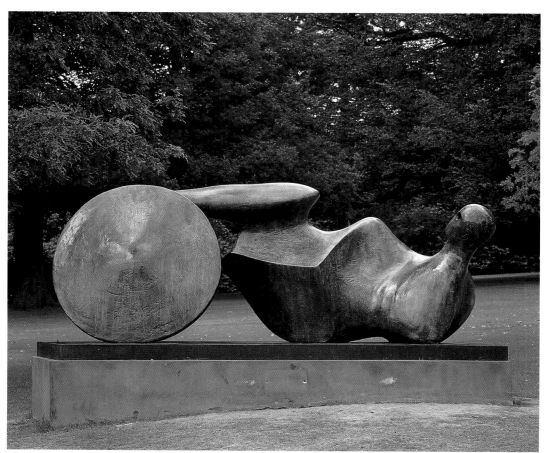

cat.233 exhibited in Wakefield, 1987

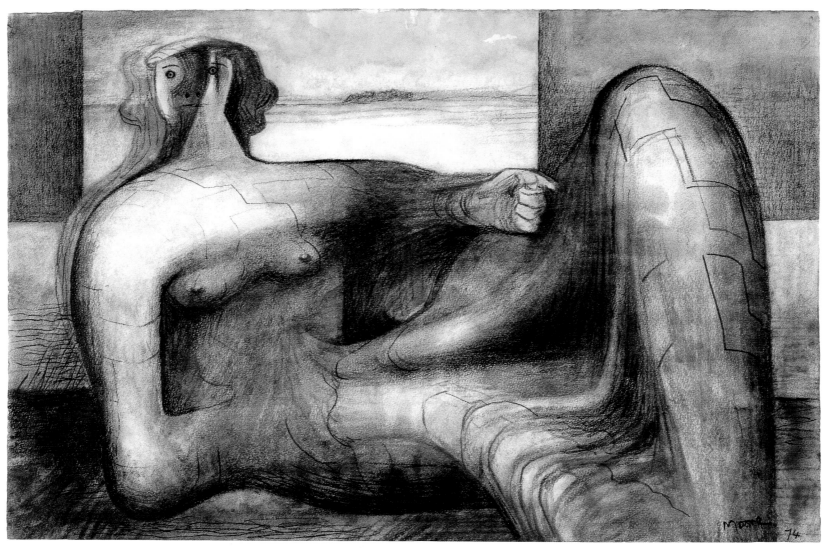

234

the theme of warriors, initially inspired – according to himself – by the shape of a pebble, though some commentators have traced Greek influences, both from his visit to Greece in 1951 and from the Elgin Marbles in the British Museum. The **Warrior's Head** 1953 (LH 359) and the seated **Warrior with Shield** [cat.171] were followed in 1956 by **Maquette for Fallen Warrior** [cat.179] which was never realised on a large scale. Dissatisfied with the representation of an apparently totally dead figure, Moore made a different version, **Falling Warrior** 1956-57 (LH 405), in which the figure was caught at the dramatic moment just before death, and which has become one of his best-known sculptures.

Yet clearly the theme still continued to haunt him, since he turned to it again in the early 1970s. It was while the process of casting a new 'fallen warrior' at the Noack foundry in Berlin was actually in progress that Moore learned he had been nominated as the first winner of a prestigious art prize being awarded by the ancient town of Goslar, in the Harz region of Germany. Together with the award of the 'Kaiserring' or 'Emperor's Ring' – a handsome jewel – came a commission for a major work, funded by the newly established Kaiserring Foundation, to be sited in a prominent venue within the old town. Moore visited Goslar in September 1974 to see for himself possible sites and consider which of his works might be appropriate. It was then that he decided to make available a cast of the new warrior figure just being completed by Noack, and to change its

name to **Goslar Warrior** in deference to the honour being shown him by this small but historic town.

In this piece Moore has refined and condensed the feelings of tragic defiance and resignation that imbue his earlier versions of the subject, making the figure itself more abstract, less representational, and in consequence even stronger. Between the round shield, now placed at the feet, and the half-raised head which acts as a counterbalance to it, the main 'body' of the figure has been reduced to a contorted block with one limb only, the leg, supporting the shield. There is one other, literal feature in this sculpture: the clearly visible rib-cage, which is particularly marked on the right-hand side of the body. This is a feature which Moore does not

normally emphasise in his reclining figures and one wonders whether, in this case, its pronounced lines are meant to stress that this warrior is no longer defiant but has become a stiffened, twisted corpse like those Moore himself saw in France during the First World War: fallen, indeed, rather than falling. As such its symbolism of the overall futility of war would become even more powerful.

Julian Andrews

234

Reclining Woman in a Setting 1974
HMF 73/4(17)
conté crayon, charcoal, pastel, chinagraph, watercolour wash on white medium-weight watermarked FABRIANO 2
330 × 483mm
signature: chalk l.r. *Moore/74*
Gift of the artist 1977

exhibitions: Paris 1977 (cat. 221); Toronto/Iwaki-Shi/Kanazawa/Kumamoto/Tokyo/London 1977-78 (cat.253); Bonn/Ludwigshafen 1979-80 (cat.56); London 1988 (cat.209); Martigny 1989 (cat.p.249); Leningrad/Moscow 1991 (cat.96); Helsinki (cat.96); Sydney 1992 (cat.152); Budapest 1993 (cat.111); Bratislava/Prague 1993 (cat.111); Krakow/Warsaw 1995 (cat.117); Venice 1995 (cat.119)

235

Reclining Figure: Bone 1975
LH 643
travertine marble
length 157.5cm
unsigned
Gift of the artist 1977

exhibitions: London 1978 (cat.15); Madrid 1981 (cat.116); Lisbon 1981 (cat.84); Barcelona 1981-82 (cat.92); Mexico City 1982-83 (cat.95); Hong Kong 1986 (cat.119); Tokyo/Fukuoka 1986 (cat.8); Florence 1987 (cat.3); New Delhi 1987 (cat.140); Leningrad/Moscow 1991 (cat.98); Helsinki 1991 (cat.98); Wakefield 1994; Nantes 1996 (cat.97); Mannheim 1996-97 (cat.97); Bremen/Berlin/Heilbronn 1997-98 (p.51)

publications: Strachan 1983, pls.101, 102

The sculpture is long and thin and, exceptionally, offers two surprisingly different views and thus readings. The concave side belongs to Moore's long, ever-fertile series of reclining figures, and is a particularly suave and slender version with a large head that seems to look diagonally into our space, a hole where we expect the chest but where Moore had long been carving or modelling holes, and another hole to suggest two legs within one outline. The result is a calm mother/landscape, but one that confronts us like a façade: the two holes do not lead us round the form. The convex side is almost the opposite of this. If

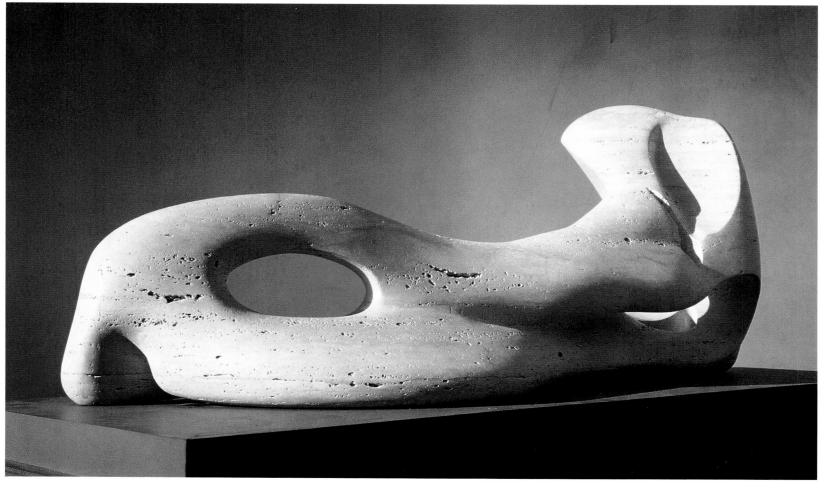

235

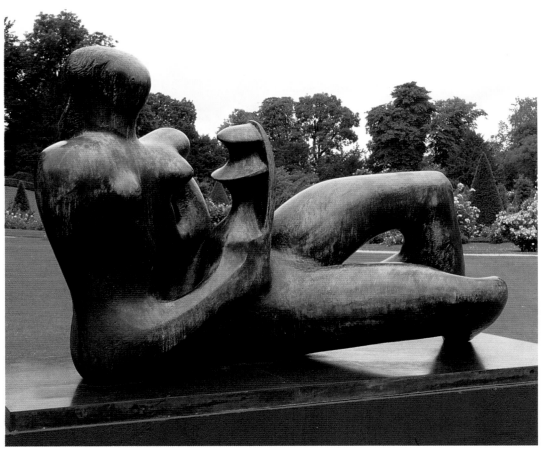

cat.236 exhibited in Paris, 1992

236
Reclining Mother and Child 1975-76
LH 649
bronze edition of 7 + 1
cast: Hermann Noack, Berlin
length 213cm
signature: stamped *Moore, 0/7*
Acquired 1986

exhibitions: Hong Kong 1986 (cat.126);
Tokyo/Fukuoka 1986 (cat.34); New Delhi
1987 (cat.139); Martigny 1989 (cat.pp.252,
253); Milan 1989-90 (p.79); Paris 1992
(cat.22); Pforzheim/Bad Homburg 1994
(cat.21)
loans: Martigny, Fondation Pierre Gianadda
1990-92

publications: Cohen 1993, pl.XXI

Moore himself used the word 'obsession' in relation to his two dominant themes, the mother and child group and the reclining female figure. Yet he rarely combined these twin themes within the same work. This need not surprise us, for the two motifs represent woman in competing relationships, on the one hand with landscape, on the other with her offspring, and these bring out respectively different sculptural aspects. The reclining woman is grounded and essentially passive and inert. Relating to her child, woman becomes active and engaged. When woman is symbolic of landscape, the life-force tends to be distributed equally throughout her body, whereas mothering focuses attention on her points of contact with her progeny: hands, breasts, lap.

A work which stands comparison with this piece is **Draped Reclining Mother and Baby** 1983 [cat.272]. The later sculpture is more strident in its efforts to present woman simultaneously as landscape and parent. Her drapery is at once a cavern, a mountain range and actual drapery, drapery that recalls Piero's marquee of a Madonna (Madonna della Misericordia), embracing her worshippers with her cape. Nestling within the generalised abstract form of its mother, Moore's baby is improbably doll-like in its naturalism. In the sculpture under view, Moore opts for a similar contrast of naturalism and

we read it as a female nude, as I believe Moore intended us to, it is a nude curving her body towards us, lying but half-floating (the way the body rises from the base is more marked in the bronze than in the carving), with one breast prominent and the lower hole now suggesting her groin as well as two legs, and her head bent back, framed by her right arm.

There is not likely to be any way of proving this, but I believe this second view of the sculpture to be the principal one, and that in shaping it Moore was recalling one of Rodin's formally and sexually most appealing pieces, the *Torso of Adèle* of 1882. The Rodin has become famous as one of his private, intimate works, many of them female nudes that, in their apparent spontaneity, resemble his drawings of moving nude models and bring a new degree of informality and immediacy into sculpture. This piece is illustrated in books

on modern sculpture, as well as in specialised books on Rodin, and of course Moore is likely to have seen the bronze owned by the Rodin Museum in Paris. In reproduction its energy and erotic power vary with the lighting and angle employed.[1] If this account is correct, we have here an instance of a directly erotic work by Moore, perhaps done consciously and developed to the point where the enticing image almost yields to an abstract play of forms. The horizontal vermiculation of the chosen stone of course works against any representational reading.

Norbert Lynton

1. The illustration in Fred Licht's well-known *Sculpture, Nineteenth and Twentieth Centuries*, Michael Joseph, London 1967 could have interested Moore; there are others, from the same photograph or from others very like it, in other books.

opposite: cat.237

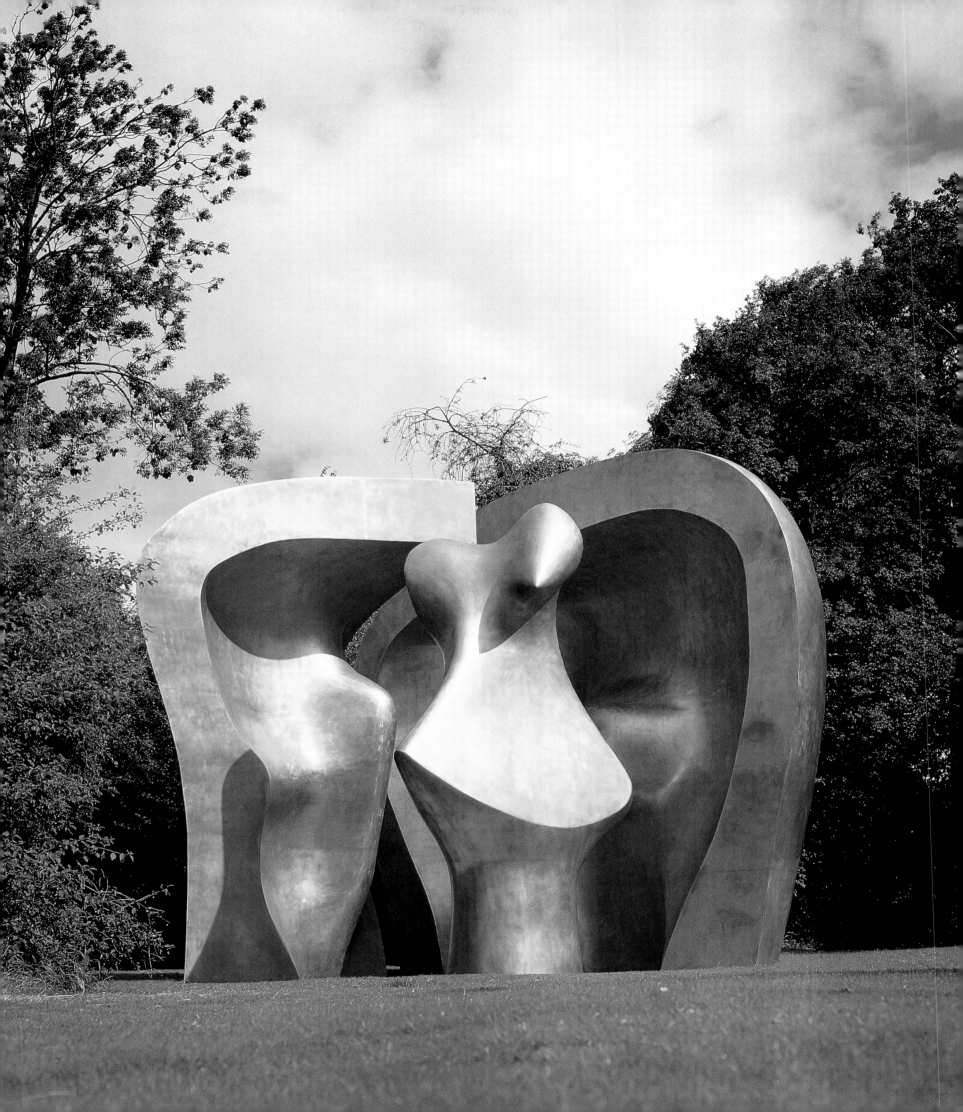

abstraction, but the other way around: the baby is a strangely schematic object, while the mother is relatively naturalistic, with most of her anatomy roughly where it should be. To my eye it is a far more convincing synthesis of the two themes than the later piece. It is the baby here who is presented as strange, intrusive, other, a sharp, hard, distinctly phallic vertical intrusion intent upon the mother's breast. The mother's posture is determined by the child, both in regard to satisfying its needs and withstanding them. Yet, despite these preoccupations, her by no means typically voluptuous lower limbs manage also to evoke mountains in the way of the great fragmented woman-as-landscape pieces of the 1960s.

Psychoanalysts could busy themselves with the contrast between an abstract baby and realistic mother, as it begs the question of whose view is being presented, who is real and who is object. It would be a shame, however, to lose sight of the marvellous formal effect the baby has of galvanising the mother's body, of arching the back, protruding the breasts, tightening the stomach, of sending tension through the thighs and flexing the muscles in the arms. Anish Kapoor once asked, disparagingly, of Moore's oeuvre, 'How can you make sculpture about women for fifty years and not make one of them sexy?' He might take a closer look at this one.

David Cohen

237
Large Figure in a Shelter 1985-86
LH 652c
bronze edition of 1 + 1
cast: Morris Singer, Basingstoke
height 762cm
signature: stamped *Moore*, [0/1]
Acquired 1987

The **Large Figure in a Shelter** was the last monumental work produced during Moore's working life. Although he never saw the two casts installed on permanent sites, he was able to see the first completed cast at the foundry. The enlargement was made in sections of expanded polystyrene,

and was cast and assembled from these pieces, first in fibreglass resin and then from the fibreglass to bronze by sand moulding.

The work was first made in a smaller size in 1975, but it was not until 1986 that the larger version was produced. This is basically the same, except that the shelter part is divided into two pieces. The sculpture started as one of a series of works, based on the original idea of the 'helmet head' of which there are many different versions and variations, from a small maquette to a larger version 167.5cm high, through to the present work 762cm high and about the same diameter. In this large size the sculpture's compelling physical presence gives it an extra dimension.

Each of the three bronze pieces is fixed on a steel frame which stands in a circular concrete base set into the ground. The surrounding area was built up with earth and a pavement of York-stone slabs, bringing it up level with the ground and the bottom of the bronze, so that the sculpture stands seemingly on the ground on a circular paved disc. This is different from the smaller version, whose thick circular base was an integral part of the sculpture, something Moore thought was not right for the larger piece.

Moore had made many huge sculptures prior to **Large Figure in a Shelter** through which he explored the relationship between the sculpture and the viewer, but in this last work the relationship became more compelling and complete. This is principally due to its physical size enabling one to walk around inside it and become part of it, as opposed to the more usual way of seeing large sculpture as part of a two-dimensional pictorial landscape.

Bernard Meadows

238
Three Piece Reclining Figure: Draped 1975
LH 655
bronze edition of 7 + 1
cast: Morris Singer, Basingstoke
length 447cm
signature: stamped *Moore, 0/7*
Acquired 1987

exhibitions: Wakefield 1987 (cat.29); Milan 1989-90 (pp.82,83); Glasgow 1990; Paris 1992 (cat.23); Pforzheim/Bad Homburg 1994 (cat.23); Venice 1995 (cat.123)

publications: Cohen 1993, pls.XXXVII, XXXVIII

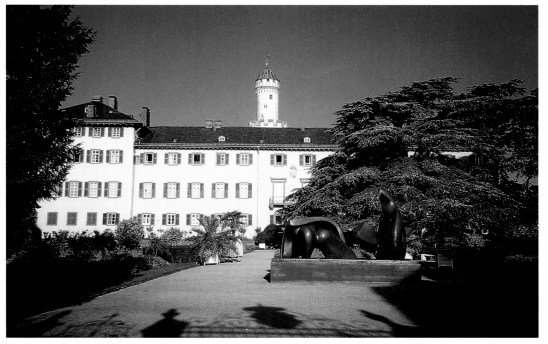

cat.238 exhibited in Bad Homburg, 1994

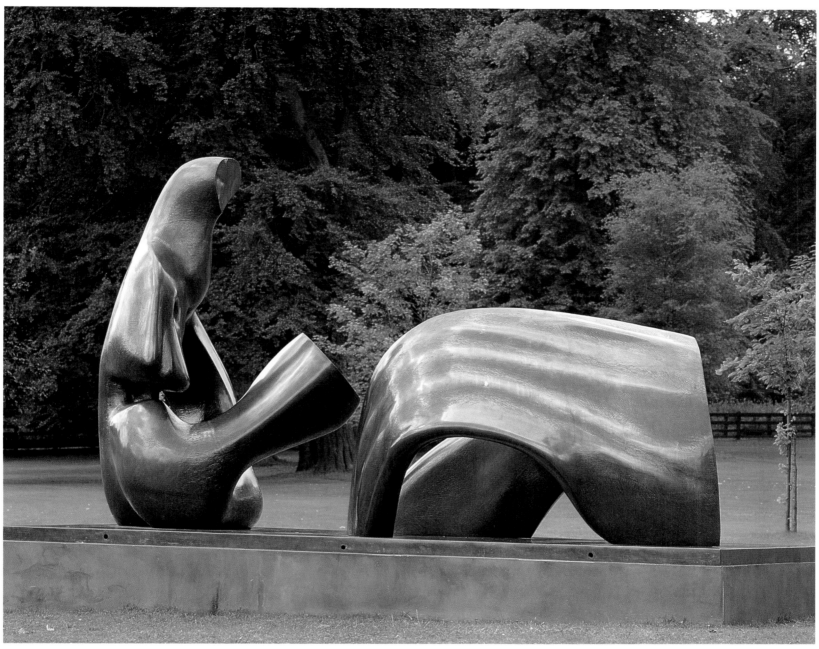

cat.238 exhibited in Wakefield, 1987

This is yet another in the series of great reclining figures, and one remarkable on several counts. Technically it is of particular interest in representing a time in Moore's career when the natural debilities of age had not yet placed too great a distance between the creative intention and the finished work, and yet certain practical adaptation had been made. There is now less sense of his personal working of the surfaces in preparation of the cast, yet the surfaces are clearly actively considered and overseen.

In the actual invention of the forms, and their disposition one against another, there is no diminution of creative energy whatsoever. In terms of physical presence, even leaving aside its monumental scale and visual weight, it is as active, positive and vigorous in its composition as could be.

It is oddly one of the least feminine in feeling of all his reclining figures, if we accept his **Falling Warrior** 1956-57 (LH 405) as not exactly a willing recliner. The head, sliced off, no more than a stump, is singularly aggressive, its blank facial plane

facing us out directly. From the base of the torso, which again is quite separate from the lower parts, rises at a dramatic angle a massive growth of improbable phallic proportions, let alone description, yet the question remains. The drape across the lower right leg could quite as well be some sort of shield.

Now an odd comparison comes to mind. Among his early surviving drawings, from 1926 and 1927, are two studies of seated women, in fact his mother and his sister (HMF 470, 488). Each sits up fairly straight,

311

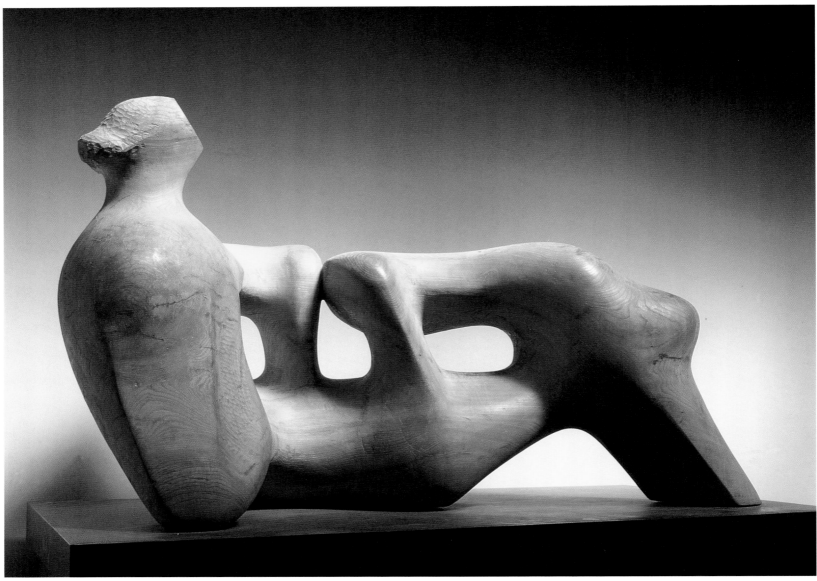

259

his mother with her arms folded across her lap, his sister holding a book in one hand. Both are wearing the long dresses that in the 1920s would still have been normal for the older and unremarkable for the younger woman. The long, draped skirts fall in folds down to the floor, concealing and simplifying the form even as they describe it, even as that leg is covered in this late reclining figure. Who can say when the image first registered in Moore's imagination. All we do know is that it did so very early, and that it remained a potent, if at times subconscious stimulus throughout his life.

William Packer

259

Reclining Figure: Holes 1976-78
LH 657
elmwood
length 222cm
unsigned
Gift of the artist 1977

exhibitions: London 1978 (cat.18); New York 1979-80; New York 1983 (front cover, p.111); Nantes 1996 (cat.106); Mannheim 1996-97 (cat.106)
loans: New York, Metropolitan Museum of Art 1980-96

Moore made six reclining figures in wood at lengthy intervals between 1935 and 1978.

They are all major works, in which the artist covered new ground for the genre of wood sculpture which has been revived since Gauguin, Brancusi and Zadkine.

Convinced as Moore was that in wood sculpture particularly the 'principles of being' should become apparent, he developed through these six reclining figures a new and flowing rhythmic interrelationship between space and compression of forms. He began the series by adopting a dual approach. In terms of the time of their origin and conception, the first and second carvings (LH 162 and 175) are closely related. Both are based on dual rhythm: in each case the space which breaks through the summarily arched leg

section faces the space breaking through the thorax. As in a reclining lemniscate, the association of forms seems to remain entirely circulatory within itself.

These compositions, so noticeably locked in dual rhythm, are radically renounced by Moore in his third elmwood figure from 1939 (LH 210), now increased to two metres, twice as long. In this version he extended the entire piece, hollowing it out in several places. A single horizontal rhythm, congested with several profiles, pushes through the head, at the same time opening it up to space on all sides.

In the fourth elmwood reclining figure of 1945-46 (LH 263), as described for the maquette [cat.145], Moore achieves a new and highly expressive balance between two moving forms facing each other. If this figure is mentally turned the other way round, this gives us the basic model for the fifth reclining figure of 1959-64 [cat.188], with much more open space overall and more extroverted, some would say even heroic, in places. The legs are now broken in two places but retain their surface undulation. A new element is represented by the encounter between the 'sign' motif pulled up from below in front of the right shoulder on which most light falls. In this motif, Moore increases the rising diagonal of LH 210. Both works are, in any case, related by their intensified opening up of space.

In this last major reclining figure carved between 1976 and 1978 from a vast and exceptionally rounded elm trunk, Moore clearly formed a centre for the first time. Both thrusts of movement, that is to say from the head down and from the feet up, converge in a club-shaped end in the centre of the figure. We have seen the groundwork for such interaction in LH 263. On the other hand LH 210 and LH 452 [cat.188] remind us of countless holes. Finally, the strict posture of the head in the last reclining figure seen here incorporates a motif from the first figure. Thus, in this powerful design, completed by Moore in his eighties, we can see how a large number of the threads of previous figures have come together. Even in the now intensified massive forms, Moore attempts to bring about the interpretation of shape and space.

Unmatched, he achieved in his mature works a majestic balance of stillness and movement.

Christa Lichtenstern

240
Broken Figure 1975
LH 663
black marble
length 108.6cm
unsigned
Gift of the artist 1979

exhibitions: Madrid 1981 (cat.12); Lisbon 1981 (cat.92); Barcelona 1981-82 (cat.91); Mexico City 1982-83 (cat.94); New York 1983 (p.116); Leeds 1984-85 (cat.33); Hong Kong 1986 (cat.120), Tokyo/Fukuoka 1986 (cat.10); Wakefield 1994; Nantes 1996 (cat.101); Mannheim 1996-97 (cat.101)

In the last period of his life Moore made a number of highly polished black carvings in gleaming marble or granite. Slightly funereal in effect, they are peaceful and assured works of great simplicity. I find them among the most attractive, if not the most vital, of his works.

One is tempted to try to put the two pieces of this sculpture back together, but in fact it does not work. They do not fit. Is this what gives me a slight sense of shock? Was something broken by accident in the course of its evolution? Was it inspired by the memory of other accidents elsewhere?

When Moore's full-scale working models were cut into sections, in order to transport them to the foundry, the separate pieces would lie in disorder on the ground. This arbitrary litter had its own attraction. In museums the fragments conserved by archaeologists do not seem to lose their power, in spite of being incomplete. We are involved in imagining what might have been. Even the *Venus de Milo* gains something from not being complete. It is the same sensation which makes me place this two-piece figure in a quite different category when compared with the sculptor's other compositions. In them the separate sections are far more deliberately placed and related. One has no wish to put the various parts together again.

I have the feeling that a great deal of Moore's work in his last decade became more personal and autobiographical than previously. I see this piece as a very gracious yet firm epilogue to a life of unbroken creative achievements.

John Read

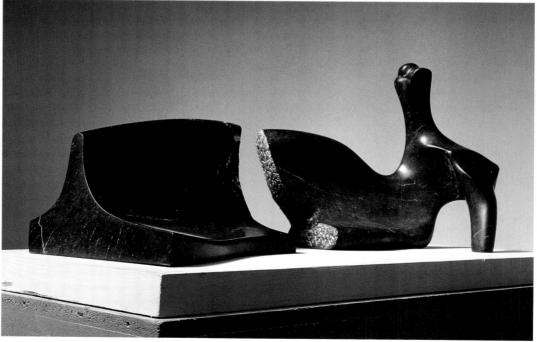

240

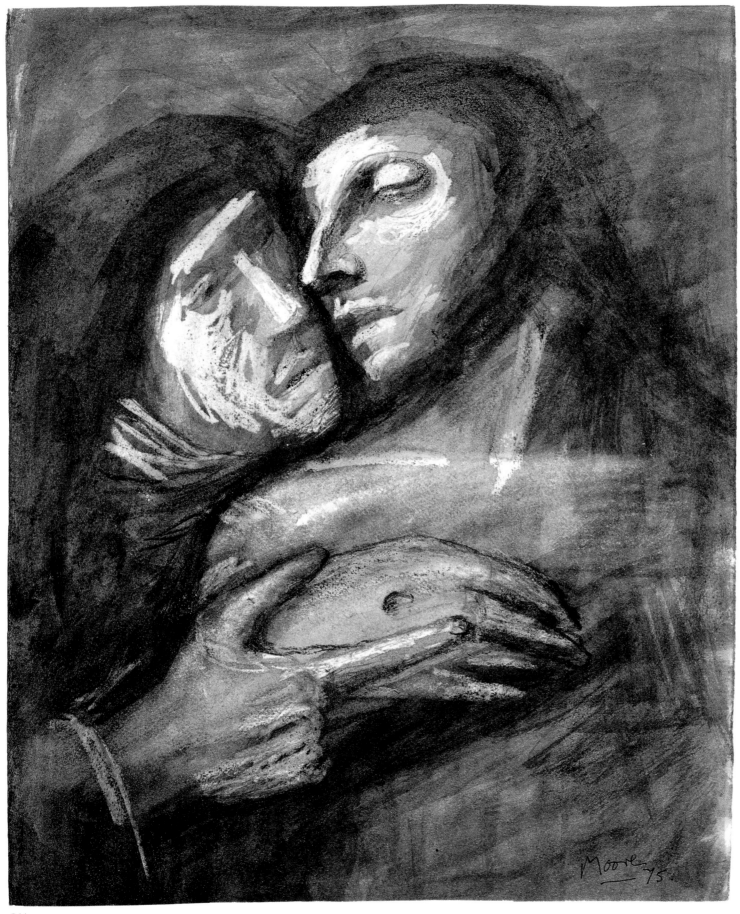

241

241

Study after Giovanni Bellini's *Pietà*
1975
HMF 75(13)
pencil, wax crayon, chalk, watercolour on
off-white medium-weight wove
413 × 321mm
signature: ballpoint pen l.r. *Moore/75*
Gift of the artist 1977

exhibitions: Toronto/Iwaki-Shi/Kanazawa/
Kumamoto/Tokyo/London 1977-78 (cat.72);
New York 1979-80 (cat.158); London 1982
(cat.21); Mantua 1981 (cat.72); Oslo 1983-
84; New Orleans 1984 (cat.51); Martigny
1989 (cat.p.250); Budapest 1993 (cat.112);
Bratislava/Prague 1993 (cat.112); Krakow/
Warsaw 1995 (cat.118); Venice 1995
(cat.120); Havana/Bogotá/Buenos Aires/
Montevideo/Santiago de Chile 1997-98
(cat.101)

publications: Garrould 1988, pl.231

Moore created this work at the height of his
recognition in Italy. Upon the instigation of
Franco Russoli, director of the Brera in
Milan, a number of artists, including
Moore, were invited to interpret a work of
their choice in the museum's collection.
This request followed a major Henry Moore
retrospective in 1972 at Forte di Belvedere,
Florence, which included over three
hundred works. At this time Moore was also
honoured with a number of Italian awards
for artistic excellence: *Premio
Internazionale 'Le Muse'*, Florence (1972),
*Cavaliere di Gran Croce dell'Ordine al
Merito della Repubblica Italiana* (1972), and
Premio Umberto Biancamano, Milan (1973).

The spatial and psychological
relationship between the two figures of
Bellini's *Pietà* (1460) captured Moore's
interest. In many of his sculptures of the
early to mid-1970s Moore had been
breaking down the figure into two or more
parts, exploring the formal relationship of
those sections to each other and to the
surrounding space. Like the two bronze
forms of the **Sheep Piece** [cat.230], the
faces in the *Pietà* are as close as possible
without actually touching, activating the
space between them and sharpening the
overall sense of tension and intimacy.

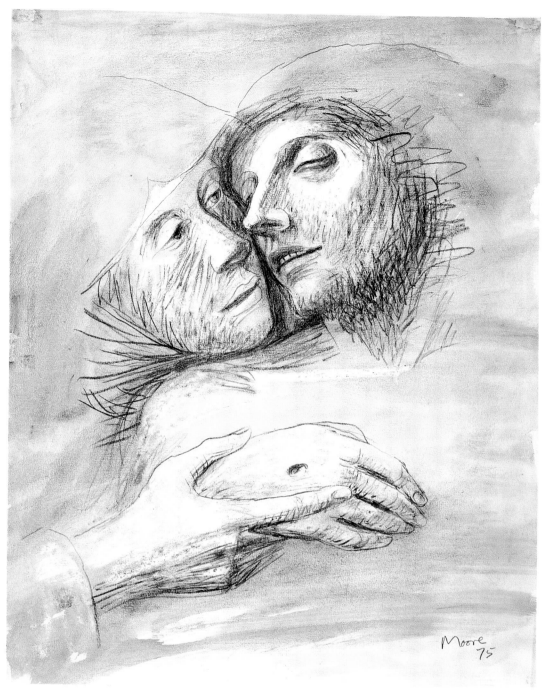

242

Moore explained: 'It's wrong to think that
form and expression are two separate
things. For instance, if I put my hand on
someone's shoulder, I can put it in a way
that seems to be gripping or just gently
touching. I may be touching it with affection
and gentleness or I may be making some
kind of empty gesture . . . it's all done by a
sensitivity to form, perhaps a greater
sensitivity than is needed in dealing only
with simple geometric shapes . . . the human
and the abstract elements [are] inseparable.'[1]

The sculptural quality of the two figures
emerging out of the darkness is intensified
by Moore's washing the composition with
watercolour over wax and heightening the
resulting forms with chalk. He thereby
retains the traditional chiaroscuro effect of
a dramatic display of light and dark, which
impressed him during his first visit to Italy

in 1925. Yet it was not until the Shelter drawings of 1941 that Moore attempted to reconcile the traditional Renaissance approaches with those of modernism. In this drawing, as with the images of the Underground, a new humanism emerges out of the contrast between the intimacy of the mother holding her dead son and the encircling atmosphere of devastation.

Anita Feldman Bennet

1. Michael Ayrton, *Giovanni Pisano*, introduction by Henry Moore, Thames and Hudson, London 1970.

242

Study after Giovanni Bellini's *Pietà*
1975
HMF 75(14)
pencil, wax crayon, charcoal, gouache, watercolour on off-weight medium-weight wove
428 × 324mm
signature: pencil l.r. *Moore/75*
Gift of the artist 1977

exhibitions: Bradford 1978 (cat.180); New York 1979-80 (cat.159); Madrid 1981 (cat.D99); Lisbon 1981 (cat.D99); Forte dei Marmi 1982; Oslo 1983-84; London (Tate)1984 (cat.104); Martigny 1989 (cat.p.251); Budapest 1993 (cat.113); Bratislava/Prague 1993 (cat.113); Krakow/Warsaw 1995 (cat.119); Venice 1995 (cat.121)

publications: Garrould 1988, pl.XIX, pl.229

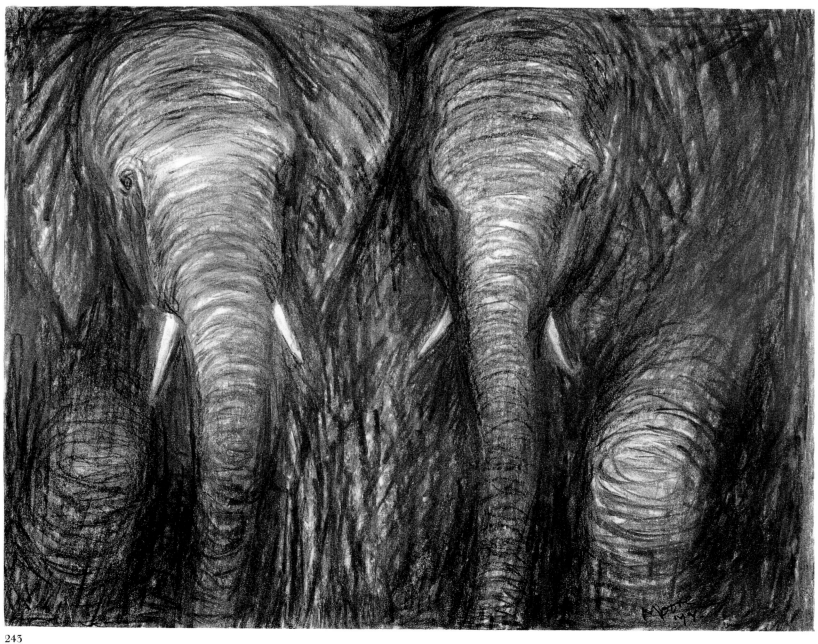

243

243

Forest Elephants 1977

HMF 77(14)

charcoal, chalk on white heavyweight wove

307 × 386mm

signature: felt-tipped pen l.r. *Moore/77*

Acquired 1987

exhibitions: London 1988 (cat.214); Sydney
1992 (cat.156); Bellinzona/Naples/Bologna
1995 (cat.37)

publications: Garrould 1988, pl.241; De
Micheli 1989; *Henry Moore: Complete
Drawings*, vol.5 1977-81, AG 77.24

Moore's **Forest Elephants** is an unusual
drawing within the sequence of his works
on paper. The catalogue raisonné of the
drawings places this work between
Drawing for Etching: 'Dante Stones' 1977
(HMF 77(13)) and **Draped Reclining
Figure: Sea Background** 1977 (HMF
77(15)), neither of which could be further
removed from the wildlife theme of these
two majestic primeval animals who appear
physically to be emerging from the picture.
Although non-abstract representations of
animals are not infrequent in Moore's
graphic work, they tended to be executed
'en bloc', in notebooks such as the **Sheep
Sketchbook** drawn in 1972 (HMF 3317-
3369) or suites of etchings like **Animals in
the Zoo** 1981-82 (CGM 631-645).

 The structure of the drawing, executed
on heavyweight wove, is densely built up
using charcoal and black chalk in order to
achieve a dark, tightly textured surface.
The composition is deceptively simple: two
elephant heads, tusks, ears, wrinkled skin.
The rendition, however, is dramatic in two
ways: there is the exuberant interplay of the
graphic black and white, and the instant
recognisability of the subject matter, both of
which confirm Moore's status as a master
draughtsman. The tusks of the animals
provide strong highlights which are set
against the chiaroscuro of the skin of the
beasts with a gentle lightening on their
foreheads; another particularly strong
compositional emphasis in terms of light
and shade is placed on the knee of the
animal on the right. The execution of the
drawing is reminiscent of the artist's

244

treatment of bronze: the microcosm of
energetically cross-hatched and circular
toolmarks is created on paper as it is on his
metal surfaces.

 The subject matter of the drawing is of
only secondary importance – the structure
and texture of **Forest Elephants** could
equally have been applied to a reclining
figure, a mother and child, or an abstract
composition. Although instantly
recognisable as elephants, the beasts are
not simply a portrayal of animals but the
two-dimensional depiction of a flayed,
rectangular segment of patinated bronze,
with the play of light and shade beautifully
rendered in a graphic medium. Texture and
form override thematic recognisability.

Reinhard Rudolph

244

Old Apple Tree in Winter 1977

HMF 77(28)

charcoal, watercolour on blotting paper

241 × 290mm

signature: ballpoint pen l.r. *Moore/77*

Acquired 1987

exhibitions: Bellinzona/Naples/Bologna
1995-96 (cat.39)

publications: Garrould 1988, p.200, pl.245;
Henry Moore: Complete Drawings, vol.5
1977-81, AG 77.38

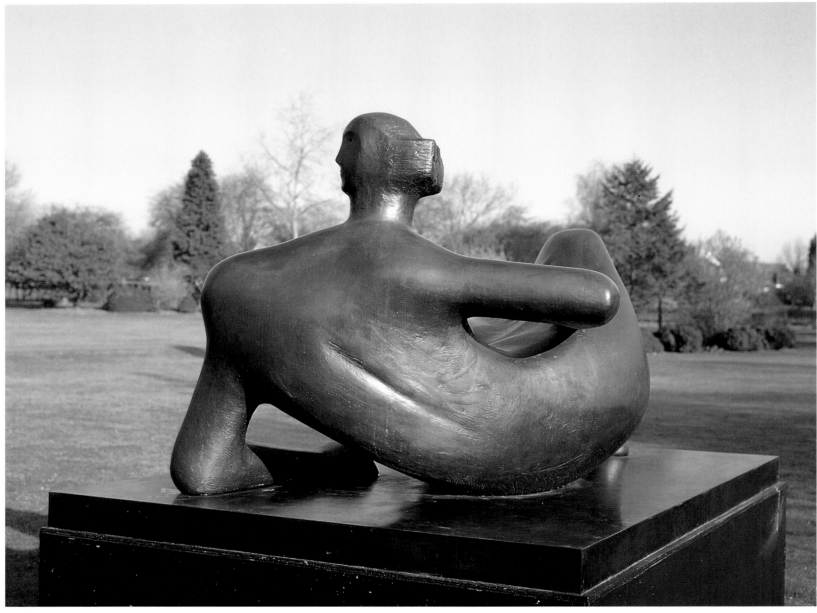

245

245
Reclining Figure: Angles 1979
LH 675
bronze edition of 9 + 1
cast: Hermann Noack, Berlin
length 218cm
signature: stamped *Moore, 0/9*
Acquired 1986

exhibitions: Hong Kong 1986 (cat.163);
Tokyo/Fukuoka 1986 (cat.13); Wakefield
1987 (cat.30); New Delhi 1987 (cat.148);
Milan 1989-90 (pp.86,87); Paris 1992
(cat.24); Bellinzona/Naples/Bologna 1995-
96 (cat.19)

loans: Strasbourg, Council of Europe 1992-94

publications: Cohen 1993, pls.XXIV, XXV,
XXVI

Moore's views on patination were formed
primarily from an artistic viewpoint. He felt
that it would be boring for exhibitions if all
his bronzes were the same colour, but he
also commented that variations in colour
offered the potential owners of his work an
element of choice when considering his
sculpture.[1] Several editions of sculptures in
Moore's oeuvre have greatly differing
patinas. This particular cast of **Reclining**

Figure: Angles is dark brown, but others
within the edition, such as that in the Art
Gallery of New South Wales, Sydney, are
patinated green.

Bronze is an extremely versatile and
also durable material for sculpture. Moore
wrote: 'I like working on all my bronzes
after they come back from the foundry. A
new cast to begin with is just like a new-
minted penny, with a kind of slight
tarnished effect on it. Sometimes this is all
right and suitable for a sculpture, but not
always. Bronze is very sensitive to
chemicals, and bronze naturally in the open
air (particularly near the sea) will turn with

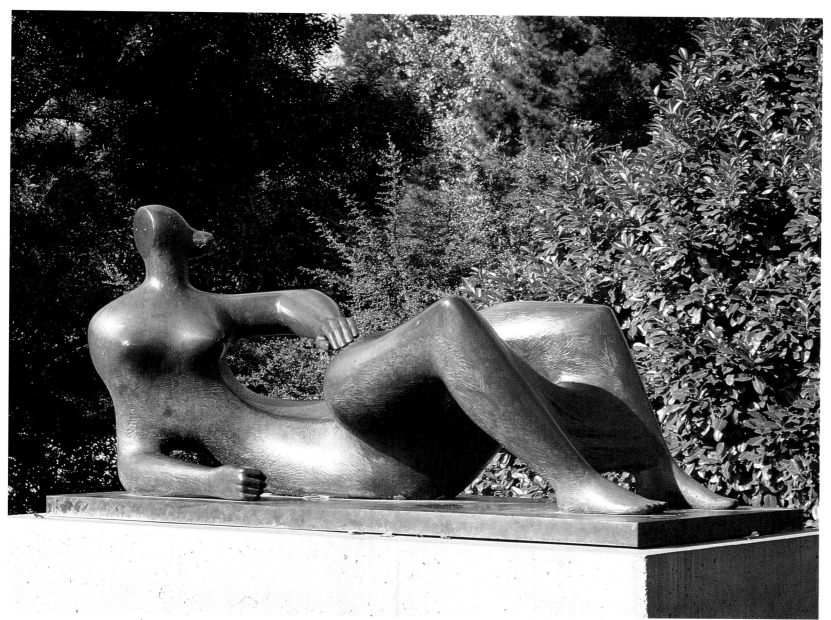

cat.246 on loan in Lisbon from 1983

time and the action of the atmosphere to a beautiful green. But sometimes one can't wait for nature to have its go at the bronze, and you can speed it up by treating the bronze with different acids which will produce different effects. Some will turn the bronze black, others will turn it green, others will turn it red.'[2] Moore used patinas to augment the forms of his sculptures and to produce a unity between colour and form which facilitated the easy reading of the sculpture. He would often highlight knees, elbows, heads – the bony areas of the body – and would leave the fleshier areas darker so that the sculpture could be understood at

a glance. Sometimes, as a result of exposure to the environment or vandalism, the patinas change and the sculptures become difficult to 'read'. At that point Moore liked to intervene in the process, to rework the patina.

This work now has to be undertaken by the Foundation, and a considerable part of the sculpture assistants' time is spent advising owners, museums and conservators on patination as well as reworking certain patinas themselves. **Reclining Figure: Angles** had to be repatinated at the very end of the 1980s[3] and the surface of the sculpture is now

maintained by a simple process of washing and waxing. The patina is developing and can be monitored, and maintained by this cleaning process. Such work can prevent the need for wholescale repatination, obviously desirable given the large number of outdoor works in the Foundation's collection.

Julie Summers

1. Malcolm Woodward in conversation with Julie Summers, 1994.
2. James (ed.) 1966, p.140; 1992, p.142.
3. In 1989 Michel Muller worked on the surface of **Reclining Figure: Angles**.

246
Reclining Figure 1982
LH 677a
bronze edition of 9 + 1
cast: Morris Singer, Basingstoke
length 236cm
signature: stamped *Moore, 0/9*
Acquired 1986

loans: Lisbon, Centro de Arte Moderna,
Fundaçao Calouste Gulbenkian from 1983

I first met Moore when I was about sixteen,
through Maurice Ash, a mutual friend who
was something of a collector and later
became a Trustee of the Foundation: we all
lived not far from Bishop's Stortford. I little
thought I would become the famous
sculptor's biographer as I diffidently listened
to Ash, Moore and Philip Hendy, then
Director of the National Gallery and a great
friend of Moore's, debating over the Sunday
roast who was England's second greatest
painter if Turner was the greatest: the
candidates, as I recall, were Stubbs, Constable
and Gainsborough. But I kept in touch with
Moore over my subsequent journalistic
career, and after my biography of Graham
Sutherland had been taken seriously
enough to impress Moore favourably, I
found myself accepted in that role.

 'Of course your book will be judged by
your success in bridging the gap between
the man and his work,' someone observed
rather dauntingly when I began
interviewing his friends and associates. I
soon saw that Moore was more complex
than his generally sunny, down to earth
manner might suggest. His hands betrayed
his restlessness, he worried excessively
about how posterity would rate him, and
tended to be ungenerous about other living
sculptors. Like most great artists he was,
furthermore, sensitive to the spirit of the
times, and reflected in his work the travails
of the eighty-six years through which he
lived, as well as his feeling for nature and
the eternal feminine.

 Where Moore's life was concerned, the
challenge was to knock his memory out of
the grooves of the record on to which he
had distilled his recollections. The most
effective technique was to play back to him
some titbit gleaned by interviewing a

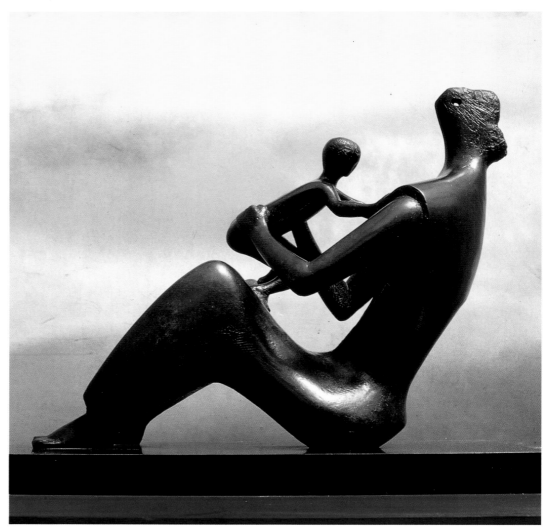

247

relative or old friend. That would
sometimes spark a few genuinely fresh
memories, but he showed the utmost
ingenuity in steering the conversation back
to proved and trusted terrain.

Roger Berthoud

247
Mother and Child: Arms 1980
LH 698
bronze edition of 9 + 1
cast: Fiorini, London
length 80cm
signature: stamped *Moore, 0/9*
Acquired 1986

exhibitions: Hong Kong 1986 (cat.134);
Tokyo/Fukuoka 1986 (cat.35); Schaan 1987;

New Delhi 1987 (cat.150); Harare/Bulawayo
1988 (cat.3); Martigny 1989 (cat.pp.260,261);
Milngavie/Ayr/Paisley/Kilmarnock/
Dumfries 1990; Leningrad/Moscow 1991
(cat.105); Helsinki 1991 (cat.105); Sydney
1992 (cat.166); Budapest 1993 (cat.116);
Bratislava/Prague 1993 (cat.116); Krakow/
Warsaw 1995 (cat.123); Venice 1995
(cat.126); Havana/Bogotá/Buenos Aires/
Montevideo/Santiago de Chile 1997-98
(cat.103)

This is one of Moore's most inventive and
vital mother and child groups: from every
viewpoint it provides unexpected new
shapes and compositions. The wiry child
explores the weighty bulk of its mother,
aptly illustrating Moore's saying: 'The idea
of the climbing child was a new little phase
of the mother and child relationship in

320

which the child is using its mother as a big object that can be played on.'[1] The psychological relationship of the two figures is embodied in the protective grasp of the mother's hands. These are arranged in an entirely naturalistic way which also provides a formal sculptural balance to the child's limbs. From the front the group appears slightly tilted, for the mother is pushed sideways by the force of the child's exertion. This is even more apparent from a view between the frontal and profile, but when seen in full profile they appear perfectly balanced.

The composition is an interesting development from the 1950s series of rocking chair sculptures, which Moore made as toys for his daughter. By 1977 that daughter was herself a mother, and the inspiration for this sculpture may well have

been her pregnancy: certainly by the time the work was enlarged for casting her son was old enough to serve as model.

Susan Compton

1. New York 1979-80, p.29.

248
Draped Reclining Figure 1978
LH 706
travertine marble
length 182cm
unsigned
Acquired 1986

exhibitions: Florence 1987 (cat.5); Wakefield 1994; Nantes 1996 (cat.108); Mannheim 1996-97 (cat.108)

To accomplish this piece, the eighty-year-old Moore returned to one of the figurative themes of the 1950s: that of the draped figure, first explored in the drawings of the air-raid shelters of 1940-41. Moore recognised how deeply involved he had been with the problem of the draped figure and how essential the Shelter drawings had been in providing the solution: '. . . what I began to learn then about its function as form', he declared in an interview, 'gave me the intention, sometime or other, to use drapery in sculpture in a more realistic way than I had ever tried to use it in my carved sculpture. – And my first visit to Greece in 1951 perhaps helped to strengthen this intention.' 'Drapery', he added, 'can emphasise the tension in a figure, for where the form pushes outwards . . . [it] can also, by its direction over the form, make more

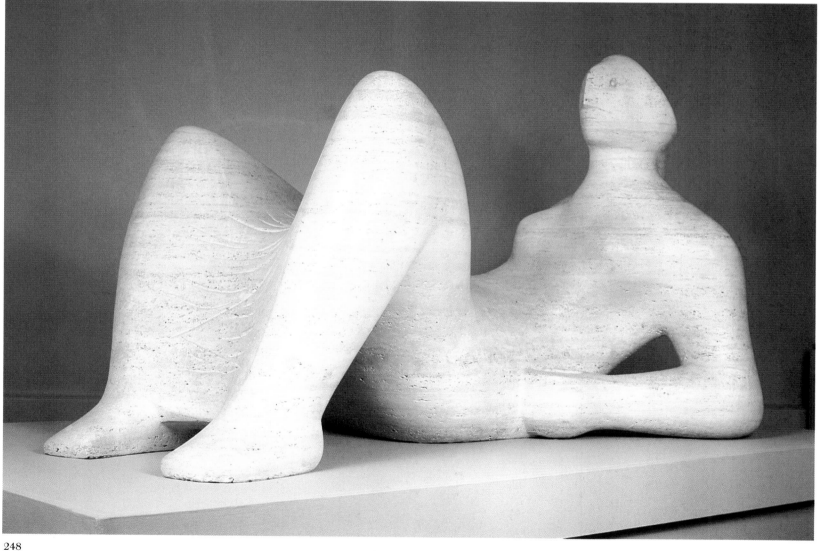

248

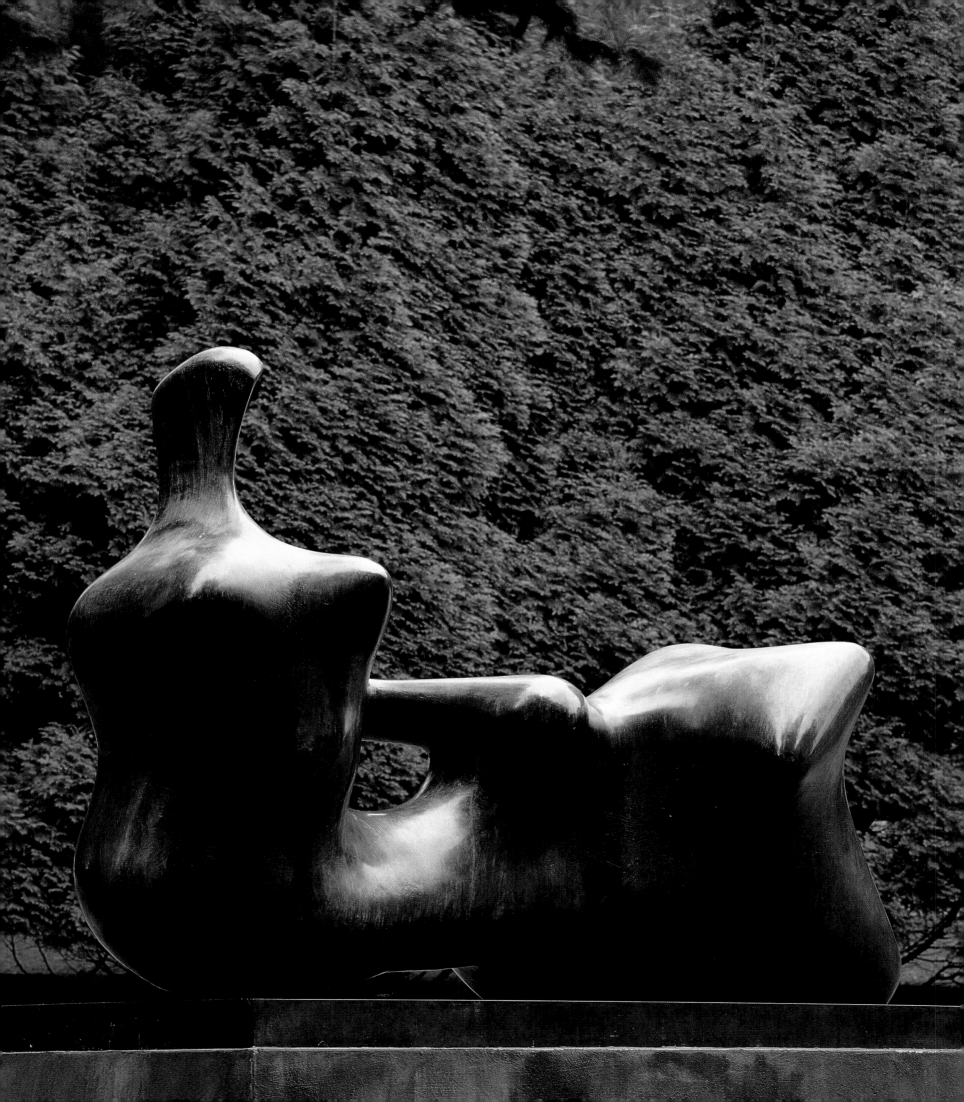

obvious the section, that is, show shape. It need not be just decorative addition, but can serve to stress the sculptural idea of the figure.' On the same occasion Moore compared folds of drapery, whether simple or complex, to the shape of the mountains, which he described as 'the crinkled skin of the earth'.[1]

The formal language of this sculpture differs from other draped pieces not only because it was executed many years later but principally because of the different nature of the material used. In his later years, Moore was increasingly drawn to travertine, and to satisfy this liking he made several trips to the caves at Tivoli near Rome. He was fascinated by the porosity and the chromatic variation offered by the stone, which could easily turn from pink to ivory, from grey to an intense amber. The versatility of travertine encouraged Moore's use of it.

In his return to the draped figure theme, the figure has grown thin and the drapery is no longer a series of stylised carvings, but the new geometrisation of forms diminishes neither the energy nor the expressive intensity of this piece.

Giovanni Carandente

1. *Sculpture in the Open Air. A Talk by Henry Moore on His Sculpture and its Placing in Open-Air Sites*, edited by Robert Melville and specially recorded with accompanying illustrations, British Council, London 1955, quoted in James (ed.) 1966, p.231; 1992, p.247.

249
Reclining Figure: Hand 1979
LH 709
bronze edition of 9 + 1
cast: Hermann Noack, Berlin
length 221cm
signature: stamped *Moore, 0/9*
Acquired 1986

exhibitions: Hong Kong 1986 (cat.164); Tokyo/Fukuoka 1986 (cat.12); Wakefield 1987 (cat.31); New Delhi 1987 (cat.152); London 1988 (cat.197); Martigny 1989 (cat.pp.264,265); Milan 1989-90 (p.89); Paris 1992 (cat.26); Pforzheim/Bad Homburg 1994 (cat.30)
loans: Edinburgh, Royal Botanical Garden 1992-94; London, BBC from 1997

250

publications: Cohen 1993, pl.XXVII

To begin by stating the obvious, this is a large bronze meant to be seen outdoors and, like most of Moore's monumental pieces, it is preferably sited and photographed against the backdrop of nature, more particularly the gentle perspectives and changeable weather of the English countryside. Again, like much of Moore's work, this is a reclining figure in which, in an old association, the female form is identified with landscape. It is not just, then, that the rural setting is sympathetic to the sculpture, but that the sculpture makes of the surrounding nature an artefact in which may be seen gendered and psychologically affecting forms.

What is the message of this transformation? **Reclining Figure: Hand** is a figure wrapped in some uniform substance, sometimes apparently skin, sometimes cloth (the suggestion of drapery is most explicit at the foot of the sculpture), and beneath this bronze cloth or skin, vague forms are stirring. It is implied that these forms are emergent, struggling to break free of what confines them. If woman

is identified with landscape, with nature, these awakening forms are not merely feminine but 'primordial', the stirring of primitive magna beneath the crust of civilisation.

Yet, and again this is a common feature, female forms are both eccentrically portrayed and placed in contrast with more masculine elements. This sculpture is part of a sequence of reclining figures made around the same time which are propped up in tension as if about to raise themselves – there is a close relation, for instance, to the elmwood **Reclining Figure: Holes** [cat.239]. The torso is twisted around so that the breasts, two oddly placed but prominent protrusions, emerge from the front of the sculpture. There is also the playing off of formal opposites against one another, of the blade-like edge of the head, for example, against the soft forms of the body.

The play of opposites is a register of Moore's consistently in-between position; his work seen as a whole is both traditional and avant-garde, Surrealistic and Constructivist, anthropomorphising and abstracting. Such placing of Moore above

opposite: cat.249 exhibited in Wakefield, 1987

251

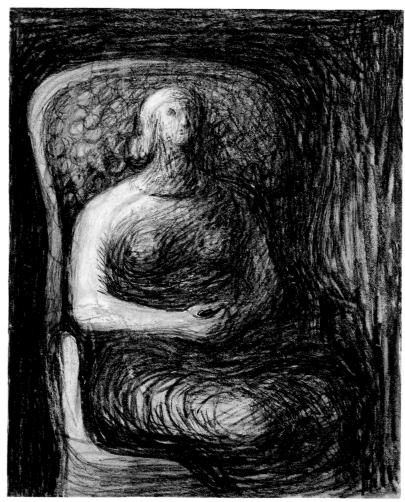

252

the fray of ordinary avant-garde dispute is an attempt to create the synthesis of themes and styles found in the great artist. Occasionally writers recognised this. The American critic Thomas Hess, for example, wrote of Moore that his reputation 'is mainly the achievement of British intellectuals who, at the end of the last war, needed *chefs d'école* who would be native, yet Continental in style; metaphysical for metaphors, yet natural (i.e. connected with a country garden of the soul); verbally Socialist in human sympathies, yet aristocratic in stance.' He saw Moore, Sutherland and Britten as filling this role. [1]

Given this programmatic ambivalence, Moore's monumental reputation was not so much overturned (despite the well-publicised criticism of Caro) as bypassed. It is only recently with the advent in some British art of flippant, flimsy, ironic little constructions, that Moore's sculptural

successors have become more visible. Among those still playing with the monumental in-between are Antony Gormley, Anish Kapoor, Shirazeh Houshiary.[2] In terms of ambition and artistic strategy, Moore showed them the way.

Julian Stallabrass

1. Thomas Hess, *Art News*, December 1954; cited in *Henry Moore in America*, County Museum of Art, Los Angeles 1973, p.135.
2. On this issue see Ann Hindry, 'Moore, Moore's Children: "Being There"', in Allemand-Cosneau, Fath, Mitchinson 1996, pp.47-53.

250
Two Reclining Figures: Ideas for Sculpture 1979
HMF 79(60)
charcoal, chalk, wax crayon, watercolour wash on lightweight wove
347 × 480mm
signature: chalk l.r. *Moore/79*
Acquired 1987

exhibitions: Martigny 1989 (cat.p.272); Sydney 1992 (cat.157); Bellinzona/Naples/ Bologna 1995 (cat.51); Nantes 1996 (cat.111); Mannheim 1996-97 (cat.111); Havana/Bogotá/Buenos Aires/Montevideo/ Santiago de Chile 1997-98 (cat.108)

publications: Garrould 1988, pl.259; *Henry Moore: Complete Drawings*, vol.5 1977-81, AG 79.87, pl.II

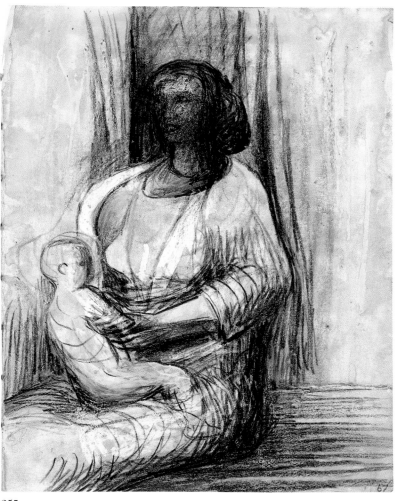

253

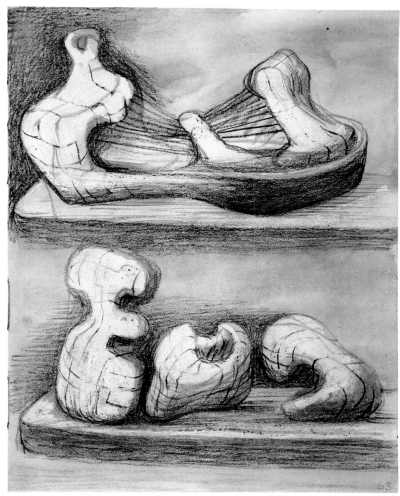

254

251-254

Sketchbook 1980

HMF 80(5), 80(12), 80(83)-(89), 80(96), 80(97), 80(323)-(356), 81(1)

Maroon cloth-covered boards 240 × 188mm, with white glossy paper cover, originally containing 72 pages of off-white medium-weight wove paper 232 × 181mm in nine inconsistently bound signatures, seven of eight, one of six, and one of ten, plus endpapers. The pages were later numbered in pencil top left on the verso. The artist drew on the front endpaper and the the first 46 pages. The inside of the front cover is inscribed in the artist's hand *Sketchbook/ 1980*. During 1982-83 a facsimile of the sketchbook was made by Kunstanstalt Max Jaffé in Vienna. Certain drawings had been removed and catalogued individually before 1982, and some of these were replaced in sequence. The pages were renumbered, on 13 April 1982, beginning on the recto of the front endpaper from 1 to 84 lower right recto and left verso, the remaining pages being left unnumbered. Since the renumbering of the sketchbook four drawings have been replaced in what appears to be their original position: HMF 80(83) as p.1, HMF 80(5) as p.8, HMF 80(12) as p.9 and HMF 81(1) as p.27. Page 28 remains unaccounted for.

Acquired 1997

251

Two Reclining Figures: Ideas for Sculpture 1980
Page 36 from Sketchbook 1980
HMF 80(346)
pencil, charcoal, chalk, wax crayon, gouache, watercolour wash
232 × 181mm
unsigned, undated

252

Woman Seated in Armchair 1980
Page 37 from Sketchbook 1980
HMF 80(347)
chinagraph, wax crayon
232 × 181mm
unsigned, undated

253

Mother and Child 1980
Page 38 from Sketchbook 1980
HMF 80(348)
chinagraph, wax crayon, gouache, watercolour wash
232 × 181mm
unsigned, undated

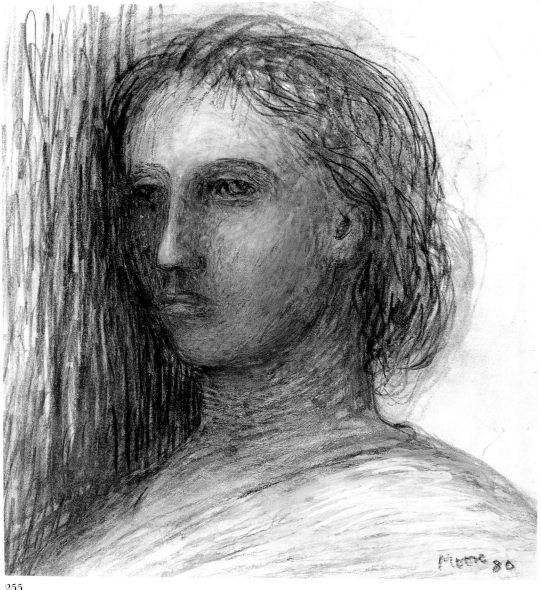

255

256
Colour Composition with Half Moon
1980
TAP 17
tapestry woven at West Dean College by
Valerie Power and Pat Taylor
from a drawing of 1979 (HMF 79(43b))
wool warp; wool, cotton, linen weft
205 × 145cm
Acquired 1980

publications: Garrould, Power 1988, cat.10,
pp.60-63

First, to dispel a myth, Moore was neither
interested in the technicalities of how
tapestry was produced nor was he
knowledgeable about the skills required by
the weavers to transform his small drawings
into works of life-size proportions. None of
Moore's tapestries was produced in an
edition; the technique is slow, and even
with more than one weaver involved a large
work might take a year to complete. It was
never an activity he expressed an interest in
pursuing himself, but his understanding of
the importance of the weavers' interpretative
skills is made clear in his comment: 'If it
were just going to be a colour reproduction
I wouldn't be interested. It is because it is a
translation from one medium into another
and has to be different that you get a surprise.
It is not like a bronze caster who has to
produce an absolutely exact copy or it is
thrown away; the beauty of tapestry is that
it is different, an interpretation, and that is
to me the excitement and the pleasure'.[1]

In the case of **Colour Composition
with Half Moon**, the second from a group
of ten tapestries which Moore commissioned
from the workshop of West Dean College
specifically for the Foundation's Collection,
the random tones of the watercolour and ink
wash background in the drawing achieve a
greater depth and physical presence when
translated into a much larger area. Likewise
the counterpoint between the white wax
crayon and deep green ink pen strokes is
strengthened by both their increase in scale
and translation in one medium.

Anita Feldman Bennet

1. Garrould, Power 1988, p.8.

254
**Two Reclining Figures: Ideas for
Sculpture** 1980
Page 41 from Sketchbook 1980
HMF 80(351)
chalk, charcoal (rubbed), wax crayon,
watercolour, ballpoint pen
232 × 181mm
unsigned, undated

255
Head of Girl 1980
HMF 80(305)
charcoal, chinagraph, gouache,
watercolour wash on white lightweight
wove
272 × 241mm
signature: chinagraph l.r. *Moore/80*
Acquired 1987

exhibitions: London 1988 (cat.221);
Bellinzona/Naples/Bologna 1995-96 (cat.65)

publications: Garrould 1988, p.221, pl.275;
Henry Moore: Complete Drawings, vol.5
1977-81, AG 80.338

256

257

Three Figures on a Stage 1981
HMF 81(227)
chalk, charcoal, wax crayon, gouache,
watercolour, wash on T.H. Saunders
watercolour paper
301 × 387mm
signature: chinagraph l.l. *Moore*, undated
Acquired 1987

exhibitions: London1988 (cat.223);
Martigny 1989 (cat.p.287); Sydney 1992
(cat.179); Budapest 1993 (cat.124);
Bratislava/Prague 1993 (cat.124)

publications: *Henry Moore: Complete
Drawings*, vol.5 1977-81, AG 81.208

This is not the first drawing in which Moore
has set figures within an architectural or
theatrical setting but it is the one which is
most directly inspired by the theatre. He
had already explored the subject in a
number of drawings dating from 1938
including **Figures with Architecture** 1938
(HMF 1377), but here the allusion to a
theatrical setting of an Italianate piazza is
unmistakable.

Moore was always fascinated by the
theatre. As an art student he wrote a play

entitled *Narayana and Bhataryan* which
was performed at his old school in
Castleford with Moore himself in the lead
role of Bhataryan and his sister Mary as
Narayana, his stage sister, whom he saved
from being sacrificed to the hippopotamus
goddess Chandrasati, heroically dispatching
the hippo.[1] He produced the play himself in
1922 at the Easter Social of the Royal
College of Art.[2]

Moore sat on the board of the National
Theatre from 1962, and in 1965 was asked if
he would provide the settings for an
evening in memory of T.S. Eliot at the
Globe Theatre. Moore was too busy to make

a backdrop, but a plaster cast of **The Archer** 1964-65 (LH 535) was placed on the stage on a rotating plinth and was used as a set for the readings of Eliot's poetry.[3] It was a source of some regret to Moore that he never realised his potential in the field of theatre, but he was quoted by John Russell in 1973 as saying: 'I was frightened of it. If I got my coat-tails into the mangle of the theatre I'd be drawn in bodily . . . Sculpture takes up so much of one's time, and it would be the simplest thing in the world to have one's energies dissipated in other ways.'[4]

The figures on the stage are almost ghostly, lit in a way that renders them very two-dimensional against the theatrical background. They seem to float inches above the stage and have a somewhat dreamlike quality which is untypical of his figures of this period. The drawing, which was later used as a design for a silk scarf, stands out as quite different from anything else Moore drew in 1981, although architectural and domestic settings do appear in his late work.

Julie Summers

1. Berthoud 1987, p.52.
2. Ibid. p.54.
3. London 1988, p.282.
4. Russell 1968, pp.84-8; 1973, p.117.

258

Mother with Child Holding Apple II
1981
HMF 81(253)
chalk, wax crayon, pastel, gouache,
chinagraph on Bockingford white
heavyweight wove
355 × 253mm
signature: chinagraph l.r. *Moore*, undated
Acquired 1997

259

Imaginary Architecture 1981
HMF 81(258)
charcoal, wax crayon, chinagraph,
watercolour on Bockingford white
heavyweight wove
253 × 355mm
signature: chinagraph l.l. *Moore*, undated
Acquired 1987

exhibitions: Bellinzona/Naples/Bologna
1995-96 (cat.67)

publications: *Henry Moore: Complete Drawings*, vol.5 1977-81, AG 81.237

As in *Alice in Wonderland*, we are invited to enter an imaginary world, one where the artist's conservatory chairs have become

258

259

classical temples, where mysterious caves beckon like giant eyes, and scale is arbitrary and constantly changing. Moore has created a landscape of blurred architectural, sculptural and organic forms; the soft edges increase the sense of a dream-like vision. Time itself has become an element of fantasy. The watercolour wash reveals traces of the white wax beneath, conveying an effect of decay, of peeling paint, fragments of ruined frescoed walls. For Moore architectural ruins could become the starting point for the imagination, and he vividly recalled his first visit to Stonehenge: 'As it was a clear evening I got to Stonehenge and saw it by moonlight. I was alone and tremendously impressed. Moonlight as you know enlarges

everything and the mysterious depths and distances made it seem enormous'.[1]

Moore never abandoned his interest in the relationship between sculpture and architecture. A few years after this drawing he re-evaluated their ability to fuse: 'I have always thought Rievaulx Abbey a most impressive monument – more sculpture than architecture. When it is no longer usable, architecture inevitably becomes aesthetically like sculpture. This is perhaps why I like ruins, the Parthenon for instance. Now that light passes through it, it is far more sculptural than if it were all filled in.'[2] In this composition Moore has attempted to capture a similar sense of light filtering through an architectural landscape; our eye passes over a range of subtle hues: beige,

smoky blue, golden amber, pale grey. The sunlit yellows and dazzling whites project forward while the black charcoal streaks recede into space, drawing us further into the imaginary vista.

Abstraction is used to liberate architecture from its subservience to function, a dependency which Moore considered a major impediment, and a sentiment shared by the Circle Group in the only issue of what was intended to be an annual volume on International Constructive art: 'Architecture and sculpture are both dealing with the relationship of masses. In practice architecture is not pure expression but has a functional or utilitarian purpose which limits it as an art of pure expression. And

sculpture, more naturally than architecture, can use organic rhythms.'[3] This sensibility is embodied in the bone-white organic forms of this composition, which echo **The Arch** (LH 503c), Moore's monumental work in travertine marble sited the previous year in Kensington Gardens.

Anita Feldman Bennet

1. HM to Stephen Spender, letter quoted in Spender's introduction to *The Stonehenge Suite – 15 Lithographs and Etchings*, Ganymed Original Editions, London 1974.
2. Hedgecoe 1986, p. 41.
3. Leslie Martin, Ben Nicholson, Naum Gabo (eds.), *Circle: International Survey of Constructive Art*, Faber & Faber, London 1937, p.118.

260
Head of Alice 1981
HMF 81(415)
pencil, charcoal, wax crayon, watercolour wash on Bockingford white heavyweight wove
245 × 254mm
signature: ballpoint pen l.r. *Moore*, undated
Acquired 1987

exhibitions: Bellinzona/Naples/Bologna 1995-96 (cat.71)

publications: *Henry Moore: Complete Drawings*, vol.5 1977-81, AG 81.388, dust jacket front, pl.XI

This gently tilting head of a young girl emerges from the surrounding clouds as a vision in a daydream. Atmospheric pale greys and blues of a disquieted sky are electrified by intense orange and white streaks. These seemingly random markings cross the girl's brow and frame her face as if embodying her emotions. Similarly the whites of her eyes pierce through her shadowy, half blue, half grey-green form.

Although the most striking aspect of this composition is Moore's bold use of colour, for Moore colour was always subservient to form: 'I like colour . . . but for me colour is a bit of a holiday . . . [to depict] the falling of light on a solid object, like Rembrandt doing his interiors, with the mystery and the shafts of light coming down on to an object and revealing its form,

colour isn't necessary at all.'[1] Moore would have been aware of the colour theories of Delacroix, Van Gogh and Kandinsky – especially their use of complementary colours to heighten psychological tension – but he never discussed them. Moore's use of colour here is more intuitive than contrived.

Just prior to this composition, in the summer of 1980, Moore created a series of five drawings with a similar free approach to colour which he referred to as 'imagined heads', thought to be composite portraits of his companions at his holiday home in Forte dei Marmi, Italy (HMF 80(177)-80(181)). This period also represented a culmination in his experimentation with colour in his graphic work. In many of the initial proofs, he began the compositions with a spontaneous use of strong colour, which was later toned down and subdued in the final stages. Ultimately Moore felt that a

bold and free use of colour detracted from his overriding and more inherently sculptural concern with light and form.

Moore recognised that it was work on paper that allowed him the greatest freedom with colour: 'For me applied colour does not help in three dimensional sculpture . . . but in drawing I enjoy using colour and now and then I use it just for its own sake.'[2]

Anita Feldman Bennet

1. Pat Gilmour, *Interview with Henry Moore*, HMF 1975
2. New York 1979, p.15

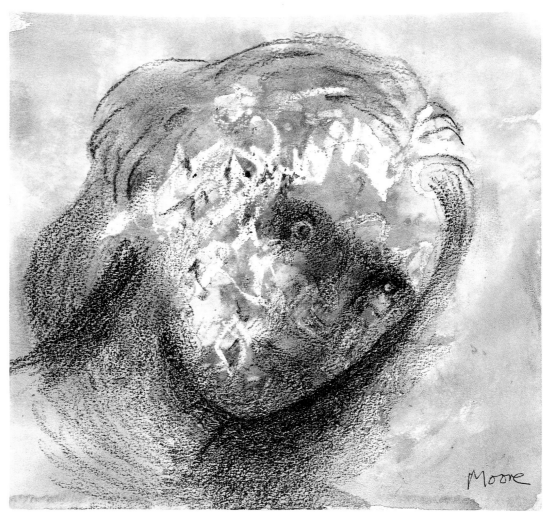

260

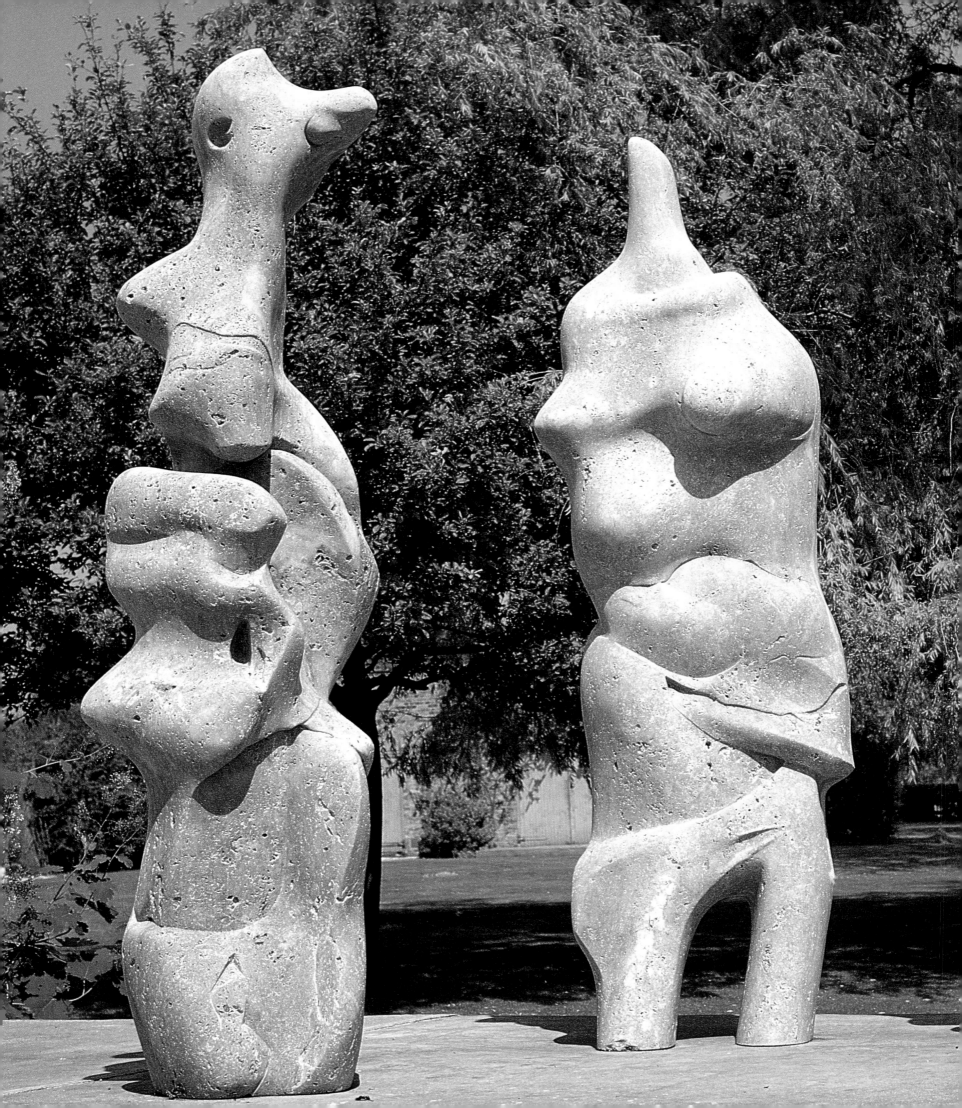

261
Two Standing Figures 1981
LH 715a
travertine marble
height 246.5cm
unsigned
Acquired 1987

Moore's later works fuse figure and landscape in a way never before attempted in sculpture. In straining to recognise human forms in these two standing figures, the viewer finds himself exploring the smooth cratered surface of the travertine like a lunar landscape. Deep crevices navigate through the terrain, recalling ancient dried river beds and creating folds of flesh.

This evocative and sublime relationship between figure and nature had only been previously visually rendered in landscape paintings, of which Moore had several examples in his personal collection, including works by Corot, Courbet, Seurat and Turner. In these paintings, the figures are represented engulfed by their environment; nature often takes on a threatening role and in turn inspires a sense of awe and appreciation of the fragility of life. For Moore, however, the assimilation of man and nature is more harmonious and expresses a reassuring continuity between all life forms. Moore explained: 'It's a metaphor of a human relationship with the earth, with mountains and landscape. Like in poetry you can say that the mountains skipped like lambs. The sculpture itself is a metaphor like the poem.'[1]

At a time when naturalism in art had been condemned for generations – with the proliferation of Abstract Expressionist, Pop, Minimal and Conceptual Art – Moore's abandonment of the constraints of the avant-garde allowed him the freedom to create a new and positive approach to modern sculpture, one which would unify it in permanence of material and subject matter.

Anita Feldman Bennet

1. Huw Wheldon, *Monitor: An Anthology*, Macdonald, London 1962, p.23.

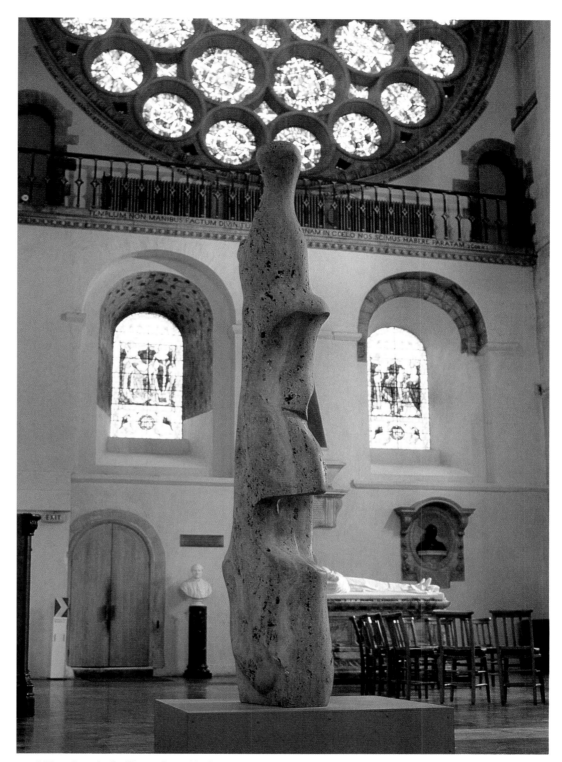

cat.262 on loan in St Albans from 1995

262
Single Standing Figure 1981
LH 715b
travertine marble
height 246.5
unsigned
Acquired 1991

loans: St Albans, Cathedral and Abbey Church of St Alban from 1995

263

Thin Reclining Figure 1979-80
LH 734
white marble
length 196cm
unsigned
Acquired 1986

exhibitions: Wakefield 1994; Nantes 1996
(cat.112); Mannheim 1996-97 (cat.112)

This reclining figure has come a long way
from the wholesome creatures of the 1930s.
The cold white marble figure, over life-size,
is disquieting. The body is too close to the
representational for one to be able to accept
its deformities as simply a formal
abstraction from life. The feeling of realism
is heightened by its emaciated appearance.
The androgynous figure's body-lines are
not displeasing in themselves, and its upper
contour in particular is rhythmically
undulating like an English landscape. It

bears the stamp of nature in every feature.
Its back is a smooth, white, organic shape
that recalls an Arp, but from it protrudes a
pointed neck/head and foreshortened,
skeletal legs. The whole is like skin pulled
over an armature of cartilage and bone, and
right at the centre the bone punctures
through to the outside. Moore had been
investigating this form in drawings and
sculpture in the 1970s and many have this
same bone-like quality.

The **Maquette for Thin Reclining
Figure** 1977 (LH 732) lies on a 'wedge' base
large enough to hold the figure inside it and
decorated with abstract gouges along the
front edge. Moore sometimes designed
pedestals for his work, for example for the
Unesco Reclining Figure 1957-58 (LH 416)
[see cat.180]. However, early drawings
show he had also been interested in
sarcophagus designs since he started going
to the British Museum in the 1920s. It is
possible that **Thin Reclining Figure** was

conceived as a kind of *memento mori*,
reminding man of the mortality of the flesh:
that only the soul lives after death
(symbolised perhaps by the bone
puncturing the skin), while the body simply
decays and becomes again a part of nature.

Clare Hillman

264

Horse 1984
LH 740a
bronze edition of 9 + 1
cast: Fiorini, London
length 68.5cm
signature: stamped *Moore, 0/9*
Acquired 1986

exhibitions: Hong Kong 1986 (cat.158);
Tokyo/Fukuoka 1986 (cat.108); Florence
1987 (cat.14); Chandigarh/Bombay/
Baroda/Bhopal/Madras/Bangalore/
Calcutta/Jaipur 1987-88 (cat.8); Milngavie/
Ayr/Paisley/Kilmarnock/Dumfries 1990;
Bellinzona/Naples/Bologna 1995-96
(cat.33); Havana/Bogotá/Buenos Aires/
Montevideo/Santiago de Chile 1997-98
(cat.113)

This late piece is one of only a few
sculptural representations of horses in
Moore's oeuvre, and the only one enlarged
from the maquette to working-model size.
Moore's perception and representation of
this horse differs radically from that of
other artists known to have explored this
subject. The sculpture owes nothing to the
elegant anatomical studies of George
Stubbs, the velocity of the animal as painted
by Degas, or to the analytical photographs
of the sequence of a horse's movements by
Muybridge, or the precise skeletal rendition
of animals by Bryan Kneale, or Elisabeth
Frink's heroic sculpture. Moore shows no
interest in the skeletal or muscular
structure of the animal. Flesh and bone are
of no representational importance.

Moore's horse is made up of a sequence
of solid, abstracted forms, seamlessly
connecting and rhythmically worked
through the animal's body; the essence of a
thoroughbred is captured in the fluid
dynamism of the bronze shape.

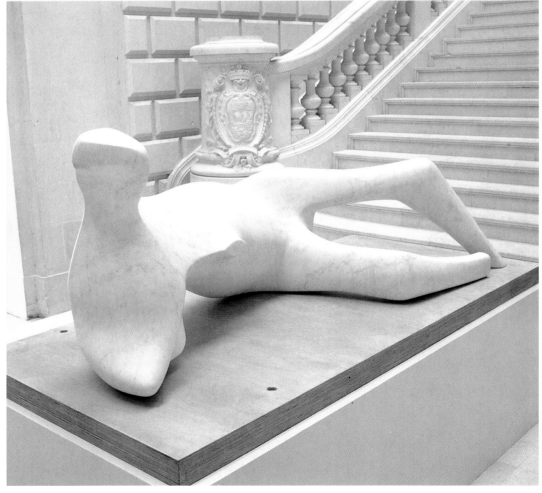

cat.263 exhibited in Nantes, 1996

Nonetheless, the animal projects a physical alertness, ears upright and head tilted. Eyes and nostrils are indicated by the simplest circular incisions, but are immediately recognisable. Any part of the body, however, which does not constitute or lend itself to being made into solid, rounded form has been cut away. Legs, tail, mane: these appendages are of no relevance; they have been eliminated, as only voluminous form matters in this representation. The horse's legs are left as solid stumps, the cropped tail echoes the shortening of the legs, although the rugged toolmarks in this area create visual tension contrasted with the overall smooth surface of the sculpture. Non-figuration is taken furthest in the modelling of the hindquarters of the animal: Moore employed an almost identical anthropomorphic shape to the one used for the lower leg and foot section of the large **Mother and Child: Block Seat** [cat.275], cast the same year.

The formal analogy between the mother's feet and the horse's buttocks is made clear in a recorded conversation between David Mitchinson and Henry Moore in 1980, when the artist spoke specifically about the animal theme in his work: 'Although my work is fundamentally based on the human figure – and it is the human figure that I have studied, drawn from, modelled as a student, and then taught for many years at college – because the human being is an animal and alive, naturally one is also interested in animal forms which again are organic and alive. I see a lot of connections between animals and human beings and I can get the same kind of feelings from an animal as from the human being. There can be a virility, a dignity or there can be a tenderness, a vulnerability. To me they are all organic life and life that can move, which is different from plant life which ordinarily is rooted. Of course, the human figure is still the most interesting for me because it expresses one's own feelings, but animal form is still very alive. I can see animals in anything, really.'[1]

Reinhard Rudolph

1. Mitchinson (ed.) 1981, p.148.

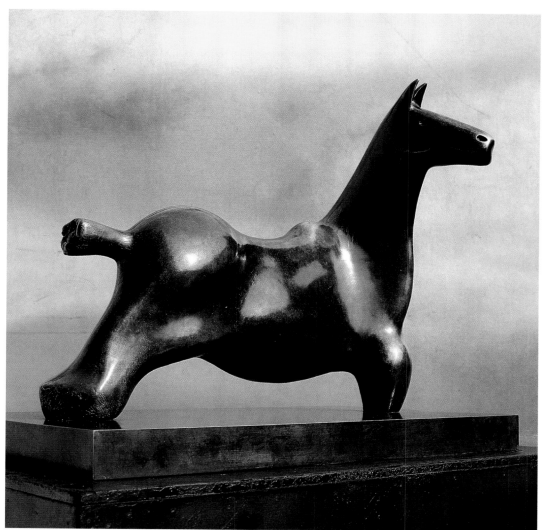

264

265
Three Bathers after Cézanne 1978
LH 741
bronze edition of 7 + 1
cast: Fiorini, London
length 30.5cm
signature: stamped *Moore, 0/7*
Acquired 1987

exhibitions: Leningrad/Moscow 1991 (cat.106); Helsinki 1991 (cat.106); Sezon/Kitakyushu/Hiroshima/Oita 1992-93 (cat.Fo-8)

In Moore's profound appreciation of Cézanne, which stretched right across the sculptor's career, the key word is 'monumentality'. Describing the tremendous impact of a large bather composition in the Pellerin Collection, which he saw in Paris on his first visit there in 1922, Moore talked of the nudes 'lying on the ground as if they'd been sliced out of mountain rock. For me this was like seeing Chartres Cathedral.' Forty years later in 1960, and after much success with his own 'as if sliced out of mountain rock' figures, Moore acquired a small Cézanne, *Trois Baigneuses* 1875-77. In so doing, he joined the historic club of artists to own Cézanne bathers which numbers Picasso, Matisse, Derain and Jasper Johns among its members. 'It's only about a foot square, but for me it has all the monumentality of the bigger ones,' he said.[1]

In March 1978 Moore demonstrated the sculptural appeal of the three figures by transcribing them in plasticine before BBC cameras. This was for a documentary about him, directed by John Read, on the occasion

of his eightieth birthday. Moore's sketchbooks are filled with transcriptions of sculptural works and, more rarely, of paintings too, but this work is only the second instance of a transcription by him in sculptural form (the other is his carved student copy, done in 1922-23, of Rosselli's *Virgin and Child with Three Cherub Heads*, see cat.11). While modelling the three Cézanne bathers in the round, aiming for the same 'spatial relationships as they have in the picture',[2] he expressed the conviction that Cézanne himself 'could have done the same', so substantial and convincing are his figures, so real must they have been in his imagination.

The fact of Moore's seeking to translate the experience of a painting into sculpture is another instance in which he anticipates his sometime student and assistant (and in some people's estimate, his successor as Britain's pre-eminent sculptor), Sir Anthony Caro. Manet, Mantegna, Matisse and Rembrandt are among the painters whose works have been rendered as sculptures by Caro. A difference, however, is that Moore's

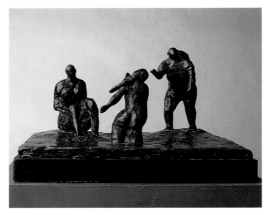

265

transcription is far more literal; the sculptural result is less ostensibly in Moore's personal sculptural language and more faithful to the *écriture* of the original. It is more of a drawing in three dimensions than an independent sculpture as such.

David Cohen

1. James (ed.) 1966, p.190; 1992, p.205.
2. New York 1979-80, p.74.

266
Reclining Figure No.7 1980
LH 752
bronze edition of 9 + 1
cast: Hermann Noack, Berlin
length 91.4cm
signature: stamped *Moore, 0/9*
Acquired 1986

exhibitions: Hong Kong 1986 (cat.137); Tokyo/Fukuoka 1986 (cat.14); Florence 1987 (cat.9); New Delhi 1987 (cat.166); Martigny 1989 (cat.pp.280, 281); Cologne/ Kreis Unna/Norden/Ratzburg/Huddersfield 1992 (cat.19); Budapest 1993 (cat.120); Bratislava/Prague 1993 (cat.120); Krakow/ Warsaw 1995 (cat.132); Venice 1995 (cat.137)

Moore made the maquette for **Reclining Figure No.7** in 1978, enlarging it two years later. The form derives from a flint to which he has added a head, a second breast, and legs, thereby forging that age-old link between woman and nature. Moore was intrigued by her form and drew and etched her in different settings, sometimes with children.

The artist originally named this piece **Reclining Figure: Distorted** but later changed the name to remove the reference to distortion.[1] Her breasts and buttocks are immensely enlarged, and her upper hip has slipped round, making her look awkward. Moore was interested in both Cézanne and Rubens at this time and seemed to be concentrating particularly on hips and buttocks in his drawings – exaggerated, swelling forms weighing the figures down. Rubens used such techniques for titillation, Cézanne to make a more misogynistic point about woman's emancipation. Moore's reclining female figures are of course in some sense voyeuristic, for he was inspired by his appreciation of woman's form. However, this piece does not appear to be a Rubenesque celebration of woman's physical beauty. Rather, coming at the end of the 1970s that saw so much active feminism, this piece, and other works of this time, seem to refer to the final loss of Moore's model for sculpture, the salt-of-the-earth woman. The image is highly sexually charged to tempt the viewer. She

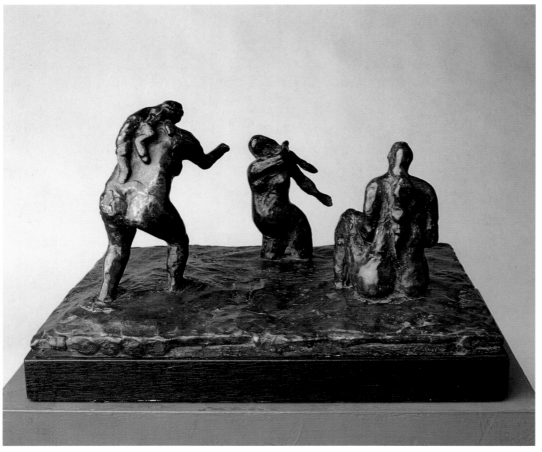

265

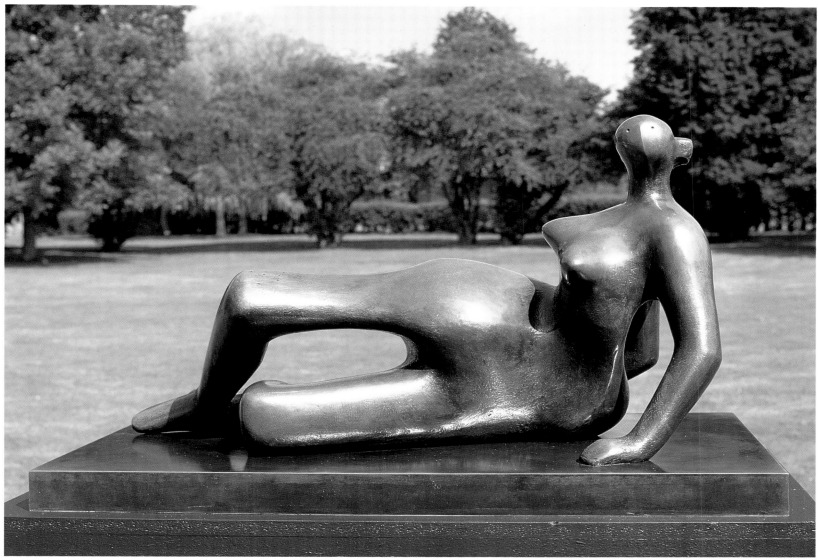

266

seems to be the temptress revealed, like Manet's *Olympia* 1865 – woman as both corrupted and corrupting. Moore has tied her to his enduring ideal by constructing her from a stone, but imbued her with the more sinister sexuality of a woman with power.

Clare Hillman

1. *Henry Moore: Complete Drawings*, vol.5, 1977-81, p.28.

267

Mother and Child 1978
LH 754
stalactite
height 84cm
unsigned
Acquired 1986

exhibitions: Hong Kong 1986 (cat.122); Tokyo/Fukuoka 1986 (cat.37); Florence 1987 (cat.6); New Delhi 1987 (cat.167); Sydney 1992 (cat.170); Wakefield 1994; Nantes 1996 (cat.110); Mannheim 1996-97 (cat.110)

Photographs cannot do justice to the rare material from which this group is carved. Stalactite is a crystalline structure formed

over millennia from droplets of water containing calcium carbonate accumulating on the roof of a cave. The carving shares with the **Mother and Child** in rosa aurora [cat.214] its connection with Moore's ideas from the 1930s when he first explored the psychology rather than the appearance of the mother and child relationship. It is difficult to 'read' the mother's head, and if, as in 1930s carvings, the protrusion stands for her hair, the mother is turning her head away from the child in her arms. The child seems to have been reduced to a fusion of mouth and ear, drawing attention to the two most developed senses in the relationship of mother and child. However, Moore does not intend us to interpret the carving with our intellect: he expects us to

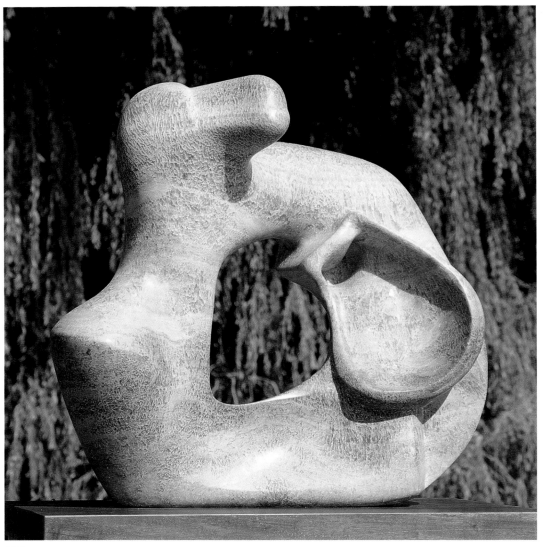

267

The Hyatt Foundation in Rosemont, Illinois, purchased the entire edition of nine casts for use as architectural awards, the first of which was presented to Moore's friend Philip Johnson. A working model nearly one hundred centimetres long soon followed, and the series culminated with this prepossessing enlargement.

Compositionally and thematically, this sculpture is a reworking of a figure completed nearly twenty years earlier for the Lincoln Center in New York (LH 519). Both reclining figures are divided into two parts – a sharply angled upright torso and a completely separate voluminous form which can only be read as figurative through association with the other section. The mountainous, rugged, organic forms of the earlier sculpture have become highly abstracted, smoothed over and polished. The result is a figure which is at once elegant and enigmatic.

Moore recalled: 'The two and three piece sculptures were experiments and you must experiment. You do things in which you eliminate something which is perhaps essential, but to learn how essential it is you leave it out. The space then becomes very significant . . . If you are doing a reclining figure you just do the head and the legs. You leave space for the body, imagining the other part even though it isn't there. The space then becomes very expressive and you have to get it just right . . .'[1]

Anita Feldman Bennet

1. Hedgecoe 1986, p.112.

intuit from it his own intimations of the complexity of the relationship. It is as though he equates the beauty of the idea of mother and child with the beauty of the material, and then, by means of ambiguous forms, conveys the physical and psychological pain that is as much the reality of child-bearing and child-rearing as love.

Susan Compton

268
Two Piece Reclining Figure: Cut
1979-81
LH 758
bronze edition of 3 + 2
cast: Hermann Noack, Berlin
length 480cm approx.
signature: stamped *Moore*, [00/3]
Acquired 1986

loans: New York, Colombia University, at Arden House from 1986

Moore completed this monumental work at the age of eighty-three, despite his gradually declining health. Originally a mere 20 centimetres in length, the maquette was enlarged to 30 centimetres and retitled **Architecture Prize** (LH 756).

269
Girl with Crossed Arms 1980
LH 776
travertine marble
height 72.4cm
unsigned
Acquired 1986

exhibitions: Hong Kong 1986 (cat.123); Tokyo/Fukuoka 1986 (cat.38); New Delhi 1987 (cat.167); Leningrad/Moscow 1991 (cat.111); Helsinki 1991 (cat.111); Wakefield 1994; Nantes 1996 (cat.113); Mannheim 1996-97 (cat.113)

opposite: cat.268 on loan in New York from 1986

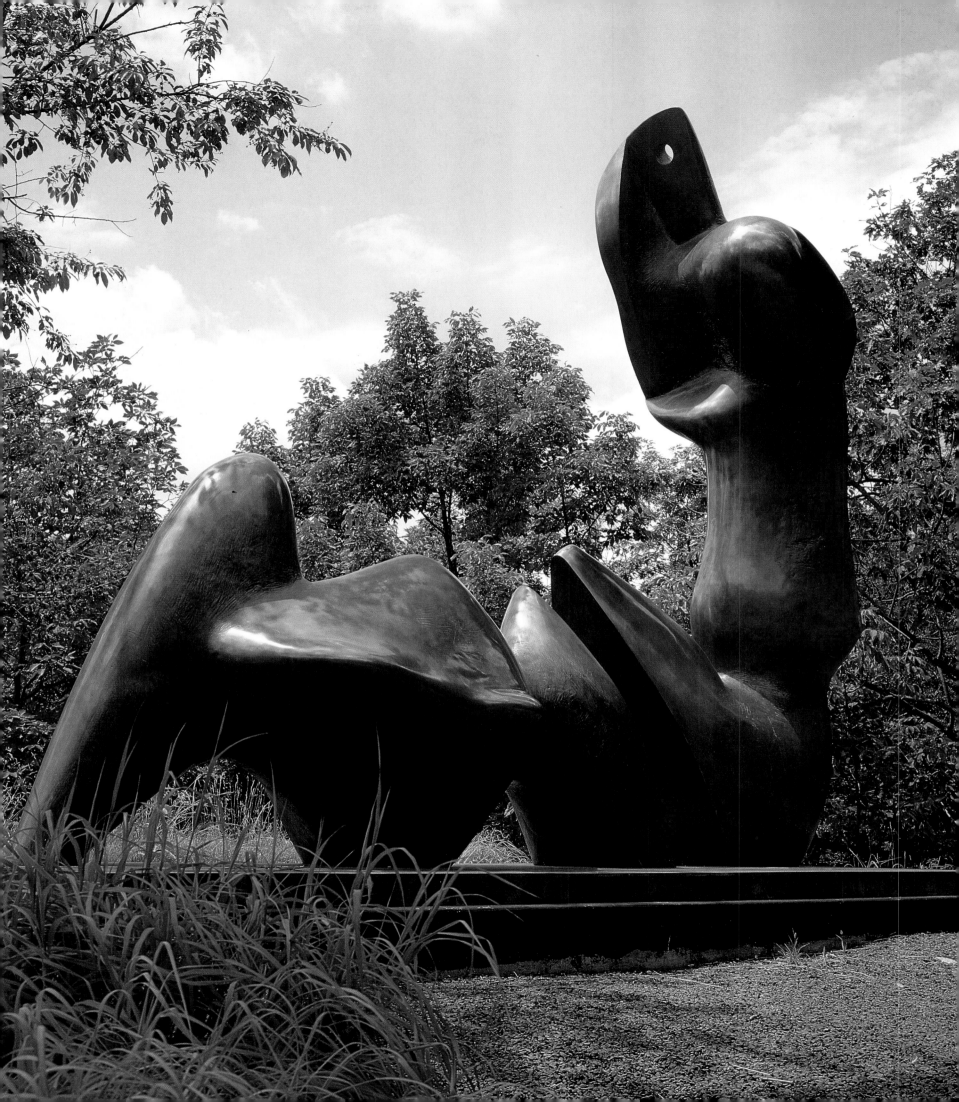

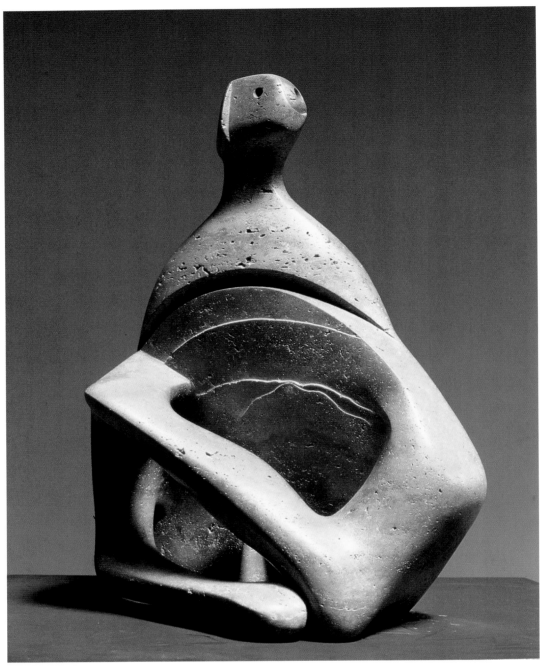

269

objects to be found along the coast held a particular fascination for the artist, whose collection of assorted shells, driftwood and smooth sea-worn stones and bones fill drawers and boxes in his studio at Perry Green. Many of these were discovered along the beach near his home at Forte dei Marmi, not far from the marble quarries of Carrara where this figure was carved. Early in his career Moore had frequently admired the Monet seascape *Cliff at Etretat* (1883), in the home of his lifetime friend and early patron Kenneth Clark (now in the collection of the National Gallery, London). Moore later acquired two seascapes by Courbet for his home in Hoglands, *Marine* (1866), and *La grotte de la loue* (1864) with a similar dramatic overhanging cliff and dark entrance to a forbidding sea cave.

Anita Feldman Bennet

1. Hedgecoe (ed.) 1968, p.131.

270
Three Quarter Figure: Lines 1980
LH 797
bronze edition of 9 + 1
cast: Fiorini, London
height 84cm
signature: stamped *Moore, 0/9*
Acquired 1986

exhibitions: Hong Kong 1986 (cat.156); Tokyo/Fukuoka 1986 (cat.107); Bellinzona/Naples/Bologna 1995-96 (cat.24)

Throughout his career, Moore continued to draw on the resources of the European avant-garde sculpture he had looked to in the 1920s and 1930s. Some of Arp's figures from the 1930s, elongated vertical forms with biomorphic bulges, are close to **Three Quarter Figure: Lines**, especially *Growth* 1938. Whereas the Arp is a smooth and generalised organic form, the Moore is most definitely a female figure, with eye hole and incised nipple, and, compared to the almost ethereal nature of the Arp, it is a solid, armoured form.

The lines dividing the skin of this figure like seams are related to many drawings in which Moore used similar lines to define

A creature of the sea, this waif-like girl with hollowed chest and small pinched face crosses her fragile arms in a calm yet protective gesture. The porous texture of the travertine marble, with its coarse and smooth qualities of sand, coupled with the repetition of ripples, gives the effect of having been worn continually by the sea – both timeless and ever changing. The deep crevice adds a sense of mystery, lending to the association of unexplored caves beneath the ocean cliffs. Echoing the

rhythms of the ocean, the girl emerges from and dissolves into the landscape of natural forms which inspired her creation. Moore explained: 'I am tremendously excited by all natural forms, such as cloud formations, birds, trees and their roots and mountains, which are to me the wrinkling of the earth's surface, like drapery. It is extraordinary how closely ripples in the sand on the seashore resemble the gouge marks in . . . carving.'[1]

The rich variety of rock formations and

the form of a body, which sometimes appear to represent blocks of stone or brick. Here, however, they have a disturbing feel, giving the impression of being the divisions between armoured plates.

This hybrid being, part-mechanical, part-organic, is reminiscent of Epstein's *Rock Drill* which holds within its aggressive and shielding forms a fragile embryonic figure. Here, too, male and female elements coexist – the sculpture is male and mechanical, especially in the head and the ribbed shoulder which links the two breast-like protrusions, and female and organic in the stirring of rounded forms beneath an elastic skin. The two are combined in a deeply ambivalent phallic form. In the 1920s and 1930s it is likely that this would have been read in Freudian terms as a condensation of male and female elements in a single contradictory image, as in photographs by Brassai which make of a female torso an image of the phallus, or as in Brancusi's *Princesse X* which did the same for a woman's head and shoulders. In 1980 it was likely to be read mainly in terms of Moore's own oeuvre and individual style. The penchant of some of Moore's supporters to see his work outside history was retrospectively confirmed by the growth of the artist's reputation, but it may be that in the process something was lost.

Julian Stallabrass

271
Reclining Woman: Elbow 1981
LH 810
bronze edition of 9 + 1
cast: Morris Singer, Basingstoke
length 221cm
signature: stamped *Moore, 0/9*
Acquired 1986

loans: Leeds, City Art Gallery from 1982

This is among Moore's last large-scale reclining figures. He selected it as particularly appropriate for display on the exterior entrance terrace to the Moore Sculpture Gallery extension to Leeds City Art Gallery, which was opened in November 1982 by Her Majesty The Queen

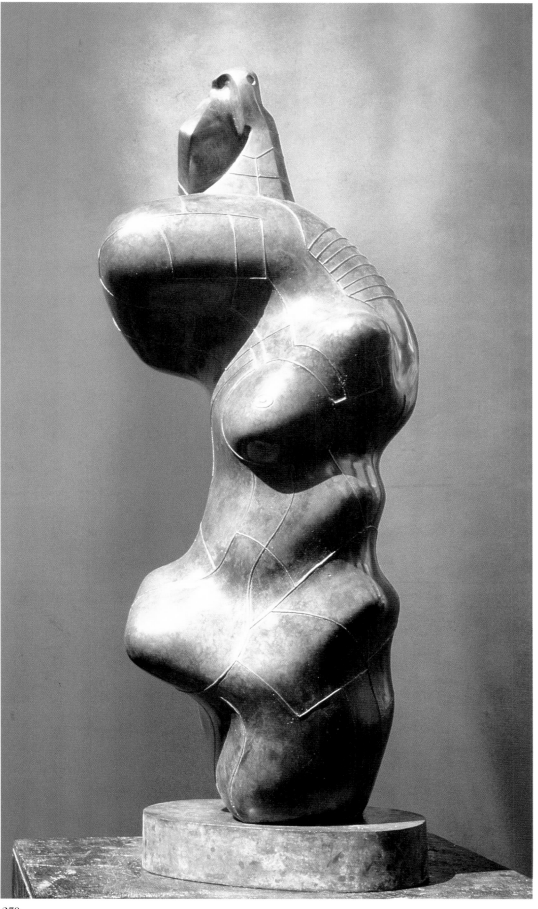

270

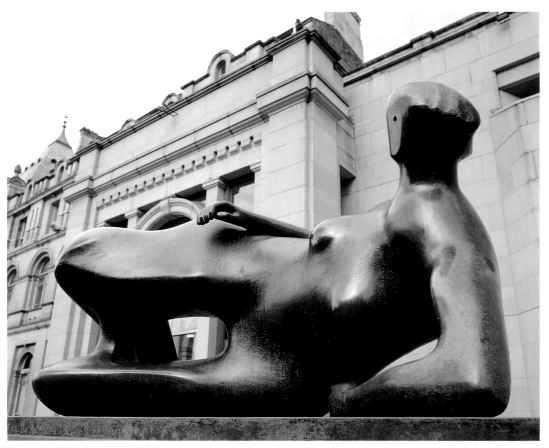

cat.271 on loan in Leeds from 1982

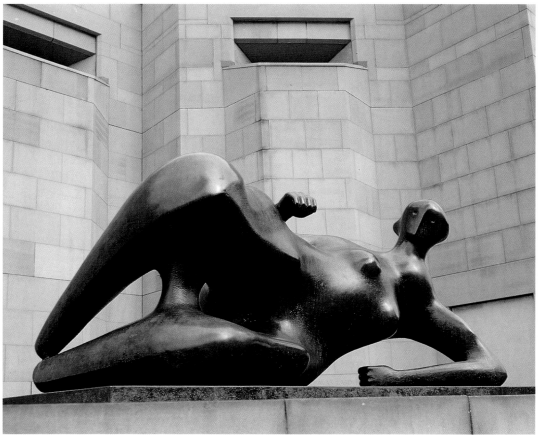

271

in the sculptor's presence. In the summer of that year, a few months before the completion of the new gallery, Moore visited Leeds to sort out problems of siting. The sculpture itself had not yet arrived. To give some idea of scale and mass in relationship to the façade, David Mitchinson (Curator at the Henry Moore Foundation) and the then Principal Keeper at Leeds (the present writer) were volunteered into acting as the surrogate figure, posing on the platform as its head and rump, while Moore, by then confined to a wheelchair, was wheeled back and forth across the piazza.

The possibility of an upright sculpture was briefly discussed and then dismissed. Moore liked the horizontality and the full rounded female forms of **Reclining Woman: Elbow**, its lustrous, deeply polished bronze set against the straight-edged, cliff-like Yorkshire limestone walls of the building, partly glimpsed through the cavernous openings between arms and legs. It was vitally important to get it right, for the image had to stand as a symbolic reminder of Moore's youth in Leeds, sixty years earlier, when he began his sculpture training at the College of Art just around the corner, but also as a fitting introduction to the gallery, with its outstanding permanent collection of twentieth-century British sculpture housed in the spacious and dramatic top-lit spaces within, which includes his celebrated early masterpiece, the brown Hornton stone **Reclining Figure 1929** (LH 59), and **Three Piece Reclining Figure No.2: Bridge Prop** 1963 (LH 513).[1]

Terry Friedman

1. *Leeds' Sculpture Collection Illustrated Concise Catalogue*, Centre for the Study of Sculpture, Leeds 1996, pp.23, 34.

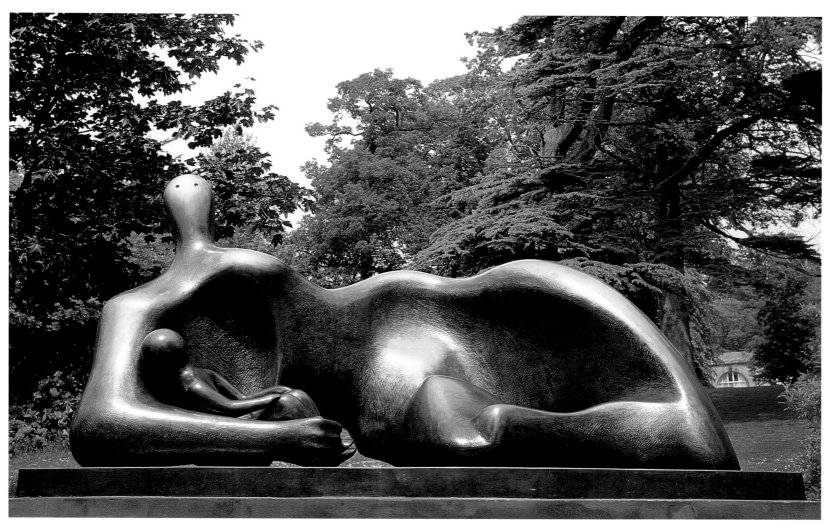

cat.272 exhibited in Wakefield, 1987

272

Draped Reclining Mother and Baby
1983
LH 822
bronze edition of 9 + 1
cast: Morris Singer, Basingstoke
length 265.5cm
signature: stamped *Moore, 0/9*
Acquired 1986

exhibitions: Hong Kong 1986 (cat.128);
Tokyo/Fukuoka 1986 (cat.62); Wakefield
1987 (cat.32); New Delhi 1987 (cat.196);
Martigny 1989 (cat.pp.296-298); Milan 1989-
90 (p.95); Glasgow 1990; Sydney 1992
(cat.181); Wakefield 1994-95 (cat.6)

Moore wrote: 'There are three fundamental
poses of the human figure. One is standing,
the other is seated, and the third is lying
down . . . But of all the three poses, the
reclining figure gives me the most freedom
compositionally and spatially.'[1] For Moore
the reclining figure has always related to
the land. We see here the rise and fall of the
earth. The hollowed out forms suggest a
womb and reiterate the Greek myth in
which Gaia, the Earth-mother, gives birth
to the sun and the moon. The piece
explicates the ritual of birth and growth, of
the interrelationship between the mother
and child. Moore literally plays with these
natural and humanistic forms until they
become interwoven and synonymous. The
main figure is the quintessential Moore
reclining figure because she is the Earth
goddess. She is the landscape and
mountains, nurturer and source of growth,
the protector of life.

The reclining figure has always had
references to the land for Moore, but a
reclining figure with a child is rare within
his oeuvre. He experimented with the
position of the baby, placing it first on and
then against the mother's thigh, but it
seemed unprotected until he finally moved
it into the space near the mother's breast.
The figure retains a relationship to the
land, but the addition of the child suggests
that land has given birth to a new form. She
is the stable form which gives life to
children and to the earth. Her undulating
forms melt into the land, conveying a sense
of timelessness. Moore became a
grandfather in 1977, and this work perhaps
also alludes to the presence of the
grandparent revelling in and protecting the
new life.

Gail Gelburd

1. Hempstead/University Park/Philadelphia/Baltimore
1987, p.37.

273

273

Man Drawing Rock Formation 1982
HMF 82(437)
charcoal, chinagraph, chalk, pencil over
lithographic frottage
on T.H. Saunders watercolour paper
321 × 402mm
signature: chinagraph l.l. *Moore*, undated
Acquired 1987

exhibitions: London1988 (cat.234);
Martigny 1989 (cat.p.292); Leningrad/
Moscow 1991 (cat.115); Helsinki 1991
(cat.115); Krakow/Warsaw 1995 (cat.135);
Venice 1995 (cat.138); Nantes 1996
(cat.118); Mannheim 1996-97 (cat.118);
Havana/Bogotá/Buenos Aires/Montevideo/
Santiago de Chile 1997-98 (cat.122)

publications: Garrould 1988, pl.314; *Henry
Moore: Complete Drawings*, vol.6 1982-83,
AG 82.428

In a way, this drawing is Moore's answer to
the *Vollard Suite*. Just as Picasso's legendary
images of the artist and his model, from the
series of etchings begun in September 1930,
depict an artist but are not self-portraits, so
too Moore's draughtsman is an everyman
figure, rather than a recognisable likeness
of himself, or a personal surrogate. If we
are entitled to read this work as symbolic of
the creative act, it is significant that, despite
Moore's 'fundamental obsession' with the
female body, the artist here confronts
nature in its slowest incarnation, rock,
rather than selecting a living, breathing
woman as his muse.

Much as he held Picasso in awe, and
borrowed liberally from him earlier in his
career, it is another artist whose work
Moore loved who was the formal influence
in this drawing: Seurat. Moore particularly
admired Seurat's dense, black drawings,
two of which he owned. 'I look at these
almost every day,' he wrote in 1974,
admitting that they had influenced his own
recent 'black' drawings and lithographs,
where the image emerges in shadowy form
from within a rough, all-over mass of black
lines and shading.

The unusual texture of **Man Drawing
Rock Formation** owes something to the
fact that the drawing was done over the
proof of an uneditioned lithograph which in
turn derived from a 'frottage', a rubbing
taken, as it happens, from the wall of the
Curwen print workshop. This anecdotal
information further enriches an
interpretation of the drawing as allegorical
of the creative act. For when Moore
declared 'I can find a landscape in blots or
random marks on paper' he directly
recalled – whether wittingly or not –
Leonardo's famous defence of landscape, as
recounted by Vasari. When Botticelli
dismissed landscape painting as no harder
to achieve than throwing a sponge willy-
nilly at the picture plane, Leonardo retorted
that precisely for this reason landscape
painting is a supremely creative art-form,
for it draws upon the psychological power
of random association. Elsewhere he
exhorted students to 'gaze long at an old,
crumbling wall'. One place Moore may
have encountered these references, so
obviously fitting to the present drawing, is
the epigraph to Max Ernst's 1937 essay 'Au-
delà de la peinture' (Beyond Painting).
Immediately following this quote is a
passage in which Ernst recalls the chance
discovery which led to his invention of
frottage.

David Cohen

274

Three Fates 1983-84
TAP 27
tapestry woven at West Dean College by Pat
Taylor and Fiona Abercrombie
from a drawing of 1943 (HMF 2163)
cotton warp; linen, wool weft
243 × 350cm
Acquired 1984

exhibitions: Leningrad/Moscow 1991
(cat.116); Helsinki 1991 (cat.116); Sydney
1992 (cat.184); Krakow/Warsaw 1995
(cat.138); Venice 1995 (cat.141)
loans: London, Queen Elizabeth II
Conference Centre 1986

publications: Garrould, Power 1988, cat.20,
pp.88-91

275
Mother and Child: Block Seat 1983-84
LH 838
bronze edition of 9 + 1
cast: Morris Singer, Basingstoke
height 244cm
signature: stamped *Moore, 0/9*
Acquired 1986

exhibitions: Hong Kong 1986 (cat.127);
Tokyo/Fukuoka 1986 (cat.42); Wakefield
1987 (cat.33); New Delhi 1987 (cat.200);
Martigny (cat.pp.300-302); Milan 1989-90
(p.97); Glasgow 1990; Paris 1992 (cat.27);
Bellinzona/Naples/Bologna 1995-96 (cat.34)

publications: Cohen 1993, pl.XLIII

'The whole of my development as a sculptor is an attempt to understand and realize more completely what form and shape are about, and to react to form in life, in the human figure and in past sculpture.'[1] During the period 1975-83 Moore created more images of the mother and child than at any other time in his career. In **Mother and Child: Block Seat**, the child is the foetus, held by a monumental mother. The grand nobility, the majestic character of the simplified figure reminds us of the Northampton **Madonna and Child** 1943-44 (LH 226). Indeed, the earlier maquette for cat.275 even more closely resembles that **Madonna and Child**. The head of the figure at first appears reduced when compared to the massive body; but it is that very reduction in scale of the head that gives the form even more grandeur.

Moore's long and careful study of the human figure is evident in these more abstract later works. Within the power of the form the viewer can sense the figure emerging from the abstract embryonic shape. Moore's women recall the grand images of women from antiquity or prehistory, the Renaissance or Modernism, but they are always figures of power. While they can appear sensuous, they are not women as sex objects. They are associated with the earth and regeneration. They have a quiet dominance, a protective and physical presence which is universal.

Gail Gelburd

1. James (ed.) 1966, p.277; 1992, p.296.

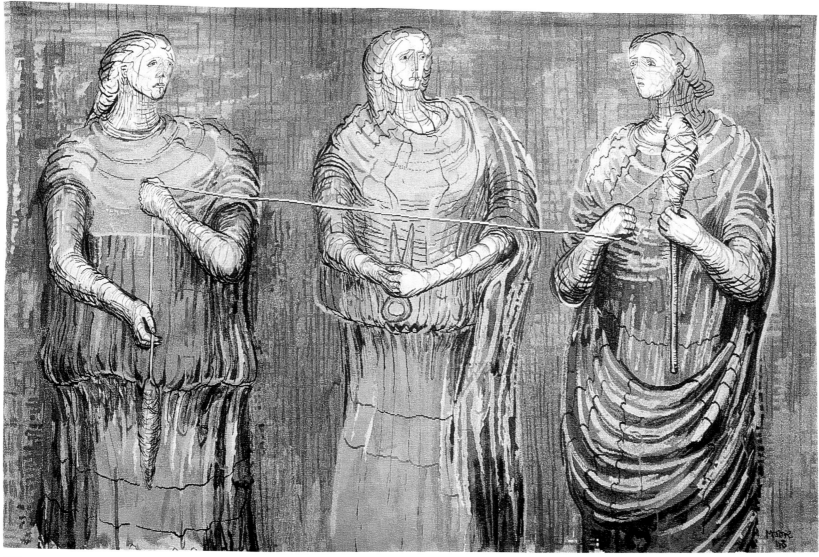

274

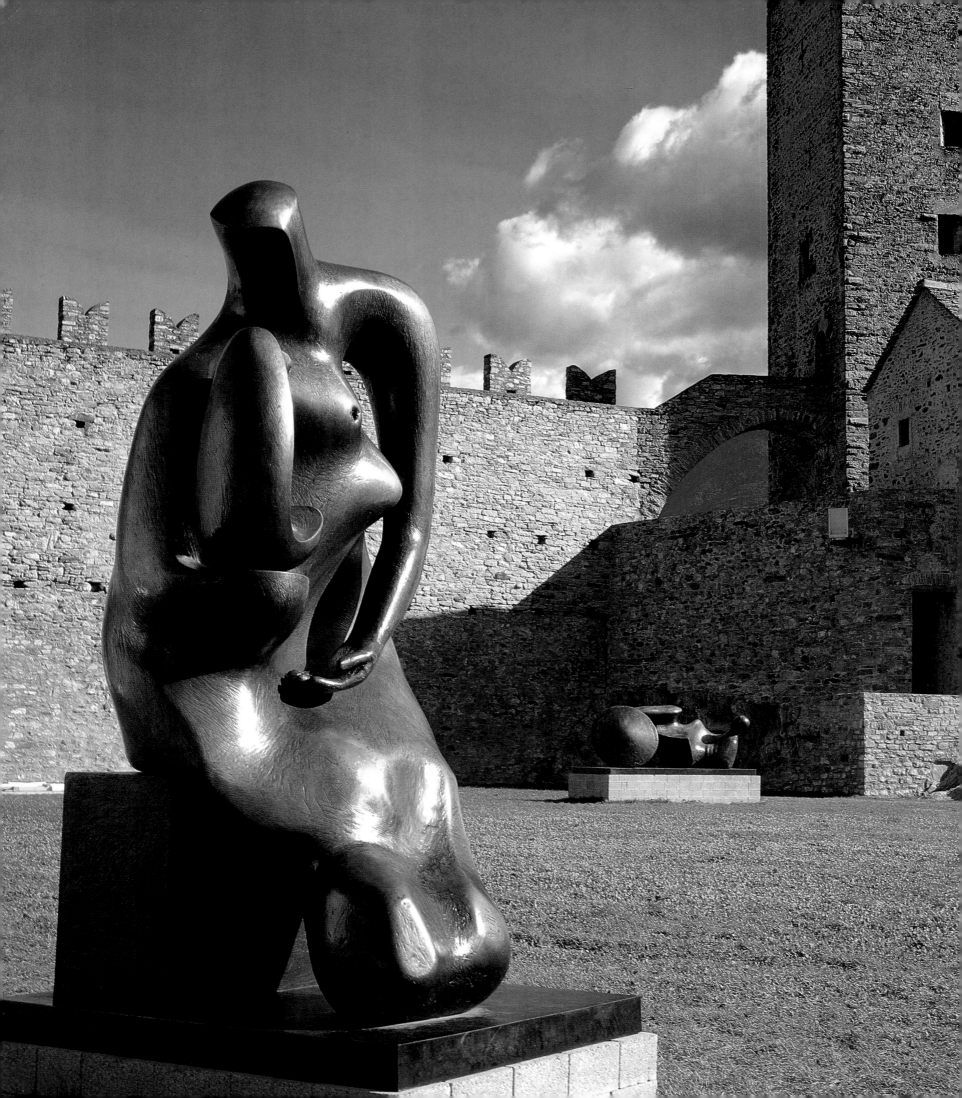

276
Mother and Child: Hood 1985
LH 851
travertine marble
height 183cm
unsigned
Acquired 1986

loans: London, The Dean and Chapter of
St Paul's Cathedral from 1984

'There are two particular motives or
subjects which I have constantly used in my
sculpture . . . they are the "reclining figure"
idea and the "mother and child" idea.
Perhaps of the two the "mother and child"
has been the more fundamental obsession.'[1]

What Moore created here was an
abstracted version of the mother and child
or Madonna and child theme. The seated
figure of the Virgin Mary holding the child
on her lap is clearly indicated. The
simplified form emphasises the protective
womb-like hollow in which the child sits as
the mother's watchful eye scrutinises the
world. The two forms fit gracefully within
each other, as if one grows literally from
the other. The image is monumental, with
precedents in the Renaissance images of
the Madonna and child where the figures
have a profound dignity, dwarfing the figures
which surround them. The crescent form at
the top of the sculpture suggests a veil, while
the rounded glistening top of the small
shape nestled in the larger figure alludes to
the subtle golden halos found in paintings
such as Raphael's *Madonna and Child*.

This mother and child sculpture has a
quiet dignity, the type that Moore usually
reserved for his images of a Madonna and
child. Despite the abstract quality of these
forms, they convey the humanistic quality
and the sanctity of the mother–child
relationship. 'The great, the continual, the
everlasting problem (for me) is to combine
sculptural form (POWER) with human
sensibility and meaning . . . finding the
common essentials in all kinds of sculpture.'[2]

Gail Gelburd

1. Quoted in 'Symposium: Art and Religion', *Art Digest*,
vol. II, 1953.
2. Hempstead/University Park/Philadelphia/Baltimore
1987, p.57.

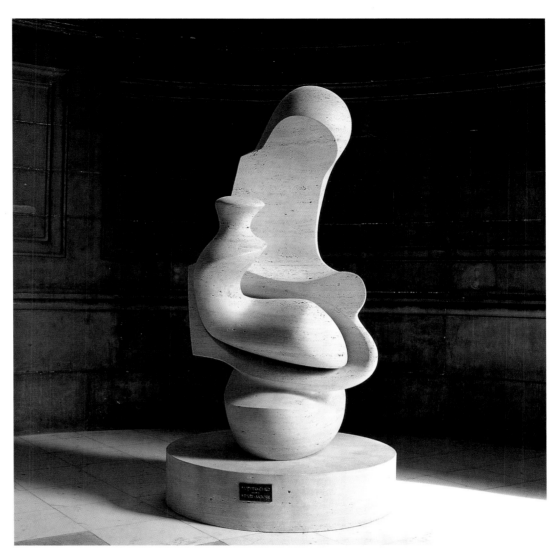

cat.276 on loan in London from 1984

277
Mother with Child on Lap 1985
LH 870
bronze edition of 9 + 1
cast: Fiorini, London
height 78.5cm
signature: stamped *Moore, 0/9*
Acquired 1986

exhibitions: Helsinki 1987 (cat.23);
Hempstead/University Park/Philadelphia/
Baltimore 1987-88; Singapore/Kuching/
Kuala Lumpur/Penang/Bangkok/Manila
1989-90; Cologne/Kreis Unna/Norden/
Ratzburg/Huddersfield 1992 (cat.56);
Bellinzona/Naples/Bologna 1995-96 (cat.55)

In the mid-1970s Moore began a series of
maquettes of the seated mother and child,
exploring new aspects of this favourite
theme. The mother balances herself stiffly
upright in a position which prevents her
truncated legs from reaching the ground;
her impassive mask-like face further
removes her from the child, which –
necessarily cast separately in bronze – is
balanced at arms' length so that it barely
impinges upon her. A pun on eyes and
nipples suggests that the child yearns for
closer contact with its mother, whose
gimlet eyes and proud breasts remain
unresponsive to it. Moore conveys the
inevitable separation between mother and
offspring as the growing child is weaned
and becomes increasingly aware of its own
identity as a person.

The bland surface of the bronze cast
further removes all sense of feeling. The

opposite: cat.275 exhibited in Bellinzona, 1995,
with **Goslar Warrior** 1973-74 [cat.233]

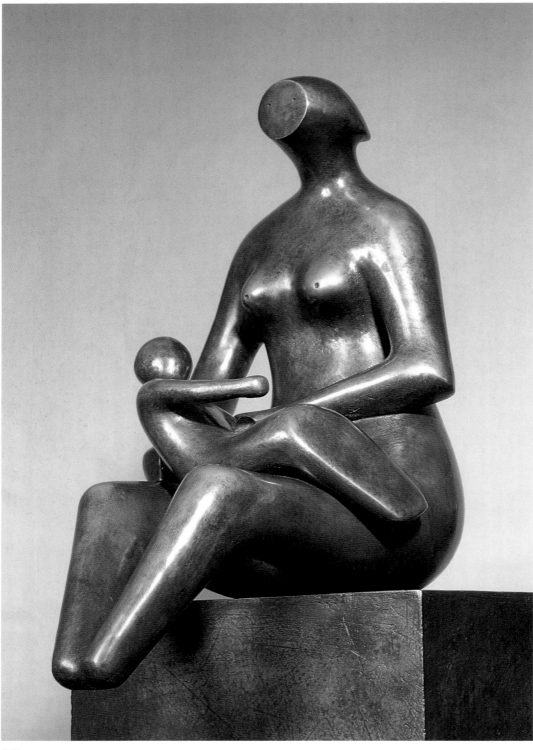

277

278

Head 1984
LH 918
bronze edition of 9 + 1
cast: Fiorini, London
height 62.2cm
signature: stamped *Moore, 0/9*
Acquired 1986
exhibitions: Helsinki 1987 (cat.22); Florence
1987 (cat.15); Chandigarh/Bombay/Baroda/
Bhopal/Madras/Bangalore/Calcutta/Jaipur
1987-88 (cat.12); Harare/Bulawayo 1988
(cat.5); Singapore/Kuching/Kuala Lumpur/
Penang/Bangkok/Manila 1989-90; Sydney
1992 (cat.183); Budapest 1993 (cat.125);
Bratislava/Prague (cat.125); Krakow/
Warsaw 1995 (cat.136); Venice 1995
(cat.139); Havana/Bogotá/Buenos Aires/
Montevideo/Santiago de Chile 1997-98
(cat.123)

This work was one of the last sculptures
Moore made and was certainly the last head
he conceived. Throughout his life he was
criticised for his heads, which people
complained were too small, too
insignificant in comparison to the rest of
the body. He would retort that the head is
the most important part of the human body:
' . . . you would not put features on the back
of a head to make the head as interesting as
the face, because it's the difference
between the back of the head and the front
of the face of the human being which
makes it interesting. But this doesn't mean
that the back has no shape.'[1] This majestic
head, with all the pride and resonance of
royalty, is pared down to the bare essentials
and from certain angles is positively thin.
The collar of the neck is created by a
sweeping thumbprint, and the head bears
the hallmarks of its creator's hand. Moore
made carvings and bronze sculptures of
individual heads throughout his long career
– even this late work exhibits some of the
simplicity and economy of form present in
the earliest, such as **Head of the Virgin**
1922 [cat.11].

Julie Summers

1. Mitchinson (ed.) 1981, p.192.

surface is the result of using polystyrene for
the enlargements made by assistants from
the original maquette (LH 869) made by
Moore himself in 1982. Although
polystyrene can be carved, it has none of
the vitality of plaster, which, after initial
moulding by hand, can be scratched and
marked with graters and chisels to produce
lively striations on the surface of the final
casting – which would, however, have been
inappropriate here.

Susan Compton

opposite: cat.278

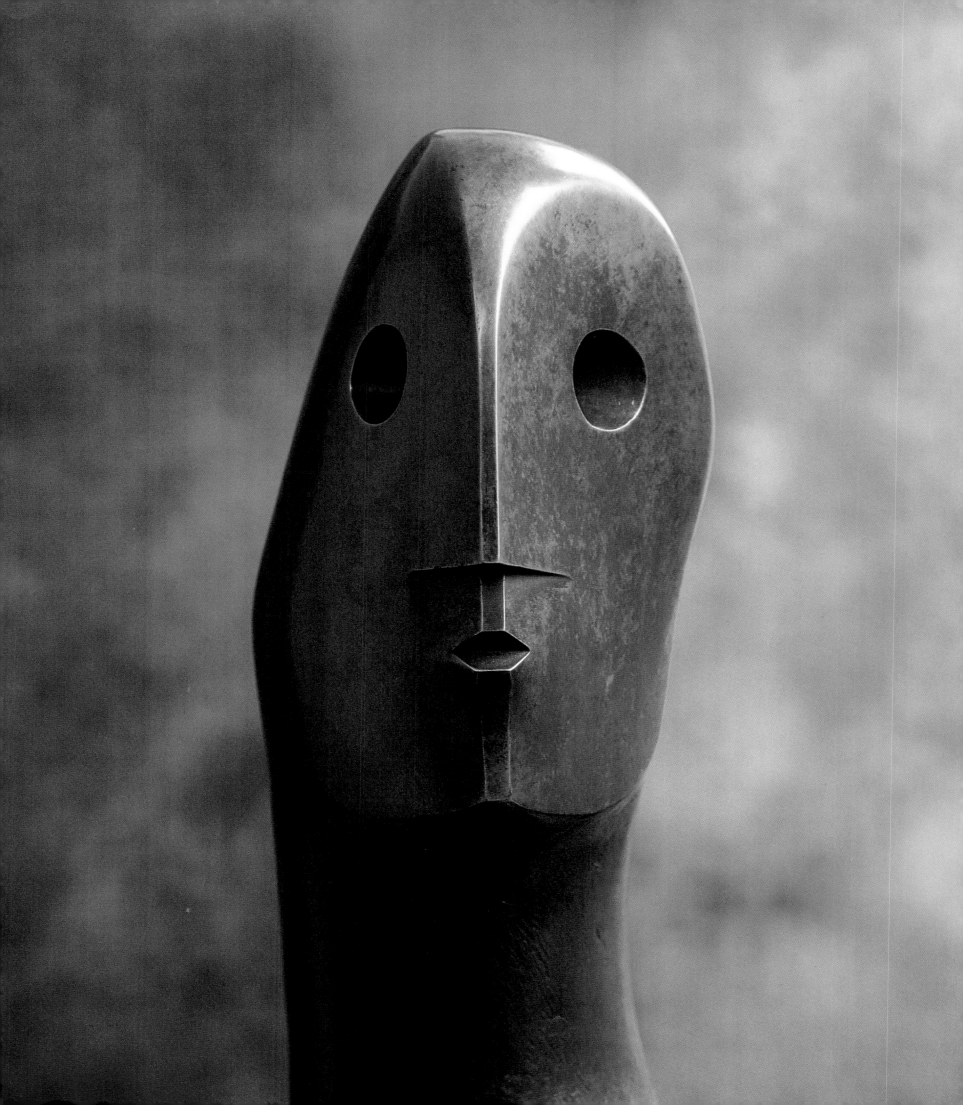

Barcelona 1981-82: *Henry Moore: Sculptures, Drawings, Graphics 1921-1981*, Miró Foundation

Barcelona/Vienna 1995: *Europa Nach der Flut, Kunst 1945-1965*, Centre Cultural, Barcelona; Künstlerhaus, Vienna (Vienna catalogue numbers cited)

Basel 1982: *Henry Moore: Sculptures, Drawings*, Galerie Beyeler

Basel 1984: *Skulptur im 20. Jahrhundert*, Merian-Park (Werner Druck AG)

Beijing/Shenyang/Hong Kong 1982: *British Drawings and Watercolours*, Beijing Art Gallery, Beijing; Shenyang Art Gallery, Shenyang; Hong Kong Museum of Art, Hong Kong (The British Council, London)

Bellinzona/Naples/Bologna 1995-96: *Henry Moore: gli ultimi 10 anni*, Castelgrande, Bellinzona; Castel Nuovo, Naples; Galleria d'Arte Moderna, Palazzo Re Enzo, Bologna (Skira Editore, Milan)

Berlin 1997: *The Age of Modernism – Art in the 20th Century*, Martin Gropius Bau

Bilbao 1990: *Henry Moore*, Museo de Bellas Artes de Bilbao

Bonn/Ludwigshafen 1979-80: *Henry Moore: Maquetten, Bronzen, Handzeichnungen*, Bundeskanzleramt, Bonn; Wilhelm Hack Museum, Ludwigshafen (Eduard Roether Verlag, Darmstadt)

Bradford 1978: *Henry Moore: 80th Birthday Exhibition*, Bradford Art Gallery, Cartwright Hall and Lister Park

Bratislava/Prague 1993: *Henry Moore*, Galérie Mesta, Bratislava; Ceské Muzeum Véytvarnyéch Umeni, Prague

Bremen/Berlin/Heilbronn 1997-98: *Henry Moore – Animals*, Gerhard Marcks Haus, Bremen; Georg Kolbe Museum, Berlin; Städtische Museen, Heilbronn

Brussels 1979: *Malou Seventy-Nine*, Malou Park (Comité Culturel et la Galerie de Prêt d'Oeuvres d'Art de Woluwe Saint Lambert)

Budapest 1993: *Henry Moore*, Museum of Fine Arts

Buenos Aires/Rosario/Mar del Plata/Córdoba/ Montevideo 1996: *Interno y Externo: Henry Moore; Bronces y Grabados*, Museo Nacional de Bellas Artes, Buenos Aires; Centro Cultural Parque de Espana, Rosario; Centro Cultural Villa Victoria, Mar del Plata; Museo Provincial de Bellas Artes Emilio Caraffa, Córdoba; Museo Nacional de Artes Visuales, Montevideo (The British Council, Buenos Aires)

Buntingford 1980: *Henry Moore: Sculptures and Prints*, Ward Freeman School

Cambridge 1982: *Circle: Constructivist Art in Britain 1934-40*, Kettle's Yard Gallery

Caracas 1983: *Henry Moore: Esculturas, Dibujos, Grabados*, Museo de Arte Contemporáneo de Caracas

Chandigarh/Bombay/Baroda/Bhopal/Madras/ Bangalore/Calcutta/Jaipur 1987-88: *Henry Moore, India 1987*, Government Museum and Art Gallery, Chandigarh; Jehangir Art Gallery, Bombay; MS University Faculty of Fine Arts Gallery, Baroda; Roopankar Bharat Bhavan, Bhopal; Lalit Kala Academi, Madras; Chitrakala Parishath, Bangalore; Birla Academi, Calcutta; Lalit Kala Academi, Jaipur (The British Council, London)

Chiswell/Chichester/Wighton 1993: *Henry Moore and the Sea*, Chesil Gallery, Chiswell, Portland; Pallant House, Chichester; The School House, Wighton (The Henry Moore Foundation, Much Hadham)

Cologne/Kreis Unna/Norden/Ratzeburg/ Huddersfield 1992: *Henry Moore: Mutter und Kind, Mother and Child*, Käthe Kollwitz Museum, Cologne; Schloss Cappenberg, Kreis Unna; Kunstkreis, Norden; Ernst Barlach Museum, Ratzeburg; City Art Gallery, Huddersfield (The Henry Moore Foundation, Much Hadham)

Colorado Springs 1982: *Henry Moore: The Drawings*, Colorado Springs Arts Center, Colorado Springs

Columbus/Austin/Salt Lake City/Portland/ San Francisco 1984-85: *Henry Moore: The Reclining Figure*, Columbus Museum of Art, Columbus; Archer M. Huntingdon Gallery, Austin; Utah Museum of Fine Art, Salt Lake City; Portland Art Museum, Portland; San Francisco Museum of Modern Art, San Francisco

Coventry/Huddersfield/Wrexham/Bristol/ Eastbourne/Exeter/Stirling 1990-91: *Henry Moore: Sketch-Models and Working Models*, Mead Gallery, University of Warwick Arts Centre, Coventry; City Art Gallery, Huddersfield; Wrexham Library Arts Centre, Wrexham; Bristol Museum and Art Gallery, Bristol; Towner Art Gallery, Eastbourne; Royal Albert Memorial Museum, Exeter; Smith Art Gallery, Stirling (The South Bank Centre, London)

Durham 1982: *Henry Moore: Head-Helmet*, Durham Light Infantry Museum and Arts Centre

Düsseldorf 1987-88: *Und nicht die leiseste Spur einer Vorschrift: Positionen unabhängiger Kunst in Europa um 1937*, Kunstsammlung Nordrhein-Westfalen

East Berlin/Leipzig/Halle/Dresden 1984: *Henry Moore: Shelter and Coal Mining Drawings*, National Galerie der Staatlichen Museen, Berlin; Museum der Bildenden Künste, Leipzig; Staatliche Galerie Moritzburg, Halle; Staatliche Kunstsammlungen, Dresden (Ministerium für Kultur der Deutschen Demokratischen Republik)

Florence 1987: *Henry Moore: opere dal 1972 al 1984*, Palazzo Vecchio (Vallecchi Editore)

Folkestone 1983: *Henry Moore*, Arts Centre (Kent County Council Education Committee)

Forte dei Marmi 1982: *Henry Moore: sculture, disegni, opere grafiche*, Galleria Comunale d'Arte Moderna

Glasgow 1990: *Henry Moore in Scotland*, Pollok Park (Glasgow District Council, Festival Office)

Graz 1994: *Giacometti, Marini, Moore, Wotruba: Vier Klassiker der modernen Plastik*, Kulturhaus

Hamburg 1980: *Henry Moore auf der Moorweide*, Hamburg Moorweide (Förderkreis Grossplastik im Hamburger Stadtbild e.V.)

Harare/Bulawayo 1988: *Henry Moore: Working Model Bronzes*, National Gallery of Zimbabwe, Harare; Bulawayo Art Gallery, Bulawayo (The British Council, London)

Havana/Bogotá/Buenos Aires/Montevideo/ Santiago de Chile 1997-98: *Henry Moore: Hacia el Futuro*, Centro Wifredo Lam, Havana (The Henry Moore Foundation, Much Hadham); Museo Nacional de Colombia, Bogotá (Colcutura); Museo Nacional de Bellas Artes, Buenos Aires; Museo de Artes Visuales, Montevideo; Museo Nacional de Bellas Artes, Santiago de Chile (The British Council, Buenos Aires)

Helsinki 1987: *Henry Moore in Memoriam*, Didrichsenin Taidemuseo

Helsinki 1991: *Henry Moore: Inhimillinen Ulottuvuus*, Helsingin Kaupungin Taidemuseo

Hempstead/University Park/Philadelphia/ Baltimore 1987: *Henry Moore: Mother and Child*, Hofstra Museum, Hofstra University, Hempstead; Museum of Art, Pennsylvania State University, University Park; Arthur Ross Gallery, University of Pennsylvania, Philadelphia; Baltimore Art Museum, Baltimore

Herning 1984: *Henry Moore*, Herning Kunstmuseum

Hong Kong 1986: *The Art of Henry Moore*, Hong Kong Museum of Art and other venues (Hong Kong Urban Council)

Honolulu 1983: *Henry Moore: Bronzes and Graphics*, Honolulu Academy of Arts

Ittingen 1994: *Henry Moore: Shelter Drawings*, Kunstmuseum des Kantons Thurgau

Johannesburg/Pretoria/Johannesburg/Durban/ Bloemfontein/Kimberley/Pietermaritzburg/ Port Elizabeth/Cape Town 1984-85: *Image of Man: The Human Head in Modern Sculpture*, University of Witwatersrand, Johannesburg; Pretoria Art Museum, Pretoria; Johannesburg Art Gallery, Johannesburg; Durban Art Gallery, Durban; University of the Orange Free State, Bloemfontein; William Humphreys Art Gallery, Kimberley; Tatham Art Gallery, Pietermaritzburg; King George VI Art Gallery, Port Elizabeth; S.A. National Gallery, Cape Town (Peter Stuyvesant Foundation)

Krakow/Warsaw 1995: *Henry Moore: Retrospektywa*, Galeria BWA, Krakow; Centre for Contemporary Art, Ujazdowski Castle, Warsaw

Kuching/Kuala Lumpur/Penang 1989: *Henry Moore: Etchings, Lithographs and Sculptures 1949-1984*, Sarawak Art Gallery, Kuching; National Art Gallery, Kuala Lumpur; Universiti Sains Malaysia Museum and Art Gallery, Penang (The British Council, London)

Le Havre 1984: *Henry Moore: Sculptures, Dessins, Gravures*, Maison de la Culture du Havre, Espace Oscar Niemeyer

Leeds 1982-83: *Henry Moore: Early Carvings 1920-1940*, Leeds City Art Gallery

Leeds 1984-85: *Henry Moore: Sculpture in the Making*, The Henry Moore Centre for the Study of Sculpture, Leeds City Art Gallery

Leeds 1986: *Surrealism in Britain in the Thirties*, Leeds City Art Gallery

Leeds 1993-94: *Herbert Read: A British Vision of World Art*, Leeds City Art Gallery (published in association with the Henry Moore Foundation and Lund Humphries)

Leningrad/Moscow 1991: *Genri Mur: chelovecheskoye izmereniye*, Benois Museum, Petrodvorets, Leningrad; Pushkin Museum of Fine Art, Moscow (The British Council, London)

Lisbon 1981: *Henry Moore: Sculptures, Drawings, Graphics 1921-1981*, Calouste Gulbenkian Foundation

London 1977: *A Silver Jubilee Exhibition of Contemporary British Sculpture*, Battersea Park (London Celebrations Committee, Queen's Silver Jubilee)

London 1978: *Henry Moore at the Serpentine*, Serpentine Gallery and Kensington Gardens (Arts Council of Great Britain)

London 1981-82: *British Sculpture in the Twentieth Century*, Whitechapel Art Gallery

London 1983: *Henry Moore at 85: Some Recent Sculptures and Drawings*, Tate Gallery

London 1984: *Unit One: Spirit of the 30's*, Mayor Gallery

London (Tate) 1984: *The Hard-Won Image: Traditional Method and Subject in Recent British Art*, Tate Gallery

London 1985: *The Hayward Annual 1985*, Hayward Gallery (Arts Council of Great Britain)

London 1987: *A Tribute to Henry Moore 1898-1986*, Marlborough Fine Art

London/Stuttgart 1987: *British Art in the 20th Century: The Modern Movement*, Royal Academy of Arts, London; Staatsgalerie, Stuttgart (Prestel, Munich – English edition catalogue numbers cited)

London 1988: *Henry Moore*, Royal Academy of Arts (Royal Academy of Arts in association with Weidenfeld and Nicolson)

London (F.A.S.) 1988: *Henry Moore and Michael Rosenauer at the Fine Art Society*, Fine Art Society

London 1988-89: *Henry Moore: The Shelter Drawings*, British Museum

London 1990: *Festival of Fifty-One*, South Bank Centre, Royal Festival Hall

London 1992: *Drawing from the Imagination*, Morley Gallery

London 1996: *Design of the Times: One Hundred Years of the Royal College of Art*, Royal College of Art

Madrid 1981: *Henry Moore: Sculptures, Drawings, Graphics 1921-1981*, Palacio de Velázquez/ Palacio de Cristal/Parque de El Retiro (Ministerio de Cultura, Dirección General de Bellas Artes, Archivos y Bibliotecas/The British Council/The Henry Moore Foundation)

Manchester 1985: *Human Interest: Fifty Years of British Art About People*, Cornerhouse Gallery

Manchester 1987: *Henry Moore: An Exhibition of Sculptures and Graphics*, Castlefield Gallery

Mannheim 1996-97: *Henry Moore: Ursprung und Vollendung*, Städtische Kunsthalle (Prestel, Munich)

Mantua 1981: *Lo Spirito di Virgilio*, Palazzo Ducale (Electa, Milan)

Marl 1984: *Henry Moore, Mutter und Kind: Skulpturen, Zeichnungen, Grafik*, Skulpturenmuseum Glaskasten

Martigny 1989: *Henry Moore*, Fondation Pierre Gianadda (Electa, Milan)

Mechelen 1982: *Sociaal Engagement in de Kunst 1850-1950*, Cultureel Centrum

Mexico City 1982-83: *Henry Moore en México*, Museo de Arte Moderno

Mexico City 1990: *Octavio Paz: Los privilegios de la visita*, Centro Cultural Arte Contemporaneo

Milan 1989: *Henry Moore al Castello Sforzesco*, Castello Sforzesco (Edizioni L'Agrifoglio, Milan)

Milngavie/Ayr/Paisley/Kilmarnock/Dumfries 1990: *Henry Moore: Sculptor at Work*, Lillie Art Gallery, Milngavie; Maclaurin Art Gallery, Ayr; Paisley Museum and Art Gallery, Paisley; Dick Institute, Kilmarnock; Gracefield Arts Centre, Dumfries (Glasgow District Council, Festival Office)

Munich 1978: *Henry Moore Maquetten*, Bayerische Staatsgemäldesammlungen (Bruckmann)

Nantes 1996: *Henry Moore: l'expression première*, Musée des Beaux-Arts de Nantes (Réunion des Musées Nationaux)

New Delhi 1987: *Henry Moore: Sculptures, Drawings and Graphics*, National Gallery of Modern Art (National Gallery of Modern Art/The British Council)

New Orleans 1984: *Treasures of the Vatican*, New Orleans Vatican Pavilion

New York 1979-80: *Henry Moore: Drawings 1969-79*, Wildenstein (Raymond Spencer Company Ltd, Much Hadham)

New York 1983: *Henry Moore: 60 Years of His Art*, Metropolitan Museum of Art (Thames and Hudson)

New York/Detroit/Dallas 1984-85: *Primitivism in Twentieth Century Art: Affinity of the Tribal and the Modern*, Museum of Modern Art, New York; Detroit Institue of Arts, Detroit; Dallas Museum of Art, Dallas

Paris 1977: *Henry Moore: Sculptures et Dessins*, Orangerie des Tuileries (Editions des Musées Nationaux)

Paris (Bibliothèque Nationale) 1977: *Henry Moore*, Bibliothèque Nationale

Paris 1983: *Henry Moore*, Galerie Maeght

Paris 1989: *L'Europe des Grands Maîtres*, Musée Jacquemart André

Paris 1992: *Moore à Bagatelle*, Bagatelle Park (The Henry Moore Foundation, Much Hadham)

Paris (D.I.F.A) 1992: *Henry Moore Intime*, Didier Imbert Fine Arts, Paris (Editions du Regard)

Paris 1996: *Un Siècle de Sculpture Anglaise*, Galerie Nationale du Jeu de Paume

Paris (Champs Elysées) 1996: *Les Champs de la Sculpture*, Champs Elysées (Connaisance des Arts, no.86)

Paris 1996-97: *Années 30 en Europe 1929-1939*, Musée d'Art Moderne de la Ville de Paris (Paris Musées Flammarion)

Pforzheim/Bad Homburg 1994: *Henry Moore: Ethos und Form*, Reuchlinhaus, Pforzheim; Sinclair-Haus, Bad Homburg

Rome 1981: *Henry Moore*, Vigna Antoniniana Stamperia d'Arte (2 RC Editrice)

St Etienne 1987-88: *L'Art en Europe: les années décisives 1945-1953*, Musée d'Art Moderne de Saint-Etienne (Skira, Geneva)

Salzburg 1994: *Henry Moore: Shelter Drawings*, Rupertinum

Santiago de Compostela/Oporto 1995: *Contemporary British Sculpture: From Henry Moore to the 90s*, Auditorio de Galicia, Santiago de Compostela; Fundaçào de Serralves, Oporto

Scarborough/Aldeburgh/Stromness/Canterbury 1994: *Henry Moore and the Sea*, Scarborough Art Gallery, Scarborough; Aldeburgh Cinema Gallery, Aldeburgh; Pier Arts Centre, Stromness; Royal Museum Art Gallery, Canterbury (The Henry Moore Foundation, Much Hadham)

Schaan 1987: *Henry Moore: Skulpturen und Grafik*, Galerie am Lindenplatz

Selb/Amberg/Hamburg 1980: *Henry Moore: Bronzen – Zeichnungen – Grafik*, Rosenthal, Selb; Rosenthal, Amberg; Galerie Levy, Hamburg

Seoul 1982: *Henry Moore*, Ho-Am Art Museum (Samsung Foundation of Art and Culture)

Sezon/Kitakyushu/Hiroshima/Oita 1992-93: *Henry Moore Intime*, Sezon Museum of Art, Sezon; Kitakyushu Municipal Museum of Art, Kitakyushu; Hiroshima City Museum of Contemporary Art, Hiroshima; Oita Prefectural Museum of Art; Oita

Slovenj Gradec/Belgrade 1979-80: *Za Boljsi Svet. For a Better World: International Art Exhibition*, Umetnosti Paviljon, Slovenj Gradec; Serbain Academy of Sciences and Arts, Belgrade

Sofia 1981: *Henry Moore: Sculpture, Drawings, Graphics*, Pakovski 125

Southampton/Bradford/Stoke-on-Trent/Sheffield 1983-84: *Three Exhibitions about Sculpture*, Southampton Art Gallery, Southampton; Cartwright Hall Art Gallery, Bradford; Stoke Museum and Art Gallery, Stoke-on-Trent; Mappin Art Gallery, Sheffield (Arts Council of Great Britain, London)

Spoleto 1982: *Moore a Spoleto*, Palazzo Ancaiani

Stade 1997: *Britische Kunst an der Unterelbe: Britische Skulpturen der Nachkriegszeit aus Leeds*, Schwedenspeicher-Museum

Strasbourg 1989-90: *L'Europe des Grands Maîtres*, Musée des Beaux-Arts, Palais Rohan

Stuttgart 1987: *British Art in the 20th Century: The Modern Movement*, Staatsgalerie, Stuttgart (Prestel, Munich)

Sunderland 1982-83: *Henry Moore: Bronze Working Models*, Sunderland Arts Centre, Ceolfrith Gallery

Sunderland/Swansea/Leeds 1983-84: *Drawing in Air: An Exhibition of Sculptors' Drawings 1882-1982*, Sunderland Arts Centre, Sunderland; Glynn Vivian Art Gallery, Swansea; Leeds City Art Gallery, Leeds

Sydney 1992: *Henry Moore 1898-1986*, Art Gallery of New South Wales

Tel Aviv 1982: *Henry Moore in Israel: Sculpture, Drawings and Graphics*, Tel Aviv University/Horace Richter Gallery (Nathan Silberberg Fine Arts, New York)

Tokyo/Fukuoka 1986: *The Art of Henry Moore: Sculptures, Drawings and Graphics 1921-1984*, Metropolitan Art Museum, Tokyo; Fukuoka Art Museum, Fukuoka (The Tokyo Shimbun)

Toronto/Iwaki-Shi/Kanazawa/Kumamoto/Tokyo/London 1977-78: *The Drawings of Henry Moore*, Art Gallery of Ontario, Toronto; Shimin Art Gallery Museum, Iwaki-Shi; Ishikawa Prefectural Museum, Kanazawa; Kumamoto Prefectural Art Museum, Kumamoto; Seibu Museum, Tokyo; Tate Gallery, London (A separate catalogue for the Japanese venues entitled *In Praise of Life, Henry Moore: Drawings and Sculptures* was published by the Yomiuri Shimbun)

Toronto 1981-82: *Gauguin to Moore: Primitivism in Modern Sculpture*, Art Gallery of Ontario

Venice 1995: *Henry Moore: Sculture, disegni, incisioni, arazzi*, Fondazione Giorgio Cini (Electa, Milan)

Vienna/Munich 1983-84: *Henry Moore: Skulpturen, Zeichnungen, Grafiken*, Palais Auersperg, Vienna; Residenz, Munich (Habarta Verlag)

Wakefield 1987: *Henry Moore and Landscape*, Yorkshire Sculpture Park

Wakefield 1994: *Henry Moore: The Late Carvings*, Yorkshire Sculpture Park

Wakefield 1994-95: *Henry Moore in Bretton Country Park*, Yorkshire Sculpture Park

Winchester 1985: *Henry Moore*, Great Court Yard and Great Hall (Hampshire County Council)

Zug 1978: *Henry Moore: Graphik 1939-1977*, Landis und Gyr

Bibliography

Bibliography

Henry Moore Bibliography, vols.1-3 1898-1986, compiled and edited by Alexander Davis 1992; vols.4-5 1986-1991, compiled and edited by Alexander Davis 1994; The Henry Moore Foundation, Much Hadham

Catalogues raisonnés

Henry Moore: Complete Drawings, vol.1 1916-29, edited by Ann Garrould 1996; vol.5 1977-81; vol.6 1982-83, edited by Ann Garrould 1994; The Henry Moore Foundation in association with Lund Humphries, London

Henry Moore: Complete Sculpture, vol.1 1921-48 (*Sculpture and Drawings*) edited by Herbert Read 1944, 4th revised edition edited by David Sylvester 1957; vol.2 1949-54 edited by David Sylvester 1955, 3rd revised edition edited by Alan Bowness 1986; vol.3 1955-64 edited by Alan Bowness 1965; vol.4 1964-73 edited by Alan Bowness 1977; vol.5 1974-80 edited by Alan Bowness 1983, 2nd revised edition 1994; vol.6 1981-86 edited by Alan Bowness 1988; Lund Humphries, London

Henry Moore: Catalogue of Graphic Work [vol.I] 1931-72 edited by Gérald Cramer, Alistair Grant and David Mitchinson 1973; vol.II 1973-75 edited by Gérald Cramer, Alistair Grant and David Mitchinson 1976; vol.III 1976-79 edited by Patrick Cramer, Alistair Grant and David Mitchinson 1980; vol.IV 1980-84 edited by Patrick Cramer, Alistair Grant and David Mitchinson 1988; Cramer, Geneva

Publications cited in text

Allemand-Cosneau, Fath, Mitchinson 1996: Claude Allemand-Cosneau, Manfred Fath, David Mitchinson, *Henry Moore: From the Inside Out*, Prestel Verlag, Munich 1996

Berthoud 1987: Roger Berthoud, *The Life of Henry Moore*, Faber and Faber, London 1987

Christie's, London 30 March 1982: *Impressionist and Modern Watercolours and Drawings*

Christie's, London 22 March 1983: *Impressionist and Modern Watercolours and Drawings*

Christie's, New York 13 November 1985: *Impressionist and Modern Drawings and Watercolours*

Clark 1974: Kenneth Clark, *Henry Moore Drawings*, Thames and Hudson, London 1974

Cohen 1993: David Cohen, *Moore in the Bagatelle Gardens, Paris*, The Henry Moore Foundation, Much Hadham 1993

De Micheli 1989: Mario de Micheli, *Henry Moore i disegni*, L'Agrifoglio, Milan 1989

Farr 1978: Denis Farr, *English Art 1870-1940*, Oxford University Press, Oxford 1978

Fuller 1993: Peter Fuller, *Henry Moore: An Interpretation*, Methuen, London 1993

Garrould 1988: Ann Garrould, *Henry Moore Drawings*, Thames and Hudson, London 1988

Garrould, Power 1988: Ann Garrould and Valerie Power, *Henry Moore Tapestries*, Diptych, London 1988

Hedgecoe 1968: John Hedgecoe, *Henry Spencer Moore*, Nelson, London 1968

Hedgecoe 1986: John Hedgecoe, *Henry Moore: My Ideas, Inspiration and Life as an Artist*, Ebury Press, London 1986

James (ed.) 1966: Philip James, *Henry Moore on Sculpture*, Macdonald, London 1966; Da Capo Press, New York 1992

Levine 1978: Gemma Levine, *With Henry Moore: The Artist at Work*, Sidgwick and Jackson, London 1978

Levine 1983: Gemma Levine, *Henry Moore: Wood Sculpture*, Sidgwick and Jackson, London 1983

Lynton 1991: Norbert Lynton, *Henry Moore: The Human Dimension*, HMF Enterprises/British Council, London 1991

Mitchinson 1971: David Mitchinson, *Henry Moore: Unpublished Drawings*, Fratelli Pozzo, Turin 1971

Mitchinson (ed.) 1981: David Mitchinson, *Henry Moore: Sculpture*, Macmillan, London and Basingstoke 1981

Moore 1967: *Shelter Sketchbook 1940-1942*, Marlborough Fine Art, London 1967

Moore 1976 (facsimile): *Sketchbook 1926*, Ganymed Original Editions, London 1976

Moore 1980: *Sheep Sketchbook*, Thames and Hudson, London 1980

Moore 1981: *Henry Moore at the British Museum*, British Museum Publications, London 1981

Moore 1982 (facsimile): *Sketchbook 1928: The West Wind Relief*, Raymond Spencer Company, Much Hadham 1982

Moore 1988: *A Shelter Sketchbook*, British Museum Publications, London 1988

Packer 1985: William Packer, *Henry Moore: An Illustrated Biography*, Weidenfeld and Nicolson, London 1985

Read 1965: Herbert Read, *Henry Moore: A Study of His Life and Work*, Thames and Hudson, London 1965

Read 1979: John Read, *Henry Moore: Portrait of an Artist*, Whizzard Press, London 1979

Russell 1968: John Russell, *Henry Moore*, Allen Lane, London 1968; Penguin Books, London 1973

Sotheby Parke Bernet 20-22 March 1979: *Britwell House: The Contents of the House*

Sotheby's, London 5 March 1980: *Catalogue of Modern British Drawings, Paintings and Sculpture*

Sotheby's, London 26 March 1980: *Catalogue of Impressionist and Modern Drawings and Watercolours*

Sotheby's, London 2 July 1980: *Catalogue of Important Impressionist and Modern Drawings and Watercolours*

Sotheby's, London 1 December 1982: *Catalogue of Impressionist and Modern Drawings and Watercolours*

Sotheby's, New York 15 May 1985: *Impressionist and Modern Drawings and Watercolours*

Sotheby's, New York 17 May 1990: *Impressionist and Modern Drawings and Watercolours*

Sotheby's, New York 14 May 1992: *Impressionist and Modern Paintings, Drawings and Sculpture, Part 2*

Sotheby's, New York 13-14 May 1997: *Henry Moore: Artist and Collector: Property from the Collection of Mary Moore and Various Trusts*

Spender 1986: Stephen Spender, *In Irina's Garden*, Thames and Hudson, London 1986

Strachan 1983: Walter Strachan, *Henry Moore: Animals*, Aurum Press/Bernard Jacobson, London 1983

Sylvester 1968, David Sylvester, *Henry Moore*, The Arts Council of Great Britain, London 1968

Wilkinson 1984: Alan Wilkinson, *The Drawings of Henry Moore*, Garland, London and New York 1984

Wilkinson 1987: Alan Wilkinson, *Henry Moore Remembered: The Collection at the Art Gallery of Ontario in Toronto*, Art Gallery of Ontario/Key Porter Books, Toronto 1987

Contributors and Photographers

Contributors

Catalogue numbers in **bold** refer to Notebook entries.

Julian Andrews was Director of the Fine Arts Department of the British Council, London 1980-86, when he was responsible for the co-ordination of Henry Moore exhibitions in Madrid, Lisbon and Barcelona during 1981-82, Mexico City and Caracas in 1982-83, East Berlin, Leipzig, Halle and Dresden in 1984, and Hong Kong, Tokyo and Fukuoka in 1986. He contributed the introductory text on Moore's Shelter and Coalmining drawings to the catalogue of the 1984 German exhibition and spoke about Moore's war drawings in the film *Henry Moore: A Private View* made at the Royal Academy of Arts, London 1988.
Cats.115, **116-129**, 117, 118, 120, 122, 123, 124, 125, 126, 127, 128, 129, 132, 133, **134-138**, 134, 135, 136, 138, 139, 158, 233

Roger Berthoud, freelance writer and journalist, is the author of Moore's biography, *The Life of Henry Moore*, published in 1987.
Cats.32, 137, 207, 246

Giovanni Carandente CBE, the art historian, curated and wrote the catalogue for the notable exhibition *Mostra di Henry Moore* at the Forte di Belvedere, Florence 1972. He was also author of the catalogue for *Henry Moore: Opere dal 1972 al 1984*, an exhibition held in Florence in 1987.
Cats.9, 21, 25, 56, 94, 159, 217, 221, 223, 248

Frances Carey is Deputy Keeper of Prints and Drawings at the British Museum, where she was responsible for the exhibition *Henry Moore: The Shelter Drawings* in 1988.
Cats.15, 16, 105, 118, 120, 121, 131, 140

Sir Anthony Caro CBE, the sculptor, was assistant to Henry Moore in 1951-53.
Cats.46, 49, 103, 119, 156, 168, 170, 199, 230

David Cohen is a freelance writer and journalist who contributed texts for the catalogue to the exhibition *Henry Moore in Scotland* in 1990 and for the book on the 1992 Paris exhibition, *Moore in the Bagatelle Gardens*.
Cats.92, 130, 157, 165, 173, 227, 232, 236, 265, 273

Dr Susan Compton curated the major Moore retrospective at the Royal Academy of Arts, London, in 1988, for which she compiled the catalogue. She also spoke about Moore's work in the film *Henry Moore: A Private View*. Her other writings on Moore include catalogue texts for the exhibitions in Martigny 1989, Sydney 1992, and Krakow/Warsaw in 1995.
Cats.54, 61, 113, 141, 147, 148, 149, 150, 214, 226, 247, 267, 277

Richard Cork, writer, critic and broadcaster, contributed the essay 'An Art of the Open Air: Moore's Major Public Sculpture' to the catalogue for the Moore exhibition at the Royal Academy of Arts in 1988.
Cats.2, 10, 24, 65, 66, 67, 68, 83, 85, 188

Dr Penelope Curtis is Curator of the Henry Moore Centre for the Study of Sculpture at the City Art Gallery, Leeds.
Cats.3, 4, 12, 37, 71, 79, 80, 81, 100, 107, 155

Deborah Emont-Scott is Sanders Sosland Curator of Twentieth Century Art at the Nelson-Atkins Museum of Art, Kansas City, where she is responsible for the largest collection of Henry Moore's work in the United States.
Cats.187, 225

Anita Feldman Bennet was appointed Assistant Curator of the Henry Moore Foundation in 1996. She wrote the catalogue for the exhibition *Henry Moore: Hacia el Futuro* seen in Buenos Aires, Montevideo and Santiago 1997-98.
Cats.1, 33, 96, 109, 142, 204, 208, 241, 256, 259, 260, 261, 268, 269

Dr Terry Friedman, the art historian, was Principal Keeper of Leeds City Art Gallery, when he co-curated the exhibitions *Henry Moore: Early Carvings 1920-1940* in 1982 and *Henry Moore: Sculpture in the Making*, 1984-85.
Cats.6, 11, 48, 60, 78, 108, 169, 177, 207, 271

Gail Gelburd, while Curator of the Hofstra Museum at Hofstra University, Hempstead, co-curated *Mother and Child: The Art of Henry Moore*, an exhibition which went on to University Park, Philadelphia and Baltimore. She also wrote the introduction to *Henry Moore: Mother and Child Etchings*, published in 1988. She is now Executive Director of the Council for Creative Projects, New York.
Cats.93, 117, 144, 154, 162, 189, 218, 272, 275, 276

Clare Hillman worked as a researcher at the Henry Moore Foundation during 1995 and 1996, and contributed to the catalogue for the exhibition *Henry Moore: From the Inside Out* shown in Nantes and Mannheim during 1996.
Cats.13, 69, 77, 153, 161, 182, 194, 212, 263, 266

Professor Phillip King CBE, the sculptor, was assistant to Henry Moore in 1959-60.
Cats.184, 191

Professor Dr Christa Lichtenstern is Professor of Art History at the University of Marburg. She has written several articles on Moore and contributed a major essay to the catalogue for the exhibition *Henry Moore: Ethos und Form* shown in Pforzheim and Bad Homburg in 1994.
Cats.53, 73, 145, 146, 151, 191, 211, 215, 219, 239

Professor Norbert Lynton, critic and art historian, was Professor of the History of Art at the University of Sussex. He contributed an essay to the catalogue accompanying the exhibition *Henry Moore: Sculptures, Drawings, Graphics 1922 to 1984* in New Delhi 1987, and wrote the introduction to *Henry Moore: The Human Dimension* which, in translation, was used for the catalogue to the exhibition held in Leningrad, Moscow and Helsinki in 1991.
Cats.23, 43, 57, 82, 86, 87, 171, 179, 216, 235

Professor Bernard Meadows, the sculptor, was Henry Moore's assistant during 1936-40. He was Professor of Sculpture at the Royal College of Art from 1960 to 1980. He became a Trustee of the Henry Moore Foundation in 1980, and in 1983 was appointed acting director. Since 1988 he has been sculpture consultant to the Foundation.
Cats.11, 102, 237

Peter Murray OBE is Director of the Yorkshire Sculpture Park, near Wakefield. In 1987 he curated *Henry Moore and Landscape*, an exhibition for which he also wrote the catalogue.
Cats.204, 222

William Packer, writer and critic, is the author of *Henry Moore: An Illustrated Biography*, published in 1985. The following year he contributed an essay to the catalogue for *The Art of Henry Moore*, an exhibition shown in Tokyo and Fukuoka.
Cats.14, 55, 180, 198, 203, 224, 238

John Read is a film director and producer whose work includes five films on Moore made for the BBC: *Henry Moore*, 1951; *A Sculptor's Landscape*, 1958; *Henry Moore: One Yorkshireman Looks at His World*, 1967; *Henry Moore: The Language of Sculpture*, 1973; *Henry Moore at Home: A Private View of a Personal Collection*, 1973. He is the author of *Portrait of an Artist: Henry Moore*, published in 1979.
Cats.8, 30, 44, 143, 160, 170, 200, 206, 207, 231, 240

Reinhard Rudolph was Assistant Curator of the Henry Moore Foundation from 1992 to 1997. He was co-curator of the exhibition *Henry Moore: Animals* held in Bremen, Berlin and Heilbronn during 1997-98, for which he contributed the catalogue essay.
Cats.163, 164, 178, 213, 228, 229, 243, 264

Julian Stallabrass is Deputy Editor of *New Left Review*. Between 1989 and 1995 he worked as a researcher and cataloguer for the Henry Moore Foundation, during which time he wrote the main essay for the catalogue to the Moore exhibition in Bilbao in 1990. He was also co-author of *Henry Moore*, published by Ediciones Polígrafa, Barcelona 1992.
Cats.20, 35, 50, 64, 95, 175, 185, 201, 249, 270

Julie Summers was Assistant Curator of the Henry Moore Foundation from 1989 to 1992 and Deputy Curator from 1992 to 1996. During this time she co-curated many exhibitions including *Henry Moore in Scotland* in 1990, Bilbao 1990, the *Mother and Child* touring exhibition in 1992, Budapest, Bratislava/Prague 1993, and Pforzheim/Bad Homburg 1994. She was curator of *Henry Moore and the Sea* which travelled to seven venues in Britain during 1993-94, and co-curator of the exhibition of monumental works in Paris 1992. She played a prominent role in the exhibition *Henry Moore: From the Inside Out* shown in Nantes and Mannheim in 1996, for which she also contributed to the catalogue.
Cats.88, 101, 152, 181, 192, 220, 245, 257, 278

Dr Alan Wilkinson was Curator of the Moore Centre at the Art Gallery of Ontario, Toronto, from its opening in 1974 until 1994. During the early 1970s he worked closely with Henry Moore in the preparation of his doctoral thesis on Moore's drawings, which was subsequently published in 1984. He has written several other works on Moore, including *Henry Moore Remembered*, published in 1987. He curated *The Drawings of Henry Moore*, a touring exhibition in 1977-78 which began in Toronto and travelled to four venues in Japan and then to the Tate Gallery, London, for which he also wrote the catalogue.
Cats.**3-6**, 3, 5, **15-18**, 16, 17, **27-29**, 27, 28, 29, **36-41**, 38, 39, 41, 42, 63, 110, 111, 174, 186, 205

Photographers

The Henry Moore Foundation
archive photographs: fig.12; cats.103 (first), 105, 112, 140, 154, 189, 230 (both), 237, 266

Bo Boustedt: figs.7, 8, 10

Brian Coxall: cats.67, 94, 145, 167, 170 (second), 180, 247, 264, 265 (both), 277, 278

Prudence Cuming Associates: cat.113

Rosemary and Penelope Ellis: fig.6; cats.256, 274

John Farnham: figs.17, 22; cat.225

Anita Feldman Bennet: cats.24, 102, 108, 156 (both), 162, 164, 166, 175, 182, 185, 186, 190, 192, 203 (lower), 209, 213, 221, 268

Fondation Pierre Gianadda, Martigny: fig.15

Dennis Gilbert, London: cover; figs.18, 19; cats.171, 212

Jerry Hardman-Jones: cats.23, 64, 232

John Hedgecoe: fig.4

Errol Jackson: front flap; p.6; figs.9, 11 (reproduced by kind permission of John Farnham); cats.11 (both), 48, 57, 85, 109, 146, 178, 179, 217

Barry Lee/Hawkeye Aerial Photography: fig.1

David Mitchinson: figs.2, 3, 5, 16, 23, 26, 27; cats.191, 194 (second), 238 (first)

Henry Moore: cats.22, 93, 101, 110, 111, 160, 163, 172, 173, 193, 198, 199, 202, 205-207, 210, 214, 228, 229, 235, 240, 261, 265, 269, 270

Michel Muller: p.67; fig.24; cats.1-10, 12-21, 26-32, 34-41, 44-47, 49-56, 58-63, 65, 68, 69, 72-78, 86-92, 95-100, 103 (second), 104, 107, 114-139,

141, 143, 144, 147-153, 155, 157-159, 161, 165, 168, 169, 170 (first), 174, 176, 177 (both), 181, 183, 184, 187, 188, 195-197, 201, 203 (upper), 204, 208, 215, 216, 218, 220, 223, 224, 227, 233, 234, 236, 238 (second), 239, 241, 243-245, 248-255, 257-260, 263, 267, 272, 273, 276

Mário de Oliviera/Fundaçao Calouste Gulbenkian, Lisbon: cat.246

Sotheby's, New York: cats.33, 66, 106

Julian Stallabrass: cats.82, 83, 194 (first), 200, 231, 275

Mark Stower: cat.262

Norman Taylor/City Art Gallery, Leeds: cat.271

Rosemary Walker: fig.25

John Webb: cats.25, 242

Margita Winkenhäuser/Kunsthalle, Mannheim: cats.42, 43, 70, 71, 79-81, 84, 226

Yorkshire Sculpture Park
archive photographs: figs.13, 14, 20

Jerry Hardman-Jones: cats.211, 222

Alan Mackenzie: fig.21

Jonty Wilde: cat.219

Index of Works

Page numbers in **bold** refer to main entries, those in *italic* to illustrations in the introduction.

General Index

Page numbers in *italic* refer to
illustrations in the introduction.